THE FIRST GUANGZHOU

Reinterpretation: A Decade of Experimental Chinese Art

(1990-2000)

Wu Hung

with

Wang Huangsheng

Feng Boyi

This publication was produced with the exhibition "The First Guangzhou Triennial — Reinterpretation: A Decade of Experimental Chinese Art 1990-2000" at the Guangdong Museum of Art from November 18 , 2002 to January 19, 2003.

Edited by Wu Hung, Wang Huangsheng, Feng Boyi
Designed by Wu Tao, Tan Peng, Zhi Zhi, Tang Yan
Production coordinated by Artron Colour Printing, Ltd.

Co-Published and Distributed in the USA by
Art Media Resources, Ltd.
1507 South Michigan Avenue
Chicago, IL 60605 USA
Tel: 312-663-5351
Fax: 312-663-5177
E-mail: info@artmediaresources.com
Web: www.artmediaresources.com

ISBN: 1-58886-036-1 (Softcover)
ISBN: 1-58886-057-4 (Hardcover)

Contents

Foreword

Wang Huangsheng
Director, Guangdong Museum of Art
November, 2002

Since the establishment of the Guangdong Museum of Art in November 1997, Mr. Lin Kangsheng, the former director of the museum, and I have been contemplating the idea of planning and hosting a series of large, representative exhibitions, which would reflect our contemporary thoughts and academic standards. We also hope to promote the cultural strengths and build a new image of Guangzhou, the city where the museum is situated, through such large art exhibitions. To borrow a popular phrase, we hope to "create the city's cultural brand." In some major cities and regions in China and abroad, these large exhibitions are usually entitled "biennial," "triennial," etc., which refer to characteristics such as large, contemporary, international and periodic. Consequently, the exhibition often becomes the cultural symbol of a city, a region, and even a country. Of course, whether an exhibition can become a "cultural symbol" or not must also depend on its quality, seriousness, and overall effect. The notion of "perseverance" also plays a key part in this.

In 2000, Dr. Wu Hung, the Harrie A. Vanderstappen Distinguished Service Professor of Chinese Art History at the University of Chicago, came to visit the Museum. We consulted with him about the idea of organizing a large contemporary art exhibition. After inspecting our facilities and studying our history, he gave enthusiastic encouragement for our ideas and methods. In January 2001, while attending the East Asia Museum Experts Workshop held at MoMA, New York, I had many detailed discussions with him regarding our project, and worked out a tentative theme and intellectual intent for the first Guangzhou contemporary art triennial exhibition.

Shortly after my return from New York, we convened a conference of the Guangdong Museum of Art advisory committee, presenting to the committee our preliminary ideas. The committee's response was absolutely positive; the experts carefully discussed the feasibility of the exhibition and provided valuable advice. Following this conference, the museum embarked on the intensive preparation of the First Guangzhou Triennial. A curatorial committee was set up, comprising Dr. Wu Hung, Professor Huang Zhuan, Mr. Feng Boyi and myself, with Dr. Wu Hung as the chief curator. We defined the academic theme and title of this first Triennial as "Reinterpretation: A Decade of Experimental Chinese Art (1990-2000)." The exhibition consists of four parts: "Memory and Reality," "Self and Environment," "Global and Local," and "Experimentation Continues." We also decided to organize, in conjunction with the exhibition, an international symposium on contemporary art exhibitions and curatorial practices entitled "Place and Model: Rethinking and Reinventing Contemporary Art Exhibitions." A large catalogue including essays from many specialists in China and abroad will also be published. This catalogue will be an overall presentation of Chinese experimental art in the 1990s, as well as a systematic study of special subjects and an academic "combing" of related issues.

From the museum's point of view, our task of planning and hosting such a series of large and on-going exhibitions is to make it different from other "Triennials." In other words, the Guangzhou Triennial should have its own features, characters, and positioning. At the present time, when "Biennial" and "Triennial" exhibitions are fashionable, there are weeds among the seedlings. Therefore, an idealistic and hard-working spirit, an open-minded academic attitude, a realistic and humanistic mind, and an intense and rigorous historic attitude are extremely important. It would be our last wish to see this exhibition turn out to be a bustling yet inane formality.

For this reason, our basic ideology for the long-term program of the Guangzhou Triennial is: "care for culture, respect history." It appears to us that culture is rooted in history and contributes to history; culture is the "face" of history and the reflection of the spiritual state of reality and people. The accumulation of cultural specimens makes up an unabridged history — a history with depth and breadth. To explore reality and history through culture should be a valid way to express contemporary thinking. Art is a special form of culture, and it recounts history in a keen and perceptive way; it is not only the result of culture but also the narrator of culture. Art's dual identity enables it to do two things — recount culture while constructing history — simultaneously.

Based on the above thought, we believe that the Guangzhou Triennial will not turn out to be a mere concentrated display of artwork, but will surely contain the cultural themes of caring for reality, responding to history and narrating human existence. This is the soul of our exhibition. To record our spiritual reaction against and correlative thought of our time in the form of art, and to participate in the construction of human civilization in a distinctive way is the career ideal which we hold deep in heart. *The First Guangzhou Triennial* takes this as its starting point.

Our deepest gratitude goes to Dr. Wu Hung for his profound sense of history, his open cultural and intellectual vision, which ensures that from theme-planning to content-creation, this exhibition can be handled on the basis of serious theoretical reflections. My sincere thanks also go to Mr. Feng Boyi and Professor Huang Zhuan for their keen rational spirit and high sense of duty, which made the implementation of our plans efficient and speedy. I extend my deepest thanks to all participating artists as well as all experts and scholars who were involved in the study, writing and translation of the special subjects in this catalogue. I am grateful to all the organizations and friends for their incredible support, encouragement and sponsorship. This exhibition would not be possible without the dedication and enthusiasm of the colleagues who have been involved in this ambitious project. I am therefore especially grateful to them for all their hard work in support of our exhibition.

The First Guangzhou Triennial— Reinterpretation: A Decade of Experimental Chinese Art (1990-2000) starts off with our ideal.

From the Editors

As a vital component of *The First Guangzhou Triennial*, this volume complements the exhibition rather than simply recording it; its purpose is to provide a systematic account and *reinterpretation* of 1990s Chinese experimental art in terms of the general development of this art as well as its representative examples. Because this publication will outlive the exhibition and be available to readers around the world, we have planned it as a self-contained volume with a broader agenda. Most fundamentally, we hope that it will establish a new base for studying Chinese experimental art by providing many kinds of information, including textual analyses, illustrations and explanations of representative works, and reference materials.

Part One of this volume is an overview of Chinese experimental art and film during the 1990s. The introduction to this part explains the concept of "experimental art" and outlines the basic characteristics and historical significance of 1990s experimental art. This introduction is followed by thirteen specialized essays; their topics range from various art mediums and forms to the artist's social status and roles, and from the globalization of Chinese experimental art to exhibitions of and criticism on this art both inside and outside China. Also included here are three essays on Chinese experimental cinema during the 1990s. These texts complement and interact with one another, together constituting a general narrative of Chinese experimental art and film in that decade.

Part Two analyzes 1990s experimental art on a more concrete level by focusing on its representative works. For this triennial, the curatorial committee has selected 166 works by 135 artists through repeated discussions. Exemplifying important directions of 1990s experimental art and the artists' breakthroughs at certain stages, these works are grouped into three thematic sections entitled "Memory and Reality," "Self and Environment," and "Global and Local." Each section begins with a general discussion of the theme and its relevance to the works in the section. For the explanations of the individual works, we asked the artists to provide basic data, which we then compiled into concise statements. In so doing, we hope that these explanations can closely reflect the artists' own understanding of their art. Because of the special nature of video art, the curatorial committee invited Wu Meichun and Qiu Zhijie to design an "exhibition of video works" as part of the triennial and to introduce these works in the volume. The last section in this part consists of project proposals by 16 artists, who have been invited to create new works for the triennial. Under the title "Experimentation Continues," these projects indicate current and future directions in Chinese experimental art.

Part Three provides two kinds of research materials for studying 1990s Chinese experimental art. The first is a chronicle of experimental art exhibitions and other events related to this art. The second is a bibliography of reports and research works in different languages. Because many experimental art exhibitions during the 1990s were privately organized and their catalogues are difficult to locate, it is almost certain that the chronicle and bibliography are incomplete. These materials are provided here as a basis for future refinement. In compiling the bibliography we have consulted previous bibliographies on contemporary Chinese art in books and on the internet. A major resource is a bibliography of contemporary Chinese art up to 1999 compiled by Britta Erickson, which is available through the website of Stanford University's Art History Department. We want to express our thanks to the compilers of this and other bibliographies.

The basic structure of this volume was proposed by Wu Hung and approved by the triennial's curatorial committee. According to the original plan, Wu Hung, Huang Zhuan, and Feng Boyi — the three curators of the triennial—were to compile and edit the volume. But because Huang Zhuan fell ill, Wu Hung and Feng Boyi ended up carrying out this task. As the director of the Guangdong Museum of Art , Wang Huansheng oversaw the entire organization of the Guangzhou Triennial, including both the exhibition and this publication. To broaden the volume's readership, we decided to publish two separate versions, one in Chinese and one in English. We are grateful to Karen Smith, who organized the huge amount of translation work involved and who also initially edited

the English translations. We are grateful to Joy Le (Le Qi), who spent many hours checking all the Chinese and English translations against the originals, and made many suggestions for further revisions. We thank also Philip Tinari for his diligence in copy editing the final English manuscript. We want to thank the translators, including Mao Weidong, Wen Jingen, Li Yuan, Zhang Shaoning, and Zhang Zhiqiu, and people who contributed to the Chronicle at different stages of its compilation, including Liu Libin, Hua Tianxue, Qian Zhijian, Cai Ning, Song Dong, Guo Shirui, Sun Hongbing, Qiu Zhijie, Gu Zhenqing, Zhu Qi, Robert Bernell, Xie Wenyao, and Han Jinsong. The American publisher Art Media provided funding for printing the English version and is serving as the overseas distributor of this version. We want to thank Mr. Jeffrey Moi, the general manager of Art Media, for his support of this project.

Finally, as independent curators and editors invited to participate in this project, we want to express our sincere thanks to the Guangdong Museum of Art , the organizer of the triennial and the publisher of this volume. We are especially grateful to Mr. Wang Huangsheng, who initiated this whole project and guaranteed its realization. Mr. Wang Jia and Ms. Guo Xiaoyan also made crucial contributions to the organization of the exhibition and the compilation of this publication. Without their initiation, support and participation, our plan to compile this volume could never have become reality.

Part One: Overview

Introduction:
A Decade of Chinese Experimental Art (1990–2000)

Wu Hung

As the title of this exhibition indicates, its main purpose is not just to showcase a group of works of Chinese experimental art from the 1990s; it is, more importantly, to *reinterpret* this art through various means. These means include selecting works for the exhibition through a comprehensive review of Chinese art in those ten years, developing an interpretative structure for the exhibition to highlight major themes and trends, and especially compiling this volume, which frames individual artists and their works (discussed in Part Two) with an overview of 1990s Chinese experimental art in this section.

A reinterpretation always reacts to and revises existing interpretations. In this case, however, our purpose is not simply to replace one opinion with another. The organizers of this project share the understanding that Chinese experimental art in the 1990s is at once a highly significant and extremely complex phenomenon; any serious interpretation or reinterpretation of this art and cinema must respond to both historical and methodological challenges, as the interpreter needs not only to expand research materials but also to re-examine analytical standards and approaches. It is on this basic level of scholarship that we question previous interpretations of this art, which more than often lacked research basis and/or expressed the interpreter's self-interest. Especially, the simultaneous introduction of this art to the West through exhibitions and publications is itself a complex phenomenon in the 1990s. While these exhibitions and publications helped globalize this art, their organizers and authors often had limited knowledge of contemporary Chinese artists and the social-cultural context of their works; their promotion of this art often reflected their own tastes and biases. In China, experimental art has been condemned by orthodox art critics. But even the supporters of this art are divided by different views and ideological positions; some of them oppose cultural and stylistic hybridity—an important feature of Chinese experimental art in the 1990s—from a nationalistic stance.

Envisioned as a collective effort rather than another individual expression, the *reinterpretation* pursued through the current exhibition/publication project has an important goal in establishing a platform for group research and discussion. The fourteen essays in this section focus on various aspects of 1990s experimental art, from various art mediums and genres to artists' changing status, and from broadening exhibition channels to overseas reception. The authors of these essays include six Chinese art critics and curators, a Chinese experimental artist and a filmmaker, a British curator/critic residing in Beijing, and four scholars living and working outside China. No attempt was made on this editor's part to unify the narratives and approaches of these authors. On the other hand, although resulting from independent research, these essays complement each other and together depict a larger picture of 1990s Chinese experimental art. The inclusion of three essays on Chinese experimental cinema in the 1990s reflects our hope to study experimental art in conjunction with contemporaneous artistic phenomena. Through exploring the parallels and connections between experimental art and other art forms, we can better understand the general tendencies in Chinese art and culture during this period.

Methodologically, these essays exemplify three types of analysis, which are essential to any study of Chinese experimental art of the 1990s. The first type contextualizes this art both synchronically and diachronically, exploring its relationship with 1980s experimental art on the one hand, and with China's transformation and globalization in the 1990s on the other hand. The second type of analysis traces the development of Chinese experimental art during the ten years from 1990 to 2000. By investigating changes in content, style, function, and intention of experimental art, such study reveals a dynamic process of constant renewal. The third kind of analysis responds to questions concerning the relationship between experimental art and the surrounding world: How did this art create its "public" and how was it perceived by various kinds of interpreters —critics, curators, and historians—both inside and outside China?

This introduction does not summarize these essays. Rather, it intends to provide these more specialized discussions with a common basis by focusing on three general issues: (1) the concept of "experimental art" as

understood in the Chinese context, (2) the historical background of 1990s experimental art, and (3) the changing roles and status of experimental artists in the 1990s. This introduction and the thirteen essays constitute part of our attempt to reinterpret Chinese experimental art in the 1990s. Part Two in this catalogue continues this discussion on a more concrete level, and analyzes specific examples of this art in three thematic sections centered on "memory and reality," "self and environment," and "global and local."

The Notion of "Experimental Art"

It is necessary to first explain the concept of "experimental art" (*shiyan meishu*) —the subject of this exhibition and publication. Many books and articles correlate this type of contemporary Chinese art with more familiar concepts and historical categories, especially the Western avant-garde that aimed to subvert existing art traditions and institutions. On the other hand, scholars have noted that because of the special experience and socio-political context of contemporary Chinese art, such general correlation can only provide initial entries to closer observations and interpretations. Instead of understanding contemporary Chinese art according to a ready-made Western model, it is crucial to define the experimental or revolutionary nature of this art historically and contextually. We agree with this second approach.

The applicability of the term "avant-garde" to contemporary Chinese art is the subject of on-going debate. Some scholars, mostly specialists in European modernism, argue that historical avant-gardism is strictly a Western phenomenon and so the term "avant-garde" should be used only in its original historical context. Other scholars, typically writing on contemporary Chinese art, hope to apply the concept of avant-garde to this art by broadening its definition. [1] A third position, however, is to get away from this debate: instead of putting too much pressure on "naming" a specific tradition in contemporary Chinese art, it is perhaps more productive to find a more flexible designation for this tradition. The purpose of such a designation is not to bring interpretation to a closure, but to encourage fresh observations and to open up new spaces for historical and theoretical inquiries. The term "experimental art" offers such a possibility. It is interesting to note that while *xianfeng* and *qianwei* —both meaning "avant-garde" enjoyed overwhelming popularity among unofficial Chinese artists in the 1980s, these artists increasingly called their art "experimental" in the 1990s. [2] The reason, as I will suggest later in this introduction, is that while 1980s experimental art closely followed Western prototypes, 1990s experimental art developed its own characteristics and demanded an independent identity. A parallel movement is found in Chinese cinema: compared with the Fifth Generation directors of the 1980s who were eager to bring their creations to the world, independent filmmakers of the 1990s placed individual experimentation over audience's reception. The term "experimental cinema" (*shiyan dianying*) became more frequently associated with new types of documentary and feature film; and filmmakers like Jia Zhangke call their teams "nuclear experimental groups" (*shiyan xiaozu*).

To historians and critics, the concept "experimental art" allows them to analyze a larger body of materials and to contextualize radical artistic expressions of avant-garde types. It is an established view that experimental art is related to but never equals avant-garde art. Renato Poggioli, for example, states in his *Theory of the Avant-Garde* that although the "experimental factor" is crucial to any invention of avant-gardism, the desire to experiment is not limited to avant-garde artists, nor must an experiment result in a revolutionary style or concept. Thus he distinguishes avant-garde experimentalism from other kinds of experimentalism. [3] Similar differences are found within contemporary Chinese experimental art. Some artists exhibit stronger antagonism and nihilism toward society and fit a conventional Western notion of the avant-garde more closely; other types of experiment may focus more on stylistic or technical matters. The subject of experimentation can also go beyond art *per se* and includes the manner and method of art exhibition and publication, and even the social role and position of the artist. An "experiment" can be undertaken either by individuals or by groups.

On the other hand, although it may be said that experimentation is essential to any kind of artistic invention, what we call "Chinese experimental art" is a specific historical phenomenon defined by a set of specific factors. Chronologically, this art started from the late 1970s, when unofficial artists, art societies, and exhibitions emerged in post-Cultural Revolution China. Sociologically, this art claims an "independent" or "alternative" status domestically, and allys itself to international contemporary art. Artistically, it shows a penchant to new art mediums and novel styles; its "experiments" often challenge conventional methods and languages of artistic expression. Among these defining factors of experimental art, the most essential one is the artist's self-positioning in a rapidly changing society; unorthodox styles and content, or new types of mediums and exhibitions, are concrete means to consolidate the artist's "alternative" self-identity. In other words, Chinese experimental art is

the art of Chinese experimental artists.

But who are the "experimental artists" (*shiyan yishujia*) in post-Cultural Revolution China? In the most fundamental sense, what makes a Chinese artist an "experimental" one is his/her determination to place him/herself at the *border* of contemporary Chinese society and the art world. This determination is often sustained by a sense of mission to enlarge frontiers and open new territories in Chinese art. By taking up this mission, however, an artist must also constantly renew his/her own marginality and must constantly re-position him/herself on the *border* in order to be continuously "experimental." The notion of "border" is thus crucial for understanding Chinese experimental artists and their art. Here a "border" refers to a political, ideological, and/or artistic space around which a particular type of identity is developed and articulated.[4] A border evokes self-consciousness. By placing themselves at a real or fictional frontier, experimental artists identify themselves as an oppositional force against various kinds of cultural hegemony. While an established art tradition or institution (e. g. academic art or a "global" exhibition system such as the Venice Biennale) often relies on fixed agendas and guarded territories, experimental art favors pluralism and cultural crossing; the borderland it opens up deterritorializes conventional cultural and political spheres. It is thus understandable why this art presents a constant threat to art establishments. "A border maps limits," writes Alejandro Morales. "It keeps people in and out of an area; it marks the ending of a safe zone and the beginning of an unsafe zone. To confront a border and, more so, to cross a border presumes great risk."[5] A border is always policed and a border-crosser faces the danger of repudiation. But such risk is unavoidable because, as explained earlier, a self-imposed marginalization is one of the most important characteristics of Chinese experimental art, while the sense of danger inspires heroism and camaraderie among experimental artists.

Although in theory experimental artists must constantly re-position themselves to escape from becoming mainstream, not many artists can keep meeting such challenge. In many cases during the past twenty-five years, Chinese experimental artists of a given period lost their edge after having acquired social positions and secured financial status for themselves. In other cases, unorthodox art styles and mediums were accepted by mainstream art and thus lost their "experimental" qualification. As a result of these and other situations, while some artists have indeed made courageous efforts to renew their alternative identity, the development of Chinese experimental art in general has produced "generations" of artists and filmmakers, whose works have responded to different tasks at different times, and whose activities have been associated with various phases of contemporary Chinese art and cinema.

Departing from the 80s

Such "generation shifts" are most clearly seen in contemporary Chinese filmmaking. It has often been said that the experimental movement in this field started from the Fifth Generation of filmmakers, that is, the first class to graduate from the famed Beijing Film Institute after the Cultural Revolution, in 1982. From 1983 onward, they made a series of controversial films to challenge orthodox representations of China's history and the Chinese people. Almost immediately their impressive works won international applause, partly because of their unorthodox ideology and partly because of their grand melodramatic style and stoning visual effect. By the end of the 1980s, however, this type of film had largely been popularized and lost its experimental edge. From the early 1990s, the Sixth Generation of filmmakers initiated a new line of experimentation by focusing on contemporary Chinese urban life, and so it is also known as the "Urban Generation." Reacting against the earlier generation, they redefined the role of a filmmaker from a master storyteller to a participant of spontaneous events; their fragmentary cinematic style showed clear impact from the "on-site" (*xianchang*) documentary film, another important branch of 1990s experimental Chinese cinema.

In the domain of experimental art, we can roughly divide its development during the past twenty-five years into four phases or trends: (1) the emergence of alternative, unofficial art in China from 1979 to the early 1980s, (2) the '85 Art New Wave and *China/Avant-garde* exhibition from the mid-1980s to 1989, (3) post-89 art and the internationalization of Chinese experimental art from the early 1990s, and (4) a "domestic turn" from the early and middle 1990s, a movement in which experimental art increasingly conveyed social and cultural critiques. The last two trends overlapped each other during the most part of the 1990s and represented two main directions of experimental art during this period. Because both trends appeared as conscious departures from 1980s experimental art, to understand their significance and historicity we need to look into their relationship with the '85 Art New Wave.

The '85 Art New Wave (*'85 Yishu Xinchao*) started from the spontaneous appearance of numerous unofficial

art groups: according to one statistic, more than eighty such groups emerged in 1985 and 1986 and scattered across twenty-three provinces and major cities. [6] The members of these groups were mostly in their twenties; a considerable number of them had just graduated from or were still studying in prestigious art schools. Compared with earlier alternative artists such as the members of the Stars Art Society (*Xingxing Huahui*), experimental artists of this new generation were more knowledgeable about recent developments in Western art, and their works often showed unmistakable influence from it. In fact, almost all major styles of Western modern art invented over the past century could be found in these works. Such stylistic pluralism — one of the most important features of Chinese experimental art of the 1980s — was closely related to an "information explosion," a phenomenon of crucial importance in understanding experimental art during this period.

From the early 80s, all sorts of Western art forbidden during the Cultural Revolution were introduced to China through reproductions and exhibitions; hundreds of theoretical works, from authors such as Heinrich Wölfflin to Jacques Derrida, were translated and published in a short period. These images and texts aroused enormous interest among younger artists and greatly inspired their work. It was as if a century-long development of Western art was simultaneously re-staged in China. The chronology and internal logic of this Western tradition became less important; what counted most was its diverse content as visual and intellectual stimuli for a hungry audience. Thus, styles and theories that had long become past history to a Western art critic were regarded as "contemporary" by Chinese artists and used as their models. In other words, the "experimental" nature of these Chinese imitations was located not in the styles themselves, but in the transference of these styles to a new place and time.

From 1986 on, local and individual groups of experimental artists began to contact one another to organize joint exhibitions and activities. [7] This then paved the way for a nation-wide network of experimental artists, a development facilitated by a group of art critics committed to promoting experimental art in China. Their plan of organizing a national exhibition of experimental art in Beijing was finally realized in 1989, when the *China/Avant-garde* exhibition took place in the National Art Gallery. Looking back at this exhibition and '85 Art New Wave, some of these critics commented in the early 1990s on the idealistic tendencies of experimental art of the 1980s, and contrasted this exhilarating but chaotic period with Chinese experimental art that followed it. [8] According to them, experimental artists of the 1980s "believed in the possibility of applying modern Western aesthetics and philosophy as a means of revitalizing Chinese culture." From the early 1990s on, however, many of these artists turned "against heroism, idealism, and the yearning for metaphysical transcendence that characterized the '85 Art New Wave movement." [9] One finds a similar ideological shift in the contemporary cinema. In Zhang Zhen's words, "While the mythic, larger-than-life icon of the repressed peasant woman (embodied by Gong Li) dominates Fifth Generation's glossy canvas in the era of reform, the subjects that populate the new urban cinema are a motley crew of plebeian but nonetheless troubled people on the margins in the age of transformation — ranging from aimless bohemians, petty thieves, taxi drivers, KTV bar hostesses, disabled people, and migrant workers, and other marginalized subjects at the bottom of the society." [10]

Another important transformation of Chinese experimental art from the 1980s to the 1990s is a shift from "collective experiments" to "individual experiments:" disengaging themselves from large-scale political, ideological, and artistic movements, artists focused more or developing individual languages as expressions of personal ideas and tastes. A large-scale political, ideological, or artistic movement or campaign is called a *yun dong* in Chinese. Although seldom analyzed by historians and sociologists, *yun dong* has been one of the most fundamental concepts and technologies in Chinese political culture. Three major characteristics of a *yun dong* include a definite and often practical agenda, a propaganda machine which helps define and spread this agenda, and an organization which helps forge a cohesive "front" of participants. It can be said that up to the 1980s, every Chinese was routinely schooled in this political culture, while those who went through the Cultural Revolution received the most intense training in such a program. *Yun dong* became part of people's normal life and way of thinking. It is therefore not surprising that it would continue to control people's thinking even after the Cultural Revolution was over. The persistence of a *yun dong* mentality is clearly seen in the Chinese experimental art of the 1980s: while evoking the spirit of the avent-garde, the advocates of the '85 Art New Wave tried hard to galvanize experimental artists into a unified front and to develop this art into an organized movement. (In fact, they called their collective activities a *yun dong*.)

This *yun dong* mentality lost its appeal to experimental artists of the 1990s. At the beginning of the decade, some leaders of the '85 Art New Wave still tried to regroup experimental artists into a unified front, but their effort could never recapture the momentum and collective spirit of the "avant-garde" movement in the previous decade. [11] Instead, artists of the new period largely developed their styles and social connections independently; "trends"

in experimental art emerged not as synchronized social movements but as linked artistic solutions to common problems. Consequently, it would be a mistake for an interpreter to perceive 1990s experimental art through the lenses of the 1980s as a continuation of the earlier movement. A better way to analyze this art is to identify specific problems in the 1990s and to explore artists' responses to these problems. This analysis, carried out in the thirteen essays in this section of the catalogue and also in Part Two, demonstrates another general change in Chinese experimental art and cinema—a shift from 1980s fascination with historical evolutionism to 1990s obsession with contemporaneity.

Chinese experimental artists and filmmakers of the 1980s were deeply engaged in historical thinking: their art bore memories of the bygone Cultural Revolution and expressed their yearning for a future utopian society. Many of their works aimed to rediscover the roots of Chinese civilization; others were allegories staged in the past or in remote geographical settings. Experimental artists were particularly historiographically self-conscious: recognizing how much they had "fallen behind" art history and theory, they rushed to bring themselves to the current stage of contemporary art by reliving a century of Western art history in a few years. In contrast, experimental artists and filmmakers of the 1990s were more "spatially" oriented, as they had secured their positions in the international art world, and as their art increasingly responded to changes taking place around them, especially the transformation of the city and the urban life. Different artists and filmmakers of course had different aspirations and developed different styles, but all of them were attracted by the notion of *contemporaneity*: they had to embody this notion to make their art new and exciting. To a large extent, their art is "experimental" because it is self-consciously "*contemporary*."

Contemporaneity (*dangdai xing*) differs from "contemporary art:" it does not simply pertain to the prevailing styles and techniques here and now, but is an intentional construct of a particular subjectivity. To achieve this construct an artist pushes everything before him into "history," and his method is to substantiate the present —an unmediated time in common sense —with "contemporary" references, languages, and points of view. In 1990's Chinese experimental art and cinema, the most common and immediate visual signifier of *contemporaneity* was the artists' adoption of art mediums, materials, and genres that were new and novel to the Chinese art world. This also means that to realize their contemporaneity, these artists and filmmakers had to subvert established art mediums and genres, such as painting, sculpture, and conventional documentary and feature film. Historically speaking, this trend indicated a deepening stage of the Chinese experimental art movement. Experimental artists before the mid-1980s, even the most radical ones such as the members of the Stars, still worked with conventional forms of painting and sculpture. From the mid-1980s and especially during the 1990s, however, an increasing number of young artists abandoned their former training in traditional or Western painting, or only made paintings privately to finance their more adventurous but less marketable art experiments. Installation and performance became the two hottest art forms in contemporary Chinese art. Experimental films of the 1990s often deliberately abandoned the artistry and careful planning of earlier cinema; their general style as unscripted, spontaneous records of real life was related to their independent production as well as the popularity of portable camcorders and digital technology.

On the surface, such a penchant to contemporary art mediums and visual techniques can be explained by the growing influence of Western contemporary art and cinema in China. But a more essential reason for the popularity of installation, performance, and multi-medium art must still be found in the fundamental purpose of the experimental art movement itself, which was to forge an independent field of art production, presentation, and criticism outside official art and academic art. Through denouncing conventional representational systems, experimental artists and filmmakers of the 1990s effectively established an "outside" position for themselves, because what they rejected was not just particular art forms or mediums, but was an entire new system, including education, production, exhibition, publication, and employment. Such a break from the art establishment was sometimes related to an artist's political identity. But it could also be a relatively independent artistic decision, as these artists routinely found the new art forms both liberating and challenging, encouraging them to express themselves directly by using whatever means at their disposal. It is on this level of individual experimentation that the new art mediums and visual techniques not only signifed a general sense of contemporaneity, but also facilitated the creation of genuine and original artistic expressions.

Experimental Artists of the 1990s

China underwent a profound socioeconomic transformation during the two decades after the Cultural Revolution. Starting in the late 1970s, a new generation of Chinese leaders initiated a series of reforms to develop

a market economy, a more resilient social system, and an "open door" diplomatic policy that subjected China to foreign investments as well as cultural influences. The consequence of this transformation was fully felt in the 1990s: major cities such as Beijing and Shanghai were completely reshaped. Numerous private and joint-venture businesses, including private-owned commercial art galleries, had appeared. Educated young men and women moved from job to job in pursuing personal well-being, and a large "floating population" entered metropolitan centers from the countryside to look for work and better living conditions.

Many changes in the world of experimental art and cinema were related to this larger picture. Among these changes, two phenomena especially gave this world a different outlook in the 1990s. First, although a majority of experimental artists received formal education in art colleges and had little problem finding jobs in the official art system, many of them chose to become freelance, "independent artists" (*duli yishujia*) with no institutional affiliations. The same situation was found in the field of experimental cinema: independent filmmakers appeared, exemplified by the documentary filmmaker Wu Wenguang who made "the first independent film in PRC" from 1989 to 1990 about four bohemian artists. There were of course artists who still wished and even struggled to maintain their jobs in other public institutions. But to the end they were often forced to give up such options because of their unconventional lifestyle and irregular travel schedules, if not because of their unorthodox artworks and approaches. To be "independent" also meant to become "professional"—a move which changed not only these artists' career paths but also their social status and self-perception. On the surface, freelance artists were free from institutional liabilities. But in actuality, to support their livelihood and art experiments they had to submit themselves to other kinds of liabilities and rules. It was in the 1990s that experimental Chinese artists learned how to negotiate with art dealers and Western curators, and how to obtain funding from foreign foundations to finance their works. Not a few of them developed a double persona, supporting their "unsalable" experiments with money earned from selling paintings and photographs.

Second, starting from the late 1980s and especially during the 1990s, a large number of experimental artists immigrated from the provinces to major cultural centers, especially the country's capital Beijing. The result was a situation that differed markedly from the 1980s: in the '85 Art New Wave, most "avant-garde" art clubs and societies emerged in the provinces and were active on the local level, while Beijing maintained its traditional position as the stronghold of official art and academic art. (Similarly, the powerhouse of the Fifth Generation films from 1983 to 1989 was the Xi'an Film Studio in Shaanxi.) In the 1990s, however, Beijing became the Mecca of young experimental artists throughout the country. Local experimental communities of course still existed. In particular, artists in several large cities, including Guangzhou, Shanghai, Chengdu, Taiyuan, and Nanjing, formed close working relationships to produce interesting works. Other experimental artists continued their individual activities in Hangzhou, Changchun, Ji'nan, and Yangjiang. But Beijing emerged above all these places to become the unquestionable center of experimental art, mainly because it constantly attracted talented young artists from all over the country. These immigrant artists, mostly in their twenties, emerged after the 1980s. To this new generation of experimental artists, the Cultural Revolution had become remote past, and their works often responded to China's current transformation, not to history and memory. They found such stimuli in Beijing, a city most sensitive to social changes and political tensions in the 1990s.

A direct consequence of these two changes was the emergence of residential communities of experimental artists, known as "artists' villages" (*huajia cun*). The first of such communities was located in Beijing's western suburbs, near the ruins of the former imperial park Yuanmingyuan. Avant-garde poets and painters began to live there as early as the late 1980s; but it was not until 1991 that the place became known as an artists' village. It attracted media attention in 1992, as reports of its bohemian residents stimulated much popular interest. Around the same time it was also "discovered" by art deals and curators from Hong Kong and the West. The place established its reputation as the "window" of Chinese experimental art in 1993, after Fang Lijun, who was then living there, appeared in three large international exhibitions in that year, including the *China's New Art, Post-1989* in Hong Kong, *Chinese Avant-garde Art* in Berlin, and the 45th Venice Biennale.

In a broader sense, the artists' community at Yuanmingyuan introduced a particular lifestyle and set up a model for later "villages," including the one in Songzhuang east of Beijing. Located in rural settings, these communities are also close enough to downtown Beijing so they can maintain close ties with the outside world. The initial reason for artists to move into such places was mainly economical: it is cheap to buy or rent houses there and to convert them into large studios and residences. But once a community has appeared it brings additional benefits to its members. First of all, it generates a sense of comradeship: the residents share the identity as independent artists, and some of them are close friends who have known one other for a long time. Living in close

proximity promises convenience for socialization and occasions for entertainment. Visitors, including important foreign curators and art dealers, can see works of a dozen or so artists in one day; and there is no secret that such visits are crucial to obtaining global fame and financial gains. On the other hand, such possibilities necessarily imply social stratification: some of the artist-villagers are internationally renown while others still struggle for basic living. Although artists in such a community are subjected to mutual influences (especially by those "successful" styles and subjects), they rarely form close groups based on common social or artistic causes. Such lack of shared commitment explains these communities' ambiguous artistic characteristics: while a "village" attracts a large number of experimental artists to a single location, it does not necessarily inspire new ways of thinking and expression.

To this general situation there was a noticeable exception: from 1992 to 1994, the so-called East Village (*Dongcun*) in Beijing became the base of a group of immigrant artists, who worked together closely and initiated a new trend in experimental art. Also unlike the communities at Yuanmingyuan and Songzhuang, the East Village artists developed a close relationship with their environment—a polluted place filled with garbage and industrial waste — as they considered their moving into this place an act of self-exile. Bitter and poor, they were attracted by the "hellish" qualities of the village in contrast to the "heavenly" downtown Beijing. This contrast inspired them: all their works during this period were energized by a kind of intensely repressed desire. The significance of the East Village community also lies in its formation as a close alliance of performing artists and photographers, who inspired each other's work by serving as each other's audience. This alliance was later broken under the allure and pressure of commercialism: when photographs of "East Village performances" became valuable, an argument about their authorship turned old friends into enemies.

Whether in Beijing or in the provinces, experimental artists and filmmakers of the 1990s were preoccupied by two interrelated issues, one about their participation in the international art scene and the other concerning the "normalization" of experimental art in China. The second issue became increasingly urgent when tension grew between artists' international standing and their domestic status. Here once again we find a huge difference between the 1980s and the 1990s : The '85 Art New Wave was predominately a domestic movement closely linked with China's internal situation at the time, but experimental artists of the 1990s articulated their images and developed their characteristics in an international context. (The globalization of experimental cinema occurred earlier, as indicated by the international attention received by the Fifth Generation films from the mid-1980s onward.)

At least four factors helped construct the global context of 1990s experimental art. First, even before Chinese experimental art attracted wide international attention, the diplomatic community in Beijing played an important role in supporting this art and spreading information about it. From 1992 and 1993, commercial galleries based in Hong Kong, Taiwan, and the West began to represent mainland Chinese experimental artists. This channel of globalization was further strengthened when private-owned art galleries, often backed by foreign money and aimed at a foreign clientele, appeared in major Chinese cities. Also from the early 1990s, some influential individuals and institutions in Hong Kong, Japan, and the West began to systematically collect Chinese experimental art; their interest encouraged the market for this art and directed international attention to experimental Chinese artists.

Second, from 1993 onward, experimental Chinese artists and filmmakers increasingly appeared in important international exhibitions and film festivals. Curators of these exhibitions and festivals made regular trips to China to discover new talents. Foreign media's interest in Chinese experimental art also started from 1993, when cover articles in *Flash Art* and *The New York Times Magazine* introduced this art to a global audience. [12] While these early introductions to Chinese experimental art often presented this art as a post-Cold War curiosity in a Communist country, more serious research-oriented exhibitions and publications were attempted towards the later part of the decade. Generally speaking, the 1990s was a crucial period in the history of Chinese experimental art, during which this art finally established its position as a vital component of international contemporary art. An important mechanism that enabled this advance was the network of biennials and triennials around the world, which regularly presented Chinese experimental art from 1993 onward. The 48th Venice Biennale, held in the last year of the 1990s, featured works by twenty Chinese artists, more than the combined number of American or Italian participants.

Third, a considerable number of experimental Chinese artists moved to Europe and America in the 1990s, and some of them established international fame there. Their "success stories" had mixed responses in China: many artists (especially younger ones) admired them and took them as role models, but other artists and critics saw their

successes as calculated results of a self-Orientalizing, hybrid identity. Regardless of these conflicting receptions, in the 1990s this group of artists provided a crucial link between Chinese experimental art and international contemporary art, because no matter where they lived, to their global audience they were always "Chinese artists," and because their works owed much to their experiences in China and consciously reflected upon their cultural origins. Similarly, Chinese art critics and curators who immigrated to the West also helped bridge Chinese experimental art and international art. Although writing in English or French, they maintained close ties with artists and critics in China. It is significant to note that since the mid-1990s, these scholars and curators have played an increasingly important role in introducing Chinese experimental art to the West, and have also returned to China to organize exhibitions there.

Finally, as for Chinese experimental artists, filmmakers, critics, and curators who decided to remain in China, they were also thoroughly "globalized." It would be a mistake to consider them "local"based on their residency. Throughout the 1990s, they traveled frequently to various exhibitions and film festivals around the world, and dealt with foreign museums, foundations, galleries, curators, scholars, and visitors almost on daily bases. Compared with experimental artists of the 1980s, they were vastly more familiar with the international art scene —not just with fashionable names and styles but with the international art network and standardized practices. They had become, in fact, members of a global art community; but they decided to act locally.

In sharp contrast to their popularity among foreign curators and collectors, throughout the 1990s Chinese experimental artists and filmmakers were still struggling for basic acceptance at home. Although books and magazines about avant-garde art were easy to find in bookstores, actual exhibitions of this art, especially those of installation, video art, computer art, and performance, were generally discouraged by the art establishment, including state-run art galleries and schools. Even worse, misunderstanding and antagonism caused frequent cancellations and early terminations of experimental art exhibitions. (Independent experimental filmmakers faced even greater difficulties because of the much stricter control of film production and showing. A large percentage of experimental films made since the mid-1980s were banned in China or were shown only in controlled situations.) This reality led experimental artists and curators to consider the "normalization" of experimental art the most pressing issue they faced in China. In their effort to bring this art into the public sphere, exhibitions not only served as testing cases for their legal rights, but also provided crucial means to realize their rights to practice experimental art.

A prevailing view among advocates of experimental art in the early and mid-1990s was that this art could be legalized only when it could realize its economic potentials. They therefore launched a campaign for this purpose. The most important event in this campaign was the First Guangzhou Biennale opened in October 1992, which showed more than 400 works by 350 artists. Sponsored by private entrepreneurs, the exhibition had the self-professed goal of establishing a market system for contemporary Chinese art. Two other exhibitions held in Beijing in 1996 and 1997, called *Reality: Present and Future* and *A Chinese Dream*, respectively, had the same general goal but served a more specific purpose to facilitate domestic auctions of experimental art. The fact that these two shows both took place in "semi-official" exhibition spaces — the Yanhuang Art Gallery and the Beijing International Art Palace — represented another new phenomenon in the 1990s.

Through these and other exhibitions, "independent curators" (*duli cezhanren*) began to play the leading role in the "normalization" of experimental art. Usually not employed by official or commercial galleries, these individuals organized experimental art exhibitions primarily out of personal interest. Although they found their models in the curators of large international exhibitions, their main avocation was to develop experimental art in China. From the mid-1990s, many exhibitions they organized indicated a new direction: these curators were no longer satisfied with just finding any available space—even a primary space such as the National Art Gallery— to put on an exhibition. Rather, many of them organized exhibitions for a larger purpose, which was to create regular exhibition channels and eventually a new "exhibition system" in China. To these curators, it became possible to pursue this goal because of the new conditions in their country. They believed that China's socio-economic transformation had created and would continue to create new social sectors and spaces to be exploit for developing experimental art. Their campaigning for a new exhibition system involved multifaceted social experiments: working with official and semi-official museums to renew or revolutionize their practices, convincing entrepreneurs to support experimental art and organizing exhibitions in various kinds of non-exhibition spaces — shopping malls, bars, abandoned factories, and the street. This last effort is especially significant because it resulted in a series of "experimental exhibitions," which aimed at inventing new forms, spaces, and dynamics for the public showing of experimental art.

The effort to normalize experimental art, on the other hand, also brought an identity crisis to this art. When large and small exhibitions were organized to show experimental art to the public, some curators and artists began to voice their concerns about the danger of losing their alternative identity. In their view, excessive effort to publicize experimental art would inevitably compromise its revolutionary spirit. While this rhetoric was not new, its actual consequence in China was worth noting: a counter movement emerged in the late 1990s to make private exhibitions more extreme and "difficult." The trend of using living animals and human corpses to make art emerged as part of this counter movement: since these experiments would almost certainly be prohibited by the government and denounced by the public, they justified the necessity of closed exhibitions planned exclusively for "insiders" within the experimental art circle. A debate about the artistic merit and moral credibility of these extreme "experiments" divided experimental artists and curators into two camps. The Third Shanghai Biennale in 2000 further brought these two camps into a direct confrontation: one group of experimental artists and curators took this official exhibition as a decisive victory of their reformist agendas, while other curators and artists organized "alternative" exhibitions to counter it.

Coda: Framing the Decade

The Third Shanghai Biennale marked the end of Chinese experimental art of the 1990s, just as the *China/Avant-garde* exhibition in 1989 brought a closure to 1980s Chinese experimental art. A brief comparison of these two exhibitions helps highlight many important changes taking place in the ten years between them.

China/Avant-garde was an unofficial exhibition that resulted from a grass-roots movement. It followed the logic of a mass movement action called *duoquan* — "taking over an official institution" —derived from the Cultural Revolution. The show was permeated with a kind of tragic heroism, as the long black carpets extending from the street to the exhibition hall bore the emblem of the show—a "No U-turn" traffic sign signaling "There is no turning back." The exhibition was a purely domestic event because it only featured works by Chinese artists. But because most of these works were not new, the exhibition realized its "avant-garde" intent in posing itself as an extraordinary, collective "art happening." It was shot down three times by the authorities, but such disturbances only helped unite artists with different intentions and stylistic identities, who found themselves in a single camp and shared the excitement of a social revolution. The common agendas of the exhibition, actually a collective social/artistic experiment, transcended any individual expressions.

The Third Shanghai Biennale also realized its significance by staging itself as a "historical event."[13] But the engineer of this event was a state-run institution, and the purpose of the event was for this institution to join the global club of "world famous biennial art exhibitions." [14] This purpose determined not only the exhibition's content but also its curatorial method. Its content was international contemporary art represented by carefully selected examples. For the first time, experimental Chinese art was presented as official representatives in an international convention. Following a convention in organizing international biennials and triennials, the museum invited two independent curators to design the show. But because many compromises had to be made between these curators and the museum, no clear lines can be drawn between independent decisions and government direction. The exhibition was a huge success for all parties involved, not only the museum and the curators but also the participating artists. But as I have stated earlier in this introduction, the most fundamental determinant of experimental art is its self-marginlization. Thus although The Third Shanghai Biennale represented a new stage of normalization of Chinese experimental art, to maintain its creativity this art must transcend the standard the exhibition set-up.

The First Guangzhou Triennial—Reinterpretation: A Decade of Experimental Chinese Art (1990-2000) — sets up a third model for a large exhibition of experimental art in China. On the one hand, although its curators are independent in status, their goal is not to take over an official space for a short period, but is to initiate a long-term exhibition and research program of experimental art in a large public art museum, and for this purpose they must work closely with the museum's directors and staff members. On the other hand, although it derives its model from a large international contemporary art exhibition, it focuses on Chinese experimental art and hopes to lay a new basis in studying this art. Featuring the most significant works created in the ten years from 1990 to 2000, the exhibition's title also highlights the organizers' intention to provide a systematic interpretation of these works in their artistic, cultural, social, and political context. The thirteen essays in this section focus on various aspects of 1990s experimental art, from art mediums and genres to artists' changing status, and from broadening exhibition channels to overseas reception. In so doing, these essays complement each other and together depict a larger picture of Chinese experimental art in this important decade.

Wu Hung is the Harrie A. Vanderstappen Distinguished Service Professor of Chinese Art History at the University of Chicago.

1 For these different opinions, see Bonnie S. McDougall, *The Introduction of Western Literary Theories into Modern China,* (Tokyo, 1971), pp. 196-213; Gao Minglu, "Toward a Transnational Modernity," in idem., ed., *Inside Out: New Chinese Art,* (San Francisco and New York: San Francisco Museum of Modern Art and Asia Society Galleries, 1998), pp. 15-40; Norman Bryson, "The Post-ideological Avant-garde," in ibid., 51-58.

2 For example, the art critic Gao Ling characterizes some major installations and art happenings in China as "experimentations without ideology." Gao Ling, "Zouchu pingmian di zhuangzhi yishu— jiushi niandai di shiyan yishu" (Three-dimensional installations— Chinese experimental art in the 1990s), *Xiongshi meishu* 297 (November 1995), 62. In my interviews with various artists from 1997 onward, they have frequently referred to their works as "*shiyan yishu*" (experimental art).

3 Renato Poggioli, *The Theory of the Avant-Garde,* (Cambridge, Mass.: Harvard University Press, 1968), 131-37.

4 The rising field of "border studies" has produced many scholarly works. For some recent theoretical reflections on the basic concepts and issues related to "borders," see Scott Michaelsen and David E. Johnson, ed., *Border Theories: The Limits of Cultural Politics,* (Minneapolis: University of Minnesota Press, 1997).

5 J. A. Gurpegui, ed., *Alejandro Morales: Fiction Past, Present, Future Perfect,* (Tempe, Ariz.: Brilingual Review, 1996), 86-98.

6 The most detailed account of this art movement is provided by Gao Minglu's *Zhongguo dangdai meishu shi 1985-86* (Contemporary Art of China), (Shanghai: Shanghai renmin chubanshe, 1991).

7 In September 1986, for example, a number of groups in Nanjing organized a joint activity called "Baking under the Sun" (*Shai taiyang*). More than 100 young painters, sculptors, and performing artists gathered in the Xuanwu Lake Park to show their recent works and to stage art happenings. The slogans of the activity included "The sun is the only energy source which cannot be polluted; the sun is just about to break through the clouds." The next month, many artists traveled to Nanjing from other cities, and in October 5th more than 1,000 of them appeared in the park. This kind of spontaneous gathering also appeared in other cities.

8 See, for example, Gao Minglu, "From Elite to Small Man: The Many Faces of a Transitional Avant-Garde in Mainland China," in idem, ed., *Inside Out: New Chinese Art,* op. cit., 149-66; especially, 154-56.

9 Li Xianting, "Major Trends in the Development of Contemporary Chinese Art," in *China's New Art, Post-1989,* (Hong Kong: Hanart TZ Gallery, 1993), 5-22.

10 Zhang Zhen, "Building on the Ruins: The Exploration of New Urban Cinema of the 1990s," in this volume, p.114.

11 One such effort is to organize "document exhibitions" (*Wenxian zhan*). Consisting of reproductions of recent works by experimental artists and their writings, these shows traveled to different cities and provided an important channel of communication between experimental artists throughout the country.

12 Andrew Solomon, "Their Irony, Humor (and Art) Can Save China," *The New York Times Magazine,* December 19, 1993, 42-72.

13 See Wu Hung, "The 2000 Shanghai Biennale: The Making of a Historical Event," *ART AsiaPacific* 31 (2001), 41-49; reprinted with minor changes in Wu Hung, ed., *Chinese Art at the Crossroads: Between Past and Present, Between East and West,* (Hong Kong: New Art Medium, 2001), 275-85.

14 Preface, *Shanghai Biennale 2000,* exhibition catalogue, (Shanghai: Shanghai Art Publishing House, 2000).

1990s Conceptual Art and Artistic Conceptualization
Zhu Qi

The 1990s was an important period for experimental art in China, which developed at all levels and in all ways. Within Chinese art circles, the forms of modern art, performance art, installation, video and conceptual photography, which emerged with the New Wave or Avant-garde Movement in 1985, are often referred to as pioneering or experimental art. But strictly speaking, in China there is no experimental art, pioneering art or even avant-garde art in the narrow sense of the terms as the Western world defines them. In fact, it can only be said that such forms of art in China are elite forms of art that derived their sense of modernism, post-modernism, post-colonialism from the particular experiences engendered within those rising industrial countries in Asia.

In a narrow sense, experimentation within Chinese contemporary art in the 1990s was reflected in the use of mixed media, electronic mediums (photography, video and computer art) and the Internet, the use of photography, documents or texts, and the introduction of conceptual approaches in abstract and realistic painting. In a broad sense, experimental art in China in the 1990s also includes experiments made by artists of varying individual cultural levels and personal characteristics within a period of dramatic social transition in China. Confronted by international capitalism, globalization and a new "post-ideology" era, and against a new body of concept in art and the disintegration of intellectual consciousness, art began to manifest elements of breaking social taboos and extreme emotion.

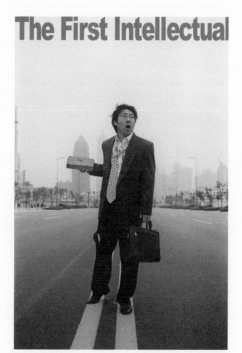

Fig. 1 Yang Fudong, *The First Intellectual*, 2000, photograph, 193 x 127 cm

In fact, to a large extent, the use of the word "experiment" in Chinese contemporary art referred to a relative level of experiment that seemed avant-garde within the general cultural environment and range of art forms that emerged within the specific political and cultural language and reality in China. So strictly speaking, in regard to contemporary art in China, the term "experimental art" differs markedly from the Western concept. Through the 1990s, however, it was employed to refer to a wide range of works within Chinese contemporary art.

Such experiments affected art in three ways. First, the experiments with medium and aesthetics. These included those in installation, video, photography, ceramics and the Internet, as well as the introduction of abstract painting styles and photography to realistic painting. It also forged links between concepts and text, installation, painting, performance and photography, any manipulation of conventional aesthetics up to the 19th century, and the imitation of historical photography, and the exploration of electronic art, such as Flash animation and computer softwares.

Second, artists experimented with various responses to the cultural framework, including their personal approach to an intellectual, critical and ironical comment on commercialism, post-colonialism and youth culture against the background of unfamiliar contemporary art systems and globalization.

Third, there was an increasing exploration of marginal aesthetics, such as feminism, the body, performance and an expression of human extremity in art that involved real animals and actual human bodies.

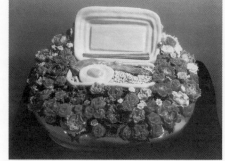

Fig. 2 Xu Yihui, *Fast Food Container*, 1994-95, porcelain, 40 x 38 x 28 cm

I. From Concept in Installation and Ready-made Objects to Conceptual Art

In the early 1990s, experimentation found its primary expression in installation and the use of ready-made objects as art. In their underlying creative concept, these experiments were largely carried out in four main areas. First, the experimentation that pivoted on a particular medium was regarded as "pure medium experiment;" this term embraced the inclusion of ready-made objects and mixed media. Second, a number of artists chose to employ ready-made objects and mixed media to substitute for traditional sculptural materials and to serve as cultural symbols. Third, installation art and the appropriation of ready-made objects were regarded as conceptual art. Fourth, there emerged an area of practice that pivoted on text-based conceptual experiments.

Prior to the mid-1990s, installation art or an art that employed ready-made objects did not exist as a pure art in China, and was regarded by the fine arts associations as a kind of anti-mainstream form of culture. That was

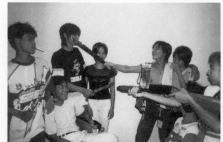

Fig. 3 Zheng Guogu, *The Life of the Youth in Yangjiang —Provocateur*, 1996, performance, photograph

unavoidable in the following respect, for artists were enmeshed in the socio-ideological framework within which they lived and worked. Equally, within the art circles, installation art was regarded as a kind of "pure art" that was anti-society and related to politics. In the north, only a few artists, mainly those in Beijing, engaged in creating art in this field. The majority of artists who were experimenting with various media were located in southern cities such as Shanghai, Hangzhou and Guangzhou, where certain trends of thought had formed between 1991 to 1995.

During this period, artists in the south started making installation works and employing ready-made objects and mixed media in their art on a large scale. However, this approach was regarded as an experiment in placing different materials within various environments, and fashioned using a range of techniques. Where the objects and materials were often non-easel forms substituted for paint and sculptural materials, this too was considered an anti-mainstream form of culture. The legitimacy of the public exhibition of installation art swiftly became a problem, which was not solved until the Shanghai Biennale in 2000.

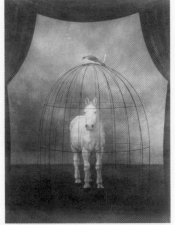

Fig. 4 Xu Lei, *Horse Cage*, 1997, work on paper, 87 x 187 cm

Exhibitions of and activities involving installation art were mainly held in Shanghai. Between 1992 to 1996, several important exhibitions took place. These include the 1991 *Garage Art* show curated by artists led by Song Haidong, *October Experimental Art Show* and *Two Attitudes Towards Images—Installations by Qian Weikang and Shi Yong* at Huashan Vocational Fine Arts School in 1993, the *Third Documentary Exhibition of Contemporary Art* curated by Wang Lin and other artists which was shown at Shanghai Southern China Normal University in 1994. Finally, *In Name of Art* curated by Zhu Qi was shown at the Liu Haisu Art Gallery in 1996. In Shanghai, those artists most actively engaged in experiments with installation art included Qian Weikang, Shi Yong, Song Haidong, Hu Jianping, Ni Weihua and Wang Nanming.

Due to socio-political constraints, few group exhibitions of installation art were held in Beijing in the early 1990s. The exceptions were a number of solo exhibitions and site-specific artworks produced by artists such as Song Dong and Zhao Bandi. The Big-tailed Elephant group established in Guangzhou in 1991, Zhang Peili and Geng Jianyi in Hangzhou, and Huang Jun and Guan Ce in Nanjing, also explored installation art in their respective locales.

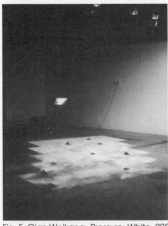

Fig. 5 Qian Weikang, *Pressure: White, 205 grams*, 1993, iron, video, paint

Primary criticisms on the battlefield of installation art came from the magazine *Jiangsu Art Monthly*, which is published in Nanjing. In the first half of the 1990s, driven by a group of editors under Gu Chengfeng and Jin Weihong, *Jiangsu Art Monthly* became almost the sole outlet or resource for creation and criticism of installation art in that period. In 1993, the critic Zhang Qing published an article titled "Mixed Media and Installation Art in the Early 1990s" in *Jiangsu Art Monthly*, which was the first general-view description of creation and concept of installation and experimental art in the Jiangsu, Zhejiang and Shanghai regions between 1991 and 1993. In 1994, I also published a critical article in the same magazine titled "A Paragraph on the Art of 1994— Validation of Installation," with the intention of making a theoretical explanation of the non-easel nature of installation art and the concept of objects and site-specific art.

Between 1993 and 1995, in Shanghai, Qian Weikang and Shi Yong pushed installation art forward towards being an extremely pure conceptual art. The works shown at their two-man show titled *Two Attitudes Towards Images* in 1993 were more like physical or scientific experiments, such as Qian Weikang's *Oppression: White Measure, Wind Direction: White Measure 205g, Crossover: White Measure 15g* and *One Example Involving Length, Width, Height and Thickness*. Shi Yong mirrored this with *Filled Projection, Incline to a Force Point, Lifting up by 5 Degrees* and *Overlapping Shadows*. In Qian Weikang's works, quantities of powder were evenly sprayed over a specified area, and the weight of powder was equal to the value of displacement in physics according to the measurements of the area where powder was sprayed. In the concept of his art, Qian Weikang tried to contain the works within specific parameters so as to eschew any influence from art history, emotion or aesthetics. In Shi Yong's works, photosensitive paper was carefully shaped to and placed in the shadow of an object onto which light was projected. He regarded this as a pure expression of time, the elapsing of which could be measured scientifically (as a period of change) in the confrontation between light and the photosensitive paper. This kind of art was actually a form of aesthetic ideology. In particular, within the general socio-political environment from 1991 to 1993, it marked a reversion against the political and social trends that were appearing in art.

In 1990, Chen Shaoping, Wang Luyan and Gu Dexin formally established the New Analysts Group in Beijing and embarked upon conceptual art experiments based on geometric and mathematical formulae. Gradually this evolved to include experiments with text which resulted in works that appeared similar to word and crossword puzzles. The three members of the New Analysts Group would jointly agree on a set of rules for manipulating or reducing a text, and the text would then be reconstructed in various new combinations and diverse forms in accordance with the rules. The New Analysts Group strictly followed all agreements on the text and the mode of

Fig. 6 New Analysts Group (Chen Shaoping, Wang Luyan, Gu Dexin), *New Analysts Group Work No. 5*, 1995

logic in the procedures. This was also a kind of reversion against the mainstream art of the moment, which largely focused on political and social subjects.

The New Analysts Group and Qian Weikang and Shi Yong emphasized a pure art that "removed social and political elements from art." In concept, they actually regarded pure art as an advanced creative experiment in philosophy and concept, and did not recognize the undertones of political resistance that colored art works focusing on social and political themes in that period. However, by about 1995, they failed to make progress with their pure art experiment, and no similar conceptual experiment appeared through the mid- to the late 1990s.

In the early 1990s, installation art and the use of ready-made objects triggered off a trend that became the peak of experimental art through the entire decade. "Conceptual art" and "concept in art" became extremely important aspects of trend of thought in Chinese art throughout the 1990s. The form conceptual art took was pure and extreme. It was not directly related to political subject matters and emotional expression, although it was linked to the overall art ideology of the period. In this sense, the scientific and document-based experiments of Qian Weikang, Shi Yong and the New Analysts Group belonged strictly to the field of conceptual art. The majority of installation works, in a broad sense, could also be described as conceptual art, that is, artworks possessed of certain concept models within the methodological techniques of expression, visual forms and themes used to create them. For example, works of Song Haidong, Zhang Peili and Ni Weihua borrowed conceptual visual forms to express their experience of existence and cultural responses to the specific reality of the moment. Their works differed only in the extent of abstractness of content they expressed. As compared with non-conceptual art, conceptual art had a precise conceptual model in its method of expression. Thus, the term "conceptual" in art largely referred to a perceived model or to the content of the work.

Fig. 7 Wang Gongxin, *Baby Talk*, 1996, video installation

In the early 1990s, installation art developed distinct concepts of expression. The majority of artists employed these methods widely to express their experience of existence and response to the cultural framework.

The works produced by artists in Shanghai and Hangzhou were more diverse and individual in concept and theme. However, on the whole, they were more inclined towards individual, personal experience in expressing ideas or allegories on the political and social transition in the early 1990s. In form, Song Haidong's works were usually produced for specific sites and combined sculptures, ready-made objects. From 1991 to 1993, works such as *Dread Erodes the Soul, Lie Detector* and *Liberate Love from Foolish Sexual Desire* were like scenes from allegorical novels or movies. The original subjects were taken from moral and spiritual notions within politics, literature and love. Zhang Peili's work displayed in the *Garage Art Show* in 1991 was perhaps the earliest work created with video equipment in China. The video recorded the repeated process of washing a chicken (*Document on Hygiene No.3*). As with his later piece *Uncertain Pleasure*, such works were designed to reflect certain abstract personal experiences within the socio-political circumstance. Ni Weihua's 1993 series *Continuously Spread Affairs* were social conceptual works that combined actual production of elements by the artists, as well as computer error codes and performance. They expressed personal depression within a highly technologically-oriented society and the difficulties faced by the public in coming to grips with the spread of information through society. It was also one of the earlier works to employ computer technology and focus on the subject of "post-ideology."

Fig. 8 Wu Xiaojun, *On the Road*, 1998, color photograph, 160 x 130 cm

The works of Guangzhou's Big-tailed Elephant group mainly reflected personal reactions to the rising commercial environment in Guangzhou, the first region in China to open its market. Such works included *Consequence of RMB 1000* (1994) and *Safely Crossing Linhe Road* (1995) by Lin Yilin, *Augmenting and Rebuilding of No.14 Sanyu Road, Guangzhou* (1994) by Xu Tan, *Change the TV Channel, Change the Bride's Decision* (1994) by Chen Shaoxiong, and *One-Hour Game* (1996) by Liang Juhui. In form, these works combined ready-made objects, performance, video and photography, and reflected their individual intellectual attitudes towards consumption, television, desire and urban redevelopment in China's growing commercial environment. In their manner of expression, such works employed much symbolism or allegory and marked attempts to incorporate aspects of conceptual expression into the specific language of realism.

Fig. 9 Ni Weihua, *Connection and Dispersion Series: Red*, 1992, installation

In terms of its basic subject matter, conceptual art in Beijing was always more colored by social criticism. *To Raise an Anonymous Mountain by One Meter* (1995), created collectively by East Village artists, was a piece of conceptual performance art [1] that was characterized by an extremely clear concept, sensitivity and visual strength. This was in line with the utopian aesthetics of East Village artists and the lingering interest in heroism through the mid-1990s, and difficult position that the "self" found itself in during this dull cultural period.

In his *Culture, Event—Process and State* in 1993, Wang Jianwei employed reams of chemical distillation tubing, television and other appliances to offer a symbol criticism of the way in which the media dominated the lives of individuals. In October of the same year, Wang Jianwei planted one *mou* (about 1/3 of an acre) of wheat with a

Fig. 10 Song Haidong, *Polygraph*, 1991, installation

farmer in Sichuan, in an attempt to show the cyclical nature of information in an even wider input and output system. In the early 1990s, Wang Youshen used newspaper to fashion articles for daily use, such as clothing and curtains. This was also an early example of conceptual art focusing on the subject of social control by the media. Zhu Jia's 1995 work *Have These People Had Sexual Relations?* was an invasive use of photography in the private lives of anonymous individuals. The artist held up a sign upon which was written "Have they had sexual relations?" in front of passersby on the street or at bus stops and took photographs of both, expressing a kind of politically motivated sense of doubt or conjecture that was prevalent in the early 1990s. Li Qiang's works was even more abstract in subject matter. He used soap in the shape of a hand that was molded to shape from his own hand to clean himself using the same hand.

In the early 1990s, many artists expressed concepts via installation art and ready-made objects. By the mid- to late 1990s, a mature conceptual art had formed that used more established artistic approaches such as ready-made objects, scene setting, performance, the public environment, photography and video. In 1996, the exhibition *In the Name of Art* displayed works of conceptual art using almost all media and approaches except actual performance. It included photography, video, ready-made objects, sound art, animals, art practices, sculpture and film. This exhibition not only showed that by 1996 Chinese contemporary art had arrived at a conceptual art in the true sense of the word, but also that conceptual art had begun to employ extensively the multitude of approaches and materials in the "pluralist" sense. Simultaneously, within aesthetics and cultural attitudes, a visual interest in "beauty" began to be manifest, and the cultural attitude of conceptual art towards public culture, post-colonial art systems and ironic parodies of consumer culture began to be transformed to a blurry uncertainty.

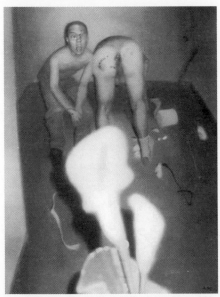

Fig. 11 Wang Jianwei, *Circulation — Sowing and Harvesting*, 1993-94, performance, video

II. New Media Art, the Concept in Painting and Sculpture, and Modern Experiments on Aesthetics

From the mid-1990s, new media was extensively included in avant-garde and experimental art. New media art, which included photography, video, Internet and computer art, quickly sprang up. Zhang Peili's 1988 work *30 x 30* was another early work in the medium of video, although it was also used by Ni Haifeng in the Garage Art Show in 1991. From 1993 to 1996, Ni Weihua, Chen Shaoxiong, Shi Yong, Yang Zhenzhong, Liang Juhui, Song Dong and Hu Jieming started to use computers, television monitors and photography in their works. However, works in this period could only be regarded as an experiment in conceptual expression aided by electronic and photographic media. Video art and conceptual photography had not yet truly formed.

Video art rose around 1995, and made a concentrated appearance in the exhibition *Image and Phenomena* curated by Wu Meichun and Qiu Zhijie and held at the Art Gallery of the China National Academy of Fine Arts in 1996. In this exhibition, two earlier video art publications *Art and Historical Consciousness* and *Video Art Articles / Documents* were published. The documents mainly included translations of articles on the concepts and aesthetics in video art in that period by western artists as Vito Acconci, Gary Hill, Norman and Bill Viola. Works in this exhibition did not employ computer painting, digital shooting and editing techniques. From their technical aspects, they belonged to video art, employing mainly analog video tape recorders and cameras. The work of Wang Gongxin, who had returned to China from abroad in 1995 did demonstrate true experimentation in technique and aesthetics, while strictly speaking, that of Zhang Peili, Qiu Zhijie, Yang Zhenzhong, Zhu Jia and Chen Shaoxiong was more conceptual art or video installation made with a video camera.

Fig. 12 Xie Nanxing, *Untitled*, 1998, oil on canvas, 190 x 150 cm

Conceptual photography emerged around 1997. A group of artists who previously engaged in painting, installation and performance started to use automatic cameras to create art. Such artists included Hong Lei, Zhuang Hui, Wu Xiaojun, Chen Shaoxiong, Zheng Guogu and Zhu Jia. In 1998, I curated the exhibition *Video Stories: China's New Concept Photography Art*, which was shown at the art gallery of the Fine Arts Institute at Shanghai University. This exhibition displayed a range of early conceptual photography works. In early 1998, Gao Ling, Dao Zi and Zhang Xiaojun published a series of articles on conceptual photography in the magazine Modern Photography. I wrote a piece for the magazine *Skyline* entitled "Stranger's Eyes — Chinese Conceptual Photography." [2]

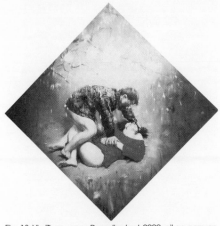

Fig. 13 Yin Zhaoyang, *Paradise Lost*, 2000, oil on canvas, 150 x 150 cm

Conceptual photography indicated that experimentation with avant-garde approaches to the medium of photography had arrived in China in the 1990s. Conceptual photography had no relation to pure photography. It was virtually a kind of conceptual art in the form of photography. In its manner of expression, conceptual photography combined hand painting, the creation of scenes or sets, computer manipulation, performance, composite images and installation. Because conceptual photography was rather easy to master in terms of

equipment and technology, a trend of conceptual photography emerged after 1998.

In the mid-1990s, the mainstream of Chinese experimental art started to switch mediums from installation and ready-made objects to photography and video. More and more artists followed suit. In fact, the shift of interest in medium not only showed the enthusiasm for experimenting in a new medium, but reflected a change in visual concept. In the trend towards mediums, installation art was closely tied to the physical nature of the materials, and an emphasis on the expression of concept, or the material image of the concept. In fact, installation reflected a kind of "material image" of concept. This indicated that visual concepts in the early 1990s were an extension and realization of notions about experiment in art established in the 1980s. The emergence of conceptual photography and video art in the mid-1990s indicated a real change within experimental art in the 1990s in terms of visual concept, especially in photography and video which placed emphasis on possibilities opened up by digital technology. Therefore, the transition from installation art to photography and video art was virtually a switch in Chinese experimental art from "material images" to "electronic images." Within the varying visual concepts of this trend, conceptual forms of art and the subject ideology in the social transition period took precedence over the actual experience of the medium.

The rise of video art in 1995 and conceptual photography in 1997 promoted the experiments in electronic art that took off in the late 1990s. Electronic games, the Internet, computer paintboxes and 3D virtual animation, digital video and personal digital editing systems, Flash animation and hypertext links to web pages were all imported into the creative process of conceptual photography, video art and conceptual art. For example, Shi Yong's 1997 work *Shanghai New Image Plan* employed the Internet for interactive experimentation, where one could make a choice of hairstyles and dress online. Feng Mengbo explored the combining of electronic games and video art. Cao Kai's computer 3D video and Jiang Jianqiu's Flash animations and He An's computer generated images demonstrated extensive applications of various electronic media to experiment in video art.

The core of experimentation with digital video lay in the visual technologies and video-like nature of electronic media, virtuality, interactivity, digital editing and technological aesthetics. Such technological experiment required much hi-tech equipment and funding support. However, for reasons of economy and the system, during the mid-1990s, individual creation within electronic art was limited to experiments with simple and basic technologies. Most of these experiments appeared as a kind of conceptual art aided by electronic media. There was nothing tangible in the way of a real technological aesthetics or visual experiment.

In the late 1990s, the greater portion of experimental creations in digital video was focused on conceptual photography. Photography and video also began to generate influences on the concept of images in painting and sculpture. From the very beginning, conceptual photography did not place too much emphasis on the technical aspects of photography, rather it emphasized conceptual form and aesthetic experience when photography was combined with other media and forms.

Around 1997 and 1998, Hong Lei began to use photography to effect a contemporary reworked invention of the visual characteristics of Chinese aesthetic symbols prior to the 19th century. For example, *Dusk in the Forbidden City* (1997) shows a dead bird lying on the ground in a cloister running alongside a major hall of the Imperial Palace. In his *Chinese Landscape* series (1998), he employed hand-painting techniques to produce a photograph of a famous private garden in Suzhou. Here, a blood-colored sun sets in a broody sky, as blood-colored water flows through the stream that runs between the stone pavilions on both banks. By re-photographing a photograph that he then painted over, Hong Lei further produced an elegant scene of a classical Chinese aristocrat's garden as a modern allegory of dead silence, decline and a strong feeling of oppression. In this way, Hong Lei converted an image of classical materialism embodied in the garden into a modern imaginary scene laced with paranoia.

As for modern manipulations of classical aesthetic symbols, there were some experiments in aesthetics in the field of sculpture, painting and video art. Xu Lei repeatedly combined the laws of perspective in oil painting, Bulaixite's approach to creating effects on stage, and Magritte's free placement of material images in virtual space, with the aesthetics that governed scholars' portraits in China prior to the 19th century. This turned his paintings into conceptual novels, as if a text had been combined with visual concepts from different disciplines. In concept, Xu Lei's painting was closer to conceptual art, while in structure, it was arranged like an avant-garde poem,

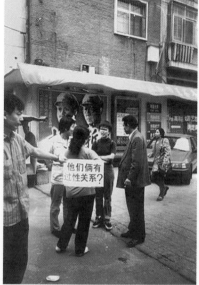
Fig. 14 Zhu Jia, *Have These People Had Sexual Relations?* 1995, photograph

Fig. 15 Zhang Peili, *Uncertain Pleasure No. 2,* 1996, video installation

Fig. 16 Li Zhanyang, *World's Stories No. 1,* 1999, painted sculpture

placing elements of traditional scholar portraiture and various modern visual aspects in juxtaposition, and endowing these with a contemporary structural presence.

The manipulation of traditional aesthetic notions was also shown in artistic concepts that appeared in the late 1990s. These include Zhan Wang's ornamental stones made from stainless steel, Cao Kai's 3D virtual image *Climbing up the West Mountain Alone*, an idea adapted from a classical poem by Li Yu. However, while Hong Lei and Xu Lei conducted true modern experiments within aesthetics and structure, such experiments were only restricted to replacing the effect of one kind of visual material with that of industrial materials and digital video.

Around 1998, photography and video also started to exert an impact on painting, sculpture and pictorial concepts. Early examples include the oil painting of Shi Chong in the late 1990s. For example, in works like *Recent Scenes* and *Surgeon*, the approach taken to painting is to produce photo-realism painting of the installation and performance. It could also be said that he transposed installation and concepts onto painting. In his style of painting, Shi Chong was influenced by photo-realism, while in visual content, he was influenced by conceptual art. The critic Gu Chengfeng published an article "New Subject of Contemporary Painting— Intervention of Conception" in the magazine *Artist*, in which he discussed conceptual painting. In the late 1990s, Wang Xingwei's conceptual painting employed a post-modern appropriation of the basic subject matters of classical painting, such as *On the Road to the East*, *Mao Zedong on the Road to Anyuan* and *In Arcadia*, a dramatic reworking of the French painting *Shepherd in Arcadia*. All these compositions grew out of the resources of art history.

Around 1998, the paintings of Xie Nanxing, He Sen and Zhao Nengzhi began to follow the effects of photography, like the relation of photography to Gerhard Richter's iconography. Shortly after, Yin Zhaoyang also adopted this painting style. Xin Haizhou's style of painting contained no photographic effects, but his compositions did attempt to imitate scenes that were more realistic than photography. He used this style to create a group of works on the subject of youth in the 1990s, and termed the "Ruthlessness of Youth Painting" phenomenon. In visual effect, Xie Nanxing's painting is like the flurry of visual halation in photography that is generated at the instance when the focus is not quite sharp or the lens or flash too close to the subject, producing a subtle poetic sense of diffusion. In his later works, Xie Nanxing started to imitate the pixilation of broadcast television images. In its visual form, Yin Zhaoyang's 2000 series *Youth Going Far Away* appears like a figure captured with the sense of light invoked in photography. He Sen's works focus on interior settings, illuminating the instinctive fear in the instance when a girl closes her eyes and covers her eyes with her arm to fend off the flash of the camera. Zhao Nengzhi's compositions are like his own demonized image in a mirror. At the end of 1990s, this kind of imitation of photography was an experiment with image that remained aligned with an academic flavor of realism.

Photography also affected sculpture in the mid-1990s. Colored sculptures as Xu Yihui's 1994 Pop-style ceramics, Wang Du's *Flea Market—Peddling News* (1999), Liu Jianhua's *Infatuated Memory* series (1999) and Li Zhanyang's series *World's Stories* (1999) and *Family* (1999) were like sculptural versions of photography in form.

Within the thinking in art in the earlier and middle part of 1990s, painting and sculpture had long been regarded as areas in which no visual experiment could be conducted. As mediums, they were considered "inferior," while installation art and new media art were regarded as "advanced" media.

In the early 1990s, pure experimentation in painting was mainly reflected in abstract painting and was concentrated in the Shanghai region, such as experiments with line and geometric structure by Ding Yi, Qin Yifeng and Chen Qiang. In sculpture, Sui Jianguo and Fu Zhongwang conducted experiments with concepts of sculptural structure in traditional modes of composition.

By the late 1990s, concepts about the state of different media gradually faded. Painting, sculpture, installation and new media art were regarded as equal mediums. What was important was that a medium was nothing more than a conduit for expressing a concept or emotion. This indicated that Chinese experimental art had become contemporary in scope. However, on the whole, painting and sculpture also began to absorb the visual characteristics of new media art. This is one reason that painting and sculpture alighted upon new possibilities for experimenting with visual form, that is, they switched from expressing material images to expressing video images.

In the early and mid-1990s, conceptual art appeared as a pluralist art. The form of these works was a vehicle for recording an idea but often failed to reflect those aspects that concept could convey. In the late 1990s, one change that occurred in conceptual art was that in its approach to expression it often employed the same manner of expression

Fig. 17 Fu Zhongwang, *Convex and Concave, Human Landscape*, 1994, 50 x 45 x 45 cm

Fig. 18 Shi Yong, *Filled Projection*, 1993, sensitized paper, fiberglass, paint

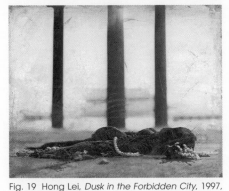

Fig. 19 Hong Lei, *Dusk in the Forbidden City*, 1997, photograph

Fig. 20 Ding Yi, *Manifestation of Crosses 92-19*, 1992, acrylic on canvas, 200 x 240 cm

and recording characteristics as mediums such as painting, photography, video and sculpture. A particular medium was chosen not to record a statement but as the ultimate form of the work. In this respect, conceptual art returned to single-medium works, such as painting, photography and video, producing forms that were conceptual in orientation with regard to their mode of expression. For example, Zhang Huan's *To Raise the Water Level of a Fish Pond* (1997) features a crowd standing in a pond, and is a photographic vision of the power of silence. It clearly goes beyond the concept of "raising the water level." In Li Yongbin's *Face I* (1996) and Song Dong's *Father and Son* (1998), the overlapping of the faces exploits the possibilities of video as a language, which was both the form of expression and of recording the action.

III. Post-Ideology Cultural Subject in Conceptual Art

In the 1990s, the practice of conceptual art and new media art provided the basis for experimentation with visual concept, the expressive potential of a medium or form, and aesthetic experiments about art. Equally, as a form of expression, conceptual art was also used to explore cultural issues in all phases of market socialism or the period of transition into a post-ideology era.

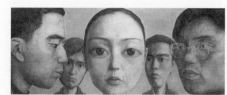
Fig. 21 Xi Haizhou, *Change—Youth*, 2001, acrylic, 135 x 300 cm

Within experimental art in the 1990s, post-modernism, scrutiny of the intellectual, an awareness of modern history and youth culture were basic subjects for art. In the 1990s, certain basic problems emerged, including the state of the intellectual or intellectualism in a peripheral region, the concentration of elitist culture, the consumerism generated by the market economy system from the south to the north, and the material, public and popular culture under capitalism. Such problems had always been regarded as a suitable topic for artistic consideration in the 1990s, except that cultural reactions within the art circles were different at different periods.

The basic evolution of culture in the 1990s was that the investigation into intellectualism inclined towards disintegration and restructuring, while materialism and mass consumer culture gradually achieved cultural legitimacy. The new-generation painting of Liu Xiaodong and Zhao Bandi become a trend in art in the 1990s. This group reflected the daily situation of those young intellectuals on exile on the fringe of society after 1989. Their paintings had characteristics of youthful ideology. Elements that signified youth and "scars" were given a new visual appearance and psychological depth. The paintings of the new generation upheld the sentiments of Scar Art, the general background thinking, psychological consciousness and attitudes towards political ideology in the late 1970s. In their specific social outlook, they exhibited the ground-breaking aesthetics of an arrogant young elite with little interest in political culture. However, they did stress the real value of individuals within their daily life, beyond any sense of critical realism as romantic as that of Scar Art.

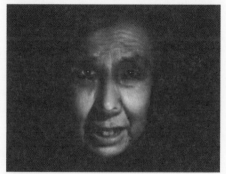
Fig. 22 Li Yongbin, *Face*, 1996, video

The sentiments of these young intellectuals and the characteristics of their art became manifest in the so-called Ruthlessness of Youth Paintings of artists such as Xie Nanxing and Yin Zhaoyang in the late 1990s. Ruthlessness of Youth Paintings expressed, in an allegorical manner, the moral concerns and plight of the generation born around 1970 that was experiencing inner conflict at the polemic experience of materialism against notions of Utopian socialism in the late 1990s. Their paintings had none of the critique of ideology that Scar Art contained, nor any sense of political resistance from this new generation. Their heart ached for no tangible reason. Ruthlessness of Youth Paintings were also a kind of experiment in connecting photography with painting.

Fig. 23 Liu Dahong, *A Tale of Two Cities (detail)*, 2000, oil on canvas

By comparison with the sad gray emotion of New Generation and Ruthlessness of Youth Painting, in the early 1990s, the Cynical Realism of Fang Lijun, Yue Mingjun and Zeng Fanzhi and the Political Pop of artists like Wang Guangyi indicated a cynical attitude towards the socio-political and cultural framework. Li Shan's allegorical schizophrenic compositions expressed his personal experience of the intellectual in political society. Liu Dahong consistently explored modern re-workings of immediately recognizable political symbolism, which he infused with modern utopian ideals.

Pop Art styles first appeared at the end of the 1980s and were extensively applied to the art through the 1990s. In the mid-1990s, Xu Yihui began to use elements of Pop Art to reproduce objects of mass consumer culture. The critic Li Xianting called it Gaudy Art in this period. Different attitudes towards expressing materialism and consumer culture began to appear in the mid- to late 1990s, as would-be intellectual artists expounded critically ironic attitude toward commerce and consumerism, while artists of the new generation fell upon materialism. The latter also increasingly began to adopt the beautiful colors of the fashion world. Works by Li Zhanxiang, Zheng

Guogu, Yang Yong and Yang Fudong reflected a sense of nihilism at the core of the young generation, born of the commercialization of Chinese society and globalization in general.

Another subject of conceptual photography was that of reviewing old photographs from recent history. Around 1996, Zhuang Hui began to organize people from all vocations together as representative of their work unit, to imitate photographic group portraits. Hai Bo regrouped the original members of old group portraits to be re-photographed with gaps left where absent members ought to have been. Both found a certain kind of modernity and historical consciousness of the self in the old photographs.

Feminism art arrived at some degree of maturity in the late 1990s. Cui Xiuwen's video work, Yu Hong's paintings, He Chengyao's performances and Chen Lingyang's works focused on the body all contained a certain rational neutral color in the concept of expression.

In the late 1990s, an anti-post-colonial stance also became the subjects of a number of art works. For example, works by Zhou Tiehai and Yan Lei sneered at Western exhibition curators, forging invitation letters from major foreign exhibitions (*Documenta*—Yan Lei and Hong Hao) and making out they had been selected for the cover of *Time* magazine (Zhou Tiehai). In the end of the 1990s, anti-humane experiments in performance art also appeared. These included the use of animals, human corpses, blood and violence in various experimental approaches.

Chinese experimental art in the 1990s occurred in a period in which artistic trends and cultural concepts were merging gradually to form a global vision. Experiments in all kinds of mediums, aesthetics and subjects began to echo new trends in international art. However, it has not yet completely established its own autonomy in subject and concept. In its cultural concept, it does exhibit certain cultural characteristics and an interest in aesthetics peculiar to China in the post-ideology period.

Zhu Qi is an independent curator and art critic.

Fig. 24 Wang Xingwei, *On the Road to the East*, 1995, oil on canvas, 180 x 146 cm

1 Participating artists included Ma Liuming, Zhang Huan, Cang Xin, Zhu Ming, Duan Yingmei, Zu Zhou, Wang Shihua, Ma Zhongren, Gao Yang and Zhang Binbin. Location is near Beijing's Miaofeng Mountain.

2 For several reasons, this article remains unpublished. Some parts of this article were selected as the foreword of the catalogue of the exhibition *Image Stories*.

Translated from the Chinese by Karen Smith and Zhang Zhiqiu

Chinese Experimental Painting in the 1990s

Yi Ying

In the 1990s, Chinese experimental painting was influenced by two important elements. The first was the avant-garde art movement that emerged in the 1980s. The second were the significant sociopolitical and economic changes that took place within Chinese society through the 1990s. In the 1980s, experimental painting was dominated by formalism and processes that sought to eschew academicism. These two strands were intricately connected. In this context, academicism had a special meaning. On one hand, it was the embodiment of an artistic form (as evolved in Europe). It was further an approach to realism that had been contrived in China in the mid-1950s, pivoted upon an imitation of Soviet Socialist Realist technique. For China, the Soviet style supplied that element of classical painting akin to the European tradition, which its oil painting had to that point lacked. On the other hand, under the special historical conditions of that time, the academic style was soon reduced to an applicable form of the original Soviet Socialist Realism, enslaved in political servitude. In this role, the political power it embodied exerted an influence on all aspects of the visual arts in China. The realism upon which it centred reached its zenith in the 1960s, whereby the production of numerous history paintings saturated with revolutionary realism had accorded it an unshakeable status.

The Cultural Revolution began in 1966. During the ten years that followed, when the door to the outside world was tightly closed, the sole *raison d'etre* of art was its role as biting political tool. A set of principles for artistic creation was formulated affirming arts subjugation to political dictates. Central to these dictates was the principle of "*san tu chu*" (translated as "three emphases" or "three prominent points"), which had a primary effect on all creativity.

The result was a pseudo style of realism, which whilst maintaining the essence of academic realism, deviated from the actual tradition that had been adopted from the Soviets and ultimately limited the artist's creative freedom. Until the end of the Cultural Revolution, and even after the Third Session of the 11th National Congress (December 1978), the established principles of this adulterated academicism continued to be the doctrine adhered to in the art academies. In truth, these doctrines governed all.

The avant-garde art movement that began in the mid-1980s initiated an approach to experimenting with art that departed from the proscribed academic criteria. It was taken up with enthusiasm by the main body of students and young teachers in the art academies. In the early stages of "reform and opening to the outside world," as Western modern art made its initial impact felt, the academies in China became centers of avant-garde art. The varying forms of Western modern art were the main source of a non-academic approach, but in truth "experiment" with modern art in China merely meant "imitating" it. The essence of this superficial imitation lay in a desire to rebel against the rigid tradition of academicism and a quest for individual emancipation and artistic freedom. The background against which this took place was a complex combination of the type of thinking spawned by the gradual liberation of minds that began through the 1980s as China's door swung open, coupled with a yearning for Western modern civilisation. When China opened its long-closed doors, it discovered an enormous gulf between its poverty-stricken landmass and the developed world outside. Any aspect of contemporary Western culture quickly became a target for fetishist worship as being the sign of an advanced civilisation. This was how the various forms of Western modern art initially functioned in China.

The avant-garde art movement in China evolved under the auspices of imitating, and then mocking, the forms and concepts of Western modern art. It was not until the late 1980s that modern artistic styles with truly Chinese characteristics began to appear. These styles evidenced elements of primitive motifs and forms, demonstrating an attempt to reform the various "isms" of Western modern art through the use of traditional Chinese culture and folk art. But the experiments that were carried out ultimately demonstrated that it was impossible to conjoin the art forms of an industrializing and a post-industrialized age, though a number of works were successful in their way.

However, the achievement of the avant-garde art movement did not rest on the production of new artistic forms but in embodying a new spirit, which was powered by an unflagging motivation to modernize China. It was against this context that artists began experimenting with painting in the 1990s.

Fig. 1 Liu Xiaodong, *Garden Song*, 1989, oil on canvas, 170 x 120 cm

The development of art always takes place within the overarching paradigm of historical contingencies: In the late 1980s, the avant-garde art movement in China found itself brought to an abrupt halt. [1] Although the political tide that swept through 1989 played a significant part in this, an equally crucial reason for the impasse was a congenital deficiency within the movement itself. Thus, as the 1990s began, artistic experiment did not proceed in the same direction as that which the 1980s avant-garde art movement had taken. In the 1990s, experimental art found its first expression in the new art of young artists who had not participated in the 1985 New Wave movement.

In April 1990, Liu Xiaodong, a young teacher at the Central Academy of Fine Arts in Beijing, held a one-man show at the Academy's gallery. The exhibition created a stir within the art circles. Soon after, another, titled *The World of Women Artists* was organized at the same gallery, featuring paintings from eight young women, the majority of whom were recent graduates from the Academy. In October that same year, a two-man exhibition featuring work from Zhao Bandi and Li Tianyuan was also held. In July 1991, an exhibition titled *New Generation Xinshengdai*, co-curated by a group of critics, formally marked the advent of this new trend of thought. It was unexpected that in the 1990s, avant-garde art would kick off with such widespread realism. The New Generation's unifying characteristic was its focus on reality (and its use of realist styles of painting), which ran counter to the formalism of the 1980s.

In the 1980s, with ideological emancipation as the motif and form, and criticism as the breach, the avant-garde paved the way for a diversity of artistic creation. The majority of the New Generation artists had not directly participated in the 1985 New Wave movement. They had not experienced the Cultural Revolution in the same way or been sent to the rural areas as educated youth, as many of the participants of the 1985 New Wave movement were. They received their secondary and college education after the Cultural Revolution had ended. As those artists who had undergone the experience of being "educated youth" were bringing forth adaptations of Western modern art, artists of the New Generation were not only receiving a training rooted in academic realism but were being influenced by the realist art of the generation immediately above them (who had been retained by the academies as teachers). They lacked any experience of real hardship or the enforced collective spirit that had characterised China from the 1950s to the late 1970s. Their concerns arose from, and were focused upon, their own personal experience. A realistic painterly approach enabled them to express this in highly individual ways.

Fig. 2 Ding Yi, *Manifestation of Crosses 97-(7)*, 1991, acrylic, 140 x 170 cm, detail

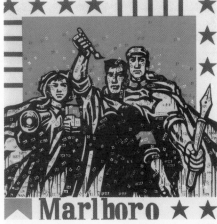

Fig. 3 Wang Guangyi, *Great Criticism-Marlboro*, 1992, oil on canvas, 175 x 175 cm

Echoing the advent of Country Life Realism (*xiangtu xianshi zhuyi*) in the early 1980s, New Generation artists again turned their eyes to real life, merely replacing "country life" with urban life and infused with critical jibes at idealism. New Generation artists observed and recorded life at first hand rather than describing a proscribed idea of reality via an established formula. Their art, therefore, was not a straightforward return to realism. Just as their counterparts in the 1980s had sought to bring forth a personal creative value through a criticism of form, in the early 1990s artists tried to demonstrate this value through their individual artistic discourse. Their paintings resonated boredom and perplexity, satire and discontentment that arose from an inability to envision the future or to find a position or status within society. The early 1990s marked an important phase for China that witnessed its transformation from a planned to a market economy. It was during this phase that the majority of the New Generation artists made their debut.

The concerns of these artists revealed in their work illustrated a desire to explicate their individual worth, demonstrating both a clear social conscience and sound moral judgement. Thus, various social phenomena such as the growing divide between rich and poor, a lust for money, and widespread corruption were taken as subject matters. The avant-garde nature of the New Generation group lay in each individual artist's reaction to the changing social reality. This laid a firm foundation for real life within avant-garde art, and also set the keynote for the development of avant-garde art in the 1990s.

At the beginning of 1992, the speeches delivered by Deng Xiaoping while on a tour of southeast China propelled reforms of the economic and political system forward. Chinese society plunged into a fury of economic development. A modern society swiftly emerged and the urban theme as pursued by New Generation artists became increasingly mainstream within Chinese modern art. In October 1992, the First Guangzhou Biennale entitled *Oil Painting in the Nineties* was held. It was the first large-scale exhibition of avant-garde painting and also the first attempt to use a market system to organise a nationwide exhibition. The event highlighted two main facts. First, the Guangzhou Biennale assisted in advancing the avant-garde cause that had lost momentum following the *China/Avant-garde* exhibition in 1989. Second, it provided an economic basis upon which to develop a market for avant-garde art. The latter reflected the rapid change taking place within Chinese society, but regardless of the ideals the organising critics might have had, China's art market had yet to prove itself sound enough to accept avant-garde art.

The Guangzhou Biennale was successful in mapping out the leading trends in experimental painting of that moment. The first was clearly marked by its focus on reality and a localization of experiment. This was not just the result of combining an exploration of artistic form with images of the new reality. It also contained examples of the practical experience that society provided for avant-garde art as that society marched towards modernization.

All this was evidenced in the paintings of New Generation artists. The New Generation style dominated works in the Guangzhou Biennale, and provided an indication of the progress that had been achieved. Artists clearly no longer depended on ready-made forms of Western modern art but paid attention to real and personal experience. This progress triggered a breakthrough in localizing the language of modern art in China.

Simultaneously, the spirit of the 1985 New Wave movement continued. Its underlying idealist spirit quickly revealed a stronger, more profound vitality than was evidenced in New Generation art. The main expression of this spirit at the Guangzhou Biennale was Political Pop.

Political Pop, which began to take shape in the early 1990s, was to become an important phenomenon. At that time it was not yet termed Political Pop but addressed as Hubei Pop because initially those artists who adopted this approach mostly lived and worked in Hubei province. The approach sprang from an appropriation of Western Pop Art concepts, to which Chinese artists added ready-made symbols that bore an apparently political nature. The works of Wang Guangyi, a painter active in Wuhan, were most typical. It was his grand-scale "pop" styled paintings of Mao Zedong that made him stand out at the *China/Avant-garde* exhibition in 1989. In his *Great Criticism* series (fig. 3), also exhibited at the Guangzhou Biennale, propaganda posters prevalent during the Cultural Revolution were juxtaposed with signs of popular American culture, e.g. the trademark of Coca-Cola or Marlboro. These suggested great political change through dislocating visual motifs in time and space.

Hubei artist Zhou Xiping's *Liquidation* symbolized a review of history. This was achieved by grouping photographs of historical figures together against a background of motifs found on various coins. Another Hubei painter, Wei Guangqing, combined pictures of the Great Wall, Chinese skullcaps and Fuji film packaging to signify the conflict between Chinese feudalistic traditions and modern civilization. Most of these artists participated in the 1985 New Wave movement and had grown up with a strong cultural-critical consciousness. However, the simple form of Pop Art was unable to rise to the challenge of narrating the Chinese situation. At the same time, these artists were unwilling to return to conventional realism. For the time being, the combination of Pop Art and Chinese iconography was still new.

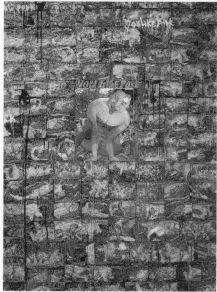

Fig. 4 Liu Wei, *Do You Like Meat?* 1995, oil on canvas, 200 x 150 cm

As distinct from the small pocket of Pop painting styles of the 1980s, the symbols that artists began to employ in the 1990s were not simple illustrations of a form but a profound breakthrough concerning real life and history, pivoted on narrative and figuration. This was only the beginning of Political Pop. Following the Guangzhou Biennale its pace of development quickened rapidly. The name was soon to be used extensively.

In 1993, the exhibition *China's New Art, Post-1989* was held in Hong Kong. Its aim was to demonstrate the development and stature of the avant-garde art following the *China/Avant-garde* exhibition in 1989. The year "1989" has particularly political connotations. During the Anti-Bourgeois Liberalization movement that followed swift on the heels of June Fourth (the day action was taken against students demonstrating for democracy in Tiananmen Square), the avant-garde art became a target for criticism within the art circle. Moreover, within this political situation, avant-garde art was naturally linked with a particular type of ideology, especially where Western countries still adhered to economic sanctions imposed against China.

China's New Art, Post-1989, which was exhibited outside of mainland China, inevitably invoked associations with vanguard Soviet art during the Cold War. After 1989, in terms of form, Chinese avant-garde art was mainly characterised by Neo-Realism and elements of Pop Art. Beneath common ground these two strands enjoyed lay the fact that they both incorporated an exploration of form and approach with a sense of the Chinese socio-cultural reality. Pop combined with politically loaded visual symbols constituted Political Pop. Although this tendency was visible in works at the Guangzhou Biennale, these mainly referred to historical, cultural or individual experience rather than to actual politics.

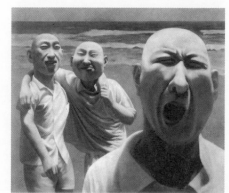

Fig. 5 Fang Lijun, *The First Group No. 3*, 1990, oil on canvas, 80 x 100 cm

However, in tandem with the showing of *China's New Art, Post-1989*, this style of Pop Art was endowed with political meaning by critics overseas. This resulted in the popularity of its progenitors in the West, affording them invitations to participate in major international exhibitions. In this way, their works were introduced to the international art market.

Strictly speaking, Political Pop never truly formed a movement nor were the works that so-called Political Pop artists produced exhibited in China. It was only due to its success overseas that a group of domestic followers were encouraged to rally to the Political Pop cause. Though its impact was tremendous on the development and evolution of contemporary art in China, it operated within the narrow scope of a small arena. To a large extent, Political Pop became the exclusive representative of Chinese avant-garde art in the West, for it was the typical embodiment of post-colonial culture in China, which made it unmistakably controversial.

Yet, the *China's New Art, Post-1989* exhibition did not have works containing symbols rich in political meaning. It was only following this show that, with outside interest in modern Chinese art, and when discovered, the embrace of this new Pop, the impact of Political Pop abroad led some artists to the direct appropriation of political icons. Suddenly imagery of the army or the police, portraits of national leaders, the national flag and other cultural symbolic markers like the Great Wall or the Forbidden City appeared on canvases everywhere. These were

tampered with in vulgar ways, integrated into kitsch scenes of daily life that at times uglified the Chinese people. In the view of Western critics, these works, which undeniably carried political implication and allusion, indicated an alluring political confrontation.

While Political Pop created a sensation abroad by virtue of overseas critics and exhibitions, it went largely unknown in China, and the influence it exerted remained limited. The political symbolism upon which Political Pop drew tended to disguise the weakness of its form. Since the critical realism produced in the early 1980s influenced by the ideological liberation that was taking place in society as it — and artists in particular — reflected upon the Cultural Revolution and cultural despotism. For this reason, an element of sociopolitical criticism was present in all the main new artistic trends. Yet, the representation of these subjects continued to involve either a comparatively academic style or an imitation of the forms of Western modernism. The content of the work, and the visual metaphors that were invoked, were difficult for overseas critics to perceive clearly.

Once introduced to the West, Political Pop was accepted unquestioningly within the prejudices and historical contingencies of foreign minds and experience. Ironically, although it had become simple for the general public in China to understand, it was no longer possible for the ordinary people to participate in modernist art activities as had been the case in the 1980s. [2] From one angle, the nature of Political Pop demonstrated how China's social change was exerting a profound influence on the form of avant-garde art. Most obviously, it fundamentally changed the direction of experimental painting and put an end to the tradition of academicism and the tendency to imitate Western modernism.

Fig. 6 Wang Yuping, *Fish*, 1999, oil on canvas, 160 x 170 cm

The realism of New Generation artists, with their characteristically direct use of images, was totally different from orthodox approaches to academicism. Some artists like Liu Xiaodong, Yu Hong, Wang Hao and Wei Rong elected to work directly from either photographs or pictures; the difference lay in the transformation of the photographs by Liu Xiaodong against the direct duplication employed by Wang Hao.

Artists like Fang Lijun and Liu Wei felt the influence of the New Generation and they began to shift their practice to oil painting (figs. 4, 5). Their formal training in printmaking enabled them to work in a far more graphic, two-dimensional way that had more in common with public advertising. This made it more possible for a general public to identify and accept the images and their meanings within the work.

Although Zhang Xiaogang did not directly employ this form of public image in his paintings, his habitual use of old photographs demonstrated his reflection upon history. His paintings resonated with the public, especially in the prevailing aura of nostalgia in the early 1990s. As the decade unfolded, led by rapid economic development, mass culture was making equally rapid strides into the public arena. The prevalence of television, feature films, advertising, pop magazines, fashion, VCDs and computers brought urban life together with a world of public images. This altered the visual experience of ordinary people enormously and also influenced conventional concepts of painting, even very contemporary painting.

Fig. 7 Wang Yigang, *Work #45*, 1992, oil on canvas, 175 x 175 cm

Expressionism, which emerged in China in the mid-1980s, gradually broke away from the trend of self-expression and formalism, and began to focus on the experience of reality, including daily life and visual observation. In Sichuan province, a group of young painters began to present personal experience in expressive forms, expanding their subject matter to social issues, thus infusing new vigour into the expressionistic style. Artists Guo Jin and Guo Wei imbued representations of the human environment with extraordinary visual tension. The images and forms represented here paralleled the artists' experience of reality with that of the viewer. Shen Xiaotong produced remarkable works using an expressionistic approach to present realistic themes before turning to a narration of his own experience, finally arriving at simple, iconographic compositions. Beginning with a style close to that of the New Generation, Zhong Biao developed compositions out of a collage of images that invoked the contradictions between modern urban life and traditional culture.

One of the most characteristic works was produced by Beijing-based painter Wang Yuping (fig. 6). Shown in the *Annual Exhibition of Oil Paintings Nominated by Chinese Art Critics* in 1994, this figure composition was typical of his expressionistic style. Wang Yuping's approach was not only a free expression of emotion but also drew heavily upon the experience of colour within the realm of mass culture, imbuing the work with a strong modern sensibility. Wang Yuping aligned an aesthetic representation of color with a sense of existentialism, apparently questioning the harmonious coexistence between man and modern civilization.

Abstract painting in China evidenced a similar experience. As a primary form of Western modern art, abstract painting never occupied an important position within Chinese avant-garde art because it lacked an historical context or a common sensibility. Its advance was further deterred by a lack of form against which to react, or which would provide the springboard for a cultural reaction. Abstract art aroused no association with reality or any sympathy from the general public despite the fact that would-be abstract artists experimented with all kinds of abstract forms ranging from traditional art to cultural symbols, from folk art to Abstract Expressionism.

Although experimental painting in the 1990s remained focused on representation, abstract painting did undergo some change and was injected with new energy. It remained primarily governed by a combination of

individual language and contemporary visual experience. A good example of this is the work of Shenyang painter Wang Yigang, whose early works were expressionist abstracts, full of expressive, energetic brush strokes and motion (fig. 7). The coded blocks of colour and additional motifs combined to a precise structure. But gradually, he replaced this approach of modernistic art with casual brush strokes, which juxtaposed disharmonious colours, and covered canvases with marks and signs to create a grotesque urban aura. This did bring something fresh to abstract painting.

Tianjin painter Jiang Hai shifted between representation and abstraction (fig. 8). However, far from being pure abstracts, his compositions remained narrative as he conjoined the predicaments evoked by the contemporary urban environment with a strong visual impact suggestive of conflict between human existence and relentless development. These paintings revealed clear Post-Modernist themes.

But whether it was expressionist or abstract, the source of the artist's language lay in Western modern art forms and the Chinese tradition of academic painting. Abstract painting consistently evidenced of the lingering visual features of academic painting in terms of structure, colour and brush stroke. This was to be thoroughly terminated by the development of two types of paintings in the 1990s.

China's induction to mass culture meant that not only were artists developing ideas and styles from out of their individual experience and the visual elements of the actual environment, but that these forms were evolving as both individual and local in breadth. The forms included irascible aspects of the Chinese experience. They were no longer generalized, formal styles of representation but had expanded to evoke society, culture and history, which signified the transition from "form" to "content," from "Modern" to "Post-Modern."

Although to date, China has not undergone a modern industrialized revolution in process *per se*, within a couple of decades of "reform and opening," the nation had grown rapidly from an agricultural or pre-industrialized society into a modern one. In the major cities, the issues associated with a post-industrialized society, or with Post-Modernism, had already emerged, yet that of mass culture had only just begun to rear its head.

The second phase of Political Pop differed from the pop style apparent in the Guangzhou Biennale. There was, however, no direct link between the two in nature. In the early 1990s, critic Li Xianting called the works of a group of young artists Rogue Art or Cynical Realism. These works pivoted upon human confusion and an aura of depression. These sentiments derived from the contradictions and polarization that had been brought on by the period of social transition as well as the desire to seek escape and find relief from the negative ironies of life and a strong sense of self-depreciation. The anti-academic technique of Pop Art contributed to this "roguishness" and laid a platform for the subsequent advent of Gaudy Art.

In a sense, Gaudy Art was more roguish than Rogue Art. Without being defined clearly by theory, Gaudy Art received its name from an exhibition of that title organized by three artists, first at the Beijing Art Museum (*Models From the Masses*, 1996) and then a second at Wan Fung Art Gallery by a different group of artists (*Gaudy Life*, 1996). One suspects the name was chosen to cater to the sphere established by Political Pop.

In terms of form, the most distinct difference between Gaudy Art and Political Pop was that the latter used Pop style techniques to paint, whilst the former largely took the form of non-painted graphics, which hinted at the advent of a post-painting era. Most of the artists from the Gaudy Art movement were not native to Beijing; they were largely "vagabond" artists living at the edge of society. Most Political Pop artists had stable jobs, especially the first generation. Some of them were even college teachers, who came to Political Pop in line with their contemplation of history and cultural criticism.

Conversely, motivated by an urgent need to make a living, Gaudy artists stretched the various aspects of mass culture and Political Pop to a vulgar extreme. No matter how they started out, compared with Political Pop artists, members of the Gaudy group, with their "edge of society" status and working class experience, had more to say about vulgar culture. They were more expressive of personal experience and thus more closely approached the artistic concepts of Post-Modernism.

Superficially, Gaudy Art appropriated low-level, vulgar art to create works composed of flamboyant colour, simple images and a structure at odds with the conventions of painting. Moreover, the images or motifs were rooted in daily life, ranging from bank notes to Chinese cabbage, from advertising or film posters to public signs that could be seen anywhere. Of course, a handful of grand and solemn images like those of the Forbidden City, the Summer Palace, Chinese soldiers or policeman — the familiarity of which also appealed to foreigners — made the occasional appearance. Essentially, these Gaudy artists projected a direct reflection of life experience at a working class level. They attempted to effect a true avant-gardism with a thoroughly roguish attitude that made clear its objections to academic art and the refined element within the avant-garde. However, Gaudy Art works did not specifically portray social conflicts; it remained a reflection of low cultural life such as prostitution, gambling, drug addiction and general social vices. But by representing them with intense emotions, Gaudy Art did embody some of the more heated social contradictions, conveying a real social polarisation. However, it was almost a foregone conclusion that Gaudy Art would not produce any really excellent artists or works because its

Fig. 8 Jiang Hai, *Big Can*, 2001, oil on canvas, 180 x 125 cm

Fig. 9 Li Hong, *Sisters*, 1998, oil on canvas, 60 x 50 cm

fundamental principles objected to successful art forms, including those of avant-garde art. This placed it in an antagonistic position towards art in general. Non-painting art forms, such as photography, video, installation and embroidery, also began to permeate the Gaudy Art scene. No one could predict that, as an art form, Gaudy Art would enter Post-Modernism in this way.

The emergence of Gaudy Art actually marked the end of experimental painting. The latter remained within the domain of Modernism, mainly characterised by an exploration or innovation of form. Located somewhere between Modernism and Post-Modernism, Pop Art merely reproduced public images in a manual way. Replacing painting with ready-made images indicated that any ready-made could be art, including people and their behaviour. In the 1990s, Chinese experimental art was to take this road. From the advent of Gaudy Art onwards, the experimental side of avant-garde art no longer found expression in painting alone. Post-Modern artistic forms such as performance, video, installation and body art—in public or in private—became mainstream within Chinese avant-garde art. In respect of its significance within the avant-garde art, painting would become marginalized. For painting to develop following its own logic, conceptual art would become its main source of reference, likewise advancing within the context of Post-Modernism. This was to become a trend in the development of experimental painting from the mid-1990s.

From the mid-1990s, experimental painting again developed in two ways, both of which fell under the influence of Post-Modern concepts. The first was the subject of Post-Modernism itself. The second was conceptual painting. Post-Modern issues were, in essence, those of human existence and the difficult positions of post-industrialized contemporary society. This was especially serious in China as a developing country rapidly striding forward into modernity. Gaudy Art reflected the human living environment through social conflict and collision, invoking issues of identity and margin, with which women's art was closely associated.

For a long period of time, the art of Chinese women artists had no explicit gender consciousness and women artists explored the same themes and forms as their male counterparts. In the mid-1990s, the situation underwent a sudden change. With the Fourth International Women's Congress held in China in 1995, a group of women artists seized the opportunity to step forward onto the contemporary Chinese art stage demonstrating an explicitly female consciousness. Artistic concepts of feminism, which had emerged several years prior, were not fully expressed in a concentrated manner until this moment. A woman's awareness, views and identity constituted the main forms of the art these women artists produced. Their art challenged the long conventional history of male-dominated society through the narrative of personal experience. It reflected both a feminist consciousness and evidenced a feminine approach to representation within contemporary Chinese art.

The female consciousness found vivid expression in painting but was most radically represented in conceptual art from which a group of distinguished artists emerged. The *Contemporary Chinese Art Exhibition of Women Artists* in 1997 offered a concentrated display of trends in feminist painting. Compositions by the young painter Li Hong illustrated the life of women at the bottom of the society (fig. 9). In her capacity as a reporter, she conducted a survey of general living conditions of these women, and her works took the form of reports on these conditions. They revealed the inequality of genders in an incisive way. Her later works gradually adopted a more Pop quality as she turned her criticism onto women themselves, exposing the social phenomenon of women who throw themselves at money and power.

Incorporating a Pop style of painting with profound visual metaphors, Yuan Yaomin juxtaposed the figures of ancient terracotta warriors from the Qin dynasty with fashionabe modern women in a grotesque way, lampooning male domination in the form of satire. Conversely, women artists such as Yu Hong or Shen Ling were more inclined towards dealing with their own experience of daily life, representing it from a feminine perspective. This rebutted themes and forms that had been made into conventions by male artists. More radical women artists, such as Cui Xiuwen and Feng Jiali, adopted the physical features of the opposite gender as their language of representation, to react against the dominance of male power. They were direct expressions of a strong feminist consciousness.

Like "feminism" being a theme of Post-Modern art, so have history, culture, politics and society become increasingly of interest to artists. The result is Neo-Realism or Neo-Figurative painting. Personal experience and daily life with which the New Generation artists were concerned gradually became tainted with political meaning, just as Political Pop began with the forms but was progressively endowed with a political cast. Though these two forms differed dramatically in style and approach and failed to remain a unified movement, Neo-Realist paintings shared one common feature, which was to "bid farewell to the avant-garde and self-expression of forms in favor of a directly expressed social consciousness." In addition, thanks also to the positive influence of conceptual art, this was a far-reaching change.

Qi Zhilong's works realistically rendered the image of Red Guards from the period of the Cultural Revolution. His manner expressed his view of history that "collective experience was not able to take the place of individual memory even during such a crucial historical event like the Cultural Revolution. Nor did individual

Fig. 10 Yin Zhaoyang, *Spring*, 2000, oil on canvas, 150 x 200 cm

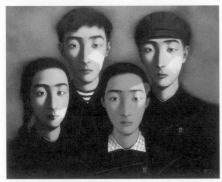

Fig. 11 Zhang Xiaogang, *Big Family No. 3*, 1995, oil on canvas, 180 x 210 cm

memories always match collective experience." In conclusion, it was the artist's intention to demonstrate the post-Cultural Revolution generation's experience and conflicting sense of value between collective experience and individual memories.

Ma Baozhong continues to work with the realistic features of academic painting in his compositions-features that proved suitable for themes of international politics, of the Cold War and other critical international events such as the war in Kosovo (and the bombing of the Chinese Embassy in Belgrade). The artist used these to suggest the notion that catastrophes do not end with the conclusion of a war; that human lives were vulnerable and fragile, and peace the most valuable of all things.

Hubei-born artist Shi Chong (now based in Beijing) duplicated performance art with painting. It seemed that he sought a correlation between conceptual art and painting. He first designed an act then recorded the act with a photograph before duplicating the photograph via painting. Painting played a role of a graphic. The act itself was usually related to a specific social issue. In particular, the artist chose those acts that could mirror the human living environment, governed by an absurdity and irony that demonstrated the loss of spirituality.

The 1990s was a dramatically changing decade for China. It seemed that Chinese society made the transition from pre-modern to post-modern within these ten years. Deriving from the artists' impulses and aspirations to respond and understand these tremendous changes, with its innate narrative attributes, painting emerged as a spiritual reflection of contemporary Chinese reality. Zhang Xiaogang is a good example here. He came into prominence in the early 1980s as a vanguard in experimental painting. In the mid-1990s, his series entitled *The Big Family* moved in a new direction as he replicated old family photographs on canvas using academic painting techniques yet in a Pop style (fig. 11). The artist himself appeared in these photographs, which seemed to imply that the works were autobiographical. This apparent personal experience and narration actually reflected the mood of nostalgia that had been permeating the public sphere since the early 1990s. The ordinary people were not used to the corruption and social polarization that arose as a consequence of economic development, and began to recall the higher moral standards associated with a traditional, though impoverished, lifestyle. Artists did not attempt to make any ethical judgement but speculated on history and reality. In this aspect, with its natural narrative attributes, Neo-Realism demonstrated its vigorous advantage.

Yi Ying is professor at the Central Academy of Fine Arts and the editor of the Academy's journal.

1 A primary reason given was the firing of gunshot into an installation at the opening of the *China/Avant-garde* exhibition at the National Art Gallery, Beijing, February 1989. It is also suggested that, in only following Western Modernism as a model, which was without historical context in China, the art of the avant-garde had reached an impasse.

2 This is compared with the participation of large numbers of ordinary people in the activities of the Stars Group in Beijing.

Translated from the Chinese by Karen Smith.

Zero to Infinity:
The Nascence of Photography in Contemporary Chinese Art of the 1990s

Karen Smith

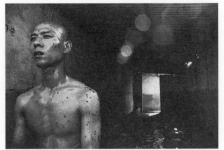

Fig. 1 Rong Rong, Zhang Huan, *12 Square Meters* (East Village No.20), 1994, black and white photograph, 127 x 198 cm, edition of 15

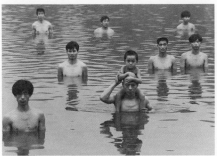

Fig. 2 Zhang Huan, *To Raise the Water Level in a Fish Pond*, August 15, 1997, color photograph , (performance at Nanmofang fishpond, Beijing), 27" x 40", edition of 15, photograph by Robyn Beck

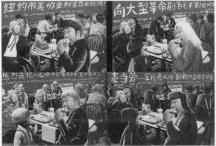

Fig. 3 Zhao Qin / Liu Jian, *I Love McDonald's*, 1998, color print, acrylic paint, set of eight images, 24" each

Preface

It is necessary to preface the following text on "art" photography in China with a brief explanation of how the medium of photography was utilized, perceived and experienced from 1900 to the late 1980s. This will clarify the claims I will make as to how, when and in what manner photography emerged as an independent element of the contemporary art scene, and how it was defined and identified. The following example illustrates the narrow, or one might say highly specific functions or models of photography prior to the mid-1990s.

In 2002, Shen Shaoming completed a documentary film about the life of Li Tianbing, born in 1935, who was apprenticed to a photographer in 1945, and is now in the *Guinness Book of Records* for travelling the greatest distances — on foot — to photograph the greatest number of people in one single lifetime. Li Tianbing lives in Fuzhou and walks from village to village for miles around, box camera over his shoulder, servicing communities by providing identity card portraits, and snaps of important events such as weddings, births and deaths. The camera he was still using in 2002 was the same one he bought in the mid-1950s and all prints are developed at home without the aid of electricity or any conventional darkroom equipment.

His son, Li Jingcheng, became a photographer, too, of the kind employed by *National Geographic* and whose subject matter never strays far from vistas of magnificent scenery and natural beauty. At one point in the film father and son compare cameras; a worn box brownie against a polished state-of-the-art Nikon. The father, Li Tianbing neither comprehends nor has interest in the new technology. For him, special effects and user options have no correlation with the function that drives his photographic activities. Meanwhile, the son is representative of a legion of amateur and professional photographers that emerged from the early 1980s and who are entirely blinkered to any approach to picture-taking that is not pivoted on light, sharpness, clarity and the perfection of a frame chosen to evoke the visible, external world.

This documentary was shown in Kunming where by chance the Jiangwu Tang, the former military academy, was hosting an exhibition of photographs of old Kunming taken in the early 1900s by the then French Consul General. The images were equivalent to socio-political reportage, a systematic exploration of the lives, habits, working and living conditions, as well as the physical and cultural environment of the region. The world they captured was harsh and bleak, in a style that was grainy and a manner full of compassion and pathos. It was an approach that would be taken up by Chinese photographers in the late-1970s, who saw themselves as making "realistic" photography, termed *xieshi sheying*, pivoted on social documentation.

These three approaches formed a neat triangle of perceptions about, attitudes towards and models for photography in China prior to the early-1990s: 1. utilitarian, 2. technical perfection as photographers attempted to interpret nature through a photograph as classical masters had done with brush paintings, 3. socio-political as Chinese photographers strove to usurp the role of foreign photo-journalists such as Henri Cartier-Bresson and address domestic social issues from their own indisputable perspective. Within the broad mass of the population outside of the minority elite of artists, educated people and those who have access to or interest in culture, this largely remains the case.

It is for this reason that one can not speak of "experimental" or "art" photography in the contemporary conceptual sense prior to the early-1990s, at which point artists struck out along a path independent of and tangential to function, formalism or photo-journalist-styled "reportage."

Article

The 1990s instigated a new phase in what had become China's avant-garde. Following the natural pause inserted by the *China/Avant-garde* exhibition in 1989,[1] the exuberant experimental era of adopting and adapting concepts of modernism based on the Western model took a more mature and considered turn. The precepts of academicism that had dominated the system even beyond academy life began to loose their hold as artists suddenly grasped how the skills they had acquired through the system could be applied to their individual agendas.

As China ploughed ahead with social and economic reform, the issues and objectives to which the 1985 New Generation artists had responded underwent a subtle but radical shift. As the decade got underway, in the sanctum of their studios, artists were left to create more freely than at any time in living memory and, with the experience gained through diverse experiment with "Western" form and theory, they were able, and keen, to turn this knowledge to relevant, cutting-edge comment upon their own environment.

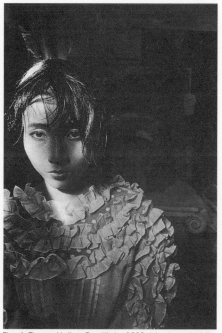

Fig. 4 Zhang Hai'er, *Prostitute*, 1989, black and white photograph, 24"

In 1990, the medium of photography, as photographs themselves, were markedly absent from what was pursued, discussed and presented as contemporary Chinese art. Yet, as the decade drew to a close, the volume of photography-based art accounted for the largest number of works in any single medium and formed an inexorable element of its conceptual art. Only a small portion contained aspects of image-making that might fall within the delimitation of pure or conventional approaches to photography. The camera was used to produce art as narrative as any painting, as conceptual as any object or action. Yet, even here it could only be deemed experimental photography in a handful of cases. The unavoidable realism with which it reproduced scenes from the real world, kept the emphasis on content, and narrative, which encouraged a tendency towards illustrating ideas. This would change as digital technologies and better computer software became more widely available.

Compared with the categories of "performance," "installation," and "conceptual art" that rounded out modernism in the West, "avant-garde" or "art" photography was significantly slower in gaining acceptance in China. It is not easy to determine whether its inherent language was a factor here. Unlike notions of painting and appreciation of three-dimensional objects, both of which were unquestionably more abstract through history in China than their Western equivalents, the science of photography was imported wholesale. Equally, one could argue that photography's struggle to gain credibility as a high art in China merely mirrored the battle fought within the western paradigm. After all, it was that very paradigm that had been so readily followed from 1985 to the early 1990s.

Yet photographs were not entirely locked out of avant-garde art practices. Where they appeared they were put to a specific range of limited uses, which largely involved documenting events and happenings. In the early 1990s, that was almost the exclusive role of the photograph.

It is important to remember that in 1990, in line with the vast majority of the population, artists were exceedingly poor, as were the academies. Photography was not on the curriculum of art school syllabuses. Its more practicable applications were taught instead at schools of arts and crafts or design. For the most part the cameras that had been available since the mid-1980s were simple, automatic Instamatics. Scarcity, due to a lack of domestic production and lack of competition— importing foreign products was extremely complex—forced up the price. The cost of more sophisticated manual models was prohibitive. The majority of avant-garde artists barely had enough money to purchase the materials required for their artworks. Few were in a position to think of acquiring the camera to document these works for a posterity of which they could not yet even dream. But significantly smart cameras were associated with artisan technique that was not considered relevant to contemporary art practice. Most artists used photographs only as source material for paintings or sculpture.

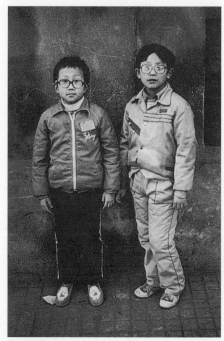

Fig. 5 Han Lei, *Peking*, 1990, black and white photograph, 24"

In a subconscious yet reactionary turn against the 1980s aesthetic dynamic, artists of 1990s— particularly the latter half—replaced explosive group synergy with individual enterprise. The urge to be distinct encouraged artists to unearth new forms and approaches, which required new tools as much as innovative ideas and concepts. Photography—a camera, just as the video cameras that would soon follow it—was the perfect answer. As interest in the medium took off, a subtle but important shift was set in motion as the random documentation of activities to which it had been ascribed gave way to more focused and orchestrated sequences of images. Until 1995, where the still camera was a tool, its product—the photograph was not an end in itself. As artists sought to promote performances,

installations and conceptual works to the outside world, the medium became pivotal. By the mid-1990s such documentation was finding acceptance as artworks.

The first photographs to be circulated and draw attention to the medium in contemporary art circles—although not the first to be produced—were shots of performance artist Zhang Huan taken by fellow East Village resident Rong Rong They captured a mixture of serious activity and play-acting, Zhang Huan's "official" performances and experiments in posing for the lens with various props. A friend with a camera nurturing strong aspirations for photography, Rong Rong applied the keenness of his eye to capturing Zhang Huan on film, but did not usually intervene in the action (fig. 1).

Rong Rong's photographs, like those Xing Danwen was simultaneously recording of Ma Liuming and other East Village artists, were documents of incidents and situations that could never be repeated. In 1994, the camera permitted them to exist. *Xing Danwen's Beijing Diary*, a compendium of her photographs of the Chinese art world taken from 1993 to 1996,[2] would provide an invaluable personal account of the mood of the times by a fellow artist-photographer intimately embroiled in the scene.

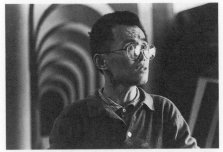

Fig. 6 Luo Yongjin, *Shu Qun*, 1990, black and white photograph

It was a small step but in changing the way they thought about photography, these artist-photographers permitted the medium to change the way artists thought about art. This had a knock on effect. By 1997 when Zhang Huan produced *To Raise the Water Level in a Fish Pond* (fig. 2), although it was primarily formulated as a performance, the resultant photograph taken to record the event was definitely conceived of as a stand alone artwork. Building on success launched with *To Raise an Anonymous Mountain by One Meter* in 1995,[3] Zhang Huan and his followers demonstrated that foreign interest in arresting photographic frames from China — of Chinese by Chinese — was large and ripe. Images of a "rebellious" creative slice of a society of which the outside world knew little provided a deliciously fascinating contrast to the rapidly changing, economically advancing and socially modernizing side of China that was receiving increasing international news coverage.

As 2000 dawned, young, ambitious and eagerly impatient artists within China, who had yet to gain experience of "abroad," were firmly convinced that photography was the most efficient way to get ahead in art. From the Chinese perspective, producing photographs effectively killed two birds with one stone for it had become the coolest, hottest medium on the international contemporary art scene next to video. It was widely in demand for exhibitions and was enjoying the benefits of the extraordinarily buoyant market for the contemporary in (Western) art. From the creative angle, an artist could do wacky real-life things with photography in crazy, fantastical ways. And within China's highly competitive and increasingly expensive parameters, for a relatively low outlay in cost and time, the artist could have multiples of a work and get a multiple return on the original investment.

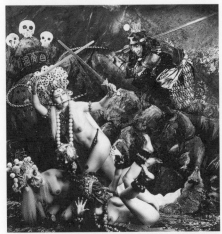

Fig. 7 Liu Zheng, *Martial Arts Marrow*, 1997, black and white photograph

From an innocuous start in 1990, by 2000 photography had gone native. Furthermore, as contemporary artforms began to win incremental recognition from domestic official circles, the explosion of interest in photography was given credence and support as the mainland's leading academies were given the go ahead to establish new media and photography departments. The situation was also helped as the quality of private commercial printing facilities improved dramatically. From zero in 1990, the possibilities were now infinite. In one decade, art photography—the photograph—had come into its own.

Documenting Life

By virtue of the camera's function, photographs were automatically understood to capture "true reality," in China as initially in the West. As a glass extension of the operator's eye, the lens brought the external world into clearly demarcated frames, the narrative qualities of which could be read more easily by the general populace than those sensed in painting, where notions of artistry and metaphor impinged upon the simple act of looking. In China, many ordinary people were becoming familiar with a camera, even if they had not used one themselves.

Photography was about the real world, now. It was natural that the first people to pick up a camera in China in the late 1980s would use it to examine or reflect the world around them. They did not consider themselves avant-garde artists but their action was made radical by the political construct within which they acted.

Mao's regime (1949-76) relied upon the services of its propaganda bureau. All media was mobilized to the socialist cause and under the approach it imposed upon journalistic reportage, photographs were used to speak directly to the newly liberated and largely illiterate peasantry. But in adhering to the proscribed

ideology, photographs were frequently not the "truth" deemed unchallengeable in the West. Skilled Chinese technicians quickly learned the art of touching up negatives and constructing composites in the darkroom. The people became used to seeing altered versions of previously published photographs as the political hierarchy altered. Even as China opened up and underwent radical change, photojournalism struggled to shake off the image of its implicit role in glorifying socialism to the exclusion of all other topics, i.e. truth.

One might imagine that here the avant-garde found a rich seam of inspiration in highlighting or parodying the so-called truth of the lens in the light of their own experience of that "truth." That did happen but later. A fine example can be found in the works of Zhao Qin and Liu Jian who in 1998 produced series of reworked versions of one idea. Take the two artists eating at McDonald's (fig. 3) Each version employs a different colour scheme, a costume change for Joe Public, a change of the artists' garb and hairstyles, and the alteration of phrases incorporated into the composition. The result was a set of equally plausible alternative realities. To single any one out as being "the truth" was impossible.

In the late 1980s, the more radical path was presenting reality uncut, unadulterated and as gritty and volatile as artists personally knew it to be. Those individuals who had access to good cameras were often assigned to newspaper or magazine publishing houses and tended to be photographers by "profession."

By the late 1980s, professionals like Zhang Hai'er (fig. 4), Han Lei (fig. 5), Gao Bo, Liu Zheng, Xiao Quan, Xu Zhiwei, Luo Yongjing and Yuan Dongping, were actively making photographs. These largely took the form of social portraiture, using the kind of conventional documentary approach established by Western photo-journalists known in China like Henri Cartier-Bresson and Sebstiao Salgado, evidenced in Yuan Dongping's series on inmates of mental institutions. The preference was for the naturally seductive atmosphere of black and white. These photographers remain known because even where their subject matter clearly overlapped, they each managed to evolve a particular style. All concentrated on the harsh, murky side of the new reality China faced. Black and white photography did that beautifully and with arresting power. The best of their work set a poignant and enduring stage for the environment within which they lived and worked and which surrounded their counterparts in contemporary art, yet they did not conceive of themselves as making "artworks" or of being "artists" at that time — theirs was a truth to the medium of photography and not truth to the tenets of concept, of art. That fell to the more conceptual members of the early avant-garde movement like Zhang Peili and Geng Jianyi who began using photography in the early 1990s, and we will pick that up in a moment.

Applying a statutory approach to a specific framework, Xiao Quan elected to record the leading creative lights of the era, which he astutely identified as changing the face of the cultural scene. The result was *My Generation*, published in 1994, which contained portraits of figures from all areas of creative practice: critics, filmmakers, artists, writers, poets and musicians. It fed photography into the consciousness of artists newly informed of Andy Warhol's notions of fame and artistry. The raw, unposed shots effected a subtle infusion of celebrity, pop-style, throwaway snap, into the consciousness of youth.

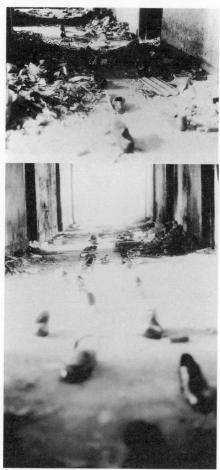

Fig. 8 Geng Jianyi, *Building No.5*, 1992, series of black and white photographs, 100 x 80 cm each

Luo Yongjin and Xu Zhiwei also devoted a portion of the early 1990s to photographing artists. Luo Yongjin had a particularly fine eye for capturing personality and a convincing grasp of technique (fig. 6) The exuberance of other would-be portraitists often betrayed them with poor lighting, slow-shutter-speed shake and grainy texture that, however Warhol in flavor, was not the intended effect.

Through time, many of these photographers would deviate from their early path. Gao Bo gave up photography and took up architectural design. Continuing with a camera, Liu Zheng staged intricately theatrical "scenes" as extrapolations of classical sayings in photographs that played with notions of an exotic oriental cultural atmosphere (fig. 7). Han Lei moved away from images of social misfits towards landscape and by 2001 was producing delicately nuanced scenes of his own invention and coloration, which resonate with allusions to the ethereal aura of Chinese ink painting, playing with the conventions of his inherited cultural language (fig. 30).

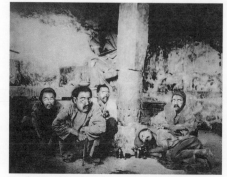

Fig. 9 Zhang Shaoruo, *Opium Smokers*, 1997, color composite photograph, 55 x 70 cm

In the early 1990s, these photographers were heralds at the dawn of a new genre. In addition to being familiar with Warhol's doctrine of fame, artists were experiencing at first hand the rampant flow of domestic consumerism that was inextricably tied to media advertising, which was wholly reliant upon the power of the photographic image. Increasingly, artists would find freelance work in the advertising industry, which further reiterated the impact of modern commercial images.

Documenting Art

As previously mentioned, photography was initially a conduit for recording group and individual activities and performances. It had also been employed on occasion to archive artworks, which was the primary means by which artists knew of each other's work. Photographs could be published in magazines and catalogues, which was useful in the absence of regular public exhibitions.

Through the first half of the nineties, the Chinese art scene was hand-molded by small but significant chance encounters and opportunities that continually moved the goal posts. An example of how this worked in assisting photography to gain a foothold is found in Geng Jianyi's 1992 photographic version of his 1990 installation work *Building No. 5* (fig. 8).

In 1992, contemporary Chinese art scholar Hans van Dijk was selecting works for *China Avant-garde*,[5] which opened in Berlin in January 1993. Keen to convey the breadth of new Chinese art, Hans van Dijk determined to include *Building No. 5*. Originally produced as a site-specific piece in Hangzhou, *Building No. 5* comprised a trail of discarded shoes spaced a pace apart throughout a small administration building earmarked for demolition and vacated for the purpose. The shoes reconfigured the footfalls of the building's former inhabitants through the imagined course of their day, poignantly emphasizing the melancholy of emptiness and imminent loss against the imagined bustle of its former functional life.

The only means of exhibiting *Building No. 5* was to enlarge the photographs that Geng Jianyi had originally taken as record of the work, captured using a domestic brand of black and white film. The images were grainy and thin on textural depth, yet as a photowork, *Building No. 5* was a successful, powerful piece, enhanced by black and white to a haunting, dramatic aura that convincingly conveyed a sense of dereliction against the building's former subjugation to socialist simplicity and function, and the sparsity demanded by each.

The process of producing this representation of the work kindled Geng Jianyi's interest in the role photography could play in conceptual art. He was swift in putting this to the test. The initial result was conceptual works like *Who Is He?*, *A Reasonable Relationship* and the *How To ...* (*Walk, Laugh, Put on a Jumper, Take off a Coat*) series, *This Person*, *Identity Card* and *Floor*, in which photographs were juxtaposed with texts or deliberately manipulated to test audience perceptions of photography as incontrovertible "truth" It inspired an ongoing fascination with the medium.

It is not hard to imagine that Zhang Peili, Geng Jianyi's close friend and associate, might have found inspiration in the new direction his friend was taking and the motivation to test the possibilities of photography himself. In 1993, shortly after their two-man show in Beijing, Zhang Peili produced *Continuous Reproduction*, a photograph of a photograph, photographed again and again until it abstracted itself into oblivion, and implying the distortion of ideas, notions, preconceptions and even facts through time and repetition. It remains a most succinct photowork, although the simple form of its content tended to be overshadowed by glossy and complex images that became vogue as gaudy, kitsch and media oriented art converged. *Continuous Reproduction* (fig. 10) was a sharp reminder of how the past fades through time and repeated viewing until all "facts" are distorted. Also, of the camera's limitations in picking up detail; loosing minute fragments at every round which we might not notice from one incremental step to the next, but are proven essential to completing the "whole picture" when the first image is compared with the last.

Both Geng Jianyi and Zhang Peili would continue to subvert photography to the message they wished to convey. Their works were statements about ideas that could only be explored through the medium, and with results impossible to realize with any other.

Indicative of the open environment in Hangzhou at that time, and the influence of these two artists, in 1992, Qiu Zhijie, who had completed studies at Zhejiang Academy (print-making department, 1989) was also experimenting with photography, which would form a significant aspect of his oeuvre. In Hangzhou, contingent to the experiments carried out by the avant-garde elders based there, photography had credibility, which was not the case everywhere as Qiu Zhijie discovered when he moved north to Beijing. There it was still seen through the viewfinder of conventional function, not yet recognized as a powerful medium for art.

Fig. 10 Zhang Peili, *Continuous Reproduction*, 1993, set of 25 black and white photographs, 10" each, edition of 15

Fig. 11 Zhang Shaoruo, *Zionnish*, 1997, color composite photograph, 47.5 x 70.5 cm

Documenting Performance

As I have suggested, even where artists were beginning to employ photographic elements in their work, no one thought of being a photographer. Not even Rong Rong who initially determined to be an oil painter. Three failed attempts to enter art school persuaded him otherwise and following experiments with a rented medium format Seagull camera — the domestic Shanghai brand—he put canvas aside in favor of light-sensitive paper.

Moving to Beijing to begin photography studies at the Central Institute of Art and Design, student poverty brought Rong Rong to an impoverished place, but social comment did not yet interest him. He was drawn to the creativity that the environment spawned in the artists living there. The village was home to Zhang Huan, Ma Liuming, Zhu Ming, Cang Xin, poet/singer Zu Zhou and numerous others, who collectively christened it the East Village. The artists were almost entirely unknown. Publicizing events was not a sensible option. Thus, with only a limited audience to spread the word, Rong Rong's photographs became testimony to the East Village "movement." His stills successfully captured the tense anxiety and baited silence that underlay all gatherings and the darker reality which these artists faced every day. Each of these artists eventually achieved recognition, but external awareness of their art was undeniably fast-tracked via the images taken by Rong Rong and Xing Danwen.

Ma Liuming later used a camera in his performances with a self-timer that allowed him to photograph himself with his audience, but his work, like that of Zhu Ming and Zhu Fadong was primarily about performance not photography.

The performance art movement gained currency with the East Village's group ethic from early 1994. That did not mean that other artists were not experimenting with performance, nor with photographic documentation of their endeavors. Here, Wang Jinsong, Liu Anping and Zhang Shaoruo stand as early pioneers of performance photography. Wang Jinsong and Liu Anping recorded their joint performance pieces in images of varied quality. Where one was immediately aware that the photograph is of an act, the act took precedence over the "photograph."

Wang Jinsong acquired a camera in 1992, but it did not occur to him to use it to make "art" until 1996 when he produced *Standard Family*, which we will look at later (fig. 15). He had a fabulous eye and would be asked by many artists to capture their performances, like Wang Jin's *Red Train Tracks*, in 1994.

Zhao Shaoruo's early experimentation with photography followed in the well-trodden footfalls of official practice of rewriting pictorial history by reordering political line-ups (figs. 9, 11) He appropriated known images of Mao amongst the people, which he recreated, inserting himself as the radiant heart of the crowd. While this was not great art, it was in line with the mood of the times. In commandeering the same type of political and cultural signifiers, Zhao Shaoruo's photomontages paralleled the growth of "political pop" in painting. The technique was instantly apparent to a non-Chinese audience, which delighted in avant-garde works loaded with readable, daring iconography. Especially as the artist could have a cameo in their own photograph.

In summer 1994, at the home of artists Lin Tianmiao and Wang Gongxin, Wang Jin presented a test print of *Red Dust* (fig. 12), hot from the darkroom. It was a stunningly arresting image of the artist standing on an idyllic stone bridge above a gently meandering stream, flanked by lushly vegetated banks somewhere deep in China's agricultural heartland. Wang Jin's then long hair echoed the flow of water and the red dust he was emptying from a sack in his hands descended to the tributary's surface like a delicate autumn mist.

Lin Tianmiao was moved to question the artist's motive for what appeared a deliberate desecration of the environment. Wang Jin, ultimately concerned with making a visual impact, denied desecration. The ensuing discussion illustrated the varying attitudes towards environmental issues amongst artists. Blissful ignorance lay in provision for what seemed almost moral anarchy in photoworks of the late 1990s.

In 1994, Wang Jin—also a graduate of Zhejiang Academy[6] — used photography to record an event in step with East Village performers. He continued with works like *To Marry a Mule* (1995) and *100%* (1999). The success of these, particularly *To Marry a Mule*, added fuel to the fire that claimed the photographic "record" as the all-important cash-cow.

It was another exhibition in 1995 that effected the next alteration in views held of photography. Almost no photoworks had yet been exhibited in China although several had been published at home and abroad.

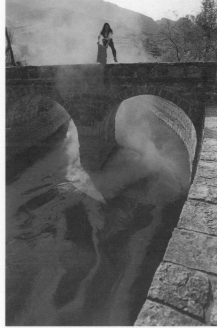

Fig. 12 Wang Jin, *Red Dust*, 1994, color photograph, 110 x 160 cm, edition of 3

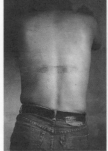 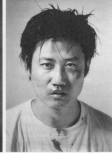

Fig. 13a Yan Lei, *Invasion - Back*, 1995, color photograph

Fig. 13b Yan Lei, *Invasion - Face*, 1995, color photograph

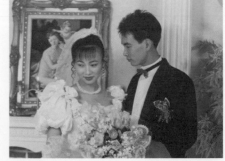

Fig. 14 Zheng Guogu, *The Life of the Youth in Yangjiang - My Bride*, 1995, color photograph

This "first" exhibition highlighted the Beijing art circle's conservative perceptions of the medium but did precipitate a degree of change.

In October 1995, Yan Lei—and the fact that he too graduated from Zhejiang Academy suggests a pattern here — showed photographs of two performance works in his solo show *Invasion*. The performances were done in private without an audience, so the photographs were the artworks (figs. 13a, b).

If photography purveyed truth, then mightn't it be capable of capturing images of reality stranger than fiction? East Village performance works were not always accorded credibility as art but the photographs that documented them were compelling for the "truth" they depicted. However, the opening of Yan Lei's exhibition produced an outcry against "performances fabricated for the camera." It was curious given that photographer-artists like Cindy Sherman and Yasumasa Morimura were at that time riding high on the success of imitating and recreating familiar scenarios for the camera. There would be a 360-degree turn around in attitudes in 1998, but in 1995, "standards" set by the brute actuality of East Village performances, meant that to be credible an act had to be authentic, no "cheating" allowed.

Yan Lei's actions were real enough yet the works were intended to convey more than the document of an event. He was deliberately tampering with "truth," what it was and how it was appraised. The aim was to play with audience perception. Unfortunately, at that moment, no one wanted to be toyed with. Artists did not wish to be challenged by other artists. Tolerance was low.

Fig. 15 Wang Jinsong, *Standard Family*, 1997, set of 200 color photographs, 5" x 7" each, edition of 5

The breakthrough in altering attitudes was wrought by Zheng Guogu whose series on *The Life of Youth in Yangjiang*, begun in 1995, validated play-acting to the hilt. Anyone who took these images for real was plain naive (fig. 14). Zheng Guogu's native town was a stone's throw from Guangzhou where the Big-tailed Elephant group resided. The group was a primal influence in the region, forward-looking in concept and diverse in use of materials which often included photography, primarily as stills. It was present in their collaborative and independent activities as documentation and an element of a piece like Xu Tan's prostitute series or Chen Shaoxiong's projection works. The geographical location provided a specific set of influences for artists within its sphere. It was just over the border from Hong Kong and part of the Pearl River Delta region, a special economic and trade zone. Daily issues were more localized than the politically driven ones that manipulated agendas in the north. Guangzhou's youth were particularly conscious of the unsupervised squandering of cash and time enjoyed by the progeny of the Hong Kong elite.

Exploiting local responses in deliberately obvious parodies of dressing up and grown-up make-believe, Zheng Guogu relayed the narrative of his stories through negative-sized contact prints placed in rows on a single sheet of paper like a storyboard for a film. Cruel mockery was made to appear as heaps of fun. He even enacted his own ideal wedding suffused with the idealized romance promoted on every billboard on every corner. The practice of using multiple images to complete one work created rhythmic flows that reinforced the farce of the romp. But soon his frames started to appear like real life. Or was it that real life had grown increasingly fantastical and performed in line with his photographed performances? The mood became cynical as he manipulated fragmented porn images, making ugly distortions of that which was meant to excite. Whilst the police dealt with the nastiness of vice, Zheng Guogu's subject paralleled an official campaign to oust distributors of pornographic material. The artist hinted at the nastiness of minds that thrilled to manufactured stimulation.

The issue could have been interpreted in many ways. Zheng Guogu was just making art. 1990s Chinese art played with racy topics in a syncopated fashion, groomed and combined for immediate impact, a momentary jerk of emotion and a lingering nod to the grey matter that never quite explained itself. Zheng Guogu's photography was ahead of itself and his work inspired a bevy of followers dedicated to youthful fantasy, like that subsequently employed by Yang Yong, whose photographic documentation of "twenty-four hours in the life of bored but cute twenty-something Shenzhen girls of dubious employ" owed much to the narrative style evoked in Zheng Guogu's work. Perhaps the most important contribution Zheng Guogu made to the advance of contemporary art photography in China was in evacuating the sense of preciousness that had crept into overly posed images of artists performing. It was an awareness that both he and Yan Lei would continue to exploit though not always via the medium of photography. And he made the multiple key.

Outside Help

An important factor in the advance of photography in China's contemporary sphere was the opportunity to exhibit photographic-based works. It sounds obvious but through the initial period of the avant-garde's evolution at home and for first showings of its art abroad, the emphasis was clearly on media that resonated within the Western contemporary art model. This was first painting and then sculpture, installation and video.

By the mid-1990s, as photography took its place in the broader scheme of mainland art, suddenly everyone was at it. In being validated by exhibition space, it had become ripe for so much more.

It is also worth mentioning outside influences—although there is no space to trace them in depth here. British artist Sam Taylor-Wood was clearly known in the later 1990s. A 2002 piece by Liao Bangming showed an apparently seamless 360 degree street panorama but lacked her skill at infusing oddity that makes it all work. She provided similar inspiration for the Gao Bros.' "Last Supper" among others.

Richard Billingham was another favorite. Song Yongping had been to New York where Billingham had work at Holly Solomon Gallery. Artists were travelling more widely and frequently so books and catalogues were winging their way back to China in profusion. Chinese artists were swift to clock new trends.

In 1997, artists in Beijing had the chance to see photographs by Thomas Struth. The blandness of his works struck a chord with Luo Yongjin with whom he exhibited. Then there was German Roland Fischer who took a leaf out of Zhuang Hui's book and made portraits of hundreds of students from Beijing University. Lois Conner had been travelling to China since 1984 and was close with artists in Hangzhou in particular like Geng Jianyi and Zhang Peili. This represents but a toe in the surf.

Fig. 16 *Yang Zhenzhong, Family Series: Standard Family,* 1998, digital color photograph, 60 x 100 cm

Trends and Motifs

Perhaps because the history of photography in contemporary Chinese art is brief, it all unfolded at once and with a jumbled range of themes, forms and approaches. Do these relate to general issues at work across the contemporary art board? Which artists influenced what? How did photography go from zero to infinite in just ten years? With a brief chronology in mind, we can now look more at content.

To gain credence as pure art within a society where Western-style advertising and magazine culture were only just beginning to make any sense to the people's visual experience, art photography needed to differentiate itself from the principles it served in the mass media. Perhaps for this reason, towards the late 1990s artists took pleasure in subverting the fantasies and ideals thrown up by popular culture. Evidently, in appropriating photography to fine art, the first act was to reject all notions of a conventionally "meaningful" event unless ratified in a deliberately petulant manner.

Artists retained the core criteria of photo-journalism, the importance, which was the supremacy of a single image, in telling a story, conveying message and meaning in one ten-second blast: One characteristic of art photography in China was the attention-grabbing nature of the subject, action and scale employed: testy; dynamic and huge.

Fig. 17 Zhuang Hui, *One and Thirty Children,* 1996, set of 30 black and white photographs, 24" each, edition of 3

Photography offered artists a way to survey their socio-political, economic and cultural environment in a direct, contemporary way. The key lay in personal intervention, the artist as director-performer, whose presence in the work—physical or conceptual—was crucial to distinguishing a photowork from a pure photograph. This kind of approach was clearly demarcated in photoworks produced by Qiu Zhijie and latterly Xu Zhen and Yang Fudong, where the artists are both actors and choreographers of the action.

Obviously there were issues at work, in styles conducive to message, and a variety of compelling concepts. It is not always helpful to categorize art—as was attempted for nascent forms of expression in contemporary Chinese art in the early 1990s. Unhelpful because as they gain more experience and their art evolves in other directions, most artists tend to confound the label accorded them. The majority of those who used photography did so in multifarious ways to different ends as their various concepts demanded. In the 1990s, the Chinese adapted to change quicker and in ways more pronounced than most foreigners could comprehend.

At first glance, clearly discernible approaches seem apparent that make tracing trends easier, such as social documentation versus pure concept. The technique is different and there would be

different ideas at work but these do not explain the reason or motive for the difference, nor the context against which the difference is made pronounced. The motifs and signs might be missed by someone from another culture unfamiliar with the local lingo. It mattered because those artists concerned to comment on Chinese contemporary social reality needed to convey the context if their work was to be understood and not perceived as oddly, exotically curious.

One reason that labelling works is problematic is that it is often hard to distinguish between "categories." Take for example terms like "social commentary" or "photographed images of self-performed pieces highlighting social issues," what is performance and what is comment? Either can, of course, be both. So do we put them together or in separate groups? What about self-portraits? Where is the line between performance, fantasy and self? What is the boundary between any of these beyond which might be termed pure concept?

There are grounds to argue for these subject headings: The human figure as vehicle for social comment and pure self-enacted performance as means to social comment — as in painting, very few artists choose to work in a non-figurative or abstract genre, with but a handful looking at "landscape." Most "purely conceptual" work also employed the figure as did those focused on the environment. Then there was the umbrella of new media and technology which was as much subject as tool. Some of these could also be termed pure performance whilet a case could be made for conceptual comment.

The permutations are endless and most artists could be said to slot into most categories raising the issue of whether we analyze photoworks from an individual artist's overall direction or from specific isolated pieces. It seems more important to discuss specific works because — in all but a few cases where the artist concentrates largely on photography — more is revealed by a single piece about contemporary art and life in China as a whole. Trying to group disparate entities by trend only highlights the in their diversity.

However, there clearly were several different approaches being followed. The most significant category circles around straightforward social comment. Second, as described earlier, photography provided an interface between the new field of private performance, which was especially useful for theatrical ideas that would have required an enormous amount of social skill and financing to present publicly, neatly side-stepping issues of official permission and approval.

Third, and what was to become the dominant trend by 2000, a number of artists picked up the threads of narrative realism and story-telling that had previously been the exclusive domain of painted compositions. In addition to composing photographic frames, they could use multiple photographs to complete a work, relating the message through succeeding images. Fourth, but by no means last, new technology—technology that was largely new to China—opened up ways to manipulate images with applications that were more usually associated with hand-crafted not machine-made art. Artists used the camera to produce profound visual comments on the contemporary Chinese situation. Within the span of a few years, from zero visibility and interest, a photography-based work had proved it could be many different things to many very different people.

Games and Gestures

Qiu Zhijie began exploring how contemporary life shaped daily existence and the outlook of society as individuals or en masse by appropriating cultural human gestures. These were humor and relied on familiarity to strike at the borders of conservatism. From ideology to the physical realm, from smiles to shaking hands, he recognized that human action was governed by an impulsive response. In *Fine*, the posturing of his subjects demonstrates a theatricality, which comes naturally to the Chinese, for even if they don't practice, *Taiqi* has instilled people with an extraordinary ingrained sense of poise and balance. Using the notion of a game with the exaggerated nature of acting out actions that games permit, Qiu Zhijie made the meaningful ridiculously simple.

He exhibited *Calendar 1998* in 1999 in a solo show at the Central Academy in Beijing. It comprised an image of the same scene on each day of the month, taken at a different time of day forming a Hockney-like conglomeration. Later, photographs were also used as the "print" from stencils he created of carved bamboo and embossed on human skin. Qiu Zhijie used photography for what it brought to his art as and when he

Fig. 18 Hai Bo, *Them No.6*, 1999, black and white/color photograph, diptych, each image 60 x 42 cm

Fig. 19 An Hong, *Rain Buddha*, 1997, color photograph, 61 x 41 cm, edition of 10

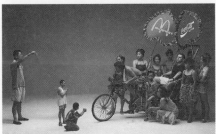

Fig. 20 Wang Qingsong, *Can I Help You?*, 2000, digital composite photograph, 200 x 120 cm

required it.

Humor also radiates from *Clock*, a 1996 black and white photowork by Wang Jinsong, which depicted the artist at various tourist sites in Beijing. Pinned to time and place by the hands of time affixed to the image, he thrust himself into each frame, asserting his power as witness to the changing capital. The rapid pace of change was inferred by the passage of twelve hours that complete the work but the gesture was of youth stepping out from the weight of history.

Against the sobriety of topics addressed, a light-hearted strain permeated Wang Jinsong's classic works *Standard Family* and *Parents. Standard Family* (fig. 15) comprised two hundred photographs of one-child families and was a quiet lament that these children would grow up without any extended family. It is a Chinese expression of a uniquely Chinese problem, a statement and record of fact, but a conceptual artwork and not a series of photographic family portraits. Almost no other work, report or study could encapsulate the change sweeping society, like the external influences of clothing and accessories worn that reveal as much about poverty and wealth as fashion trends and personality. This approach fell neatly between conceptual thought in Zhang Peili's *Continuous Reproduction* and Geng Jianyi's work, and straightforward documentation. It set a new standard.

The family was the subject of Yang Zhenzhong's 1996 "chicken" series (fig. 16) The chicken had been a common metaphor because the geographical form of China on a map resembles a chicken. It was a metaphor appropriated by Zhang Nian from 1989. A quiet strength in Chinese art, he consistently produced work relevant to the social moment, a large portion of which was performance or object-based, so photography served as documentation and not always intended form.

Social Performance

Taking a cue from familiar conventional forms of photography in China and his own "serve the people" performances, between 1995 and 1997 Zhuang Hui produced a series of panoramic group portraits. These were executed in tandem with a four-part work titled *One and Thirty... Workers, Peasants, Children* and *Art World People* (fig. 17).

The group portraits, with Zhuang Hui position at the far right of each, had instant appeal, particularly for foreign audiences intrigued by modern Chinese society. This engendered endless invitations to exhibit the works abroad. The *One and Thirty* series conjured an insightful survey of proletarian life in the way Wang Jinsong achieved with *Standard Family.* Exploring the categories of the common people in socialist society, Zhuang Hui participated in the snapshots. In each one the pose is the same, the artist's smile fixed, but the between-the-lines variants are striking. It remains a valuable record of the era that achieved full credibility as art.

Whilst many artists chose to act for the camera, Hai Bo elected to re-enact the past re-staging group portraits found in his family's album (fig. 18). He sought out survivors of 1970s images and, by re-photographing them in the same positions, presented the great leap forward China has achieved since that era. The gaps created by those who had departed make a poignant space that spoke with the same power as blank space in Chinese ink painting.

As Gaudy Art emerged in the mid-1990s, mass media had gained a broad profile in daily life and kitsch-like colour, glamour and life-styles were omnipresent. This was coupled with an increasing proclivity of computers and the availability of a vast array of affordable — pirated — software. The possibilities for playing with a photographed image were endless and colour now clearly distinguished art-photography from its conventional counterpart. An Hong was the first artist to experiment with "gaudy" as a photographic process in outrageous self-portraits of glittering rainbow makeovers and saturated hues. Gaudy? Yes, but somehow fantastical.

Fantastic Reality

In 1995, in the greatly restricted confines of his city-center apartment, An Hong created the *Buddha Series* (fig. 19). Peking opera, traditional myths and fairy tales, all provided visual metaphoric elements transcribed to contemporary concerns. Lilly pads, pink gauze, sensual swathes of colored silks, sweet youth and innocence, melded together in the halo of light before the camera lens. All combined to an adulative but

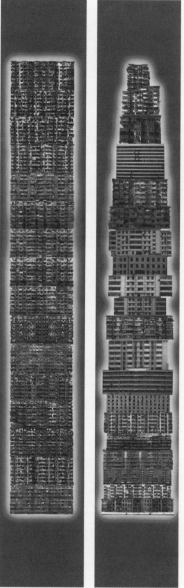

Fig. 21 Xiang Liqin, *Purple Diptych*, 2000, digital color photograph, diptych, 130 x 20 cm each

invented life of Buddha. An Hong's Buddha preached, enjoyed carnal pleasures, and then sought to free the world of sexually transmitted diseases. The image first grabbed attention before imparting a more serious message. The approach celebrated bright sensual impulses and pleasure that gently nudged the ribs of the viewer's moral nature conscience. An Hong's small series was responsible for liberating practice, subject and content, paving the way for the next phase of creation.

The most successful and sublime member of the gaudy movement to make photography was Wang Qingsong (fig. 20). His work was as fantastical as Pierre and Gilles who were undoubtedly an early inspiration. Yet beyond the glitzy surface, he too raised questions about the direction in which society was heading under the glaring gloss of lush material extravagance. Parodying new social ideals, he portrayed himself as Buddha, Shiva, Christ, and a plethora of revered icons enmeshed in lavish clusters of mass culture consumer products. His visual language picked up where An Hong left off, drawing on widely varied sources. All serious elements were counterbalanced by a mockery of how developing nations fawn upon the first world and willingly kow-tow before the pantheon of design gods that materialism engendered. Thus, he reduced the scale of Chinese figures, playing with the subtle nuances of religious and historical painting that suggested power over insignificance as an exaggerated presence versus a diminished one. The works inferred a bitter indignation.

Media Projections of Real Life, Manipulated

A number of artists played with television and print media in obvious ways but none so well as Xu Yihui and Zhao Bandi. In the 1996 exhibition *Models for the Masses*, Xu Yihui included photographed images of himself stuck on mock television screens in a parody of permitted programming. Funny but smart.

The power of mass media to shape opinion and present the facts of the (art) world was a force Zhou Tiehai manipulated for his own poignant ends. In 1995-97, this took the form of a series of magazine covers imitating the well-known faces of publications like *Art in America*, *ArtNews*, *frieze*, *Stern*, and the New York *Times*, recreated as format perfect copies, but with headlines and images that make direct and succinct reference to the situation of, and the influences governing, art in China as he perceived them.

The obsession with media, exemplified in Zhao Bandi's work, was prefigured in Xu Xiaoyu's product shots. In a series of diptychs, she juxtaposed urban street scenes in which the American flag cropped up—as design element of pedestrian clothing or advertisement—with a photograph of an available product with the same flag used on the packaging as a marketing ploy. It was an astute observation of the subliminal manner in which the "American Way" was infiltrating daily life, given a further edge during the backlash against the US that occurred after the Chinese embassy bombing in Belgrade in May 1999.

In 1997, Zhao Bandi started exploring ways to bring Chinese society closer to his art and vice versa. The result was *Zhao Bandi and the Little Panda* (fig. 22), a humorous, ironic motif for the Chinese situation that imbued his satire with pathos. Zhao Bandi's aim was social art that could be accepted and enjoyed by the masses. With the *Little Panda*, he succeeded, his topics referencing relevant social situations of the moment. The posters propagated public issues such as drug abuse, safety, public health, the prevalence of fake products on the market, cleverly dovetailing with municipal government directives. The astuteness of the "panda" concept was to combine humor with the heart-melting cuteness of the toy and a serious acceptable message.

In late 1997, Hong Hao began inciting materialist ambition in photoworks that parodied slick, glossy Western-style advertising media. It was his conduit for pointing to the standards that Chinese society had accrued as benchmarks of advance, modernization, Western, First World, and wealthy (fig. 23) He dressed in smart suits, donned blond wigs and blue contact lenses—an approach also used by Shanghai-based Shi Yong in a similar conceptual game—and surrounded himself with the proscribed trappings of an ideal, civilized and successful lifestyle.

The picture-postcard images of 1999 *The Tour Guide Series* jested about Western perceptions of China, whilst mocking the face China presented to the world. Hong Hao played enthusiastic, amicable guide, the implication being: Who has the power to show what to whom? This led him to the journeys depicted in exemplary classical scroll paintings, journeys he revisited to examine physical environments past and present, not unlike Hai Bo's human comparative.

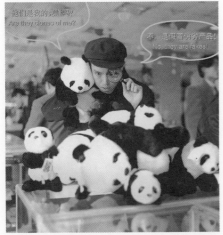

Fig. 22 Zhao Bandi, *Clones/Fakes?*, 1999, color photograph, 60 x 60 cm, edition of 40

Fig. 23 Hong Hao, *Mr. Gnoh Usually Waits in the Sunshine by the Pool*, 1998, color composite photograph, 95 x 120 cm

An undercurrent in 1990s art in China was satirical reworking of Pop Art ideas gleaned from Andy Warhol and taken to new heights by Jeff Koons. Notions of the bright, garish and throwaway attributes of contemporary life and capitalist consumerism, which was making inroads to the mainland, made sense to Chinese artists who found themselves in a nation whose socio-cultural level provided plenty kitsch in everyday life.

In acutely advanced Shanghai, Yang Fudong took a cue from Hong Hao's glossy life style branding and turned the issue around to demonstrate the boredom and vapidity of obsessions with possessions. This spawned several followers in a like style.

Meanwhile in the capital, returning to the concept of truth associated with news reportage, Zhu Jia explored the power of media influence encapsulated in a single incontrovertible image (fig. 24). In common with an approach artist Wang Youshen had taken in the 1997 work *Shining—Military Clubhouse*,[7] Zhu Jia subverted the "truth" of a photograph by inferring a damaging message via outrageous association. He proved how easily the mind is deceived by a misleading pictorial inference. Once an insinuation is created the damage is done.

In *Have These People Had Sexual Relations?* ordinary people are tainted by implication although it is obvious that their proximity is incidental. It echoed the weight accorded plain images of doorways in Yin Xiuzhen's 1996 *Door*. These were simply the doorways through which she had passed from childhood to adulthood, but like the images of vacant stairwells that featured in Geng Jianyi's 1994 piece *Who Is He?* they hinted at so much more.

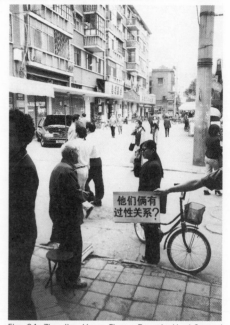

Fig. 24 Zhu Jia, *Have These People Had Sexual Relations?*, 1998, black and white photograph, installation work

Song Yongping employed media exposé in a devastatingly direct documentation of the mental and physical decline of his parents. Sensational maybe, especially the frames of himself stuck naked between his two tortured parents. Perhaps as example of vibrant health beside health ravaged bodies? Or "son" as product of "parents" meeting the demands of filial piety? The work is tough, moving and was born out of frustration at the artist's distance from Beijing, the lack of attention or exposure afforded. *My Parents* (fig. 25) predetermined to confront people with what this artist was not afraid to face. His act ran contrary to the basic tenets of conventional society, taboo of the utmost extreme and, while not necessarily disturbing for mind-numbed foreigners, was distressingly shocking for a Chinese audience. But therein lay its significance. The issue the work addressed required urgent resolution in China for an increasing number of parents found themselves alone and uncared for in old age, a sentiment mooted in Wang Jinsong's *Parents Nursing* is a full-time job and Song Yongping had to make a choice. He gave up art to provide twenty-four hour care for his dying parents. But in making the choice to care for his family first, he found a powerful subject for art. *My Parents* is the complete antithesis of Hai Bo's rose-tinted remembrance and healthy subjects. Even where people are missing, the gaps are clean and empty not riddled with pain or neglect, at least none that is visible.

Against all this reality, in 1996 Wu Xiaojun chose a fictional fable style of story-telling through a cast of small plasticine figures. These he molded himself to represent specific historical characters and recognisable types from within Chinese society. In staged compositions, Lu Xun rubs shoulders with Lenin, gun-toting John Wayne types with solid revolutionaries. The stories Wu Xiaojun dreamt up for his imaginary satirical dramas related to history, plotting the course of "known" factual events and positing an alternative outcome to the inevitable. The works represented those slender moments during which the incontrovertible was held to ransom; one slight shift of position or presence and the whole history might have been altered.

Fantasy Performed

From 1997, the styles and choice of subject matter introduced by the fantastic performances of An Hong and Wang Qingsong were taken up by a new breed of younger artists who combined them with media ideals of family, beauty and modern living. Some were good, some not so good, for few did it better than Wang Qingsong.

Wuhan-based Li Wen came close but in a completely different way, employing a quiet, simple means of reminding the world that life is never quite so black and white, particularly poignant in the Chinese cultural context (fig. 26). Everything imaginable from his room to his own face, groups of friends and natural objects were incised with a stark dividing line between a blackened and a whitened half. He developed this in small equally black and white still-lifes that were elegantly subtle.

By now the self in photographic images was widespread and favored in a volume of works too

numerous to list beyond the innovators mentioned above. One that merits mention is Li Haibin's revisitation of the look of every decade from the 1900s to the 1990s, spot on all the way. Liao Bangming also made a valiant attempt to parody the new categories of "profession," dressing himself up as doctor, patient, businessman, sports personality, soldier, teacher etc. And mention must be made of video artist Li Yongbin whose photographic output is small but whose projections were clearly an influence on many artists, notably Song Dong.

Plurality: The Contemporary Environment

By 1998, photography in contemporary Chinese art was almost the dominant medium. Many artists continued performing for the camera, but a growing body of work was dedicated to the physical environment, particularly cities and urban life. Speaking of change and China had become a cliché , yet change was everywhere and happening so rapidly that enthusiasm for propelling China into the modern age had turned to confusion. People no longer recognized the world around them. The disintegration of the familiar bred anxiety. This was reflected in a diverse range of photoworks.

First, in 1997, Rong Rong began a series about the ruins of the urban center as the old city gave way to redevelopment. *Ruins* was infused with nostalgia and, like Wang Jinsong's *Standard Family*, offered no solution, just fact.

Zhang Dali had returned from Italy inspired by graffiti and embarked on a city-wide daubing of his tag. The simple, sweep-of-the-arm outline of a large, bald head mapped his extensive wanderings through the metropolis, sites to which he returned to photograph his handiwork. The photographs were then reproduced as inkjet prints on canvas, the color soft, the hard edges of buildings, walls, streets blurred by the process, giving them a quality alien to the urbanity they represented. Where they looked like painted cityscapes, they lost the tension of the original graffiti, becoming elevated to aesthetics. But too pretty and they lost their punch which pushed Zhang Dali to experiment. He turned to light boxes and the illuminated transparencies put the viewer back on the street, restoring a sense of rawness.

Looking at acceptable "graffiti" used to mark out sites for demolition, in 1999 Wang Jinsong produced *Chai* which bore witness to all tagged parts of the city, ear-marked for the bulldozer as low-rise made way for the grandeur of height. By 2001, even Zhang Nian was producing marvellous and humorous composite images referring to Beijing's large-scale transformation in anticipation of the 2008 Olympics. By now, Luo Yongjin had turned his full attention to systematically photographing incongruent new building styles where they invaded and clashed with existing architectural styles. The Hockney-like patchwork form of his complete work as unseamless and deconstructed as the physical reality. The skill of execution applied to these multiple images rendered this one of the most enduring comments on contemporary change.

From the images of urban and provincial environments, the rich sweep of China's geographical breadth was revealed. Hong Hao, Wang Jinsong and Zhang Dali focused on Beijing. Luo Yongjin's preference was for Luoyang and Shanghai. Down south, Chen Shaoxiong was making painstakingly fine miniature models of street scenes which he "slotted" into the actual landscape. He cleverly illustrated Guangzhou's buzzing pace. Contrasting the ideal of bright modern contemporary living with the actual result of pollution and detritus caused by rampant consumerism, the photographed models trick the eye and require a close look to untangle truth from fiction.

Not far away, Xu Tan was capturing images of planes flying into Hong Kong airport, apparently only just above the buildings. The planes grab attention first but then eyes shift to the buildings which are old, tired, and run down. It was not exactly the glossy, well-heeled image that Hong Kong sought to promote. We assume this is the area to which the poorer section of society is relegated, which was not made clear but was not necessary for reading the attendant environmental and psychological dangers invoked.

In Hangzhou, Xiang Liqin produced digital compilations of architectural features characteristic of buildings in the city, painting them in a decorative and colourful fashion with immediate visual — if acid — appeal (fig. 21). Even this could not disguise the dilapidated state of structures only thirty years old, whose living conditions were neither decorative nor colourful.

For *House, Home, Family*,[8] Hangzhou-based Wang Qiang produced a beautiful sequence of sanitized panoramic sweeps of construction and destruction encased in lightboxes. The work echoed the moment in terms of form as much as content. Numerous artists were employing lightboxes in various ways and to

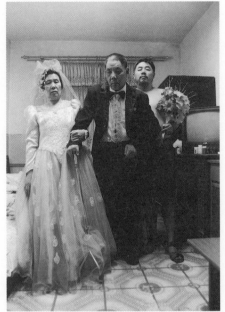

Fig. 25 Song Yongping, *My Parents*, 1999-2000, black and white photograph

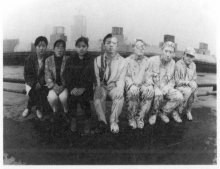

Fig. 26 Li Wen, *Half-Half*, 1997, black and white photograph, 61 x 50.6 cm

varying degrees of success. Some of the most interesting works were by Wang Wei and Liu Wei, which we will come to by reference to content in a while.

The most immediate way to pronounce the gulf between reality and the ideal living environment was to construct a set in the manner instituted by Chen Shaoxiong. Model-making requires skill and dexterity often considered the province of women. In Shanghai, Wang Yiwu was creating worlds to match the "Chinese dream." Her fantasy constructs were filled with gardens blooming, landscapes flourishing and people pocket-sized floating or submerged under water. Implied problems took on a serious aura as grass was replaced by sand, arid, dry and incapable of sustaining life. Hers was a standard morality tale informed by an awareness of how humans abuse their living environment, provoking awareness in a cute, seemingly pretty, certainly alluring fashion.

Other young artists would pick up the element of cute and shift up a gear in the vernacular of the new millennium. It provided a stark contrast to the brutality of another strain of imagery that burst upon the fin-de-siè cle scene.

The Traditional Body: Aggravating Taboo

Brutality is relative. Standards of morality forever shift their ground. What emerged in the final months of the 1990s in Chinese art was not particularly brutal by some standards, nor especially immoral by others. It was new to China, shocking for those who confronted it and were unacquainted with the broader circumstances of the moment or comparable pursuits in Western art.

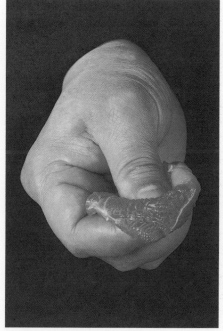

Gu Dexin had been a prime mover in shaping contemporary art in China since the mid-1980s. His impact derived first from his installation pieces but was reinforced by his major photowork *Meat/Hand* (fig. 27), which set a pace for the art-photography moment in which others were still grappling for appropriate form.

Performance-installation artists Sun Yuan and Peng Yu needed photography to document their works, works that were altering the subtext of truth to materials in art, an alteration that fed back into photography. Huang Yan also used photographs to document an unusual painterly approach— gouache on pork chops —but his appropriation of classical ink techniques evolved out of a performance that was less actual performing than using his own flesh as the ground for painting. Like the female lead in Peter Greenaway's *Pillow Book* whose father used her skin as his "canvas," Huang Yan turned his wife's skill with a brush from conventional rice paper to tattooing his torso with meandering Chinese landscapes (fig. 28). Here, photography was part of an ongoing process of drawing his cultural heritage into the modern age.

Fig. 27 Gu Dexin, *Meat / Hand*, 1996, color photograph

In this new mood, the human figure was subject to tortuous interaction with animal and plant life. Wang Wei degraded the notion of portraiture by forcing his subjects under water, sandwiching the photographs in light-boxes, layered under swills of krill. A subsequent series slopped all manners of food stuffing over the subjects, which induced a stronger sense of revulsion than earlier images of fish and eels protruding from the orifices around his head.

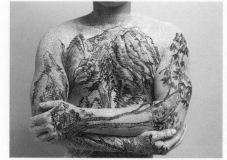

Wu Ershan extrapolated stills from his video work of bodies roiling in vats of decay. The element of rot intrigued him enough to prompt experiments with Sherman-like single images, which seem plucked from a greater narrative. Isolated, they took on a disturbing aura of misdemeanor that even the obvious falsity of the forms could not erase.

Fig. 28 Huang Yan, *Chinese Painting Series*, 1999, color photograph, 50 x 60 cm

Jin Feng, another conceptual artist with a penchant for flesh and living organisms, turned to photography for its fabulous detail and true-to-life colour to produce multi-image triptychs revealing the transformation of a living animal to nicely jointed cuts of meat; ready to cook and complete with illustrations of the kind of dishes one might produce. This marked a pause in the computer-manipulated photographs he previously produced, which like many such experiments confounded its message in a profusion of technical whiz.

With the body so exhaustively exploited and images of it overstuffed with icons, decorative imagery and an overwhelming array of signs, artists increasingly needed to find simple, direct means to define their content. In Shanghai, Xu Zhen alighted on a way to achieve profoundly memorable images that strayed into new territory. Amongst photographs of prostitutes at rest—the subject was becoming par for the course by 2000—he created a set of monumental male nudes tainted by subtle trickles of blood that ran down their inner thighs like untamed menstrual blood. These were mesmerizing even as they shocked.

Female genitalia have never moved far beyond being taboo in art, a taboo that Beijing-based Chen Lingyang encountered in presenting her work *Twelve Flower Months*. This comprised a series of compositions constructed as still-lifes, each pivoted on the centrepiece of a hand mirror. Each mirror reflected the artist's own genitalia during menstruation, appropriating the physiological fact of menstruation through the passage of the year to the poetic concept of twelve flower months in traditional Chinese culture. Here, she finished what 1970s US feminists started by "celebrating" the most fundamental aspect of womanhood, subjecting conventional culture to a very contemporary reading.

Similar initiatives could be found in the works of other young women artists, like the bold expression of sexual emotions and relations by Cui Xiuwen. *Little Ones* was unique in touching on disturbing strains of sexual perversion relating to paedophilia, a profoundly controversial and polemic issue in the West. Nothing shocks or angers more. Cui Xiuwen's subjects seem fully aware of the provocation they exude, which compounded the artist's own point and an experience which, though it might raise hackles, we cannot deny her.

In the late 1990s, Lin Tianmiao produced some of the finest reflections on the physical body that relied neither on sexual innuendo or shock. Her intent negated both as she adulterated images of her own body, removing the organs of gender and hair (fig. 29). Her female eunuchs invoked the confused state of femininity in modern China and beyond. In soft shades of grey, printed digitally on canvas and not photographic paper, her works took photography to a different, extraordinarily integral level.

From 1997, one of the most influential contemporary art-photographers was Nanjing-based Hong Lei. His "bodies" were animal, his inspiration Song-dynasty painting, and his photographs subject to savage manhandling between the shutter closing and the emergence of the final print (figs. 30, 31). Playing with the delicate, ethereal aspects of classical painting, his stylized compositions replayed the inspiration through contemporary elements and mood where ancient gardens met damaged, dead birds — beautiful, intact, but dead. The negatives were scratched to soften images then saturated with overblown hues of color. These techniques demonstrated a new level of creative control over the photograph, putting artists back in the driving seat. Hong Lei's work was a visible influence on others of his generation, like Dong Wensheng who made solid but variegated attempts at imitation.

Technology

Technology came of age in China in the 1990s, aided by economic reforms that advanced individual circumstances enough to support it. By the end of the decade, artists who had travelled regularly abroad were familiar enough with the centers of Western creativity to have re-appraised their initial understanding of modernity. Photography matched the increasing disposability of the moment as the world moved towards a new millennium and the unknown it was perceived to contain.

New technology created the potential for disarming new techniques, like satellite imaging which Li Tianyuan explored in 2000, and infrared and medical optical sensing appropriated by Feng Feng from 1998. But such have yet to find a balance with concept in the work. The mere form of a new process or technology alone was not enough to win work credence as art, equally illustrated in the use of computer software for digital photography and video. But as artists became more comfortable using special effects, the urge to incorporate as many as possible gave way to a focused concern on what was specifically appropriate to the concept of a particular artwork and, in identifying the effect they required, finding innovative ways to make existing techniques achieve it. An example is He An's *Woman Raped by an Alien*, which took months of trial and error to generate on computer.

He An first produced computer-generated images in the style of popular advertising, combining the "cool" exhorted in the slogans of Western sports advertisements—like those produced for Nike, Adidas and Reebok — with figures of a grim Chinese reality. The juxtaposition of "cool" slapped over the image of a figure with withered legs imparted a callous slant to the "Just Do It!" hype, questioning attitudes towards physical perfection (fig. 32).

The next project was *Fifteen Reasons for Fashion*. Intrigued by the role of the Internet in connecting people from all social spheres, and the anonymity it provides for expressing fantasies, He An placed a personal ad on a Chinese server calling for young people willing to be photographed as their interpretations of "cool." The result was a startling series of images, mainly of teenage girls, whose burning desire was to appear scarred. The sexy sleaze that they associated with their fantasy was similar to the morbid fascination

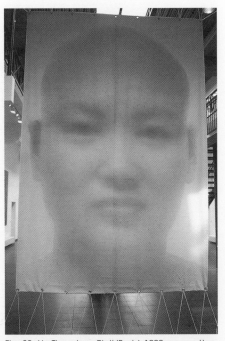

Fig. 29 Lin Tianmiao, *Plait/Braid*, 1999, raw cotton, photographic print on industrial canvas, 213 x 162 cm

Fig. 30 Hong Lei, *After the Painting A Picture of Loquats and Mountain Birds by Zhaoji*, 1998, color photograph, 80 cm diameter

with injury projected in David Cronenberg's film *Crash*, one of the few Western films that has not been widely seen in China.

Wang Peng, who devoted much of the mid-1990s in New York to familiarizing himself with creative computer software, demonstrated an advantageous application of effect. An initial series of neat, precise and exquisitely elegant works on rice paper explored the presence of expatriates in their adopted environments. A second focused on the changing face of Beijing in seemingly innocuous street scenes with a twist, an odd angle, a subtle distortion of perspective that threw out a deliberate challenge to the keenness of the viewer's eye, and most importantly, in one of the world's most populous capitals, was made devoid of all vestiges of human life. Recognizing the desertedness only made the work more astounding.

Conclusion

The volume of photographic works produced from the mid-1990s accounted for an indispensable proportion of important Chinese artworks of the period. Equally, photography *per se* exerted an equitable influence on contemporary art practice and form. The new millennium found Yu Hong revisiting her life using family album snap shots as the basis for oil paintings. In a more conceptual way, Yan Lei produced a series of monochrome paintings that were specifically intended to appear as photographs and blur the distinct visual boundaries between photograph and painting. These were somewhat in vein of Luc Tuymans' canvases, a style also adopted by Sichuan painter Xie Nanxing whose compositions took a cue too from Sam Taylor-Wood's photographic constructs.

Fig. 31 Hong Lei, *After the Painting Quail and Autumn Chrysanthemum by Li Anzhong,* 1998, color photograph, 80 cm diameter

Many of the issues in evidence were sharp, insightful and conscientiously evocative of the Chinese situation. But by 2000, some artists had slipped into a flippant exploitation of the process. The mass embrace of photography by contemporary art circles and the growing interest of the international art world had encouraged an anything-and-everything approach to churning out photoworks. In particular, a seam of fantasy performance had become twee and shallow, the compositions badly framed with the background clutter of daily life visible on the fringes. This was not kitsch, conceptual or clever, but was due to laziness, complacency and a blind faith in the unquestioning interest of foreign institutions by young, ambitious artists impatient to make their mark. Or perhaps it was evidence of naive technical skill, where like the average tourist snap, the photographer saw only the subject and not the entire frame. Either way, photography had acquired a tacky, salubrious underside.

Fig. 32 He An, *Just Do It!* 1999, 100 x 80 cm

Photoworks were never an easy option, nor a fast-track to artistic success. Like all good art, the concept and the message that inspired it was critical for a work to be endowed with enduring value. It is interesting that of all the artists employing photography through the 1990s, only Geng Jianyi and Bai Yiluo could be deemed to be experimenting with its essence, light, exposure, chemicals and intervention in the darkroom.

From this decade emerged a large number of striking works ranging from more conventional approaches to documentation of and comment upon the social environment, to dynamic conceptual invention. E.H. Gombrich said of Cartier-Bresson, "In his capacity to record physiognomic qualities and thus to make reality speak, he found the camera to be superior to the brush." It is certain that many contemporary Chinese artists chose the medium for its specific qualities and superiority to painting in expressing what they wanted to say. The explosion of photography in China through the 1990s demonstrated how artists recognised this potential, but more significantly, how they made it work for them.

Karen Smith is an independent curator and arts writer based in Beijing and specialized in contemporary art in China.

1 *China/Avant-garde* was at the National Art Gallery, February 1989, the first major survey of the 1985 New Art Movement.

2 Compiled as a book by the artist but not yet published as of May 2002.

3 A collaborative work by nine members of the East Village commune, produced in August 1995 in the Beijing suburbs.

4 This was the first large-scale touring exhibition of new art from the mainland at the Haus der Kulturen der Welt, Berlin.

5 Hangzhou is home Zhejiang Academy of Fine Arts, which changed its name to the China National Academy of Fine Arts in 1995.

6 Department of Chinese painting, 1987.

7 *Shining — Military Clubhouse*, 1997, transparent sheets, 600 x 365 cm, tables, chairs, fluorescent lamps, Breda, Chassé — Kazerne, part of the exhibition *Another Long March: Chinese Conceptual and Installation Art in the Nineties*.

8 Installation exhibition held in furniture factory in Shanghai in 2000, curated by Qiu Zhijie and Wu Meichu

The Rise and Development of Video Art and the Maturity of New Media Art

Wu Meichun and Qiu Zhijie

Fig. 1 Zhang Peili, *Water: Standard Pronunciation, Ci Hai (Sea of Words)*, 1992, video

Fig. 2 Yan Lei, *1500 cm*, 1994, video

We can say that, across the board, Chinese art carries enormous vestiges arising both directly and indirectly from concerns present within society through the 1990s. These were compounded by the artists' instinctive response to the allure of commercial culture and the popularity of post-modern theories. Against this, individual preferences for video art in China sprang up in a fragmented way being neither conjoined to, nor reft from, the social environment. On occasion, works proved to be quite successful. Video art might appear to have flourished in recent years, yet one must recognize that there was a great deal of ersatz work produced. Success is achieved only when the conditions are ripe, and a certain level of progress has been reached.

In 1990, Professor Mijka of the Hamburg Institute of Art brought a number of videotapes to China that had been shown on German television to mark the nine-hundredth anniversary celebrations of the city of Cologne. The video works were shown during two lectures to the teaching staff and students at Zhejiang Academy of Fine Arts (renamed China National Academy of Fine Arts in 1995). This was the first time a meaningful connection had been made between video and art in China. By way of a striking contrast, representatives from provincial television stations across China were simultaneously holding a meeting at Huajiashan Hotel in Hangzhou during which the videotapes were also shown. The industry professionals showed not the least bit of interest in the works and the screening was abandoned after one hour.

These events were a springboard that was responsible for structuring the basic development of video art in China. Video art was immediately accepted and utilized by artists. It was never employed as an actively political medium as was the case with early Western video art. Unlike The Street Video Group in Germany in the 1960s, Chinese artists were not interested in documenting news, recording social reform, or fighting the museum system. On the contrary, Chinese artists took video as a new mode of individual expression, placing emphasis on its aesthetic value.

In 1991, Zhang Peili, one of the organizers of the *Garage Show* in a storage space in Hengshan Road, Shanghai, showed the work *Document on Hygiene No. 3*. This was the first showing of a video work produced by a Chinese artist in China. It showed the artist repeatedly washing a chicken with soap and water in a basin. In the exhibition space, Zhang Peili placed several rows of red bricks in front of the television monitor to evoke the sense of a meeting. This corresponded to "Political Pop," which had not yet become a recognized genre; yet it was more devious and ingenious in its use of language. Zhang Peili produced three video works in 1992 : *Homework No. 1*, *Children's Playground*, and *Water: Standard Pronunciation, Ci hai* (fig. 1).

Homework No. 1 was an installation consisting of six videotapes showing blood samples being taken from human fingers. It was similar in tone to the breaking of glass in *30 x 30* (1988), and the chicken washing exercise in *Document on Hygiene No. 3. Water* showed a professional news broadcaster from CCTV (China Central Television), reading every explanation of the character "water" from a dictionary. [1] Zhang Peili recreated the same lighting, background, set-up and face as an actual news broadcast, but with the content replaced by a non-expressional and neutral lexicon. Mockery is the timed spirit of 1992, further demonstrated in the way that Zhang Peili synthesized the filmed sequence of washing the chicken to a soundtrack of ancient music entitled *Chuna Jiang Hua Yue Ye* (Blossoms in the Moon over Spring River).

After graduating from Zhejiang Academy of Fine Arts, Yan Lei came to Beijing where he produced the works *Dissolve, Clear Away* (1993), *1500 cm* and *Beijing Haw* (1994). *Dissolve* showed two hands repeatedly playing variations of cat's cradle. *Clear Away* followed the artist as he bent his head in concentration while plucking armpit hair with tweezers. *1500 cm* (fig. 2) was shot in four segments each focusing on a specific yet mundane act of human behavior. The act employed 1500 cm of rubber bands, which he washed, measured, forced into his mouth, and then pulled back out again like magicians do with handkerchiefs. In a similar style

to Zhang Peili's *Hygiene No. 1*, Yan Lei's three video works were all compiled of long shots taken from the fixed focus of a single camera position. There was almost no narrative within these events because with the aim of recording fact, truth itself was demonstrated to have no obvious process. Conversely, where the mere record of an object is meaningless, action becomes "truth" on the screen. In this regard, the single, fixed focus, close-up shot then is a compelling medium.

If this interesting approach was found in the work of two artists alone, we might suppose some kind of collaboration or aesthetic influence to be at work between them. Yet, it soon became clear that more and more artists were also exploring this approach. In 1994, *Living with a "Lady"* by Li Juchuan, and *The Focused Sleep* by Tong Biao among others, revealed that this phenomen on was actually the result of a problem: the lack of any other personal inclination. At the same time, if we take the wider picture, the situation of that moment largely denied the artists ready accessibility to editing and post-production equipment. Cameras themselves were often borrowed, so the original concept of these works was aimed at avoiding the subsequent problems of editing. This was a smart move. Unavoidably, the deliberate and repeated paring down of technical elements under these difficult conditions resulted in unbearably simplified work. The love of minimalism, the interest in extreme simplification and an obsession with process apparently provided faith in the truth of simplicity.

Video art had just colonized an area within visual awareness when it came up against limitations within technology and material. More creative artists actively engaged in the medium by exploiting the circumstances that they found themselves in.

Fig. 3 Qiu Zhijie, *Assignment No. 1: Copying "Orchid Pavilion Preface" a Thousand Times*, 1990-95, video

The element of timely relevance has always been key to Qiu Zhijie's approach. In 1992, after three years of continuous work, he completed the piece *Copying "Orchid Pavilion Preface" a Thousand Times* (fig. 3). This was a video recording of fifty rewrites of the famous text. A hand-held brush was delicately moved across a sheet of paper, which was increasingly blackened as multiple layers of the text built up. It engendered a strange, disturbing tension. Following this, sensitivity towards the images became a particular feature of his video works: intense movement, dramatic altering processes, life experience evoked from the physicality of a recorded object, etc. The interests revealed in his works demonstrated less about contemporary concept than about his broader awareness. Qiu Zhijie's installation works were often pivoted on concept and notable for their philosophical inspiration and inference. These aspects of the works reflect the diorama of his spiritual life. By the time he saw *To Bury a Secret* by Bill Viola, whose work represented the US at the 1995 Venice Biennale and who would quickly became the main force inspiring and driving video art in China, video art had become the central focus of his art.

Fig. 4 Zhu Jia, *Forever*, 1994, video

As the 1990s approached, video art flourished in the Western world, and became embraced by audiences as an independent medium. However, it was something quite beyond the imagination of ordinary Chinese people. Although the circumstances of the moment were difficult, an exhibition of video art seemed necessary. By 1995, the growing practice around the country, albeit scattered, indicated the importance video art was beginning to assume. At the end of 1994, Zhu Jia produced his ingenious work *Forever* (fig. 4), executed by fixing a small camera to the edge of a flatbed bicycle wheel as the artist pedaled through the streets of Beijing. The image of the streets ceaselessly spins round and round with the changing speed of the flatbed bicycle. When *Forever* was later exhibited in Hangzhou, the images were accompanied by a soundtrack of loud snoring.

In 1995, Li Yongbin finished his first video piece by projecting colour slides of his deceased mother onto building and trees immediately outside his apartment in the early hours of the morning. As the dawn arose, the image faded and eventually disappeared. The second work *Face No. 1* (fig. 5) was shown at a group exhibition in Hangzhou the following year. Here, a video taped image of an old man's face is projected onto the face of the artist. The two superimposed faces sometimes coincide and sometimes dislocate. Within the realm of video works composed of long shots, Li Yongbin evolved his own rationale and would continue experiments with projections.

Fig. 5 Li Yongbin, *Face No. 1*, 1996, video

Wang Gongxin and Lin Tianmiao lived in New York for ten years prior to their return to Beijing in 1995. Wang Gongxin produced his first video installation work *The Sky of Brooklyn* in Beijing soon after his return. For this, he dug a well within their courtyard home and placed a television monitor at the bottom showing the video-taped image of a blue sky over Brooklyn. A voiceover says "What are you looking at? There's nothing to see here!" in a strong Beijing accent. The underlying metaphor of the work illustrated China's curiosity about the West and the element of desire contained within the attitude. It appealed to the audience to draw near and then repelled them with a jolt.

In September 1995, Yan Lei held a solo show titled *Invasion* in Beijing. The video works *323cm²* and

No.031007 were less about art than his *Clear Away* (1994). These largely functioned as documentation, relaying on the process of an event that had already taken place.

Chen Shaoxiong, an active member of the Big-tailed Elephant group in Guangzhou, has a unique approach to working with the video medium. With a strong capacity for logistical organization, his work has a two-way streak. On one hand, his video installations are tight contrapositions of images combined with lambent editing. This is counterpoised by his awareness of the physicality of visual experience. The former impels him to create intricately configured installation works; frequently use elements to create a kind of rationale; or follow his preference for forms like word games. The latter allows him to successfully translate what might originally have been relatively uninteresting epistemological issues into a direct, easy language and actual physical experience. Chen Shaoxiong began work on the *Sight Adjuster* series in 1994, and has persistently pushed the subject to its limit, demonstrated in the work presented for the exhibition *Phenomena/Image* in 1996.

In September 1995, Weng Fen and female artist Yan Yinhong held an exhibition titled *A Talk Between a Man and a Woman* (fig. 6) in Haikou. This contained elements similar to another work of Chen Shaoxiong's , *The Bride Changes Her Mind When the Television Channel is Changed* (1994). Liu Yi from Shenzhen showed her work *Who Am I?* in Beijing. The work showed a number of the artist's friends talking about her, which placed an overriding focus on linguistics within the work. The problems that underlie the works by these artists indicate a similar crisis: that their author was content to focus on terribly simple ideas of little significance.

We find similar problem in the work of Beijing artist Song Dong, but his obsession with tiny details comes closer to being Zen. Song Dong held a solo exhibition titled *Uncovering* in Beijing. The work shown took the form of projected scenes or close-up shots of lifting a cloth covering various objects. This straightforward methodology became a fertile ground for his work. The installation *Shut Up and Listen to Me* carried a social metaphor. Song Dong placed two television monitors face to face, each one playing footage of a close-up shot of one mouth that appeared to be speaking to another, one in English, one in Chinese. His approach was similar to that of Weng Fen but the effect was more concise.

In 1994, Shi Yong and Qian Weikang gained recognition through a series of exhibitions in Shanghai. In Qian Weikang's installation works he often juxtaposes an object with the image of it on the screen, portraying the actual object as a simple physiological phenomenon, or even physical phenomenon. He was not inclined to make explorations of society, culture and politics. Compared to him, Shi Yong was more of a humanist, although his work exhibited the same kind of sententious outline, flowing surface and diverse process. The materials he chose often imbued the work with metaphor. For instance, he approached film and sound based on his attitude towards the mass media. That approach engendered an independent relationship with electronic media.

As we approached the mid-1990s, Zhang Peili's persistent efforts in the field of video art were paying off. He had gained an increasing number of opportunities to exhibit internationally. As compared with the instinctive spontaneity in his earlier practice, his works now revealed the greater input of researched techniques from Western video art. Zhang Peili regularly used multiple screens in exhibiting his works as an installation in a gallery space. Compared with the close-up shots, fixed camera angles and repeated movements that characterize his earlier works, he had begun to create a direct visual impact across the screens. If he merely arranged the monitors and electrical components of his installation to construct the desired effect, then obviously it would be more difficult to imbue the work with historical context and the thrill that derives from the integration of other objects. These generally appeared to be more delicate. As an excellent artist, Zhang Peili frequently breaks ground with his instinctive sensitivity, accurate grasp of technique and motion, creating a sensation of life with the simplest equipment. A representative later work of this period by Zhang Peili is *Uncertain Pleasure* produced in 1996.

After moving to Beijing in 1994, Qiu Zhijie spent much time thinking about his earlier work in Hangzhou, which was a series of conceptual works, focused only on pure academic notions. He reduced the enormous volume of content about social culture, at the same time trying to differentiate his work from other small-minded approaches to video, so that his works began to emphasize certain physical sensitivities, such as in *Washroom* (fig. 7) and *Hands of Escher*. This tact clearly runs through Zhang Peili's works, whereas Qiu often takes pains to avoid blankness in his video work, and turns the process to focus upon the body, or impels the body to adopt the gestures suggesting a more dramatic plot when the characters perform in front of the camera.

Experimental video as a medium emerged nationwide in China around 1996, and on an odd occasion was included in exhibitions. It was evident that more people were becoming interested in this field. The exhibition *Image and Phenomenan* arose from this situation.

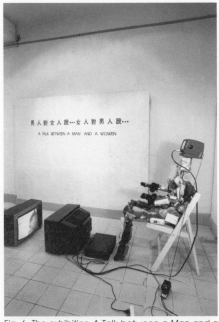

Fig. 6 The exhibition *A Talk between a Man and a Woman held* by Weng Fen and Yan Yinhong, November, 1995.

Fig. 7 Qiu Zhijie, *Washroom*, 1994, video

When Qiu Zhijie and Wu Meichun decided to take up this challenge, the biggest problem confronting them was funding. They had absolutely no experience of fund-raising, yet in the friendship and trust of their fiends Lin Shiming and Hong Lumei who were doing business in Shanghai, they found sponsorship committed to the event. If their challenge had not been realized in April 1996, we would have had to wait a couple of years to continue the story. Artists collaborated together to produce the two English-version catalogues, but the most important work was to procure the equipment required and to insert an academic structure into the exhibition.

In an unpublished exhibition catalogue, exhibition curator Wu Meichun outlined her thinking on academicism in *Image and Phenomena*: What possibilities does video art bring to contemporary art? Does video art exist as the image of the phenomenon or the phenomenon of the image?[2]

When everything was prepared the group of artists participated in *Image and Phenomena* included nearly the entire roll call within the field of video art at that moment. "We wished to take a more active stance in facing reality. We could not sit back and wait for a general elevation in the quality and quantity of video works. We decided to take an exhibition as the starting point for exploring video in art. Neither the works, nor the act of organizing an exhibition itself was a response to reality."[3] Such zeal tended to spoil things with its excessive enthusiasm and idealistic outlook that refused to acknowledge the reality. Following the exhibition, the nationwide exploration of video became a hot topic. Meanwhile the structural defects and difficulties that were exposed during the preparation for the exhibition provided a direction for further efforts. The exhibition itself and the response to it became a landmark in establishing a healthy system and environment for creativity that is little more than the predetermined goal of the curator.

The works in the exhibition may be divided into two parts according to trends exhibited. First, the works that were introspective in regard to the medium itself, and which were generally simple in structure. Second were the intricately structured scenes, which pushed at the boundaries of the video's image by adding rich layers and a finer perception. Representative of the first were works such as *Uncertain Pleasure* and *Focal Distance* by Zhang Peili, *Breath/Breath* by Qian Weikang, *Forever* by Zhu Jia, *Face* by Li Yongbin, *The Afternoon of August 30th* by Tong Biao, and *Absolutely Safe* by Yan Lei. Representative of the second installation works were *Present Progress* by Qiu Zhijie, *Baby Talk* by Wang Gongxin, *Fish Tank* by Yang Zhenzhong, and *Integrated World* by Geng Jianyi.

Image and Phenomena produced a group of unforgettable video works and initiated a series of research and exchange activities. The two catalogues produced, *Literature of Video Art and Art* and *Historical Consciousness*, presented a compendium of important information about video art in China and abroad. The popularity of the two catalogues demonstrated the impact upon people's understanding and acceptance of video over the next few years.

Following *Image and Phenomenan*, which was held at the art gallery of China National Academy of Fine Arts in 1996, many high-quality solo exhibitions sprang up in Beijing, such as Wang Gongxin's *Myth Powder No.1*, Song Dong's *Look*, Qiu Zhijie's *Logic: Five Video Installations*, etc. This indicated that Chinese video artists had not only become focal points within the artistic community, but had also started to use more mature and individual methods to redraw the map of contemporary culture. Within China, people from different backgrounds such as documentary filmmakers, writers and those engaged in experimental music or drama began to venture into video art, and various new possibilities for the art form began to develop. Equally, equipment became more affordable with each technological advance, and artists were able to achieve richer effects using their own PC to carry out post-production—if determined to do so. With the renovation of and change within video technology, it became a trend along with the use of domestic digital cameras and non-linear video editing systems.

The results were demonstrated in *China's Video Art*, an exhibition produced in 1997 curated by Wu Meichun. In the catalogue essay "Curator's Thoughts" she wrote: "The real question we face concerns the uses to which video art can be put, not what video art is. It is too early to define. Although standards for video art appear to be falling into place, they are not accepted by everyone. The inherent characteristics of the medium make it powerful yet cheap, intimate yet easy to copy and disseminate. It can expose the truth but also can give rein to the imagination. This exhibition is an attempt to show everything and not to select work to illustrate a specific theme. It is broadly inclusive in its selection and indicates our courage to exist in the world of media."[4]

Wu Meichun mentioned that standards for video art are constantly challenged by a multitude of experiments. At the end of 1998, Huang Yan curated *0431—China's Video Art* in Changchun and Johnson Chang curated *Fast Shots*: *China, Hong Kong and Taiwan Video Art 1999* in Macau. The core elements took their

lead from *Image and Phenomena*.

The activities of Chinese video artists had begun to attract the attention of international art circles. In 1997, new media works by Wang Jianwei and Feng Mengbo were exhibited in *Documenta X* in Kassell. In 1998, Qiu Zhijie participated in the Berlin video festival *Transmediale '98*, the *Esperanto '98* exhibition in New York, and received invitations from important video festivals in Bonn, Helsinki and various other places. Chen Shaoping and Qiu Zhijie both participated in *Videos from International Artists* held at the Ludwig Museum in Cologne; Song Dong and Wang Jianwei both participated in *Information* in the Kwangjiu Biennial curated by Nam Jun Paik. In 1999, Zhu Jia and Li Yongbin attended the *World-Wide Video Festival* held in Amsterdam. New media art festivals and institutions worldwide were expressing strong interest in holding an exhibition of Chinese video art. The Museum of Modern Art in New York and the Berlin Video Forum each collected video works by Zhang Peili and Qiu Zhijie, and the works of China's new media artists began to appear frequently in festivals of new media art all over the world.

Meanwhile, members of the international art world made frequent visits to China. Rudolph Filindas, director of New Media Art Center in Germany, gave several lectures introducing new developments at the Goethe Institute in Beijing and Shanghai. Robert Karn, the poetic master of French video art visited the China National Academy of Fine Arts twice, and left a profound impression on the students. Barbara London, curator of film and video at the Museum of Modern Art, New York, traveled to China in the fall of 1997. She was amazed that China not only had excellent video artists, but also absorbed information at a very rapid speed. Her essay was later translated into Chinese, commenting "the flourishing of China's video art is the starting point of a new circle since the circumference was already closed around new media art in the West."

Although the prospects of China's new media art are bright, the current situation has its problems. Until 2000, not one of the art academies in China had established a new media course, and although China's television channels have advanced equipment, they do not encourage experimental art programs. The interest of international art circles towards Chinese new media art grows with each passing day, but we lack the institutional structure necessary to enter into a dialogue. The problems of gathering funds and establishing venues and facilities are exacerbated by the fact that there are no stable institutions organizing video festivals or exhibitions. These structural deficiencies have further increased the restrictions on new media art. There is an urgent need for not-for-profit new media workshops operated by non-governmental institutions, technical support for experimental artists, and the investigation, exchange, collection and popularization of new media art.

At the beginning of 2001, one non-governmental new media center did appear in Beijing. The Loft New Media Art Central (LNMAC) is located in Sanlitun, adjoined to the Loft Restaurant and Bar, known for its cutting-edge cultural image and design. It is a space where people relax and celebrities meet, and which hosts a range of performances and art events. The space was established by artists Wang Gongxin and Lin Tianmiao, and is run by Lin's sister Lin Tianfang. In September 2001, it hosted an exhibition of works by new media artists from France and the US who were teaching at the Central Academy of Fine Arts together with Chinese artists Zhang Peili, Wang Gongxin and Qiu Zhijie. Wang Bo's solo multimedia show was exhibited here in November 2001. The Loft also participated in the International Alternative Space Seminar in Hong Kong in December. In March 2002, it was invited as a non-governmental organization to exhibit China's new media art at the Kwangju Biennial in Korea.

More recently, the New Media Research Center was established in June 2001 with the support of Xu Jiang, dean of the China National Academy of Fine Arts. Its brief includes a theoretical research department and studios; it will launch new media art courses in 2003. At present, the center functions as follows: building a broad symbiosis with media centers, media institutes and video festivals around the world; welcoming new media artists from abroad for the creation, investigation and exhibition of new media art works; conducting regular lectures about developments in new media art; organizing new media art festivals annually in China; and sending new media art works to participate various international activities. The prolific databank is available to artists, students and researchers, providing the opportunity for research and curating exhibitions. The focus is on new technological advances, to which end periodical invitations will be extended to technical staff from computer and electronic appliance companies for the purpose of introducing new technologies including regular training courses. It will also introduce developments in new media art from China and abroad via the Internet. The greatest, most positive success has been that achieved by *New Media Art Festival: Non-Linear Narrative*, which took place at the end of September 2001, and the intensive training courses organized in

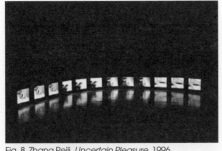

Fig. 8 Zhang Peili, *Uncertain Pleasure*, 1996, video installation

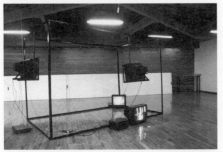

Fig. 9 Gao Shiming, Lu Lei, Gao Shiqiang, *Visible and Invisible Life*, video installation

association with professors from the new media art department of Berlin University in March 2002.

In 2002, Phoenix Television launched a new program titled *DV New Generation* (*DV Xin Shidai*). Recognizing the booming popularity of digital video and the possibilities of independent production, it provides college students with professional digital cameras and then televises the works they shot each day. The Phoenix Television initiative confirmed a new trend, setting a precedent within Chinese media. Its significance is immeasurable.

Video art is a medium that takes a morbid delight in constructing its own history. In the early days, the artistic standpoints of its cultural heroes were clear, albeit too exaggerated and simplified. Then again, it is only simple attitudes that are able to gain attention and understanding. More sophisticated insights are generally ignored.

Zhang Peili is the most important representative of the first stage of Chinese video art. He has consistently used the body to master the medium of video installation. Using multiple screens each broadcasting different images, he creates a sort of 3-D collage and sets up contrasting, yet mutually involved semantics. In the piece *Uncertain Pleasure* (fig. 8), more than ten monitors broadcast different close-up shots of a hand scratching a part of the body. The fleshy images within the neat monitors create a powerful tension. There is a similar sensation in the new work *Taking Food*. For Zhang Peili, video is a sort of "electric mirror" with powers of amplification that can be used to examine the body in minute detail. It can expose certain elements that due to the defenses of our fragile psyches are usually filtered out by the naked eye. Zhang Peili's standpoint has influenced several younger artists, although the physical narcissism of young people gives their work even more intimate and counter-cultural characteristics.

Fig. 10 Yang Fudong, *Shen's Hutong*, 2000, video

Xu Zhen is one of these artists. His video *From Inside the Body* (fig. 9), produced in 1999, comprises three screens. On each one, left and right, a man and a woman sniff their own bodies in a curious and exploratory manner, before simultaneously entering the central screen and sniffing each other's bodies. His emphasis on an exaggerated sense of smell makes Zhang Peili's strategy of amplifying minute bodily motions and imbuing them with existential angst seem a much more metaphoric stage. The obviously influenced artists are Yang Zhenzhong and Kan Xuan in Shanghai, an influence which may be traced back to Bruce Nauman.

As compared with works of an uninteresting or severe style, a number of other artists are keen on using realistic video images to create semantic meanings. These realistic images create a substitute reality, rather like an opera stage, with narratives and experiences being constructed directly within the framework of this imaginary space. Gao Shiming, Gao Shiqiang and Lu Lei's *Visible and Invisible Life* (fig. 9) is an angular framework for a room, constructed of welded iron. Three monitors separately show footage of feet passing through — in and out of — a door, hands turning a door handle and the curtains blowing in the wind, all of which are moved only to return to their original location. The substitute reality forms a kind of abstract room, and the audience needs to draw on their individual imagination and experiences to fill in the details.

Fig. 11 Wang Gongxin, *The Sky of Brooklyn*, 1995, performance, installation, video

The similar artifice can be partly found in *Location* and *Butterfly* by Weng Fen, *In the Situation* by Feng Xiaoying, and *Hard to Restrain* by Liu Wei in the exhibition *Post-sense Sensibility*; Song Dong's *Looking in the Mirror* in his solo show *Look*, and Yang Fudong's *Shen's Hutong* (fig. 10) in the exhibition *Period of Validity* in Shanghai. All were semantic installations. In a concrete stage set, a semantic relationship is formed between video images and "props." Not only can a semantic meaning be produced from visual images but props can also be made use of to convey the artists' ideas.

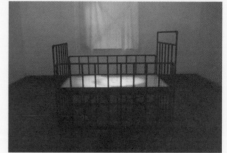

Fig. 12 Wang Gongxin, *Baby Talk*, 1996, video installation

The former is demonstrated by Wang Gongxin's works *Baby Talk* (fig. 12), *The Sky of Brooklyn* (fig. 11)and *Face*. In *Baby Talk*, a baby's crib shaped like a shallow basin was filled with milk, which is constantly circulated via means of a pump, forming a whirlpool in the center. A moving sequence was projected onto the surface of the milk, the video images showing the facial expressions of older relatives teasing a baby shot from baby's angle. The latter, can be illustrated by Song Dong's *Hit the Gambling Table* (1998) exhibited in Macao, and *Narrative of Non-Linearity-Elevator* (fig. 13) shown in *Non-Linear Narrative* in 2001.

When talking about works that use video in a symbolic way we may also mention Yang Zhenzhong's *Face of Shanghai* in which the video projector projects upwards from the bottom of a water tank. The stable picture is distorted by the effects on the water of the vibrations caused by the amplification of low-pitched sound. The picture is of a mask through which to view the street scene. In Qiu Zhijie's *Outcome and Premonition*, the lines of the artist's own palm were enlarged and projected on the floor of the exhibition space, with monitors placed at various positions according to the principles of palmistry. The images on the screens included a figure skating on a revolving compass, hands throwing dice, and distorted figures in a landscape; the sort of highly symbolic

images often used by artists, as in Chen Xiaoyun's *Shears, Shears* and Shi Qing's *Latent Period in Summer*, both of 2001. The interest of this piece lies in its ingenuity of form, where the theme of reflections appears to be a pretext.

Chen Shaoxiong's short film *Landscape 2* comprises a street scene shot through a piece of glass placed in front of the lens, so that the doodling on the glass appear to be part of the scene. Zhao Liang's film *Game* has the picture gradually transform from blurry to clear in a process open to misreading. Liu Wei's *Hard to Restrain* draws an analogy between rolling, crawling, capering human figures and wild beasts.

Zhou Xiaohu's installation *The Strange Tale of the Emperor's Snake*, of 1998, is a strange and mysterious snake-dance invented by the artist, and similar to the performance of amateur circus, enhanced by a kind of emotional appeal to weird, anecdotal things. Reactions to the piece varied widely.

Yang Fudong's *City Light* and *Back Yard of 2000*, places the tastes and poetic preferences of classical Chinese scholars (*wen ren*) under a microscope, transforming them in the process. Jiang Zhi's *The Old Cruller* employed a curious logic to reflect an interlacing of innocent and subjective ideas.

Chain, produced by Cao Fei in Guangzhou, 2000 and *Where Did You Sleep Last Night*, produced by Cao Kai and Wang Fang from Nanjing in 2001, both explored the controllable pace of change in the implications and meaning of images in the media age. Works of this kind especially tended towards the use of video to express illusions, and were able to effectively develop a humorous small-scale style of narrative.

Fig. 13 Song Dong, *Non-linear Narrative: Elevator*, 2001, video installation

In the mid-to late 1990s some other works such as Qiu Zhijie's *On the March Now* (1996), Chen Shaoxiong's *Sight Adjuster* (1996), and Song Dong's *Family Portrait* (2000), further explored the interactive nature of video installations. Qiu Zhijie's *On the March Now* incorporated two floral wreaths placed at a 90-degree angle to each other, with a monitor in the center of each wreath. Each of the screens relayed pre-recorded images of relatives gathered round a deathbed, shot from the point of view of the dying person. The camera passes slowly over the face of each relative, the black and white shots closely resembling portraits of the deceased. As the viewer faced this screen, his own visage appeared on the second screen on the right, at right angles to the first. If he turned to face the first screen, then he would see the left side of his face in profile. Around the wreaths, many small screens showed looped images of flowers bursting into bloom. This was the first interactive video installation work in China.

Qiu Zhijie's most diligent work, *Back Massage* (fig. 14), produced in 2001, pushed the interactive aspect of video to perfection. The work was divided into two parts, an inner and outer portion. Across the four outer monitors, the prophetic text contained with the *Back Massage* was superimposed over the image of the film *The Street Angel*. The timing of each film had been offset by a two-second difference, thus the same phrase never appeared over the same image so that the images established a dual relationship to space and time. At any moment, the images on four screens formed a sort of *zou ma deng* (i. e. a traditional lantern with revolving papercut figures). In the center of these monitors, projected onto the ground was the image of a revolving compass, its needle turning round and round. The image of *Back Massage* was superimposed over the image of the compass, thus made a double image. The participants were forced to rotate physically to follow the images. Carrying salvers filled with milk, they turned around with the moving images and tried to get a hold of it with salver. They had become puppets controlled by the video.

Fig. 14 Qiu Zhijie, *Back Massage*, 2001, video installation

Song Dong's *Family Portrait* invited audience to stand front of an image projected onto a wall and have their photograph taken with the pre-taped "family group." Song Dong intended to combine the warmth of family life with his video work, a preference that subsequently became one of his main approaches.

We are most directly able to experience the special spiritual aesthetics of Chinese people among the works of Qiu Zhijie, Song Dong and Yang Fudong. Qiu's efforts are directed towards using the language of video art to capture the subtle poetics of everyday life, engaging in Zen-like meditations on unconscious details from within diverse everyday language environments. In his installation *Objects* (1998), the videos show hands repeatedly striking matches to illuminate various objects, with unequal periods of darkness between the striking of one match and the next. The four videotapes were filmed in different rooms in the artist's family home. *Objects* strives to evoke a chance-like quality aroused by the interchange of light and dark, death and chance where meetings are decided by fate.

Another of Qiu's installations *Landscape* consists of two projections facing each other. One cuts swiftly between images of different people against the same landscape, while the opposite projection shows the artist himself in various locations around the world, the landscapes slowly and constantly rotating. The antithetical relationship between the two is similar to a Chinese "*dui lian*," a poetic couplet, and also evokes a typically

Chinese wistfulness about life that is evoked in the image of a bird's delicate footprint left in deep snow.

In Song Dong's 1998 work *Father and Son*, he projected the image of his father onto his own face. Both related their life history to the camera. Visually, the superimposition and similarity of father and son created an emotional association between transmigration and reincarnation.

At the end of the 1990s, as the IT industry further advanced, editing equipment for PCs became cheaper and more widely available. Video could no longer be regarded as a mere sociological tool, and its cultural and aesthetic functions were researched more thoroughly. Not only did video art continue to flourish, but an increasing number of artists started to explore interactive multimedia and Internet-based works. The tendency towards sensuousness and the emphasis upon *in situ* works within the art circles was embodied in the medium as artists began to work with sound. Internationally, the fact of having more opportunities for exchange greatly expanded the artists' field of vision, and an increase in the number and types of channels of circulation encouraged diversity. At this time, most concepts of "new media art" consist of video shorts and installations, which is a generalization of the wider practice, more inclusive than the original terminology of "video art." New media art is also recognized by a broader range of people.

Fig. 15 Qiu Zhijie, *The West*, 2001, multi-media

The new media art festival *Non-Linear Narrative* curated by Xu Jiang and Wu Meichun took place at the China National Academy of Fine Arts, from September 25th to 30th, 2001. This exhibition brought together more than one hundred works from forty active new media artists from China and abroad, including video installations, sound installations, short films, compilation digital images, conceptual photographs, and interactive multi-media and Internet works. *Non-Linear Narrative* aimed to investigate the various emerging possibilities of new technology when aligned with the general meaning of concept. Further, the direction of conventional approaches was explored, thus making room for artists to extend the new media. Compared with the video show in 1996, there was a great deal more new technology involved.

When talking about multi-media works and Internet works we may also mention the *China Internet Art* exhibition in 2000 curated by Huang Yan and Hai Bo in Changchun. This highlighted the agenda of Internet experience and its influence on Chinese art. It was significant that such an avant-garde activity could be hosted by Jilin Art Academy. Yet the works did not entirely conform to the title and theme of the show. On March 1, 2000, the *Loft Digital Art Festival* curated by Qiu Zhijie, Wu Meichun and Li Zhenhua took place at the LNMAS in Beijing, bringing together local works in digital media from recent years. This included interactive multimedia works via CD-Rom, Flash works, and even newer and excellent computer games.

Shi Yong's Internet works take the subject of controlling people as their theme. This type of control acts from within the very structure of language itself, and is even more conspicuous in the current phase of post-colonial cultural exchange. The type of involvement used in his works does not provide a solution. Quite the contrary, part playful and part technical jargon, it intensifies our powerlessness in the face of many forms of art control. Feng Mengbo created the first model using electronic games employing a political symbolism that imbued the electronic game with a heavy dose of current affairs. He produced the first piece of interactive multimedia work, *The Taking of Tiger Mountain by Strategy*, in 1997. *A Silver Dollar*, created in 1996, was a work based on photographs from the family album through the past twenty years. It included images documenting the period, old records, copies of books, film clips, music and homemade discs, rather like a sort of historical biography than artwork.

Shi Qing's works *Salvation Apocalypse* (1999) and *Handbook of Home Suicide* (2000) were both based on games. Instead of playing with a lesser art form as some initially considered, he was making games into art.

Qiu Zhijie's video installations capture the poetry in the rituals of everyday life, his multimedia work *The West* (fig. 15) appears like a report of the findings of a comprehensive investigation. It illustrates how the Chinese people's understanding of the West is full of self-contradictions, both serious and comic. Interactive multimedia provided the best way to recreate this kind of feeling. Due to the limitless complexity of its subject, this work is as labyrinthine in form as the concept itself.

The computer network technology changes with each passing day. The 1999 edition of Flash 4 enhanced cartoon production and script editing, giving rise to a rapid growth in "flash" works in just a year. An example is the new media art show in Hangzhou, which included MTV, like Jiang Jianqiu's *Rock n 'Roll on the New Long March*, Qi Zhaohui's *Love Song 1980*; short cartoon videos, like Zhou Xiaohu's *Ne Zha Chuang Guan*, Qi Zhaohui's *City Three Love Songs*, Jiang Jianqiu's *The Bandit's Paradise*; interactive games, like Zhu Zhiqiang's *Gu Du Qiu Bai*, *Guoguan Zhanjiang* and *King of Kungfu*, and Wang Bo's *Play With Me* (fig. 16). In spite of the fact that Internet art is still in a period of utopia imbued with world-shaking and dynamic changes, flash cartoons

have temporarily became a trend. Its nature has yet to be realized.

As the Millennium turned, the aesthetic possibilities of video art have been fully excavated and the revolutionary role of video art is accomplished. It will be delivered to the mass players by means of DV camera and the slogan "Digital-Video Revolution," and become the new writing tool of an average person's diary. 3-D computer cartoon technology has brought little in the way of new possibilities to the video. Much more was turned into the imitation of a surrealistic approach. However, artists who tend towards employing animated computer images to "create art" have been compelled to push the boundaries of this medium forward. New media art has only a marginal overlap with video art. Its representative character is hybridizing with other media: video has been used in performance and action art, drama, dance, and music, not only in setting a stage, but in the very structuring of the medium. Thereby, new media art has a more hybrid element.

From last April, many theaters and performance halls in Beijing became arenas for new media artists to carry out large-scale invasions with other art mediums. Wang Jianwei produced the play *Screens*. In his persistent independent approach, the drama not only included stage, lighting, scenery and drama performance, but incorporated video and performance within the performance space, not just as a backdrop.

Wu Ershan participated in a jazz festival. There was *Fashionable News*, directed by Qiu Zhijie, and Wen Hui's *Dance with Workers* (fig. 17) in participation with Song Dong. Zhang Hui's *Oh, My Sun* (fig. 18) was shown in *Non-Linear Narrative* in 2001, and combined drama performances with ready-made video works, and they created an interactive relation by mini-cameras attached to marker pens. All this demonstrated that new approaches were quietly gestating in the Chinese soil.

The work of Zhang Peili, Wang Gongxin and other first generation Chinese video artists is now becoming mainstream, and familiar to many people. Whereas Shi Yong and Shi Qing's works show the possibility of new media art engaging in cultural contemplation and appraisal, Qiu Zhijie and Song Dong explore the possibilities of combining new media art with the delicacy and rich experience of traditional Chinese fine arts. These are newly emerging tendencies; they are walking on the way of new media art to develop in even more directions.

To maintain a continuous dialogue with technological advances, and explore a Chinese language, come into the consideration of globalization phenomena: these new media artists working in a land full of energy and desire have already become deeply involved in pondering these ideas.

Wu Meichun is a critic and curator in the New Media Art Center of the China National Academy of Fine Arts. Qiu Zhijie is an artist, critic, and independent curator.

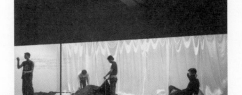

Fig. 16 Wang Bo, *Play with Me*, 2001, Flash animation

Fig. 17 Wen Hui, *Dance with Workers*, 2001, video, performance

Fig. 18 Zhang Hui, *Oh, My Sun*, 2001, video, performance

1 *Cihai* (Sea of Words) is the name of the most well-known and complete Chinese dictionary.
2 Wu Meichun, "Image and Phenomenon," in an unpublished exhibition catalogue.
3 Ibid.
4 Wu Meichun, "Curator's Thoughts," in *China's Video Art*, exhibition catalogue, 1997.

Translated from the Chinese by Karen Smith.

'Women's Art' as Part of Contemporary Chinese Art since 1990

Liao Wen

I am not sure how a (Chinese) public reacts to the term "women's art." Do they find it absurd? Does it raise doubt, contempt, or an inexplicable dislike, in the manner a western artist might respond to the term "feminist art?" Any of these responses is normal: apart from being "experimental," and bearing a number of general epithets, women's art encompasses a range of problems from the artists' gender and identity to violation of tradition and customs, as well as sensitive issues closely linked to history and society. Of significance in terms of this article is that, as I discuss women's art within the broader framework of art, I have placed strongest emphasis not on painting in the traditional sense, but on the value of art produced by women as a new field within contemporary creativity in China. To be precise, I examine women's art from the angle of contemporary art as opposed to that of women's painting. In doing so, I must address sensitive problems that continue to exert an influence on women's art, which is why I have elected not to bury my head in the sand of individual works, like an ostrich presenting its rear without clear context for the audience.

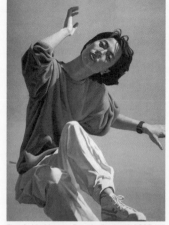
Fig. 1 Yu Hong, *Purple Portrait*, 1989, oil on canvas

Women's Art: A Non-entity in the 1980s

Contemporary Chinese art emerged in the late 1970s. It gained maturity through the vigorous Art New Wave movement that gathered momentum through the 1980s. In the early 1990s, attempts to dovetail contemporary Chinese art with the international scene and its practices, and to engage in a dialogue, were made. But strictly speaking, as an issue within contemporary Chinese art, women's art has a history of less than ten years. In 1987, I began to promote and review contemporary artworks in the *Chinese Fine Arts Weekly* (*Zhongguo Meishu Bao*). I believe I matured with the generation of artists that belonged to the '85 Art New Wave movement. But it was not until the mid-1990s that I began to study and pay close attention to women's art.

During that time many artists were energetically promoting contemporary art. They faced an important problem—namely how to liberate art from its dependence upon politics, as had been the situation for many years. Few people paid attention to the fact that the participants of this movement were mostly male and that women artists were extremely rare, their influence ephemeral. In 1992, a curator from a British national museum travelled to China to investigate the new art being produced. Perhaps because she discovered that most artists were men she was particularly excited to meet me, a female colleague. She asked me if feminist art existed in China. I responded that since China had not resolved its human rights issues, it was hardly possible to talk about women's rights, not to mention feminist art. We both dismissed the topic with a laugh. I did not realize at the time that this acted as the catalyst for some profound thinking. In short, women's art did not become a topic in contemporary Chinese art until the mid-1990s.

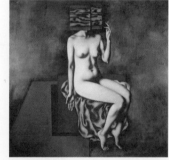
Fig. 2 Liu Hong, *Soliloquy*, 1994, oil on canvas

Chinese women brought up within the institutionalized "women's lib" movement of the twentieth century "hold up half the sky" (an early Communist catch phrase) as men do. Theoretically, there is no obstacle for them to engage in art. Indeed, there continue to be many women artists who have created a significant volume of works during that period. Having undergone the same art education, why was it that only men became involved in the great ideological changes taking place in China during the 1980s? After analyzing of the emancipation of Chinese women in the twentieth century and the art they produced in the 1980s, I discovered that the crux lay in the fact that the "emancipation of women" was curiously a battle waged neither by nor for women. This emancipation was led by men, its ultimate aim being to strengthen political standing. This determined its revolutionary, utilitarian nature. The impact of a predominantly patriarchal vocabulary on the depth of consciousness and the actual situation for women within this deep-

Fig. 3 Zhou Jing, *Toy*, 1995, tempera

Fig. 4 Xiang Jing, *Bright Colored Skirt*, 1995/2000, Doll

rooted ideology were overlooked. If women want to gain equality within a society whose patriarchal foundation has never been undermined, the prerequisite is to accept the value system installed by men. The level of "emancipation" is a direct measure of how much the standards set by men have been attained.

In spite of the emancipation of women through the last fifty years, with tradition deeply imprinted upon them, Chinese women were never mentally prepared for the "new life" suddenly accorded them. They were carried away by the torrent of revolution towards a destination of which they knew nothing. Their social status changed from being a dependant within a family group to being one of the collective dependants on the larger "family" of the state. Thus, emancipation brought forth strong women modelled upon revolutionary men.

Against the social background of opening and reform, and the "rediscovery of human nature" in the early 1980s, women, who had laboriously "held up half the sky" for more than fifty years at the expense of their inborn nature, yearned to become women once again. Only then could they off load the heavy burden that had oppressed them physically — even distorting them sexually (in denying any display of normal feminine traits, having them dress in a similar fashion to men, hair cropped short and forbidden to use make-up) — with a huge sigh of relief. Nevertheless, as they discarded the image and characteristics of female revolutionaries, they began to return to the traditional model of "woman." Thus, as they became women once again, they fell back into the web of traditional values placed upon women. As the forward advance began to experience a backward slide, the awareness of women's rights diminished. Women's art became trapped within its social context.

Fig. 5 Song Hong, *Fear of Birth*, 1995

Since the 1980s, women artists who had once produced revolutionary paintings as their male counterparts did, as well as a number of younger women artists, shook off the yoke of Revolutionary Realism, [1] but they still could not find a place for women's art. As they timidly gave a wide berth to utilitarianism, they shunned social motifs as well. With no example to follow, their creation appeared rootless, without context or purpose. Consciously or unconsciously, they returned to the traditional ideology on art. Their choice of subjects stressed everyday life, plants, flowers, pure and innocent girls, loving mothers and sons. Aesthetically they held the expression of pure emotions as being the highest standard of art. In their works, one saw bright sunlight, people at leisure and the sweetness of dreams. In short, they adopted modes of expression that were acceptable both in China and internationally. What they feared most was that people would say they were not "women" artists. In fact, there was no essential distinction between their works and the traditional "ladies' painting" (*guige hua*). [2]

Fig. 6 Cai Jin, *Canna, 48*, 1994, oil on canvas

Still worse, in the final two decades of the twentieth century, under the policy of opening and reform, contemporary Chinese art throve. These stereotypical "new ladies' paintings" (as I will tentatively call them) revealed no ideological change but they were fixed as the "mainstream" of women's art in China. Works of this type formed the greater part of works by Chinese women artists in the 1980s. They were approved of and favoured by the authorities and the public alike because they were as a twin sister to "mainstream" styles being promoted by the official academies. [3] Unfortunately, within the mainstream women's art served only as a feminine ornament on the broad sweep of government ideology and had little to do with the women's perspective or existence in contemporary China.

Fig. 7 Liu Liping, *Golden Corn, Green Corn*, 1995, oil on canvas

Women's Art in the Early 1990s

As contemporary Chinese art advanced in the 1990s and information about the art of Western women flooded in, some women artists began to feel discontented with the status quo in China and embarked on a period of experimentation. The quest for rediscovering the female "self" proved an arduous journey. Some women artists "warmed themselves in borrowed coats," exploiting their skills with the techniques of realism with the addition of special effects, which they could do with ease. In this way they expressed their inner world and awareness of the "self" of a contemporary woman. Other women artists, influenced by the limited information about Western feminist art they had received, relied on their intuition and talent, exploring women's own awareness and experience. In so doing they sought to achieve a mode of expression that would transcend common language in art.

Fig. 8 Chen Qiaoqiao, *Blooming Brush in a Dream*, 1994, oil on canvas

1. 'Warming Oneself in a Borrowed Coat'–Women's Self-Awareness in Soliloquy

In the same way that symbolic, absurd and grotesque images were employed to describe the inner

Fig. 9 Yang Keqin, *Wine Bottles*, 1993, oil on canvas

world of women artists in late nineteenth-century Western feminist literature and art, from 1990 the inner world of Chinese women artists surfaced in their works too. Such works took the form of soliloquies, similar to the literary forms of autobiography, monologue or diary. Their manner of expression was identical with those employed in symbolist, surrealist and stream-of-consciousness literature. Take Yu Hong's *Purple Portrait* (fig. 1). Though in the form of a portrait executed with realist techniques, the sitter in the painting represents more than a persona to be reconstructed through likeness on canvas. The portrait is somewhat symbolic. The image of a human as a symbolic sign, its fantastic pose, the blurred and romantic facial expression, the unusual composition, the strong purple tone and ornamental depiction employed in the background, all convey a feeling of the unreal and boredom.

Liu Hong's series *Soliloquy* (1994-98, fig. 2), the title of which suggests a monologue, presents self-portrait-like nudes sitting or standing or walking against cloth-like structures, while the heads are separated or veiled by a piece of cloth fixed in a different space on the picture plane. It is as if these materials are intentionally used to conceal a dislocated or shattered state of mind, and to calm confusion.

Zhou Jing's series *Toy* (1995-97, fig. 3), employs the dolls that young girls perceive as tender and loving, in memories full of affection, placing them in strange environments: caught in the branches of a pine tree, sitting astride the rim of a smudged, abandoned cistern, and lying on worn stone stairs. The dolls' eternally humorous expression, that emits a frightening grotesqueness or even horror, is the conduit by which the artist conveys her deepest feelings.

Fig. 10 Sun Guojuan, *Heart's Flower*, 1996, oil on canvas

Xiang Jing's *Path, Daydream, Cat Who Doesn't Sleep, Doll in a Brightly Colored Skirt* (1995-2000, fig. 4) captures moments of boredom, lethargy, fear and the dullness that taints the life of small girls and young women. With details executed in an Impressionist style, these pictures vividly convey the mentality of contemporary city girls.

Song Hong's works are all mirrors of spontaneous momentary feelings and emotions: hilarity, sentimentality, depression, or tranquillity. Her surrealistic images and the strong, bright tones immediately convey these emotions. *Music*, *Flower of Birth* and *Fear of Birth* (1995, fig. 5), are faithful records of her experience through pregnancy to labour. Song Hong says that for her painting is like keeping a diary, chatting with a friend or talking to herself. It makes her content as it makes her dependent on painting.

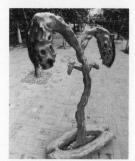

Fig. 11 Liao Haiying, *Love*, 1995, mixed media

To some extent these works convey individual experiences in a common language, but the solitude they hint at within the individual's inner world, the expression of the women's mentality, feelings and emotions, clearly manifest these women's self-awareness They break away from previous women's painting where women artists pursued false peace in paintings on a small range of subjects.

2. Women's Intuitive Approach – Its Evolution as a Genre/Brand

In the 1990s, artists largely worked at home or in small rented studios. The methodology of art critics like myself changed too. Art theorists began to pay occasional visits to these workshop-like studios. In particular, one thing marked a latent but important change: creative practitioners began to call themselves "artists" rather than "painters." This indicated that they no longer perceived their works within the context of a traditional meaning; they had turned their attention to problems of existence. In order to understand and grasp the new phenomenon in contemporary art, we also chose and studied artists from this angle. Initially, it did not occur to me that the owners of such studios were largely men. I didn't even ask myself why there were no women artists.

Fig. 12 Pan Ying, *Fiction*, 1994, ink and wash

Somewhere between late 1993 and early 1994, a number of women artists did establish their own studios and initiate activities. When I toured these studios, I began to notice something special emerging in their works, particularly those of Cai Jin, Pan Ying, Liu Liping, Lin Tianmiao and Shi Hui. In 1995 I curated an exhibition of their budding but as yet unripe art. I called their collective styles "women's approach."

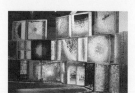

Fig.13 Shi Hui, *Knot*, 1994-95, raw cotton, paper pulp

Women's approach demonstrated the artists' awareness of life, and was often specifically related to their understanding of their own body, of reproduction and personal experiences and emotions. In their effort to transform the language of realism in which they had been trained, they placed direct emphasis on personal sensibilities and gradually relinquished their obsessive pursuit of "likeness." Such works usually symbolically reflected their (women's) experiences of emotional distress, of being affected or harmed by the social environment.

Cai Jin's series *Canna*, begun in 1992 (fig. 6), is notable for the ulcer-like veins depicted in sticky and

Fig. 14 Lin Tianmiao, *Winding Spreading*, 1995, actual objects, raw cotton thread

oily touches, the patches of dark green and purple against dazzling flesh-like tones. The form of the objects is blurred, appearing like an organism eroded by a virus. These paintings in bold colors reveal a strong reaction to the experience of being violated and aroused.

Liu Liping's *Golden Corn*, *Green Corn* (1995, fig. 7), and *Icy Lotus* focus on small details of withered and tangled plant-matter meticulously depicted in a manner almost surrealist in appearance. Others were more moderately blurred. These compositions suggest an elusive moist breeze as if some inexplicable vitality was being breathed into the dried stalks and reeds.

The series *Heart's Flower* (1996, fig. 10) by Sun Guojuan transformed the traditional notion of a still-life by injecting strongly personalized images with the artist's peculiar perception. The "still-life" in her painting became a carrier of life and emotion. She reduced her images to a petal or a patch of pink applied in loose, almost dripping touches, which suggest blisters or scratches on a living body.

In the series *Blooming Brush in a Dream* (1994, fig. 8) by Chen Qiaoqiao, the forms and colour of the depicted objects alone set up associations with various aspects of life. The flowers appear like cotton or fog and fill the entire picture plane. Distinctly visible, long, thin styles run wilfully from within them, implying an over-saturated desire for life here refined into some transcending existence.

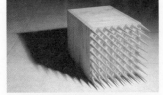

Fig. 15 Chen Yanyin, *Box*, 1994, installation

Fig. 16 Zhang Lei, *Soft Archive II*, 1998, brushed cotton padding

In Yang Keqin's series *Water Taps and Wine Bottles* (1993, fig. 9), the loosely composed forms of bottles are softened, almost deformed. One intuitively senses that the complementary colors used — bright red and green, yellow and purple—should be bright and simple, yet they are mixed with sticky or even unclean colours. The expressive touches are too jerky to be languid and imbue the apathetic industrial products with a vigorous life. The forms are a metaphor for the strength of an innate, heartless desire that overthrows reason.

Liao Haiying's sculptures *Love* (1995, fig. 11) and *Bride* fuse images of the reproductive components of flowers and the female genitals, further blurring the boundary between flower and woman. Soft sculpting, the use of real hair and the form of female genitals rendered as a fully bloomed flower, all indicate a strong vitality and the vice of temptation.

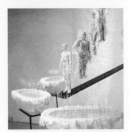

Fig. 17 Jiang Jie, *Magic Flower*, 1997, doll, wax, acupuncture needles

Objects or materials chosen intuitively by women artists are largely sensitive, subtle and enticing. The process they elect to use in producing such works, as well as the final appearance of a work, suggests perpetual generation and proliferation. Technically, the process is often one like knitting, or of a delicate nature which informs the whole procedure. Such works offer the audience a delicate experience of life. They usually convey subtle, lingering and complex states of mind, against awareness of reproduction and an enduring of the tests life throws at individuals. Women artists also altered traditional notions associated with women, qualities such as irrationality or tasks like needlework. Take Pan Ying's series *Fiction* (1994, fig. 12) for example, in the series the crudest, simplest ink-and-wash is used to outline and shade clumps of intertwining and winding ribbons, which appears to be many ribbons in great disorder but are actually one coiled ribbon. Like a thread from an entangled yarn, the repetitively undulating ribbon evokes an unruffled and serene mind.

Fig. 18 Chen Qingqing, *Seeking a Partner in Marriage*, 1998, mixed media

Knot (1994-95, fig. 13) and *Chain* by Shi Hui were produced by knitting and winding actual cotton thread and hemp strings according to certain patterns and inserting a large quantity of paper rolls amongst the strings. The final work suggests an endlessly multiplying life, woven together in heavy and complicated manner. Countless fine and invisible things in the seemingly mild manner of traditional materials stealthily stir a dizzying array of emotion and sensitive desire.

Lin Tianmiao's *Winding Spreading* (1995, fig. 14) abstracts one traditional form of women's labor — winding thread or knitting—away from the primitive language. She further emphatically combined the tools and materials used for such labour within the form of a bed (suggesting intimacy and privacy), serving as the central focus and the point from which hundreds of threads radiated out, across the bed and onto the floor. The dense bush of needles created a fur-like sensation and the radiating threads implied a test of life's ultimate innate capacity to endure violation of one's privacy and the complexity of world affairs.

In time, women artists began to demonstrate their ability to choose and manipulate different materials. Zhang Lei created a series of works using cotton; from cotton-wrapped glass bottles to Barbie dolls, airplanes to pistols cut in cotton, butterflies, envelops, poems and letters attached to a cotton wadding titled *The Soft Archive* (1997, fig. 16). The contrast between the soft cotton and fragile, cold glass, between feminine objects like the Barbie doll and butterflies, and virile ones like airplanes and pistols, underlie this woman's sense of vulnerability and the self-protective instinct.

Fig. 19 Yin Xiuzhen, *Yin Xiuzhen*, 1998, installation, photographs, cement, etc.

Jiang Jie uses wax, gauze and other fragile and soft materials to create works. Her *Magic Flower* (1997, fig. 17) comprises a figure marked with acupoints and a potted flower wrapped in wax, gauze and silicon rubber. The dense needles on the figure imply the sober-minded treatment of wounds and apparent grace. What the needles touch is in fact the unuttered pains in life.

Chen Qingqing's works include hemp cloth, garments, pillows and quilts made by patching together and weaving hemp strands, dry petals and branches, according them a fluffy quality. In the series *Seeking a Partner in Marriage* (1998, fig. 18), personal or lonely hearts advertisements from newspapers were cut out and glued onto a translucent hemp gown. Chen Qingqing's rather exhibitionistic and self-ridiculing works satirize a contemporary custom that engenders relationships between men and women where public taste is pandered to at the expense of one's privacy.

Other women artists' works also exhibit women's views and feelings in their own way. Yin Xiuzhen among others has created works about her growing up and her cultural memory. Her *Suitcase* is an old-style suitcase with her clothes of different sizes she has worn over her thirty years cemented together. *Yin Xiuzhen* (1998, fig. 19) combined photographs taken during ten periods of her life in ten pairs of old-style cloth shoes that she had kept with her.

Fig. 20 Xu Yaoyu, *Substitutes*, 1998, color photographs

The collecting of intimate household objects and the nostalgic narration of one's passage to adulthood are themes much favored by women. Xu Xiaoyu's *Substitutes* (1998, fig. 20), are photographs of artificial human organs including false teeth, artificial eyes, artificial limbs, artificial breasts, artificial hearts and even artificial genitals. Every indispensable organ, except the brain, has its artificial substitute. The extraordinary workmanship brings practical benefit to mankind and also stirs deeply hidden fears.

The series *Qin-dynasty Terra-cotta Warriors* by Qin Yaomin, begun in 1996 (fig. 21) treats terra-cotta warriors that carry distinctly virile (male) characteristics as female figures in a personalized way The clear-cut cultural meanings and formal characteristics in the figures of warriors are thus reduced to an ambiguous state. The robust, easy, indolent and womanish postures, the sensitive women's dress and the loose and personalized colors and brushwork make the armor, usually a symbol of firmness, soft. The vagueness and ambiguity in the picture is made analogous to the conflict between men and women.

Fig. 21 Qin Yaomin, *Qin-dynasty Terra-cotta Warriors 12*, 1997, oil on canvas

The experiments of these artists may need be carried out in a more thorough and profound way. The quality of their works is not yet uniform. Even within the body of work of one artist it is hard to find a unifying relationship, the links that mark the evolution of an idea. Nevertheless, some works have begun to break away from a common language of art and exhibit a more personalized style. This is commendable. The value of the women's approaches is that they transcend the common language and the efforts of women artists to stress a female individual style of perception and expression.

Fig. 22 Cai Jin, *Canna 155*, 1999, oil on canvas

Since the mid-1990s, contemporary Chinese artists came to realize that a "personal approach" is a key factor in an artist's success. Just as each brand of product must have its comparatively fixed style, artists too must seek their own personal style and identify the traits of their "brand." As women artists intuitively alighted upon the catalyst for their individual styles, they were inevitably carried away by this trend. Unfortunately, before the women artists, who had just intuitively discovered their starting points, had time to develop their "approach" in line with what they had innovated, their approaches were physically and partially "enhanced" losing their initial innovative quality. Instead they became fixed schemata. Since what appeared to be emphasized were several so-called common women's traits, such as being sensitive, enticing, meticulous, fragile, fine, intuitive, and even sexy, they became manifest in the art via simple devices like winding thread, pricking, sewing, softening images of depicted objects and using emblematic images. They became so homogeneous that after viewing numerous works by a large number of Chinese women artists in a show held in Germany, [4] one German woman critic described them as a heap of works about sex that are resentful against man, done by one woman. I was upset as I tried to consider this problem. We had emphasised a number of features contained within the "woman's approach" to confirm the characteristics that have been proclaimed to be symbols of woman—such as perception, psychology, body, fantasy, material, flesh, affection, sexual love. But had we misguidedly been encouraged to single-mindedly strive only to differentiate ourselves from men? How far did this go from achieving the initial aim of finding our "selves" from within our own perception of our own existence?

Fig. 23 Jiang Jie, *Being*, 2001

Women's Art Since the Late 1990s

1. Individuality in Women's Art —The Search for the Deep Inner 'Self'

From the mid-1990s, women's art began to show signs of greater experimentation. At the same time, the problems surrounding women's art became more important than ever within contemporary art as a whole. Some women artists had already rid themselves of the stereotypical features of women's art. They searched for their "self" more thoroughly, becoming increasingly mature as they make progress along their chosen path. Cai Jin's *Canna 155* (1999, fig. 22) is an example. In this painting the more familiar single tone of dazzling pink is replaced by a dim, even smudgy, grey, with small patches of light pink scattered here and there, like new wounds on crusted scars. Having travelled abroad, fallen in love, married and given birth to a child, Cai Jin finds herself in a very different frame of mind from anything she knew prior.

Jiang Jie's *Auspicious Clouds Magnified 10,000 Times* and *Being* (2001, fig. 23) represent a naturalistic and at the same time idealized baby, quite different from the fragile, strange and symbolic baby in her previous works. The baby appears serene, pretty and real. Being a mother herself, Jiang Jie has a more precise and delicate sense of a baby, and through her sensibilities, tries to understand life and herself in a more profound way.

Braid (1999, fig. 24) and other installation works by Lin Tianmiao present an enlarged, unaffected self-portrait-like figure from which all external elements (like hair or parts of the body that denote gender) have been removed. Out behind this figure flows a long braid of natural raw cotton threads (representing a plait of hair) that extends to the ground and continues on to many times that length. The viewer accurately intuits what the artist perceives of life: an innumerable web of threads that are always behind the person, arranged in a disordered order that in spite of its most immediate complexity all starts from one single thread.

Beginning with the work *Sweet Dressing Table* (2000, fig. 24), Sun Guojuan started sugar-coating real objects that she found synonymous with "women." sugar being the symbol of "sweetness." The range of sugar-coated objects includes dressing tables, cosmetics, fragments of toys, greeting cards, and hair of unspecified origin. In a more direct way, in *Eternal Sweetness* and *Everlasting* she simply covered her maturing body with sugar. The *Sweet Dressing Table* illustrates an imaginary sweetness; an accurate, universal symbol of women's intimate private life. The two subsequent works invoke a gloomy and depressive edge. In a self-pitying manner, they convey a middle-aged woman's nostalgia for her former sweet youthfulness, and call into question the aesthetic value men have asserted and which is based on their consumptive desire for feminine beauty.

Following her paintings, between 1997 and 1999, Zhou Jing took a series of photographs entitled *Dolls* (1998, fig. 25). These photographs further extrapolate the strange environments visible in the paintings. What is new in these works is that the strange scenes they depict can take close study. It is the destiny of lifeless dolls to be discarded by a dirty riverbank, in the corner of a room or on the floor. In short, any place where people dump rubbish. Playing on the doll's human characteristics and the emotions they arouse within us, Zhou Jing creates cruel poetics by means of close-up shots, strange angles, abrupt changes of light and overlapping shadows. Here, she draws a direct line linking the "misfortune" of dolls with the tragedy of mankind.

2. Facing up to Existence – Self-Awareness in Women's Art

In the late 1990s, a group of younger women artists emerged. From the first, they knew to create according to their own instincts and themselves as women. They began to "live their parts" quickly. But to become outstanding artists they need to be unremitting in their creative efforts. These "new, new human" (*xin xin ren lei*) girls who were born in 1970s have not been overly indoctrinated with traditional social morals pertaining to sexual difference, nor have they been shrouded in notions of the absolute equality between men and women, ethics prevalent during the Cultural Revolution (1966-1976). In an open society and information era which are becoming more internationalized daily, not only is it possible to attach importance to one's own idea of beauty and pleasure, but it becomes necessary to stress an individual ideology and pursue personal success. It is right and proper for them to examine their own existence squarely and not to shun their female identity any longer. They bravely entered what were clearly "adventurous" yet no-go areas, such as using the female body as a medium or a sign, the expression of sexual psychology and a woman's perspective.

Fig. 24 Sun Guojuan, *Sweet Dressing Table*, 2000, installation, wooden dressing table, sugar

Fig. 25 Zhou Jing, *Dolls*, 1998, black and white photograph

Fig. 26 Chen Lingyang, *Twelve Flower Months*, 2001, series of twelve color photographs

Fig. 27 Cui Xiuwen, *Heaven, Earth, Washroom*, 1999, Video

Fig. 28 Pang Xuan, *Sweet Life*, 2001, Performance

In Chen Lingyang's *Twelve Flower Months* (2001, fig. 26), what we see through the mirror in traditional Chinese form is not a woman's beautiful face or the kind of nude we are used to seeing. Instead, she presents a woman's genitalia during the time of menstruation. The traditional Chinese poetic idea that different species of flowers bloom in each of the twelve months of a year is made a metaphor for the physiological fact of monthly menstruation. Traditional Chinese forms, such as the mirrors and lattice windows, and mild, sedate lighting and color, are used as a setting for the female genitalia, and their explicit, shocking companion. Chen Lingyang breaks with tradition in a seemingly traditional form, destroying femininity in a seemingly feminine way. Her direct reflection of a woman's problem, the equal attention paid to the actuality and beauty of a woman's body, and her use of traditional Chinese feminine forms, are both purposeful and ingenious.

Fig. 29 Chen Qiulin,, 2002, performance

Box by Ma Lengyan (2001, fig. 32), presents a bound female nude in a box that conjure associations with the work of Japanese photographer Araki; works that express Japanese-styled sado-masochism. The bound and imprisoned body in *Box*, however, awakens memories of the childhood experience of hiding in a box or cupboard and indulging in one's concealed world as a special experience of escape. The smooth silk ribbons and the continuous curves formed by the ribbons sinking into the flesh highlight the soft and resilient nature of the female body as an aesthetic object.

Cui Xiuwen's works always stress sexual mentality. Her *Heaven, Earth and Washroom* (1999, fig. 27), comprises a series of candid shots concerning the harsh truth of a prostitute's work experience. The special resonance of the "bathroom" provides a backdrop for the girls' conversations and activities during "work" breaks. Here, they make-up, adjust their clothing, make telephone calls to clients, chase up money owed to them. We see the joy and sorrow of their life, as if on a sordid stage. The absence of explicit scenes of sexual activities removed some of the difficulty in shooting the piece for the artist, and at the same time, implies that this is a profound social problem. It is the whoremongers that safely hide behind the scenes who are the real culprits.

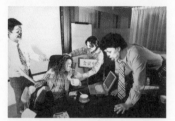

Fig. 30 Cao Fei, *Dog*, 2002, video

Still younger women artists, who were born in the late 1970s, express their own understanding of life in a seemingly easy, "playful" way. Pang Xuan's *Sweet Life* (2001, fig. 28) focuses on a ball game in a residential district. The high buildings, ball court, lawns and classical music all contribute to a "sweet" modern life in a new residential district, but the players are tied to both ends of a rope that passes through a wire netting. Thus, attempts to catch the ball are turned into a struggle for the players whose movement is always restricted. The blue facial make-up, the bloodstains and the plastic raincoats painted with patterns of red berries, more directly insinuate some injury inflicted upon the physical body and the characters' sense of being estranged. "Sweet injury" epitomizes the fragility, weakness and vulnerability of the young generation, called the "darling of life" (meaning pampered youth).

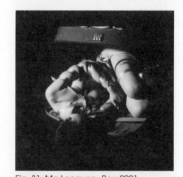

Fig. 31 Ma Lengyan, *Box*, 2001, color / black and white photograph

Liao Wen is an independent curator and art critic.

1 This style is also called Soviet Socialist Realism. There is not much difference between Soviet Socialist Realism and Revolutionary Realism, but the latter was preferred by Chinese artists during the Cultural Revolution when Soviet Revisionism was denounced in China. Also, Mao Zedong preached "combination of Revolutionary Realism and Revolutionary Romanticism."

2 This phrase literally means "paintings done in and about boudoirs." As we understand it this genre has a narrower scope of motifs than the "beauty painting."

3 The original text here "*guanfang yishu yuanxiao*" means "art schools and academies (universities) run/sponsored by government" and not private schools.

4 This is the exhibition Die Hälfte des Himmels: Chinesische Künstlerinnen, organized by Chris Werner, Qiu Ping, and Marianne Pitzenar at the Frauen Museum in Bonn in 1998.

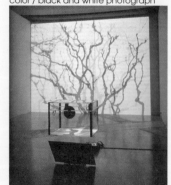

Fig. 32 Xing Danwen, *Dream*, 2001, molti-media

Translated from the Chinese by Wen Jingen and Karen Smith

The Periphery and Cultural Concerns: Making and Exhibiting Installation and Experimental Sculpture in the 1990s

Yin Shuangxi

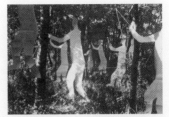

Fig. 1 Pond Association, *Walking Man in Green Space*, 1986, Hangzhou

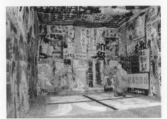

Fig. 2 Wu Shanzhuan, *Red Humor Series: Red Ink*, 1987

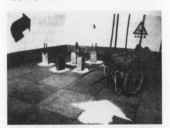

Fig. 3 A Xiamen Dada art event, *An Exhibition at the Fujian Art Gallery*, 1986

Fig. 4 Zhao Bandi, *The Moon*, 1994, Beijing

Fig. 5 Yin Xiuzhen, *Butter Shoes*, 1996, Lhasa

I.

It is difficult to specify the exact moment that installation art appeared in China, but it was clearly an important approach in Chinese contemporary art by the mid-1980s. This was closely tied to the American artist Robert Rauschenberg, whose solo exhibition at the China Art Gallery in Beijing, which opened on November 18th 1985, was the first major showing of modern art in China. His skillfully executed "ready-made" installations were to leave a deep impact upon young artists. In January 1986, a fine art teacher from a Fujian provincial middle school wrote a letter to a friend in which he said: "Rauschenberg has brought us post-modernism, the impact of which will soon be seen. At least, I personally believe that it will be the next landscape to develop on the horizon⋯."[1]

In September 1986, a young artist named Huang Yong Ping and a dozen friends organized the *Xiamen Dada — Contemporary Art Show* in Xiamen, Fujian province. The title of Huang Yong Ping's work was *A Memo to Rauschenberg in 1986*. In mid-December, together with Lin Jiahua, Jiao Yaoming and other artists, Huang Yong Ping exhibited handcarts, iron girders, concrete and old frames as works in the *Fujian Art Show*. They constructed a scene by catalogues and video tapes in order to challenge the public's concept of "artwork" and "art gallery/museum."

Simultaneously, artists from Hangzhou, Taiyuan, Guangzhou, Shanghai, Luoyang and Quanzhou combined installations of objects with performance art, producing a number of controversial shows. Those comparatively outstanding installation works were the *Taiji* series by the Pond Group whose members were graduates of Zhejiang Academy of Fine Arts (Zhang Peili, Geng Jianyi, Wang Qiang) and Wu Shanzhuan's *Red Humor* series.

The singular element that made the most significant contribution to the rise of Chinese contemporary art was the external influence of Western art. In the mid-1980s, Chinese young artists did not understand the concept, connotations or origins of installation art. They did not employ the term "installation" comprehensively even as they adopted it. They drew confidence and encouragement from initial, and limited, information on Western art that entered China as it opened up to the world. Their motivation was to embrace installation art as a means of striking the rigid art system that had been in place since the Cultural Revolution. It was, as critic Fan Di'an wrote: "to reveal artists' modern consciousness through new art forms, even to dispute existent standards and principles for official art with the ambiguous content of so-called anti-art."[2] A few artists had already become aware of the potential of ready-made objects, of combining various approaches towards pluralism, and the effects of controlling space. In 1988, Xu Bing and Lü Shengzhong, who were both then teaching at the Central Academy of Fine Arts, held an exhibition at the China Art Gallery, which received broad favorable comment. Xu Bing's *A Book from the Sky* comprised several thousand invented Chinese characters, carved onto wooden blocks and printed in the form of a classical book, volume after volume. Lü Shengzhong transformed the folk art of paper-cutting into a solemn sacrifice of human life. Significantly, both artists focused on excavating new images for contemporary art from traditional art forms. From the beginning of the 1990s, this became a basic tactic among Chinese artists, aimed at attracting attention of the international art circles.

In 1989, the exhibition *China/Avant-garde* held at China Art Gallery offered a summary of the Chinese response to the wholesale import of Western art through the 1980s. The exhibition had a profound impact on the course of Chinese contemporary art history. Many artists not only employed installation as an art form, but also turned to specific materials and ready-made objects to express particular meaning in their work.

In the early 1990s, Chinese contemporary art entered a period of decline. A number of vanguard art magazines, which had been a propellant force in contemporary art, ceased publication. Many young artists and critics looked for their future development abroad, the experience of which was to imbue each of them with a more concrete understanding of Western contemporary art. In Shanghai, Guangzhou and Hangzhou, young artists gradually set aside their craze for the utopian in art, transposing their focus to their individual daily life. In Beijing, groups of artists congregated in the Yuanmingyuan and (East Village) artists' villages[3] in search of a new mode of living with/for art. During that period, the rapid development of China's economy gave rise to an unprecedented pressure upon daily life. Many artists gave up art to engage in business, while others turned to the newly emerging art market for which they produced somewhat commercial paintings. The cost involved in producing works meant that activities within the field of installation art greatly decreased due to lack of a market for installation works. But the New Analysts Group (also translated as the New Measurement Group) formed by Wang Luyan, Chen Shaoping and Gu Dexin in Beijing, the Big-tailed Elephant group in Guangzhou and other art groups maintained the discussion and regularly produced, or participated in, exhibitions.

In the early 1990s, because of the limitation of space, funds, and other objective conditions in China, a number of installation exhibitions were held in non-exhibition spaces and abroad. Installation as an art practice was confined to a few people within the circle. The couple Wang Gongxin and Lin Tianmiao returned to Beijing from New York in 1995, and began showing installation works at their home. This attracted the attention of the critic Yi Ying. Wang Youshen and Song Dong also engaged in installation experiments in their homes. This gradually acquired the name "Apartment Art," a term coined by critic Gao Minglu.

Fig. 6 Lin Yilin, *I Stand on the Right*, 1997, Guangzhou

Against this background, in 1994, *The International Contemporary Art Show from China, Korea, and Japan* was held at The Art Museum of Capital Normal University. This space was subsequently the host to a number of other exhibitions, including *Beijing-Berlin Art Exchange* (*Open Your Mouth, Shut Your Eyes*), *Displaced: Work by Four Artists* (Zhang Lei, Yin Xiuzhen, Ruan Haiying and Karen Smith) and solo exhibitions by Zhu Jinshi, Song Dong and Yin Xiuzhen. The art gallery became an important space for vanguard art during that time in Beijing.

Fig. 7 Huang Yihan, *Uncle McDonald is in the Village*, 1997, Guangzhou

Also in the capital, the Hanmo Art Center just off Wangfujing was the host to Xu Bing's "live" installation work *Cultural Animals* in which the principal parts were played by two pigs. This was followed by Zhao Bandi's *The Moon*, and an installation of soft sculptural works by Jiao Yingqi, all of which left a profound impression. In addition, small-scale installation shows were held frequently at The Gallery of the Central Academy of Fine Arts and the art gallery of its affiliated middle school.

Fig. 8 *Xu Tan, Untitled - Dream Pig*, 1997, Taipei

In the mid-1990s, installation art flourished in Shanghai and Guangzhou. In March 1996, a group of young artists produced a comprehensive exhibition titled *In the Name of Art* at the newly completed Liu Haisu Gallery in Shanghai. The first Shanghai Biennale was held at the Shanghai Art Museum. This contained mostly oil paintings, but overseas Chinese artists like Chen Zhen were invited to participate although the installation works they planned to show were challenged and approved for exhibition only after much revision. However, this did indicate the sparks that Shanghai, as an international metropolis, was creating in small bursts of energy.

Lin Yilin, Chen Shaoxiong, Liang Juhui and Xu Tan, the four primary members of the Big-tailed Elephant group exhibited their comment on present life in the basement of a school in Guangzhou. Lin Yilin folded paper currency which was "built" into a brick wall, then wrenched free and thrown to the public. Xu Tan drove through the city on a motorbike in the company of a blow-up doll. By placing their installation art in the public space, these acts reflected their concern for engaging in a dialogue with the audience. But it was not easy to present installation art to a public in Beijing. The majority of installation shows were held in abandoned factories, private homes, and non-exhibition spaces. At the end of 1996, *The First Academic Exhibition of Chinese Contemporary Art*, curated by Huang Zhuan, Yang Xiaoyan and Yin Shuangxi, was shut down before it even had a chance to open in spite of the fact that it contained relatively few installation works.

From August 18 to September 3, 1996, the collaborative event *Protecting the Waters*, organized by US artist Betsy Damon and Chinese scholar Zhu Xiaofeng was held in Lhasa. Participants included Dai Guangyu, Li Jixiang, Liu Chengying, Song Dong, Yin Xiuzhen, Zhang Xin, Zhang Shengquan, Zhang Lei, Ruan Haiying and artists from the US and Sweden. Together, they expressed concerns for the environment, nature, human existence and the importance of a spiritual homeland via performance and installation art.

In the winter of 1996, Wang Jin produced an installation titled *Ice: Central Plains* for the opening

Fig. 9 Sui Jianguo, *Studies of Folds - Bound Slave*, 1998, fiberglass, 220 x 100 x 70 cm

ceremony of the Tianran Shopping Mall in Zhengzhou, Henan province. The work comprised an ice wall thirty meters long and two and a half meters high, built of ice bricks into which numerous commodities had been frozen. The audience was encouraged to "break down the wall" and retrieve the products inside. They attacked it with ardent enthusiasm and by so doing, not only did the audience unconsciously participate in the work but allowed the work to illustrated the changing moral values of people thrown into confrontation with commercialism.

On January 2 1998, *Trace of Existence*, curated by Feng Boyi and Cai Qing, was held at the Contemporary Art Studio located in Yaojiayuan, a suburb of Beijing. Participants included Qiu Zhijie, Wang Jianwei, Lin Tianmiao, Zhang Yonghe, Zhan Wang, Song Dong and Yin Xiuzhen. The particular theme of the exhibition was a discourse on the subject of exhibition spaces and forms. In his catalogue essay Feng Boyi expressed comments common to young Chinese curators, pertaining to the face of Chinese art selected by Western curators which contrived to distort the image of Chinese contemporary art abroad. He stressed the need to explore the present state of Chinese people, to identify universal human concerns via an innovative art with enduring native "traces."

In March 1998, Fan Di'an curated the *Fuzhou Asia-Pacific Contemporary Art Invitational Exhibition*, which included works by thirty artists from the US, Canada and Japan. This exhibition promoted a discussion and exchange about installation art by artists from China and abroad. It was one of the few exhibitions to gain official sponsorship for inviting foreign artists to exhibit in China.

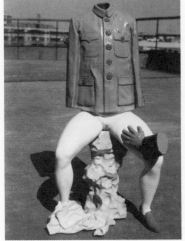

Fig. 10 Liu Jianhua, *Colored Ceramic Series*, 1997, polyethylene, 78 x 41 x 32 cm

In 1999, Li Xianting curated *Poly Phenolrene* in Beijing. The exhibition focused on the artists' concerns over the destruction of the urban environment in an increasingly industrial age. Some artists simply employed plastic (the material selected as the "theme" of this exhibition) to express personal experience, with no recourse to environment issues.

In the late-1990s, the increasingly active Chinese contemporary art scene had attracted the attention of overseas art circles. Chinese artists began to take steps onto the international stage. In January 1996, the exhibition *China!* opened at the Bonn Contemporary Art Museum, Germany, containing work from over thirty Chinese artists from the mainland and resident abroad and representing a survey of China's contemporary art at that moment. Between March and September 1997, *Immutability and Fashion: Chinese Contemporary Art in the Midst of Changing Surroundings* curated by Fumio Nanjo travelled between Tokyo, Osaka and Fukuoka. Chinese critics Yin Shuangxi and Huang Du provided essays for the exhibition catalogue. Participating artists included Chen Zhen, Geng Jianyi, Wang Jinsong, Yin Xiuzhen, Zhang Peili and Zhu Jinshi. The exhibition explored these artists' commentaries on and influences from popular culture, the aim being to highlight how in all its diverse approaches, art seeks out the common spirit of humankind.

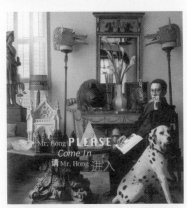

Fig. 11 Hong Hao, *Come in Please, Mr. Hong*, 1998, computer generated photograph, 145 x 120 cm

From May to August 1997, *Another Long March: Chinese Conceptual and Installation Art in the Nineties* was held in Breda, the Netherlands. Participants included Chen Shaoxiong, Chen Yanyin, Feng Mengbo, Geng Jianyi, Gu Dexin, Lin Yilin, Lin Tianmiao, Wang Jianwei, Wang Youshen, Xu Tan, Zhang Peili and Zhou Tiehai. Curated by Marianne Brouwer (formerly curator of sculpture at the Kröller-Müller Sculpture Museum, the Netherlands) and Chris Driessen (of the Fundament Foundation), with the assistance of Tang Di in Beijing, this exhibition presented work from the most active installation artists. It therefore provided a Western audience with an illustration of the development of installation art in China.

From July to September 1997, *Against the Tide* was held at the Bronx Museum, New York. Participants included Cai Jin, Hou Wenyi, Hu Bing, Lin Tianmiao and Yin Xiuzhen. It was the first exhibition of work by Chinese women artists to be held in a US museum. The majority of works were installation, the female artists did not carry heroic expression through the huge subject such as politics and history, but expressed common encounter and experience of the impact of a commercial environment on daily life.

In 2000, the Third Shanghai Biennale took the form of a large-scale exhibition of contemporary art from China and abroad. It attracted international curators and participating artists. Not only was the international profile of the Biennale enhanced by the inclusion of foreign artists, but also a number of overseas Chinese artists led by Cai Guo-qiang. Both the scale and quality of installation works attracted attention, and indicated how much progress had been made through the proceeding decade. The arrival of foreign gallery directors, critics and news media, indicated the recognition from international art circles Chinese art had accrued. Moreover, the exhibition created the stage for a large number of unofficial external exhibitions. These small-scale exhibitions mostly dominated by installation and video art, invoking the strong desire of Chinese artists to enter into an international dialogue. Feng Boyi and Ai Weiwei curated the exhibition *Non-*

Fig.12 Zhang Dali, *Demolition*, 1998, Beijing

Cooperative Approach (its English title was *Fuck Off*) which encapsulated the new uncompromising aesthetic stance.

In the late 1990s, Chengdu became the most active city for contemporary art in China. Dai Guangyu, Luo Zidan, Yu Ji and other artists held numerous installation and performance events at cinemas, libraries, underground parking lots, parks and lake sides, placing emphasis on the site-specific and *in situ* nature of works. This approach to utilizing public spaces drew attention to the relationship between the artists' interest in site-specific work and formalistic language games.

On January 18th 2001, installation works by Dai Guangyu, Yu Ji and Yin Xiaofeng were part of the *Directness Installation Show* held at Chengdu Painting Institute. Their works related to diverse aspects of Chinese traditional culture and formed an historical dialogue with the Institute's classical courtyard. This established an antinomy between a life of comfort and the modernization transforming China's interior cities through traditional cultural motifs such as mahjong, music, Chinese chess, painting and calligraphy.

Although the focus of the 2001 Chengdu Biennale held at the Chengdu Contemporary Art Museum was oil painting, a number of installation artists were included as well as Chinese artists living abroad. This indicated that installation art had come to obtain validity within the Chinese exhibition system. Wenda Gu's large-scale work, *United Nations: People and Space*, represented national flags created from human hair collected from around the world. It occupied a large area of the exhibition space and produced an intense visual impact. Xiang Dingdang and Huang Yihan from Guangzhou employed brightly colored toys assembled together to reflect the impact on traditional values of urban cultural trends.

Fig. 13 Zhang Xin, *Climate No. 4*, 1998, ice, pants, glass

In the late 1990s, installation art turned to mainstream culture as a resource from which elements such as ready-made objects, advertising images, film and television motifs, computer-generated cartoons and profiles of fashionable consumer magazines were drawn. There was less of an urge to criticize a rigid social system or to oppose society, and more of an interest in shifting emphasis to daily life. Works increasingly avoided profundity, in favor of a keen enjoyment of life and swift reactions to development in China's booming urban sprawls in the 1990s. These elements marked an important difference in aesthetic values between the new, emerging generations of artists and those of the early 1990s.

In the late 1990s, Beijing, Shanghai, Guangzhou and Chengdu became regional centers for contemporary art. Installation art flourished, reflecting the cultural openness and advance of China's society. The government increasingly recognized the importance of international cultural exchange, and many artists participated in international exhibitions via official channels. Equally, a variety of small-scale, contemporary exhibitions were frequently held. A young generation of curators had appeared led by Feng Boyi, Huang Du, Leng Lin, Wu Meichun and Pi Li. They were joined by a number of foreign professionals, such as Johnson Chang, Karen Smith, Tang Di, Hans van Dijk, Eckhard Schneider and Robert Bernell, who promoted contact between Chinese artists and the international scene. Symbolized by the Shanghai Biennale, the Chengdu Biennale, and the Guangzhou Triennial, Chinese art museums and spaces attempted to introduce an international exhibition system, drawing installation art and other experimental forms into the mainstream system step by step. Simultaneously, international exhibition curators and art museum directors began to visit China. Asian art was now on the radar screen of the Western art center, and contradictions between "national" and "international" began to emerge.

Fig. 14 Liao Haiying, *Potted Plant Series No.3 - Details of a Case*, 1997, fiberglass, hair, 75 x 56 cm

In the late 1990s, a number of exhibitions of installation and performance art appeared quite wild and brutal, indicated by the exhibition titles: *Corruptionists* (1998, Beijing), *Post-sense Sensibility: Image and Phenomenon* (1999, Beijing), *Out of Control* (1999, Beijing), *Usual and Unusual* (2000, Shanghai), *Big Art Meal* (2000, Beijing), *Infatuated with Injury* (2000, Beijing), and *Post-sense Sensibility: Carnival* (2000, Beijing). Some young artists entered into a Neitzschesque craziness involving live animals, human corpses and extreme violence. As compared with the genres of painting such as Political Pop and Cynical Realism that had been enthusiastically embraced on the international market, these represented the individual approaches of new generation artists to gain international attention. Once again it raised the issue of what kind of approach, form and outlook contemporary art in China should have and in order to engage in an international dialogue, as well as an awareness of how ready-made objects and materials could be made to express a contemporary spirit.

Fig. 15 Shi Hui, *Knot*, 1998, cotton thread, rice paper, wood, 800 x 270 x 120 cm

Most Chinese installation artists did not have professional training in installation art. Few art academies had any information resources or courses that embraced non-academic art in the 1990s. Some artists returning from abroad had more exhibition experience. Domestic artists formerly engaged in

Fig. 16 Wang Youshen, *Newspaper Curtain*, 1992

painting and sculpture tended to turn to ready-made objects for their installations.

Generally, among the most active artists, installation may be divided into several types. The first combines installation with video, such as Zhang Peili, Wang Jianwei, Wang Gongxin, Wang Jinsong, Chen Shaoxiong, Feng Mengbo, Xu Zhen, Liang Yue and Chen Yunquan. The second is an emphasis on employing ready-made objects to express individual experience, such as Ai Weiwei, Gu Dexin, Wang Youshen, Geng Jianyi, Huang Yan, Yin Xiuzhen, Xiong Wenyun and Peng Yu. The third is site-specific works such as those created by Xu Tan, Qin Ga, Lin Tianmiao, Jiang Jie, Zhang Lei, Zhang Xin, Wang Peng, Wang Nanming, Jin Feng, Dai Guangyu and so on. The fourth is the construction of work focused on the body and/or incorporating performance art, such as Lin Yilin, Luo Zidan, Liang Juhui, Sun Yuan, Zhu Yu, Lu Qing, Chen Qingqing, and Yin Xiaofeng. The fifth is to adopt different approaches to installation art in accordance with a particular theme or specific site, such as Zhu Qingsheng, Qiu Zhijie, Song Dong and so on. The above synopsis of classifications cannot fully cover all approaches. Artists have employed a diversity of approaches, within which individuals like Shang Yang, Wang Guangyi, Zhan Wang, Yu Fan, and Wang Qiang were clearly more concerned with form.

In the 1990s, installation art became grouped together with conceptual art within the greater framework of the contemporary scene. Under the disinterested vigilance of mainstream art, installation was pushed to the edge during the distribution of society's art resources.

Partly for this reason, within the field of Chinese contemporary art, installation artists were relatively few. But as the works they produced gained a wider media exposure, their ability to initiate events and art had an increasing impact on the teaching and creation of oil painting. Some young students had come to believe that only installation art was considered an avant-garde form of art, and that oil painting was in decline. By comparison with oil painting, installation art was by nature not possessed of any unifying features, except the common reflection upon the artist's daily experience of modern urban life. Topics such as the mass control of society's outlook, violence and injuries, money and sex, individual status, or the impact of Western culture all found themselves under scrutiny. Installation could convey the artist's individuality and private opinions. But from another perspective, installation art easily became an event within the public's visual scope due to the informal choices of exhibiting space and forms. Equally, it attracted the attention of the media and the authorities.

Installation art has not yet enjoyed the market that oil painting does. This compelled some installation artists to be overly competitive, to increase the expense or scale of works for exhibition, the form and approach being increasingly extreme. In the late 1990s, the impulse to enter the international art world, to acquire more exhibition opportunities and to be well-known, imposed the obvious opportunism on the development of installation art in China.

Another important issue in Chinese contemporary art is the field of art criticism and the extent of the research that has been done on installation art. In the 1990s, this rather fell into a state of stagnation. The circles of Chinese critics were retroactive. Besides offering rough descriptions of individual installation art works, many exhibitions lacked an academic standpoint, mixing good works and bad. In reviewing the development of installation art through the 1990s, we can see that a number of artists produced good works by chance and then disappeared like a passing cloud. But those artists that always persist in a conviction seem to be very precious, with their continuously exploring the language of installation art and the expression of spiritual social life by diverse forms.

Fig. 17 Hu Xiangdong, *Dream Plant*, 1999, resin

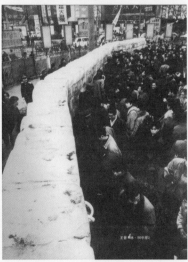

Fig. 18 Wang Jin, Guo Jinghan and others, *Ice: Central Plains*, 1996, Zhengzhou

II.

In order to discuss experimental sculpture through the 1990s, one needs an understanding of the system for sculpture in China through the twentieth century. The development of sculpture falls into three main areas: European classical sculpture brought back to China by the generation of students who studied in France in the 1920s and 1930s; the academic training system imported from—and that was evolved out of — Socialist Realism from the Soviet Union in the 1950s; and the initial Chinese characteristics formed through a dialogue with traditional Chinese sculptural forms that began in the 1960s. As mentioned above, the influx and appropriation of Western contemporary art forms, which began in the late 1980s, was an important momentum in development of experimental sculpture.

The development of sculpture resulted in much diversification. Realism in sculpture continued to exist and it was only relatively recently that artists took to infusing realist works with conceptual notions.

Those experimenting with various sculptural materials are making efforts to fuse modern materials with forms or structures, to employ abstract visual forms to express a psychological reality. There are also sculptors who cross the divide between sculpture and installation art, bringing together elements of space, materials and ready-made objects within conventional culture and expressions of contemporary lives.

Through the 1990s Chinese sculpture increasingly adopted a uniform mode of portraiture and a realistic character, drawing on every possible sculptural resource. It included first, an open attitude towards various materials, from traditional ones, like clay, wood or plaster, to every kind of modern material, and even explored relevant processes of technology. Second, it was open to various languages, from the realism of the figure, to diverse sculptural forms such as abstraction or minimalism, and Chinese and foreign forms of folk sculpture. Third, it was open to the history of sculpture, building on the work of important artists and their representative style, Chinese or foreign. Fourth, it moved "interior" creation to an exterior context, allowing sculpture to leave the art museum, and enter an urban or natural space in which it become a part of the public living environment. During this process of opening, experimental sculptors gradually explored particular avenues of Chinese contemporary sculpture, such as sculpture and environment, sculpture and space, sculpture and materials, sculpture and concept, drawing Chinese sculpture into mainstream contemporary cultural life.

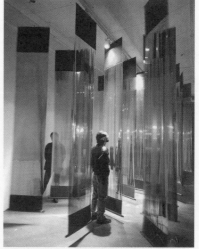

Fig. 19 Wang Gongxin, *Sense*, 1995, installation

The *Young Sculptors Invitational Exhibition*, held in Hangzhou, Zhejiang province in 1992, was an important turning point. Bringing together the best young artists from around China, the show revealed a diversity of style, even if the works were experiments within the basic framework of sculpture. Almost across the board, young sculptors focused on hard materials such as forged and wrought bronze, steel and stone. In fact, the use of "hard" materials reflected young sculptors' discovery of modern industrial materials, effectively transforming Chinese sculpture from the hand-craftsmanship of traditional sculpture to the industrial production of modern sculpture, something which would have enormous and far-reaching implications for sculpture in the 1990s.

In the catalogue accompanying the exhibition, the question of the ethnicity of sculpture is raised. Most sculptors acknowledge that Chinese art could not flourish in a closed environment. The classical modes of realist sculpture could no longer adapt to the changes of the modern age. New concepts, new materials, and new techniques would be required and became central issues to work produced at that time. Equally, with the influx of information related to Western art, Chinese sculpture sought new resources within its tradition and social reality. In this way it could establish a dialogue with international sculptural practices.

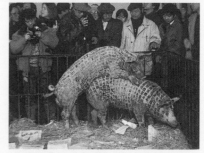

Fig. 20 Xu Bing, *Cultural Animals*, 1994, installation

With the exhibition *Contemporary Chinese Sculpture: A Cross-Straits Exhibition* in 1993, the move toward new materials and its resulting new artistic language deepened. The exhibition also increased the sculptors' understanding of international trends and experimentation became increasingly common.

The 1994 series of solo exhibitions by Sui Jianguo, Zhan Wang, Fu Zhongwang, Zhang Yongjian, and Jiang Jie, held at The Gallery of the Central Academy of Fine Arts, illustrated a commonality in a strong emphasis on contemporary reality and a serious contemplation of the spiritual state of contemporary society. In terms of the language they employed, these sculptors broke away from sculptural structures placed on pedestals, and used multiple forms as a basic structure, arranged in a variety of ways. The result was an environment in which the audience could interact with the works of each of these artists, with the feeling that they were in very different types of spaces. This series of exhibitions raised many academic issues for sculpture in China. First, there was the issue of materials and concept. In modern sculpture, materials were not to be employed simply for their own sake, but rather as a medium for conceptual expression. Another question pertained to the relationship between sculpture and installation art. Through frequent combinations of ready-mades and a mix of media, artists blurred earlier distinctions between sculpture and installation art. Sculptors not only helped to propel installation art forward, but also had a profound and positive impact on the development of sculpture *per se*. Their works highlighted the way in which sculptors were caught in the cultural clash between East and West, and forced to confront many problems in contemporary society and personal choice with regard to cultural influences.

At the Chengdu exhibition *Sculpture and Contemporary Culture* in 1996, accompanied by a symposium, Chinese sculptors were revealed to be seriously reflective and introspect. The central theme was "venerating life." Artists took up the challenge posed via installations and ready-made objects. They demonstrated that sculpture, too, could deal effectively with issues of real life. In doing so, they helped differentiate and further define the characteristics that made sculpture unique in the relationship between art and contem-

porary life.

A number of vanguard critics (Sun Zhenhua, Yin Shuangxi, Wang Lin, Huang Zhuan, Feng Boyi, and Yi Ying) actively participated in the modernization process of sculpture in China, driving it into mainstream contemporary art. In 1996, events and exhibitions relating to sculpture flourished in Beijing, Shenzhen and Chengdu, among other cities. Most were centered on a theme and artists were chosen to the degree that their works fit the curator's and critic's agenda. The element of infusing the contemporary cultural environment and with current cultural thinking was essential. The He Xiangning Art Museum in Shenzhen instituted an annual sculpture exhibition project in 1998. Each year the museum invites leading sculptors to participate in the event and in the development of the city. The He Xiangning Museum also began to acquire representative works by top artists in China and abroad, including, amongst others, a work by the French sculptor Bernard Venet.

Through the 1990s, the local governments of Changchun, Tianjin, Weihai and Guilin amongst other cities, joined together with art museums and private corporations to organize annual sculpture symposiums and competitions, as well as a number of solo exhibitions of works by young, emerging artists.

The exhibitions and events that took place in 2000 earned that year the accolade of "Year of Chinese Sculpture."*The Qingdao Contemporary Sculpture Invitational Exhibition* and *Tomorrow's Stars* were presented as the inaugural shows for the Qingdao Sculpture Art Museum. The seminar on twentieth century sculpture in China and the *Second Young Sculptors Invitational Exhibition* were held in Hangzhou in September. In December, the *Third Contemporary Sculpture Art Annual Exhibition* held at Shenzhen's He Xiangning Art Museum, followed by the *Fourth Contemporary Sculpture Art Annual Exhibition* in 2001. Curator Huang Zhuan consistently placed emphasis on the efforts and works of those artists who were not trained as sculptors, and for the 2001 event invited installation artists from China and France. These exhibitions revealed a tendency towards academicism. The sculptors were clearly most concerned about existence and the meaning of sculpture in contemporary environment and life. By the end of the twentieth century, Chinese sculpture clearly had a new self-consciousness relating to the commonality or the public art.

Artists Zhu Cheng, Zeng Chenggang, and Li Yanrong are all determined to preserve a national cultural sensibility in their sculpture. Employing a variety of materials, they depict modern life as it touches various aspects of Chinese tradition and history. Zhu Cheng's works possess the meticulousness and intricacy of earlier handicrafts, Zeng Chenggang's works explore the relations of China's ideographic written characters with sculptural space.

Through the 1990s, Chinese sculpture awarded itself an active role in real life, and revealed the individual's search for expression in the space between tradition and contemporary. Li Ming, Huo Boyang, Yang Jianping, Liang Shuo, Cai Zhisong and others, employ concrete approaches to express the different standards of living and role of "status" engendered by the rapid changes taking place in society. Sun Wei, Wang Shaojun, Yang Ming, Lu Pinchang, and Sun Lu amongst others, all place emphasis on abstraction and material forms. The works of Tang Songwu and Sun Yi took a new tangent in employing modern materials and computer software, by which they aimed to find a vehicle for expressing contemporary life.

Even if they do not claim a feminist agenda, many works produced by women artists still possess a uniquely feminine view of reality. Shi Hui's works are both intricate in the way they weave together materials, and complex in terms of their relationship with the surrounding space. Her works expresse a fine sensibility to diversity in organic forms, and demonstrate an amazing visual sense of construction. Yu Gao's minimalist works, involving air and brightly-colored materials (polyester/plastic sheeting), reflect her unique understanding of the relationship between space and existence. Xiang Jing's sculpture *Family Life* contrarily depicts a fantasy of an elegant girl from a past era, presenting the mediocrity in daily life with a keen sense of critical realism. Li Yanrong's sculpture employs elegant poses to recreate a history which to her has long since past. Her works give physical presence to the role of women in Chinese history.

Sui Jianguo's works reflect the cultural background in contemporary China. His *Legacy Mantle* series and *Studies of Folds* take as their starting point the two-piece garment (the Mao suit as it is commonly referred to in English) made popular in the twentieth-century in China. Using a symbolic appropriation and alteration of the classical sculptures of the European Renaissance and a symbolic form of Chinese political life, he forces both to undergo transformations in the new language environment from which they evolved. Similarly, Liu Jianhua's painted ceramic series *The Memory of Fascination*, depicts the figures of women dressed in traditional costume (*qipao*) lounging or seated on modern sofas. His works reveal the male

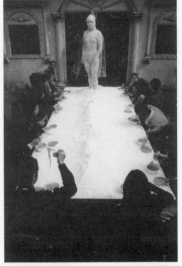

Fig. 21 Dai Guangyu, *Food and Sex*, 2001, installation

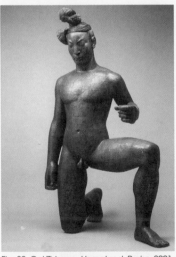

Fig. 22 Cai Zhisong, *Homeland: Praise*, 2001, copper plate, copper thread, resin

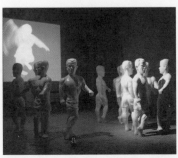

Fig. 23 Sun Yi, *Post-Human*, 2001, mixed media

psychology of voyeurism, and aim at a cutting critique on the position of women in modern society.

The exploration of individual status is a common concern amongst young generation artists. Yu Fan's *Flying* and Fu Zhongwang's *Shadow* remind us of the coldness and absurdity of man's existence in times of war. Almost all the younger sculptors seem to be concerned with manifestations of the state of modern human existence. Shao Kang's *Monument* and Jin Le's *Hovering Man-Fish* are plaintive cries about survival; Yang Jianping's nudes and Lu Pinchang's *Self-Portrait Sculptures* weld steel to ceramics to reflect a helplessness in the face of modern life. Yang Chunlin's *Split Man* and Li Xiangqun's *Second Melting* both touch upon the trend towards group conformity and the subsequent alienation of the individual that inevitably follows. Zhang Yongjian and Zhang Wei's works address the abusive nature of life, but from different perspectives, while Qin Ga's works employ powerful realist visual language to depict the physiological damage done to life forms by modern diseases such as AIDS.

Zhan Wang, Jiang Jie, Lu Hao, Liang Shaoji and other artists are outstanding among installation-sculpture artists revealing finely tuned concepts. Zhan Wang's works could be termed conceptual sculpture. The unique transformation and reinvention he achieves via personal materials and images, results in an organic combination. His works *Kong-Ling-Kong* (1994), the stainless steel series *Ornamental Stones*, and the work *Twelve Nautical Miles — Stone Afloat on the Open Sea*, shown at the 2000 Shanghai Biennale, express his reflection upon the concept of "real" and "replica" through an invented replication of actual objects.

In the 1990s, Jiang Jie was an active sculptor, and her works often appeared in installation shows. The *Magical Flower* series was based on ready-made plastic models. By employing the elements of wax and gauze, wrapping forms with bandages, acupuncture needles and relevant medical treatments, it expressed her concerns about the life of modern people.

Lu Hao's works employ transparent plexiglas to imitate China's traditional architectural structures, into which he places animals and plants for their various symbolic appropriation. His fictions express his satire on traditional Chinese culture and contemporary life.

The experiments of many of the young sculptors who featured in *Tomorrow's Stars* in Qingdao and the *Second Contemporary Young Sculptors' Invitational Exhibition* in Hangzhou presented new directions for Chinese sculpture in the twenty-first century. In Li Zhanyang's works, the irony and humor of the painted, cartoon-like, sculptures depict an everyday reality. Works by Liang Shuo and Liang Gang are a reinterpretation of real life, but their depiction of the human figures has been subject to their notions and personal language of expression. Li Na and Wu Baoxu employ unique materials to process their forms and visual language, resulting in some extraordinary expressions of human existence and China's changing family structure. The use of welded iron in the works of Sun Lu and Zhang Yaohong reflect the changing use of materials by sculptors in recent years, but also present the homogenization and simplification of the individual in the industrial age. Li Liang's synthesized organization of a variety of materials expresses the artist's thoughts on nature and history.

The maturity of these young sculptors and the emerging new generation of sculptors indicate the robustness of Chinese sculpture in the twenty-first century. Contemporary sculpture is moving ever closer to contemporary Chinese life, and experimental sculptures offer a sensitive and profound outlook on the course of Chinese history. They pass enduring comment on the spiritual state of Chinese people in an age of dramatic transformation, and contribute to cultural exchange and international dialogue.

Yin Shuangxi, Ph.D., is an editor of *Meishu Yanjiu* (Fine arts research) at the Central Academy of Fine Arts.

1 "A letter to Yan Shanchun," in Gao Minglu, *China's Contemporary Fine Art History 1985-1986*, Shang Hai: Shanghai renmin chubanshe, 1991, P.434.

2 "The summary of Hunan Young Artists Group Show Symposium," *Fine Arts*, volume 2, 1987.

3 Yuanmingyuan was located on the site of the former imperial Summer Palace. The art community was established in 1989/90. *Dong cun* was Beijing's so-called East Village, a bastion of performance artists that lasted from early 1994 to early 1995.

Translated from the Chinese by Karen Smith

Systems of Chinese Experimental Art in the 1990s

Pi Li

I. The 1980s

When experimental art emerged at the end of 1970s, then flourished in the 1980s in terms of its artistic language, there was an initial drive to legitimize its form within the official discourse. In terms of the artistic community, the experimental forms of art that emerged during that period were closely linked with the prevailing ideology, to the point of being a cultural movement under the umbrella of officialdom. In spite of the challenge that experimental artists sought to throw at Socialist Realism, their struggle was largely aimed at the cultural domination that upheld this style.

Through the 1980s, experimental artists rampaged through every style of art in Western art history from Impressionism on. In the process, artists conveyed their belief that they had the right to ideas outside of the proscribed ideology, even those of liberalism that stood in apposition to orthodox values. These artists hoped their activities would eventually exert some influence on Chinese society.

Within the social framework, experimental art in the 1980s had several underlying characteristics: first, artists adopted a collective work mode, in groups large and small and cliques formed around a number of leading charismatic critics and artists. But, although artists strove most towards individualism at that time, society did not provide a suitable environment for growth. China's economy remained a centralized planned economy, under which artists were unable to become economically independent and support individual experiments with art. Many of those who were most avant-garde relied on the state for assigned lodgings, salaries and job opportunities. It was natural for artists to form networks and groups to support each other. This collective mode was linked to notions of idealism and allowed them to aim criticism at collectivism within society and centralized power in politics. At the same time, art criticism was conducted in a collective way.

The second characteristic, closely associated with the first, was that in the 1980s, experimental art was not widely circulated in the public arena in China. Under the planned economy, China lacked a stable, regular and clearly defined art market. Artists were but workers in society with a fixed salary and assigned housing. They were not reliant on an income from the sale of their works. Within this environment, artistic criteria were set by mainstream art, which was represented by "national art shows." Once an artist strayed from mainstream criteria, the doors of art institutions became closed to him or her. Equally, without a market or collectors, new standards were not established. In this light, experimental art appeared rather "arbitrary" and lacked any common cultural features. The exhibitions that were held in public spaces were a means of release for the artist's personal ego as opposed to an appeal for communication with the public.

Third, the "megalomania" in experimental art in the 1980s not only derived from the absence of an essential distribution channel within society, but from lack of general knowledge about and information on experimental art. Whether within education generally or within specialized publications, introductions to international contemporary art were sporadic and less than systematic.[1]

In general terms, the system for experimental art in the 1980s was comparatively simple. Due to the above-mentioned characteristics and the mood of "enlightenment" nourished by the first-phase policy of reform and opening, experimental art in China had a heroic beginning. From the first, we saw endless arguments between sensitive artists with a strong sense of mission, and ignorant, conservative bureaucrats. In such polemics, the value of art was determined by the charisma of certain persons and events. Experimental art was exciting, but society required a more complete framework in order to arrive at an accurate evaluation of it.

II. 1900–1993: Seeking Structural Dynamics

In the 1990s, the system for experimental art in China acquired an unprecedented level of complexity. This was partly the result of reforms within the economic structure in the 1990s, of the art attaining an international circulation, and of globalization. Throughout the twentieth century, the fundamental formats of economics, politics and culture were founded by the West. In the 1990s, as China became increasingly involved in global communication, contemporary Chinese artists were increasingly in the thrall of Western standards. In the sphere of art, the so-called structural relationship was tied to the channels through which art works circulated and to the regeneration and creation of artistic styles and language. A standard circulation system of art consists of artists, critics, galleries, collectors, museums and academics. This system represents the process of creation (production) to acceptance (consumption) and then to research (reproduction). It is this mechanism that perpetuates interaction between art and society, and enables art to grow and to reinvent itself. It is hard to describe this as a good or virtuous system, but to date it has proved a functional one.

In China such a system did not exist at least in the early 1990s. There were no commercial or non-official galleries, the art academies were relatively closed, and there were few collectors. The China Art Gallery and large official art shows displayed largely works of Socialist Realism.

The political disturbance at the end of the 1980s temporarily undermined the development of experimental art and led to economic and political sanctions being imposed on China by the West. In the first two years of the 1990s, experimental art was suppressed. The groupings of artists that had formed in the 1980s dispersed and many artists and critics went abroad. In China, most artists cloistered themselves in their studios.

In 1992 on his famous "speech in the southern tour," Deng Xiaoping stated that China's main objective was to develop a "socialist market economy" and implied that ideological disputes should give way to the establishment of a market economy. While Deng aimed to alleviate the tension in the sphere of ideology by encouraging rapid economic growth, his ultimate purpose was to meet the need of "reform and opening to the outside world," and tactically to respond to the Western sanctions that had been imposed after 1989. As activity within the art circles diminished, people began to reflect on the experimental art of the 1980s and try to identify new opportunities. The setbacks suffered by the *China/Avant-garde* exhibition of 1989 helped artists to reach the common conclusion that experimental art would not gain legitimacy within China's local political framework, at least in the near future. Consciously or unconsciously, experimental artists began to seek alternative solutions.

Since the establishment of the Stars Society in the late 1970s, a circle of non-professional virtuosos gradually appeared in Beijing. The circle around them consisted of a small number of diplomats from foreign embassies, curious international journalists and representatives of transnational corporations who were kept idle by China's planned economy. Being so different from mainstream styles, experimental art caught their attention. The political disturbance at end of 1980s only served to increase their interest. In the early 1990s, as experimental art was suppressed, those people acted as a conduit for the art and a connection between Chinese and international contemporary art. A small number of non-official art shows was held in the offices and apartments of foreign diplomats, and a small market — not exactly as the term market is understood internationally — arose. Despite its drawbacks, fragility and lack of clear standards, this market was attractive to artists. A number resigned the posts assigned to them by the state and came to Beijing, where they rented cheap houses from local farmers, which they used as their studios. In the early 1990s those artists largely gathered at Yuanmingyuan (the old Summer Palace) in the northwest of Beijing. It soon became known as the "artists' village." Still influenced by the collectivism of the 1980s, these artists united around the well-known critic Li Xianting, one of the few critics who paid consistent attention to experimental art of that time. The artists were drawn to his modest and straightforward personality, while the "international circle" in Beijing took an interest in the trials and tribulations he had experienced in the 1980s. If we say the experimental art "bloomed everywhere" during the 1980s, then during the 1990s it was "flowering only in Beijing."[2] One cannot neglect the fact that with the changes in the world political structure at the end of the 1980s, Beijing, as the capital city of a socialist country, attracted more attention from the international society and mrass media than ever. During this period, the circle of experimental artists around Li Xianting in Beijing became an "epicenter." Materials on new artworks came to him from different parts of China, which he in turn shared with journalists, gallery managers and curators. Those who

came to Li Xianting first were international gallery managers and journalists, including Johnson Chang, owner of Hanart TZ Gallery in Hong Kong, and American journalist Andrew Solomon. The former organized the well-known exhibition *China's New Art, Post-89* while the latter published his long article "Their Irony, Humor (and Art) Can Save China" in *The New York Times Magazine*. In 1993, the Italian embassy helped to bring Chinese contemporary art to the 45th Venice Biennale.

If the fame and influence of the experimental art system in Beijing during the 1990s emerged intuitively, then the Guangzhou Biennale in 1992 that ended in financial failure represented an active search for a truly effective system. By comparison with the situation in Beijing, the Guangzhou exhibition was based on a far clearer theoretical framework. At the end of the 1980s, as the '85 Art New Wave Movement reached its pinnacle, disagreements and conflicts occurred among experimental artists. A number of younger critics and activists held that the methodology within experimental art through the 1980s had been too "metaphysical" and its theories unduly focused on "macroscopic" issues. Thus they began to denounce "Hegelism." During this theoretical retrospection and criticism, many of E. H. Gombrich's writings played an important role. Specifically, it was Gombrich's discourse on the logic of "context" and "figuring" in artists' creation and art history which exerted a great influence on approaches to experimental art. Young critics like Lü Peng and Huang Zhuan believed that the most serious problem in the 1980s had been an excessive anarchy and lack of order with necessary academic rules. In their view, the relativism and nihilism in experimental art during the 1980s were the antithesis of totalitarianism. The ills and extremism following the '85 Art New Wave movement were caused by a lack of academic training on the part of both artists and theorists. They were also the "product of common people's romanticism" (Lü Peng).

While Huang Zhuan tried to interpret the '85 Art New Wave movement in line with the "logic of context," Lü Peng set his hand to the art market, believing that value of experimental art in the marketplace would justify its social value. He launched the journal *Art Market* in 1991 and then organized *The First Guangzhou Biennale: Oil Painting in the Nineties*. The basic idea of the Biennale was to produce an exhibition funded by local entrepreneurs, who would "collect" art works through their support of the exhibition. With hindsight, this does not appear as very innovative, but at the time it was an entirely new mode of working in China. The Biennale was the first national exhibition to be organized without state sponsorship. The Biennale draw a selection of works from all parts of China, but those chosen to participate were largely experimental, which reflected the organizer's personal preferences. The exhibition undoubtedly played a significant role in breaking the monopoly of the national art shows practiced since 1949. Unfortunately, in the later phase of organization, the first sponsor had to withdraw support because he discovered himself unable to meet the costs. Consequently, a company from Shenzhen stepped in but conflicts then arose during collection and purchasing of art works.

The Guangzhou Biennale was a turning point in the system of experimental art in the 1990s. On one hand, it was the product of the on-going formation of a market in the early 1990s. On the other, it resulted from a reflection by experimental art advocates on the development of this art in the 1980s. It also illustrated the efforts of younger theorists to establish an effective system and to legitimize the art with an economic value within a local Chinese environment. Within the transition from a planned economy to a market economy, a middle class had yet to emerge. Contemporary art still upheld the heroism of the 1980s, which was why the tragic conclusion of the Guangzhou Biennale was inevitable. However, in the ensuing years where a suitable alternative did not exist, the non-standard mode of operation established by the Guangzhou Biennale to a large extend served as a "normal" mode of promoting contemporary art in China.

III. 1993–1996: the Establishment of an Export-oriented Art System

The enthusiasm derived from the enlightenment sparked by the policy of reform and opening in the 1980s disappeared almost completely from experimental art in the 1990s. For this reason, the first years of the 1990s witnessed a new drive to identify a new supportive force. Obviously, since China was in transition to a market economy, this supportive force could hardly be found in China. Against this background, the "international conduit" which emerged in Beijing became important and effective. The effectiveness manifested itself in two aspects: first, artists' work began to be sold abroad, and second, international exhibitions were held with increasing frequency—regardless of the quality of the works exhibited. This was a double-edged sword, which removed obstacles and initiated new opportunities for experimental art yet was constantly harmful to it. In the mid-1990s, mature private or commercial galleries emerged in China,

such as the CourtYard Gallery in Beijing, ShanghArt Gallery in Shanghai and, still earlier, Red Gate Gallery in Beijing. Those local galleries largely derived their financing from international investors and their clientele were usually foreigners—even today China's cultural market is not open to the international society. In other words, even within the increasing commercial mechanisms in China, support for experimental art is unlikely to be found in the near future. The ultimate cause lies in China's local economic mechanism. As the domestic market began to form, the devastating effects of this "export-oriented" art mechanism became even more evident.

In 1992, the overall advance towards a market economy in China and the changes in the world political situation saw contemporary Chinese art become represented by Cynical Realism and Political Pop, which was frequently exhibited in the West. Those artists who committed themselves to "expose the suppression of human nature in China's society" won commendation from the West. Though they illustrated the suppression in society, the abundant incomes they achieved enabled them to enjoy a luxurious lifestyle. They became society's *nouveau riche*. To Western tourists, such styles of art which clearly alluded to a non-Western ideology were taken as the image and standard for contemporary Chinese art. The art was, in turn, then used as the reference point for identifying Chinese culture.

The crux of the matter is that due to political and economic inequality, the West's understanding of Chinese art was distorted from the beginning. The success of Cynical Realism and Political Pop inspired artists to elaborate their "internationally best-selling" style and to add more political ingredients to it. Equally, it encouraged younger Chinese artists to join the rank of "dissidents." This was exemplified in the subsequent style of Gaudy Art that emerged in the mid-1990s. If the art of the 1980s was too weak to support its own faith, and Cynical Realism and Political Pop gave up their commitment to their ideal, then under guidance of the West the new art forsook commitment to any faith. It danced hand in hand with cultural nihilism and in the end was reduced to "roguish" Cynical Realism.

On the back of the styles of Political Pop and Cynical Realism which were in vogue in the 1990s, a series of international exhibitions not only brought the artists success that could not have been expected in the 1980s, but also brought huge wealth to the artists. What now formed as the standard framework for experimental art was far from healthy. The central position of Beijing that had been shaped in the 1980s was now further strengthened, and along with this, Li Xianting's authority was strengthened too. This situation and the Political Pop and Cynical Realism promoted by Li Xianting were criticized by critics beyond Beijing. The most radical criticism came from Wang Lin in Sichuan province. He wrote: "The so-called art trends in Beijing are not launched by critics, but are incited by embassy parties. This culture is in effect a colonialist culture that represents the political centralism world-wide. It flaunts the banner of culturally specific art, but it mixes with vulgarism spiritually and ideologically. It shows no concern for the relation of art to man and human culture, and does not testify to an independent, rich and profound expression of human nature. Identification with the prevailing culture, clinging to the West as the arrogated world center, and the general easing of political pressure, finally turned so-called resistance into eclecticism and opportunism... The environment for art at present should provoke a self-examination on part of those critics who seek to expand their sphere of influence by encouraging unhealthy art." (See *First Academic Exhibition of Contemporary Chinese Art*, Ninnan Fine Arts Publishing House, 1997)

Wang Lin may have used strong words to state the issue but the truth was that the fruit of Cynical Realism and Political Pop resulted in abundant incomes which turned artists into a *nouveau riche*, with a penchant for luxury. It further encouraged other artists to elaborate upon this "international best-selling style" and to add new political ingredients. This again was evidenced by Gaudy Art.

Outside China, exhibitions of contemporary Chinese art were usually organized according to two modes. One was the "impact vs. response" mode, which held that the leading factor in the development of modern Chinese culture was Western aggression, and that development and changes of Chinese culture could be interpreted in terms of "Western impact—Chinese response." Typical shows of this type have been *China's New Art: Post -1989* and *Inside Out: New Chinese Art* in New York, 1998. Such exhibitions largely took a politicized perspective on Chinese experimental art.

The other was the "tradition vs. modernity" mode, according to which modern and contemporary Western society provided the model for all countries in the world, where China was expected to make the transition from a "traditional" to a "modern" society according to the Western model. Following this logic, Chinese experimental art became basically a folk art, which was demonstrated in the exhibition *China!* held

in Germany in 1996. It seemed to some people that Chinese society could follow the Western beaten track towards a "modern" society only if the West gave China a stern warning. Both modes represent Western-centric views; both believe that the industrialization of the West had been a blessing and Chinese could never achieve favorable conditions to hatch such modernization. Therefore, all significantly historic change in 20th-century China could have not been other than the changes experienced by the West. It goes without saying that this guideline greatly oversimplified Chinese experimental art and hindered its progress. It may be true that both artists and art in China had been distorted by the impact or its own cultural framework, but if we only focus on a narrow and distorted picture, this will become a new form of suppression that further harms Chinese art by limiting it to a false and narrow political theme which allows it only an unreal, distorted existence.

Wang Lin's criticism represented the voice of those scholars who, due to reasons of geographic location and educational background, could not be "internationalized." The reality in the mid-1990s made it seem impossible to have a better system of experimental art than the "export-oriented" one. Of course, the "export-oriented" system led to disorderly academic activities related to experimental art in China. The most explicit sign of these through the 1990s was the constant emergence of new curators. In the 1990s, no new critics emerged, while a whole new crop of curators appeared. This was caused by a lack of self-discipline on the part of individual artists and critics and by the powerful influence of the art circulation system controlled by the West. Experimental art in the 1990s opened the field for curatorial opportunities and this led to a neglect of academic research and theoretical writing. Furthermore, in several cases, exhibitions in China were held for international journalists and were actually intended to be closed down by the state. "Curator-oriented" art creation cannot be regarded as an element of progress for experimental art in China because, to certain extent, it covered up the deficiency in theoretical research and critical works with a false appearance of prosperity. The neglect of critical writing seriously hampered the development of Chinese contemporary art, with the destructive consequence that it confirmed the unhealthy circulation system as the status quo and gave full rein to comments colored by West-centrism. On the other hand, it prevented contemporary Chinese creativity from becoming the fruit of research and educational subjects, and enjoying a natural growth. In the latter case, Chinese experimental art produced only art works and not the fruit of engagement with the local cultural environment. All was constantly fabricated and arranged by the West.

The shortage of home-grown writing about experimental art can be attributed to the "export-oriented" art system, but the fault also lay in China's unsound academic system. Since the 1980s art academies in China had never been open to experimental art. In the 1980s, the conservative nature of the academies goaded experimental art to take an antagonistic stance. When the "export-oriented" system was established, however, the closed state of art academies was accepted as a status quo; the academies could not affect the economically independent artists and instead, at times brought benefits to them. Nevertheless, viewed from a macroscopic level, the conservatism of the academies led to the aphasia of experimental art, i.e., it has not been academically studied in any profound way.

The academies were in no position to serve as an "information resource." In China there remained no effective channel to import external information. Any information about Western contemporary art was not learned in schools, or introduced objectively in the mass media, or acquired by students studying abroad. It passed from mouth to mouth, and was seen in catalogues brought back to China from artists travelling abroad. Upon seeing a new issue of a foreign art magazine, young artists could only glean information from pictures a few square centimeters in size — most could not read the text. Prior to creating any work that might be construed as contemporary art, Chinese artists have scarcely any opportunity to view an original work. In such a situation, young artists who don't understand the original work dissipate the worthless "freedom" and "notions" that the mass media propounds.[3]

As with the art academies, China's mass media and exhibition spaces remain largely state-owned. Beginning in the 1990s, publications that had introduced experimental art virtually ceased or began to publish features on topics other than experimental art. As in the 1980s, the openness to experimental art in the mass media and art exhibition spaces then depended on how open-minded the leading officials in such institutions were. One thing that should not be overlooked was that regular financial input for the publication and exhibition of experimental art was non-existent.

Due to this defect in the system, the limited number of publications often charged artists or writers for

articles and the illustrations, and exhibition spaces charged a rental fee, even state-run galleries. In the beginning, some artists were willing to make a financial input to publications and opportunities to exhibit their work. But where this approach brought no benefit to artists and as the "export-oriented" system was established, it quickly declined. The mid-1990s was a time when most advocates of local experimental art felt suppressed and hopeless. The "power of interpretation" for experimental art had been handed over to commercial galleries and international curators, which resulted in the degeneration of China's academic mechanism. In turn, the worsening local academic mechanism sped up the transference of the "power of interpretation." When the *First Academic Exhibition of Contemporary Chinese Art*, purporting a local interpretation of China's experimental art, was aborted before it was able to open on December 31, 1996, many sank into despair.

IV. 1997–2000: A Limited Relaxed Situation

Comparatively speaking, the mechanism of experimental art as the external conditions played a more vital role in promoting creation of this art. The vitality derived from the sensitivity and vigor of the young artists.[4] During the first half of the 1990s, the main medium of experimental art was painting. However, since 1995 video and photography found their way on an unprecedented scale in a number of exhibitions in Beijing. Although efforts in this respect had begun in the early 1990s, it was only in the mid-1990s that such art works prospered. To a certain extent this phenomenon reflected the young artists' dissatisfaction with an art system guided by the singular goal of having works collected. Perhaps what fascinated young artists was that there were few norms surrounding video art and at the same time it was not restricted by the "export-oriented" art system, i.e., based on collection and sales. The expansion of media was the most profound change in the 1990s. Within a short period of time, Chinese contemporary art was catalyzed, for which there had been little preparation in knowledge. Trials in the use of new media made up for what Chinese contemporary art had missed.[5] Almost simultaneous to the extension of media, controversy within experimental artist's circle occurred. The debate on "meaning" in 1996 made manifest the young artists' reflection on the relationship between Realism, contemporary art and utilitarianism.

With Qiu Zhijie as their representative, some artists put forward the proposition that "art cannot help us approach truth," "art is just for fun," or in more "academic" terms, "art is just pre-thinking, a preparation for process, but it refuses to become any thought. It does not lead us to any standpoint, but helps us to redraw from any definite position." Their original intention was to reverse the tendency of non-art within contemporary art and the tendency of "vulgar sociology," which was hindering the development of contemporary art. They also meant to dispose of the pro-Western nature of Cynical Realism, Political Pop and Gaudy Art. Qiu's view and explorations—which were largely carried out by artists from the south of China — had a fundamental affinity with the Enlightenment movement begun in the 1980s.[6]

A direct outcome of the expansion of media pushed Cynical Realism, Political Pop and Gaudy Art into the category of "commercial avant-garde." Rapid economic growth offered more opportunities for employment. Thus, many artists could make a living without exclusive engagement in art and thereby they were not bound by a relationship to a commercial gallery. At the same time, the development of the market made it possible for non-profit or alternative art spaces run by artists to emerge, such as the Loft New Media Art Space in Beijing and BizArt in Shanghai. The ultimate motivation of these spaces was to mitigate the artists' discontent with the general art system. Since the early 1990s, the "export-oriented" art system made Cynical Realism, Political Pop and Gaudy Art dominate most exhibitions of Chinese contemporary art abroad. In the view of new experimental artists, the works of artists included in the 1999 Venice Biennale could not represent the achievements of Chinese experimental art. The list of those artists chosen for the Venice Biennale was controlled by commercial groups, which again revealed the drawback of "export-oriented" art. In the meantime, there was a shortage of exhibition spaces in China and this gave rise to artists' "self-managed spaces." From a macrocosmic view, these spaces complemented the commercial galleries and state-run museums. As Chinese experimental art was repeatedly exhibited internationally and the outside world learned more about China, more serious research in China began to focus on such spaces. With the help of contributions from Chinese individuals who had received some education in other countries, experimental art developed in a much healthier direction.

Early experimental art styles like Cynical Realism, Political Pop and Gaudy Art might have been shifted to the position of a "commercial avant-garde," but their commercial success helped to give experimental art a public profile. The high market value of such art works aroused the interest of local merchants and the mass

media. A direct consequence was the emergence of a number of galleries managed by Chinese people, and private galleries, like the Upriver Gallery in Sichuan and Dongyu Gallery, in Shenyang. However, where China still had no foundation system to support art or tax laws favourable to art sponsors, the existence of these institutions remained rather precarious.

The most noteworthy change in Chinese society in the 1990s was the flourishing of mass media. During this process, the lifestyles of Cynical Realistm, Political Pop, and Gaudy artists became the focus of fashionable journals, which gradually made experimental art"harmless"to society, and somewhat helped to expand its living space.

In the late 1990s, as younger officials were promoted to important positions in government, the living environment of experimental art became more favourable. In education, the most noticeable change was that the Central Academy of Fine Arts and the China National Academy of Fine Arts opened special courses on new media and a number of experimental artists were invited to give lectures. At the same time, Shanghai Art Museum, Guangdong Museum of Art, and He Xiangning Art Museum in Shenzhen held regular exhibitions of experimental art, such as the Shanghai Biennale, *China Contemporary Sculpture Annual Exhibition* and the Guangzhou Triennial. From 2000 on, experimental art was listed in cultural exchange programs between governments. Nevertheless, such relaxations were usually determined by the executives of a special regulation, not by a specific mechanism. Therefore the situation continues to fluctuate. We can be sure that the awakening of local museums and emergence of "alternative art spaces" indicate a transformation from the "export-oriented" to "local-oriented" systems for Chinese experimental art. Those phenomena not only signify a structural change within the experimental art system, but will bring forth changes in the language of art as well.

Even where the relaxations are unstable or sporadic they are effectively transforming the social context of experimental art in China. Analyzed from within, the "export-oriented" art system of the 1990s led to a logic based on the manipulation of ideological differences and antagonism between China and the West. Those differences and antagonisms obviously cannot serve as the basis for the existence and success of experimental art in China, otherwise, China's experimental art would only interpret and fawn upon Western values and standards. If we take a lesson from the experimental art of the former Soviet Union and Eastern Europe, we will learn that empty ideology cannot be a permanent *raison d'etre* for art.

With China's entry to the WTO, Chinese society will undergo great change. As the factual process of globalization continues, ideological differences will be altered too, and the narrow-minded Cold War ideology will disappear, giving way to conflicts between different values caused by different ways of perceiving things within the context of globalization. Grasping the gist of the new world situation has become an increasingly urgent issue. Therefore Chinese experimental artists must prepare for an era where pressure from different ideologies gradually disappears. When ideological differences no longer exist, Chinese experimental artists will only have a future if they turn their attention to deeper layers of Chinese society. This social context will provide sufficient resources for China's experimental art system that involves academies, the mass media and various exhibition spaces.

Judging by the external environment, the rendering "harmless" of experimental art has raised an even more challenging problem. When the public-interest poster, performed by Zhao Bandi and a toy panda, appeared throughout Beijing and the artist appeared on CCTV (Chinese Central Television), it provoked discussion amongst art theorists. The discussion was a re-examination of contemporary Chinese art in a colonial context. By borrowing Jurgen Habermas' notion of "commonness," art theorists had been looking for a way to bring art from international biennials back to the local society. But Zhao Bandi's approach raised doubts: "When an artist co-operates with the ruling will of the society, what is the artist's minimum morality?" The essential nature of experimental art is anti-establishment. Yet, without support from an establishment, experimental art is rootless and vulnerable to manipulation by others. This paradox was at the fore of the "export-oriented" experimental art in the 1990s. We frequently see experimental art appear in public spaces, yet we know that experimental art can gain legitimacy only if it shuns sensitive topics; if artists shun sensitive areas, can experimental art exist? And if artists do not shun sensitive issues, what will happen to experimental art?

Pi Li is a researcher at the Central Academy of Fine Arts.

1 Few exhibitions of international art works held in Beijing were organised outside of the system but every exhibition

effected a profound influence on Chinese artists. For example, exhibitions on Andrew Weisse and 19th century French painting inspired Country Life Realism. A show of Edvard Munch's works led to Chinese Expressionism, and Robert Rauschenberg's solo exhibition had an impact on Political Pop art.

2 The special characteristic of Beijing lies in it being China's largest center of political power and a focus of international attention. Due to the international attention, experimental artists in Beijing enjoy certain freedom.

3 Ever since the 20th century, all choices made in borrowing from foreign culture have been partial and snobbish. China may accept Expressionism but not analytical abstract art. It may accept Surrealism but not Structuralism, as it accepted Pop Art but not Minimalism. The one-sided practice came from the utilitarianism latent in Realist Art established by the Communist ideology. This utilitarianism is implanted in every artist's mind through the academic education, mass media and other channels. Cultural snobbism points to China's status as a third-world country; that whatever China has done in the political, economic or cultural spheres should be judged by foreign standards.

4 It is a rather complex problem to keep the pureness of experimental art in a harsh environment. However, the effect of "logic of figuring"(E. H. Gombrich's word) in this process is undeniable.

5 Video Art first emerged in the work of Zhang Peili, an artist in Hangzhou. His students Qiu Zhijie and Wu Meichun spread and popularized this medium by organizing a large exhibition of Chinese video art, *Image and Phenomena* (1996, Gallery of the China National Academy of Fine Arts). Only a few Beijing artists participated in this exhibition, because few engaged in exploration of this media in Beijing at that time. Due to China's special historical and social background, ever since the early 20th century, China has adopted utilitarian attitude towards art. The Enlightenment movement in avant-garde art in the 1980s purported to reverse this social phenomenon, but after 1989, post-colonial reality and available channels to the outside world turned Socialist utilitarian art into post-colonial utilitarian art. In the political and cultural center Beijing, the search for new art language ceased. New art languages are, to a limited extent, used by a small number of artists in southern cities.

6 There is no tradition of reasoning and analysis within contemporary Chinese art. So young artists believe that searching for new art language means discovering original motifs. They regard the relationship between art and society as antagonistic. In Beijing where there is no academic atmosphere, but much blind impulse, this view has been understood as Modernist cliché . Thus art becomes an Olympic game of technical innovations. This misconception led to anti-human, extremist activities. The use of human bodies reflects the implication of Modernism and Post-modernism within the context of post-colonialism, as well as the real effect of a thirst for action, novelties, stimulation, and new sensations in contemporary Chinese art. The exhibitions *Post-sense Sensibility* (1999) and *Infatuated with Injury* (2000) markedly demonstrated the bad effect of the "export-oriented" art system. That it attracted international attention again displayed the power of the "export-oriented" art guided by curious international journalists and curators. When the journal *Fine Arts* launched an attack on the use of such bodies, experimental art theorists were between devil and deep blue sea. They had to point out how the "export-oriented" system had alienated Chinese experimental art, and at the same time acknowledge the "extrality" of these artists. Unfortunately, in debate of this issue, experimental art theorists were in an inferior position and failed to give a convincing explanation. From this instance one can see how badly theoretical research on experimental art was neglected through the 1990s.

Translated from the Chinese by Karen Smith and Wen Jingen.

'Experimental Exhibitions' of the 1990s

Wu Hung

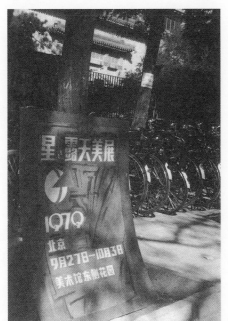

Fig. 1 "Stars" exhibition, 1979, Beijing

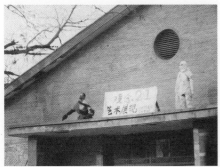

Fig. 2 Experimental art exhibitions were organized in all sorts of places, from a classroom in an art school to an open ground in a park.

The "issue" of exhibition attracted many Chinese experimental artists, art critics, and independent curators in the 1990s, and subsequently brought them into linked activities and discussions. At the center of this issue was a question: How to exhibit experimental art publicly? It was evident that throughout the decade, although "closed" shows were still routinely held as private communications among experimental artists themselves, an increasing number of curators and artists had chosen "to go public." This phenomenon became especially obvious after the mid-90s. The advocates of this approach hoped that by finding new channels to bring experimental art into the public sphere, they could realize the social potentials of this art and undermine the prohibitions traditionally imposed upon it. They also hoped that these new channels would eventually constitute a social basis for the "normal working" of experimental art, thus enabling this art to contribute to China's ongoing social and economic transformation. These agendas were not simply concerned with the exhibition *per se*, but rather intimately related to large questions about the roles of experimental art in China as well as the relationship between experimental artists and the society at large.

Historical Background

To understand the "experimental" nature of many exhibitions organized in the 1990s, we need to briefly review the history of experimental art exhibitions in China since the late 1970s. We can divide the twenty-one years between 1979 and 2000 into three periods. The first period, represented by the exhibitions of the Stars group in 1979 and 1980, marked the beginning of public exhibitions of experimental art in post-Cultural Revolution China. Most members of the group never received formal art training and were not affiliated with any official art institution. The group's early activities included private discussion sessions and informal art shows. Its members made a breakthrough by exhibiting their works in a small public park next to Beijing's National Art Gallery (now called the China Art Gallery) in September, 1979 (fig. 1). A big crowd gathered. The local authorities interfered and cancelled the exhibition two days later. The Stars responded by holding a public demonstration on October 1st, the 30th anniversary of the People's Republic of China.

Going one step further, the group hoped to take over an official exhibition space. A year later this hope was partially realized: supported by some open-minded art critics in the semi-official Chinese Artists' Association, the *Third Stars Art Exhibition* was held on an upper floor in the National Art Gallery. More than 80,000 people went to the show in a period of sixteen days. From the very beginning, therefore, Chinese experimental art had a strong tendency to expand into the public sphere and to participate in social movements. But in the case of the Stars, a public sphere was narrowly defined as a "political space" — the National Art Gallery. Members of the group followed a mass movement action called *duoquan* — "taking over an official institution" — derived from the Cultural Revolution itself. Although the *Third Stars Art Exhibition* was the first experimental art exhibition held in the National Art Gallery, its impact on the official system of art exhibition was as brief as the show itself. This triumphant moment of the Stars was followed by a 10-year long absence of experimental art in the National Art Gallery, till the enormous *China/Avant-garde* exhibition took over this official space again in 1989.

This 1989 exhibition concluded the second period in the history of experimental art exhibitions. During this period, the Stars' precedence was followed by a nationwide movement of experimental art that emerged around the mid-80s. Known as the '85 Art New Wave, this movement involved a large number of individual artists in different cities and provinces. These artists formed many "avant-garde" art groups

and societies, experimenting with art forms and concepts that they had just learned from the West. In terms of exhibitions, what distinguished this period from the previous one was mainly the large number and variety of shows and public performances. Experimental art exhibitions were organized in all sorts of places, from a classroom in an art school to an open ground in a park (fig. 2). The organizers made little effort to develop these spaces into regular channels of exhibiting experimental art, however. Rather, many of them were still preoccupied with the idea of taking over an official art gallery through an organized movement.

This approach was especially favored by the leaders of the '85 Art New Wave. In an effort to bring scattered groups into a nationwide movement, they proposed as early as 1986 to hold a national exhibition of experimental art in Beijing.[1] They finally realized this plan three years later in the *China/Avant-garde* exhibition. Without compromising the seminal importance of this exhibition in the history of contemporary Chinese art, it is also necessary to recognize its limitations. First, although it included many works that were radical and even shocking, the notion of a comprehensive, "national" exhibition was traditional and, ironically, found its immediate origin in the official National Art Exhibitions. Second, although its organizers gave much thought to the location of this exhibition, there was little discussion about how to change the system of art exhibition in China. The 1989 exhibition was envisioned as a grand but temporary event — another triumphant moment of "taking over" a primary official art institution. The National Art Gallery was transformed upon the opening of the exhibition: long black carpets, extending from the street to the entrance of the exhibition hall, bore the emblem of the exhibition — a "No U-turn" traffic sign signaling "There is no turning back" (fig. 3). Many "accidents" during the exhibition, including a premeditated shooting performance, made a big stir in the capital (fig. 4). There was a strong sense of happening associated with this exhibition, which was closely related to the social situation of the time.

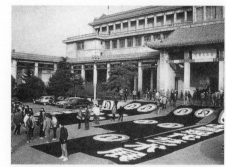

Fig. 3 *China/Avant-garde* exhibition, 1989, National Art Gallery, Beijing

The third period in the history of experimental art exhibition started in the early 1990s. As I have discussed elsewhere, a fundamental development of Chinese experimental art since the early 90s up till now has been a shift from a collective movement to individualized experiments.[2] These experiments are not limited to art mediums and styles, but are also concerned with the forms and roles of exhibitions. These concerns reflect a new direction of Chinese experimental art toward normalization and systematization. Instead of pursuing a social revolution, curators and artists have become more interested in building up a social basis, which would guarantee regular exhibitions of experimental art and reduce interference from the political authorities. A number of new factors in Chinese art have encouraged this interest and include: (1) the deepening globalization of Chinese experimental art, (2) a crisis in the existing public exhibition system, (3) the appearance of new types of exhibition space as a consequence of China's socioeconomic transformation, and (4) the emergence of independent curators and their growing influence on the development of experimental art. These factors all interact, contributing to new kinds of exhibitions that have been planned to expand existing exhibition spaces and to forge new exhibition channels. Because these exhibitions are, to a large degree, social experiments and because their results are still to be seen, I call them "experimental exhibitions."

Fig. 4 Tang Song, Xiao Lu, Performance during the *China/Avant-garde* exhibition, 1989, National Art Gallery

Stimuli of 'Experimental Exhibitions'

Chinese experimental art was "discovered" by Hong Kong, Taiwan, and western curators and dealers in the early 90s. A series of events, including the world tour of the *China's New Art, Post-1989* exhibition organized by Hong Kong's Hanart TZ Gallery, the appearance of young Chinese experimental artists in the 1993 Venice Biennale, and cover articles in *Flash Art* and *The New York Times Magazine*, introduced this art to a global audience.[3] Since then, Chinese experimental art has attracted growing attention abroad. To list just a few facts in 1999, the last year of the decade: at least two large exhibitions of this art took place in the United States; the Beijing-born artist Xu Bing was awarded a MacArthur Fellowship; another New York-based Chinese artist Wenda Gu was featured on the cover of *American Art*; twenty Chinese artists were selected to present their work in that year's Venice Biennale, more than the number of either the American or Italian participants; Cai Guo-qiang won one of the three International Awards granted at this Biennale. While Xu Bing, Wenda Gu, and Cai Guo-qiang were among those Chinese artists who have emigrated to the West and established their reputations there, artists who decided to remain home found no shortage of invitations to international exhibitions and art fairs. Their works were covered by foreign media and

appeared regularly in books and magazines.

Many artists in this second group were "independent" in status, meaning that they were not associated with any official art institution and often had no steady job. This lifestyle had become prevalent among experimental artists since the early 90s, and had allowed them to go back and forth between China and other countries.[4] A parallel phenomenon in the 90s was the appearance of "independent curators" (*duli cezhanren*). Usually not employed by official or commercial galleries, these individuals organized exhibitions of experimental art primarily out of personal interest. They normally had other things to do as well — some of them were art critics and editors while others were artists themselves. In either case, they kept close relationships with experimental artists, and introduced them to a larger audience through their exhibitions and writings. Experimental artists and independent curators played an increasing role in the 90s' art because of their familiarity with the international art scene — not just with a few fashionable names and styles but, more importantly, with standardized art practices including various types of exhibitions and exhibition spaces. They had become, in fact, members of a global art community; but they identified themselves with "Chinese art" and decided to act locally.

A key to understanding these independent artists and curators — many of them seem to have been thoroughly Westernized — is their deep bond with China. They believed that their work was part of contemporary Chinese culture and had be inspired by the Chinese reality. Ironically, this self-realization was encouraged by their frequent participation in international exhibitions. If before the mid-90s an invitation to a major international exhibition was a big deal, such invitations were no longer rarities in the late 90s. While still traveling abroad, some artists began to question whether such exposure had any real significance. Many experimental artists also became increasingly critical toward foreign curators, accusing them of coming to China to "pick" works to support their own views of China and Chinese art, which the artists saw as a typical Orientalistic or post-colonial practice. This criticism was shared by many independent curators.[5] It then became natural for these curators and artists to launch projects to hold indigenous exhibitions facilitated by their familiarity with Western exhibitions. But here they ran into another problem.

In sharp contrast to its popularity among foreign curators and collectors, Chinese experimental art in the 1990s was still struggling, to say the least, for basic acceptance at home. Although books and magazines about avant-garde art were easily to be found in bookstores since the mid-90s, actual exhibitions of this art, especially those of installation, video art, computer art, and performance, were still generally discouraged by state-run art museums and galleries. Moreover, to organize any public art exhibition, one had to closely follow a set of rules. According to a government regulation, all public art exhibitions must be organized (*zhuban*) by institutions entitled to organize such exhibitions, and all public art exhibitions must be held in registered exhibition spaces and be approved by responsible authorities. This regulation gave the government and its agencies almost unlimited power to turn down any proposed exhibition or to close down any exhibition that had already been installed or even opened.

Any independent curator who planned to organize an exhibition of experimental art in the 90s had to face this reality. On the other hand, the fact that so many exhibitions of experimental art, including some extreme ones, did take place in those ten years proves that the aforementioned regulation only represents part of reality; there was much room for artists and curators to explore. Starting from 1994 and especially after 1997, many exhibitions organized by these curators indicated a new direction: these curators were no longer satisfied with just finding any available space — even a primary space such as the National Art Gallery — to put on an exhibition. Rather, many of them organized exhibitions for a larger purpose: to create regular exhibition channels and to "legalize" experimental art. To these curators, it had become possible to pursue these goals because of the new conditions in Chinese society. They believed that China's socioeconomic transformation had created and continued to create new social sectors and spaces that could be exploited for developing experimental art.

Fig. 5 A billboard erected in 1999 next to Tiananmen Square, showing a collage of many recently constructed buildings in Beijing.

Fig. 6 Poster for an exhibition held in 1991 in the Diplomatic Missions Restaurant, Beijing.

New Conditions for Exhibiting Experimental Art

This socioeconomic transformation started in the 1970s and 1980s: a new generation of Chinese leaders made a dramatic turn to develop a free-market economy soon after the Cultural Revolution was over. The consequence of this transformation, however, was not fully felt until the mid-1990s when numerous private

and joint-venture businesses began to overwhelm state enterprises. Major cities such as Beijing and Shanghai were completely reshaped, showing off their newly gained global confidence with glimmering shopping complexes and five-star hotels (fig. 5). Changes also took place in people's lifestyle. While private real estate was abolished during the Cultural Revolution, the hottest commercial items in the 90s were houses and apartments. Hollywood films conquered Chinese movie theaters; fashion shows and beauty pageants were ranked among the most popular TV programs. Of course there were also serious things to worry about: millions of laid-off (*xiagang*) workers were struggling to support their families; a widening gap between the rich and the poor constantly threatened social stability. Generally speaking, China in the 1990s was a huge mixture of old and new, feudal and post-modern, excitement and anxiety. The country's future seemed to depend on the outcome of the negotiation between conflicting traditions, desires, and social forces.

These words also describe the situation of art exhibitions in the 90s: important progress was definitely taking place, but a new system of public exhibitions remained the goal for a future development. In China, any art exhibition is defined first of all by its physical location. My survey of the exhibition spaces of experimental art in 1999 and 2000 yielded the following varieties:[6]

Fig. 7 A poster for an exhibition held in Beijing's Courtyard Gallery in 1999.

1 Spaces for public exhibitions (or "open" exhibitions) of experimental art:
 a) Licensed exhibition spaces
 1) Major national and municipal galleries (e. g. the National Art Gallery in Beijing, the Shanghai Art Museum, the He Xiangning Art Museum in Shenzhen)
 2) Smaller galleries affiliated with universities and art schools (e. g. the Capital Normal University Art Gallery and the Contemporary Art Museum in Beijing)
 3) Semi-official art galleries (e. g. Yanhuang Art Gallery in Beijing, Art Gallery of Beijing International Art Palace, and Chengdu Contemporary Art Museum)
 4) Versatile exhibition halls in public spaces (e. g. the Main Hall of the former Imperial Ancestral Temple in Beijing)
 b) Private-owned galleries and exhibition halls
 1) Commercial galleries (e. g. the CourtYard Gallery, the Red Gate Gallery, and the Wan Fung Art Gallery in Beijing)[7]
 2) Non-commercial galleries and exhibition halls (e. g. the Design Museum in Beijing, the Upriver Art Gallery in Chengdu, and Taida Art Gallery in Tianjin)[8]
 c) Public, non-exhibition spaces
 1) Open spaces (e. g. streets, subway stations, parks, etc.)
 2) Commercial spaces (e. g. shopping malls, bars, supermarkets, etc.)
 3) Mass media and virtual space (e. g. TV, newspapers, and web sites)
2 Spaces for private exhibitions (or "closed" exhibitions) of experimental art:
 a) Private homes
 b) Basements of large residential or commercial buildings
 c) "Open studios" and "workshops" sponsored by individuals or institutions
 d) Embassies and foreign institutions

Fig. 8 The exhibition *Women/Here* in the Contemporary Art Gallery of the Central Academy of Fine Arts High School, Beijing, 1995.

The main exhibition channels of experimental art in the early 90s were private or closed shows, whose audience were mainly artists themselves, their friends, and interested foreigners. Terms such as "apartment art" and "embassy art" were invented to characterize these shows (fig. 6). Starting from 1993, however, exhibitions began to be held in various public spaces.[9] Commercial galleries started to appear; some of them supported experimental art projects that were not aimed at financial return (fig. 7).[10] Some university galleries, such as the Capital Normal University Art Museum and the Contemporary Art Gallery of the Central Academy of Fine Arts, became major sites of experimental art in Beijing, mainly because their directors — in these two cases Yuan Guang and Li Jianli, respectively — took on the role of supporting this art (figs. 8, 9). Sympathizers of experimental art also emerged in state-run exhibition companies. For example, one such individual, Guo Shirui, then the director of the Contemporary Art Centre under the National News and Publication Bureau, began in 1994 to organize and sponsor a series of influential

Fig. 9 Yin Xiuzhen's exhibition, *Ruined City*, in the Art Museum of Capital Normal University, Beijing, 1996.

experimental art exhibitions.[11]

"Experimental exhibitions" of the late 1990s continued this tendency. Their organizers focused on the three types of public spaces listed above, and tried to develop them into regular meeting places of experimental art with a broader audience, thereby cultivating public interest in this art. Their basic means to realize this goal were to develop exhibitions of experimental art in these spaces. Following this general direction, independent curators could still work with large or small licensed "official" or "semi-official" exhibition spaces, but tried to convert their directors into supporters of experimental art. Alternatively, they could devote their energy to help private-owned exhibition spaces to develop interesting programs. A third strategy was to use "non-exhibition" spaces to bring experimental art to the public in a more flexible manner.

Expanding Existing Spaces: Exhibiting Experimental Art in Public Galleries

Fig. 10 He Xiangning Art Museum in Shenzhen

Fig.11 *Factory No.2* exhibition held in Beijing's Wan Fung Gallery in early 2000.

Let's take a closer look at these efforts and their conditions. First, important changes had taken place in many licensed public galleries, thus created the possibility to bring experimental art into these places. Traditionally, all these galleries were sponsored by the state, and their exhibitions served strong educational purposes. Although this was still true in theory in the late 1990s, in actuality most of these public galleries had to finance their own operations, and for this and other purposes had to modify their image to appeal to a wider audience. As a result, their programs became increasingly polyfunctional. Even the National Art Gallery in Beijing routinely held three different kinds of exhibitions, which were more then often ideologically self-contradictory. These included: (1) mainstream exhibitions organized by the gallery to support the government's political agendas and to showcase "progressive" traditions in Chinese art, (2) imported exhibitions of foreign art, including avant-garde Western art, as part of China's cultural exchanges with other countries, and (3) short-term and often mediocre "rental" exhibitions as the main source of the gallery's income (the gallery collects a handsome fee for renting out its exhibition space and facilities). It became easily questionable why the gallery could show Western avant-garde art but not Chinese avant-garde art, and why it willingly provided space to an exhibition of obviously poor quality but not to an exhibition of genuine artistic experiment.

Unable to respond to these questions but still insisting on its opportunistic practices, the National Art Gallery — and indeed the whole existing art exhibition system — was rapidly loosing its credit. It is therefore not surprising to find that the position of the National Art Gallery was not always shared by other official art galleries. Some of these galleries, especially those newly established and "semi-official" ones, were more interested in developing new programs to make themselves more cosmopolitan and "up-to-date." The He Xiangning Art Museum in Shenzhen, for example, advertised itself as "a national modern art museum only second to the National Art Gallery in Beijing."[12] Instead of taking the latter as its model, however, it organized a series of exhibitions to explore "the complex relationship between experimentation and public function, academic values and visual attractiveness" in contemporary art (fig. 10).[13] A similar example was the Shanghai Art Museum, which assembled a collection of contemporary oil paintings and sculptures in less then five years, and organized *Shanghai Spirit: The Third Shanghai Biennale (2000)* to feature "works by outstanding contemporary artists from any country, including Chinese experimental artists."[14] The organizers of this exhibition placed a strong emphasis on the relationship between the show and its site in Shanghai, a city which "represents a specific and innovative model of modernization, a regionally defined but globally meaningful form of modernity that can only be summed up as the 'Shanghai Spirit.'"[15] Some independent curators were attracted by the opportunities to help organize these new programs, because they saw potential in them to transform the official system of art exhibition from within. In their view, when they brought experimental art into an official and semi-official exhibition space, this art also changed the nature of the space. For this reason, these curators tried hard to work with large public galleries to develop exhibitions, although such projects often required delicate negotiation and frequent compromises.

Generally speaking, however, national and municipal galleries were still not ready to openly support experimental projects by young Chinese artists. Even when they held an exhibition of a more adventurous nature, they often still had to emphasize its "academic merit" to avoid possible criticism. Compared with these large galleries, smaller galleries affiliated to universities, art schools, and other institutions enjoyed more freedom to develop a more versatile program, including to feature radical experimental works in their

galleries for either artistic or economic reasons. If a director was actively involved in promoting experimental art, his gallery, though small and relatively unknown to the outside world, could play an important role in developing this art. Examples of such cases include the Art Museum of the Capital Normal University and the Gallery of the Central Academy of Fine Arts, which held many original exhibitions from 1994 to 1996. On the part of an independent curator, if he proposed to stage an exhibition for a short period and to keep it low profile, he was more likely to use such exhibition spaces.

Exhibitions housed in universities and art schools became prevalent around the mid-1990s, although some curators and artists made a greater effort toward the end of the decade to attract official sponsorship and to make an exhibition known to a larger audience. One such example was the recent *2000 China: Internet, Video and Photo Art*, held in the Art Gallery of the Jilin Provincial Art Academy. As many as fifty-two artists throughout the country participated in this exhibition; their works were grouped into sections such as "conceptual photography," "multi-media images," and "interactive Internet art." The sponsors of the exhibition included the Jilin Provincial Artists' Association and Jilin Provincial Art Academy, which provided the exhibition not only with an exhibition space, but also computer equipment, supporting facilities for internet art, and a fund of 50,000 *yuan* (about $3,900). An additional fund of 50,000 *yuan* was raised from private businesses in Changchun. The exhibition attracted a local crowd, and also linked itself with artists and viewers far away through the Internet.

Forging New Channels: Exhibiting Experimental Art in Semi-public and Private Galleries

From the early 90s, some advocates of experimental art launched a campaign to develop a domestic market for experimental art. The first major initiative in this regard was the *First Guangzhou Biennale* in October 1992, which showed more than 400 works by 350 artists and was supervised by an advisory committee formed by fourteen art critics. Unlike any previous large-scale art shows, this exhibition was sponsored by private entrepreneurs and with a self-professed goal of establishing a market system for contemporary Chinese art. Its location in an "international exhibition hall" inside a five-star hotel was symbolic. The awards set aside for several prizes was 450,000 *yuan* (about $120,000 at the time), an unheard of amount of money for any of the show's participants. Suffering from the inexperience of the organizers as well as antagonism from the more idealistic artists, however, this grand undertaking ended with a feud between the three major parties involved in the exhibition: the organizers, the sponsor, and the artists.[16]

Two exhibitions held in 1996 and 1997 were motivated by the same idea of developing a market system for experimental art, but had a more specific purpose to facilitate the earliest domestic auctions of experimental art. Called *Reality: Present and Future* and *A Chinese Dream*, both events were curated by Leng Lin and sponsored by the Sungari International Auction Co. Ltd., and both took place in semi-public art galleries. The location of the 1996 exhibition was the Art Gallery of Beijing International Art Palace located inside the Holiday Inn Crowne Plaza Hotel in central Beijing. Established in 1991, this gallery was funded by a private foundation, but obtained the legal status of a "public exhibition space" from Beijing's municipal government largely because of the political connections of the gallery's founder Liu Xun, who was the head of the semi-official Artists' Association before he created this place and became its first director. The Yanhuang Art Gallery, location of the 1997 exhibition/auction *A Chinese Dream*, was the most active semi-official exhibition space in China in the early 90s. Founded by the famous artist Huang Zhou in 1991 and supported by two foundations, it was a private institution affiliated with an official institution, first with Beijing's Municipal Bureau of Cultural Relics and then with the Chinese People's Political Consultative Conference.[17]

The semi-public status of these two galleries gave them greater flexibility to determine their programs. This is why each of them could have hold an exhibition/auction as a joint venture between three parties: an independent curator, a semi-public gallery, and an auction house. The position of the auction house in this collaboration was made clear by its vice chairperson Liu Ting, a daughter of the late Chinese President Liu Shaoqi: "At present, as a commodity economy continues to expand in China, how to build up an art market for high-level works has become one of the most pressing issues in cultural and artistic circles. The current exhibition, *Reality: Present and Future* sponsored by the Sungari International Auction Co. Ltd.,

represents one step toward this goal."[18]

Another noticeable example of a semi-public gallery is the Chengdu Contemporary Art Museum founded in September 1999. Large enough to contain several football courts, this enormous gallery is part of an even larger architectural complex including two luxury hotels (one five-star and one four-star). The whole project is financed by Chengdu's municipal government and a Chinese-American joint venture company called the California Group (Jiazhou Jituan). Deng Hong, the museum's director and the chairman of the group's board of trustees, states the purpose of the museum:

> Twenty years after China opened its doors and began to undertake a series of reforms, the achievement of our country in the economic domain is now recognized by the whole world. But we must also agree that progress in the cultural sphere, especially in the area of cultural infrastructure, falls far behind our economic growth. Since the mid-1990s or even earlier I have been thinking that we should not only build a large scale modern art gallery with first-rate equipment, but, more importantly, need to introduce more advanced operating mechanisms and new modes in curating exhibitions, in order to facilitate and promote the development of Chinese art. . . This is the fundamental and long-term goal of the Chengdu Contemporary Art Gallery.[19]

Fig. 12 *Supermarket* exhibition held in the Shanghai Square Shopping Center, 1999.

The museum's inauguration coincided with an enormous exhibition. Called *Gate of the New Century*, this exhibition included a considerable number of installations and some performance pieces — content which would normally be omitted in a mainstream state-run gallery. But the exhibition as a whole still followed the mode of a synthetic, anonymous National Art Exhibition. Partly because of such criticism, the museum decided to sponsor versatile exhibitions of more experimental types.

Unlike the Chengdu Contemporary Art Museum, which is partially funded by the local government and is thus defined here as "semi-public," some art galleries are entirely private-owned. A major change in China's art world in the 1990s was in fact the establishment of these private galleries, which far out - numbered semi-public galleries and provided more opportunities to exhibit experimental art outside the official system of art exhibition. Commercial galleries appeared first in the early 90s, and by the end of the 90s had constituted the majority of private galleries. Strictly speaking, a commercial gallery is not a licensed "exhibition space." But because it is a licensed "art business" (*yishu qiye*), its space can be used to show art works without additional official permissions. In the middle and late 90s, quite a few owners or managers of these commercial galleries took a personal interest in experimental art, and supported "non-profit" exhibitions of installations, video art, and performances in their galleries. Maryse Parant, who interviewed a number of such owners or managers in Beijing, noted that "these galleries are also precursors. They not only sell, they also serve and educational purpose, digging a new path for art in China, shaping a market so that artists can continue their work and be seen."[20] While mainly offering "milder" types of experimental art to Western collectors, these galleries occasionally held bolder shows organized by guest curators. One such show was the *Factory No. 2* exhibition held in Beijing's Wan Fung Gallery in early 2000. Curated by three young students in the Department of Art History, Central Academy of Fine Arts, this impressive exhibition featured installations and works with explicit sexual implications seldom seen in a commercial gallery (fig. 11).

Non-commercial, privately funded art galleries were an even later phenomenon in China. These were galleries defined by their owners as "non-profit" (*fei yingli*), meaning that they supported these galleries and their operations with their own money, and that the art works exhibited there were not for sale. Although most of these owners did collect, the main program of these galleries was not to exhibit private art collections, but to hold a series of temporal shows organized by guest curators. These galleries thus differed from both commercial galleries and private museums, and had a greater capacity to exhibit more radical types of experimental art. For this advantage, some independent curators devoted much time and energy to help establish non-commercial galleries.

There had been no precedent for this type of exhibition space in Chinese history. Nor was it based on any specific Western model, although its basic concept was certainly derived from Western art museums and galleries funded by private foundations and donations. Because China did not have a philanthropic tradition to fund public art, and because no tax law was developed to help attract private donations to support art, to found a non-commercial gallery required originality and dedication. It was a tremendous

90

amount of work for curators and artists to persuade a company or a businessman to establish such an institution to promote experimental art. But because a gallery like this did not belong to a government institution and was not controlled by any official department, some curators and artists saw a new system of exhibition spaces based primarily on this kind of private institution. Their hope seemed to be shared by the owners of some of these galleries. Chen Jiagang, the owner and director of Upriver Art Gallery in Chengdu, Sichuan province, made this statement:

> The rise of great art at a given time originates not only from the talented imagination and activities of a few geniuses, but also from the impulse and creativity of a system. To a certain extent, an artistic work completed by an individual needs to be granted its social and historical value by a system. After the sustained efforts and striving of several generations, contemporary Chinese art has made a remarkable progress. But the system of contemporary Chinese art still remains mired in its old ways. Art galleries, agents, private-owned art museums as well as a foundation system have not yet been established, which, as a result, has obstructed the participation of contemporary Chinese art in contemporary Chinese life and establishment of its universality to a certain extent. As an important part in the contemporary art system, the function and development of art galleries is urgent.
>
> The Upriver Art Gallery has been established to provide the finest Chinese artists, critics and exhibition planners with a platform in order to support experiments in and academic research on contemporary Chinese art. In this way, it hopes to stimulate the achievement of first class art and its dissemination in society at large and the selection of works on academic merit.[21]

Fig. 13 The exhibition *Art as Food* held in Beijing's Club Vogue, 1999.

It is unclear how many galleries of this kind were established in the 90s; the best known three were respectively located in Chengdu, Tianjin, and Shenyang.[22] Each of them had a group of independent curators and experimental artists as advisors. Some of the most original exhibitions of experimental art in 1998 and 1999 took place in these and other private galleries. Because the owners of these galleries were either large companies or rich businessmen, their influence and relationship with local officials helped protect the exhibitions held in their galleries. In addition, their connections with local newspapers and TV stations helped turn these exhibitions into public events. Several shows held in the Upriver Art Gallery, for example, supplied the media with sensational materials and attracted people of different professions and classes to the exhibitions. Encouraged by such attention, some curators took public interaction as their goals, developing exhibitions around themes that would arouse public discussion and debate. However, there was a serious drawback to this type of gallery and exhibition spaces: its operation and existence relied on the financial situation of its owner. It was not uncommon that when a company began to lose money, it immediately stopped to support art exhibitions and even closed down its exhibition hall.

Fig. 14 Zhao Bandi's photo displayed in Beijing's subway stations, 1998.

Creating Versatile Exhibition Spaces: Bringing Experimental Art to the Public

A significant effort made by independent curators and artists was to hold experimental art exhibitions in versatile, non-exhibition spaces. Instead of creating either official or private regular exhibition channels, these were "site-specific" exhibitions that served two interrelated purposes: they brought experimental art to the public in a dynamic, guerilla-fashion, and in so doing transformed non-exhibition spaces into public exhibition spaces. The organizers of these exhibitions shared the belief that experimental art should be part of people's lives and should play an active role in China's socioeconomic transformation. Because these curators often wanted to demonstrate an unambiguous relationship between an exhibition and its social environment, most of these projects were strongly thematic and centered on certain public spaces. It was also common for these curators to ask artists to submit site-specific works for their exhibitions, and in this way encouraged these artists to contextualize their art within a public space.

Fig. 15 People reading *Talents* on Beijing's streets, 1999.

This direction was exemplified by a number of original projects developed in 1999 and 2000. For example, the exhibition *Supermarket* was actually held in a supermarket in downtown Shanghai (fig. 12); the fashionable bar Club Vogue in Beijing became the site of the exhibition *Art as Food* (fig. 13); upon the opening of the largest "furniture city" in Shanghai, customers had the opportunity to see a huge experimental art exhibition, called *Jia*? or *Home?*, on the store's enormous fourth floor. The fact that a majority of these shows used commercial spaces reflected the curators' interest in a "mass commercial culture," which in their view had become a major moting force in contemporary Chinese society. While affiliating

experimental art to this culture, their exhibitions also provided spaces for artists to comment on this culture, either positively or critically. Practically speaking, an exhibition held in a commercial space often involved a nuanced negotiation between the curator and the owner or manager of the space. Only because the latter saw benefit from the proposed exhibition — the prospect of bringing in more customers or gaining the image of being a "cultured" businessman — could the negotiation reach a happy conclusion. On the part of the curator, however, this negotiation was approached as an integral component of the experiment, because only through this process could a commercial space be transformed into a public exhibition space.

Related to such experiments in expanding public exhibition spaces was the effort to adapt popular forms of mass media to create new types of experimental art. The artist Zhao Bandi, for example, not only turned his conceptual photographs into "public welfare" posters in Beijing's subway stations (fig. 14), but also convinced the directors of CCTV to broadcast these photographs for similar purposes. Other experimental artists created works resembling the newspaper. The most systematic undertaking along this line was a project organized by the art critic and independent curator Leng Lin. Here is how he described this experiment:

> This project was put into practice in July, 1999. Called *Talents*, it initially consisted of four artists: Wang Jin, Zhu Fadong, Zhang Dali, and Wu Xiaojun. Its purpose was to explore a new way of artistic expression by adapting the form of the newspaper. Derived from this popular social medium, this form combines experimental art with people's daily activities, and brings this art into constant interaction with society. This project produced a printed document resembling a common newspaper. Each of its four pages was used by one of the four artists to express himself directly to his audience. In this way, these artists' final products became inseparable from the notion of the newspaper, and the idea of artistic creativity became subordinate to the broader concept of mass communication... We put *Talents* in public spaces such as bookstores and fairs. People could take it free of charge (fig. 15).[23]

But for some artists and curators, the newspaper was already too traditional a mass medium, so they began to explore newer information technologies such as the Internet. It became a common practice in the 90s for Chinese experimental artists to open personal web pages to feature their art works. But independent curators also discovered this space to organize "virtual exhibitions." For example, supported by the website "Chinese-art.com" based in Beijing, these curators took turn to edit the *"Chinese Type" Contemporary Art Online Magazine*. Each issue of the magazine, primarily edited by an active independent curator of experimental art, integrated short pieces of writings with many images; the form was more like an exhibition than a conventional art journal (fig. 16). The significance of such "virtual exhibitions" could also be understood in a more specific context: when public display of experimental art became difficult in the early 90s, some art critics curated "document exhibitions" (*wenxian zhan*) to facilitate the communication between experimental artists. Consisting of reproductions of works and writings by artists scattered throughout the country, these traveling shows provided information about recent developments of Chinese experimental art. These "document exhibitions" were replaced in the late 90s by "virtual exhibitions" on the Internet, which served similar purposes in a new period.

Fig. 16 Part of *Nine Chinese Artists*, a "virtual exhibition" organized by Leng Lin for the Web site www.chinese-art.com in 1998.

Public and Private 'Experimental Exhibitions'

Generally speaking, an exhibition becomes "experimental" when the focus of experimentation has shifted from the content of the exhibition to the exhibition itself: its site, form, and function. Issues about these aspects of exhibitions loomed large in the 90s because of an increasing conflict between a rapidly developing experimental art and a backward system of art exhibition. Instead of seeking solutions in a radical social revolution, advocates of experimental art placed their hopes on China's socioeconomic transformation, and decided to speed up this transformation with their own efforts. Consequently, they planned many exhibitions to widen existing public spaces and to explore new public spaces for exhibiting experimental art, and to find new allies, patrons, and audience for this art. In this sense, the experimental nature of these public exhibitions lay, first of all, in their professed goal of forging a "new system" of art exhibition in China. Under this general goal, each exhibition became a specific site for a curator to conduct a series of experiments. These experiments again stimulated the participating artists to experiment new concepts and forms in their art.

Although in theory an open exhibition is a public event and a closed exhibition is a private affair, the

line between the two was not definite in the 90s. An open exhibition was probably not so open after all because of concern with a possible cancellation. According to the artist Song Dong, for example, careful planning and keeping a low profile are two key reasons why the Art Museum of Capital Normal University was able to develop a consistent program of experimental art exhibitions during the three years from 1994 to 1996.[24] Although the gallery is a licensed, public exhibition space, the exhibitions held there during these years were short and mainly organized over weekends. These exhibitions inside a walled campus were not widely advertised; their timing was also carefully determined. All these factors made these "public" exhibitions actually semi-public or half-closed events.

On the other hand, although a closed show could be an informal gathering held in someone's house or apartment, it could also be a serious undertaking with a grand goal, realized only after painstaking preparation. Its opening could attract hundreds of people; and its impact could be felt in the subsequent development of experimental art for a long period. One artist has summarized what he sees as the only thing separating a closed exhibition from an open one: you know it's happening not through a formal announcement or invitation, but from an e-mail or a telephone call. Closed exhibitions still remained an important channel for exhibiting experimental art throughout the 90s, but their significance changed in new social environments, and especially in relation to exhibitions of experimental art in various public spaces. In fact, the increased efforts to organize public exhibitions of experimental art altered the meaning and direction of closed exhibitions, and brought these private events into a broader movement of "experimental exhibitions."

Fig. 17 Song Dong's work in the exhibition *Trace of Existence* curated by Feng Boyi in Beijing, 1998.

In most part of the 90s, the reason for organizing a closed exhibition was mainly a matter of security and convenience: its organizer did not have to obtain permission and worried less about outside obstruction. But this reason was no longer sufficient for a closed show organized at the end of the 90s: when many curators and artists were urging that experimental art be brought to the public, and when there was indeed a strong possibility to exhibit experimental art publicly, a closed show had to justify itself by providing additional reasons. A main reason was sought in protecting the "purity" of experimental art. Against the trend of exploring public channels for experimental art, some artists and curators insisted that any effort to publicize this art would inevitably compromise its experimental spirit. While this rhetoric was not new, its actual consequence was worth noting. Parallel to the ongoing effort to make experimental art accessible to the public, there appeared a counter movement of making closed shows more extreme and "difficult." The experiments of using living animals and human corpses to make art can be viewed, in fact, as part of this counter movement: since these experiments would almost certainly prohibited by the government and denounced by the public, they justified the necessity of closed exhibitions planned exclusively for "insiders" whtin the experimental art circle.

Many closed exhibitions organized toward the end of the 90s were no longer informal and casual gatherings at someone's home, but had become serious undertakings and reflected a growing concern with the purpose and form of this type of exhibition. Much thought was given to their sites and ways of organization, making these shows a special brand of experimental exhibition. One of them, *Trace of Existence*, was a major exhibition of Chinese experimental art in 1998. The curator Feng Boyi explains the exhibition's site in an article he wrote for the exhibition catalogue:

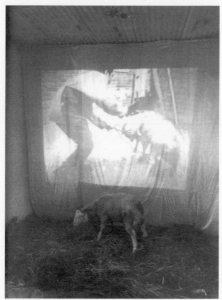

Fig. 18 Wang Gongxin's work in the exhibition *Trace of Existence*, Beijing, 1998.

> Because experimental art does not have a proper place within the framework of the official Chinese establishment of art exhibitions, it is difficult to exhibit this art openly and freely. We have therefore selected a disused private factory in the east suburbs of Beijing as our exhibition site, hoping to transform this informal and closed private space into an open space for creating and exhibiting experimental art. Held in this location, this exhibition allows us to make a transition from urban space to agricultural countryside in a geographical sense, and from center to border in a cultural sense. This location mirrors the peripheral position of experimental art in China, and this exhibition adapts the customary working method of contemporary Chinese experimental artists: they have to make use of any available place to create art.[25]

Each of the eleven participating artists selected a specific location within the exhibition space as the site of his or her work (fig. 17). Song Dong, for example, used the factory's abandoned dining hall to stage his installation: twelve large vats containing 1,250 cabbages picked on the spot. Wang Gongxin projected his video *Tending Sheep* in a sheep pen with a real sheep in it (fig. 18). The curator sub-titled the exhibition "a private showing of contemporary Chinese art," but they also supplied large buses to take several

hundred people to view and participate in this one-day event.

Going one step further, some curators and artists made an attempt to create regular channels for private exhibitions. One of these channels was the "Open Studio" program sponsored by the Research Institute of Sculpture in Beijing. Initiated by Zhan Wang, the director of the institute and an active experimental artist himself, this program offered young artists spaces to exhibit controversial artistic experiments; the institute posed no limit on their experimentation. The second Open Studio, held on April 22, 2000, was actually a carefully prepared exhibition, called *Infatuated with Injury*, organized by independent curator Li Xianting.[26] Several works on display used living animals and human corpses. During this exhibition, the hallway and the five "open studios" were packed with people. An investigation was soon conducted by the leadership of the Central Academy of Fine Arts, the superior organization of the institute, to look into this "highly abnormal" event.[27] Here, the division between a public exhibition and a private one again became nearly indistinguishable.

Concluding the Decade: The 2000 Shanghai Biennale and 'Satellite' Shows

The Third Shanghai Biennale was held from November 6, 2000, to January 6, 2001. From the moment Shanghai Art Museum announced its plan to organize a "truly international" biennale, this forthcoming exhibition had been perceived, discussed, and debated as an event of extraordinary historical significance. Representing the Museum's approach, Director Fang Zengxian, who also headed the Biennale's Artistic Committee, made this grandiose statement: "The significance of its [i. e. the Biennale's] success will far transcend the exhibition itself. As an activity established on an international scale that seriously addresses the issues of globalization, post-colonialism and regionalism, etc., this Shanghai Biennale will set a good example for our Chinese colleagues and is bound to secure its due status among other world-famous biennial art exhibitions."[28]

The Biennale also stimulated unofficial activities, mainly a host of "satellite" exhibitions organized by independent curators and non-government galleries.[29] As events, these exhibitions — both the Biennale and the "satellite" shows — largely fulfilled their mission upon their opening, which all took place within two to three days around November 6, 2000 as a series of linked "happenings." This strong sense of happening was also generated by the sudden get-together of a large number of artists and critics, reinforced by all the bustle and movement. Not only did the Museum invite many guests (including some of international renown), each of the "satellite" shows also formed its own "public." While the gap between the official and unofficial activities remained, participants from diverse backgrounds often intermingled and roamed together from one show to another, one party to another. However, a few days later Shanghai was left empty: most artists and art critics left and all the "satellite" shows were over. No longer threatened by competition and possible disruption, the Biennale alone persisted, though the excitement and exuberance once surrounding it was also gone.

The active events and happenings surrounding the Biennale confirmed my observation that, in the late 1990s and 2000, a dominant issue in Chinese art was the exhibition: its form, timing, location, and function. This is also why we find conflicting notions and positions surrounding the Biennale. Returning to the Shanghai Art Museum's own rhetoric, the Biennale was identified as an instant historical milestone because it inaugurated a "global" era for the industry of contemporary Chinese art exhibitions. This view may puzzle some people because, as it is well known, contemporary Chinese art had been part of the global art scene since the early 1990s, and many important international exhibitions now regularly feature works by contemporary Chinese artists. What needs to be understood was that this statement was limited to officially sponsored exhibitions, which had remained largely "local" before the 2000 Shanghai Biennale. Recalling that Beijing's National Art Gallery still refused to show installation, performance, and multi-medium works, sympathizers of the Shanghai Biennale could easily see its reformist, if not even revolutionary, nature.

To the Shanghai Art Museum, the Biennale was also a huge breakthrough: it allowed this official art institution to proudly announce its entrance into the global art scene. Since 1996, the Museum had adopted the fashionable term "biennale" (*shuang nian zhan*) for a sequence of its exhibitions. Such adoption was superficial, however, because the two earlier Shanghai Biennales in 1996 and 1998 were basically domestic

events. From the Museum's point of view, they consisted of a preliminary stage in a long-term evolution towards an established international norm: the Museum would eventually shed its "local" image and identity, and its Biennales would be "true to their names" (*ming fu qi shi*) and join the rank of other "true" biennales and triennales at Venice, Lyon, Kwang ju, Sydney, and Yokohama — to name just a few.

This evolutionary approach to contemporary Chinese art had a definite locality in 2000: Shanghai. In fact, only by linking the Biennale to a Herculean effort of this city to (re)assert its global, cosmopolitan identity can we understand the exhibition's true rationale and feasibility. Viewed in this context, this flashy and costly Biennale was not exactly the prime showcase in 2000's Shanghai. Housed in a refurbished colonial building, the visual excitement it offered to an international audience was nowhere close in comparison to the spectacular cityscape of Pudong (fig. 19). An oversized architectural circus, this cityscape startles visitors with a desire to impress and with an ambition to propel the whole city from the past to the future. Just a few days prior to the Biennale, Shanghai also expressed the same desire and ambition through "the largest staging of Verdi's Aida ever attempted in the world." Performed by Chinese and foreign musicians, it featured a grand march consisting of 3,000 PLA soldiers disguised as Egyptian warriors and all the elephants available in Shanghai.

The 2000 Shanghai Biennale also facilitated such a globalization program on a municipal level. The exhibition's thematic title was *Shanghai Spirit* in English but *Haishang Shanghai* in Chinese. The latter title, which means literally "Shanghai Over the Sea," aimed at relating this coastal city to the outside world. But having pushed the "Shanghai spirit" this far, the exhibition's organizers had to stop and reassert the national identity of their project. Thus in their rationalization of the Biennale, internationalization or globalization eventually retreated to the background, while the Biennale itself "endeavored to promote Chinese mainstream culture."[30]

Fig. 19 Third Shanghai Biennale, November 2000-January 2001

Since the Shanghai Art Museum invited Hou Hanru and Toshio Shimizu — two international curators of independent status — to join its curatorial team, to some independent Chinese curators, the gap conventionally separating a government-sponsored art exhibition from their own independent projects had significantly diminished. Even though none of these curators were directly involved in organizing the Biennale, to them, this government-sponsored exhibition still reflected some refreshing changes. The two most significant changes were also the most sought-after goals of previous "experimental exhibitions" organized by these independent curators. As mentioned earlier, their first goal was to take over the curatorship of major art exhibitions; their second goal was to "normalize" or "legalize" (*he fa hua*) experimental art.

The Shanghai Biennale not only invited two independent guest curators but also included video and installation works by some experimental Chinese artists. To those independent curators who had been campaigning for these reforms, this was certainly a victory for their part. Thus they constructed the Biennale's "historical significance" in a quite different way from that of the Museum's. While the Museum interpreted the Biennale as representing a new stage in an officially-sponsored evolution from "local" to "global," these independent curators and critics linked the Biennale to previous unofficial exhibitions. From their point of view, the reforms in this Biennale were resulted, to a large extent, from their persistent effort in challenging and reinventing the old exhibition system. Zhu Qingsheng — a Peking University professor who is also an avant-garde artist and critic — claimed that the 2000 Shanghai Biennale was the most important Chinese exhibition since the 1989 *China/Avant-garde* exhibition. Gu Chenfeng — another veteran organizer and critic of experimental art — compared the 2000 Shangahai Biennale with the 1992 Guangzhou Biennale organized by independent curators, which according to him initiated many new curatorial practices that then influenced subsequent art exhibitions in China.[31] Taken together, many of these statements reflected a collective attempt to forge an unofficial historiography, which attributed the main force behind the opening up of China's exhibition channels not to official reforms, but to initiations made in the unofficial sectors in Chinese art and to the general course of globalization.[32]

It would be mistaken, however, to take Zhu and Gu as representatives of all independent curators and experimental artists, because their views were by no means shared by everyone in the multi-faceted community of experimental art. As mentioned earlier, some independent curators and artists openly opposed any collaboration with public art institutions, which they considered to be opportunistic and against the

spirit of the avant-garde. In late 2000, this position was most self-consciously embodied by the off-Biennale exhibition entitled *Buhezuo Fangshi* — literally "Ways of Non-Cooperation" but rendered into English by the exhibition's organizers as *Fuck Off* (fig. 20). Ai Weiwei and Feng Boyi, co-curators of the show, explained this project: "*Fuck Off* is an event initiated by a group of curators and artists who share a common identity as 'alternative.' In today's art, the 'alternative' position entails challenging and criticizing the power discourse and popular conventions. In an uncooperative and uncompromising way, it self-consciously resists the threat of assimilation and vulgarization."[33]

Fig. 20 *Fuck Off*, Eastlink Gallery Shanghai, 2000.

Thus in their view, the main purpose of their exhibition was to counter and subvert the "master event" — the Biennale. In their vision, this "alternative" exhibition, though much smaller in scale, would challenge and debase the Biennale's centrality and dominance. In an interview, Ai Weiwei refused to call his show a "satellite" or "peripheral" activity.[34] To Ai and Feng, since their exhibition represented the "alternative" position in contemporary Chinese art, it played a critical role in challenging the dominant "power discourse" at this historical moment. From this position, they interpreted the Biennale as posing a "threat of assimilation and vulgarization:" the inclusion of experimental artists in this official showcase could only destroy these artists' experimental spirit. Their refusal of this reformist official exhibition, therefore, also implied their rejection of a reformist historical narrative centered on the evolution or transformation of the official exhibition system, whether this narrative was formulated by the art establishment itself or by independent curators who hoped to change the system from within.

Some artists shared this anti-establishment position and designed their works as private critiques of the Shanghai Biennale.[35] But such projects were few; most works in the off-Biennale exhibitions — even in Fuck Off — did not engage with the "master event." Moreover, to my knowledge no Chinese artist invited to participate in the Biennale turned down the invitation. I was also not surprised to learn that the organizers of *Fuck Off* also practiced certain self-censorship to ensure the show's realization, eliminating and restricting some art projects that might provoke a cancellation. These situations raised questions as to the effectiveness of this rebellion approach. In what sense did an "alternative" exhibition such as *Fuck Off* challenge the official show? How effectively did it shift the power center? To what extent could it realize its uncooperative intentionality? The significance of *Fuck Off*, in my view, mainly lies in its assertion of an alternative position, thus keeping this position vital in contemporary Chinese art. But it was far from clear, either in this particular exhibition or in the general practice of Chinese art in the last decade, what the "alternative" meant beyond self-positioning, attitude, and verbal expressions. This is perhaps why no real confrontation between the Biennale and other shows was found in the actual art works they exhibited. It is true that the off-Biennale exhibitions contained some works that were aggressive or deliberately shocking. But stylistic and ideological solidarity was not the goal of these shows. On the other hand, the Biennale's selection of artworks — ranging from Liang Shuo's realistic *Urban Peasants* to Matthew Barney's iconoclastic *Cremaster 4*, was clearly a compromise of hugely different aesthetic positions and judgments. With their conflicting self-identities and complex self-contradictions, all these exhibitions — both the official and unofficial ones — contributed to something larger than the exhibitions themselves, and will be remembered as part of an exciting moment in the history of contemporary Chinese art.

Wu Hung is the Harrie A. Vanderstappen Distinguished Service Professor of Chinese Art History at the University of Chicago.

1 This proposal was made in an important conference held in the southern city of Zhuhai and Guangdong in August, 1986. Participants from various regions reviewed more than a thousand of slides of recent works by experimental artists and proposed to organize a national exhibition of experimental art in Beijing in 1987. This plan was interrupted by the "Against Capitalist Liberalization" campaign mobilized by the government that year. When the campaign subsided, organizers of the 1986 conference returned to the drawing board and envisioned an even larger national exhibition of experimental art. A planning conference was held in October 1988 at Huangshan. The proposed location of the show was changed from the Agricultural Exhibition Hall to the National Art Gallery. Most of the seventeen members of the preparatory committee of the exhibition were young art critics, with Gao Minglu as the chief coordinator.

2 See Wu Hung, *Transience: Chinese Experimental Art at the End of the Twentieth Century*, (Chicago: Smart Museum of Art, 1999), 23-24.

3 Andrew Solomon, "Their Irony, Humor (and Art) Can Save China," *The New York Times Magazine*, December 19, 1993, 42-72.

4 Some artists intend to keep their jobs, but have found it difficult or impossible. For example, Song Dong, who maintains his job as a high school art teacher, had to finish teaching a year's courses in the first few months in 2000, before he joined an international workshop in London. His wife, the installation artist Yin Xiuzhen, has finally lost her job, partly because of her frequent travels abroad.

5 Such criticism is expressed in essays such as Zhu Qi's "Do Westerners Really Understand Chinese Avant-Garde Art?" *Chinese-Art.Com Bulletin* 2:3 (June 1999), 13-19.

6 I should emphasize that this survey only covers spaces that have been used for experimental art exhibitions in recent years. The varieties listed here thus do not represent all types of exhibition space in China.

7 The Red Gate Gallery was one of the earliest private-owned art galleries in Beijing. Its owner, Brian Wallace, an Australian, became interested in contemporary Chinese art in the 1980s, and began to organize exhibitions in Beijing's ancient Observatory in 1988. He subsequently opened the Red Gate Gallery in 1991. The CourtYard Gallery, located in a spectacular location across the moat from the East Gate of the Forbidden City, was established in 1996 by Handel Lee, a Chinese-American lawyer. The Wan Fung Gallery is also located in a formal imperial building, in this case the former Imperial Archives. A branch of a Hong Kong art gallery, it was established in 1993.

8 It is important to note that the "non-profit" status of these galleries is defined by the owners of these galleries, who fund the galleries and their activities by using part of their business income. A gallery in this category usually does not have an independent license, and should be considered a "non-profit" enterprise within a larger licensed "business for profit" (*qiye*) sector.

9 It is true that some public exhibitions before 1993 featured experimental art works. For example, the influential "New Generation" exhibition was held in 1991 in the Museum of Chinese History. But participants of the this exhibition were all academic artists, and the show was sponsored by the official Chinese Youth Daily as part of the anniversary celebration of the May Fourth Movement that year.

10 One such project was Xu Bing's *A Case Study of Transference*, held in 1994 at the Hanmo Art Center, one of the first commercial galleries in Beijing.

11 These exhibitions include *Now, Dream of East: '94 Beijing. International Com-Art Show, Beijing-Berlin Art Exchange* (1995), *The First Academic Exhibition of Chinese Contemporary Art* (1997), *Demonstration of Video Art '97 China, It's Me* (1998), and *Art For Sale* (1999).

12 He Xiangning Art Museum, brochure of the gallery.

13 Ren Kelei (Director of the He Xiangning Museum), "Social and Academic Goals of the Second Annual Contemporary Sculpture Exhibition," foreword to The Second Annual Contemporary Sculpture Exhibition at He Xiangning Art Gallery, (Shenzhen: He Xiangning Art Gallery, 1999), 8. (The venue has since changed its name to He Xiangning Art Museum)

14 Zhang Qing, an organizer of the exhibition, told me this during an interview I conducted in April, 2000.

15 Shanghai Art Museum, "Announcement of Shanghai Biennale 2000."

16 For a critiue of this exhibition, see Gu Chengfeng, "Lixiang zhuyi degangfen yu pibei — Guangzhou shuangnianzhan, wenxianzhan texie" (The excitment and exhaustion of idealism - a close-up observation of the Guangzhou Biennale and the Documenta Exhibition), in idem., *Ganshou youhuo — zhongguo dandai yishu jingguan* (Experiencing temptation - a quiet observation of contemporary Chinese art), (Chongqing: Chongqing chubanshe, 1999), 7-13. For an introduction to this Biennale, see Lü Peng, *Zhongguo dangdai yishushi 1990-1999 (90s Art China)*, (Changsha: Hunan meishu chubanshe, 2000), 124-33.

17 For a brief introduction to these and other semi-official galleries, see Ma Hongzeng, "20 shiji woguo meishuguan de fazhan guiji yu sikao" (Outlining and reflecting on the development of art galleries in China in the 20th century), *Meishu guancha* (Art observation), 4 (2000), 58-61.

18 Xianshi: Jintian yu mingtian (Reality: Present and Future), (Beijing: Sungary International, 1996), "Foreword."

19 Deng Hong, "Cujin he fanrong Zhongguo bentu yishu" (Promoting native Chinese art), *Meishu guancha* (Art observation), no. 53 (April 2000), 11-12.

20 Maryse Parant, "Foreigners Define Market: City Galleries Compete to Supply Contemporary Works." *Beijing This Month*, no. 77 (April 2000), 42-43; quotation from 42.

21 *Zhuanshi shidai (Time of revival)*, (Chengdu: Upriver Art Gallery, 2000), Chen Jiagang 6-7. English translation

revised based on the original Chinese text.

22　These are the Upriver Art Gallery in Chengdu, Taida Art Gallery in Tianjin, and Dongyu Museum of Fine Arts in Shenyang. Among Them, Donyu Museum focuses more on building up a private collection of contemporary Chinese art. See Robert Bernell, "Interview with Wang Yigang, Managing Director of the Dong Yu Museum of Fine Arts in Shenyang," "*Chinese Type*" *Contemporary Art Online Magazine*, 2:3 (May/June 1999), 19-22.

23　Leng Lin, "Yige zhide zhuyi de dongxiang" (A noticeable tendency), in idem., *Shi wo* (*It's me*), (Beijing: Zhongguo wenlian chubanshe, 2000), 67-81, quotation from p. 69.

24　An interview with Song Dong conducted by this author in February 2000.

25　Feng Boyi, "'Shengcun henji' de henji — guanyu 'shengcun henji - '98 Zhongguo dangdai yishu neibu guanmozhan' de yizhong miaoshu" (The Path to *Trace of Existence: A Private Showing of Chinese Contemporary Art '98*), *Shengcun henji - '98 Zhongguo dangdai yishu neibu guanmozhan* (*Trace of Existence: A Private Showing of Chinese Contemporary Art '98*), (Beijing: Art Now Studio, 1998), 9-11; quotation from 9.

26　For a published account of this exhibition, see Shu Kewen, "Mikailangjiluo jiepou de shiti" (Corpses under Michaelangelo's scalpel). *Sanlian shenghuo zhoukan* (Sanlian life weekly), no. 112 (May 2000), 70-71.

27　Typical examples of these exhibitions include the *Post-sense Sensibility* exhibition curated by Qiu Zhijie and Wu Meichun and the *Infatuated with Injury* exhibition curated by Li Xianting. The former took place in the basement of a large residential building, and the latter was presented as an "open studio" in the Research Institute of Sculpture. Both shows attracted many people to their openings and made a strong impact on Chinese experimental art.

28　Preface to Shanghai Art Museum, *Shanghai Biennale 2000*, (Shanghai: Shanghai shuhua chubanshe, 2000). English translation slightly modified based on the original Chinese text.

29　Four of these unofficial exhibitions had stronger thematic focuses and published exhibition catalogues. These were *Buhezuo Fangshi* (*Fuck Off*) curated by Ai Weiwei and Feng Boyi, *Richang yu Yichang* (*Normal and Abnormal*) curated by Gu Zhenqing, *Youxiao Qi* (*Useful Life*) organized by Yang Zhenzhong, Yang Fudong, and Xu Zhen, and *Yu Wo Youguan* (*About me*) curated by Lin Xiaodong.

30　Zhang Qing, "Beyond Left and Right: Transformation of the Shanghai Biennale," in Shanghai Art Museum, *Shanghai Biennale 2000*.

31　Zhu expressed this opinion in his speech given to the symposium held in conjunction with the 2000 Shanghai Biennale. For Gu's view, see his article "Xiangqi Guangzhou Shuangnianzhan" (Recalling the Guangzhou Biennale), *Shanghai Meishuguan tongxuan* (SAM magazine), 34 (2000), 5.

32　One can also find evidence for this attempt in Lü Peng's *Zhongguo dandai yishu shi, 1990-1999* (*90s Art China*), (Changsha: Hunan meishu chubanshe, 2000). This most up-to-date narrative of contemporary Chinese art represents an individual Chinese art critic's point of view.

33　Ai Weiwei and Feng Boyi, "About *Fuck Off*," in *Buhezuo fangshi* (*Fuck Off*), private publication, 2000, 9. English translation modified based on the original Chinese passage.

34　"'Buhezuo' shi yizhong licheng zitai — guanyu 'Buhezuo Fangshi' de duihua" ("Non-cooperation" is a standpoint and an attitude — a conversation about "A Way of No-Cooperation"), *Xiandai yishu* (*Contemporary Art*), no. 2, January 2001, 31.

35　Such examples include: Xu Tan's *Web Advertisement*, Gu Dexin's *2000.11.4: Easy Chair*, and Li Wei's performance at the opening of the Biennale.

Criticism on Chinese Experimental Art in the 1990s

Yi Ying

Criticism on experimental art in China through the 1990s began with a reflection upon its own history. The *China/Avant - garde* exhibition held in early 1989 pushed the avant-garde art movement that emerged in the mid-80s to a peak. The event also marked the end of a piece of history. At that point the most practical question was to ask where modern art in China would go from there. An obvious superficial characteristic of the modern art movement was the imitation of modern Western art, regardless of one's own cultural background or the thinking or motivation as to why one should imitate Western art. But the movement did have both historical and social significance. It radically changed the shape of modern art in China, introducing more open ways of thinking, and directing the awareness of the artists toward the international scene. What was more important, it made a positive contribution to the ideological emancipation movement, and to social democracy within Chinese society. It had just one fatal weakness: it replaced criticism's tools with weapons inflicting criticism, directly borrowing from various forms of modern Western art indiscriminately. It might have exerted a great impact, but did not create a localized language of modern art, nor did it address real issues pertaining to China. But this phenomenon of rushing to the opposite extreme was somehow creating an *a priori* ideological model for a pre-industrialized society, and once modernization got underway, there was no longer any need to seek a modern language.

At the end of the 1980s, avant-garde art criticism contained two main streams of thought about the development of modern art in China. One was combining modern approaches with traditional Chinese elements to arrive at a modern art with Chinese characteristics; and the other was engaging with the international scene, skipping modernism and leaping straight into the embrace of post-modernism. Both attitudes/theories were in step with the mood of the 1980s, and assisted in promoting the development of avant-garde art. This development was abruptly terminated by the political turmoil in late spring and early summer of 1989, and along with the avant-garde art movement, its associated field of criticism was hushed temporarily. In fact, it was during this sudden historical turn that the modern art movement experienced a deep change.

As the critics became puzzled about the direction modern art would take from there, the art was already changing and developing after its own fashion. Art criticism was both fast and slow in reacting to the change. It was fast because it quickly sensed the change; and slow because it did not respond in terms of theory. So the theory began to lag behind the movement. In the early 1990s, avant-garde art criticism made little progress in grasping/reflecting the reality. Under the pressure of another round of anti-liberalization, criticism retreated into itself, producing only abstract discussions about the fundamental goals and methodologies of critical discourses, which were certainly significant as theoretical reviews, as a summary of art criticism in China in the 1980s, or as theoretical preparation for the further development of criticism.

In April 1990, two exhibitions were held at the Gallery of the Central Academy of Fine Arts. One was a solo painting exhibition by Liu Xiaodong; the other, *World of Women Artists*, was jointly organized by eight women artists. By comparison with the avant-garde art styles of the 1980s, the works of those young artists displayed an obvious academic tendency. The majority were born in the 1960s, and did not experience the Cultural Revolution or work in rural areas as educated youth. They were university students in the 1980s, when the ideological emancipation and the avant-garde art movements were at their height. Their art conveyed new signals. First, it was a direct reflection of real experience and a direct depiction of the situation people found themselves in as China began to experience a period of social transformation.

Secondly, it was an important symbol of modern society— their works showed urban culture and life, which were also important symbols of social transformation in China. Thirdly, the presentation of individual experience showed the surfacing of individual value as collectivism dissolved in the 1980s, and the tradition of heroism and beliefs were lost. To some extent, these factors indicated the path of development that experimental art would embark upon in China in the 1990s.

In March 1991, the Institute of Fine Arts under the China Academy of Arts sponsored a seminar reviewing the fine arts in China during the 1980s. In addition to summarizing the 1985 Art New Wave movement, the seminar anticipated the further development of avant-garde art in the 1990s. The emerging new academic-styled art naturally drew the attention of critics. The emergence of this style was intricately tied up with the unique political background of that time, when the avant-garde was losing its momentum and coming under criticism as being capitalist liberalization in essence. It provided an opportune moment in history for a new academicism to emerge as a stopgap. New academicism was a temporary term, for the artists had just graduated from academies, and their works carried an obvious tinge of the campus. Yet their natural styles were hinged on academic and realistic approaches, which were vastly different from the main style of the avant-garde art of the 1980s. In July 1991, an exhibition called *New Generation* was held in the Museum of Revolutionary History in Beijing, which was a concentrated display of the new academic school. Thereafter this artistic trend was referred to as New Generation. This reveals that the New Generation not only represented a style, but also a new trend in art, the influence of which extended over the entire 1990s.

In Beijing, the New Generation attracted attention with a style that itself was at once supplement and reaction to avant-garde art. In his article "A Strong Focus on Reality," Xiao Chen expresses his understanding of the academic art: " They were re-establishing general principles for easel painting and realism ... extra close observation of details and a subjective shaping of language, a deepening of the spirit of realism and a free use of expressionism form the wings of their arts." Yin Jinan, however, emphasizes the New Generation's relationship with urban culture: "Urban life is the backdrop to their creation, and evaluations of life and art combine into a basic point of view of art that closely scrutinized the immediate environment."[1] In Beijing, criticism on the new academic school was relatively specific, but lacked theoretical depth. Analyses of the new academic school were inseparable from analyses of the particular historical conditions and background of that time. However, most critics, consciously or not, avoided that issue. This further reflected the fact that, faced with the question of the relationship between art on one side and social and historical conditions on the other, many critics had not fully mastered the method of microanalysis.

A typical example of this complex was Li Xianting's evaluation of the "rogue art" of Fang Lijun and others. He said, "By grasping a sense of meaninglessness, the rogue humoristic realism is significant in terms of how it deconstructs the world. It dissolved the significance of the value systems that had controlled the people and their entire social reality for many years."

Lü Peng opposed this by saying: "In the present age, it is really ridiculous to believe the cultural force of a certain mentality, that is, to believe that a primitive garden can be built in a modern cosmopolitan environment." But, what was puzzling was that Lü Peng's refute was not based on the concrete changes in the Chinese society after 1989. Instead, it started from a fabricated argument, which was "the deconstruction project in the new historical stage." If from 1985 the avant-garde to a great extent blindly accepted the control of Western modernism and its theories, after 1989, it was clear that Chinese critics remained under this influence. While the artists were being transformed by real life, the critics were often blind to concrete social reality. To get rid of the "1985 complex" and reconstruct modern arts, Lü Peng created the task of "ideological criticism," which was like building a house on sand.

The development of art did not stop because of critics' misreading of it. In 1992, the *The First Guangzhou Biennale: Oil Painting in the Nineties* was held in Guangzhou, and was the first large-scale exhibition of modern art in the 1990s. Works with urban subjects dominated the exhibition, but there were three different approaches to expression, which again hinted at the direction Chinese experimental art would take in the 1990s. These were realism, of which the New Generation was representative, Pop Art, mainly seen in the work of artists from Hubei province; and experiments with language by artists from Hunan and Jiangsu provinces.

The first tended to use abstract languages, while the latter mainly used materials and devices. No

matter how different the three were in their way of expression, they had something in common, which was a localization and individualization of experimenting with art. The artists no longer had their sight focused on modern Western arts or indiscriminately imitated forms of modern Western art. Instead, they focused on China's reality and their own personal experience. Even their experiments with language sought individual means of expression. In 1992, following the exhibition *China's New Art, Post-1989*, the pairing of Pop painting styles and political elements, known as Political Pop, gained much attention both within China and abroad. In this way, the progress from the urban realism of the New Generation to Political Pop formed the main trend of experimental art in China in the early 1990s, and the focus of art criticism finally switched from extremities in the 1980s to reality in the 1990s.

In 1994, in my article *"Significance of Seeking Explicitness,"* I summarized this new trend in a theoretical manner: "It was the so-called New Generation artists who first dissolved the obscurity of the period around 1985. They directly portray their own lifestyle in such a simple, flat way that viewers find it easy to understand their works. And because of this the meanings of their works are obvious. From their depiction of everyday life, one can clearly feel the coldness and dullness of life. Lacking the sense of responsibility and rationality that characterized works produced after 1985, these paintings reveal the loss of social beliefs and central values among this generation. A mental state of lacking ideals, beliefs and pursuits has become a theme behind the paintings."[2] Prior to this, Li Xianting had presented the concept of "meaningless realism." The "meaning" here had two meanings. First, it referred to the modernist spirit during the period around 1985, which was the embodiment of humanistic ideals through forms of art. Secondly, it referred to the significance of traditional realism, such as revolution, ideals and sentiments.

In his article "On Cultural Idealism," Huang Zhuan points out: "In modern Chinese art during the 1990s, a healthy framework with a certain cultural quality and in a unique state is being formed. However, to one's disappointment, the decadent, dejected, cynical attitudes shown in this process, and the direction toward pan-politics shown by the *fin de siecle* cultural pessimism in various international occasions have become forces that have the potential to impede this positive development. What is especially embarrassing to us is the fact that, where our ideal, healthy art market has not yet been established, the worship of money, egoism, and opportunism that is fashionable for the sake of fashionableness—none of which has a cultural quality—now occupy the market. Having abandoned idols, we are even abandoning the basic values and ideals, therefore faced with a great sense of loss."[3]

The speeches made by Deng Xiaoping during his tours of southern China were an important turning point in China's reform, opening and restructuring of its economic system that was implemented in the early 1980s. In the process of transformation from a planned to a market economy, Chinese society modernized rapidly to match the high-speed economic development. In the same manner as modern Chinese art within a pre-industrial society being confronted by the challenge of modernism in the 1980s, in the 1990s, we felt the pressure of post-modernism, which was reflected by the New Generation phenomenon. The loss of cultural idealistic values is not a rational discarding of what was or was not healthy or good, but a product of the reality. Economic development gave rise to a wealthy middle-class against rising unemployment amongst workers and peasant workers. The entire nation was experiencing either prosperity or poverty. On one hand, the recreational culture of middle-class and petty bourgeois culture become fashionable; on the other, vulgar mass culture spread unchecked. In the age of market economy, mass culture is not only over-taking avant-garde art and elite culture: as a subject and object at once, mass culture provides new visual experience and a new world of images. In this way, new meanings and forms of language have been derived, deeply changing avant-garde art and experimental art.

Yang Xiaoyan's *The Cartoon Generation—a Report on the Survival of Consuming Culture in Southern China* reacted sharply to this issue through the significance of the Cartoon Generation: "First, the sprightly nature and frankness of the Cartoon Generation ended aesthetics that emphasized formalism, such as modernism and even post-modernism. Popular taste entered the field of art, and artists finally realized that the high wall between popular and individual tastes is actually surmountable through the work style of the Cartoon Generation, and that the key is to find a place to join the reality, and a unique form of language. Secondly, as art is never limited to one form in expressing thoughts, we can work with various forms, including equipment and comprehensive media, to express a new aesthetic appeal, ideas and knowledge.

Thirdly, different choices of art forms reflect different people's pursuits. Their healthy contents are not necessarily to be expressed with classical forms."[4]

Zou Yuejin, editor-in-chief of *Dangdai Yishu* (Modern Art), also talked about this in the magazine: "Having arisen rapidly, and relying on the forces of market economy, cultural industry, mass media and commercial operations, mass culture with its relaxing, exciting, entertaining, commercial and flat characters has become a major means of recreation for the masses. Once silent in front of the power of mainstream and elite culture, the masses have obtained unprecedented space for self-imagination in today's mass culture. This means that, within the context of contemporary culture in China, mass culture, which was marginal in the 1980s, has come to the fore, standing together with mainstream and elite culture. In China's fine art community, Gaudy Art, thus named by critics, was the first to react to the mass culture."[5]

The entangled question of avant-garde art was then faced with the challenge of post-modernism, but Chinese society was far from entering a real post-industrial age or post-modern society. The overlapping of pre-industrial society, industrial society and post-modernism formed an important aspect of Chinese society in the 1990s. As mass culture spread unchecked in cities, the most basic of communication projects were under constructionr in villages in suburban areas. Experimental art chose mass culture as its breach. Was this the avant - garde's response to the mass culture, or a strategy for producing avant-garde art? In fact, it was Political Pop, not Gaudy Art that was the first to respond to the mass culture. But Political Pop did not respond to Chinese mass culture itself, but marched toward the world, that is, the Western world, using a form of mass culture. Consciously or unconsciously, Political Pop used strategies that catered to Western styles of interpretation, which was the only way to enable the West to exercise its power of speech over Chinese art.

Since the 1993 exhibition *China's New Art, Post-1989*, contemporary Chinese art has been present at large international exhibitions, and Western museums, galleries, art critics and art collectors have begun to pay attention to contemporary Chinese art. This attention is both unidirectional and colonialist. In his speech at the *Seminar on the Status Quo and Trend of Chinese Fine Arts in the 1990s* held in 1998, critic Feng Boyi said: "Since the beginning of the 1990s, many Chinese artists have introduced elements of traditional Chinese culture into their work, such as *fengshui*, Taoist magic figures and incantations, divination, Chinese medicine, Zen and Taoism. It was the naturally formed habit of doing the exact opposite of what they should in China that drove them consciously to use those mysterious, not understood elements of their own culture, achieving their integration into the new environment by way of invasion. Contemporary Chinese artists in the mainland create works using the cultural elements of the current reality, focusing on the natural flowing state of life experience, tracing memories and impressions of existence, and integrating these with the everyday life of the common people. As artists remolded daily life, viewers' participation and the process of dialogue are transformed into certain clever devices and behaviors."[6]

As Feng Boyi has pointed out, from cultural subversion in the 1980s to cultural utilization in the 1990s, Chinese artists, both in China and abroad, were "supported by a well-organized international network." The "cultural utilization" of contemporary Chinese artists, or utilization of traditional and contemporary cultural symbols, has been supported and used by this "international network." And the so-called "international recognition" has in turn promoted the "internationalization" of contemporary Chinese art, and encouraged more Chinese artists, especially marginal artists, to create works according to the standards of this "international network" in order to enter further into international exhibitions and the international market. From Political Pop to Gaudy Art and then to an "underground avant-garde," we can see that there is an invisible hand controlling contemporary Chinese art. Cultural power and colonial language are not individual phenomena, but are closely connected to the post-Cold War cultural strategy of Western countries, and fit the political need of the Western media for demonizing China. They are grave threats to the serious exploration of contemporary Chinese art. Discussions about power of speech became a hot topic in fine art criticism after the mid-1990s. We should point out that critics are not in agreement on this question.

As Huang Zhuan said, they are against cultural monopolies within China and at the same time criticize the cultural "colonialism" of foreign countries. This is a question that has been recognized theoretically but is hard to identify and solve in practice.

Zou Yuejin said, "Faced with the present culture and art in China, we often find ourselves facing a difficult dilemma, a contradiction. That is, on the one hand, we wish we could create more forms and works of art that belong to our own nation, and be influenced by Western culture as little as possible, so as to prove our identity as a nation. On the other hand, we wish China would catch up with developed countries in terms of material wealth, and be prosperous and strong enough to rival any world power. And this requires us to learn more elements beneficial to modernization from Western civilization and culture."[7]

Sun Xinmian, who sees no crisis in cultural colonialism, said,"Faced with the post-colonial cultural hegemony and awareness of the power of speech, we need not become emotional and hold up the banner of nationalism. As China has lag behind the West in the progress of modernization since the dawn of the modern era, there has been 'a crisis of existence' among the Chinese people. As 'crisis of existence is in nature crisis of culture,' the only way out of the crisis is to open to the world and learn from foreign cultures, which is called 'cultural revolution.'"[8]

Wang Nanming, while criticizing post-colonialism, stressed the relationship between language and subject. In his opinion, it was due to double standards on the part of the West that art criticism in China gradually left the motif of art language and focused on social and cultural themes. Although this shift of attention cannot be totally attributed to double standards from the West, Wang's criticism on post-colonialism was to the point. He said, "Chinese art does not draw attention as art. To Westerners, Chinese art needs only to provide a kind of ideological proof, and this is the reason why Cynical Realism drew attention. So, when we discover such dual standards, we should replace our delight with a sense of crisis concerning art. We have been told of the true colors of Western double standards, that is, Westerners use a standard of artistic supremacy that they have used since ancient times when judging their own contemporary art, while using a standard of how much they can learn about the present situation in China when judging Chinese art. In other words, Westerners are interested in contemporary Chinese art merely out of a partiality for novelty."[9]

In general, the discussions on the power of speech and criticism of post-colonialism did not go very deep, nor did it analyze or study the various concepts and terms. The key problem is that criticism itself is a disadvantaged part of culture. In the tide of globalization, and under pressure from advantaged cultures, art criticism expresses only intellectual concerns, having no power to change the status quo. However, as Wang Nanming realized, post-colonial criticism has brought about an important change in criticism, which is a switch from formal criticism to social criticism, or a switch from modernism to post-modernism. And he has expressed his worries about it. *Back to Society: A Reflection on Contemporary Chinese Art* by Pi Li clearly shows this attitude: "The influences of illiberal nationalism and the view of the West as the center have resulted in the fact that 'contemporary Chinese art' emphasizes 'Chineseness,' while the ideas of the disguised new formalism focus on 'art,' trying to achieve development in art through studies of the genealogical system of the language. In fact, against the background of globalization, the two of them can hardly lead to any equal-dialogue relationship about value. Perhaps we can only deduce our standpoint by putting 'Chinese,' 'contemporary' and 'art' together for study. Such pairings of the words as Chinese contemporary, contemporary Chinese, Chinese art and contemporary art make it inexorable that we should regard popularization of forms, democratization of tastes, diversification of languages and socialization of exchanges as the basic orientation of value in Chinese art creation and research in the new century, so as to lead contemporary Chinese art back to Chinese society."[10]

The switch from formal criticism to social criticism does not represent a development of art criticism as a field of study, but that the status quo of contemporary art has made critics pay attention to elements beyond art movements and works of art, such as context, background and social conditions that have informed a work of art. An individual critic may not belong to any school or use any fixed means. As with contemporary Chinese society, the rapid development of which has resulted in a high degree of complexity and diversity, contemporary Chinese art does not have a certain means or school that could challenge the complex reality and rapid change alone. In fact, this is part of what led to the formation of social criticism. In contemporary Chinese art criticism, social criticism emerged in the mid-1990s. Although we can understand it as a means of criticism, it has been most efficient in its involvement with the status quo of art, adapting itself to mainstream developments in contemporary art. Besides post-colonial cultural criticism,

in mid- and late 1990s, realistic criticism and theoretical discussions on a series of issues and phenomena such as promotion, experimental ink and wash, globalization and art of new media showed a more and more obvious tendency towards social criticism. Here, social criticism is embodied in two tendencies. One is on context, with post-colonial cultural criticism as an example. This analyzes the conditions that surround the creation of works of art from social, historical and cultural angles of view, and ignores the subjective intentions of the artist or what the works imply. The other tendency is studying cultural conditions without consideration of individual works and movements. An example of the second tendency is the study of promotion and globalization, the background of which, of course, is still the requirements of the reality. In the late 1990s, discussions about promotion formed a major topic in fine arts criticism.

Discussions about promotion originated from the development of contemporary Chinese sculpture. The late 1990s saw unprecedented activity in contemporary Chinese sculpture. A series of activities, such as *Invitational Exhibition of Sculptures by Young Artists* in Hangzhou, the exhibition of *Modern Sculptures* in Qingdao, and the *Contemporary Sculpture Art Annual Exhibition* held at Shenzhen's He Xiangning Art Museum, broke the mode of exhibiting sculptures on pedestals and brought contemporary sculpture into the public domain. Sun Zhenhua and Gao Tianmin remarked in a survey they wrote: "the question of promoting contemporary sculpture is a question of how to effectively express the artist's personal experience in creating the sculpture in public, which is a new question that has emerged within the contemporary cultural situation. Its essence is that, with the thriving of contemporary social mass cultural and transferring of power of art to the public, traditional elitist sculpture is called into question. In the past, people were used to sculptures on a pedestal in an area exclusive to sculpture, disrespecting public art. The development of contemporary culture requires us to reconsider this question."[11]

In Huang Zhuan's opinion, "China's traditional system of art has always been based on a kind of administrative power beyond promotion. The New Art movement has not radically undermined the power. On the contrary, because of its elitist tendency, it has made the question lack the basis of social practice. And this has been aggravated by the all-round interference of the Western contemporary art system into contemporary Chinese art."[12] The promotion is a way of existence of modernism. We are faced with two extremities. On the one hand, there is the popularization of art, commercial oil paintings, vulgarly luscious ink and wash, and calligraphy in political and commercial communities. On the other hand, we have the colonization of avant-garde art, embassy art, underground avant-garde art and marginal artists, and a formless controlling hand behind them all. The former caters to public taste and stunts the spirit of art; while the latter is kept out of the public domain, in spite of its modern form. Li Gongming mentioned promotion when talking about the power of speech: "Should exhibitions be for an elite or for common people? We are faced with the attitude of the public in regard to the question of promotion, which is a very practical question. The origin of the question of the promotion and the shift of social structure in the new age have led to discussions in the public arena. In the past, there was state versus individual, and there was no platform of equality between the two."[13]

Yin Shuangxi pointed out another aspect of publicity: "Contemporary art should not become an underground art exclusive to a few artists and stay in an half-concealed state, for that is not a healthy mentality toward the public. We should seek possible channels and use various ways to communicate with the public and win their understanding. We should regard the healthy development of contemporary art as an essential part of modernizing the Chinese nation and constructing an advanced culture and actively promoting it in a dialogue between world cultures. The promotion of contemporary art should include active and discreet promotion of the progress of diversification and democratization of China's contemporary art system."[14]

The question of promotion involves various aspects, such as the lowest moral standard of art, popular art and elite culture, public images, and mass media. Discussions about promotion have extended into the new century. From the discussions one can see that, at the turn of the century, contemporary Chinese art has a different situation than it did in the early 1990s, being more open. As a large country with a rapidly developing economy, China must meet the challenge of globalization with a more open attitude. This is also an opportunity for contemporary Chinese art to develop. Criticism can perceive things beyond the movements, and show an unprecedented depth. The first decade of the new century is very likely to witness

a restructuring of theory, a deepening reflection in the field of art criticism. With rich experience from the previous decade, when criticism was so close to movements that it was unavoidably influenced by them, in this decade we should usher in an age of real criticism as a science by means of observation, analysis and critique.

Yi Ying is professor at the Central Academy of Fine Arts and editor of the Academy's journal.

1 *Jiangsu huakan* (Jiangsu Art Monthly), no. 1, 1992.

2 Yi Ying. *Xueyuan de huanghun* (The sunset of academicism), (Changsha: Hunan meishu chubanshe, 2001), 225.

3 *Jiangsu huakan* (Jiangsu Art Monthly), no. 1, 1994.

4 *Jiangsu huakan* (Jiangsu Art Monthly), no. 7, 1997.

5 *Dangdai Yishu* (Contemporary art), vol. 15, (Changsha: Hunan meishu chubanshe, 1996).

6 "Jiushi niandai Zhongguo meishu xianzhuang yu qushi yantao hui" (Seminar on the status quo and trend of Chinese fine arts in the 1990s), *Meishu yanjiu* (Fine arts research), no. 1, 1999.

7 "Zhongguo meishu zhong de wenhua zhimin wenti sanren tan" (Three person discussion about cultural colonialism in Chinese fine arts), *Meishu guancha* (Fine arts observation), no. 12, 1996.

8 Ibid., "'Hou zhimin' huati: lishi yu xianshi" (History and reality: the subject of post-colonialism).

9 "Xifang shuangchong biaozhun yu dandgai yishu piping de qitu" (Double standards of the West and the wrong path of contemporary art criticism), *Jiangsu huakan* (Jiangsu Art Monthly), no. 5, 1998.

10 *Meishu yanjiu* (Fine arts research), no. 3, 2000.

11 Sun Zhenhua and Gao Tianmin, "Di er hui dandgai qingnian diaosu jia yaoqing zhan zongshu" (a survey of the *Second Invitational Exhibition of Contemporary Young Sculptors*), *Jiangsu huakan* (Jiangsu Art Monthly), no. 1, 2001.

12 "Jianli Zhongguo dangdai yishu gonggong hua zhidu de jiben qianti" (Basic preconditions for the construction of a publicity system for Chinese contemporary art), *Meishu guancha* (Fine arts observation), no. 8, 2000.

13 Taken from a speech given at the conference *Xin Shixian, Xin Meiti* (New View, New Media), May, 2002.

14 Ibid.

Translated from the Chinese by Karen Smith and Zhang Shaoning.

The Reception in the West of Experimental Mainland Chinese Art of the 1990s

Britta Erickson

Fig. 1 Zhou Tiehai, *Press Conference*, 1997, mixed media

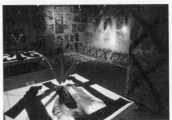

Fig. 2 Gu Wenda, *Dangerous Chessboard Leaves the Ground*, 1987, mixed media installation, Art Gallery of York University

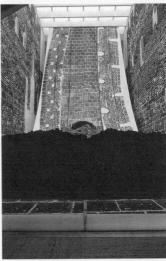

Fig. 3 Xu Bing, *Ghosts Pounding the Wall*, 1991, mixed media installation, Elvehjem Museum of Art, 1991

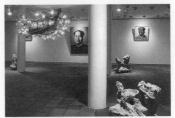

Fig. 4 Cai Guo-qiang, installation view from *Flying Dragon in the Heavens*, 1997, Louisiana Museum of Modern Art

Introduction

During the 1990s, the overseas profile of the Chinese art world increased dramatically, as the number of overseas exhibitions and publications focusing on—or featuring—Chinese art grew year by year. At the same time, the relationship between Chinese artists and overseas art workers and consumers evolved from one of keen but largely uninformed interest to one that was both better informed and more self-conscious. By 2000, Chinese art had achieved a sustainable profile on the international art circuit, and scholars, critics, curators, and collectors had begun to treat it as part of the general scenery, rather than as an exoticism. The artist Zhou Tiehai has famously stated in his 1997 painting *Press Conference* that "The relations in the art world are the same as the relations between states in the post-Cold War era" (fig. 1). I would say that the art world relationship between China and the outside world, particularly the West, developed more like a romantic relationship during the 1990s: at first, both parties were curious about the newly discovered other, and wondered what could be gained from a connection. By the end of the 1990s, the heady excitement had gone, replaced by a sustainable long-term association. Although there is now a deeper understanding, there are still areas of uncertainty, moments of idiocy, and room for enjoyable flirtation.

For the sake of clarity and simplicity, this essay consists of separate histories of the profile of art by mainland Chinese artists as it appeared in exhibitions, publications and scholarly research in the West, with an additional small section about strategies. The reception of Chinese art in other parts of Asia, particularly Japan, is a separate and rich story revolving around different shared interests and different misperceptions, and will not be covered in this essay.

Exhibitions

In the late 1980s and early 1990s, contemporary Chinese art was featured in a few exhibitions in the West, either small exhibitions at minor venues, or as a minor element of a large exhibition. In North America, for example, the first exhibitions of avant-garde Chinese art were held in colleges in the 1980s and were not widely publicized. These include *Painting the Chinese Dream: Chinese Art Thirty Years After the Revolution*, curated by Joan Lebold Cohen at the Smith College Museum of Art (1982)[1] and *Artists from China—New Expressions* at Sarah Lawrence College (1987).[2] In Europe, Chinese art was featured as a minor element in Jean-Hubert Martin's 1989 exhibition, *Magiciens de la Terre*, at the Centre Georges Pompidou, which introduced the young avant-garde artists Gu Dexin, Huang Yong Ping, and Yang Jiecang (and other third-world artists) to an important center of the contemporary art world.[3] Ten years later avant-garde Chinese art was in demand for major exhibitions.

The 1990s witnessed both rapid globalization and the artistic results of China's policy of "striding to the world." This confluence of circumstances implied an interest on the part of the West in other cultures and the production in China of art intended for consumption overseas. Particularly a decade ago, to introduce an exhibition of contemporary Chinese art into the schedule of a museum or public gallery required determination, leverage, and strategy. Over the years, the strategizing has become more sophisticated, and more effective. The other side of the coin is the fact that some Chinese artists have set out to design works of art to suit overseas consumption, often laying their machinations bare as part of the work.

Three issues colored Western reception of Chinese art at the beginning of the 1990s, and endure to this day: first, vestiges of the colonialist search for exoticism in "the other" persisted; second, June

4 dominated Western perceptions of China; third, Western art experts frequently had difficulty seeing beyond the surface appearance of contemporary Chinese art, with the result that they perceived much as derivative. The first two issues have surfaced in exhibitions, and may have been exploited as points of accessibility for the art, particularly in group shows where there is a need for a unifying theme. Critics accused *Magiciens de la Terre*, for example, of fostering the perception of Chinese artists as shamans.

Early solo exhibitions launched the overseas careers of outstanding emigré artists. In 1987, Wenda Gu installed a major show, *Dangerous Chessboard Leaves the Ground*, in the Art Gallery of York University in Toronto (fig. 2).[4] Yang Jiecang exhibited in Paris and London in 1990 and 1991, and Chen Zhen had shows in those same years in Paris and Rome. Xu Bing's first solo exhibition in the West was *Three Installations by Xu Bing* in Madison (Elvehjem Museum of Art; fig. 3) in 1991.[5] Huang Yong Ping and Cai Guo-qiang began to have major solo exhibitions in the West slightly later. In the early 1990s Cai lived in Japan, where he was a resounding success. *Flying Dragon in the Heavens* (Louisiana Museum of Modern Art, Humlebaek, Denmark, 1997; fig. 4) was Cai's first solo exhibition in Europe,[6] and *Cultural Melting Bath: Projects for the 20th Century* (Queens Museum of Art, New York, 1997) his first in the United States. [7]

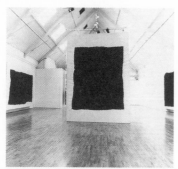

This group of exceptional artists was drawn on as a core for several group exhibitions, including *Art Chinois, Chine Demain pour Hier* (curated by Fei Dawei, Pourrières, 1990),[8] *Silent Energy* (curated by David Elliot and Lydie Mepham, eight artists, Museum of Modern Art, Oxford, 1993; fig. 5), [9] *Fragmented Memory: The Chinese Avant-Garde in Exile* (curated by Julia Andrews and Gao Minglu, four artists, Wexner Center for the Arts, Columbus, Ohio, 1993; fig. 6),[10] and *Out of the Centre*, curated by Hou Hanru five artists, Pori Art Museum, Pori, Finland, 1994).[11] These artists became integrated into the fabric of the international realm of conceptual art, appearing in such important exhibitions as *Heart of Darkness* (an exhibition of artists from throughout the world), curated by Marianne Brouwer (Kröller-Müller Museum, Otterlo, 1994).[12]

Fig. 5 Yang Jiecang, *Untitled (6 works)*, 1993, mixed media with ink and rice paper, 409 x 292 cm each, installation view from *Silent Energy*, Museum of Modern Art, Oxford

Fig. 6 Wu Shanzhuan, *Missing Bamboo*, 1993, mixed media installation, *Fragmented Memory*, Wexner Center for the Arts

In general, Australia and Europe proved to be open to experimental Chinese art earlier than the United States. While for decades Australia had considered itself culturally linked to Europe and the United States, during the 1990s it increasingly recognized ties to its neighbors in Asia. This mindset launched the Asia-Pacific Triennial (APT), originally planned as a series of three exhibitions to be held at the Queensland Art Gallery in Brisbane in 1993, 1996, and 1999 (fig. 7), under the direction of Caroline Turner. The exhibitions' success has resulted in the triennials' continuation into the twenty-first century. Although the art included in the APT exhibitions was not limited to China (The first, second, and third triennials featured eight, six, and eleven Chinese artists, respectively), the exhibitions are nevertheless significant for Chinese art because of the idealism behind their organization, including the minimal influence exerted by commercial galleries and collectors in the selection process. As the triennial's Senior Project Officer, Rhana Devenport, stated, the APT core principles include: "the desire to enhance cultural understanding through long-term engagement with contemporary art and ideas from Asia and the Pacific; a commitment to co-curatorship and consultation; and the location of the artist and the artist/artwork/audience relationship as central to the entire process."[13]

Fig. 7 Yin Xiuzhen, *Beijing*, 1999, mixed media installation, *Beyond the Future* (APT 3)

What set this series of exhibitions apart from all others were the extreme lengths to which the organizers went in their efforts to be open to new kinds of art. For the first triennial, a conscious decision was made to not organize the exhibition according to an overall theme—a method that had become *de rigueur* for large periodical exhibitions—but rather to allow multiple curators to select art representative of the area for which they were responsible. The second triennial sought to avoid a Euro-Americentric perspective, first, by convening a series of forums to discuss issues relevant to the curatorial process, and second, by forming fifteen curatorial teams each of which included a curator native to the country whose art the team was selecting. For the third triennial, fifty-three curators and researchers worked with seventy-seven artists, ensuring a plurality of vision. While the curatorial process became cumbersome, it encouraged the emergence of artists who would not have otherwise achieved recognition. The East Coast of Australia also saw the first significant Australian exhibition devoted exclusively to Chinese art: Claire Roberts' small but powerful *New Art from China: Post-Mao*

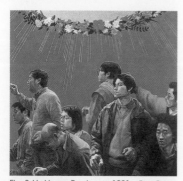

Fig. 8 Yu Hong, *Beginners*, 1991, oil on linen, 168 x 176 cm, exhibited in *China Avant-Garde: Counter-Currents in Art and Culture*, Haus der Kulturen der Welt

Product, at the Art Gallery of New South Wales, Sydney in 1992 (seven artists).[14]

During the mid-1990s, Europe produced a flurry of group exhibitions focusing on contemporary avant-garde Chinese art, beginning with *China Avant-garde: Counter-currents in Art and Culture*, at the Haus der Kulturen der Welt in Berlin in 1993 (sixteen artists; fig. 8).[15] In 1995, *Change—Chinese Contemporary Art*, organized by Folke Edwards, opened at the Konsthallen in Göteborg, Sweden (seventeen artists);[16] and *Des del Pais del Centre: avantguardes artistiques xineses (Out of the Middle Kingdom: Chinese Avant-garde Art)*, curated by Imma Puy, was exhibited at the Centre d'Art Santa Monica in Barcelona (thirty-four artists; fig. 9).[17] The next year, *China! Zeitgenössische Malerei*, curated by Dieter Ronte, Walter Smerling, and Evelyn Weiss, opened at the Bonn Art Museum (thirty-one artists; fig. 10).[18] An almost identical exhibition, *"Quotation Marks:" Chinese Contemporary Paintings*, opened at the Singapore Art Museum in 1997, with twenty-seven artists.[19] Many others followed.

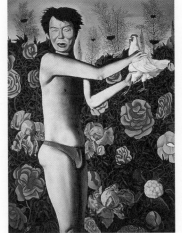

Fig. 9 Song Yonghong, *Spring Sunlight*, 1993-94, oil on canvas, 59 x 43 cm, exhibited in *Des del Pais del Centre*, Centre d'Art Santa Monica

Probably the most influential of all the early 1990s exhibitions of contemporary Chinese avant-garde art was the 1993 blockbuster, *China's New Art, Post-1989* (fig. 11).[20] Co-curated by Johnson Chang (Chang Tsong-Zung) and Li Xianting, *China's New Art, Post-1989* opened at the Hong Kong Arts Centre and City Hall, and featured fifty-four artists, most of whom had drawn attention at the 1989 *China/Avant-garde* exhibition at the National Art Gallery in Beijing.[21] *China's New Art, Post-1989* went on to tour the globe for several years, and had a long-lasting impact, shaping the overseas roster of important Chinese artists. A pared-down spin-off of this exhibition, *Mao Goes Pop, China Post-1989* (with twenty-nine artists), appeared at the Museum of Contemporary Art, Sydney in 1993.[22]

Group exhibitions from the first half of the 1990s introduced contemporary Chinese avant-garde art to the West. Typically the catalogue texts accompanying the exhibitions located the art in terms of its political and sociological background, and sometimes explained its historical development. Some catalogues included comments from the artists. Once contemporary Chinese art had been thus introduced, however, exhibitions in this vein became redundant, except to the local populations.

Fig. 10 Ding Yi, *Manifestation of Crosses 93-11*, 1993, oil on canvas, 140 x 160 cm, exhibited in *China! Zeitgenössische Malerei*, Bonn Art Museum

Important exhibitions of the later 1990s provided new angles or introduced new materials. Examples include *Die Hälfte des Himmels: Chinesische Künstlerinnen*, organized by Chris Werner, Qiu Ping, and Marianne Pitzenar at the Frauen Museum in Bonn in 1998 (twenty-four artists from mainland China; fig. 12).[23] This exhibition of female artists' works was a direct reaction to *China! Zeitgenössische Malerei*, which had appeared in Bonn two years earlier, purporting to present a comprehensive view of Chinese painting but including no women among its thirty-one artists. The under-representation of female artists is a pervasive problem in the field, and *Die Hälfte des Himmels* made a decisive statement.

Some exhibitions explored particular media. In 1997, *Another Long March: Chinese Conceptual and Installation Art in the Nineties*, curated by Chris Dreissen and Heidi van Mierlo (eighteen artists; Fundament Foundation, Breda, the Netherlands; fig. 13) focused on installation and performance art.[24] That same year saw a major exhibition of contemporary Chinese photography, *Zeitgenössische Fotokunst aus der Volksrepublik China*, at the Neuer Berliner Kunstverein (sixteen artists; fig. 14).[25]

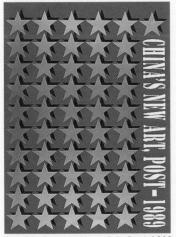

Fig. 11 *China's New Art, Post-1989* catalogue, by Johnson Chang, Valerie Doran, et al., published by Hanart T Z Gallery, 1993

Other exhibitions brought out particular themes. *Im Spiegel der Eigenen Tradition: Ausstellung Zeitgenössischer Chinesischer Kunst*, curated by Eckhard Schneider at the German Embassy, Beijing (technically German territory; thirty-four artists) in 1998, showcased modern expressions of traditional artistic practices and aesthetics.[26] Three exhibitions focusing on language appeared in 1999 and 2000: *Contemporary Chinese Art and the Literary Culture of China*, curated by Patricia Eichenbaum Karetzky, Lehman College Art Gallery (ten artists; 1999);[27] *Power of the Word*, curated by Johnson Chang and circulated by Independent Curators International, New York (six mainland Chinese artists; 2000; fig. 15);[28] and *Word and Meaning: Six Contemporary Chinese Artists*, curated by Shen Kuiyi, for the University at Buffalo Art Gallery, Buffalo, New York (five mainland Chinese artists; 2000).[29] *Transience: Chinese Experimental Art at the End of the Twentieth Century*, curated by Wu Hung for the Smart Museum of Art at the University of Chicago (twenty-one artists; 1999; fig. 16) broke experimental art into several thematic divisions, "Demystification," "Ruins," and "Transience."[30]

Regionalism proved a viable angle for the exhibition, *Jiangnan: Modern and Contemporary Art from South of the Yangzi River*, organized by Hang Bull, David Chan, Zheng Shengtian, and Xia Wei,

exhibited in various Vancouver venues (eighteen contemporary mainland artists; 1998; fig. 17). [31] Another angle was painting genres: in curating *Representing the People* for the Chinese Arts Centre, Manchester (ten artists; 1998; fig. 18), Karen Smith focused on figurative paintings.[32] All of the focused exhibitions provided their audiences with a view of China as a multi-faceted culture, breaking down the notion of China as a homogeneous monolith, and encouraging a more nuanced appreciation of Chinese art.

The second blockbuster exhibition of Chinese avant-garde art (after *China's New Art, Post-1989*), *Inside Out: New Chinese Art*, was curated by Gao Minglu in association with the Asia Society and the San Francisco Museum of Modern Art (forty-two mainland Chinese artists/groups; fig. 19).[33] Although its core consisted of the major artists of the '85 Art New Wave movement, its scope was widened to include younger artists, as well as artists from Hong Kong and Taiwan. After opening at the Asia Society and PS 1 in New York in 1998, the exhibition traveled to other American venues and several countries. This exhibition brought wide attention to Chinese art, and encouraged a debate on the viability of considering artists from mainland China, Taiwan and Hong Kong as a unit. The exhibition's presence in New York had the side effect of temporarily heating up the market for contemporary Chinese art.

Fig. 12 Chen Haiyan, *Dream (Series I)*, 1986, woodcut, 60 x 60 cm, exhibited in *Die Hälfte des Himmels*, Frauen Museum

The end of the decade saw two shows that made creative use of the exhibition format. Wu Hung's *Canceled: Exhibiting Experimental Art in China* (Smart Museum of Art, Chicago, 2000), conjured a canceled Beijing exhibition as an opportunity to address the special issues surrounding the display and reception of art in China.[34] *Word Play: Contemporary Art by Xu Bing*, featuring many works created during the 1990s, was the Arthur M. Sackler Gallery's (Washington, D.C.; 2001; fig. 20) first major exhibition of contemporary Chinese art. Through the juxtaposition of early Chinese art with Xu Bing's works, I intended the exhibition to establish a provocative tension that led viewers to question whether the contemporary pieces drew on the superficial appearance of the traditional art, or made a deeper connection.

The 1990s saw the increasing inclusion of Chinese artists in group exhibitions of international artists. For the 1993 *Venice Biennale*, curator Achille Bonito Oliva (consulting with Francesca dal Lago) included fourteen Chinese artists in a section titled *Passaggio a Oriente*.[35] *Cities on the Move*, an innovative evolving exhibition curated by Hou Hanru and Hans-Ulrich Obrist, opened at the Wiener Secession, Vienna in 1997, with works by nineteen mainland Chinese artists (fig. 22).[36] Twenty Chinese artists appeared two years later in the *48th Venice Biennale*, curated by Harald Szeemann (fig. 23).[37] In 2000 Jean-Hubert Martin selected sixteen for *Partage d'Exotismes: the Fifth Lyon Biennial of Contemporary Art* (fig. 24).[38] In choosing twenty percent Chinese artists, Szeemann shocked many people— yet twenty percent of the world's population is Chinese, and we can guess that a similar proportion of the world's artists are Chinese. Many accused the curator of "playing the China card," particularly when he chose only three Chinese artists for the following biennial. The same was thought of Jean-Hubert Martin, who selected several artists who created shocking works from animal or human body parts—supposedly "exotic" works that were created in an "exotic" land. Conflicting feelings surround the selection for important overseas exhibitions: the desire to be included, plus an insecurity concerning the motivations for inclusion.[39]

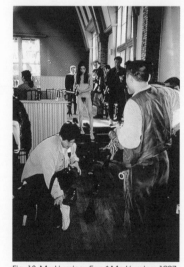

Fig. 13 Ma Liuming, *Fen * Ma Liuming*, 1997, performance for *Another Long March: Chinese Conceptual and Installation Art in the Nineties*, Fundament Foundation

Strategies

Because inclusion in the international art scene is perceived as vital for contemporary Chinese art, concerned figures in the art world have developed strategies to further this goal. Key strategists are Johnson Chang, Hou Hanru, and Zheng Shengtian. Others—notably the foreign directors of commercial galleries in China—have played essential roles, but with a lower profile. Possessing an astute grasp of the workings of the international art world, combined with exceptional facility with both English and Chinese, and with the financial means provided by his increasingly successful commercial art gallery, Hanart T Z Gallery, Johnson Chang was in the perfect position to introduce avant-garde Chinese art to the West. He not only organized *China's New Art, Post-1989*, but also curated several exhibitions associated with international periodical exhibitions, such as the *Sao Paulo Biennall* (fig. 25)[40] and the

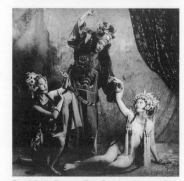

Fig. 14 Liu Zheng, *The Golden Stave*, 1997, tinted photograph, 60 x 51.2 cm, exhibited in *Zeitgenössische Fotokunst aus der Volksrepublik China*, Neuer Berliner Kunstverein

Venice Biennale,[41]thus bringing young Chinese artists to the attention of international curators.

A brilliant polyglot, Hou Hanru has been particularly effective in furthering the integration of Chinese art into the global art scene. In the early 1990s he wrote about contemporary Chinese art for progressive European journals, and became a voice for the "third space." As he moved into curating exhibitions of international art, he drew on the Chinese artists with whom he was familiar, naturally leading them into a widened milieu. Working with the artist-strategist Huang Yong Ping, he engineered the symbolic piercing of the French pavilion at the *48th Venice Biennale* by works of art created by a Chinese artist (fig. 26).[42] As co-curator of the first *Shanghai Biennale* to exhibit international artists (2000; fig. 27), Hou Hanru provided the exhibition with his imprimatur, thus drawing the attention of important international curators to the Chinese art world.[43]

Zheng Shengtian was a key organizer of *"I Don't Want to Play Cards with Cezanne" and Other Works: Selections from the Chinese "New Wave" and "Avant-Garde" Art of the Eighties*, the first large group exhibition of avant-garde Chinese art in the United States (curated by Richard Strassberg, Pacific Asia Museum in Pasadena, California, 1991).[44] At the time, he was affiliated with the Zhejiang Academy of Fine Arts in Hangzhou. He went on to play an extremely important role in introducing avant-garde Chinese art to the West, as director of Art Beatus, a gallery with branches in Hong Kong and Vancouver, and through his involvement with the Annie Wong Foundation. The Annie Wong Foundation contributed essential funding to important exhibitions, such as *Cities on the Move*, and Cai Guo-qiang's installation at the *48th Venice Biennale*.[45] Unfortunately, the foundation has since redirected its efforts.

Johnson Chang, Hou Hanru, and Zheng Shengtian have frequently acted as middle men for overseas curators. As such, they have strongly influenced which artists were introduced to the world. Zheng Shengtian accomplished this on a large scale in 2000, organizing a "curators' tour," which took a group of important overseas curators on a tour of China's art centers.

Another strategy to introduce Chinese artists to the world was devised by the major collector, Uli Sigg, who funds an art competition—the Contemporary Chinese Art Award (CCAA)—that is judged by international curators flown to China for this purpose (fig. 28). As he has stated, the goal of this enterprise is to further a "continuous dialog [of the artists] with their peers, with an interested public and ultimately with the international art world" as well as to "create a detailed record of the art produced over a given period by younger artists."[46]

Scholarship and Publishing

Publishing and scholarship conform to the same general pattern of dramatic and steady growth of interest apparent in exhibitions during the 1990s. Although the scholar Michael Sullivan has followed contemporary Chinese art for decades, ever since living in China in the 1940s, other Western scholars were slow to investigate this field. Fifteen years ago, one of my professors told me I was crazy to want to research contemporary Chinese art—because there was no such thing as contemporary Chinese art! Now that the field is gaining a higher profile, scholars are jumping into it, becoming instant "experts." Not surprisingly, the most valuable research is being done by those with a long-term interest in the field, particularly those who have spent long periods of time in China.

In a field that is new, it is extremely important to assemble data while it is fresh. Those most dedicated to gathering raw data include John Clark, an associate professor at the University of Sydney, and Hans van Dijk, the late director of the China Art and Archives Warehouse in Beijing. For years, John Clark has been compiling archives of recorded artist interviews and other material, and Hans van Dijk worked tirelessly to create a database indexing research materials on artists. A readily available bibliography of materials published up to 1999, that I compiled, is available online at http://www.stanford.edu/dept/art/china/. Several academic libraries, including the Art Library at Stanford University and the library of the Nelson-Atkins Museum of Art, have built up substantial holdings in the field of late twentieth-century Chinese experimental art, ensuring the future viability of research in this field at their institutions. In 2000, Asia Art Archive was founded in Hong Kong, with a mission to gather materials on Asian contemporary art, beginning with a year-long focus of resources on China.

Fig. 15 Qiu Zhijie, *8th of April*, 1996, mixed media installation (detail), exhibited in *Power of the Word*

Fig. 16 Cai Jin, *Canna No. 48*, 1994, oil on canvas, 200 x 190 cm, exhibited in *Transience: Chinese Experimental Art at the End of the Twentieth Century*, Smart Museum of Art

Fig. 17 Lin Yan, *To Beijing #4*, 1997, mixed media on paper, 229 x 229 cm, exhibited in *Jiangnan: Modern and Contemporary Art from South of the Yangzi River*, Art Beatus

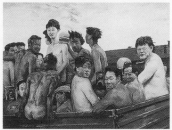

Fig. 18 Liu Xiaodong, *Violating* Rules, 1996, oil on canvas, 180 x 230 cm, exhibited in *Representing the People*, Chinese Arts Centre

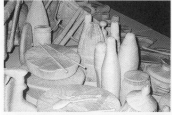

Fig. 19 Lin Tianmiao, *Bound Unbound*, 1995-97, mixed media installation with cotton thread, detail, exhibited in *Inside/Out: New Chinese Art*

A second step in approaching a new area of study is to create narrative and descriptive histories. This is a way of sorting the raw data into meaningful form. Such narratives commonly appear in texts designed to explicate the works of art displayed in exhibitions, for example in *China Avant-garde: Counter-currents in Art and Culture* (fig. 29), published in conjunction with the Haus der Kulturen der Welt exhibition of the same title.[47] The majority of articles published on the subject of avant-garde Chinese art in such journals as *ART Asia Pacific, Asian Art News*, and *"Chinese Type" Contemporary Art Online* Magazine (ak.a. Chinese-art.com) are in this vein, although they may include some art analysis or criticism, too. The most prolific writers with great facility in this manner include Johnson Chang, Gao Minglu, Li Xianting, Karen Smith, and others. Narrative texts in book form are much rarer, and are almost invariably fragmented, either being collections of essays, or constituting a section of a wider narrative. An early effort was *Gebrochene Bilder—Junge Kunst aus China*, an assemblage of essays and artists' biographies organized by Martina Köppel-Yang, Peter Schneckmann, and Eckard Schneider.[48] Until a decade or so ago, general surveys of Chinese, Asian, or world art gave the impression that Chinese art faded out circa 1850 or 1900. This situation has improved, and experimental Chinese art has an appearance in such texts as Robert Thorpe and Richard Vinograd's *Chinese Art and Culture*.[49] It is afforded significant coverage in Michael Sullivan's narrative history, *Art and Artists of Twentieth Century China*.[50] Another kind of narrative study is that which focuses on a single artist. Surprisingly, only one such book-length text has been published. My exhibition catalogue, *The Art of Xu Bing: Words without Meaning, Meaning without Words*, deals largely with the artist's works of the 1990s.[51]

Fig. 20 Xu Bing, *Landscript*, 2001, ink on Nepalese paper, 100 x 342 cm, exhibited in *Word Play: Contemporary Art by Xu Bing*, Arthur M. Sackler Gallery

A special mention should be made of Chinese-art.com, for many years publisher of the only Western language periodical devoted to contemporary avant-garde Chinese art, and unique in its mission to disseminate information in the field as expeditiously as possible, via the worldwide web. Publisher Robert Bernell launched *"Chinese Type" Contemporary Art Online Magazine* in late 1997, having devised a format that ensured both Chinese and overseas writers would be given the opportunity to publish their unedited texts. No other publication has brought such a volume of information or such a wide range of points of view to the attention of the West. A second English language periodical focusing on contemporary Chinese art, *Yishu*, has just published its first issue from Vancouver. A third may be in the works, based in Honolulu.

Fig. 21 Wang Gongxin, *The Face*, 1999, video, exhibited in *Translated Acts: Performance and Body Art from East Asia 1990-2001*, Haus der Kulturen der Welt and Queens Museum of Art

The third step in comprehending a new field, following data gathering and the assembly of narratives, is analysis. John Clark has led the field with his superior ability to maintain a critical distance. If one seeks to understand the various approaches that have been used in writing about contemporary Chinese art, a good staring point is the introductory chapter to John Clark's *Modern Asian Art*.[52] Hou Hanru, too, has critically articulated issues in contemporary Chinese art. Many articles germane to the study of experimental Chinese art of the 1990s have been published in his collected essays, *On the Mid-Ground*.[53] Scholars who have just completed or will soon complete doctoral dissertations in twentieth century Chinese art, and who are making important contributions to a more critical analysis of experimental Chinese art include Martina Köppel-Yang, Francesca dal Lago, Qian Zhijian, and Sasha Su-ling Welland.

Fig. 22 Zhan Wang, *Ruin Cleaning Project*, 1994, photo documentation of intervention, exhibited in *Cities on the Move*

As we enter the 21st century, a time that may well turn out to be the "Asian Century," art can serve as a unifying force, laying grounds for mutual understanding and appreciation. Chinese experimental art is becoming better represented and better comprehended in the West, but it is essential that more effort be made to look beyond the surface. It is too easy to make assumptions, to project irrelevant desiderata onto the works of art, and to be satisfied by a surface sheen of "Chinese-ness."

Britta Erickson is an independent scholar and curator.

Fig. 23 Wang Du, *Marche aux puces-Mise en vente d'informations d'occasion*, 1999, mixed media installation as exhibited at *48th Venice Biennale*

1 Joan Lebold Cohen, *Painting the Chinese Dream: Chinese Art Thirty Years After the Revolution*, (Northampton, Massachusetts: Smith College Museum of Art, 1982).

2 *Artists from China—New Expressions*, (Bronxville, New York: Sarah Lawrence College, 1987).

3 Jean-Hubert Martin, et al., *Magiciens de la Terre*, (Paris: Centre Georges Pompidou, 1989).

4 Bruce Parsons, comp., *Dangerous Chessboard Leaves the Ground*, (Toronto: Art Gallery of York University, 1987).

5 Britta Erickson, *Three Installations by Xu Bing*, (Madison, Wisconsin: Elvehjem Museum of Art, 1991).

6 Anneli Fuch and Geremie Barme, *Flying Dragon in the Heavens*, (Humlebaek, Denmark: Louisiana Museum of Modern Art, 1997).

7 Jane Farver (curator) and Reiko Tomii, *Cultural Melting Bath: Projects for the 20th Century*, (New York: Queens Museum of Art, 1997).

8 Fei Dawei, *Art Chinois, Chine Demain Pour Hier*, (Paris: Carte Secrete, 1990).

9 David Elliott and Lydie Mepham, ed., *Silent Energy*, (Oxford: Museum of Modern Art, 1993).

10 Julia F. Andrews and Gao Minglu, *Fragmented Memory: The Chinese Avant-Garde in Exile*, (Columbus, Ohio: Wexner Center for the Arts, The Ohio State University, 1993).

11 Jari-Pekka Vanhala, ed., *Out of the Centre*, (Pori, Finland: Porin Tadeimuseo, 1994).

12 Marianne Brouwer, ed., *Heart of Darkness*, (Otterlo: Stichting Kröller-Müller Museum, 1994).

13 *Beyond the Future: the Third Asia-Pacific Triennial of Contemporary Art*, (Brisbane: Queensland Art Gallery, 1999), 25.

14 Claire Roberts, *New Art from China: Post-Mao Product*, (Sydney: Art Gallery of New South Wales, 1992).

15 Jochen Noth, et al., eds., *China Avant-Garde: Counter-Currents in Art and Culture*, (Hong Kong: Oxford University Press, 1993).

16 Folke Edwards, *Change — Chinese Contemporary Art*, (Götaborg, Sweden: Konsthallen, 1995).

17 Imma González Puy, et al., *Des del País del Centre: Avantguardes art ístiques xineses*, (Barcelona: Generalitat de Catalunya, Departament de Cultura, 1995).

18 Dieter Ronte, Walter Smerling, Evelyn Weiss, et al., *China! Zeitgenossische Malerei*, (Bonn: Dumont, 1996).

19 Dieter Ronte, Walter Smerling, Evelyn Weiss, et al., *"Quotation Marks:" Chinese Contemporary Paintings*, (Singapore: Singapore Art Museum, 1997).

20 Johnson Chang, et al., *China's New Art, Post-1989*, (Hong Kong: Hanart T Z Gallery, 1993).

21 *China/Avant-Garde*, (Guangxi People's Publishing House, 1989).

22 Nicholas Jose, ed., *Mao Goes Pop, China Post-1989*, (Sydney: Museum of Contemporary Art, 1993).

23 Chris Werner, Qiu Ping, and Marianne Pitzen, eds., *Die Hälfte des Himmels: Chinesische Künstlerinnen*, (Bonn: Frauen Museum, 1998).

24 Chris Dreissen and Heidi van Mierlo, eds., *Another Long March: Chinese Conceptual and Installation Art in the Nineties*, (Breda: Fundament Foundation, 1997).

25 Andreas Schmid and Alexander Tolnay, *Zeitgenössische Fotokunst aus der VR China*, (Berlin: Edition Braus, 1997).

26 Eckhard R. Schneider, et al., *Im Spiegel der Eigenen Tradition: Ausstellung Zeitgenössischer Chinesischer Kunst*, (Beijing: Botschaft der Bundesrepublik Deutschland, 1998).

27 Patricia Eichenbaum Karetzky, *Contemporary Chinese Art and the Literary Culture of China*, (Bronx, New York: Lehman College Art Gallery, 1999).

28 Johnson Chang, *Power of the Word* , (New York: Independent Curators International, 1999).

29 Shen Kuiyi, *Word and Meaning: Six Contemporary Chinese Artists*, (Buffalo, New York: University at Buffalo Art Gallery, 2000).

30 Wu Hung, *Transience: Chinese Experimental Art at the End of the Twentieth Century*, (Chicago: Smart Museum of Art, 1999).

31 Hank Bull, ed., *Jiangnan: Modern and Contemporary Art from South of the Yangzi River*, (Vancouver: Annie Wong Art Foundation and Western Front Society, 1998).

32 Karen Smith, *Representing the People*, (Manchester: Chinese Arts Centre, 1999).

33 Gao Minglu, ed., *Inside Out: New Chinese Art*, (Berkeley: University of California Press, 1998).

34 Wu Hung, *Exhibiting Experimental Art in China*, (Chicago: Smart Museum of Art, 2000).

35 *La Biennale di Venezia, XLV Esposizione Internazionale d'Arte, vol. 2*, (Venice: Marsilio Editori, 1993).

36 Hou Hanru and Hans-Ulrich Obrist, eds., *Cities on the Move*, (Ostfildern-Ruit, Germany: Verlag Gerd Hatje, 1997).

37 Harald Szeemann and Cecilia Liveriero Lavelli, eds., *La Biennale di Venezia, 48th Esposizione Internazionale d'Arte*, (Venice: Marsilio Editori, 1999).

38 Thierry Prat, Thierry Raspail, Jean-Hubert Martin, et al., *Partage d'Exotismes: 5e Biennale d'Art Contemporain de Lyon*, (Réunion des Musé es Nationaux, 2000).

39 For more information about the inclusion of Chinese artists in major international periodical exhibitions, see Francesca dal Lago, *"From Crafts to Art: Chinese Artists at the Venice Biennale, 1980-2001,"* unpublished paper.

Fig. 24 Xiao Yu, *Ruan*, 1999, mixed media with animal parts, documentation exhibited in *Partage d'Exotismes: the Fifth Lyon Biennale of Contemporary Art*

Fig. 25 Fang Lijun, *1993 No. 15*, 1993, oil on canvas, 170 x 260 cm, exhibited in the Chinese Exhibitions-curated by Johnson Chang-at the *22nd International Biennial of São Paulo*, 1994

Fig. 26 Huang Yong Ping, *One Man, Nine Animals*, 1999, wood and aluminum, installed at the French Pavilion, *48th Venice Biennale*

40 Valerie Doran, Melanie Pong, Stephen Cheung, Ying Yee Ho and Una Shannon, eds., *Chinese Contemporary Art at Sao Paulo,* (Hong Kong: Hanart TZ Gallery, 1994).

41 Melanie Pong, Josette Balsa, Stephen T. N. Cheung, Una Shannon and Louisa Teo, eds., *L'altra Faccia: Tre Artisti Cinesi a Venezia,* (Milan: Zanzibar, 1995).

42 Denys Zacharopoulos and Hou Hanru, *Huang Yong Ping: La Biennale de Venise 48e Exposition Internationale d'Art Pavillon Francais 1999,* (Association Franc ais d'Action Artistique—Ministère des Affaires Etrangères, 1999).

43 Chen Tong, et al., eds., *Shanghai Biennale 2000,* (Shanghai: Shanghai Shu hua Chubanshe, 2000).

44 Richard E. Strassberg, ed., *"I Don't Want to Play Cards with Cezanne" and Other Works: Selections from the Chinese "New Wave" and "Avant-Garde" Art of the Eighties,* (Pasadena, California: Pacific Art Museum, 1991).

45 Cai Guo-qiang, *Venice's Rent Collection Courtyard,* (Vancouver: Annie Wong Art Foundation, 1999).

46 "Harald Szeemann Talks to Chinese Artists about Venice, CCAA and Curatorial Strategies," Chinese-art.com, vol. 3, issue. 1 (2000); reprinted in Wu Hung, ed., *Chinese Art at the Crossroads: Between Past and Future, Between East and West,* (Hong Kong: New Art Media, 2001), 148-61.

47 Noth, ibid.

48 Martina Köppel-Yang, Peter Schneckmann and Eckard R. Schneider, *Gebrochene Bilder—Junge Kunst aus China,* (Hamburg: Drachenbrücke, Horlemann Verlag, Unkel/Rhein and Bad Honnef, 1991).

49 Robert Thorpe and Richard Vinograd, *Chinese Art and Culture,* (New York: Harry Abrams, 2001).

50 Michael Sullivan, *Art and Artists of Twentieth Century China,* (Berkeley and Los Angeles: University of California Press, 1996).

51 Britta Erickson, *Words without Meaning, Meaning without Words: the Art of Xu Bing,* (Washington, D.C.: Arthur M. Sackler Gallery and Seattle: University of Washington Press, 2001).

52 John Clark, *Modern Asian Art,* (Roseville East, New South Wales: Craftsman House, 1998).

53 Hou Hanru, *On the Mid-Ground,* (Hong Kong: Timezone 8, 2002).

Fig. 27 Sui Jianguo, *Study on the Folding of Clothes* (*Dying Slave* and *Discus Thrower*), 1998, as installed at the Shanghai Biennale (2000)

Fig. 28 Chen Shaoxiong, *Street,* 1999, photo installation (Chen was a Contemporary Chinese Art Award 2000 prize winner.)

Fig. 29 *China Avant-garde: Counter-currents in Art and Culture,* by Jochen Noth et al., Hong Kong, 1993

Building on the Ruins: The Exploration of New Urban Cinema of the 1990s

Zhang Zhen

Fig. 1 On the Beat, directed by Ning Ying, 1995

Fig. 2 Beijing Bicycle, directed by Wang Xiaoshuai, 2001

Fig. 3 Suzhou River, directed by Lou Hua, 2000

Introduction: The Emergence of the 'Urban Generation'

It is no exaggeration to say that the most prominent characteristic of Chinese cinema of the 1990s is its focus on the drastic urbanization of the so-called "post-New Era." Quite different from commercial films that also deal with urban themes, the films with an experimental spirit produced by the "Urban Generation"[1] not only record the urbanization process from a witness's point of view, but also critically reveal violent aspects of a society in transformation, deploying the perspective of an insider. More importantly, in addition to their constructive exploration in the domain of film of language and form, the creative work of the Urban Generation also includes the opening up of new spaces in the area of production and distribution, despite all kinds of pressures and obstacles.

What used to be called the "Sixth Generation" independent cinema has transformed itself into a broadly defined movement of experimental urban cinema at the turn of the 21st century, which is now generally known as the "Newborn Generation."[2] At the beginning of the 1990s, this cinema encountered many hardships, and operated within the limits of the "underground" (as represented by Zhang Yuan, Wang Xiaoshuai and He Yi). By the middle to the end of that decade, it became a multifaceted constellation. While Chinese cinema as a whole has declined rapidly under the impact of various internal and external constraints, an independent or independently minded cinema grows steadily and brings new energy and hopes to a new wave of moving images in China.

The tradition of a city-oriented cinema can be traced back to the earliest experiments in filmmaking in Shanghai, in the beginning of the 20th century. Early examples of this tradition include short films made by the Asia Company, and several first long story films, such as *Yan Ruisheng* and *Red Skeleton*, by some ephemeral "one-film" companies. By the 1920s and the 1930s, Shanghai urban modernity not only became the chief background of many films, in the so-called "Golden Age" of silent film and early sound film, it was also the key element in the content and form of these films.[3] While the process of intensified modernization resulted in the flourishing of a metropolitan material civilization, it also brought about a great gap between the rich and the poor, class differences, the intensification of gender politics, and the struggle and resistance of local culture against the onslaught of Western culture. The historical irony is that after a nearly half century-long socialist experiment, another turn to the "open door" policy and the desire to "complete" modernity and to "march into the world" (*zouxiang shijie*) has opened a new chapter in the history of urban cinema in China.

The swath of yellow earth, a symbol of the culturally marginal and materially impoverished home of China's modernity, entered the lens of the Fifth Generation's camera in the 1980s. This pushed Chinese cinema onto the center stage of international film scene in the post-Cold War era. The camera of the Urban Generation, which emerged in the 1990s, however, focused without any hesitation on the city in transformation and on the social groups on its margins. The ubiquity of bulldozers, road machinery, building cranes and urban ruins became the hallmark of a new urban cinema. While the mythical, larger-than-life icon of the repressed peasant woman (embodied by Gong Li) dominates Fifth Generation's glossy canvas in the era of reform, the subjects that populate the new urban cinema are a motley crew of plebeian but nonetheless troubled people on the margins in the age of transformation— ranging from aimless bohemians and petty thieves to taxi drivers, KTV bar hostesses, disabled people, migrant workers, and other marginalized subjects at the bottom of the society. The rise of the new urban cinema and the simultaneous emergence and maturation of a new generation of actors, professional or non-professional (such as Zhou Xun, Jia Hongsheng, Wang Hongwei), signaled the end of the Gong Li era. More importantly, these new urban "characters" share the same contemporary social space as the

creators as well as of the intended viewers of the new urban cinema.

(Post-)Modern Ruins, Historical Refractions, and Experiments in Film Language

Since the early 1990s, the infrastructure as well as the social fabric of large and small Chinese cities have undergone tremendous change. In big cities like Beijing, Shanghai, Tianjin and Guangzhou, vernacular housing (*hutong* in Beijing and *longtang* in Shanghai, for instance) and adjacent social spaces have encountered the fate of "tearing down and relocation"(*chaiqian*). They are replaced by highways, subway stations, shopping plazas and office buildings. Medium- to small- sized cities and even rural areas have also been swept into this urbanizing process. Large areas of arable land have almost overnight been turned into the site of the so-called small-town enterprises (*xiangzheng qiye*) or of joint-venture companies. Ancient towns with distinct traditional styles are given "plastic surgery" that transforms them into similar"modernized"or quasi-industrial cities, if not the satellite towns of big cities. This craze of urban construction of a highly destructive nature has brought about brand-new skylines. At the same time, it has also produced urban ruins and resulted in altered environment and alienated social relations. This, on a fundamental level, has reshaped the spiritual as well as material topography of contemporary Chinese society.[4] The so-called "postsocialist" ideology and economical structure are most manifest in these cities. The incursion of global capitalism, the commercialization of everyday life and culture, the gradual privatization of state enterprises — all these have resulted in the synchronous existence of different social systems or forms. This commingled socio-political form has the energy and cruelty of primitive accumulation of industrial capitalism as well as the sleekness of computerized, post-industrial global capitalism, along with its less apparent structural social inequity. These two faces of capitalism co-exist, side by side, with the remnants of socialism, together giving shape to the unique and shocking socio-scape of the era of *zhuanxing*.

Fig. 4 *Lunar Eclipse*, directed by Wang Quanan, 1999

The city has thus also become the concentrated site of cultural transformation.[5] Urbanization goes hand in hand with the growth of an energetic mass culture, which in turn has stimulated the growth of a marginal as well as an avant-garde culture. The relatively stable boundary between the city and the country in the 1980s broke down completely in the 1990s. Thousands of rural migrants have swarmed into the cities, partaking in the demolition of old urban areas, the expansion of existing cities, and the construction of the so-called "global cities"(such as Shenzhen, Zhuhai and Pudong of Shanghai).[6] Countless young female migrants (*dagongmei*) have entered the service-and-entertainment industry, joining the army of those who eat the "rice bowl of youth." In doing so they have also penetrated and re-drawn the urban map of everyday life and desire.[7] Films by the Urban Generation are populated by these "floating" or temporary urban residents, which makes up one of the most salient characteristics of this cinematic phenomenon. Examples include Ning Ying's *On the Beat* (1995, fig. 1) and *I Love Beijing* (2001), Wang Xiaoshuai's *So Close to Paradise* (1997) and *Beijing Bicycle* (2001, fig. 2), Jia Zhangke's *Xiaoshan Goes Home* (1995) and *Xiao Wu (1997)*, Ah Nian's *Call Me* (2000), Tang Danian's *City Paradise* (1999), Shi Runjiu's *A Beautiful New World* (2000). The prominent position of these floating urban subjects reveals the startling unevenness and unequal distribution of wealth during the so-called"transformation." The exploration in both content and form of the new urban cinema is thus intimately connected to its attention to and representation of such marginal figures.

Fig. 5 *Lunar Eclipse*, directed by Wang Quanan, 1999

In attempting to register both the extensive presence and contemporary character of the figure of the migrant worker (male as well as female), the style of the new urban cinema manifests a dynamic interplay of narrative and documentary approaches. At times it tends toward hyper-realism. The latter is particularly visible in Ning Ying's works. Because these marginal characters stand for the most dramatic aspect of social contradictions in contemporary China, the sympathetic representation of the weak and victimized endows this cinema with a deeply felt empathy, as well as an archival character and a critical consciousness. In this respect, the new urban cinema of the 1990s has something in common with the urban cinema of the 1930s, which was marked by a pronounced critical realism. The latter, blending documentary and melodramatic elements, recorded the changing physiognomy of urban life under the stress of intensified modernization. Simultaneously borrowing "imported" film techniques and mining domestic traditional styles, the filmmakers of that period created a particular "Shanghai style" film language. Classical works such as Sun Yu's *Daybreak* (1933) and *Little Toys* (1933), Cai Chusheng's *Morning in a Metropolis* (1934), and Zheng Zhengqiu's *Sister Flowers* (1934) are good examples how a popular medium and cultural form was engaged, through infusing education into entertainment, to carry out an analysis of the "anatomy" of the social stratification and alienation brought about,

in part, by a booming urban material and commodity culture. While it is not the aim of this essay to construct a parallax film and urban historiography, the use of a historical zooming lens may help us to better appreciate the significance of the emergence of the Urban Generation at the end of the 20th century. The "repetition" of history underscores the "incompleteness" of modernity in China and worldwide; at the same time, it reminds us again the constant interpenetration or interaction between local cinema and global culture.

If the films of the early 1930s are replete with war ruins, especially after the Japanese attack of Manchuria and Shanghai, the new urban cinema is suffused with urban ruins resulted from global capitalism and the most recent wave of modernization in China. Scenes of demolition and relocation are ubiquitous — a telling index of the new urban cinema. The sequence in which Tao Lan, the protagonist in Zhang Yuan's *Seventeen Years* (fig. 11), is allowed out of the prison for her first parole in seventeen years, and seeking to attend the new year reunion and celebration but cannot find the home she left, offers a poignant portrayal of the "ruin" consciousness found in the new urban cinema. The sequence allegorically superimposes the cost of reform and the lost youth of a woman on the social margins. Her homeward journey becomes an odyssey across the urban wasteland and the labyrinth of commodity world in the era of "transformation." We witness and feel her anxiety when she crosses the busy street. Under the gigantic billboards advertising women's underwear, this "out of fashion" character appears both pathetic and tragic. In fact Tao Lan has no *home* to return to anymore, although she finally finds her parents in one of the new residential areas in the suburbs.[8] The melodramatic ending departs significantly from Zhang Yuan's previous works, harking back instead to Zheng Zhengqiu's family melodramas centered on ethics— a form Zheng perfected in order to represent or remedy the spiritual loss of modern urban dwellers.

The main setting (or "character") of Lou Ye's *Suzhou River* is the skeletal remains of the industrial era along the eponymous river, which serves as a kind of "living ruins" of Shanghai (fig. 3). The well-known film critic J. Hoberman calls the film a "dreamy documentary." He writes in *Village Voice*: "Lou has transformed Shanghai into a personal phantom zone. Named for an urban stream of consciousness, *Suzhou River* is a ghost story that's shot as though it were a documentary —and a documentary that feels like a dream."[9] *Suzhou River*'s quality as a "dreamy documentary" of Shanghai is encapsulated in the opening of the film before the title appears. The invisible videographer-qua-narrator holds his camera and drifts down the river on a boat and surveys the people and the urban landscape along the river. We see the turbid water, then the embankments lined with decrepit buildings, many of them in the process of being demolished. The film was begun as two separate projects for television in 1996. By the time the finished film entered the circle of international art cinema in 2000, it had become an important part of the city's archive. Within a few years, the river was "cleaned" up with a large infusion of money from the World Bank, and the views on the embankments changed beyond recognition. Expensive condominiums and office complexes are rapidly taking root along the riverbanks, where the half-torn buildings seen in the film once stood. The boathouses were forced out, and the sewage pits on the embankments replaced by strips of green promenades, at least on the stretches near the river mouth and the Bund. The urban lore today has it that even edible fish have begun to return to the creek, after decades of absence. If Huangpu River is commonly seen as the display window of Shanghai's (and China's) globalizing ambitions, proudly showing off the old and new architectural landmarks on its embankments, Lou Ye's choice of the Suzhou River, a *fleur du mal* of the city as it were, as the protagonist of his dreamy documentary can be seen as a specific critical posture. As the "negative" side of the prosperous metropolis, the story of *Suzhou River* demonstrates the vitality of the "other" of modernization and globalization. The "ghostly" aspect of the film, embodied by the two look-like girls played by the same actress Zhou Xun, further amplifies this theme.

The techniques used in *Suzhou River* for representing urban transformation and the uncanny of the particular historical period are also evident in Wang Quanan's *Lunar Eclipse* (1999, figs. 4, 5). Having the same actress playing two women, who are like "sisters" or mutual incarnates, and allowing their fates intertwine through their relationship with the same man who is a photographer or videographer, are shared traits of these two experimental, noir-style films. Both films rely on nonlinear narration, an open ending, discontinuous editing, mobile cinematography, extreme close-ups, an overall tactile film language, and above all on the skillful manipulation of "accidents" as narrative devices.[10] Like their contemporaries, the two filmmakers boldly borrow some of the idioms of international art cinema, including those used or created by Scorsese, Kieslowski, Iwaii Shuji, Hou Hsiao-hsien, Abbas Kiarostami, just to name a few. At the same time, their creative use of elements from Chinese narrative or dramatic traditions (such as the ghost love story in *The Peony Pavilion*, as

Fig. 6 The author interviewing Jia Zhangke, 2000

FESTIVAL DES 3 CONTINENTS · NANTES 98
MONTGOLFIÈRE D'OR · PRIX D'INTERPRETATION FEMININE

un film de jia zhang ke

artisan pickpocket
XIAO WU

Fig. 7 *Xiao Wu*, directed by Jia Zhangke, 1997

well as from early Chinese cinema, and liberal mixing of Hollywood melodrama with Soviet montage, among other things), together forge a film language that is full of the dynamic tension between the local and global, between art cinema and mass culture.

Two women who look the same but with different experiences appear in parallel, or multidimensional spaces of the same city. They are like twins but have no blood relations. They might be approximate simulations, but not exact copies of each other. The German scholar Hillel Shwartz stresses in his book *The Culture of Copy* that the ubiquitous examples of the use of twins, multiples, doppelgangers or replications as metonyms or metaphors in modern consumer culture demonstrate a popular imagination galvanized by modern technology. On the other hand, Schwartz argues that the vanishing (or disappearing) twin in the industrializing society serves as "mute testimony to vanishing kin" in an epoch of massive social dislocation and "fading networks of blood relations." The (vanishing) twin rekindles in us the belief in magic powers such as telepathy and miracle making in an age shot through with mechanical power.[11] Since the beginning of film history, images of doppelgangers or the like have never ceased to fascinate modern viewers, from The *Student of Prague* of 1913 to *La double vie de Veronique* of 1991. Its incarnation in China at the turn of the 21st century is itself a telling indication of the deeply fragmented and rapidly transforming society as well as of the identity of its citizens (especially women). On the metanarrative level, because of the suggestive relation between the image of the double and the ontology of cinema (especially given the overwhelming presence of diegetic cameras), these films also reveal a certain epistemological anxiety caused by the advancement and popularization of new imaging technologies.

Fig. 8 *Xiao Wu*, directed by Jia Zhangke, 1997

Construction 'on Location'

In terms of its contribution to cultural and aesthetic reconstruction on the ruins of modernity and postmodernity, the significance of the Urban Generation cinema extends to a renewed affirmation of the ontology of cinema as well as its social function. The contemporaneity of this group of films lies not only in their documenting and representing the changes in urban China today, but also in the emphasis on the complex relationship between the filmmaker and his or her object of representation. Some of the films (particularly Jia Zhangke's works) may be seen as products of a method that comes close to socio-anthropological "field work." A crucial component of this method is an awareness of being "on location" or "on scene"(*xianchang*). In the words of Wu Wenguang, a leading figure of the new documentary movement and the main spokesperson of the "on location" aesthetic, *xianchang* represents a cinematic operation in the "present tense" by virtue of "being present on the scene."[12] The essence of *xianchang* is embedded in the sensitivity toward the relationship between subject and object, and in a conscious reflection on the aesthetic treatment of this relationship. It is a cinematic practice and theory about space and temporality, which is charged with a sense of urgency and social responsibility.

The appearance of Jia Zhangke and his films at the end of the 1990s marked the consolidation of the poetics of *xianchang* (fig. 6) Very different from the Sixth Generation directors and cinematographers trained in the elite departments of Beijing Film Academy, the emergence of Jia Zhangke, a self-proclaimed "people's director" (*minjian daoyan*), posed a challenge to the established tradition or genealogy of directors as a privileged cultural elite class. As a non-matriculated student at the department of cinema studies, Jia was not entitled to make films. When Jia and his friends formed the "Young Experimental Film Workshop" and advocated an "amateur"(*yeyu*) or"non-official"(*minjian*) film practice, they encountered ridicule and criticism. Their first experiment was simply taking a borrowed video camera to "record" daily scenarios on Tiananmen Square.[13] *Xiao Shan Goes Home*, the short narrative film that followed, is a story about a migrant worker. Jia's breakthrough film, *Xiao Wu*, portrays a pickpocket in Jia's hometown Fengyang, who finds himself in an awkward and lonely existence after being reduced to a superfluous person in the era of "transformation." These films were made entirely outside of the official system, using very little money (only $2500 for *Xiao Shan* and $ 30, 000 for *Xiao Wu*) and working under very difficult or "primitive" conditions.

Most members of the Sixth Generation come from big cities and have advantageous social and educational background. Jia comes, however, from a remote small town and began to lead a migrant "artisan" life ever since his high school years, by writing fiction, painting advertisement billboards, and performing breakdance in a traveling troupe. While studying at the Beijing Film Academy, he paid his

tuition and supported himself by taking on "ghost writing" jobs piecing together TV drama episodes. His personal experience and his sympathy and respect for people at the bottom of the society led him to create Xiao Wu, a character who is both a singular individual and a general image (fig. 7)[14] Wearing a pair of outdated plastic eyeglasses, Xiao Wu is the only person with an "intellectual" air in town; but this "intellectual" is a pickpocket. The "artisan" thief has no place in a town being rapidly destroyed and rebuilt. He finds momentary solace in a KTV hostess.[15] This uncategorizable, awkward character is a far cry from the angry yet stylish and self-important avant-garde artists found in Zhang Yuan's *Beijing Bastard* (1993), Guan Hu's *Dirt* (1995), Wang Xiaoshuai's *Days* (1995) and *Frozen* (1998). Xiao Wu, directly coming from the *xianchang* of life, is the spokesperson of the new generation of "amateur" filmmakers. This figure, brilliantly played by Wang Hongwei, received in depth interpretation in Jia's masterly *Platform* (fig. 8) and became the embodiment of a collective identity. If Xiao Wu is a lonely outsider, in the epochal *Platform* Wang Hongwei's character stands for the incessant transformation of a local traveling troupe between the end of the Cultural Revolution and the end of the 1990s.

Fig. 9 *Shower*, directed by Zhang Yang, 2000

The rise of Jia Zhangke and the expansion of the amateur cinema in the social "location" at large have ushered in a film movement that is fundamentally different from the earlier independent cinema. This new wave takes the democratization of cinema as its motto and primary goal, thereby converging with the new documentary movement. More recently, the use of digital video and editing software, which were first embraced by the documentarians, in experimental feature filmmaking further demonstrates the impact of the aesthetic of *xianchang*. Many feature films incorporate footage shot on video, as in *Suzhou River*, *Lunar Eclipse* and *Shower* (fig. 9). This technique gives a feature film a dynamic feel of *xianchang* and contemporaneity, implicating both the filmmaker and the viewer as a direct or indirect "witness." With this new tendency, Bazinian documentary realism, Kracauer's phenomenology of material redemption, post-modern hyper-realism and other cinematic elements are constructively activated for the understanding and representation of the era of "transformation."

Fig. 10 *Mr. Zhao*, directed by Lü Yue, 1998

The involvement of video in feature filmmaking renews cinematic consciousness and language. Just as the rise of television influenced cinema vérité in the US in the 1960s, the flexibility of video camera combined with the intensity of long takes greatly enables the representation of the "unity of the event."[16] Those who have dabbled in commercials, MTV and other kinds of televisual practices, and hence possess a large and rich amount of visual vocabulary, can more easily blend idioms from popular media into feature films, further breaking down the barrier between the high and the low, professional and amateurish practices. As a result, the aesthetic effect and social function of film made for the large screen will change as well.

Xianchang also means literally "on location," on site. Most of the low-budget films are shot outside the studios (or the "system"). Subsequently, the entire society and social space become the natural location. For instance, the shooting of *Xiao Wu* was done in Fengyang, with an all-nonprofessional cast including local residents. Discussing the making of the film, Jia Zhangke comments, "I realized that working on this film was going to be an adventure on the scene of shooting. Experiences told me that when you were shooting on a live location, many unexpected things would happen. But unexpected possibilities would also arise."[17] One such "adventure" and its possibility created the unforgettable ending of *Xiao Wu*, where the onlooking crowd during the shooting, refusing to be dispersed, came to "play" the diegetic witnesses, "on the scene" of crime, as it were, of a pickpocket's utter humiliation and marginality. Ning Ying, the only prominent woman director of the Urban Generation, is also known for her enthusiastic use of real locations and nonprofessional actors. She admits that her films about her native Beijing are particularly suitable for casting nonprofessional actors, as can be seen in *For Fun* and *On the Beat*.[18]

Inseparable from the aesthetic of *xianchang* grounded in real places and locations is the use of local dialects. Beijing vernacular, Shanghai dialect (in Lü Yue's *Mr. Zhao*, for instance, fig. 10), local dialects in Shanxi, and so on serve to infuse the new urban films with the vitality of lived speeches and experiences, while also demonstrating the multiplicity and complexity of Chinese society. In this sense, many new urban films depart significantly from state productions, which more often than not use the standard Mandarin, as the embodiment of the "national soul." The new alternative practices open up new space for Chinese cinema. The linguistic space filled with local colors and rich human experiences allows fuller articulations of the *xianchang* aesthetic, including its liveliness and performativity. At the same time, *xianchang* also becomes a broader social, epistemological space. It is the space for witnesses; more importantly, it is a space for intervention on the part

of cultural producers and critics.

Non-official Images and the Public Sphere

The emergence of Urban Generation is not only directly connected to the destruction and reconstruction of the city, but also to the restructuring of the film system. The tremendous economic development after the introduction of market economy has impacted on the social and cultural life. The series of changes in film policy and reforms in the film industry since 1993 have loosened up a system that had been under strict state monopoly. Especially after the reforms of 1997, film production became increasingly divorced from distribution sectors. The incursion of Hollywood and Hong Kong cinema further contributed to the decline of domestic cinema. At the same time, however, this chaotic situation has also inadvertently provided some breathing space for a host of alternative forms of non-official or semi-official film practices. Despite daunting difficulties arising from being sandwiched between market forces and state control, the new generation of filmmakers and their supporters have made some constructive attempts in the production and dissemination of non-official film and video works.

The maturation of the Urban Generation by the end of the 1990s ended the antagonistic opposition between what had been known as the "underground cinema" and the official apparatus. Increasing numbers of joint productions between state-owned studios and non-official sectors, the commercial use of studio labels, lease of studio equipment and space, and other commercial practices have forced the studios to open up. In fact, many Urban Generation films are products of collaborations with, among others, Beijing Studio and Xi'an Studio. At the very least, a studio label was paid for in order for the film to be released. Such collaborations between the state and the filmmaker, between the studio and private capital, often fraught with tension and problems, reveal the complexity and multifacetedness of social and political structure during the "transformation."[19] An ambiguous area located in between the state, the individual and an incipient civil society has emerged. There are not only substantial changes within the studios, with some "oases" forming within the walls (from space lease and so on). Outside the walls, there have also emerged private media companies such as Imar, (which has successfully produced *Shower, A Beautiful New World, All the Way* and *Yesterday*), concentrating on opening up the domestic market. Some of the films produced by such companies have done well at the box office.

Fig. 11 *Seventeen Years*, directed by Zhang Yuan, 1999

While Hollywood blockbusters, state-sponsored "main-melody" films and politically safe commercial films take up most of the market in China, an alternative film public sphere with its distinctive strategies and characteristics has also appeared. Although festivals remain the chief means toward international recognition for non-official experimental films, the new generation filmmakers are more and more aware of the importance of cultivating a domestic audience. While a few entrepreneurs are trying to set up alternative distribution networks, a group of young filmmakers and film buffs have committed themselves to the creation of a public sphere in the urban space. A number of movie bars and film clubs have appeared in the cities. The popularization of VCD and DVD has greatly aided these collective viewing activities. The inspiration of the movie bar may have come in part from KTV and other commercial establishment that use screen images. Registered as eating and drinking businesses, the movie bars make up an ambiguous kind of public space. In Beijing alone, there are several, such as the Yellow Pavilion and the Box Cafe.

The programs at movie bars in Beijing are mostly coordinated by a non-official film association called "Practice Society," made up of BFA graduates and other independent cinephiles. Those who often visit these venues are mostly students, intellectuals, amateur filmmakers and other film buffs. The core members of the society have strong organizational skills and are well-versed in film history and theory. The programs they organize cover Chinese as well as world cinema; some of these focus on individual directors (such as Pasolini, Godard, Hou Hsiao-hsien) while others focus on particular film movements. These are often accompanied by lectures and discussions. The Society publishes a semizdat, not-for-profit journal called the *Practice Handbook*, reporting on recent activities of Chinese independent filmmaking as well as news on experimental film worldwide. The column on the Society's DV group concentrates on developments in digital video technology and practice. The Society also has extensive connections with major culture-oriented websites, co-hosting online discussions on independent filmmaking, thereby bringing the filmic public sphere into virtual space.[20]

Through the Internet, program exchanges, traditional print media and other means, the influence of Practice Society has reached many cities. In Shanghai, Guangzhou, Wuhan, Shenyang and Shenzhen, similar associations have also been formed. The 101 Club in Shanghai came into existence in as early as 1996. As of 2001,

it has 160 members and many new applicants. During the 1999 Shanghai International Film Festival, the club published a film guide which was widely popular. The Film Connection club based in Shenzhen was initiated jointly by several film critics and "feverish friends"(*fashaoyou*) of music and video. The motto of the club is "sharing film and sharing life." Taking advantage of the geographic proximity to Hong Kong, the club organized a special program on Hong Kong cinema and invited Ann Hui and others to come to Shenzhen to meet and talk to club members. [21]

In the fall of 2001, these non-official, not-for-profit, non-professional associations jointed forces and inaugurated the first Unrestricted New Image Festival. The Festival showcased a large number of short features, documentaries, experimental films, and animation films made since 1996. The main venue for the Festival in several cities is the municipal public library. This unprecedented event received support from Beijing Film Academy, the *Southern Weekly* and other institutions and organizations, becoming the first major non-official film movement to enter public space on a large scale. The planning and operation of the event was by and large nomadic in nature. But as one of the organizers Yang Zi stresses, these efforts are aimed at constructing an "open platform" for independent cinema. With tireless work, we can expand these "oases in the desert, which signify possibilities."[22]

From a global perspective, these non-official film-related practices represent, to borrow the words of the India-born, US-based anthropologist Arjun Appadurai, a kind of "grassroots globalization"movement. The goal of such a movement is to strive for"a democratic and autonomous standing in respect to the various forms by which global power further seeks to extend its dominion."[23] In this regard, the cultural and historical significance of the exploration of the Urban Generation cinema goes far beyond the limits of aesthetics and national geography. It is in fact connected to the challenges mounted by non-official organizations or communities to global capitalism and local authoritarianism worldwide.

Zhang Zhen is assisting professor in the Tisch School of the Arts and the department of cinema studies at New York University.

1 The term "Urban Generation" was coined by Jia Zhijie and me when we set out to organize a series of contemporary Chinese films by a new generation of directors. Unsatisfied with labels such as the "Sixth Generation" or "underground cinema," which are imprecise, to say the least, we realized that the single most important common feature of recent films by innovative young filmmakers is an acute sensitivity toward the problems brought by urbanization. The film series was exhibited at the Lincoln Center for the Performing Arts in New York, New York University, Harvard Film Archive and the National Gallery of Art in Washington D.C. in spring of 2001.

2 See Yin Hong, "Shiji zhijiao: 90 niandai Zhongguo dianying beiwang"(At the turn of the century: a memorandum for Chinese cinema of the 1990s), *Dangdai dianying* (Contemporary cinema), no. 1, 2001. The official recognition of the "New Born Generation" is manifest in the "Seminar on films by young directors" sponsored by Beijing Film Studio, China Film Corporation, Association of Chinese Filmmakers and the magazine *Dianying yishu* (Film Art), and held in Beijing in 1999. See the editorial article, "Yingru xinshiji de qingchun yingxiang: ji 'qingnian dianying zuopin taolunhui,' " *Dianying yishu* (Film Art), no.1, 2000.

3 On the relationship between early Chinese cinema and urban culture, see Yingjin Zhang ed., *Cinema and Urban Culture in Shanghai, 1922-1943,* (Stanford University Press, 1999). See also Li Daoxin,"Zhongguo zaoqi dianyingli de dushi xingxiang jiqi wenhua hanyi" (Images of the city in early Chinese cinema and their cultural meaning), *Shoudu shifan daxue xuebao* no. 6, 1999, 87-94.

4 "Ruin consciousness" was well articulated in the experimental art of the 1990s. See Wu Hung,"Ruins, Fragmentation, and the Chinese Modern/Postmodern," in Gao Minglu, ed., *Inside Out: New Chinese Art,* (Berkeley: University of California Press, 1998), 59-66. For a Chinese translation of the article, see Wu Hong,"Feixu, posui he Zhongguo xiandai yu hou xiandai" (Ruins, fragmentation, Chinese modernity and postmodernity), trans. from English by Zhang Zhen, *Qingxiang,* no. 2, 1999, 77-86.

5 On the impact of urbanization on contemporary Chinese society and culture, see Nancy N. Chen ed., *China Urban: Ethnographies of Contemporary Culture,* (Durham: Duke University Press, 2001); and Deborah Davis et al. eds., *Urban Spaces in Contemporary China: The Potential for Autonomy and Community in Post-Mao China,* (Cambridge University Press, 1995).

6 On "global city," see Saskia Sassen, *The Global City: New York, London, Tokyo,* (Princeton University Press, 1996).

7 See my article, "Mediating Time: The 'Rice Bowl of Youth'in fin de siècle Urban China," *Public Culture* 12:1 (Winter 2000).

8 See my article, "Zhang Yuan," in Yvonne Tasker ed., *Fifty Contemporary Filmmakers,* (Routledge, 2002).

9 J. Hoberman, "Vertigo-a-go-go and More Déjà Viewing: Eternal Return,"*Village Voice*, Nov. 14, 2000, 131.

10 See *Beijing dianying xueyuan xuebao*, no. 2, 2000 for a series of articles and discussions on *Lunar Eclipse*.

11 Hillel Schwartz, *The Culture of the Copy: Striking Likeness, Unreasonable Facsimiles,* (Zone Books, 1996), 24.

12 Wu Wenguang ed., *Xianchang* (Document), (Tianjin shehui kexueyuan chubanshe, 2000), 274.

13 Gu Zheng, "Women yiqi lai pai bu dianying ba— huiwang 'qingnian dianying xiaozu'" (Let's make a film— remembering the "Young experimental film workshop"), *Jintian*, no. 3, 1999.

14 See Wu Wenguang's interview with Jia Zhangke, in *Xianchang*, 184-213.

15 My conversation with Jia Zhangke, June 2000.

16 Roy Armes, *On Video,* (Routledge, 1985/1995), 130.

17 Lin Xudong's interview with Jia Zhangke, "Yige laizi Zhongguo jiceng minjian de daoyan" (A director who comes from the non-official bottom of society), *Jintian*, no. 3, 1999, 10.

18 On Ning Ying and her films, see Shen Yun, "Guanyu Zhaole he Minjing gushi — he Ning Ying de fangtan" (About *For Fun* and *On the Beat*—an conversation with Ning Ying); and Li Yiming, "Sheme shi dianying?—Zhaole he Minjing gushi de dianying xingtai" (What is cinema? The cinematic form of *For Fun* and *On the Beat*); Ni Zhen, "Jishixing he geren fengge de wanshan—ping Minjing gushi" (Documentary style and the perfection of personal style—on *On the Beat*). All of them are collected in Yang Yuanying et al., *Jiushi niandai de "di wudai"* (The"Fifth Generation"in the 1990s), (Beijing guangbo xueyuan chubanshe, 2000).

19 See Rao Shuoguang, "Shehui/wenhua zhuanxing yu dianying de fenhua yu zhenghe" (Socio-cultural transformation and the disintegration and reintegration of cinema), *Dangdai dianying*, no. 1, 2001.

20 See *Shijian shouce*, no.1, 2, 3, 4, 2000-1. Another English translation of the title of the publication is *Touch Film*, which suggests the importance of practice (by using one's own hands) and the tactile quality of cinema.

21 Mei Bing, "Chengshi dianying gaoshaozu" (Urban film buffs), as seen on www. Beida-online.com, November 2001.

22 Yang Zi, "Fengge yizhong, huo qita" (A style, or something else), *Shijian shouce*, no. 4, 2001, 49.

23 Arjun Appadurai, "Grassroots Globalization and Research Imagination,"*Public Culture* 12:1 (Winter 2000), 3.

Facing Reality: Chinese Documentary, Chinese Postsocialism

Chris Berry

Innovative documentary is one of the hallmarks of Chinese film and video since 1989. Most of the documentary makers associated with this new direction have professional backgrounds completely separate from the "Urban Generation" or "Sixth Generation" of young feature filmmakers. They usually shoot on video and come from the world of television, which has its own training institutions and regulations apart from those of film. However, there are notable similarities between the works they have produced and those of the "Urban" or "Sixth" generation. This essay examines the new documentaries within a comparative framework, arguing that both the new documentary and feature film makers face reality (*miandui xianshi*) in two senses.

First, there is a strong drive to represent reality behind both the new documentaries and feature films. Second, in the People's Republic since 1989, there has been a strong move towards developing a new understanding of the limits of the emergent public sphere and the possibilities of social transformation after, on the one hand, the events of 1989 and, on the other, the negative example of the former Soviet Union's fragmentation and decline following transition to democracy and capitalism in the nineties. Facing reality in these two senses works together as a productive tension, or over-determining contradiction, which conditions the new Chinese documentary. A more difficult question is whether the new documentary participates in the maintenance of Chinese postsocialism or disturbs it.

I specify "Chinese postsocialism" for two reasons. First, this essay is written out of the conviction that the new documentary in China can only be understood in this locally specific context. By way of comparison, Berenice Reynaud has introduced some of the work considered here in a survey essay that bristles with wonderful insights and provocations by placing it along with a range of other critical and independent Chinese video from before 1989, from Hong Kong, from Taiwan, and from the diaspora, including the United States. She links this material with the framework of response to the experience of colonialism and a general progressive politics of critical intervention.[1] While not challenging broad takes such as Reynaud's, this essay supplements them with an emphasis on the local specificity that makes independent documentary distinctive in post-1989 China. For example, many of the new documentary makers have drawn upon the *cinema verite* of Fred Wiseman and Ogawa Shinsuke's socially engaged documentary modes. But beyond formal similarities, both the appeal and the significance of these modes in post-1989 China is quite different from in 1960s United States and Japan, or in Taiwan and South Korea, where Ogawa's mode has also been appropriated.

Second, postsocialism is at once a condition shared across many different countries and experienced in locally specific ways. The term "postsocialism" has been used colloquially to mean simply "after the end of socialism." This makes sense in the countries that have appeared after the break-up of the Soviet Union, for instance. In the People's Republic of China, however, postsocialism has more parallels with Lyotard's postmodernism, where the forms and structures of the modern (in this case socialism) persist long after faith in the grand narrative that authorizes it has been lost.[2] Furthermore, this condition is even felt in the West, where the fall of the Berlin Wall in 1989 forced those on the Left—do such terms make sense anymore?—to confront not only declining faith in liberal capitalist democracy but also the absence of any visible alternative.[3] In other words, I write this essay not with a neo-Cold War hope that China may one day join the "free world," but out of a shared interest in the question of tactical responses to having to work in the globalizing territory of what de Certeau calls "the space

of the Other," at a time when the absence of visible and viable outside space threatens the meaningfulness of the very phrase.[4]

Who, then, are the new documentary makers in the People's Republic, what characterizes their work, and when did it begin? Probably the best-known Chinese documentary internationally and the one many people would assume initiated new documentary is *River Elegy* (*Heshang*, a.k.a. Death Song of the River, 1988). This polemic on cultural isolationism and the persistence of feudalism aired on the national state television network, China Central Television (CCTV), in the months prior to the 1989 events in Tiananmen Square and made its producers among China's most wanted fugitives in its wake.[5] However, although its message was challenging, in other ways it followed existing paradigms. All Chinese documentaries made prior to 1989 took the form of the pre-scripted illustrated lecture. Mostly, they were known as *zhuanti pian*, or literally, "special topic films," as opposed to newsreels (*xinwen pian*), which cover a range of topics in short reports. With the benefit of hindsight, the criticism is often made that the "cultural fever" and "democracy spring" of the late eighties were isolated from ordinary people. And indeed, the continued use of the illustrated lecture format in *River Elegy* implies its arguments are part of disputations amongst the governing elite. It belies both the Maoist rhetoric of going down amongst the people to learn from them and the newer participatory rhetoric of democracy, suggesting that the ordinary people (*laobaixing*) are not involved in the process of determining the future of their society but are waiting to be educated about the decisions made above and about them through documentaries such as this and other pedagogical materials.[6] Therefore, *River Elegy* cannot be considered the beginning of new documentary in China; the defining feature of the new documentary is a more spontaneous format.

Furthermore, the first Chinese documentary to move away from the illustrated lecture format and towards spontaneity was made outside the state-run system. Wu Wenguang's *Bumming in Beijing: The Last Dreamers* (*Liulang Beijing*, 1990) was first shown outside China at the Hong Kong Film Festival in 1991, and then traveled the world. It has, of course, never been broadcast in China. *Bumming in Beijing* provoked the same excited response that the feature film *Yellow Earth* (1984) did when it screened in Hong Kong in 1985.[7] Berenice Reynaud speaks of "the feeling that a new chapter of the history of representation was being written in front of my eyes."[8] Lu Xinyu, author of *The New Documentary Film Movement in China*, also traces the first manifestations of that "movement" to this film.[9]

Four main characteristics, all shared with the other new documentaries that began to appear in China at this time, made *Bumming in Beijing* so striking. They also provided a framework for comparing it to the new feature filmmaking and situating both phenomena within contemporary Chinese postsocialism. First, the experience and memory of 1989 is a crucial structuring absence. Second, the focus is directly on city life in China today among educated people like the documentary and filmmakers themselves. Third, as mentioned above, the illustrated lecture format is abandoned for more spontaneous shooting. And fourth, production within the state-owned system is eschewed for independent production. All of these characteristics change over time. The first fades as the immediate possibility of redress and political change also fades. The second increasingly comes to mean a focus on ordinary people in China today rather than the educated elite. The third undergoes a shift from more experimental to more mainstream modes of spontaneous documentary shot on more lightweight technology, including digital video. And the fourth is increasingly imbricate with television, making it more difficult to draw lines between independence, government direction, and determination by the market in a manner following the broader social and economic direction of postsocialist China, where it is harder and harder to draw a clear line between the state and private enterprise.

To start with 1989, *Bumming in Beijing* consists of four vignettes about four artists living in Beijing and working, like Wu Wenguang himself, outside the state-run system. Shooting began in mid-1988 and ended in late 1990.[10] We observe the independent artists' difficult living conditions, and their depression. By the end of the documentary, all but one have married foreigners and are preparing to leave or have left China.[11] The documentary does not directly address the 1989 events and the associated dashing of ideals. But it resonates with their absent presence, and without any other reason offered for the overwhelming atmosphere of hopelessness and the desire to leave the country, they are

most likely understood as accounting for both. Indeed, the lack of discussion of the events may imply that it is too dangerous to mention and effectively communicate the conditions producing the mood of the interviewees and the documentary itself.

1989 sees also the structuring absence at the heart of other relatively early new documentaries. Shi Jian, who together with his colleagues ran a documentary making team known as Structure, Wave, Youth and Cinema (SWYC) Group, is another pioneer of the new Chinese documentary. *I Graduated* (*Wo Biyele*, 1992) screened at the Hong Kong International Film Festival in 1993. Also interview-based, it focuses on members of the graduating class of Beijing University. There is much hand-held camera work, possibly because, as we see in the film itself, the equipment has to be smuggled onto campus in sports bags. At first sight, this may be puzzling. Also, these soon-to-graduate students are not at all ebullient. Instead, they worry about their job assignments[12] and mention other students that they miss. Eventually, viewers may recall that this campus and this class of students were very active in the 1989 democracy movement. That is why the campus is so strictly guarded, why they miss friends and why their futures are so uncertain. As the documentary develops, the interviewees allude more and more to the events that haunt them. In the years before and after 1989, SWYC also made an eight-part series called *Tiananmen Square* (1991), and it was also marked by the absence of the events of 1989 themselves. An important later documentary film that also seems over-determined by the taboo of 1989 is Zhang Yuan and Duan Jinchuan's feature-length documentary, *The Square* (*Guangchang*, 1994). A cinema verite portrait of the various daily activities and power plays that occur on the stage-like square. No one in the film addresses the event precisely because it is taboo.

This structuring absence of 1989 also lies at the heart of two of the earlier examples of the new feature filmmaking of the 1990s, He Jianjun's *Red Beads* (*Xuanlian*, 1993), and Wang Xiaoshuai's *The Days* (*Dongchun de Rizi*, 1993). The title of the first refers to bloodshed, and the narrative centers on post-traumatic mental illness. The second, like *Bumming in Beijing*, focuses on alienated artists and the question of whether or not to go overseas. Here, it seems important to note that whereas documentary filmmaking played little or no role in the wave of new Chinese cinema associated with the "Fifth Generation" of directors in the 1980s, it seems to have been central to the post-1989 cinema, and possibly to set the tone for feature filmmaking.

Both the new documentaries and feature films allude to politically sensitive topics indirectly, as the Fifth Generation did. But where Fifth Generation films like Zhang Yimou's *Raise the Red Lantern* (1991), Chen Kaige's *Yellow Earth*, and Tian Zhuangzhuang's *Horse Thief* (1986) used historical and/or geographically remote settings as allegories for the present, the new documentaries and feature films focused squarely on contemporary life. This second characteristic has continued after the triggering event of 1989 receded into the background with the passing of time, new economic growth, and the negative example of democratic change accompanied by social chaos in the former Soviet Union. But where the new features have a reputation for focusing on urban youth earned through features ranging from Zhang Yuan's *Beijing Bastards* (1991) to Wang Xiaoshuai's *Beijing Bicycle* (2001), the documentaries have diversified more within the common focus on contemporary life.

Initially, documentaries like *Bumming in Beijing* and *I Graduated* examined the lives of young, urban, and educated people similar to the filmmakers themselves. Wu Wenguang continued this in his follow-up to *Bumming in Beijing, At Home in the World* (1995), where he interviews the same subjects in their new homes around the world, and *My Time in the Red Guards* (1993), where he interviews former Red Guards, including Fifth Generation filmmaker Tian Zhuangzhuang. But other filmmakers have moved out to cover everyday life outside the major cities and as experienced by more ordinary people. Examples would include Duan Jinchuan's trilogy of films about Tibet (to be discussed further below), Lu Wangping's video about a traveling rural opera troupe, *The Story of Wang Laobai* (*Wang Laobai de Gushi*, 1996), or Wen Pulin's various videos about his own involvement in contemporary Tibetan Buddhism, such as *The Living Buddha of Kangba* (*Kangba Huofu*, 1991), *The Nuns of Minqiong* (*Minqiongan de Nigu*, 1992), *The Secret Site of Asceticism* (*Qingpu*, 1992, co-directed with Duan Jinchuan), and *Pa-dga' Living Buddha* (*Bajia Huofu*, 1993).

The interest of many documentary filmmakers in "minority nationalities" and the far-flung border

regions of China is a feature they share more with the Fifth Generation of feature filmmakers than the "Sixth" or "Urban" generation forming the primary framework in which the documentaries are considered here. This link can be traced to the mid-1980s fascination with these regions and peoples as some kind of "others" within China. By virtue of that paradoxical status, they could express the sense of alienation and distance from their own culture felt by many educated Chinese amidst the disillusion of the post-Mao era.[13] At this time, feature filmmakers went to shoot in these areas, and many future independent documentary makers went to visit, live, and or work in these areas. For Wen Pulin, Tibet is clearly an appealing place of refuge from the failure of modern materialist culture, whereas Duan Jinchuan seems to approach life in contemporary Tibet as one aspect of life in the People's Republic as a whole.

In the process of recording scenes of contemporary Chinese life, many documentaries have inevitably also touched on contemporary Chinese postsocialism's turn to the market economy for economic growth under the overall umbrella of the state-run system. In some cases, this is clearly deliberate. For example, Liu Xudong's *Diary of Tai Fu Xiang* (*Taifuxiang Riji*, 1998) details the efforts to put ownership of a bankrupt state-owned department store in Shijiazhuang into the hands of its employees, including the difficulties that many of those employees have finding the funds to invest in this dubious venture. Li Hong's *Return to Phoenix Bridge* (*Huidao Fenghuangqiao*, 1997) follows a group of young women who have come to Beijing as undocumented workers from the village of Phoenix Bridge in Anhui province to work as maids, a phenomenon which could not have occurred before the new mixed economic and social structure. And Wu Wenguang's latest DV (digital video) documentary, *On the Road* (*Jianghu*, 1999), follows the efforts of an entertainment troupe's efforts to find forms that will appeal to the market. This diversification in subject matter means the new documentary is no longer a phenomenon confined to the educated elite.

But even more significant in this broadening out of the new documentary is how the films and videos are made, both stylistically and institutionally, and their increasingly wide appeal. For not only do these new documentaries regularly "go down among the people," but they also give (or appear to give) the ordinary people a direct voice, which enables (or appears to enable) them to speak directly to other ordinary people and resonates with the economic agency that the development of a market sector gives (or appears to give) them.

Stylistically, this giving of a voice is centered in unscripted spontaneity. This was also one of the most immediately striking features *of Bumming in Beijing*, and of all the other new documentaries that have followed it. In Chinese, the most frequently used term in publications to describe this filmmaking mode is "on-the-spot realism"(*jishizhuyi*). In practice, in documentary it refers to a spontaneous and unscripted quality that is a fundamental and defining characteristic distinguishing them from the old scripted realism of the "special topic" documentaries. It is frequently accentuated by hand-held camera work and technical lapses and flaws characteristic of uncontrolled situations. The documentaries often also highlight events that conspicuously signify spontaneity and lack of script. The most obvious example in *Bumming in Beijing* would be the nervous breakdown painter Zhang Xiaping undergoes on camera. In *I Graduated* the cracked voices and tears of the interviewees function in the same way.

This drive to produce a new vision of the real is one aspect of the "facing reality" referred to in the title of this essay. The political significance of this change should not be sidestepped by invoking the rhetoric of emerging Chinese pluralism (*duoyuanhua*), but at the same time it must be acknowledged that its precise political significance is difficult to determine in an environment where economic liberalization has been accompanied by tighter political and ideological control. At a minimum it suggests the old realism is out of touch with China today and needs to be updated. But it may also be read as suggesting implicit contestation and challenge to the authority and legitimacy of those associated with the older pedagogical mode, appropriate to a structure where agency and leadership is concentrated in the state apparatus and its functionaries.

The same term used to describe the new documentary, *jishizhuyi* or "on-the-spot realism," is often also used to describe the contemporary urban films made by the younger generation of feature filmmakers. However, whereas for documentary makers "on-the-spot realism" is distinguished from

the scripted quality of the old "special topic" or *zhuanti* films, "on-the-spot realism" distinguishes the new features from two older stylistic traditions. One is the realism associated with "socialist realism," which is expressed in Chinese using a different term, *xianshizhuyi*, meaning representational realism. With the decline of faith in socialism, *xianshizhuyi* has come into disrepute. Where once it simply meant "realism," these days it seems to carry a connotation of fakery and at best reality as the authorities wish it were. This disrepute has prevailed for twenty years now, and indeed the "Fifth Generation" directors also saw many of the key characteristics of their work as reclaiming the real from *xianshizhuyi* . The use of locations as opposed to sets, natural light or darkness rather than artificial lights and blue filters, and unknown actors rather than stars, are all examples of this that can be readily observed in foundational Fifth Generation works like *One and Eight* (*Yige he Bage*, 1984) and *Yellow Earth*. However, the use of "on-the-spot realism" or *jishizhuyi* to describe the new trend of the nineties in feature films also distinguishes it from the art film stylizations and historical allegory of many Fifth Generation work, going instead for an unadorned contemporary look that is the fictional counterpart of the new documentary's spontaneous style.[14]

Perhaps one framework in which to consider this shift from the more conventional structures of the illustrated lecture format documentaries, socialist realist feature films, and even some of the more dramatic Fifth Generation films, on the one hand, and the new documentaries and "Sixth" or "Urban" generation films on the other would through Deleuze's ideas on the "movement-image" versus the "time-image." For Deleuze, the movement-image refers to the regime most commonly associated with Hollywood studio filmmaking. Here, time appears indirectly as a regime of movement, where framing, cutting, and so forth follows movement as marker of change and therefore of time. The rational and step-by-step logic of the documentary lecture also fits this logic.[15] By contrast, when the rational cause-and-effect subtending these linear structures disappears and it becomes less possible to predict when the cut will come, how the next shot will be linked to the last, or how long the shot will last, Deleuze believes a more direct representation of time appears.[16]

On occasion, this seems like a quest for some sort of transcendent truth. But Deleuze's prime examples of cinema of the time-image are more historically and socially grounded. They are drawn from European art films, and he links them to the collapse of faith in the grand narratives of modernity following Nazism and World War II; the same environment that laid the groundwork for the kind of postmodernity discussed by Lyotard. I have already indicated that the Chinese postsocialist environment and culture bear comparison to this phenomenon. Some of the independent documentaries and "Urban" or "Sixth" generation features also break away from the logic of the "movement-image" towards a distended form in which shots continue beyond any movement logic either in the literal sense or in the sense of narrative development. Both Jia Zhangke's feature films and Wu Wenguang's documentaries seem to follow this pattern, dwelling on time passing in a seemingly uncontrolled manner. (Perhaps it is not a pure coincidence that Jia's second feature, *Platform* (*Zhantai*, 1999) followed an entertainment troupe, as does Wu's *On the Road*.) Although this time passing is not the sense of "duration" invoked by Deleuze in reference to the time-image, this distended form does loosen the structure of the films. The relation between shots never becomes completely unpredictable and indeed chronology is followed; this is not quite the condition of what Deleuze calls "any-space-whatever." But it becomes hard to have a sense of teleology or progress as interviewees ramble verbally in Wu's films and characters ramble literally in Jia's. One loses any sense of knowing when a shot will end or exactly what it will cut to. This is quite different from the certain sense of progress invoked by the ideologies of modernity, be it driven by the socialist command economy or the alleged socialist market economy of the new era. Instead, the certainty of progress is replaced by a contingent life in which the characters react and respond rather than initiate, looking for ways to get by rather than having a clear sense of purpose.

Both Duan Jinchuan and Wu Wenguang have told me that their preference for unscripted work, hand-held cameras and events that signal spontaneity can be traced back to their encounters with foreign television crews, who started coming to shoot in China at the stations where they worked in the eighties. This preference also helps to explain why they and other new documentary makers were also

drawn to cinéma vérité , be it in the French interview style associated with Jean Rouch and his classic film *Chronique d'un Eté* (1961), which Wu Wenguang's interview films seem to echo, or the American observational style associated with filmmakers such as Fred Wiseman. After the screening of some of the early independent works in Hong Kong and elsewhere, documentary makers such as Wu Wenguang and Duan Jinchuan were invited to attend Asia's leading documentary film festival at Yamagata. There, in 1993, a special retrospective of Wiseman's work was held. The most direct evidence of the impact of this event can be seen in two films Duan went on to direct afterwards; *The Square*, mentioned above and co-directed with Zhang Yuan, and *No.16 Barkhor Street South* (*Bakuonanjie Shiliuhao*, 1996), part of his trilogy of Tibetan works. Both these films scrupulously followed Wiseman's formula of pure observational work with no interviews or arranged scenes, complete dependence on editing to bring the material together into a coherent whole through "mosaic structures."[17] Barkhor Street also followed Wiseman's well-known interest in social institutions, for the address that gives the film its title is that of the neighborhood office on Barkhor Street in central Lhasa, where pilgrims circumambulate and protestors sometimes gather. Duan's own eight years of living in Lhasa in the 1980s and his links with local Tibetan audio-visual groups put him in a unique position to carry out this project. The result is also unique; an unscripted record of the workings of Chinese government at the grassroots level and a picture of daily life in Tibet not written according to the ideological requirements of either Beijing or Dharamsala. For this film, Duan won the 1996 Prix du Réel in France, the first major international award won by a Chinese documentary film.[18]

The appeal of cinéma vérité and other more spontaneous documentary techniques because of their ability reclaim the authority of realism from the increasingly devalued "special topic" films can be understood as an example of cultural translation. Most theorists of cultural translation emphasize incommensurability, and that everything is somewhat changed in the process of translation. In her article "Translingual Practice," Lydia Liu recognizes how the direction and impact of translation may be conditioned by power, but also that whatever may enter a culture or society from overseas can only be made sense of in terms of the existing local cultural conditions and conventions. She therefore emphasizes the role of local agency in this process.[19] With this in mind, some additional local factors need to be borne in mind in accounting for the appeal and significance of spontaneous documentary techniques in the nineties.

First, in an environment saturated by institutional and self-censorship, spontaneous documentary techniques have a distinct advantage. For one thing, it is impossible for the authorities to require that a script be submitted. Also, it is difficult to blame for the documentary makers for what subjects say or do if they are not being told what to say or do by the documentary maker. Furthermore, if the subjects are the ordinary people revered by socialism, it is difficult for the censors to complain if their people say things they do not want to hear.

Second, these spontaneous documentary techniques seem like an extension of the well-established and very popular local genre of reportage literature (*baogao wenxue*). Reportage also derives a certain authority and ability to withstand censorship from its claim to veracity. This has not always exempted reportage writers from getting into trouble with the authorities when they publish accounts of events the authorities wish had not happened. But it has also made reportage a powerful site of resistance within China.[20]

Third, by giving voice to ordinary people, spontaneous documentary also taps into the longstanding practice of seeking out a public space for the airing of otherwise unresolved grievances. Most famously, this was co-opted by the Communists in the tradition of "speaking bitterness"(*suku*), where public meetings were held after a community was liberated and the local poor were encouraged to speak out about their sufferings at the hands of the local rich and powerful as a prelude to punishment. As regards to spontaneous documentaries made by individual filmmakers and given little circulation within China, this pattern is of less relevance. But the spontaneous techniques of the new documentary have spread like wildfire. As well as all manner of home movie documentaries produced by complete amateurs with access to digital video cameras but no training or idea of broadcast standards, (but often with an eye for remarkable materials,) the spontaneous documentary has become a television staple. It

appears most famously in magazine shows such as *Oriental Moment* (*Dongfang Shikong*) and *Life Space* (*Shenghuo Kongjian*), both aired by the national state-run station, China Central Television (CCTV). But it has also been taken up by all manner of local stations and programs. The resulting shows have been extremely popular, one surmises at least in part because seeing ordinary people speaking relatively openly and without rehearsal is refreshing.[21] However, although there may be no kindly Party Secretary "uncle"(*shushu*) visible on-screen and guiding what happens, television broadcasting does raise issues relating to commercial sponsorship (now estimated in many conversations with television executives to contribute 95% of Chinese television budgets), television station "gatekeepers" who self-censor, and government censorship itself.

This brings us to the final original distinguishing characteristic of new documentary, independence. As the increasing appearance of television programs that take on many of the characteristics of the early new documentary films indicates, independent production may no longer be such a hallmark. But at the beginning of both the new documentary and the new feature films of the nineties, this was a very notable characteristic. In a country where any form of production of anything outside the state-owned system was frowned upon as "capitalist roading" for many years, it was very striking indeed. Furthermore, it seems that after many years of difficult negotiation with the government censors in the late eighties experienced by feature filmmakers and the specter of much tighter control in the wake of the events of 1989, the decision to pioneer independent production was a common and distinguishing feature of both new documentary and new feature filmmaking. All the early films that won attention as new documentaries, such as *Bumming in Beijing* and *I Graduated*, as well as many of the early feature films of the younger Urban Generation of directors, such as *The Days*, *Beijing Bastards*, and *Red Beads*, were made independently.

However, what does "independence" mean for documentary makers in postsocialist China? There are two aspects that need to be addressed to answer this question. First, there is the difference between independence for feature filmmakers and for documentary makers. Second, there is the issue of what independence means under contemporary Chinese postsocialist conditions. In many ways, independent production is the film and video making equivalent of the broader appearance of a market sector of the economy within the overall state-planned socialist framework, which is one of the defining hallmarks of Chinese postsocialism. Not only is the market sector licensed by the state, but also as a smaller sector of the overall socio-economic structure, it is dependent upon and has to work with the state-owned sector regardless of tension, frictions and disjunctures.

First, the implications of independent status for the documentary makers and the feature filmmakers are quite different. Both China's independent documentary and feature filmmakers resist the label of "underground" and insist that independence does not necessarily equate to opposition to the state, the Party or the government. However, historically, film and television have been two separate worlds in China, administered by two different ministries until the mid-nineties and as a result covered by very different regulations. Filmmakers and television program makers train in different institutes, and there are few connections between them. While many connections can be seen amongst the documentary makers, for example in the co-direction of films listed above, none of them have made feature films. There is one notable exception to this pattern. Zhang Yuan is a member of the so-called Sixth Generation of feature filmmakers who graduated from Beijing Film Academy in 1989. But he has shown a strong interest in documentary since his first feature, *Mama* (1990), a feature about the mother of a disabled child which features inserted documentary sequences of interviews with real life mothers in this situation. Since then, he has continued to make both features and documentaries.[22] However, he is the exception that proves the rule, and despite similar aesthetic strategies and thematic interests, feature film and documentary makers are two separate groups operating in separate worlds.

The most serious consequence of this concerns the possibility of independent production, in the sense of production outside the state system. When the separate regulations designed to monitor and control television and film production were drawn up many years ago, they could not and did not envisage the physical and organizational possibility of independent production. The equipment was too expensive and there was no independent sector.

Within the state-run film system, various proactive and reactive local and national censorship regulations have been in place at different times, insisting on script approval prior to production and approval of completed films prior to release. Throughout the nineties, the government has actively intervened to close any loopholes enabling filmmakers to get round this, such as investment from overseas, editing overseas, sending films to film festivals prior to submitting them for approval for release, and so forth. Finally, in July of 1996, the government passed a new Film Law that explicitly made any film production other than within the state-owned studio system illegal.[23] This means that although would-be independent feature filmmakers might not think of themselves as underground or subversive, they have been defined as such by the government.

Within the state-run television system, however, the situation is significantly different. It is television stations and what they air that are regulated, not the production of materials on video. Furthermore, unlike film, the production of video materials can be achieved with ever cheaper and more accessible equipment, so it is not viable to attempt to gain proactive control over video production. In these circumstances, although many new documentaries have not been aired and may never be aired, so far there have not been any regulatory or legal interventions against the makers of these independent documentaries. In other words, unlike their film colleagues, they really can be independent without being underground or subversive.

However, this does not mean that the new documentary makers feel free to make whatever kinds of films they might like. Perhaps this can be seen most readily in how the highly influential mode of production associated with the late Japanese documentary maker Ogawa Shinsuke has been taken up in China. The Yamagata documentary film festival was initiated by Ogawa and his associates and so perhaps it is unsurprising that Ogawa's impact has been felt amongst the independent Chinese documentary makers who have visited Yamagata.[24] Ogawa's filmmaking has two main features. First, Ogawa is socially and politically engaged rather than an independent observer. Possibly his most famous films compose the *Fortress Narita* series, made in the late sixties and early seventies as part of the resistance to the forced selling of land for the building of Tokyo's Narita airport. Second, he lives and works among his subjects, relating to them as friends and colleagues rather than as an outsider. For the Chinese new documentary makers, the first characteristic is not and has never been an option: politically engaged social movements are ruthlessly suppressed in the People's Republic. But the second characteristic has been common from the first. Wu Wenguang's *Bumming in Beijing* is made about people he knows well and relates to as friends. Lu Wangping spent a year traveling around with the opera troupe he documents in *The Story of Wang Laobai*, and Li Hong spent two years befriending, living with and returning home with the young women whose story she tells in *Return to Phoenix Bridge* (1997).

This apparent self-censorship (conscious or unconscious) raises the other side of the question of independence—working within postsocialism. Just as the market sector is dependent on the state sector in the economy as a whole, the independent documentary makers cannot operate without reference to the state sector. Indeed, for the most part, they were trained within and worked within the state-owned television sector for years. Many of them continue to do so, making independent documentaries on the side while they earn their income in a television station. Shi Jian, of the SWYC Group, has been a powerful figure at CCTV all along, and initiated the program *Oriental Moment in* 1992. Li Hong made *Return to Phoenix Bridge* while moonlighting from CCTV and by borrowing unused station equipment.[25] Even those who, like Duan Jinchuan, have set up their own independent production companies continue to depend on the state-owned sector to some degree, as there are no privately-owned television stations in China and they cannot air their works in any other way. Duan studied at the Beijing Broadcast Institute, then went to work at Lhasa Television Station for eight years in the 1980s before returning to Beijing. Even though all his films in the 1990s have been made independently, the main investor in *No.16 Barkhor Street South* was CCTV— which has never aired the documentary— with a Tibetan company as a smaller financial partner. And the boom in television programming featuring the new documentary styles has given the new documentary makers work opportunities that they have not passed up. Liu Xudong's *Diary of Tai Fu Xiang* and Lu Wangping's *The Story of Wang*

Laobai, mentioned above, were both made for CCTV. Jiang Yue of *The Other Bank* has since made a video for CCTV called *A River Is Stilled* (*Jingzhi de He*, 1998) about the building of the Three Gorges dam from the perspective of the workers on the project.

This mutual implication of the "independent" documentaries and the state-owned television sector raises some complex questions. Put simply, what is the relation of these documentaries to the state? Are they a challenge, or are they complicit? If the relation is not to be considered in such a binary way, do they function as a supplement that changes the system or as a co-opted token that props it up? These questions are impossible to answer in an absolute and generally applicable way. It is even difficult to give a simple answer in regard to any individual film. For example, Zhang Yuan's *Crazy English* (*Fengkuang Yingyu*, 1999) is a cinéma vérité film that follows the celebrity Li Yang around from one of his mass English-teaching rallies to another. Mixing pedagogy and demagogy, Li yells out in English nationalistic business slogans about making money and outdoing the West, which the crowd yells back at him. He has been accepted by the authorities as a patriotic paradigm, and it seems they also accepted Zhang's film as a eulogy to this popular national hero. However, I could not avoid thinking as I watched this film that Li's mass teachings seemed like perverse postsocialist mutations on Mao rallies and deeply demagogic. Given the use of the cinéma vérité mode, it is difficult if not impossible to detect the filmmaker's own attitude.

To take another example that illustrates how difficult it is to make clear-cut judgments about these issues, we need to ask if the television documentaries really do provide a voice for the ordinary people to speak back to power? Or does the fact that they are made within conditions of government control and censorship mean that actually they act as ways of fooling the people into speaking their minds, or of getting good information about public opinion for the government whose own officials ordinary people would be wary of. And if the latter is true, is this necessarily a bad thing? Does it promote positive government change or prop up the existing system and its problems?

One could ask many more imponderable questions, but the fundamentally unstable, tense and ambivalent Gramscian hegemony that is postsocialism makes it impossible to answer them in a definitive way. Instead, only future developments will determine how this period and these documentary makers are seen with hindsight—as contributors to a struggle for gradual transformation from within or to the containment of tensions that later came to the surface.

Chris Berry is associate professor of film studies and dramatic art at University of California Berkeley.

1 Bérénice Reynaud, "New Visions/New Chinas: Video — Art, Documentation, and the Chinese Modernity in Question," in *Resolutions: Contemporary Video Practices*, ed. Michael Renov and Erika Suderburg, (Minneapolis: University of Minnesota Press, 1996), 229-257.

2 For further discussion of different uses of the term in the Chinese context, see Chris Berry, "Seeking Truth from Fiction: Feature Films as Historiography in Deng's China," *Film History* 7:1, (1995), 95.

3 Providing evidence for this argument is clearly beyond the rubric of this essay, but evidence could be sited from broad phenomena such as low turn-out in elections to the more specific and arcane, such as the post-Berlin Wall film, *Hedwig and the Angry Inch*, which by coincidence I saw as I worked on this essay.

4 Michel de Certeau, *The Practice of Everyday Life*, (Berkeley: University of California Press, 1984), 36-7.

5 Su Xiaokang and Wang Luxiang, *Deathsong of the River: A Reader's Guide to the Chinese TV Series Heshang*, trans. Richard W. Bodman and P. Wan, (Ithaca, NY: East Asia Program, Cornell University, 1991). Currently resident in the United States, Su has recently published his memoirs, *A History of Misfortune*, trans. Zhu Hong, (New York: Knopf, 2001).

6 Many of the articles composing the Chinese debate about *River Elegy* have been translated into English and published in *Chinese Sociology and Anthropology* 24, no.4 and 25, no.1 (1992). For a critical analysis of the documentary's argument, see Wang, Jing, "*Heshang* and the Paradoxes of the Chinese Enlightenment," in *High Culture Fever: Politics, Aesthetics, and Ideology in Deng's China*, (Berkeley: University of California Press, 1996), 118-136.

7 According to Tony Rayns, the occasion, which he finds "tempting" to date as the birth of the "New Chinese Cinema," "was received with something like collective rapture;" "Chinese Vocabulary: An Introduction to *King of the Children and the New Chinese Cinema*," in *King of the Children and the new Chinese Cinema*, Chen Kaige and Tony Rayns, (London: Faber and Faber, 1989), 1.

8 Reynaud, 235.

9 Lu Xinyu, *Zhongguo xin jilupian yundong* (*The new documentary film movement in China*), (Shanghai: Shanghai wenyi chubanshe, forthcoming 2001). I thank Professor Lu for sharing her ideas and some of her manuscript with me.

10 Wu Wenguang, "Bumming in Beijing—The Last Dreamers," in *The 20th Hong Kong International Film Festival*, ed. The Urban Council, (Hong Kong: The Urban Council, 1996), 130.

11 The remaining subject, a theater director called Mou Sen, was the focus of another early documentary, *The Other Bank* (*Bi 'an*, 1995), by Jiang Yue. The video follows Mou Sen's eponymous workshop, which attracts youngsters from around the country, but neglects to offer any practical help beyond the experience of the modernist and experimental workshop itself. Lu Xinyu opens her book with an extended discussion of this film, which she sees as representative of the fall away from utopianism and self-criticism amongst the former avant-garde at the heart of new documentary.

12 At this time, students were still assigned work by the state on graduation.

13 For different opinions on this phenomenon in feature filmmaking, see Chris Berry, "Race (*Minzu*): Chinese Film and the Politics of Nationalism," *Cinema Journal* 31:2 (1992), 45-58; Hu Ke, "The Relationship between the Minority Nationalities and the Han in the Cinema," in Gao Honghu et.al., ed., (Chinese national minorities films), (Beijing: *Zhongguo dianying chubanshe*, 1997), 205-211; Zhang Yingjin, "From 'Minority Film' to 'Minority Discourse:' Questions of Nationhood and Ethnicity in Chinese Cinema," in Sheldon Hsiao-peng Lu, ed., *Transnational Chinese Cinemas: Identity, Nationhood, Gender*, (Honolulu: University of Hawaii Press, 1997), 81-104; Dru C. Gladney, "Representing Nationality in China: Refiguring Majority / Minority Identities," *The Journal of Asian Studies* 53:1 (1994), 92-123; Esther C.M. Yau, "Is China the End of Hermeneutics? Or, Political and Cultural Usage of Non-Han Women in Mainland Chinese Films," *Discourse* 11:2 (1989), 115-138; and Stephanie Donald, "Women Reading Chinese Films: Between Orientalism and Silence," *Screen* 36:4 (1995), 325-340.

14 Here, I have noted the mimetic realist qualities found in some Fifth Generation films. For an interpretation that sees the non-mimetic qualities of these films listed at the end of this paragraph as a form of "expressive realism" or *xieshizhuyi*, also distinct from socialist realism's representational realism or xianshizhuyi, see Chris Berry and Mary Ann Farquhar, "Post-Socialist Strategies: An Analysis of *Yellow Earth* and *Black Cannon Incident*," in *Cinematic Landscapes: Observations on the Visual Arts and Cinema of China and Japan*, ed. Linda C. Ehrlich and David Desser, (Austin: University of Texas Press, 1994), 81-116.

15 Gilles Deleuze, *Cinema I: The Movement-Image*, trans. Hugh Tomlinson, (Minneapolis: University of Minnesota Press, 1986).

16 Gilles Deleuze, *Cinema 2: The Time-Image*, trans. Hugh Tomlinson and Robert Galeta, (Minneapolis: University of Minnesota Press, 1989).

17 Bill Nichols notes, "in a conventional mosaic, the *tesserae* (facets) merge to yield a coherent whole when seen from a distance. . . The *tesserae* or sequences of a Wiseman film are already coherent and do not merge into one impression or one narrative tale so much as supplement each other . . . The whole of a mosaic is almost invariably embedded in a larger architectural whole but such a larger whole is absent in Wiseman's case . . . the films . . . offer little overt acknowledgment that the institutions under study directly relate to a larger social context." Much the same could be said of Duan's film. Bill Nichols, "Frederick Wiseman's Documentaries: Theory and Structure," in *Ideology and the Image*, (Bloomington: University of Indiana Press, 1981), 211.

18 For more on Duan, *The Square* and *No.16 Barkhor Street*, see Chris Berry, "Interview with Duan Jinchuan," *Metro* 113/114 (1998), 88-9.

19 Liu, Lydia H., "Translingual Practice: The Discourse of Individualism between China and the West," *Positions* 1:1 (1993), 160-193.

20 On reportage as resistance, see Yingjin Zhang, "Narrative, Ideology, Subjectivity: Defining a Subversive Discourse in Chinese Reportage," in *Politics, Ideology and Literary Discourse in Modern China: Theoretical Interventions and Cultural Studies*, ed. Liu Kang and Xiaobing Tang, (Durham: Duke University Press, 1993), 211-242.

21 As well as the spontaneous documentaries, nationalistic documentaries in the "special topic" (*zhuanti*) mode have also

found new audiences on television, and even in the movie theaters, where in 1996 the film *Test of Strength* about the Korean War, known in China as the War to Resist US Aggression and Aid Korea, was an unprecedented box office hit in the cities. Ye Lou, "Popular Documentary Films," *Beijing Review* 41:26 (1998), 28-9.

22 For a more detailed discussion of Zhang Yuan's films focused on *East Palace, West Palace,* see Chris Berry, "*East Palace, West Palace*: Staging Gay Life in China," *Jump Cut* no. 42 (1998), 84-9.

23 In case any reader objects that fewer films are made directly by the studios than ever, my understanding is that the law requires that at least nominally films are made within that system and in conformity with its attendant censorship practices. This often involves "buying a studio logo" (*mai yige changbiao*) or paying a studio a fee for its nominal supervision.

24 Barbara Hammer's documentary *Devotion: A Film About Ogawa Productions* (2000) not only gives useful background to Ogawa but also features historical footage of foreign documentary makers listening to the great Ogawa expound. Amongst the attentive listeners is Wu Wenguang. Also noteworthy is the decision of Ogawa's widow to invite Chinese Fifth Generation feature filmmaker Peng Xiaolian to finish his final work, *Manzan Benigaki*, which was shown at the 2001 Yamagata festival.

25 Chris Berry, "Crossing the Wall," *Dox* no.13 (1997), 14-15.

Just on the Road: A Description of the Individual Way of Recording Images in the 1990s

Wu Wenguang

When the curators of the Guangzhou Triennial asked me to write about documentary filmmaking and digital video (DV) in China in the 1990s, I decided I could only write something empirical. The 1990s are only two years behind us, and it is hard to formulate a clear overview. Looking back at the documentaries produced during the 1990s, the people involved and my own work, I feel it is premature to analyze too deeply, for all is in the process of becoming, or at an exploratory stage. This is especially true in regard to DV format, which although used by an increasing number of individuals, is a way of processing images that has only been around for a few years. It still requires time and practice for these works to achieve an enduring quality. Equally, as an independent filmmaker myself, I am not entirely detached in passing comment upon the scene. What I can do is offer a straightforward summary of what has happened within the limits of my personal experience.

Fig. 1 *Bumming in Beijing,* Wu Wenguang, 1991

The beginning of the 1990s, as I recall, was relatively quiet; the liveliness of cultural activities that had been common prior to 1989 in Beijing was rare. In fact, activities became increasingly private, as friends drew together in cliques to drink and talk about what they were doing. With hindsight, we had been as a huge army following a wagon as it careened along a road. Suddenly, a mountain loomed ahead and the wagon and its entourage were forced to a halt. We had no choice and each left to seek his own way. It is probably one of the reasons why after 1989 artists' villages like Yuanmingyuan and Dongcun appeared in Beijing, and why innocuous exhibitions of folk arts, performances by independent troupes and individual video works came to exist. Yet, it was as the group performances on large stages to which everyone had been used to slipped out of the spotlight that the truly human instinct of free exploration became manifest. Perhaps in time we will be grateful to "1989," for the enormous turmoil it engendered brought about our awakening. People began to ask themselves: Who am I? What am I going to do?; questions that became relevant to the so-called new documentaries created during that time.

Today, the term "new documentary" or "independent production" seems a set phrase, yet as the 1990s unfolded, many people involved, including myself, were not clear about it. Perhaps because of the propaganda surrounding film and television and our own education, we did not have much understanding of the real meaning of a documentary or independent production. We had been shaped by the system and, in many ways, were tied to it. Most of us wanted to explore subjects other than assignments given to us, only because we were tired of the routine work. Our attempts might have produced some new elements but they were far from being independent or a revolt against standard practices.

One thing is rarely mentioned today. At the end of 1991, Shi Jian and several other people, who had graduated from the Beijing Broadcast Academy and were working with CCTV, held a *Seminar on New Documentaries* in Beijing. They showed documentaries that had been commissioned by and for television stations, including Shi Jian's *Tiananmen Square*, which had not been approved by the censorship board, and my *Bumming in Beijing*. In addition to people from the television industry, participants in the seminar included a number of individuals without clear "status," such as Jiang Yue, Wen Pulin and his brother, and myself. I remember filling in the participation form and writing "Academy of Literature" in the column headed work unit. I was surprised to see Jiang Yue, who came immediately after me, write "independent producer" in the space and remember thinking that he was really open about it.

I have forgotten the details of the seminar, except that it took place on the campus of Beijing Broadcast Academy, and most participants were from the broadcast industry. There was seemingly little that was new or probing in the documentaries. There was definitely an undertone of "seeking reform" within the system, the

significance of which was that those few participants who were without status found themselves in the company of like-minded people. Following this, Wen Pulin and his brother Wen Puqin, Jiang Yue, Bi Jianfeng, Duan Jinchuan, and Li Xiaoshan went on to make *Qingpu, Catholicism in Tibet,* and other documentaries in Tibet.

The first depicted a sacred place in Tibet called Qingpu, where various pilgrims lived. The second was about the history of a Catholic church in a remote Tibetan village, and its relationship to local villagers. These documentaries were mainly financed by a friend and supporter who was also a businessman, and no one was paid for their work. This was the most common approach to shooting independent videos.

At the time, this group of people lived and worked closely together. In an apartment building in a residential area in Beijing, the rooms were occupied by a few large mattresses and sleeping bags. I was often there, sitting or lying on the beds with the others, drinking and chatting about life, about work. Most of the time, we simply enjoyed the camaraderie of working together, experiencing a dream of utopia, so to speak.

1992 was the last flare of the idealistic dreaming that characterized the 1980s. During the difficult years, we helped and encouraged each other, and enjoyed great mutual support. Shi Jian and Wang Guangli produced *I Graduated,* regarding students at several universities in Beijing. Hao Zhiqiang produced *Big Tree Village* about a primary school in a polluted area of Sichuan. Jiang Yue produced *On the Other Shore* about a group of young people rehearsing and performing an experimental drama while studying acting in Beijing. Zhang Yuan and Duan Jinchuan produced *The Square* about Tiananmen Square, the people and the environment. Duan Jinchuan shot *No. 16 Barkhor Street South* featuring a neighborhood committee in Lhasa, Tibet. Li Hong filmed *Return to Phoenix Bridge* showing the lives of several girls from Anhui working as maids in Beijing. Lu Wangping shot *Somersault* about a couple from the Northeast making a living as street performers. Kang Jianning produced *Yin and Yang* about a rural area in northwest Ningxia. I completed the semi-autobiographical piece *My Time in the Red Guards* and *At Home in the World,* which picked up where *Bumming in Beijing* left off. All these documentaries were finished before 1997, and are often mentioned when people talk about new documentaries.

A number of these films were produced independently. Some were funded by investors, while others were commissioned by television stations. The common thread linking them all was that the producers knew each other and frequently were friends. They had a similar understanding of documentary subjects and similar dreams of directing the camera towards deeper aspects of society. It united them. As there were few public places for screening works, they often watched one another's works on home video players, giving each other criticism or encouragement.

One day, around 1992 or 1993, the majority of the people mentioned above were gathered at Zhang Yuan's home in Xidan Lane. Through the years, people came to imagine that the gathering was some kind of movement. In fact, it was nothing more than a party of friends. As I remember, someone once suggested to Zhang Yuan that people interested in shooting documentaries should get together. Zhang Yuan said we could meet at his home. The intention was to discuss the situation, but each one had different thoughts. At that time, the word "serious" or any serious action was laughed at, or dismissed with a sneer. We talked neither about what we had done, nor about what we intended to do. Much was random and I do not remember the details except that we did discuss the difficulties we had encountered in shooting documentaries.

Even today I have doubts about the so-called "new documentary movement" (and the term "DV movement" for shooting documentaries with DV). Certain new ideas or approaches might have emerged as these people shot their documentaries, but the "new" elements in them were only new compared with the propaganda-style productions produced for television stations. These "new" documentaries did nothing more than return to the basic tenets of documentary filmmaking, focusing on human existence and social issues. Earlier attempts had swiftly become outdated; new ones were not much ahead of the game. Perhaps my sense of the term "movement" differs from that of the critics in understanding and purpose. I expressed doubts about referring to the situation of Chinese documentaries of that time as a "movement" at a screening of documentaries titled *New Vision in New China,* held at MoMA, New York, 1997. To me, "movement" means something grand, spectacular and vigorous, but my own experience was only of people around me trying to shoot documentaries as freely as possible in their own ways and expressing their own ideas.

Fig. 2 *I Graduated,* Shi Jian and Wang Guangli, 1992

Fig. 3 *On the Other Shore,* Jiang Yue, 1995

Fig. 4 *No.16 Barkhor Street South,* Duan Jinchuan, 1996

If we look at the development of various arts in China in the 1980s and 1990s, such as poetry, literature, visual arts(including painting, installation), video, performance, and rock-and-roll, we see that they were rich in new styles and genres. Yet, they were not termed "movements" or "generations"Against the profound creativity of such a large number of artists in these areas, I can not accept these labels in terms of the documentary scene. People in film and television love to talk about superficial phenomena. They would create a term like "generation" and then prove it with a "movement" like that of "new documentaries." Anyone whose name was mentioned naturally felt proud, while those who were overlooked were disappointed. I think we should rid ourselves of "collectivist" behavior and ways of thinking, and then perhaps we will see the intrinsic quality of the works.

In terms of the documentaries that appeared before 1997, the most important factor was that individualism, free of the control by the system, played a determining role. In some cases, a documentary might have been commissioned by a television station, but because of the strong will of the producer, it ended up being his triumph.

Duan Jinchuan's *No. 16 Barkhor Street South* and Kang Jianning's *Yin and Yang* are examples of this. I was one of the first to see these two documentaries still in the edit suite. Both described places, what happened there, the people travelling there to and from the outside world. From the natural routine of a largely stationary life, daily life there was both familiar and strange. The documentaries were shocking yet inspiring to me at the time. First, the producers had a sharp, somber vision in the way they used "place" to show various elements of reality, including power, politics, environment, human relations, etc. As far as I know, no such approach had been seen in documentaries produced in China prior to that time. Second, as both producers were shooting documentaries for television stations, I was surprised how they had adherence to their own styles, knowing that I would feel compelled to compromise.

Fig. 5 *Yin and Yang,* Kang Jianning, 1997

Jiang Yue's *On the Other Shore* and Li Hong's *Return to Phoenix Bridge* were produced entirely independently, so both were able to follow the director's ideas about content and style. These documentaries focused on people's lives. I was somewhat involved in *On the Other Shore*, and understood what happened then and in the process of Jiang Yue's work. I am still moved by these artists and what they did for their art. As I was involved, it was not until some time later that I realized the exaggeration and fabrication of their artistic performance, and the deception it wrought on people. It took me a while to understand the reflection and criticism that underlies *On the Other Shore*. When I think of it, I am grateful to Jiang Yue for revealing my own frivolousness, exaggeration and stupidity.

Li Hong's *Return to Phoenix Bridge* also moved and inspired me in 1997 because it was shot from a woman's perspective. I could feel Li Hong's unbiased and quiet eyes following the young woman's movements, thoughts, and the people and things around her. I knew that this documentary could not be regarded as work by a mere woman and that as a man I should not presume to look down upon it, which I was in the habit of doing.

The above works have been widely written about, and I only talk here about elements in those documentaries I feel to be important but that have been neglected. Now, I will talk about people and works that relate to DV.

Fig. 6 *Return to Phoenix Bridge,* Li Hong, 1997

It was summer of 1997. I remember the time because the open-air bar at Deshengmen Gate Tower close to my home in Beijing was open for business. It was there I met with Yang Lina who would produce *The Elderly Men* two years later. Her real name was Yang Tianyi. On the phone she told me she was an actress at the Theatrical Company of the General Political Department of the PLA, and that she had shot various footage. This young actress was interested in shooting documentaries focused on what lay behind people's public lives. It was one of the reasons why I wanted to meet her. She told me she had filmed children in orphanages, scenes at Tiananmen Square, and retired old men sitting idly in the streets in her neighborhood. The last touched me. I was surprised that a young woman should have directed her camera towards the elderly, for it was widely said that busy young people were increasingly neglectful, even the so-called socially-righteous documentary makers. Yang also told me that initially she had hired a cameraman and sound engineer because she had never shot any film before. She fired them a few days later because they kept instructing the old men to sit closer together or altering their positions, making them feel embarrassed. She continued her project using a portable

digital video camera.

I did not notice any special relation between the portable video camera and the footage she showed me until after watching for several hours; I discovered that the pictures were unique to a small video camera and an individual point of view. Here, a group of elderly men gathered their stools on the street as if they were having a daily meeting. They chatted about their private affairs and the state of the nation. One elderly couple quarreled at home, another elderly man dozes off by a window, near a fish tank. Most shots were long and steady, with little panning, tilting or focusing. It was clear that a novice was operating the camera, hesitantly and nervously. It was also clear that the person was right at the scene quietly observing what was going on. As a veteran, I could not imagine such scenes being seen through the lens of a large intimidating camera. I also don't think that professionals would have chosen to focus on such ordinary scenes of daily life.

I had used such home video cameras myself, including a digital video camera like the one Yang used, but I had never thought of using them for a serious purpose, only to film exhibitions or rehearsals. Yang Lina's material shocked me and forced me to look at my own approach. I was in a lull after the exertion of filming *At Home in the World*. Film production involves a lot of tedious preparatory work like fund-raising and organizing a crew. I felt I was losing the impulse to shoot documentaries in the manner I wanted; I was becoming unsure what a documentary was. Yang Lina's work about the elderly men wrought a change in me. It began with a young novice asking me to give her guidance, and ended with me being inspired by the novice to a new way of shooting documentaries. *A Vagabond Life*, begun in 1998, was a result of that inspiration.

In 1999, as I completed *A Vagabond Life*, I had found salvation in DV. It might be a purely personal perspective, and has nothing to do with those who have their gaze fixed on international film festivals and prizes, or who love refined artistic videos and vigorously march toward that target. It saved me from drowning in the river of my own inertia.

Digital video cameras swiftly became a cheap, portable, convenient tools requiring only one person to operate. They could also be connected to a personal computer, which only requires a video capture card to become a video editing workstation. This was good news for all young people hoping to express themselves using video but not in possession of adequate facilities. Since 1998, numerous individuals have shot works using these small machines. From 1999 to 2000, the number of DV works boomed. In addition to professionals, a wide range of people was involved, including visual artists, company employees and students. The works they produced included documentaries, experimental short films, dramas and various shorts which are hard to define at present. In many cases it was the amateurs and novices that attracted the most attention, like Yang Lina and Wang Fen.

In the summer of 1999, Zhu Chuanming brought a videotape to me of his recently-completed documentary *Beijing Tanjiang*.[1] At that time, Zhu was in his junior year at Beijing Film Academy, majoring in photography. *Beijing Tanjiang* was his first work, inspired by a young man from a rural area in Hunan, who lived by recycling cotton in Beijing. He did not raise funds in the traditional way, for, as Zhu said, who would sponsor a student production? He borrowed V8 home video cameras from classmates for an afternoon or evening, and shot it segment by segment.

As I watched the videotape, the quality of scenes in the first ten minutes was so bad that I began to get impatient. But as it went on, I was drawn into the story of the young man, who carried out his task in a makeshift tent on the street. His experiences and ambitions moved me. Most moving was the happiness exhibited as he and his brother's family took snapshots at Tiananmen Square in the snow; when he and his nephew made a snowman and hung a tie around its neck; when he purchased a 2000 calendar and paid five *yuan* to have his portrait printed onto the cover. The simple happiness of common people as demonstrated in the film was totally different from the grief often seen in documentaries; yet it truly showed an attitude of looking a forlorn life directly in the face. All this took place under the gaze of Zhu Chuanming, who was about the same age as the young man, and who hailed from a remote town in Jiujiang, Jiangxi province. It was a revelation.

Zhu Chuanming's *Beijing Tanjiang* was not a typical DV product. It was ahead of many DV works or one-man films in approach. Before DV, video cameras like V8, HI8 and HI8 with 3CCD had been in use for some years, but no one in China (except video artists) had used them for any serious purpose. I bought an HI8 with

Fig. 7 *On the Road*, Wu Wenguang, 1999

3CCD in 1994, but never used it professionally, except when there was no better machine available. This was common among all professionals. However, when these kinds of home video cameras appeared in the 1980s abroad, they were used to make experimental videos, works of video art, and some documentaries. All video works shot by Bill Viola were produced in this manner.

In China, video artists like Zhang Peili were the first to use such small cameras to produce works. They did not believe that the size of the machine or quality of images had a determining impact on the quality of the artist's work; neither did they hold the ridiculous view that using a small machine was insulting to an artist. Yet, prior to that time, that very view had been an insurmountable impediment among professionals or those who wished to become professionals.

DV introduced new freedoms, of greatest impact upon young people or those with financial limitations. From 1999 to 2000, DV-related documentaries appeared in large numbers. Ji Dan studied in Japan for several years, majoring in something unrelated to photography. Curiously, when she returned to China, she travelled to Tibet with an HI8 video camera. Unlike a tourist, or one exploring the folklore of a strange land, whose journey is but brief, she set up home in a village in south Tibet. She had all but been forgotten when she returned with two documentaries, *Gongbu's Happy Life* and *The Elderly People*, which showed in detail the everyday life of Tibetans in a remote part of a high mountain. These differed from the kind of films about Tibet that are usually produced, which inalienably pivoted on religion and politics.

Fig. 8 *Along the Railway*, Du Haibin, 2000

On the Edge of Freedom, another work of the same period, was about a group of young people living in Waishu Village in the northwestern suburbs of Beijing, who had gathered there because they loved rock-and-roll music. Sun Zhiqiang, who shot the documentary, was one of them. After graduating from high school, Sun, who came from Urumqi,[2] became a soldier and then a worker. He played in a band called Tongue, whose members all came from the same area but did not have much experience concerning music. No one questioned why someone with no previous experience in film or television production would want to make a film. We only knew that he used a National M9000, an out-of-date home video camera, which his elder brother who ran a photographic studio had used to shoot weddings. As the cameraman was friends with the people he was shooting, the major feature of the film is a free, relaxed approach. These people were not successful, famous or rich, but they were lavish with their youth and freedom. Sleeping till noon, a careless supper of noodles, random talks and jokes form main details of the plot. It is hard to imagine that someone from outside the village, even with a detailed script and great enthusiasm, could produce such a work.

Next there was *Along the Railway* by Du Haibin, a classmate of Zhu Chuanming at the Beijing Film Academy. He had a V8 home video camera, for "practice," he said. He shot *Along the Railway* by chance. According to Du, during the 2000 winter vacation, he was shooting scenes for a drama with the video camera in his hometown Baoji, when he met a group of wanderers whose ages ranged from teens to mid-30s. He approached them with his camera, and found them easy to get along with. Their lives as portrayed in his film are not thrilling or strange as one might imagine. It shows them eating, sleeping, earning a living, dressing themselves up, and picturing their future; all basic necessities of everyday life. Although their way of life is somewhat alternative, they have the same mental and physical needs, including making practical jokes such as pretending to call 911 with a toy cell phone they happen to pick up, or determining how to share an apple evenly, or singing by a bonfire at night. And we listen to these unusual people—who usually only pass briefly before our eyes—talk about their homes, parents, friends. The viewer is compelled to listen to them chat as they squat by a wall or sit by the rail track. Though their voices are often obscured by the roar of a passing train, we wait patiently. A different kind of life is being lived, yet in a way we fully understand. Unlike most documentaries that deliberately seek novelty, this work calmly offers a totally unamazing life. This is where the force of Du Haibin's work lies.

The shooting of *Along the Railway* can be understood in this way: A person holding a video camera is led by the real people in the film to events in real life. Of course, the attitude of the person holding the camera and his experience is also important. I found Du's mind open and modest in front of the changing reality that is far beyond textbooks or our imagination.

There are two other DV-related documentaries which are important works in terms of concept and

approach of shooting. These are *You Are Not the Only Unhappy One* and *Living Elsewhere*. The first appeared at the end of 2000. From the title one may imagine it being a novel, prose or even a poem; this documentary is closely related to the producer, Wang Fen, for it features her parents.

Her motivation for making a film about her parents was that she felt certain questions from her teenage years remained unanswered and continued to disturb her. She wanted her parents speak their minds in front of the camera. She rented a portable DV camera costing 50 *yuan* per day, and took it back to her hometown, a small town by a railway in Jiangxi Province. Having learned how to operate the camera, she started shooting. The work shows familiar scenes of everyday life in Wang Fen's home, preparing meals, taking pictures while visiting their family tombs, etc. It shows Wang Fen talking with her father and mother separately, who are both over 60. Affairs in the past come to light: about her father's first girlfriend, of how her father and mother married by chance, and her mother recalls unhappy moments and grievances against her father.

All of these are personal; but the unavoidably dull reality inspires the viewer's sympathy. Wang Fen has turned a home video into something that evokes our thoughts about what happy family life should be like. Shot in an intimate way, the piece gave rise to disputes and challenges that Wang Fen had never expected. Afterwards, many films about private lives appeared. People still question the moral principles surrounding the production of her work, but Wang Fen remained silent.

Fig. 9 *Living Elsewhere*, Wang Jianwei, 1999

Wang Jianwei completed *Living Elsewhere* in 1999. It often gets overlooked in the film world because Wang is a conceptual artist, away from film and television circles. At the same time, the work is far different from the "playing with concept" approach taken in video art. It is thus hard to classify. In Wang's films, including the video works, we can see that he stresses concepts, paying special attention to social reality and circumstances. In *Living Elsewhere*, he expresses concern about the dramatic social change sweeping China. This is quite different from previous works of concept art or conventional documentaries. The video shows four groups of peasants who have migrated from their land to squat in a compound of unfinished villas not far from an expressway in Chengdu, Sichuan province. The villas were built in the mid-1990s during an unbridled period of development for China's real estate industry. Due to financial problems, the half-constructed buildings were abandoned. The peasants moved in, even growing vegetables and raising pigs there. This provides a strange contrast to the incomplete and abandoned Western-style villas.

People who ought to have nothing to do with the site have become associated with it. When he shot this documentary, Wang Jianwei was not too concerned about the size of the video camera. He worked with a cameraman, who used a large camera; and he himself chose to use a portable digital video camera and shoot what he thought interesting. Unlike more conventional documentaries, which focused on developing the subjects' story and the relationship between individuals, this work focused on everyday life in this unusual setting, such as preparing meals, feeding pigs and chickens, chatting and sleeping. However, as the combination of the environment and the people in it is intrinsically preposterous, all the details of the daily life show us the depth Wang Jianwei achieved. Wang is perhaps the only visual artist in China to have produced a documentary. *Living Elsewhere* extends the scope of conventional documentaries in both content and form. Unfortunately, like Wang Fen's *You Are Not the Only Unhappy One*, no valuable discussion about this unconventional exploration has been found in any article.

All the independent documentaries mentioned above, especially DV ones, tended to emerge of themselves and disappear as easily in this particular environment. Without guarantee of receiving any acclaim, would-be documentary makers produce works for their own pleasure. It is not unusual for them to stop for lack of funds. All independent documentaries produced prior to the mid-1990s were shown in a private way in China, by gathering friends together to watch them. Only on rare occasions would they be screened at a professional seminar. Since 2000, some documentaries have been shown free at bars like the Yellow Pavilion, Sculpting in Time and Yanweidie. Most documentaries, of which DV works constitute an important part, have had no chance to be shown at cinemas or on television.

Yellow Pavilion has become an important place. It was the site of a film society founded by a group of young people. Yang Zi and Zhang Yaxuan, the leading members of the society, continue to make elaborate plans for showing various video films, and have published reading materials like "Practice Manual" at their own expense.

Most DV documentaries that appeared more recently have been screened there, and, after the screening, there are usually discussions between the producers and the audience, particularly during the weekends. The low-quality projector does not show the works very well, but the atmosphere and discussions are always lively.

Similar screenings also take place now in other cities such as Shenyang, Guangzhou, Shanghai, Wuhan, Xi'an, Chengdu, Kunming and Shenzhen, almost all of them organized by non-governmental video groups and students' art groups at universities. As a result, more and more young people throughout the country started producing DV works. A DV Group started activities at Yellow Pavilion, showing completed works and clips of those in progress, and discussing ways of shooting. They have attracted attention of the media, which regards them as fashionable cultural activities for young people. DV is frequently mentioned.

Those with experience of independent production continue to make documentaries in different ways. The list includes Jiang Yue, Duan Jinchuan and Kang Jianning, who, in their own ways, continue production on a certain scale and with some investment. Since 1999, we have seen Jiang Yue's *The Three Gorges*, Duan Jinchuan's *Retrieving: a Story in 1999* and Kang Jianning's *The Police Substation*.

Fig. 10 *You Are Not the Only Unhappy One*, Wang Fen, 2000

New DV works include Yang Lina's *Home Video Tapes* about private family life, Du Haibin's *Under High-Rises* about migrant workers laboring in Beijing, and Zhu Chuanming's *Utility Men* about people playing small roles in films or television dramas. In a positive sense, DV has influenced and promoted an independent approach to production. In the two years since 2000, a younger generation has already produced its first DV documentaries. Xue Changqing's *The Missing Woman* probes the case of a missing woman in a rural area of Anhui who suffers from mental illness.

This Winter by Zhang Hua explores the stories of three servicemen before and after their retirement. Ying Weiwei produced *The Box* about the secret love of a lesbian couple. Mao Ran's *Happy Halloween* follows a group of people chatting outside a rock-and-roll concert in Beijing. Wang Shiqing recently completed *Coming to Beijing* about the life of a peasant woman selling flowers in Beijing.

Some people who have the choice of using better equipment than DV cameras also choose to produce works with them. Jia Zhangke, who gained wide attention for his films *Xiao Wu* and *Platform*, shot *Public Space* with a DV camera. It is a new way of recording. The cameraperson can capture common scenes of public places in a seemingly casual way, deftly combining them into a story about life.

Fig. 11 *The Box*, Ying Weiwei, 2001

Jiang Zhi, a graphic artist, has recently produced a series of shorts titled *A Few Minutes of People*. It is similar to Jia's *Public Space* in concept, only more concise and exaggerated, reflecting Jiang's approach to conceptual art. One of the shorts is a close-up of people watching a television drama at the door of a shop on the street. The four-minute short consists of only two scenes. These works represent the imaginative expression of their creators in new visual languages in a free, fresh style made possible with DV cameras. Naturally, with the emergence of such a young, unconventional mode of expression, there are questions and concerns about the rough quality, the vulgarity that comes with an excessively casual style of shooting, and the lack of artistic quality. However, discussions on these issues have only taken place casually or on the Internet. Nothing has been written as a valuable study of the situation.

All this continues, including all approaches used prior to DV. As it has just hit the road, video as an individual means of expression is new to our environment. Its future is anybody's guess. What is important is that, in a society used to collective expression, people making video works are showing their individuality. Some of the works seem vague, indefinite, or temporary. Some people disappeared shortly after they emerged. Some are just coming up on the road, regardless of their lack of experience, and the pitfalls on the road ahead.

Fig. 12 Yellow Pavilion, an influential movie bar in Beijing.

Wu Wenguang is an independent filmmaker.

1 *Tanjiang* refers to outsiders who clean cotton used in bed quilts, and re-pad them.
2 Urumqi is the capital of the Xinjiang Uighur Autonomous Region, a Muslim area in northwest China.

Translated from the Chinese by Karen Smith and Zhang Shaoning.

Part Two : Artists and Work

Theme 1 Memory and Reality

Part Two : Artists and Work

Memory and Reality

Wu Hung

Reflecting on China's historical experience, expressing collective and individual memories, and forging dialogues between the past and the present, experimental art works created in the 1990s present important signposts for emerging individual subjectivity in Chinese art.

Some of these works, often large-scale performances, were undertaken at historical sites. The most prominent of these sites is the Great Wall, which attracted many experimental artists to conduct art projects there during the 1990s. Whereas all these artists designed their works to communicate with the Wall, arguably the most important symbol of Chinese civilization and the modern Chinese nation, these works reflect different historical visions and artistic aspirations. For example, in 1990 Xu Bing carried out his *Ghosts Pounding the Wall*. With a crew of students and local farmers, he labored for twenty-four days to make ink rubbings from a thirtymeter-long section of the wall. The project was conceived as a grand performance: the crew members wore uniforms printed with Xu Bing's "nonsense" characters, and each stage of the project was recorded on film and video. When the rubbings are assembled into an installation for exhibition (p. 146), the audience find themselves encountering a paper Great Wall, which transforms the solid national monument into its volumeless shadow. Zheng Lianjie, on the other hand, transformed the Great Wall itself into a spectacular work of art. Also assisted by local farmers, he used red cloth to tie tens of thousands of bricks broken off from the Wall, for the project he entitled *Binding Lost Souls: Huge Explosion* (p. 148). The message is two-fold: on the one hand, the artist planned the project as a shamanistic performance to heal the historical wound of the old Wall, with each of the broken bricks standing for a "lost soul." On the other hand, with its enormous scale and stunning visual effect, his site-specific installation reinforces the glory and mythology of the Great Wall, which to Zheng continues to symbolize China and its future.

Deconstructing historical authority is also the purpose of Cheng Xinmao's and Qiu Zhijie's works in this exhibition. Chen Xinmao's *Historical Text: Blurred Printing Series* (p. 152) features incomplete and partially smeared wood-block prints, the results of deliberate mis-printing. The blurred images appear fragmented, as ruins or traces of some canonical books from the past. The ambiguity between textual and visual expression is heightened by the contradictory use of the ink, both to reproduce texts and to make texts illegible, sometimes even burying characters under richly-textured, spreading blots. Qiu Zhijie's *Assignment No. 1: Copying "Orchid Pavilion Preface" a Thousand Times* (p. 150) can be seen as a postmodern deconstruction of traditional Chinese calligraphy, an art form linked to China's unique cultural heritage. For three years from 1992 to 1995 he kept writing "The Orchid Pavilion Preface," the most celebrated masterpiece of Chinese calligraphy, over and over on a single piece of paper, and continued to write on it even after the entire paper was pitch black with ink. Traditional calligraphic training is based on repetitive copying of historical masterpieces, and "The Orchid Pavilion Preface" has served as a primary model for the practice of copying. By making "repetition" ("remembering" in a broader sense) the subject of his art project, however, Qiu Zhijie rejected the conventional purpose of this calligraphic practice.

In contrast to these sweeping philosophical contemplation on China's nationhood and cultura l origins, some experimental works created in the 1990s resurrect dark, painful memories from the country's past. Wang Youshen's *Washing: The Mass Grave at Datong in 1941* (p. 162) remains one of the most poignant examples in this genre. In this installation, the newspaper pages on the wall report the discovery of the pit: the discoverers found the remains of tens of thousands of Chinese who were buried alive by Japanese soldiers during World War II. Below the wall, photographic images of the unearthed human remains were placed in two large basins under circulating water. "The water washes the image away," the artist explains, "just as time has washed people's memories clear of this atrocity that occurred fifty years ago." [1] The vulnerability of printed images and hence the impermanence of the history and memory that they represent

and preserve is a central theme of works by Wang Youshen and other experimental artists such as Zhang Xiaogang. In some paintings that Zhang Xiaogang created in the early 1990s, an infant child lies before a dark background comprised of eroded and scratched archival photographs, which, as physical remains of the past, have also become symbols of historical memory itself.

Zhang Xiaogang's paintings, whether the earlier *Red Characters* or the later *Big Family* series (p. 188), are always invested with his memories of the Cultural Revolution. Indeed, as mentioned in the introduction to Part One in this catalogue, even in the 1990s, the Cultural Revolution continued to stimulate experimental artists to create original works, but their different memories of the Cultural Revolution explain the differences between their works. Some artists, such as Ye Yongqing and Zhou Tiehai, evoked the image of "Big Character Posters" to encapsulate that bygone era. Other artists, such as Liu Dahong and Yang Jiecang, resurrected Communist heroes and heroines but turned them into characters of highly individualized narratives. Memories of the Cultural Revolution also inspired symbolic representations of political power, such as Ma Xuhui's *Yellow Arched Door: Parents* (p. 170), Geng Jianyi's *Drilling a Hole in a Wall* (p. 160), and Zhang Hongtu's *Untitled: Big Red Door* (p. 154). The last work imitates the shiny red door of an imperial gate in the Forbidden City. According to the artist, a door like this has had an overwhelming significance in China because it simultaneously exhibits and conceals political power. Both functions help the power-holder control Chinese people. Iconoclastic in essence, his gate mocks this political philosophy: in the place of glamorous, golden bosses on an imperial gate are ugly metal rivets, like rows of phalluses in various degrees of impotence.

Zhong Hongtu is one of the experimental Chinese artists who combined their memories of the Cultural Revolution with a Pop Art style. The result of this collective exercise was the appearance of Political Pop (*zhengzhi popu*) in the early 1990s. Generally speaking, Political Pop signaled a deepening stage of deconstructing a previous political visual culture. Unlike painters of "scar art" (*shanghe meishu*) in the 1980s, Political Pop artists had no interest in depicting tragic events in the previous decades. Rather, they derived specific visual references from the Cultural Revolution but erased their original political significance. A typical method to realize this goal was to distort the references and to juxtapose them with signs from heterogeneous sources: commercial trademarks and advertisements (Wang Guangyi, p. 178), textile patterns (Yu Youhan), sexual symbols (Li Shan, p. 182), and computer images (Feng Mengbo p. 196). As an important trend in 1990s Chinese experimental art, Political Pop brought Post-Cultural Revolution art to an end: its radical fragmentation of Cultural Revolution images finally exhausted the source of its pictorial vocabulary and reduced it to a number of pre-conceived compositional formulas. This interpretation corrects a misunderstanding often found in Western introductions to contemporary Chinese art, which identify Political Pop as a "dissident" political art under a Communist regime. But in fact, most Political Pop artists were protesting against any ideological and political commitment; their intention was to de-politicize political symbols, not to reinvest them with new political meaning. Genuine social and cultural criticism did exist in Chinese experimental art in the 1990s, but it was related to artists' observation and representation of reality, not history.

Reality, however, can never be separated entirely from history, and what links the present to the past are often personal memories. Looked at from this angle, Chinese experimental artists of the 1990s demonstrated an unmistakable interest in forging such "memory links" through their works. Hai Bo, for example, customarily juxtaposes two photographs taken several decades apart (p. 194). The first, an old group photo, shows young men or women in Maoist or army uniforms; their young faces glow with their unyielding belief in the Communist faith. The second picture, taken by Hao Bo himself, shows the same

group of people — or in some cases, the surviving members — twenty or thirty years later. In an almost graphic manner, the two images register the passage of time and stir up viewers' recollections of certain moments in their own lives. Differing from these photographs that frame a temporal duration with a beginning and an end, the subject of Wang Gongxin's *The Old Bench*(p. 156) is time itself. This succinct video installation consists of only a small black-and-white video screen attached to an old-fashioned wooden stool The single image on the screen is a moving index finger. Scratching the stool's worn surface, the finger's motion alludes to the movement of time, leaving its traces on furniture.

Wang Gongxin's work is allegorical, but other representations of the passage of time in 1990s experimental art have more concrete subjects, sometime biographical in intent. An outstanding example in this group is the installation *Women/Here* by Sui Jianguo, Zhan Wang and Yu Fan (p. 198). The creation of this work, actually an "experimental exhibition" on its own right, responded to an important event: the Fourth International Women's Congress held in Beijing in 1995. Although many leaders of women's movements around the world traveled to China to participate in the event, they were largely kept separate from Chinese people. The three artists' answer was to hold a different "congress" in the form of an art exhibition, which would create an alternative space where, in their words, "an ordinary Chinese woman could become part of the international event and the contemporary movement of women's liberation." [2] What they did was to make their mothers the "artists" in the exhibition, while reducing their own roles to that of an editor of ready-made materials, mostly their mothers' private belongings and personal mementos. Compiled into chronological sequences and displayed in a public space, these fragmentary materials told the lives of three Chinese women, unknown to most people beyond their families and work units.

Women/Here demonstrated that by the mid-1990s, Chinese experimental artists had largely freed themselves from the baggage of the Cultural Revolution. Their art now directly and forcefully responded to contemporary issues in Chinese society. Indeed, a close examination of Chinese art from the late 1980s to the early 1990s shows a steady increase in representations of contemporary subjects. But before 1993, the two art forms that were most sensitive to this change remained photography and oil painting. (After 1993, performance, installation, digital imaging, and video became increasingly prevalent.) A whole generation of independent photographers emerged in the late 1980s and early 1990s. Reacting against the doctrine of socialist realism, they took it as their mission to represent real Chinese people, often the nameless and injured. Zhang Hai'er's portrayals of urban prostitutes are among the earliest examples of this genre. Yuan Dongping photographed patients in many mental asylums around China (p. 202). Taken from eye level and deliberately unpolished, these pictures convey social criticism in a photojournalistic style. Liu Zheng's *My Countrymen* (p. 204), on the other hand, resulted from a further development of this tradition in the late 1990s. Although his subjects are again "stigmatized" people—disabled and impaired, old and sick, homosexual and transsexual, beggars and wanderers, he abandoned the earlier informal journalistic approach in favor of technical perfection and visual monumentality.

In the field of oil painting, a turning point was the "New Generation" (*Xinshengdai*) exhibition, held in 1991 in the Museum of Chinese History next to Tiananmen Square. Artists in the exhibition included Liu Xiaodong, Yu Hong, Song Yonghong, and Wang Jinsong, all are presented in this catalogue (pp. 210, 212, 218, 190). The brightest products of China's best art colleges in the early 1990s, these young painters still hoped to represent the "spirit" of their time; what distinguished them from orthodox socialist realists was their specific understanding of this spirit. Instead of depicting revolutionary masses and a broad historical drama, they developed a penchant for representing fragmentary and trivial urban life. Their works reject grand narrative and symbolism, but are devoted to seemingly meaningless scenes they found around them:

beauticians with exaggerated fake smiles, lonely men and women in a sleeping car on a train, a group of yuppies taking a picture in front of Tiananmen.

They claimed that their paintings were devoid of deep meaning because life itself no longer had deep meaning. It may be said that *superficiality* has become the real subject of New Generation Art. The painted scenes—beauty salons, escalators, night markets—are the most common "surface" phenomena in a metropolis. These scenes are selected for depiction not because they are part of reality but because they best signify the concept of the *superficial*, which is also understood in terms of emotion and mood. New Generation paintings neither represent nor demand strong feelings like love or hate. Some of them are lightly humorous or affectionate; others carry darker connotations of resentment or indifference. The boundary between New Generation painting and Cynical Realism is thus a blurry one. In fact, although Cynical Realism is much better known in the West, it was actually a branch of New Generation painting in the early 1990s. Cynical realist artists like Fang Lijun and Liu Wei (pp. 344, 192) have the same educational background and paint in a similar painting style as New Generation artists, but are distinguished by their self-identification as *liumang* (rogues) and their attitude of malaise.

The impact of New Generation painting is strongly felt in Chinese experimental art created of the middle and late 1990s, which continued to represent contemporary social life but often in a more exaggerated or distorted manner. The oil painter Zeng Hao, for example, depicts well-dressed young professionals and their material possessions as toy figures and furniture (p. 222); the figures' miniature forms heighten the sense of dislocation and objectification. Yang Fudong's comic portrayal of *The First Intellectual* (p. 224) likewise comments on the vulnerability and insecurity of the emerging generation of yuppies – a by-product of China's social and economic reforms. Wang Xingwei's *Again No 'A'* (p. 220) explores the illogicality of the visual culture of today's well-to-do Chinese. The Sichuan performance artist Luo Zidan conducted many projects amidst actual urban spaces. The subject of his *Half White Collar, Half Peasant* (p. 226) is people's confusion about their identities as they try to fit in the new social-economic system.

Staged on Chengdu's street, this performance enabled Luo Zidan to interact with his audience in the open. Indeed, the increasing popularity of performance among experimental artists in the 1990s was to a large extent related to the artists' desire to engage in public issues and with the public itself. In their search for new visual languages to further such engagement, they found in the art of performance endless possibilities to interact with society directly and unambiguously. A forerunner of such experiments is Wang Jin, who conducted a series of powerful performances from 1993 onward to address public issues (p. 200). One group of these performances, including *Red Flag Canal* and *Beijing-Kowloon*, focused on the relationship between past and present in modern Chinese history. Another group responded to the rapidly growing capitalist economy in China. *Knocking at the Door* in 1993, for example, consisted of seven old bricks from the walls of the Forbidden City, each bearing on its uneven surface a supra-realistic depiction of an American currency note. Over the following years, Wang Jin continued to paint such "cash bricks" and used them to "restore" damaged sections of the palace wall. Other projects in this group expressed, again in ironical forms, the growing material "desire" in contemporary Chinese society. For example, a new catchword in colloquial language for "making a fast buck" is "stir-frying money" (*chao qian*). Making the verbal expression literal, in 1995 Wang Jin rented a space in a night market in central Beijing and set up a food stand. With all the aplomb of a master chef he fried a wok-full of coins for his customers. The action project was called *Quick Stir-frying Renminbi.*

1 "Everyday Sightings: Melissa Chiu interviews the Chinese artist Wang Youshen," ART AsiaPacific 3 : 2 (1996), 54.

2 Sui Jianguo's letter to the art critic Gu Zhenfeng, provided by the artist.

Xu Bing
Ghosts Pounding the Wall
1990-91
installation; rice paper, ink, soil, mixed media

This installation, 15 meters high, 15 meters wide and 32 meters long, is made up of huge rubbings of the Great Wall, and a small"mountain"with a diameter of ten meters placed in the center of the space. The basic concept of *Ghosts* was to expand upon the possibilities for print-making. What interests me is the special significance of"rubbing"as a method of recording, which is different from other recorded images such as films, television and photographs. Compared with the art of rubbing, those other records are nothing but a shadow. Rubbing has a power which derives from direct contact with the recorded objects.The title *Ghosts Pounding the Wall* arose from a critical remark made about a previous work (*A Book from the Sky*). One conservative critic described this as "the art of a ghost bumping against a wall," which meant that there was something wrong with the artist's thought process and work, and that he had become so deeply involved as to become withdrawn from the real world. (Xu Bing)

Xu Bing
1955 Born, Chongqing, China
1981 Graduated, print-making department,
 Central Academy of Fine Arts, Beijing,
 China
 Current, lives and works between
 Beijing, China and New York, USA

Solo Exhibitions

1991 *Three Installations by Xu Bing*, Elvehjem Museum of Art, Madison, Wisconsin, USA
1994 *Xu Bing: Recent Work*, The Bronx Museum of the Arts, New York, USA
1997 *Classroom Calligraphy*, Joan Miro's Foundation at Mallorca (Pilar I Joan Miro a Mallorca), Spain
1998 *Xu Bing: Introduction to Square Word Calligraphy*, New Museum of Contemporary Art, New York, USA
2000 *Xu Bing: Book from the Sky & Classroom Calligraphy*, National Gallery of Prague, Czech Republic
2001 *Reading Landscape*, North Carolina Museum of Art, Raleigh, USA
 Word Play: Contemporary Art by Xu Bing, Arthur M. Sackler Gallery, Smithsonian Institution, Washington, D.C. ,USA

2000 *Sydney Biennale*, Art Gallery of New South Wales, Sydney, Australia
2001 *Tracing: Works on Paper by Chinese Contemporary Artists*, Alfred University School of Art and Design, New York, USA

Group Exhibitions

1993 *The Eastern Road: The 45ᵗʰ Venice Biennale*, Venice, Italy
1994 *Cocido y Crudo*, Reina Sofia Museum of Art (Museo Nacional Centro de Arte Reina Sofia), Madrid, Spain
1997 *Transversions, The Second Johannesburg Biennale*, South Africa
1998 *Crossings*, The National Gallery of Canada, Ottawa, Canada
1999 *Banner Project*, MoMA, New York, USA
 Art Worlds in Dialogue—Global Art Rhineland 2000, Museum Ludwig, Koln, Germany
 Zeitwenden—Looking Back and Looking Forward through the Fine Arts, Kunstmuseum, Bonn, Germany
 Global Conceptualism: Points of Origin, 1950s-1980s, Queens Museum of Art, New York, USA

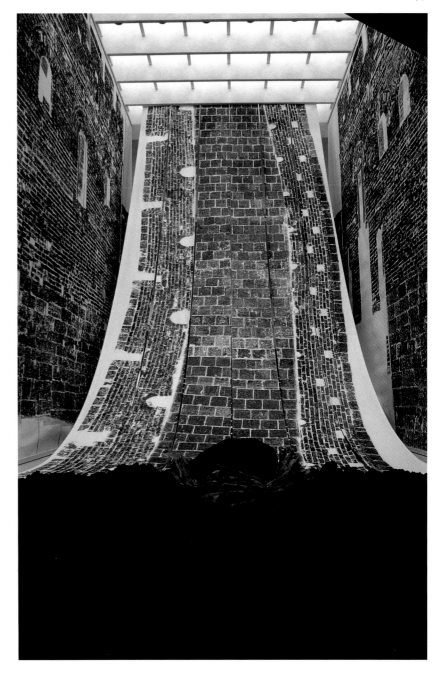

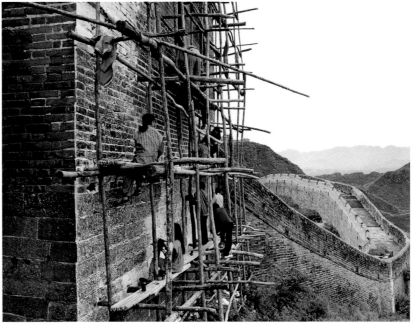

Zheng Lianjie
Binding Lost Souls: Huge Explosion
1993
performance, installation; red cloth 200 meters long

Performance art offers an accurate expression of its times that is close with which people can easily identify. By electing to use the body as language and medium, one can produce a strong visual effect. I chose to use the Great Wall as the location and backdrop to my performance not only for its symbolism but for its monumental scale and natural environment. Here, one can sense the continuation of tradition into the future. The process of urbanization lacks "atmosphere," which for the freedom and liberation of the heart and soul, is hard to achieve. (Zheng Lianjie)

Zheng Lianjie
1962 Born, Beijing, China
Current, lives and
works in New York,
USA

Solo Exhibitions
1990 *Body Performance: Immersed in a Gray Wind*, Simatai Great Wall, Beijing, China
1990-93 *Rubbing: More than 100 Meters Long*, Yanshanye Great Wall, Beijing, China
1993 *Series of Performance and Site-Specific Works: Great Explosion*, Simatai Great Wall, Beijing, China
2001 *Slide Exhibition of Performance and Installation Works by Zheng Lianjie*, Simatai Great Wall, Beijing, China

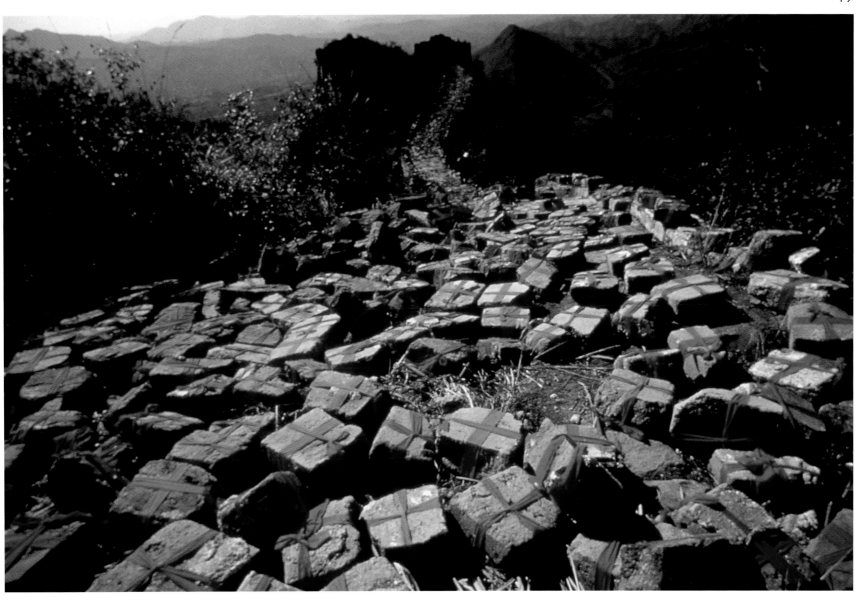

Qiu Zhijie

Assignment No. 1: Copying "Orchid Pavilion Preface" a Thousand Times

1990-95
video; ink, calligraphic text on rice paper
Collection of Hanart TZ Gallery, Hong Kong

In this work, the goal was to repeat the act of writing out the text of the "Lantingxu," (the "Orchid Pavilion Preface"), one of the most classical texts in Chinese traditional calligraphy, one thousand times on the same piece of rice paper. I also video-recorded the process of writing through the first fifty times. As the text is written the first time, the calligraphy is clearly of Chinese characters. As the number of times increases the characters are turned into a visual merging of ink, like an abstract painting. Following the first fifty times during which the characters become obscured, the text is rewritten on the paper, which gradually turns black with no trace of the brush mark or nuances of ink. Calligraphy is made Zen. The original paper blackened by the ink is exhibited together with the video recording of the changing process. (Qiu Zhijie)

Qiu Zhijie

1969 Born, Fujian province, China
1989 Graduated, print-making department, Zhejiang Academy of Fine Arts, Hangzhou, Zhejiang Province, China
 Current, lives and works in Beijing, China

Solo Exhibitions

1997 *Logic: Five Videos and Installations*, Gallery of the Central Academy of Fine Arts, Beijing, China
1999 *Calendar 1998*, Gallery of the Central Academy of Fine Arts, Beijing, China
 Innate Forces - Mixed Media Works, Art Beatus, Vancouver, Canada
2000 *Daily Touch*, Fundacao Oriente, Macau
2001 *Invisibility*, Ethan Cohen Fine Arts, New York, USA

Group Exhibitions

1993 *China's New Art, Post-1989*, Hong Kong Arts Centre, Hong Kong
1996 *Image and Phenomena*, Gallery of the China National Academy of Fine Arts, Hangzhou, China
1997 *Zeitgenössische Fotokunst aus der Volksrepublik China* (Contemporary Photography from the People's Republic of China), Never Berliner Kunstverein, Berlin, Germany
1998 *Inside Out: New Chinese Art*, Asia Society Galleries, PS 1 Contemporary Art Center, New York, USA
1999 *Post-sense Sensibility: Alien Bodies and Delusion*, alternative non-art space, Beijing, China
 Transience: Chinese Experimental Art at the End of the Twentieth Century, Smart Museum of Art, University of Chicago, Chicago, USA
 The Power of the Word, Taiwan Museum of Art, Taichung, Taiwan
 Revolutionary Capitals: Beijing-London, Institute of Contemporary Art, London, UK
2001 *Translated Acts*, Haus der Kulturen der Welt, Berlin, Germany
 Retribution, Ziyuan Art Space, Beijing, China

The 25th Sao Paulo Biennial, Sao Paulo, Brazil

其次雖無
之盛以暢敍幽情是日也天朗氣
清惠風和暢仰觀宇宙之大俯察
品類之盛所以遊目騁懷足以極視
聽之娛信可樂也夫人之相與俯仰
一世或取諸懷抱悟言一室之內或
因寄所託放浪形骸之外雖趣舍萬
殊靜躁不同當其欣於所遇暫得
於己快然自足不知老之將至及
其所之既倦情隨事遷感慨係
之矣向之所欣俛仰之間以為陳迹
猶不能不以之興懷況修短隨化
終期於盡古人云死生亦大矣豈
不痛哉每攬昔人興感之由若合
一契未嘗不臨文嗟悼不能喻之
於懷固知一死生為虛誕齊彭殤
為妄作後之視今亦由今之視昔

Chen Xinmao
Historical Text: Blurred Printing Series
2000
rice paper, ink, mixed media
50 pieces, 50 x 50 cm each

The characteristics common to abstract ink painting and mixed media are the main elements that Chen Xinmao explores in his work. In his experimental ink works, he combines actual objects with the flat picture plane. Here, the characteristics of ink and montage are traditional materials made to reflect contemporary life. In another sense, they fall outside the realm of tradition and go beyond the confines of conventional painting, yet retain a sense of Eastern aesthetics. For this reason one might describe Chen Xinmao as an optimistic classicist, not just because he borrows motifs from classical meaning or firmly defends this domain. More important is the openness he brings to his approach and the way that he looks back to aspects of history, simultaneously drawing upon the spirit of these in the realm of contemporary life. His achievement ultimately lies in combing this spirit and form. (Wang Huangsheng and Pi Daojian)

Chen Xinmao

1954 Born, Shanghai, China
1987 Graduated Nanjing, Academy of Fine
 Arts, Nanjing, China
 Current, teaches in the art department
 of China Eastern Normal University,
 Shanghai, China

Solo Exhibitions
1991 Cambridge Cultural Centre, UK

Group Exhibitions
1997 *Chinese Contemporary Art Invitational Exhibition*, Hong Kong
1998 *Shanghai Contemporary Art Exhibition*, Shanghai, China
 The First Shenzhen International Ink Painting Biennial, Shenzhen, China
1999 *'99 Shanghai Abstract Art Invitational Exhibition*, Shanghai, China
2000 *The Second Shenzhen International Ink Biennial*, Shenzhen, China
2001 *Shanghai Abstract Painting Exhibition*, Shanghai, China
 California International Art Biennial, USA
 Twenty Years of Chinese Ink Experiment, Guangdong Museum of Art,
 Guangzhou, China
 International Ink Painting Exhibition, Chicago, USA

Zhang Hongtu
Untitled: Big Red Door

1992
installation
wood, steel, coal
243.8 × 219.7 × 15.3 cm
Collection of Guy and Myriam Ullens, Belgium

Like his hollowed Mao images, Zhang Hongtu's *Untitled: Big Red Door* transforms a serious political symbol into a joke. The artist has retained (and to some extent exaggerated) the shining red door panels of an imperial gate in the Forbidden City, but has replaced their glamorous, golden bosses with ugly metal rivets, which are like rows of phalluses in various degrees of inadequate erection. The humorous effect of these "studs" cancels the sense of secrecy. The traditional symbolism of the gate is rooted in its separation of interior and exterior spaces, and its power lies in its concealment of the space behind it. In retrospect, we realize that Zhang Hongtu's two earlier door installations (*Front Door* and *Red Door*) still rely on this symbolism. Both works emphasize the interplay between the spaces and gazes divided by a gate; both address issues of political dominance, the empowerment or disempowerment of the gaze, and the exercise of power of one subject onto the other. These are not the purposes of *Untitled: Big Red Door*, which is a straightforward political satire. The phallus-like studs are the secret that the gate is supposed to hide. The gate's mystique vanishes when this (unimpressive) secret exposes itself on the outside. (Wu Hung)

Zhang Hongtu

1943 Born, Gansu province, China
1969 Graduated, Central Institute of
 Art and Design, Beijing, China
 Current, lives and works in
 New York, USA

Solo Exhibitions

1984 *In the Spirit of Dunhuang*, Asian Art Institute, New York, USA
1992 *The Angel's Ghost*, Webster Hall, New York, USA
1995 *Zhang Hongtu: Material Mao*, Bronx Museum of Art, New York, USA
1996 *Reflections Abroad: The Journey of Zhang Hongtu 1982-96*, Anthony Giordano
 Gallery, Oakdale, New York, USA
1999 *Repaint: Chinese Shan-Shui Painting*, Yale-China Association, Yale University,
 New Haven, Connecticut, USA

Group Exhibitions

1980 *Contemporary Artists*, China Art Gallery, Beijing, China
1983 *Painting the Chinese Dream*, Brooklyn Museum, New York, USA
1985 *Root to Reality 1*, Henry Street Settlement, New York, USA
1991 *From Stars to Avant-garde*, Asian-American Art Center, New York, USA
 Syncretism, Alternative Museum, New York, USA
1993 *Word!*, Jamaica Arts Center, New York, USA
1994 *The Fifth Havana Biennial*, Havana, Cuba
1995 *Other Choices / Other Voices*, Islip Museum, Long Island, New York, USA
1999 *Transience: Chinese Experimental Art at the End of the Twentieth Century*, Smart
 Museum of Art, University of Chicago, Chicago, USA

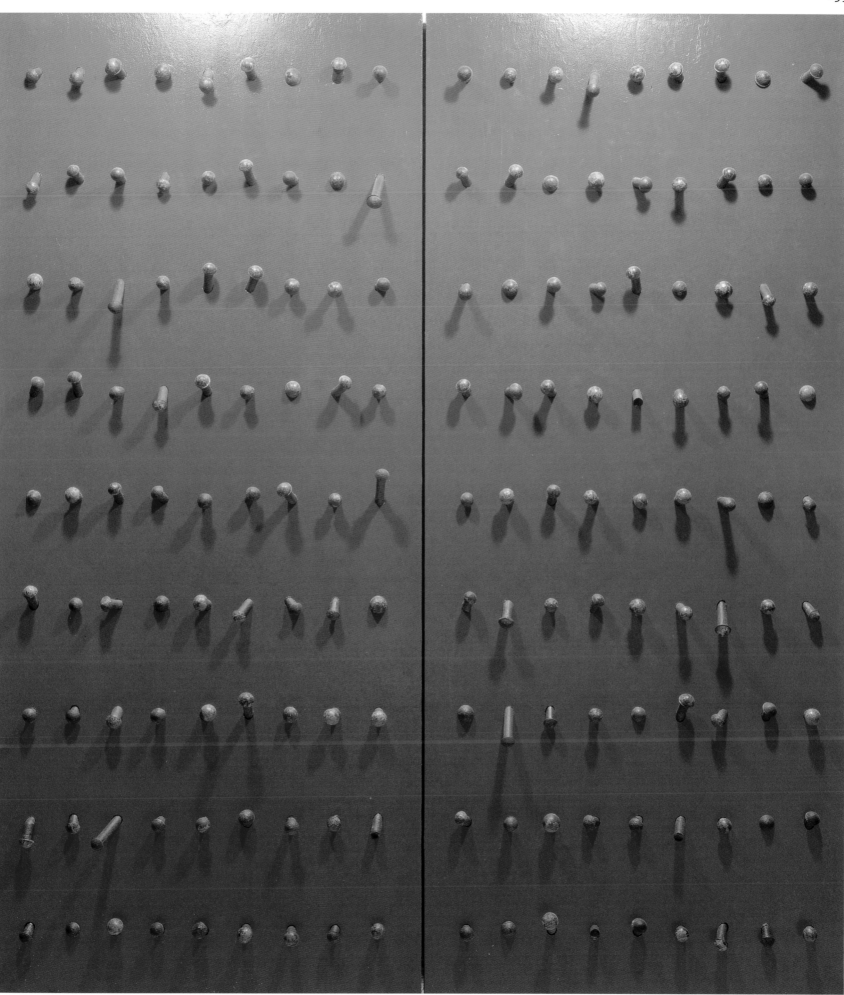

Wang Gongxin
The Old Bench
1996
installation, video

The Old Bench features a small black and white monitor inserted in the surface of a bench showing the fingertip constantly rubbing and digging the hollows of the out-off section as if it had not been removed. Is it a mere physiological, Freudian metaphor of the male sex impulse hidden in the subconscious, or a more cultural reference to a coercive complex that faithfully sticks to images, illusions, and lost moments? (Lin Dongwei)

In *The Old Bench*, the rubbing of one solitary finger produces a disquieting effect: *The Old Bench* speaks of the frustrations that wear away at human nerves and are the hazard of life in general. (Karen Smith)

Wang Gongxin
1960 Born, Beijing, China
1982 Graduated, fine arts department, Capital Normal University, Beijing, China
1987 Visiting scholar, SUNY at Cortland and Albany, New York, USA
Current, lives and works in Beijing, China

Solo Exhibitions
1995 *Biao*, Halle 10, Ludwigsburg, Germany
 Digging a Hole in Beijing, House of Arts, Beijing, China
1997 *Myth Powder No.1*, Gallery of the Central Academy of Fine Arts, Beijing, China
2003 South Australia Contemporary Art Centre, Adelaide, Australia

Groop Exhibitions
1995 *Out of the Middle Kingdom: Chinese Avant-garde Art*, Santa Monica Arts Center, Barcelona, Spain
1996 *Image and Phenomena*, Gallery of the China National Academy of Fine Arts, Hangzhou, China
1997 *W²-Z²*, Gallery of the Central Academy of Fine Arts, Beijing, China
2000 *18ᵗʰ World-Wide Video Festival*, Amsterdam, the Netherlands
2001 *Living in Time*, Hamburg Bahnhof Museum of Contemporary Art, Berlin, Germany
 Translated Acts, Haus der Kulturen der Welt, Berlin, Germany
 The 49ᵗʰ Venice Biennale, Venice, Italy
 The 25ᵗʰ Sao Paulo Biennial, Sao Paulo, Brazil

Sui Jianguo
Jolly Electrified Hero
1996
installation; nails, rubber belt, railroad ties
180 x 230 cm

I first found a piece of rubber in a power plant. The rubber had formerly been used as the conveyer belt for moving coal around the plant and now all was now dismantled. When I put the first nail into the rubber, a new sensation was immediately produced. The first nail was followed by a few more, and then more and more as I began to gain an increasingly profound sense of surprise; the ability of the rubber belt to bear the weight of the nails as they pierced its flesh. As the density of the nails reached saturation, the process of gradual change was enforced to its maximum, irreversible point. The iron nails and the black belt of rubber, two entirely opposite materials, seemed like one attacking, the other suffering. When this mutual relation reached its zenith, the whole was transformed into something previously unimaginable that was both supple and sharp. The implied attack was transmuted into a new entity. (Sui Jianguo)

Sui Jianguo

1956 Born, Qingdao, Shandong province, China
1989 Graduated, master's degree, sculpture department, Central Academy of Fine Arts, Beijing, China
 Current, chair of the sculpture department, Central Academy of Fine Arts, Beijing, China

Solo Exhibitions

1994 *Works By Sui Jianguo*, Hanart Gallery, Taipei, Taiwan
 Memory of Space, Gallery of the Central Academy of Fine Arts, Beijing, China
1995 *Deposit and Fault*, New Delhi Culture Centre, New Delhi, India
1996 *Exhibition of Works by Sui Jianguo*, Hanart TZ Gallery, Hong Kong
1997 *Meet the Shadow of a Hundred Years*, Victoria Academy of Art, Melbourne, Australia
1999 *Study of Drapery*, Passage Gallery, Beijing, China

Group Exhibitions

1993 *China's New Art, Post-1989*, Hong Kong Arts Centre, Hong Kong
1995 *Out of the Middle Kingdom: Chinese Avant-garde Art*, Santa Monica Arts Center, Barcelona, Spain
1999 *Transience: Chinese Experimental Art at the End of the Twentieth Century*, Smart Museum of Art, University of Chicago, Chicago, USA
 Partage d' Exotismes: The Fifth Lyon Biennial of Contemporary Art, Lyon, France
2000 *Les Champs de la Sculpture 2000*, Champs Elysee, Paris, France
 Shanghai Spirit: The Third Shanghai Biennale, Shanghai Art Museum, Shanghai, China
2001 *Transplantation In Situ: The Fourth Contemporary Sculpture Art Annual Exhibition*, He Xiangning Art Museum, Shenzhen, China
 Open 2001: The Fourth International Sculpture and Installation Exhibition, Venice, Italy
 Between Heaven and Hell: Classical Elements in Contemporary Art, Ostende Museum of Art, Ostende, Belgium

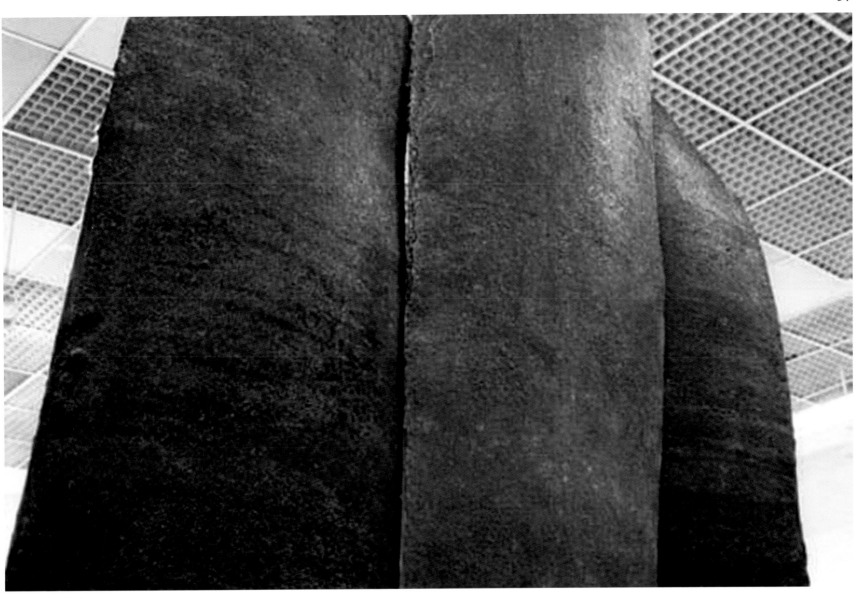

Geng Jianyi
Drilling a Hole in a Wall
1999
video installation

In the installation *Drilling a Hole in a Wall*, I seek to juxtapose sound and picture harmoniously. Like water and oil, sound and picture are separate. Sound can be added into a work, yet sound and pictures can not be paired synchronously but are separate entities. We can be sure that there is a problem here. What lies behind the "wall" is certain to be the cause. The result of any attempt can only be to escape. It is hard for us to perceive that what we hear and what we see are not synchronous, but it is obvious in the video. The sound can't keep up with the images. Although sound is requisite, it can only follow or be ahead of the image/picture. This explains the impulse behind the work *Drilling a Hole in a Wall*. (Geng Jianyi)

Geng Jianyi

1962 Born, Zhengzhou, Henan province, China
1985 Graduated, oil painting department, Zhejiang Academy of Fine Arts, Hangzhou, Zhejiang province, China
Current, lives and works in Hangzhou, China

Solo Exhibitions
1999 *Duplicity*, ShanghArt Gallery, Shanghai, China

Group Exhibitions
1985 *'85 New Space*, Gallery of the Zhejiang Academy of Fine Arts, Hangzhou, China
1986 Participates in various artistic activities of the Pond Association in public spaces in Hangzhou, China
1989 *China/Avant-garde*, China Art Gallery, Beijing, China
1993 *The Eastern Road: The 45th Venice Biennale*, Venice, Italy
1996 *Image and Phenomena*, Gallery of the China National Academy of Fine Arts, Hangzhou, China
1997 *Immutability and Fashion*, Kirin Art Space, Harajuku, Japan
1998 *Two Contemporary Chinese Artists*, Presentation House Gallery, Vancouver, Canada
2001 *Living in Time*, Hamburg Bahnhof Museum of Contemporary Art, Berlin, Germany
2002 *Pause: The Fourth Kwangju Biennial*, Kwangju, Korea Republic

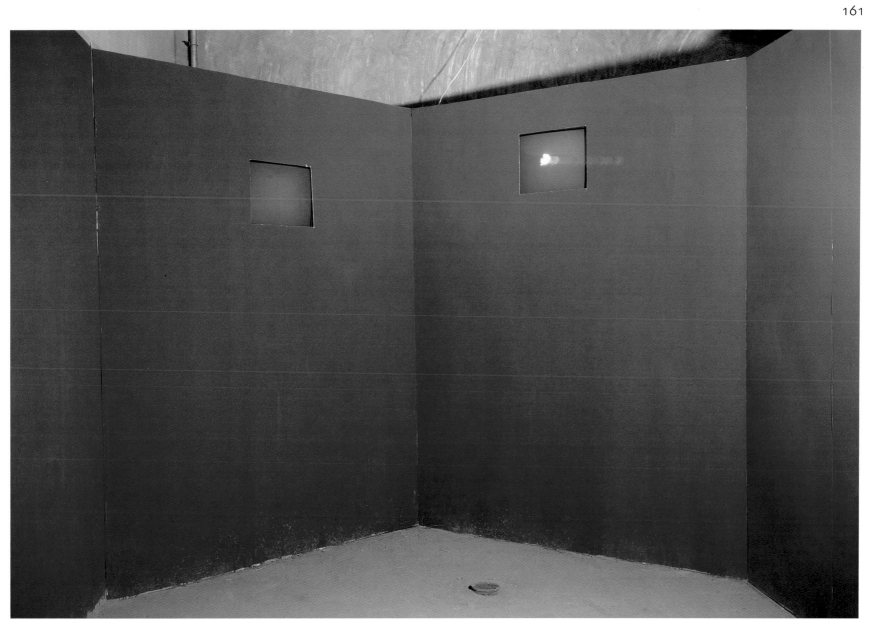

Wang Youshen

Washing: The Mass Grave at Datong in 1941

1995

installation; photographs, newspaper, running water, water containers

Washing: The Mass Grave at Datong in 1941 comprises two well-known original photographs that had been published in a newspaper. In the exhibition space, this installation comprises a source of running water that continuously washes the images that are placed in the water containers below. (Melissa Chiu)

Wang Youshen

1963 Born, Beijing, China
1988 Graduated, Central Academy of
 Fine Arts, Beijing, China
 Current, fine arts editor for the
 Beijing Youth Daily, Beijing, China

Solo Exhibitions

1998 *Wang Youshen: Washing — Darkroom*, Art Gallery of New South Wales,
 Sydney, Australia
2000 *Wang Youshen: Y2K Thousand Year Rinse*, Artist Commune, Hong Kong

Group Exhibitions

1989 *China/Avant-garde*, China Art Gallery, Beijing, China
1991 *I Don't Want to Play Cards with Cezanne*, Asia Pacific Museum, Pasadena,
 California, USA
1992 *Encountering by the Other*, K-18, Kassell, Germany
1993 *China's New Art, Post-1989*, Hong Kong Arts Centre, Hong Kong
 The Eastern Road: The 45ᵗʰ Venice Biennale, Venice, Italy
1994 *Mao Goes Pop*, Museum of Contemporary Art, Sydney, Australia
1995 *Out of the Middle Kingdom: Chinese Avant-garde Art*, Santa Monica Arts
 Center, Barcelona, Spain
1997 *Another Long March: Chinese Conceptual and Installation Art in the Nineties*
 Fundament Foundation, Breda, the Netherlands
2000 *Taipei Biennial*, Taipei Art Museum, Taipei, Taiwan
2002 *Cities on the Move*, Art Palace, Hamburg, Germany

Wang Luyan
W Bicycles
1992
installation

In 1992, I began redesigning bicycles. I added two cogs to the rear wheel and reversed the chain/gear mechanism. Retaining the particular mechanical features of the bicycle, through redesign it was inalienably altered, most obviously in that any attempt to go forward, results in going backwards. I called my redesigned bicycle "W." In 1996, in Australia, I participated in *the Second Asia-Pacific Triennial of Contemporary Art,* at the Queensland Art Gallery in Brisbane. My "W" bicycles were marketed at the same price level as locally manufactured bicycles. Those who purchased one or tried to ride one found all their learned experience negated as they struggled to redress the opposing of their aim by the bicycle's mechanism. (Wang Lugan)

Wang Luyan
1956 Born, Beijing, China
 Current, works for *Transport News*, Beijing, China

Group Exhibitions
1979 *Stars Art Exhibition*, China Art Gallery, Beijing, China
1989 *China/Avant-garde*, China Art Gallery, Beijing, China
1993 *China's New Art, Post-1989*, Hong Kong Arts Centre, Hong Kong
 Silent Energy, Museum of Modern Art, Oxford, UK
1996 *The Second Asia-Pacific Triennial of Contemporary Art*, Queensland Art Gallery, Brisbane, Australia
 First Academic Exhibition of Chinese Contemporary Art, Hong Kong Arts Centre, Hong Kong
1998 *Inside Out: New Chinese Art*, Asia Society Galleries, PS 1 Contemporary Art Center, New York, USA

Weng Fen
My Future is not a Dream
2000
video
Collection of Guangdong Museum of Art, Guangzhou

The work *My Future is not a Dream* is about my attitude towards the result of people's constant quest after idealism and desire. From the fabricated bright dream of the future as it appears in Chinese films of the 1950s, I edited what seems to be a film. Next, taking ten different people (a variety of people and friends living in Haikou) talking about their own bright hopes for their future, I edited their discussions as a video work. Both of the pieces are then shown side by side in the exhibition space. In regard to my choice of the scenes I selected, I can say that film is all about invented worlds. At the same time, people are very comfortable watching them. Reality is different in different periods, and people's mode of thinking and value systems change accordingly. (Weng Fen)

Weng Fen

1961	Born Hainan, China
1985	Graduated, Guangzhou Academy of Fine Arts, Guangzhou, China Current, teaches at the Art Institute of Hainan University, Hainan province, China

Group Exhibitions

1997	*Demonstration of Video Art '97 China*, Gallery of the Central Academy of Fine Arts, Beijing, China
1999	*Post-sense Sensibility: Alien Bodies and Delusion*, alternative non-art space, Beijing, China
2000	*Usual and Unusual*, Yuangong Art Museum, Shanghai, China
	Human and Animal, Guilin, China
	House, Home, Family, 4/F Yuexing Furniture Corporation, Shanghai, China
2001	*Virtual Future*, Guangdong Museum of Art, Guangzhou, China
	Chengdu Biennale, Chengdu Modern Art Museum, Chengdu, China
2002	*How Big is the World?*, OK Contemporary Art Centre, Austria
	Too Much Flavor, 3H Art Center, Shanghai, China

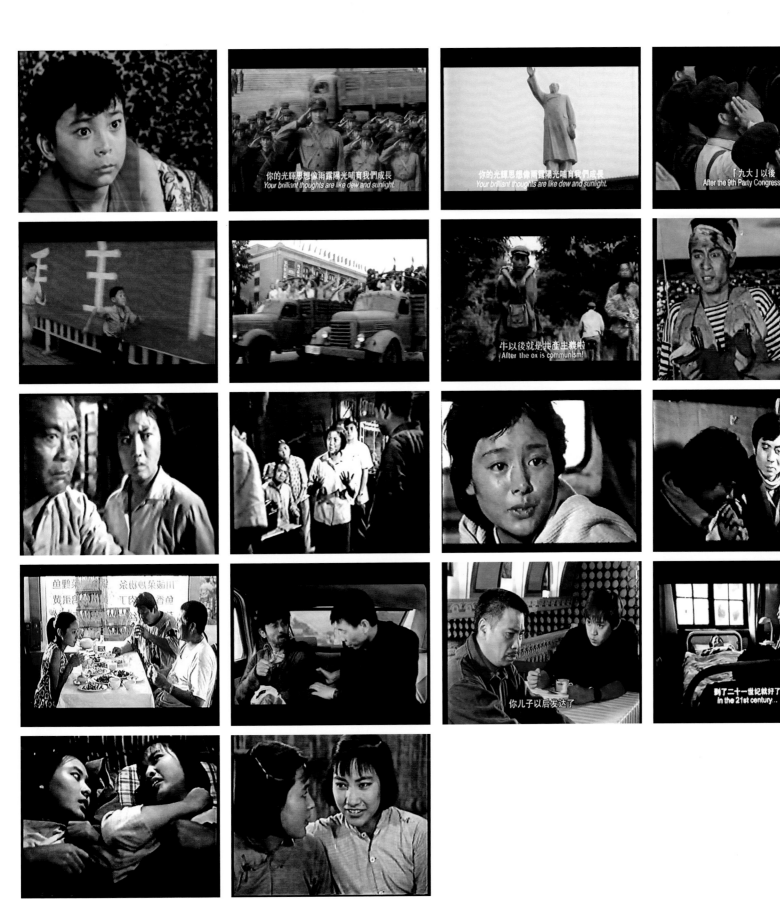

Yang Jiecang
Rebuilding Dong Cunrui
1999
installation

Yang Jiecang uses the form of an installation to talk about the Chinese war hero Dong Cunrui. In this process, the idea of the hero is constantly re-born, speaking to the organization of collective consciousness. He uses different tools of mass communication: film, photography, sculpture, cartoon, reading room, and stories made from photos. Through copying and re-copying images from films, he rids these works of their uniqueness, creating the idealistic and heroic effect of national propaganda tools, re-exhibiting the most fundamental imgaes. (Yang Tianna)

Yang Jiecang

1956 Born, Foshan, Guangdong province, China
1982 Graduated, Chinese painting department, Guangzhou Academy of Fine Arts, Guangzhou, China
 Current, lives and works in Hamburg, Germany and Paris, France

Solo Exhibitions

1997 *Cut the Fingernails from My Body*, Espace d'art contemporain Le Faubourg, Strabourg, France
1998 *Your Customs-Our Customs*, Altes Zollamt, Frankfurt, Germany
1999 *Another Turn of the Screw*, Gallery of the Central Academy of Fine Arts, Beijing, China
 Rebuilding Dong Cunrui, Chengpin Gallery, Taipei, Taiwan
2000 *You: Double View*, Project Room, ARCO 2000, Madrid, Spain
2001 *Institut Francais*, Institut Francais, Frankfurt, Germany
2002 *For Emily*, 4A Gallery, Sydney, Australia

Group Exhibitions

1989 *China/Avant-garde*, China Art Gallery, Beijing, China
 Les Magiciens de la Terre, Centre Georges Pompidou, Paris, France
1990 *Chine: Demain pour hier*, Les Domaines de l'art, Pourrieres, France
1991 *Exceptional Passage*, City Museum Project, Fukuoka, Japan
1994 *Out of the Centre*, Museum of Modern Art, Pori, Finland
1995 *Uber Holderlin*, Holderlin Museum, Tubingenm Germany
1999 *Asiart 99 Biennale d'arte contempranea*, Museum of Contemporary Art, Genoa, Italy
2000 *Paris Pour Escale*, Musee d'art Moderne de 1a Ville de Paris, Paris, France
2001 *China: Twenty Years of Ink Experiment*, Guangdong Museum of Art, Guangzhou, China
2002 *Pause: The Fourth Kwangju Biennial*, Kwangju, Korea Repubilc

Mao Xuhui
Yellow Arched Door: Parents
1990
oil on canvas
120 x 90 cm
Collection of Hanart TZ Gallery, Hong Kong

The use of yellow and gray to structure his compositions is characteristic of Mao Xuhui's painting. In the 1980s, his work was dominated by cool tones of gray, and his figures by expressions both convulsive and haggard. This intoned a sense of depression and disappointment engulfing their lives. After 1989, this *Parents* series employed "parents" as a motif to convey an image of power. The yellow-colored "parents" motif, against the tone of despairing gray, occupies an overbearing position at the center of the works. The entire picture plane is covered with violent expressive brushstrokes to effect a statement of discontent towards, and questioning of, power. (Li Xianting)

Mao Xuhui

1956 Born, Chongqing, China
1982 Graduated, fine arts department, Yunnan Art Institute, Kunming, Yunnan province, China
 Current, teaches in Yunnan University Art Institute, Kunming, China

Solo Exhibitions

1997 *Red Earth Dream Mao Xuhui Gui Mountain Series*, Soobin Art Gallery, Singapore
1999 *Scissors by Mao Xuhui*, Hanart TZ Gallery, Hong Kong

Group Exhibitions

1985 *New Concrete Realism*, Jing'an District Cultural Hall, Shanghai; Nanjing, China
1986 *The Third Exhibition of New Concrete Realism*, Yunnan Library, Kunming, China
1989 *China/Avant-garde*, China Art Gallery, Beijing, China
1991 *I Don't Want to Play Cards with Cezanne*, Asia Pacific Museum, Pasadena, USA
1992 *The First Guangzhou Biennale: Oil Painting in the Nineties*, Guangdong Exhibition Center, Guangzhou, China
1993 *China's New Art, Post-1989*, Hong Kong Arts Centre, Hong Kong
1995 *Out of the Middle Kingdom: Chinese Avant-garde Art*, Santa Monica Arts Center, Barcelona, Spain
1996 *China!*, Kunstmuseum Bonn, Bonn, Germany
1998 *Inside Out: New Chinese Art*, Asia Society Galleries, PS 1 Contemporary Art Center, New York, USA
2001 *Dream 2001, Chinese Contemporary Art*, Atlantis, London, UK

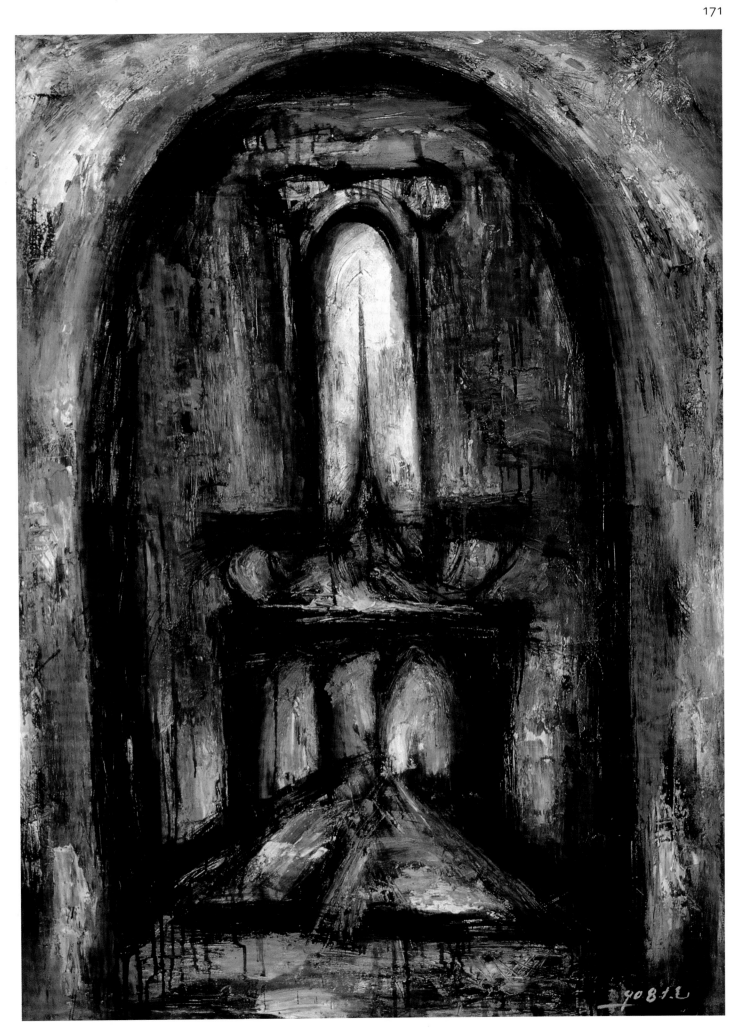

Liu Dahong
Huaihai Road, Shanghai
1996
oil on canvas
141 x 141 cm
Collection of Hanart TZ Gallery, Hong Kong

Arising out of a heterogeneous background of fine arts, Liu Dahong has an outstanding approach to expressing himself in his paintings, which often appear as proclamations of edicts at the end of a gloomy century. His approach to history against the prevailing socio-political climate, realistic modelling and thematic visions endow his works with the poignant functions of symbol and metaphor, making them profound fables that comment upon both history and reality. Liu Dahong's works contain a peculiar ideological language since all fairy tales about hell on earth aim to reveal the dubiety of mankind and his values. In addition, it also contains an inner stream of modelled forms that are evocative of his native environment. This stream arises from the depths of "people's belief" and "historical dreamland," and are built upon the foundation of existing culture and its values. Toppling and dismantling them, Liu Dahong splits these things into "words" (units of single modelling), and then regroups them according to his own experience and belief. Thus, he draws them into a new game via which he reveals a surprising critical awareness. (Zhu Dake)

Liu Dahong
1962 Born, Qingdao, Shandong
 province, China
1985 Graduated, China Na-
 tional Academy of Fine
 Arts, Hangzhou, Zhejiang
 province, China
 Current, lives and works
 in Shanghai, China

Solo Exhibitions
1992 China Club, Hong Kong
2000 *Altarpiece*, Formless Gallery, Shanghai Normal University, Shanghai, China

Group Exhibitions
1989 *China/Avant-garde*, China Art Gallery, Beijing, China
1993 *China's New Art, Post-1989*, Hong Kong Arts Centre, Hong Kong
1995 *The History of Chinese Oil Painting: From Realism to Post-Modernism*, Galerie
 Theoremes, Brussels, Belgium
1996 *Reckoning with the Past*, Fruitmarket Gallery, Edinburgh, UK
2001 *Chengdu Biennale*, Chengdu Modern Art Museum, Chengdu, China
2002 *Mercosul Biennial*, Bodoualige, Brazil
 Classical Radiance, Comune di Verona, Verona, Italy

Zeng Fanzhi
Xiehe Triptych
1990
oil on canvas
467 x 180 cm

Xiehe is pivoted on the topic of hospitals. Beyond the borders of realism lie a profusion of forms and motifs, especially the expressive force of brush marks. In the relationship between a hospital and its patients, Zeng Fanzhi expresses a sense of masochism and sado-masochism. The doctors appear to grin menacingly, the patients lie pathetically on the beds, seemingly calm, waiting. But the entire picture plane is dominated by a sense of unease, especially marked in the bruised redness of the flesh against the cool tones of white. Using expressionistic brushstrokes, he uncovers the acrid odor of blood and danger. *Xiehe Triptych* reflects the artist's pessimism; the hints of masochism and sado-masochism are clearly encapsulated in Zeng Fanzhi's brush marks and cool palette of color. (Li Xianting)

Zeng Fanzhi
1964 Born, Wuhan, Hubei province, China
1991 Graduated, oil painting department, Hubei Academy of Fine Arts, Wuhan, Hubei province, China
Current, lives and works in Beijing, China

Solo Exhibitions
1990 *Zeng Fanzhi: Works*, Art Museum, Hubei Academy of Fine Arts, Wuhan, China
1995 *Zeng Fanzhi: Masks Series*, Hanart TZ Gallery, Hong Kong
1998 *Zeng Fanzhi, Mask Series 1993-98*, CourtYard Gallery, Gallery of the Central Academy of Fine Arts, Beijing; ShanghART, Shanghai, China

Group Exhibitions
1992 *The First Guangzhou Biennale: Oil Painting in the Nineties*, Guangdong Exhibition Center, Guangzhou, China
1993 *China's New Art, Post-1989*, Hong Kong Arts Centre, Hong Kong
1994 *Invitational Exhibition of Works Selected by Chinese Critics*, China Art Gallery, Beijing, China
1995 *Out of the Middle Kingdom: Chinese Avant-garde Art*, Santa Monica Arts Center, Barcelona, Spain
Out of Ideology, Kampnagel Halle - K3, Hamburg, Germany
1996 *China!*, Kunstmuseum Bonn, Bonn, Germany
1997 *Quotation Marks*, Modern Art Museum, Singapore
1998 *The Exhibition of Seven Contemporary Chinese Artists*, Nikolas Sonne Fine Arts, Berlin, Germany
2001 *Towards a New Image*, China Art Gallery, Beijing, China

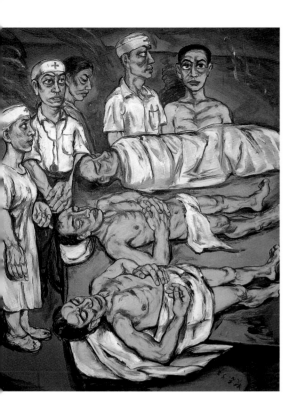

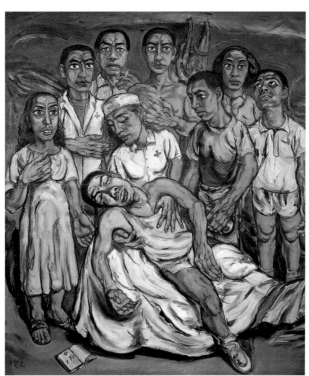

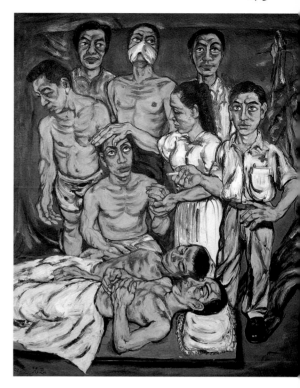

Ye Yongqing
Big Poster
1990-92
installation

Ye Yongqing has discovered the uniqueness of Chinese society in the space between traditional prin-making, Cultural Revoltion "big character posters," bulletin boards, and the branded advertisements of commerce. He has found the overlap between popularity and trend, and taken a warning from it. In his unique style and from his individual cultural perspective, Ye Yongqing makes a strong criticism of real problems. He is different from the other Chinese avant-garde artists who have been introduced often in Europe in recent years. As far as the Western viewer is concerned, the theme of Ye Yongqing's art is a deep-seated conflict, a kind of destruction of aesthetic meaning, a structural conflict. From the perspective of visual aesthetics, his works cross the boundaries of both language and place.

Ye Yongqing
1958 Born, Kunming, Yunnan province, China
1982 Graduated, painting department, Sichuan Academy of Fine Arts, Chongqing,China
 Current, professor, Sichuan Academy of Fine Arts, Chongqing, China

Individual Exhibitions
1989 Cultural section of the French Embassy, Beijing, China
1995 *Living in History*, Augsburg Studio, Germany
1999 *China in the Eyes of Scholar-Painters*, Munich, Germany; Soobin Gallery, Singapore
2000 Chinese Contemporary Art, London, U.K.
2001 ShanghArt Gallery, Shanghai, China

Group Exhibitions
1989 *China/Avant-garde*, China Art Gallery, Beijing, China
1990 *I Don't Want to Play Cards With Cezanne*, Pacific Asia Museum, Pasadena, USA
1992 *The First Gungzhou Biennale: Oil Painting in the Nineties*, Guangdong Exhibition Center, Guangzhou, China
1993 *China Experience*, Sichuan Art Museum, Chengdu, China
 China's New Art Post-1989, Hong Kong Arts Centre, Hong Kong
1996 *China!*, Kunstmuseum Bonn, Bonn, Germany
2000 *Gate of the New Century*, Chengdu Modern Art Museum, Chengdu, China
 Twentieth Century Chinese Oil Painting Exhibition, China Art Gallery, Beijing, China
2001 *Towards a New Image*, China Art Gallery, Beijing, China
2002 *Chengdu Biennale*, Chengdu Modern Art Museum, Chengdu, China

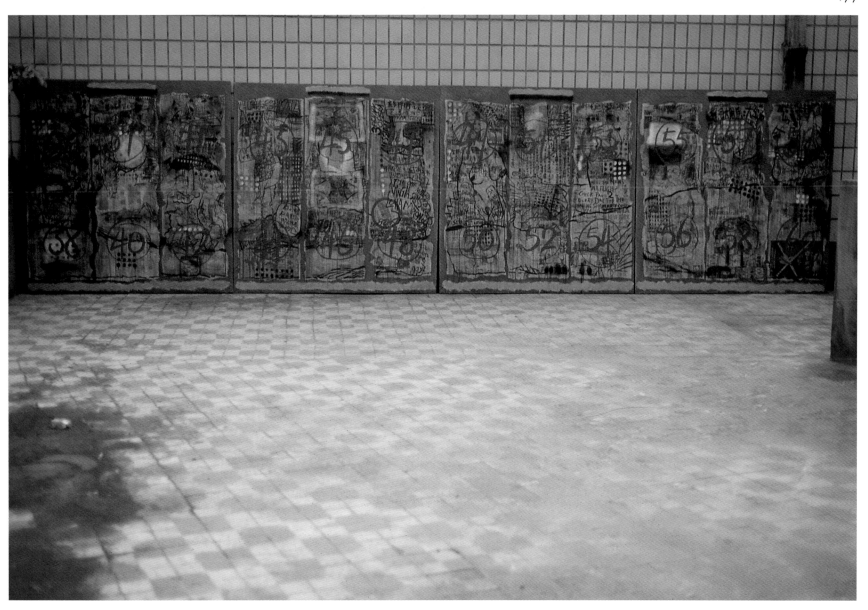

Wang Guangyi
Great Criticism –Tang
1990-92
oil on canvas
100 x 120 cm
Collection of China Club, Hong Kong

In the *Great Criticism* series, Wang Guangyi truly arrived at a dynamic image of reality. He put aside concepts of visual or painterly complexity to combine directly two very different cultural ideologies in an absolute fashion. Images from Cultural Revolution propaganda and commercial advertising meet on the canvas. This represents an individual confidence. Exploiting the contradictions, Wang Guangyi illustrates the vacuum with which culture is faced in the age of consumerism. (Huang Zhuan)

Wang Guangyi

1955 Born, Harbin, Heilongjiang province, China

1984 Graduated, oil painting department, Zhejiang Academy of Fine Arts, Hangzhou, Zhejiang province, China
Current, lives and works in Beijing, China

Solo Exhibitions

1993 Galerie Bellefroid, Paris, France
1994 Hanart TZ Gallery, Hong Kong
1994 Littmann Kultureprojekt, Basel, Switzerland
2001 *Faces of Faith*, Soobin Art Gallery, Singapore

Group Exhibitions

1989 *China/Avant-garde*, China Art Gallery, Beijing, China
1991 *I Don't Want to Play Cards with Cezanne*, Asia Pacific Museum, Pasadena, USA
1992 *The First Guangzhou Biennale: Oil Painting in the Nineties*, Guangdong Exhibition Center, Guangzhou, China
1993 *China Avant-garde*, Haus der Kulturen der Welt, Berlin, Germany
 China's New Art, Post-1989, Hong Kong Arts Centre, Hong Kong
1994 *Mao Goes Pop*, Museum of Contemporary Art, Sydney, Australia
 The 22nd International Sao Paulo Biennial, Sao Paulo, Brazil
1995 *Out of the Middle Kingdom: Chinese Avant-garde Art*, Santa Monica Arts Center, Barcelona, Spain
 Out of Ideology, Kampenagel Halle-K3, Hamburg, Germany
1996 *China!*, Kunstmuseum Bonn, Bonn, Germany
 The Second Asia-Pacific Triennial of Contemporary Art, Queensland Art Gallery, Australia
1998 *Inside Out: New Chinese Art*, Asia Society Galleries, PS 1 Contemporary Art Center, New York, USA

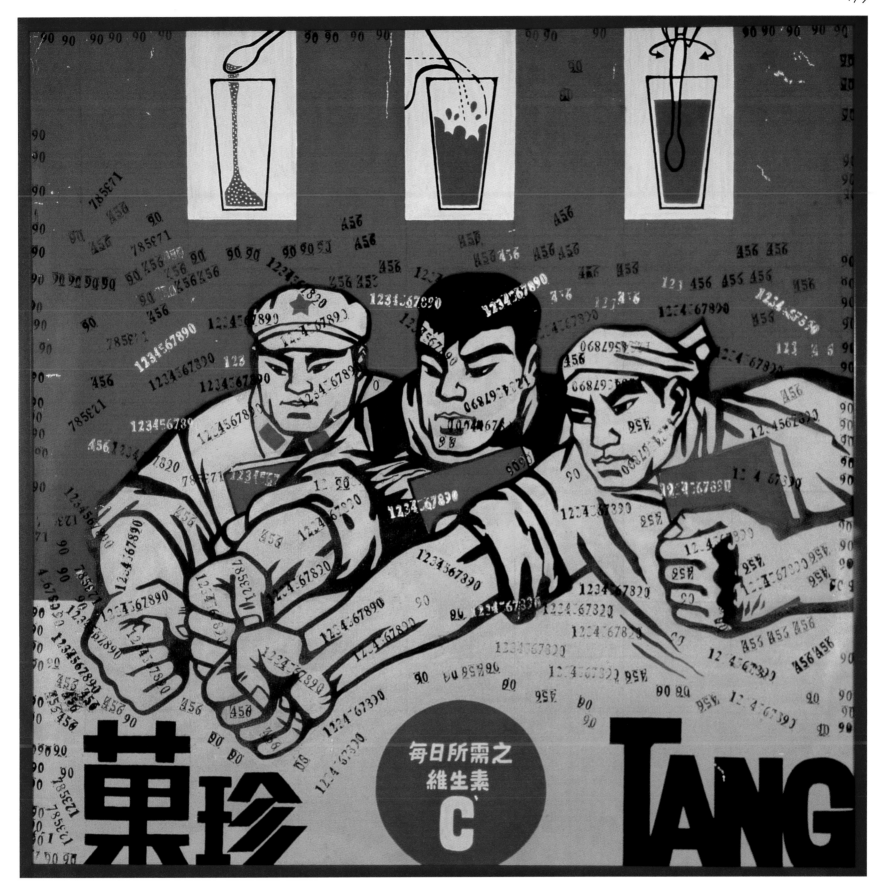

Zhou Tiehai / Zhao Lin

Famous Call Girl, Setting Trends that All Follow

1994
mixed media on paper
250 x 400 cm

I experience Western art and the inner problems of art on the basis of China's domestic and my own personal situation. China and the West are essentially the same. Individuals East or West all have to face and deal with the so-called problems of "modernity," problems related to the inclinations and advance of mankind. Its significance is beyond the reach of individuals and nations. Our language resource and system of knowledge are naturally born of the tradition of realism. We express our feelings candidly. The feelings are sincere. (Zhou Tiehai)

Zhou Tiehai is the true cynicist of the avant-garde, the sharp tongue of the artist-as-commentator on both his own society and the interaction and symptoms of the Chinese art circles. His work is conceptual but, in line with the evolution of a society with a preference for instant and disposable culture, his work has the fleeting quality of impermanence; today's that becomes tomorrow's garbage. The power of mass media to shape opinion and present the facts of the (art) world has been a force he manipulates for his own poignant ends. The huge drawings he produces with Zhao Lin frequently appear to carry "headlines," satirical slogans that are their own approach to graffiti that unfolds over random spreads of paper. No matter how careless the works might first appear, they demonstrate a refinement that has awarded their authors a distinct niche in the contemporary art world in China. (Karen Smith)

Zhao Lin
1968 Born, Shanghai, China
1991 Graduated, Fine Arts Institute, Shanghai University, Shanghai, China
Current, lives and works in Shanghai, China

Zhou Tiehai
1966 Born, Shanghai, China
1989 Graduated, Fine Arts Institute, Shanghai University, Shanghai, China
Current, lives and works, Shanghai, China

Selected Solo Exhibitions
1996 *Too Materialistic, Too Spiritualized*, Gallery of the Central Academy of Fine Arts, Beijing, China
1998 *Zhou Tiehai*, Kunsthal Rotterdam, the Netherlands
Beyond the Borderline, Galerie Bernhard Schindler, Bern, Switzerland
1999 *Don't be Afraid to Make Mistakes*, ShanghArt Gallery, Shanghai, China
2000 *Placebo Swiss*, Hara Museum, Tokyo, Japan
Met in Shanghai, Schloss Morsbroich, Germany
Will, Quadrum Gallery, Lisbon, Portugal
2001 *The Artist Isn't Here*, ShanghArt Gallery, Shanghai, China; ISE Foundation, New York, USA

Group Exhibitions
1996 *In the Name of Art*, Liu Haisu Museum of Art, Shanghai, China
1997 *Another Long March: Chinese Conceptual and Installation Art in the Nineties*, Fundament Foundation, Breda, the Netherlands
1997 *Cities on the Move*, The Secession, Vienna, Austria
1998 *Medialisation*, Edsvik Konst och Kulture, Sollentuna, Finland
1999 *International Photography Biennale*, Mexico City, Mexico
The '99 Biennale de Maya, Maya, Portugal
The 48th Venice Biennale, Venice, Italy
Looking Out / Looking In, Plug In Contemporary Art, Winnipeg, Canada
2000 *Our Chinese Friends*, Bauhaus-University and ACC Gallery, Weimar, Germany
2001 *Living in Time*, Hamburg Bahnhof Museum of Contemporary Art, Berlin, Germany
2002 *Pause: The Fourth Kwangju Biennial*, Kwangju, Korea Republic

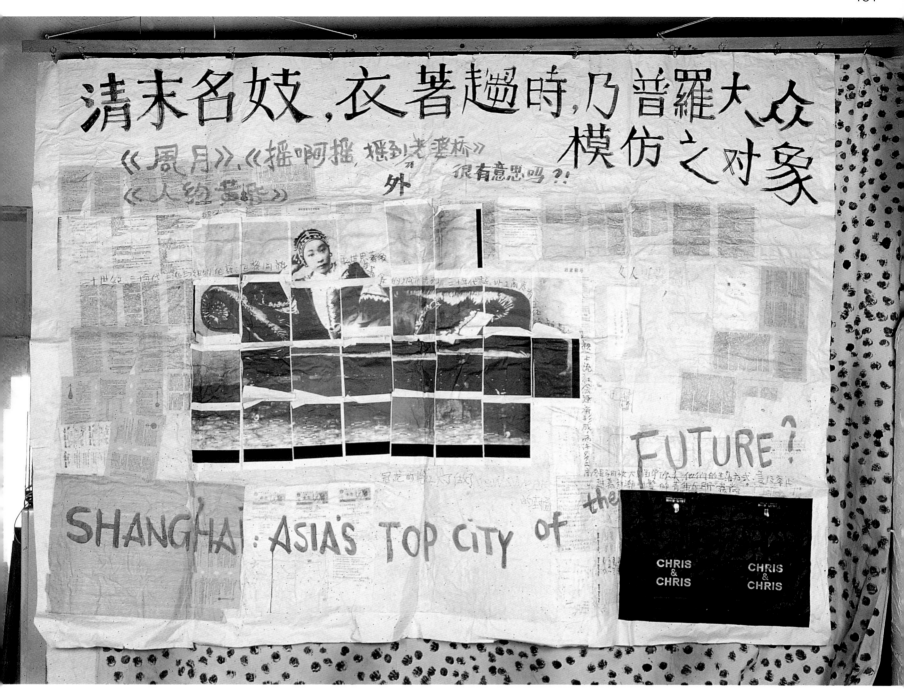

Li Shan
Rouge Series — The Young Mao Zedong

1994
oil on canvas
115 x 200 cm
Collection of Hanart TZ Gallery, Hong Kong

The leaders series by Li Shan reflects the power and psychological consciousness hidden behind political myth. He intentionally blurs sexual disparities, adding mystic charm under the authority of political idol. Li Shan's artistic presentation is extremely individualized. His personal state of mind integrated with his images of public idols presents a psychological phenomenon hidden in contemporary culture. (Yi Wen)

Li Shan

1942 Born, Lanshi, Heilongjiang province, China

1963 Entered, Heilongjiang University, Harbin, Heilongjiang province, China

1967 Graduated, Academy of Drama, Shanghai, China
 Current, lives and works between Shanghai, China and New York, USA

Group Exhibitions

1983 *1983 Experimental Painting Exhibition*, Fudan University, Shanghai, China
1986 *The First Aotu Exhibition*, Shanghai, China
1988 *The Second Aotu Exhibition: The Last Supper*, Shanghai Art Museum, Shanghai, China
1989 *China/Avant-garde*, China Art Gallery, Beijing, China
1992 *Encountering the Other*, K-18, Kassell, Germany
1993 *China's New Art, Post-1989*, Hong Kong Arts Centre, Hong Kong
 The Eastern Road: The 45th Venice Biennale, Venice, Italy
1994 *The 22nd International Sao Paulo Biennial*, Sao Paulo, Brazil
1995 *Out of the Middle Kingdom, Chinese Avant-garde Art*, Santa Monica Arts Center, Barcelona, Spain
1998 *Inside Out: New Chinese Art*, Asia Society Galleries, PS 1 Contemporary Art Center, New York, USA

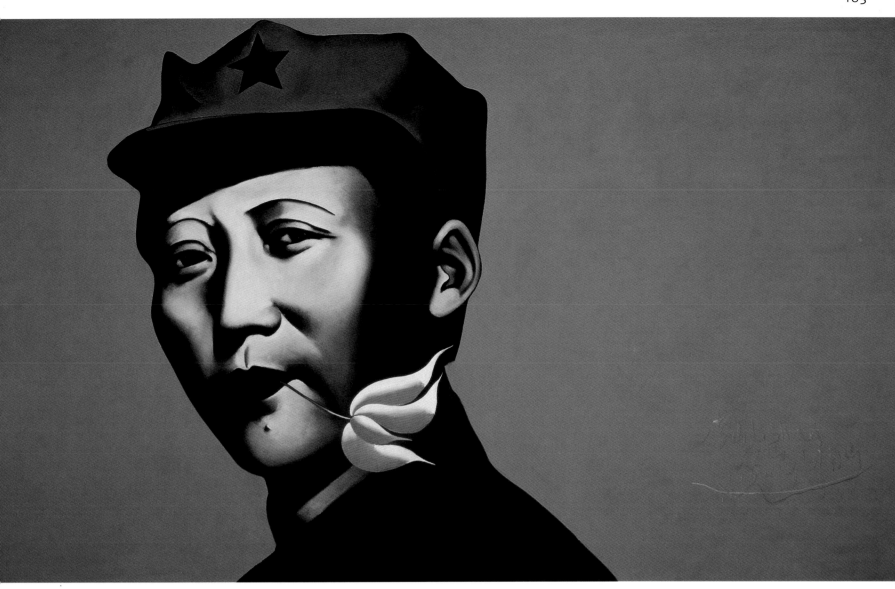

Wei Guangqing
Red Wall: Family Gathering
1992
oil on canvas
175 x 300 cm

Wei Guangqing uses the images and stories from Chinese traditional woodcuts in his work. These are subjected to his Pop Art style and accorded various new meanings from their alignment with contemporary life. In his works he does not directly portray standard scenes of daily life, preferring to use symbols, like the roll of Fuji film, to convey his meaning. Technically, his works evoke a strong sense of Andy Warhol's style, but this does not prevent the artist from producing profound compositions that emphasize the visual power of the paintings. (Yang Xiaoyan)

Wei Guangqing

1963 Born, Huangshi, Hubei province, China

1985 Graduated, oil painting department, Zhejiang Academy of Fine Arts, Hangzhou, Zhejiang province, China
Current, teaches in the oil painting department, Hubei Academy of Fine Arts, Wuhan, China

Solo Exhibitions

2000 *Actually You Could Also Make it Wider: Wei Guangqing Red Wall Series*, ShanghArt Gallery, Shanghai, China

Group Exhibitions

1989 *China/Avant-garde*, China Art Gallery, Beijing, China

1992 *The First Guangzhou Biennale: Oil Painting in the Nineties*, Guangdong Exhibition Center, Guangzhou, China

1993 *China's New Art, Post-1989*, Hong Kong Arts Centre, Hong Kong

1995 *Out of Ideology*, Kampnagel Halle - K3, Hamburg, Germany

1996 *China!*, Kunstmuseum Bonn, Bonn, Germany

1997 *Quotation Marks*, Modern Art Museum, Singapore

1998 *Contemporary Chinese Art Exhibition*, Haus der Kulturen der Welt, Berlin, Germany

1999 *Global Conceptualism: Points of Origin 1950s-1980s*, Queens Museum of Art, New York, USA

2000 *Hot Pot*, Kunsternes Haus, Oslo, Norway

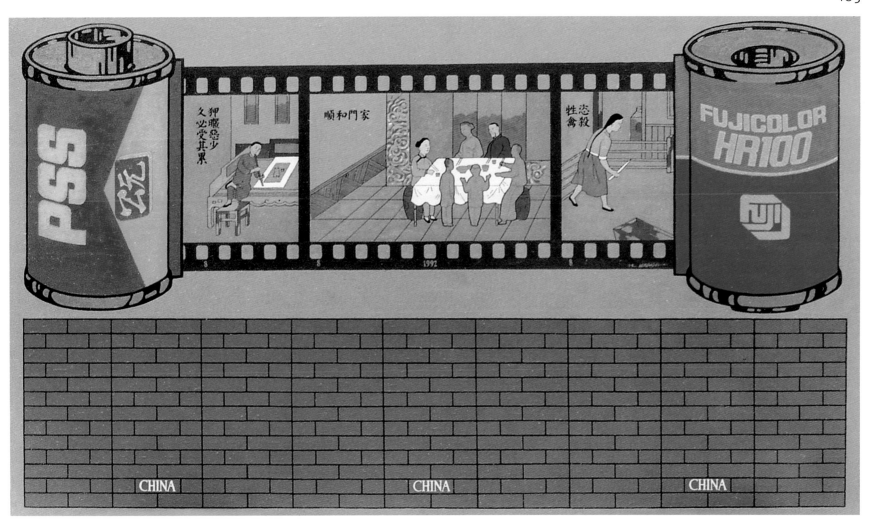

Yang Guoxin
Inside Information

1992
oil and silk-screen on canvas
173 x 243 cm
Collection of Mr.Tang Buyun

From the main theme of this work to the approach to creating it, *Inside Information* clearly takes a cue from the art of Andy Warhol. But this does not prevent the artist from freely presenting his opinion. With his use of a wide variety political motifs, elements of news media and specific products of contemporary Chinese life as motifs representing mass culture and with additional techniques from silk-screen printing, all combine to an atmosphere of gaudy culture in the work. Especially in regard to the desires of a particular generation/time, which here points to attitudes prevalent in present-day life. The compositions are arranged in an orderly way. The empty faces deny the experience we usually bring to looking at paintings, while at the same time increasing the emphasis on the space created in the works and accounting for the general air of vagueness. Thus we are given to understand the social concerns of the artist reflected in his work as he uses his own language to strike at sensitive social issues. (Yi Wen)

Yang Guoxin

1951 Born, Wuhan, Hubei province, China
1981 Graduated, fine arts department, Wuhan Normal University, Wuhan, Hubei province, China
1991 Completed post-graduate studies, Hubei Academy of Fine Arts, Hubei province, China
Current, lives and works in Guangzhou, China

Group Exhibitions

1986 *Hubei Arts Festival*, Wuhan, China
1992 *The First Guangzhou Biennale: Oil Painting in the Nineties*, Guangdong Exhibition Center, Guangzhou, China
First Exhibition of Chinese Oil Painting in the 1990s, Redwood City Exhibition Hall, California, USA
1993 *Chinese Pop Art*, Hong Kong
1996 *First Academic Exhibition of Chinese Contemporary Art*, Hong Kong Arts Centre, Hong Kong
1997 *Contemporary Chinese Oil Painting Exhibition*, Shanghai, China
2000 *Society: The Second Academic Invitational Exhibition*, Upriver Gallery, Chengdu, China
2001 *Asia 2000: Shifting Concepts in Contemporary Art*, Brighton, UK

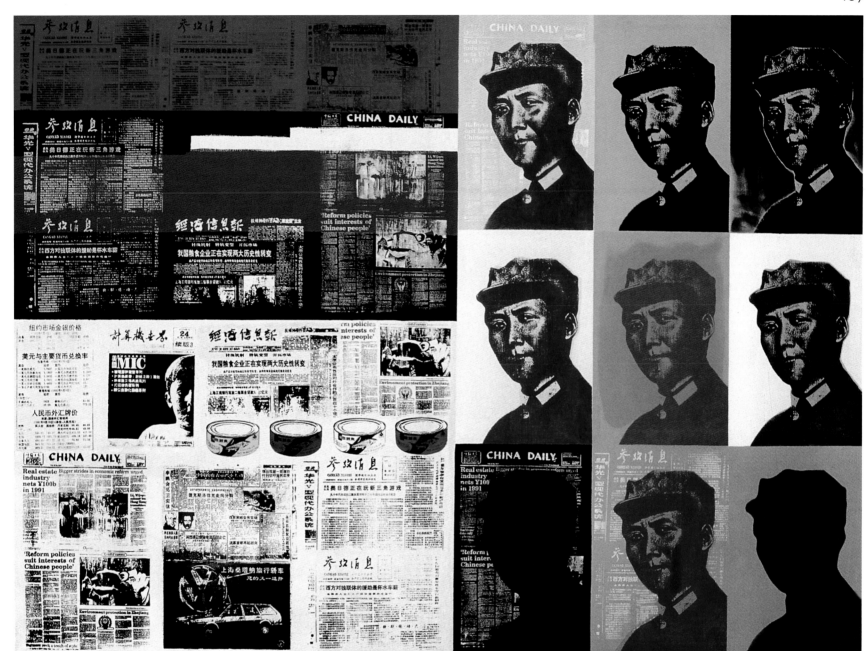

Zhang Xiaogang
The Big Family

1994
oil on canvas
150 × 180 cm
Collection of Hanart TZ Gallery, Hong Kong

The Big Family uses a post-Pop approach via a traditional *tanjing* style of painting to explore actual photographed images of contemporary Chinese family history. He gives readings of contemporary Chinese history a kind of critical insight. This group of works is characterised by a simple, direct, emotionally cool image and repetition of form and composition. It points to the Chinese people's direct personal experience of history and their identity. It becomes an expression of the artist's grasp of and response to this kind of personal experience and identity. Zhang Xiaogang's works represent an important transition in contemporary Chinese art at the end of the 1990s away from the narrow limitations of Political Pop. (Huang Zhuan)

Zhang Xiaogang

1958 Born, Kunming, Yunnan province, China
1982 Graduated, oil painting department, Sichuan Academy of Fine Arts, Chongqing, China
Current, lives and works between Chengdu and Beijing, China

Solo Exhibitions

1997 *Bloodlines: The Big Family*, Gallery of the Central Academy of Fine Arts, Beijing, China
1998 *Bloodlines: The Big Family*, Hanart TZ Gallery, Taipei, Taiwan
1999 *Comrades*, Galerie de France, Paris, France
2000 *Zhangxiaogang 2000*, Max Protetch Gallery, New York, USA

Group Exhibitions

1989 *China/Avant-garde*, China Art Gallery, Beijing, China
1991 *I Don't Want to Play Cards with Cezanne*, Asia Pacific Museum, Pasadena, USA
1992 *The First Guangzhou Biennale: Oil Painting in the Nineties*, Guangdong Exhibition Center, Guangzhou, China
1993 *China's New Art, Post-1989*, Hong Kong Arts Centre, Hong Kong
1994 *The 22nd International Sao Paulo Biennial*, Sao Paulo, Brazil
1995 *The 46th Venice Biennale*, Venice, Italy
Out of the Middle Kingdom: Chinese Avant-garde Art, Santa Monica Arts Center, Barcelona, Spain
Out of Ideology, Kampenagel Halle - K3, Hamburg, Germany
1996 *China!*, Kunstmuseum Bonn, Bonn, Germany
The Second Asia-Pacific Triennial of Contemporary Art, Queensland Art Gallery, Brisbane, Australia
1998 *Inside Out: New Chinese Art*, Asia Society Galleries, PS 1 Contemporary Art Center, New York, USA
1999 *Man + Space: The Third Kwangju Biennial*, Kwangju, Korea Republic

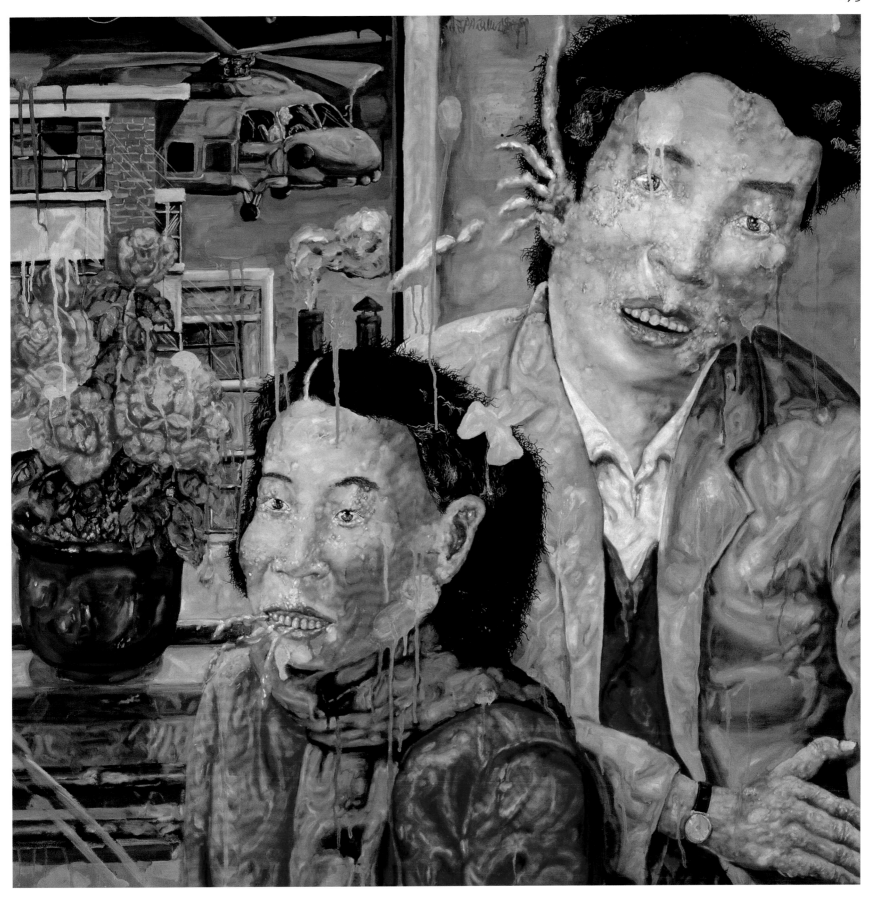

Hai Bo
Them No. 3 (Men)
1999
photograph
diptych, each 90 x 60 cm

Them No. 6 — For the Future (Women)
1999
photograph
diptych, each 90 x 60 cm

Re-conjuring the past is an activity to which my mind frequently turns, leading me into a private state that is hard to describe, yet that owns the greater part of my soul. The power of remembrance demands a powerful means of expression. These pictures are the result of remembering and re-conjuring the past through the last few years. The majority of those who feature in the photographs are friends, my parents and myself. By re-photographing these individuals again years later, I seek to illustrate the vicissitudes the people have suffered, the changes in the world, and the lapse of time. But I also want to look back to that moment when the shutter clicked. These pictures are the reproductions of a moment, a time. They parallel what I understand art to be. To look for and find a meaningful old photograph, and then to search out the persons in it to recreate a new one makes the photographs more meaningful. I believe that good art exists in the gap between art and non-art. (Hai Bo)

Hai Bo

1962	Born, Changchun, Jilin province, China
1984	Graduated, Jilin Institute of Art, Changchun, China
1989	Graduated, print-making department, Central Academy of Fine Arts, Beijing, China
	Current, lives and works in Beijing, China

Solo Exhibitions

2001	Galerie Loft, Paris, France
2002	Macau Arts Centre, Macau

Group Exhibitions

1999	*Back and Forth, Left and Right*, alternative art space, Beijing suburbs, China
2000	*House, Home, Family*, 4/F Yuexing Furniture Corporation, Shanghai, China
	Shanghai Spirit: The Third Shanghai Biennale, Shanghai Art Museum, Shanghai, China
2001	*The 49th Venice Biennale*, Venice, Italy
	Dream 2001, Chinese Contemporary Art, Atlantis, London, UK
	New Conceptual Image, Art Beatus, Vancouver, Canada

Feng Mengbo
My Private Album
1996
interactive installation

Through accumulation of family videos and visual stimulation combining with the functions of visual, hearing, and interactive gaming entertainment, Feng Mengbo, utilizing computer technology, pays close attention to the living conditions of the common people of China. He narrates their personal living environment, and in the process depicts the hard realities of survival brought on by historical change. (Feng Boyi)

Feng Mengbo

1966 Born, Beijing, China
1991 Graduated, print-making department, Central Academy of Fine Arts, Beijing, China
 Current, lives and works in Beijing, China

Solo Exhibitions
1994 *The Game is Over: Long March*, Hanart TZ Gallery, Hong Kong
1998 *Feng Mengbo*, Holly Solomon Gallery, New York, USA
 Feng Mengbo: Electronic Games, Haggerty Museum of Art, Milwaukee, USA
2001 *Feng Mengbo, Fantastic Story*, Dia Contemporary Art Center, New York, USA
2002 *Q4U*, The Renaissance Society, Chicago, USA

Group Exhibitions
1993 *The Eastern Road: The 45th Venice Biennale*, Venice, Italy
1995 *Lucky Illusions: Ten Contemporary Asian Artists*, Japan Foundation, Tokyo, Japan
 The First Kwangju Biennial, Kwangju, Korea Republic
1997 *The Fourth Lyon Biennial of Contemporary Art*, Lyon, France
 The Second Johannesburg Biennial, Johannesburg, South Africa
 Documenta X, Kassell, Germany
1998 *The Ninth International Symposium on Electronic Art*, Liverpool, UK
1999 *The First Fukuoka Triennial of Asian Art*, Fukuoka Museum of Asian Art, Fukuoka, Japan
2001 *The First Tirana Biennial*, Tirana, Albania
2002 *Documenta XI*, Kassell, Germany

The Triplicate Studio (Sui Jiangguo, Zhan Wang, Yu Fan)
Women/Here
1995
installation

The source materials for this show were provided voluntarily by the mothers and wives of the three artists. They included old photographs, journals, certificates, collections of objects, handicrafts, and documents which serve to record their lives. Personal lives and private pasts are revealed to the public in the form of wall newspapers and information boards. The mothers and wives of the three artists were all present in the exhibition space during the exhibition period. From this piece, we can see that what presents and conveys the essence of the world is the real existence of the world *per se*—the essence lies in our lives. This piece manages to mirror the living conditions of people in different historical phases more than any fabricated object or plot could achieve. (Feng Boyi)

The aim of the second exhibition of this group was to take society as an experimental place for art, to use an artistic approach to exploring common public issues as they pertained to each artist. Within a dialogue with society they further explored the potential for art. At the time of the Women's Conference in Beijing each of them brought together a display of materials about the women in their lives. *Women/Here* aimed to express the artists' attitude towards society and culture, neither opposing nor supporting, but as each perceived them. (Qian Zhijian)

The Triplicate Studio
Members: Sui Jianguo, Zhan Wang,
 Yu Fan
Established 1995

Group Exhibitions

1995 *Plan for Development*, former site of the Central Academy of Fine Arts at Wangfujing, Beijing, China
 Women/Here, Beijing Contemporary Art Gallery, Beijing, China
1997 *Returning to Remember*, (photography), Museum of Revolutionary History, Beijing, China
 Plan for Development II, (installation, unrealized proposal), Gallery of the Central Academy of Fine Arts, Beijing, China
 A New Long March, (installation, unrealized proposal), railroad bridge over the Yellow River, Ji'nan, China

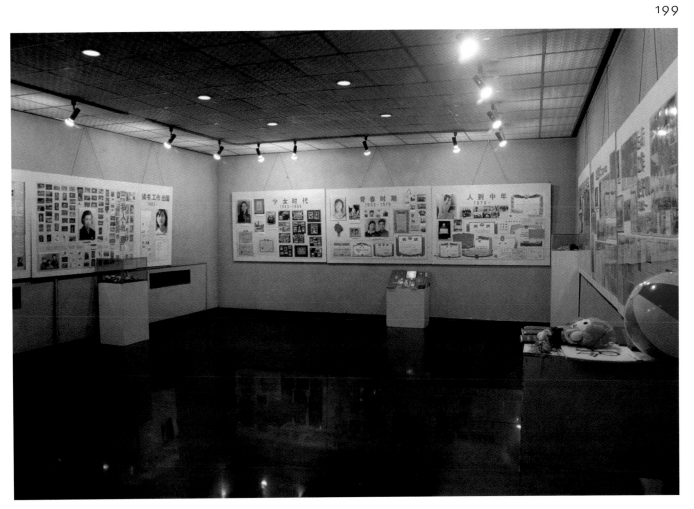

Wang Jin

Ice: Central Plains

1996
installation
Photographed by Jiang Jian

This work, realized at the Central Plains Shopping Center in Zhengzhou, Henan province, tries to create a new notion of art through direct interaction with the viewers, allowing the viewers, through their participation, to evaluate and recognize their own survival-related behaviors. As far as I am concerned, the importance of the work lies not in the size of the wall of ice, nor in the scale of the man or machine power used in its implementation, but rather in whether it accurately makes a connection with the viewers. That is to say, whether the results produced by this confluence of artistic creation and viewer can feasibly be extended or widened. It is not important that the ice be transparent, but that the materials frozen in the ice are conceptually able to evoke some ideas about mass consumer culture, to reveal our attitudes and perspectives, to give the public an opportunity to consider what is actually meant by "value." This is not a question simply of the visual effect of the ice, nor is the work realized entirely with an eye to symbolic meaning. The idea is rather to use the ice to represent a kind of rationality, a baptism, to create a response to China's current "commercial war," its increasingly consumerist ways. (Wang Jin)

Wang Jin

1962 Born, Datong, Shanxi province, China
1987 Graduated, Chinese painting department, Zhejiang Academy of Fine Arts, Hangzhou, Zhejiang province, China
 Current, lives and works in Beijing, China

Group Exhibitions

1996 *Ice: Central Plains*, installation, Zhengzhou, China
1997 *Crack in the Continent, Contemporary Chinese Art, 1997*, The Watari Museum of Contemporary Art, Tokyo, Japan
 Dream of China, Yanhuang Art Museum, Beijing, China
1998 *Museum City Fukuoka 1998*, Asian Art Museum, Fukuoka, Japan
1998 *Inside Out: New Chinese Art*, Asia Society Galleries, PS 1 Contemporary Art Center, New York, USA
1999 *Transience: Chinese Experimental Art at the End of the Twentieth Century*, Smart Museum of Art, University of Chicago, Chicago, USA
 The 48ᵗʰ Venice Biennale, Venice, Italy
2000 *Hanover 2000 International Exposition*, Hanover Exhibition Centre, Hanover, Germany

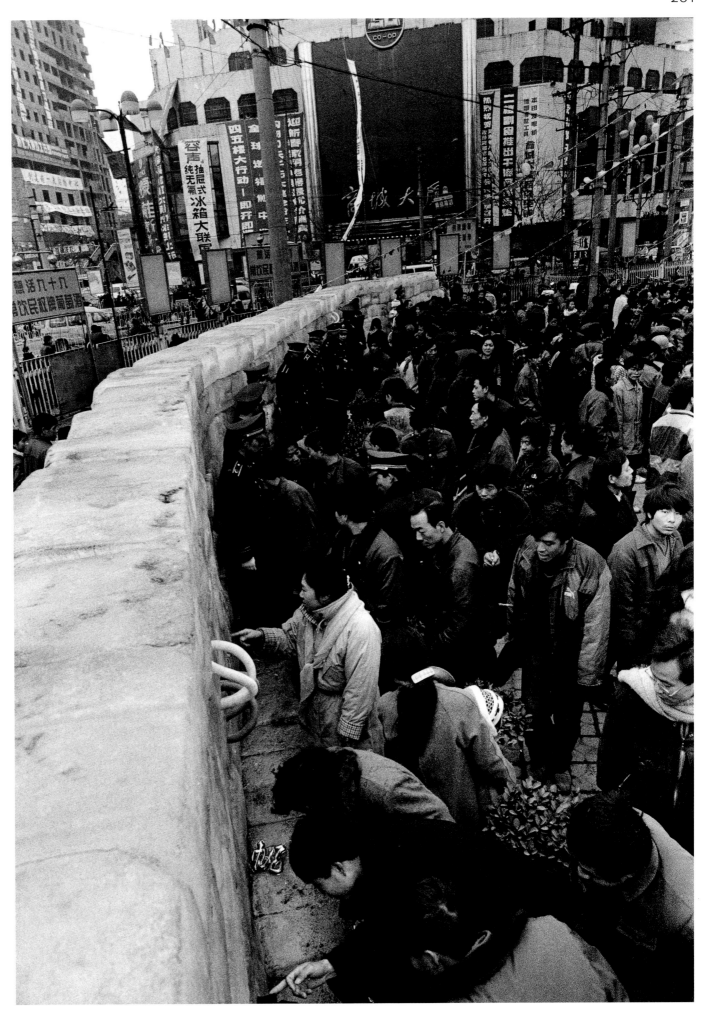

Yuan Dongping
Mental Hospital Series

1989-90
photographs
30 × 40 cm each

About reality yet going beyond reality, the subjectivity of the lens provides the pictorial space for the photograph. In reality, there exist many unfamiliar objects, like those that appear in Surrealist canvases. But it is this kind of unfamiliarity that illustrates the artist's inherent sensibility and is his spiritual guide. Here are several images from a series about a mental facility that Yuan Dongping took in 1990. They are truly an outstanding choice of approach. At the end of the 1970s, his subject was the poorest of peasants. In the mid-1980s, as modernism emerged, he turned his attention to social issues and his response to an absurd world, which led him to select specific topics like the mental institution. It was in such special topics that he discovered the real absurdity of the world. (Li Xianting)

Yuan Dongping

1956 Born, Guangzhou, China
1984 Graduated, history department, Beijing Normal University, Beijing, China
 Current, employed by the People's Pictorial, Beijing, China

Group Exhibitions

1999 *Transience: Chinese Experimental Art at the End of the Twentieth Century*, Smart Museum of Art, University of Chicago, Chicago, USA
 Contemporary Chinese Photography, Los Angeles, USA
2001 *Yiping International Photography Festival*, Dongying, China

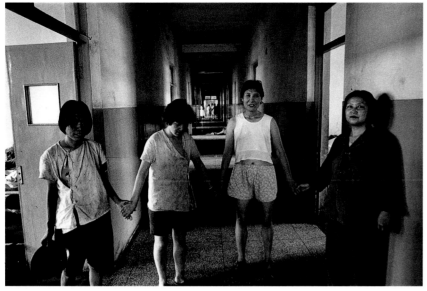

holding hands

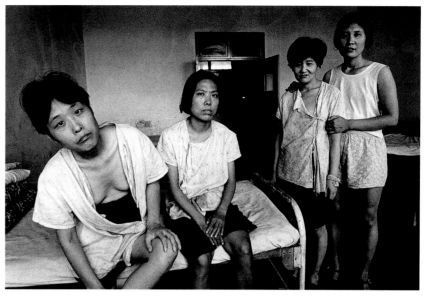

sitting around

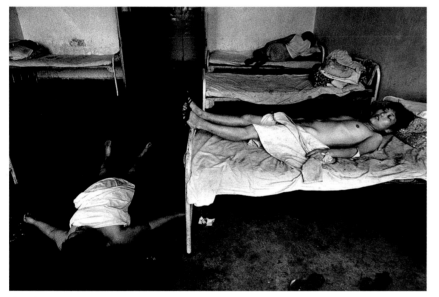

sleeping

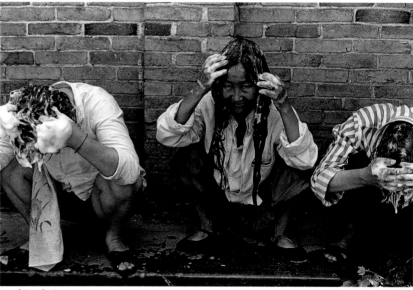

washing hair

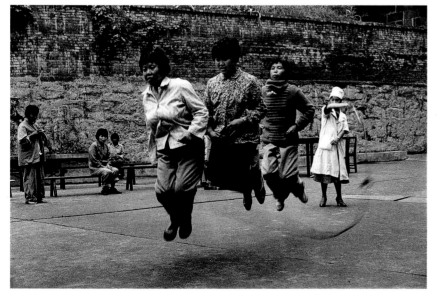

jumping rope

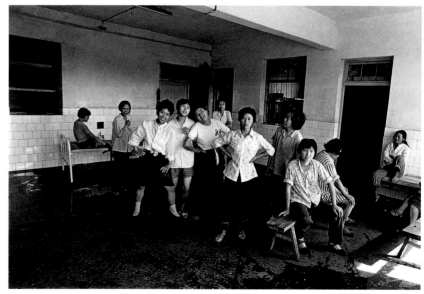

group photograph

Liu Zheng
My Countrymen
1994
photographs
120 x 120 cm each
Collection of CourtYard Gallery, Beijing

In the family tree of artistic representation, the body is always a thematic element to which are attached notions of ethics, beauty and culture formed through centuries of history. Liu Zheng explores themes of the body entangled up with desire, and of the body fighting against culture within Chinese culture. This overall, long-term and pertinacious exploration imbues his photographs with a particular allure. (Gu Zheng)

Liu Zheng

1969	Born, Wuqiang, Hebei province, China
1991	Graduated, optic engineering department, Beijing Technology Institute, Beijing, China
	Current, lives and works in Beijing, China

Solo Exhibitions

1998 *Three Realms and the Chinese*, Photo Gallery, Taipei, Taiwan
2000 *My Countrymen*, Gallery of the Central Academy of Fine Arts, Beijing, China

Group Exhibitions

1995 *Five Man Show*, Beijing, China
1997 *Zeitgenössische Fotokunst aus der Volksrepublik China* (Contemporary Photography from the People's Republic of China), Neuer Kunstverein, Berlin, Germany
1999 *Transience: Chinese Experimental Art at the End of the Twentieth Century*, Smart Museum of Art, University of Chicago, Chicago, USA
 Love: Chinese Contemporary Photography and Video, Tachikawa Art Festival, Tokyo, Japan
2001 *Next Generation*, Galerie Loft, Paris, France
 A Man, A Woman, A Machine, London, UK

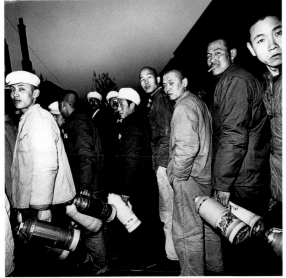

prisoners getting water

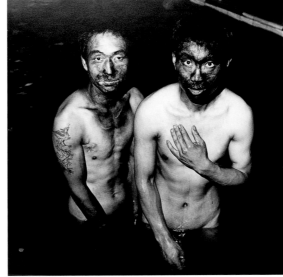

two miners

three old women

girl dead from accident

two guests

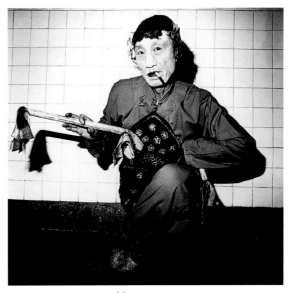

young woman grown old

Song Yongping
My Parents
1998-2001
photographs
50 x 60 cm each

Song Yongping's parents endured illness for many years, which rendered their lives chaotic and frail, devoid of any real light. As Song Yongping performed his filial duty to his parents, nursing them through their ills, he became keenly aware of feeling alienated from society; not just of his own alienation but that of his parents and, by default, of all those unable to live as "useful" members of society. His parents' pessimism shocked him. To find release for the pressure and frustration, he took up his camera and in close detail recorded his parents' daily existence through to the end of their lives. Lacking luster, enthusiasm for life, or hope, in these photographs the parents appear totally dejected and physically awkward. We are shown human vulnerability and frailty, and the unwavering support of a child to his parents. This will happen to us all. A positive outlook on life is usually praised, yet the experience of disappointment, despair is more real. (Li Xianting)

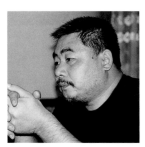

Song Yongping

1961 Born, Shanxi province, China
1983 Graduated, painting department, Tianjin Academy of Fine Arts, Tianjin, China
Current, lives and works in Taiyuan, Shanxi province, China

Solo Exhibitions

1991 *Song Yongping Paintings*, Beijing Concert Hall Gallery, Beijing, China

Group Exhibitions

1985 *Exhibition of Modern Art by Seven Shanxi Artists*, Workers Cultural Palace, Taiyuan, Shanxi Province
1989 *China/Avant-garde*, China Art Gallery, Beijing, China
1993 *China's New Art, Post-1989*, Hong Kong Arts Centre, Hong Kong
Country Life Plan Art Exhibition, China Art Gallery, Beijing, China
1998 *Inside Out: New Chinese Art*, Asia Society Galleries, PS 1 Contemporary Art Center, New York, USA
1999 *Global Conceptualism: Points of Origin 1950s - 1980s*, Queens Museum of Art, New York, USA
Representing the People, Laing Art Gallery, Newcastle, UK
2000 *Intent on Communicating: Chinese Conceptual Photography*, Genoa Asian Contemporary Art Archives, Milan, Italy
2001 *Nice International Photography Festival*, Nice, France
The Second Asian Contemporary Art Biennale, Genoa, Italy
Death Files, Artists' Storehouse, Beijing, China

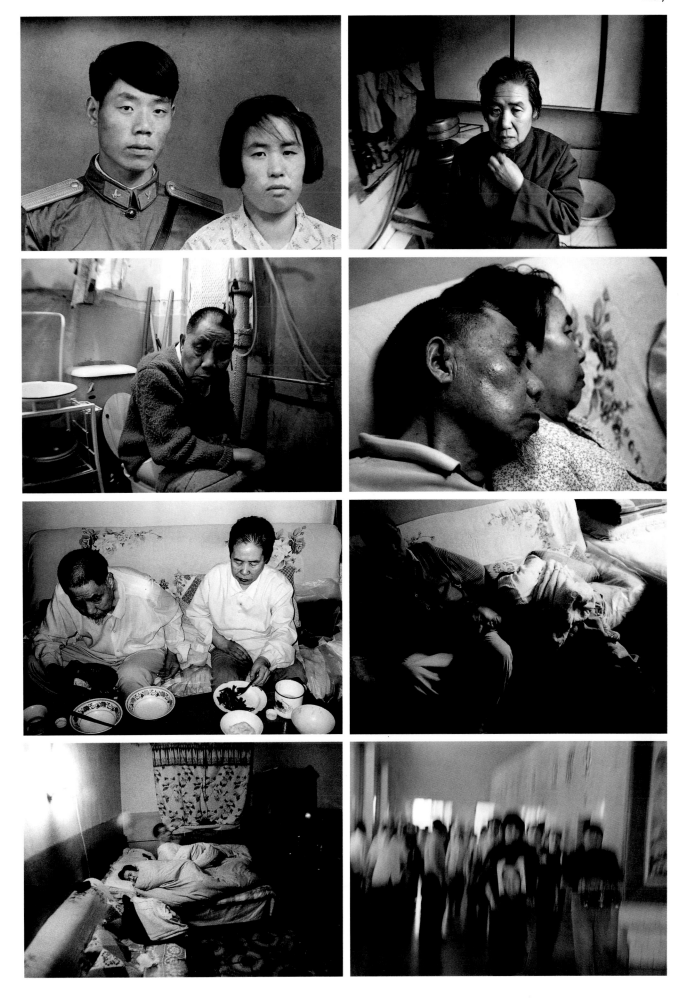

Mao Tongqiang
Death Files: No. 320
1998
industrial paint on canvas
200 x 200 cm

Mao Tongqiang continues to live and work in the remote region of Ningxia. Such remove from the center of contemporary art in Beijing and the art communities that exist in larger cities around the country has both advantages and disadvantages. It never prevented the artists from keeping informed of the general trends in art nor the styles of the leading players, but it does make for an isolated, melancholic existence. In creating the *Files* series, Mao Tongqiang's style resonates in forms of appropriation and assemblage, the mixing of painted and printed elements that were found in earlier schools of Political Pop and Cynical Realism. However, his isolation has enabled him to achieve a profound body of work exploring a set of contemporary social issues in a convincing and culturally relevant way.

Files has its origins in twentieth-century Chinese history when with mass motion all over the country, campaigns and criticisms, many individuals literally disappeared. The echo of this was rekindled with the dramatic changes in the era of reform. As China's economy bloomed and consumerism thrived, large numbers of people were seduced away from the land, from their native villages. Without residency permits for legal tenure in the cities, and without the appropriate work papers, they became invisible. Some would never return but others would never be heard of again. It is their faces that Mao Tongqiang reproduces on canvas in the indistinct way that missing persons' photographs often are, as the only record of a life. These images are juxtaposed with an imitation of bureaucratic seals and notes, first in "opening" the case, and then when no results are forthcoming, "canceling" the file and removing it from the system. This ambiguous series of "portraits" are thus made the only record of individual existence. (Karen Smith)

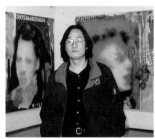

Mao Tongqiang

1960 Born, Yinchuan, Ningxia province, China
1980 Graduated, Ningxia University, Ningxia province, China
 Current, lives and works between Ningxia and Beijing, China

Group Exhibitions

1989 *The Seventh National Art Exhibition*, China
1993 *The Eighth National Art Exhibition*, Ningxia Exhibition Hall, Ningxia, China
2000 *Society: The Second Academic Invitational Exhibition*, Upriver Gallery, Chengdu, China
2001 *Death Files*, Artists' Storehouse, Beijing, China
 Chengdu Biennale, Chengdu Contemporary Art Museum, Chengdu, China
 Not On the Periphery: Video Exhibition, Ningxia, China

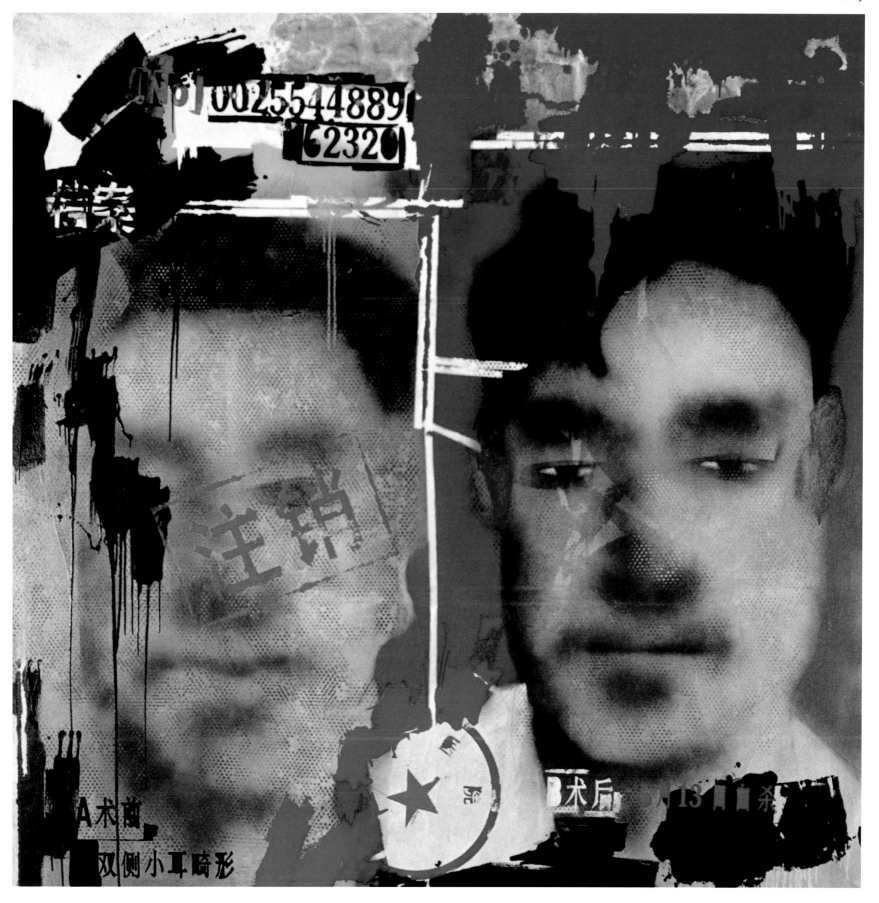

Liu Xiaodong
White Fatso

1995
oil on canvas
250 × 150 cm
Collection of Ding Bin and Zhao Shujing

Burning a Rat

1998
oil on canvas
152 × 137 cm
Collection of the Dongyu Museum of Art

Liu Xiaodong paints figures from real life from his keen feeling and impression. The people and objects in his paintings are very concrete. From the looks, postures and style of dress to the space and ambience, all have their natural attributes. We can see that his cognizance of natural reality *per se* has contemporary meaning. His compositions are based on a vision which is close to reality, creating a visual structure that appeals to the audience. His realistic style is grounded in his attitude towards reality. He holds tightly to his thinking and emotions through his acknowledgement of the reality that inspires expression. This is the new spirit of realism that emerged in the early 1990s. His art is the fruit of combining concreteness – a common feature of Liu Xiaodong's generation of painters – and realism, a spiritual form which distinguishes Liu from other painters. (Fan Di'an)

Liu Xiaodong

1963 Born, Jinzhou, Liaoning province, China
1988 Graduated, oil painting department, Central
 Academy of Fine Arts, Beijing, China
1995 Master's degree, oil painting department,
 Central Academy of Fine Arts, Beijing, China
 Current, lecturer in the oil painting
 department, Central Academy of Fine Arts,
 Beijing, China

Solo Exhibitions

1990 *Father and Son*, Gallery of the Central Academy of Fine Arts, Beijing, China
2000 *Liu Xiaodong 1990-2000*, Exhibition Hall of the Central Academy of Fine
 Arts, Beijing, China
 Limn Gallery, San Francisco, USA
2001 Galerie Loft, Paris, France

Group Exhibitions

1989 *China/Avant-garde*, China Art Gallery, Beijing, China
1991 *Twentieth Century China*, China Art Gallery, Beijing, China
1993 *China's New Art, Post-1989*, Hong Kong Arts Centre, Hong Kong
1994 *Art in the Late Twentieth Century*, The Discovery Museum, Connecticut, USA
1995 *The History of Chinese Oil Painting: from Realism to Post-Modernism*, Galerie
 Theoremes, Brussels, Belgium
1996 *The First Exhibition of the Chinese Oil Painters' Association*, China Art Gallery,
 Beijing, China
1997 *The 47th Venice Biennale*, Venice, Italy
1999 *Gate of the New Century*, Chengdu Modern Art Museum, Chengdu, China
2000 *Shanghai Spirit: The Third Shanghai Biennale*, Shanghai Art Museum, Shanghai,
 China
2001 *Towards a New Image*, China Art Gallery, Beijing, China

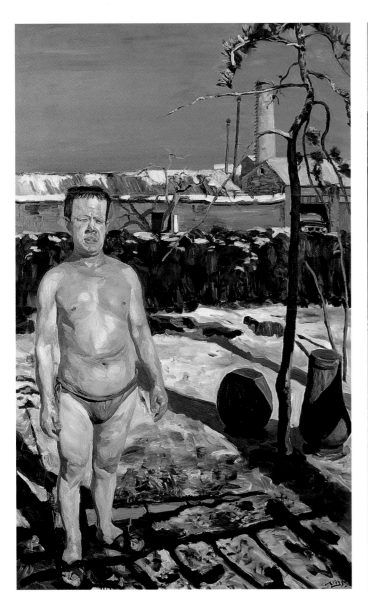
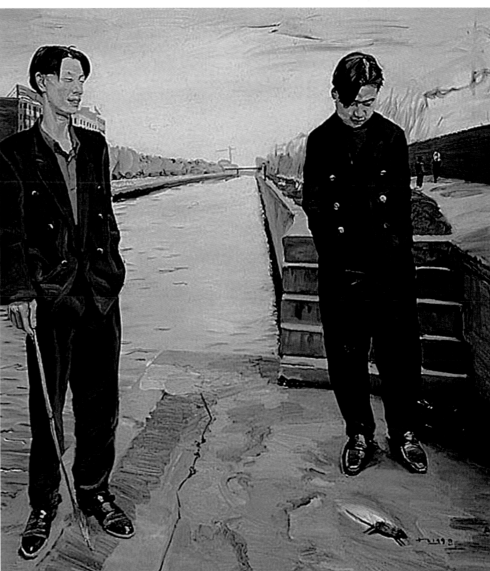

Yu Hong
Height of Adolescence
1993
oil on canvas
150 x 130 cm

Yu Hong's propensity for putting individual experience and emotion at the forefront of her works has long been one of her distinguishing characteristics. She reveals her visual sensibilities with the purity and simplicity of an advertisement poster, vividly portraying life and honestly depicting emotion, caring little whether her work is intellectually "deep." Here she has portrayed the rich colors and complex realities of this generation of young people, and thus abandoned earlier models of collective and ideological creation. In the process, she has hit upon new typology of independent creation. She paints the female experience in the space between serenity and primitive expression. (Feng Boyi)

Yu Hong

1966	Born, Beijing, China
1988	Graduated, oil painting department, Central Academy of Fine Arts, Beijing, China
1996	Master's degree, Central Academy of Fine Arts, Beijing, China
	Current, teaches in the oil painting department, Central Academy of Fine Arts, Beijing, China

Solo Exhibitions

1990	*Yu Hong*, Gallery of the Central Academy of Fine Arts, Beijing, China
2002	*Witness to Growth*, East Art Center, Beijing, China

Group Exhibitions

1987	*Chinese Oil Painting Exhibition*, Shanghai Exhibition Hall, Shanghai, China
1990	*The World of Women Artists*, Exhibition Hall of the Central Academy of Fine Arts, Beijing, China
1991	*New Generation*, China History Museum, Beijing, China
1993	*The Eastern Road: The 45th Venice Biennale*, Venice, Italy
1994	*Art in the Late Twentieth Century*, The Discovery Museum, Connecticut, USA
1995	*The World of Women Artists*, China Art Gallery, Beijing, China
1997	*The 47th Venice Biennale*, Venice, Italy
1999	*Transience: Chinese Experimental Art at the End of the Twentieth Century*, Smart Museum of Art, University of Chicago, Chicago, USA
2000	*Nature: The Third Exhibition of Women Artists*, International Art Palace, Holiday Inn Crowne Plaza, Beijing, China
2001	*Chengdu Biennale*, Chengdu Modern Art Museum, Chengdu, China

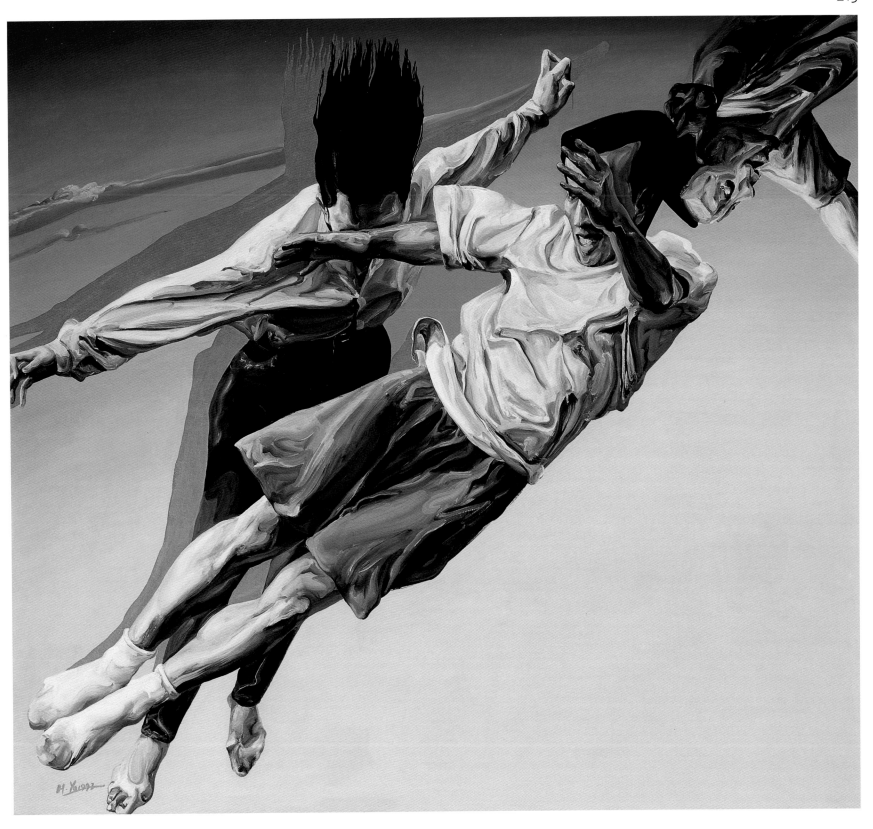

Shen Ling
Girl Reading the Bible

1995
oil on canvas
160 x 130 cm

The girl in the painting is one of my schoolmates. I chose to paint her because I realized what I wanted to express was her inner world. Every time I took the paintbrush in my hand, what arose in my mind was the feeling she conveyed. Disorderly surroundings sharply contrast with her quietness. The intricate and untrammelled brushmarks are intended to express the throbbing philanthropic heart full of passion that lies behind her tranquil appearance. (Shen Ling)

Shen Ling

1965 Born, Liaoning province, China
1989 Graduated, oil painting department, Central Academy of Fine Arts, Beijing, China
Current, teaches at the high school attached to the Central Academy of Fine Arts, Beijing, China

Solo Exhibitions
1991 Gallery of the Central Academy of Fine Arts, Beijing, China
1993 China Art Gallery, Beijing, China
2000 *Private Lives*, Yibo Gallery, Shanghai, China
2001 *Lovers*, Ethan Cohen Fine Arts, New York, USA

Group Exhibitions
1984 *Emerging Young Chinese Artists*, China Art Gallery, Beijing, China
1988 *Shen Ling, Wang Yuping*, China Art Gallery, Beijing, China
1991 *New Generation*, China History Museum, Beijing, China
1993 *The First Chinese Oil Painting Biennial*, China Art Gallery, Beijing, China
1996 *First Academic Exhibition of Chinese Contemporary Art*, Hong Kong Arts Centre, Hong Kong
1997 *The 47th Venice Biennale*, Venice, Italy
1999 *Gate of the New Century*, Chengdu Modern Art Museum, Chengdu, China
2000 *Nature: The Third Exhibition of Women Artists*, International Art Palace, Holiday Inn Crowne Plaza, Beijing, China
 One Hundred Years of Chinese Oil Painting, China Art Gallery, Beijing, China

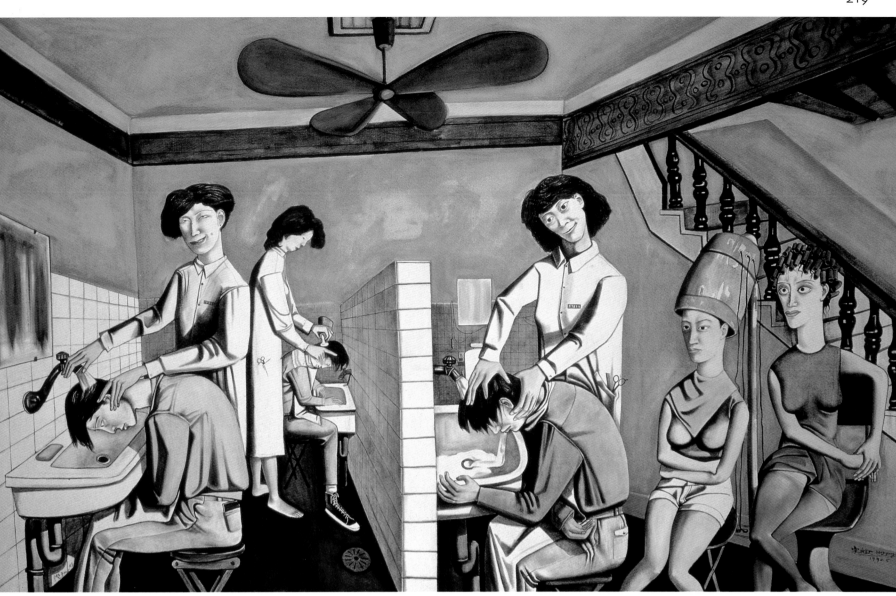

Wang Xingwei
Again No 'A'
1998
acrylic on canvas
165 x 240 cm
Collection of China Art Archives and Warehouse, Beijing

Within what I felt to be a very suitable plot for this work, I intended to explore the nuances of education that takes place within the home. As I produced several small sketches of the father sitting on the sofa with his child standing before him, I was immediately reminded of a well-known Russian painting titled *Only Scored Two Once Again*, which I knew as a child from art history books. The white shirt, blue trousers, and red neckerchief is what I will always associate with childhood. Deliberately making the sofa rather low, I arranged the figure of the father so that he was accorded an exaggerated Michaelangelo's hand gesture, his finger pointing directly at a test paper that is on the Allen Jones table but not visible within the composition to the viewer (and at the same time pointing to the naked woman's crotch). It follows the exact line of sight as the child, glancing sideways at the table. The father's yellow shirt reflects a favourite of mine at the time. Against the blue of the background it creates a color scheme redolent of the essence of spring. I added a pair of light sky blue curtains to either side of the scene to strengthen the sense of theatricality and of unreality in the painting, and to compress the depth of the space to emphasize the foreground. Finally, I chose to use acrylic paint rather than oil paint because it is fresher and swifter drying. (Wang Xingwei)

Wang Xingwei

1969 Born, Shenyang, Liaoning province, China
1986 Graduated, fine arts department, Shenyang University Teaching College, Shenyang, Liaoning province, China
 Current, lives and works in Haicheng, Liaoning province, China

Solo Exhibitions

1993 *Put to Trial: Four Man Exhibition*, Gallery of the Central Academy of Fine Arts, Beijing, China
1993 *The Dust of Romantic Male Heroism*, Gallery of the Central Academy of Fine Arts, Beijing, China
 Aktuelles aus 15 Atelliers, Reithalle, Munich, Germany
1994 *China Now*, Littmann Kulture Projekt, Basel, Switzerland
 The Fourth Lyon Biennial of Contemporary Art, Lyon, France
1998 *Confused: Reckoning with the Future*, Art Fair, Amsterdam, the Netherlands
 Corruptionists, alternative art space, Beijing, China
1999 *The 48th Venice Biennale*, Venice, Italy
2000 *Fuck Off*, Eastlink Gallery, Shanghai, China
 Usual and Unusual, Yuangong Art Museum, Shanghai, China
1997 *Between Heaven and Earth: New Classical Movements in the Art of Today*, PMMK Modern Art Museum, Belgium

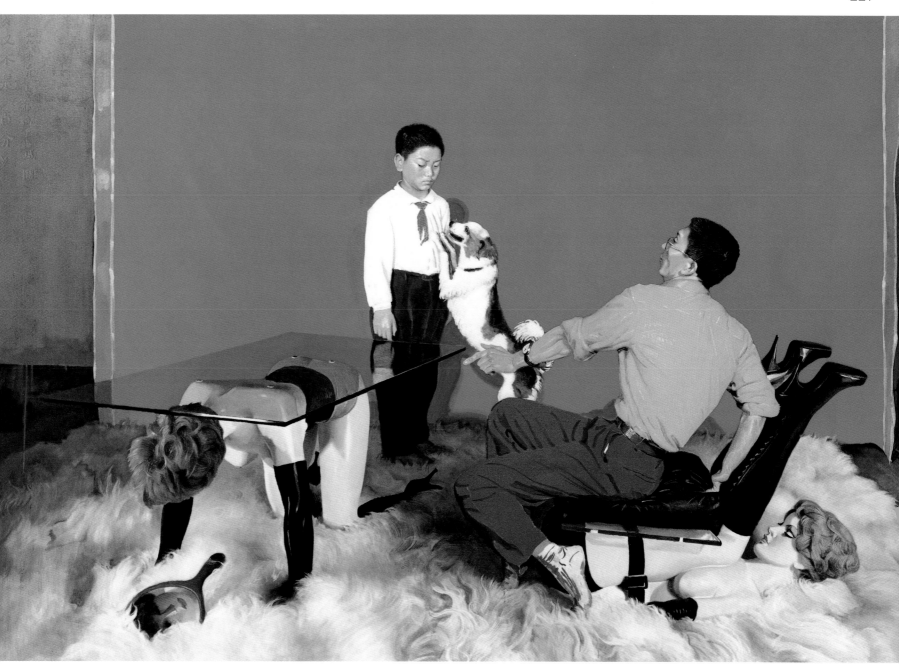

Zeng Hao
5:00 PM
1996
oil on canvas
200 x 180 cm

Zeng Hao points to the contradictions that exist within the self, which are all perceptively rendered on the canvas. In his works, the blank and fabricated states of daily life are accurately and obstinately mapped out in full. Regardless of the time of the moment, the spread of objects and figures produces an effect of disparity. This disparate and magical effect is still able to evoke a sense of time and space which conjures an unreal version of reality and time. Zeng Hao makes a deduction of real time into a realm of critical awareness, of which it offers us a taste. His painterly language goes beyond the conventional tradition of realism, and is representative of a new value system within contemporary art. (Zhang Li)

Zeng Hao

1963 Born, Kunming, Yunnan province, China
1989 Graduated, oil painting department, Central Academy of Fine Arts, Beijing, China
 Current, lives and works in Beijing, China

Solo Exhibitions
1996 Gallery of the Central Academy of Fine Arts, Beijing, China

Group Exhibitions
1992 *The First Guangzhou Biennale: Oil Painting in the Nineties*, Guangdong Exhibition Center, Guangzhou, China
1996 *China: Recent Work from 15 Studios*, Munich, Germany
1998 *Confused*, Contemporary Art Fair, Amsterdam, the Netherlands
1999 *Transience: Chinese Experimental Art at the End of the Twentieth Century*, Smart Museum of Art, University of Chicago, Chicago, USA
2000 *Hot Pot*, Kunsternes Haus, Oslo, Norway
2001 *Towards a New Image*, China Art Gallery, Beijing, China
2002 *The 25th International Sao Paulo Biennial*, Sao Paulo, Brazil

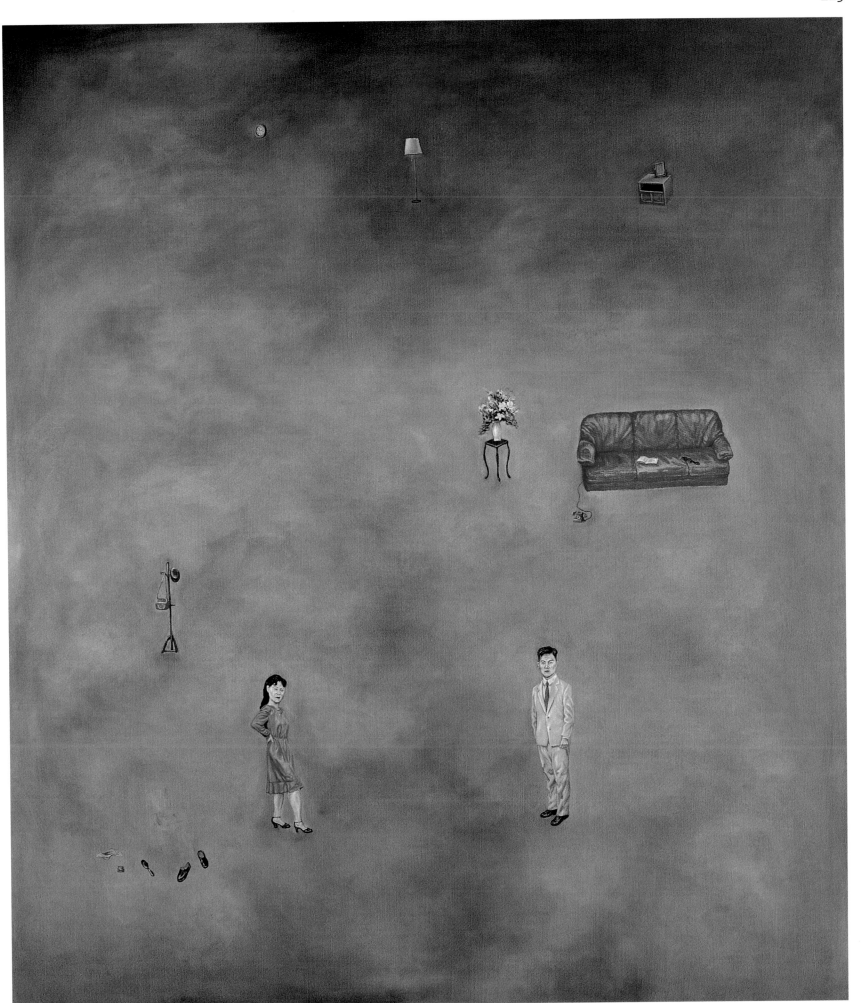

Yang Fudong
The First Intellectual
2000
photographs

Commerce has become the most noticeable activity and pursuit in Chinese society nowadays; it has quickly expanded into every niche of society. Accordingly, the position and attitude of intellectuals involved in the humanities and cultural activities face a challenge from popular culture as their centrality wanes. Yang Fudong accurately invents a so-called intellectual who seeks revenge for a beating. Holding a brick in hand but unable to find an adversary, the intellectual falls into an embarrassing state of disarray. From a certain perspective, this is the fate of Chinese intellectuals after experiencing various conflicts and traumas. Their unique historical environment determines their indescribable helplessness, anger and despair. (Feng Boyi)

Yang Fudong
1971 Born, Beijing, China
1995 Graduated, oil painting department, China National Academy of Fine Arts, Hangzhou, Zhejiang province, China
Current, lives and works in Shanghai, China

Group Exhibitions
1999 *Post-sense Sensibility: Alien Bodies and Delusion*, Beijing, China
Supermarket, Shanghai, China
Other Than Human, basement of Beihai Tower, Shanghai, China
2000 *Fuck Off*, Eastlink Gallery, Shanghai, China
2001 *Yokohama Triennial*, Yokohama, Japan
Istanbul Biennial, Istanbul, Turkey
The First Valencia Biennial, Valencia, Spain
2002 *Run, Jump, Crawl, Walk*, East Art Center, Beijing, China
Documenta XI, Kassell, Germany

The First Intellectual The First Intellectual The First Intellectual

Luo Zidan
Half White Collar, Half Peasant
1996
performance; 6 hr., 50 min.

Dressed half as a white-collar worker and half as a peasant, the performer uses theatrical make-up to differentiate between two skin tones. One sockless foot wears a worn out army plimpsole, while the other sports a famous brand Italian leather shoe. This invented superficial contrast brings together two common appearances, where one dominates the other within different settings. Walking through the area around Chunxi Road in Chengdu, the performer appears both real and illusory in his actions. At the Holiday Inn, he used the peasant's sleeve to clean the marble at the entrance. In the middle of the road he stopped to shake the mud from the holed plimpsole. At the same time, the white-collar worker showed off his Italian shoe. In a watch store, the white-collar worker tries on a 2,300,000 RMB diamond studded watch, admiring his reflection. At a KFC restaurant, he happily eats a meal, while the peasant, left with the fries and salad, is confused as to how they should be devoured. The concept of this work expressed the issues of class, and on a deeper level, social roles common to all human society and the roots of the contradictions that inhibit human desire. (Chen Hongjie)

Luo Zidan
1971 Born, Sichuan province, China
 Current, lives and works in Chengdu, Sichuan province, China

Solo Exhibitions
1996 *Performance: Half White Collar, Half Peasant*, Chengdu, China
1998 *Performance: Dead Artists and Living Artists*, Chengdu, China
1999 *Performance: Luo Zidan Sets the Price*, Shanghai, China
2000 *Performance: Hooliganism Brings Freedom to the Intellectuals*, Beijing, China

Group Exhibitions
1996 *Sculpture and Contemporary Documents*, Chengdu, China
1999 *Supermarket*, Shanghai, China
 The First Chinese People's Installation Documentary Exhibition, Hong Kong
2000 *Art Banquet*, Beijing, China
 Documentatum of Chinese Avant-garde Art in the 1990s, Fukuoka Museum of Asian Art, Fukuoka, Japan
2001 *Sixth Chinese Contemporary Art Documentary Exhibition*, Shanghai, China

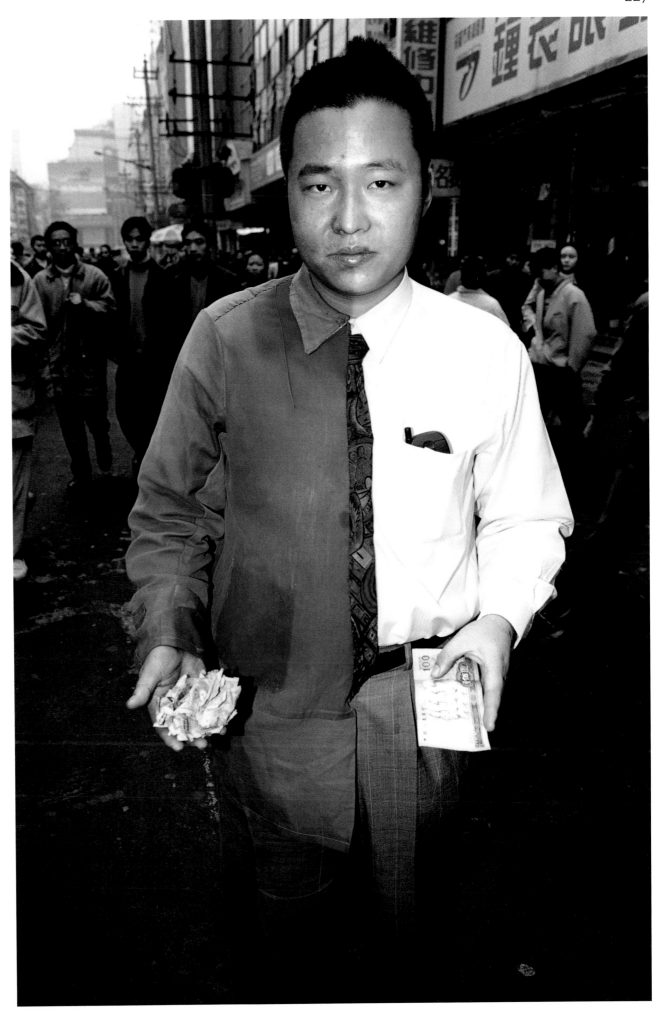

Hu Jieming
1995 – 1996

1995-96
installation
700 x 700 x 300 cm

The source of the materials in this work was television broadcasts. In 1995, from midnight on December 31 to midnight on January 1, every five minutes I shot scenes from programs on the each of the twenty-five television stations that an ordinary Shanghai household receives. I recorded the time on the right side of the photograph to produce 25 × 20 cm black and white transparencies. Then I put the twelve images from each station's broadcast in the same moment together. These are displayed as suspended fields of images that create a maze of visual information, evoking the diversity/similarity of programming filtering into daily life. (Hu Jieming)

Hu Jieming

1957 Born, Shanghai, China
1984 Graduated, department of fine art and design, Shanghai Light Industry Technical College, Shanghai, China
1985 Current, teaches in department of design at Shanghai Light Industry Technical College, Shanghai, China

Solo Exhibitions

1995 *Hu Jieming Solo Show,* East China Normal University, Shanghai, China
2000 *Raft of the Medusa,* Asian Contemporary Art Centre, Vancouver, Canada

Group Exhibitions

1982 *The Second Exhibition of Work by Shanghai University Students,* Shanghai Youth Cultural Palace, Shanghai, China
1998 *Jiangnan: Modern and Contemporary Art from South of the Yangzi River,* Western Front Society, Vancouver, Canada
 Looking In and Looking Out: Contemporary Art, Plug In Gallery, Winnipeg, Canada
1999 *The '99 Maya Biennial,* Maya, Portugal
 House, Home, Family, 4/F Yuexing Furniture Corporation, Shanghai, China
2000 *010101: Art in Technological Times,* SFMoMA, San Francisco, USA
 Manic Ecstasy, Hangzhou, Shanghai, Beijing, China
 Hot Pot, Kunsternes Haus, Oslo, Norway
 Living in Time, Hamburg Bahnhof Museum of Contemporary Art, Berlin, Germany

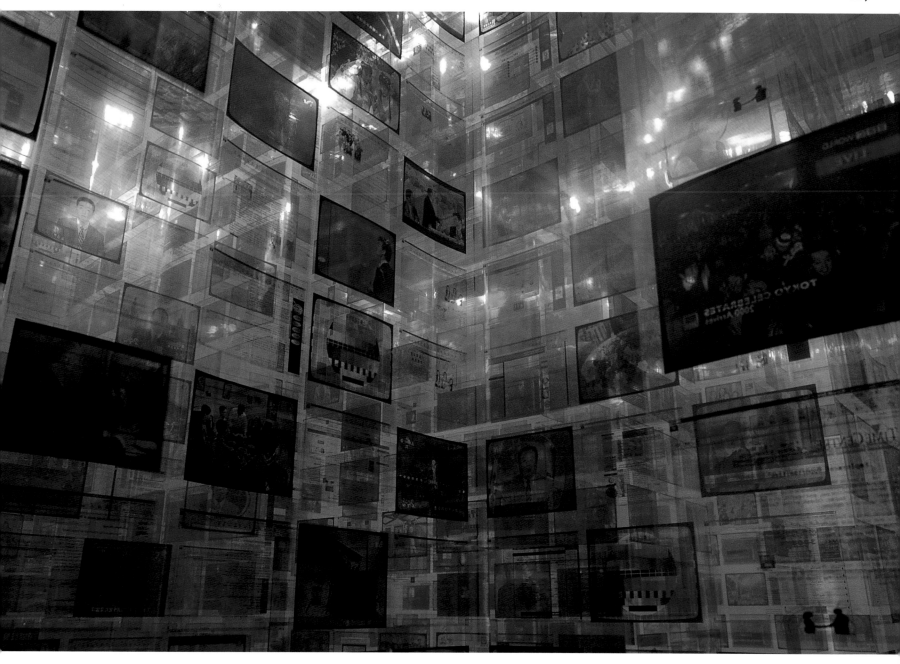

Zhang Peili
Water: Standard Pronunciation, Ci Hai (Sea of Words)
1992
video

The famous television announcer Xing Zhibin "presents" the entries from a standard dictionary beginning with the word "water." She does this in a setting similar to the CCTV network news, under the same lighting, against the same backdrop, using the same microphone. Even the facial expression is the "national" one, yet in a voice that implies apathetic neutrality. Here ideology is substituted with banal, even narration. The video, with its obvious mocking intention, leaves the audience with a strong impression of absurdity. (Wu Meichun and Qiu Zhijie)

Screen
1997
video

The lens of the video camera acts as a mirror, recording a private self-scrutiny. While looking at himself in the mirror, one subject breathes to the glass, making it foggy, and then wipes it clean with cotton and his finger. The diminished border between the lens, the mirror, and the illusion this engenders is what interests the artist. The film exposes the voyeurism of both video artists/filmmakers and viewers. It enmeshes the identities of performer, creator and viewer. (Wu Meichun and Qiu Zhijie)

Children's Paradise
1992
video

A camera in a fixed position films an electric toy (penguins climbing a slide) in motion. The three variously colored penguins climb to the top of a slide and then slide down, again and again. The clockwork mechanism endlessly moves the toy penguins up and down, mimicking an absurdly tragic Sisyphean labor. The title *Children's Paradise* naturally implies black humor. (Wu Meichun and Qiu Zhijie)

Zhang Peili

1957 Born, Hangzhou, Zhejiang province, China
1982 Graduated, oil painting department, Zhejiang Academy of Fine Arts, Hangzhou, Zhejiang province, China
 Current, teaches in New Media Arts Center, China National Academy of Fine Arts, Hangzhou, Zhejiang province, China

Solo Exhibitions
1993 Maison des Cultures du Monde, Galerie du Rond Point, Paris, France
1997 Krinzinger Gallery, Vienna, Austria
1998 MoMA, New York, USA
1999 Jack Tilton Gallery, New York, USA
2000 Artist Project Room, ARCO 2000, Madrid, Spain

Group Exhibitions
1985 *'85 New Space*, Exhibition Hall of the Zhejiang Academy of Fine Arts, Hangzhou, China
1989 *China/Avant-garde*, China Art Gallery, Beijing, China
1993 *The Eastern Road: The 45th Venice Biennale*, Venice, Italy
1997 *The Fourth Lyon Biennial of Contemporary Art*, Lyon, France
 Cities on the Move, The Secession, Vienna, Austria
1999 *The Third Asia-Pacific Triennial of Contemporary Art*, Queensland Art Gallery, Brisbane, Australia
2000 *Shanghai Spirit: The Third Shanghai Biennale*, Shanghai Art Museum, Shanghai, China
2001 *Living in Time*, Hamburg Bahnhof Museum of Contemporary Art, Berlin, Germany
2002 *Pause: The Fourth Kwangju Biennial*, Kwangju, Korea Republic

Water: Standard Pronunciation, Ci Hai (Sea of Words)

Screen

Children's Paradise

Li Yongbin
Face No. 1
1996
video; 36 min.

The idea for *Face No. 1* occurred to me at the end of 1995 shortly after I produced a video dedicated to the memory of my mother. This idea ultimately took shape in early 1996 and drew inspiration from the latter. Just as I had projected the portrait of my mother onto a tree opposite my apartment at dawn, in *Face No. 1*, I projected the face of a neighbor over the image of my face. In projecting other people's faces on my own or my own face on others, we can see another face unfamiliar to both him/her and me. This third face, dreadful and radiant with occasional smiles, lingers between him/her and me. (Li Yongbin)

Face No. 3
1996
video; 36 min.

In *Face No. 3*, the static image of an old woman is superimposed over Li Yongbin's own features. As he blinks, twitches and exchanges occasional words with the cameraman, the work takes on a macabre quality. The blend of two sets of features effects a grotesque third in which the others seem trapped, pleading to be let out. *Face No. 3* is a strangely silent and moving work, in a mood which set the tone for subsequent works. A distinctive feature of Li Yongbin's works is the element of time. Most are recorded as long as the length of elapsed time for the videotape with no subsequent editing involved. In this way he establishes a sense of each work unfolding through time. The irony is that although the slow motion of the action and the element of repetition appear to imply the build up to a finale, nothing actually happens. His quiet approach, which relies on creative invention not technical effects, is mesmerizing. (Karen Smith)

Li Yongbin
1963 Born, Beijing, China
 Current, lives and works in
 Beijing, China

Solo Exhibitions
1994 *Life Testimony*, artist's home, Beijing, China
1996 *Video Art by Li Yongbin—August 30, 1996*, Gallery of the Central Academy
 of Fine Arts, Beijing, China
2000 *Li Yongbin Video Works*, Palais des Beaux-arts, Brussels, Belgium

Group Exhibitions
1992 *New Wave*, Chameleon Contemporary Art Space, Hobart, Australia
1996 *Image and Phenomena*, Gallery of the China National Academy of Fine Arts,
 Hangzhou
1997 *Another Long March*: Chinese Conceptual and Installation Art in the Nineties,
 Fundament Foundation, Breda, the Netherlands
1998 *A New Form of Video Art in China*, 4A Gallery, Sydney, Australia
1999 *Supermarket*, Shanghai, China
 Signs of Life: Melbourne International Biennial, Melbourne, Australia
 The Third Asia-Pacific Triennial of Contemporary Art, Queensland Art Gallery,
 Brisbane, Australia
2001 *Compound Eyes*, Earl Lu Gallery Lasalle-Sia College of the Arts, Singapore
 Cross-Pressures, Oulu Art Museum and Finnish Museum of Photography,
 Oulu Finland
 Living in Time, Hamburg Bahnhof Museum of Contemporary Art, Berlin,
 Germany

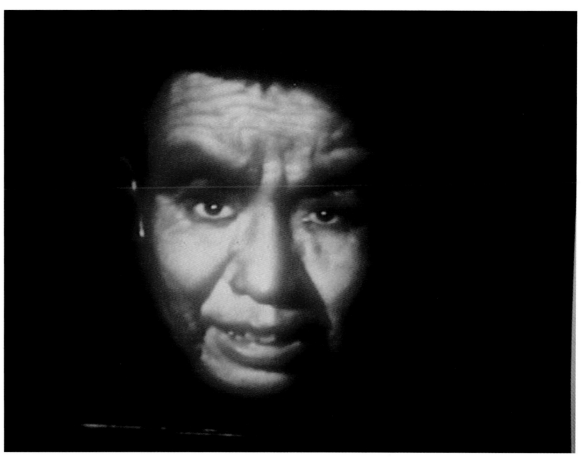

Face No. 1

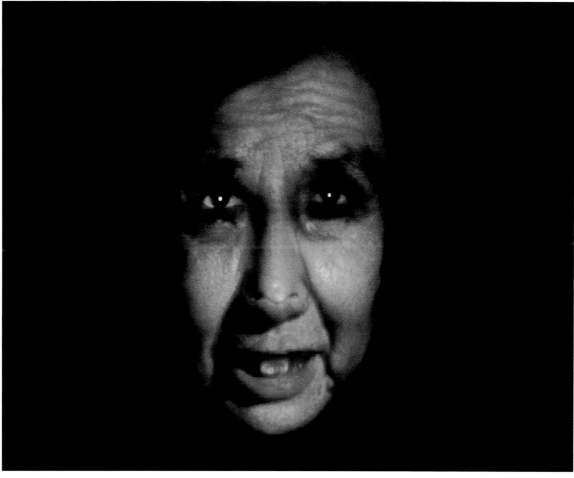

Face No. 3

Tang Guangming / Gou Zi
"Lu Xun" in Beijing
1998
video

This film is full of mimicry, whose comical effect is amplified by the shoddy make-up and Lu Xun's climbing up a tree by the Third Ring Road around Beijing. This film is undoubtedly derision of the stern face of "video art." The film is also an early attempt to direct Chinese video art from the conceptual toward the narrative. Later, the overflow of DVD proved the great potency of this attempt. (Wu Meichun and Qiu Zhijie)

Tang Guangming

1966	Born, Shanghai, China
1986	Graduated, Affiliated High School of Shanghai University Institute of Fine Arts, Shanghai, China
1991	Graduated, crafts department, Donghua University, Shanghai, China
	Current, lives and works in Shanghai, China

Gou Zi (Jia Xinxu)

1966	Born, Beijing, China
1989	Graduated, Beijing Broadcast Institute, Beijing, China
	Curent, freelance writer, Beijing, China

Group Exhibitions

1985	*M Group Art Show*, Theater of the Workers' Cultural Palace, Shanghai, China
1992	*A Failed Excursion*, Hongqiao Development Zone, Shanghai, China
1994	*Focus of Shanghai*, Hailun Hotel, Shanghai, China
1996	*International Real Estate Expo*, Shanghai Commercial Plaza, Shanghai, China
1997	*Second Video Art Exhibition*, Gallery of the Central Academy of Fine Arts, Beijing, China
2001	*0.21*, Shanghai Normal University, Shanghai, China
2002	*Contemporary Art Exchange Exhibition*, BizArt Gallery, Shanghai, China
	City Space, Shanghai World Commercial Plaza, Shanghai, China

Group Exhibition

1997	*Second Video Art Exhibition*, Gallery of the Central Academy of Fine Arts, Beijing, China

Wang Jinsong

My History Lesson

1996
video; 10 min.

The film shows a lesson in classroom. As the camera pans through the scene, at the end of the film the performer pretentiously writes "all is fact; there is nothing to discuss" on the blackboard. The artist wants to make a simple judgment that the past, the present and future history comprises a series of events. The dullness typical of conceptual video works is indispensable to this work, but the dramatic turn at the end of the film makes the whole work dynamic. The dullness in this film does not convey helplessness, but a deliberate mockery in dark humor. (Wu Meichun and Qiu Zhijie)

See page 190 for the artist's portrait and CV.

Qiu Zhijie
Objects
1997
video

Video projections in four directions in a dark room have been strung together by the artist into a single-frequency video film. In the video one sees a hand constantly striking a match to illuminate different objects. The intervals of darkness between the striking of two matches vary in length. Four videotapes have been shot in four rooms where the artist previously resided. Objects tries to arouse psychological interaction by showing the interloper's instant response to an unpredictable situation. Matches lit on screens in different places illuminate different familiar objects. Then they burn out, drowning the objects in darkness. The viewer entering the dark projection room continually encounters "objects" emerging and vanishing at random. His/her capacity for reception is activated by the alternating light and dark, existence and non-existence. Because of the matches flickering on and burning out, the "objects" are granted a finite lifespan. The viewer's encounter with the objects— like so many other things in life—is determined by chance. (Wu Meichun)

Table Tennis
1997
video

Table Tennis is an on-the-spot record of table tennis training in primary schools, secondary schools and children's sport schools in Fujian province. Combining historical documents and interviews with children, their parents and coaches, interspersed with shots of clowns and symbolic details, the film traces the history of a sport powerfully endorsed as a national myth by the prevailing official ideology. It further explores the history of this myth, which was constructed and narrated in a special way that impacted individuals' lives and destinies. This video is an early example of an artist who as a writer entered the field of experimental documentary film. (Wu Meichun)

See page 150 for the artist's portrait and CV.

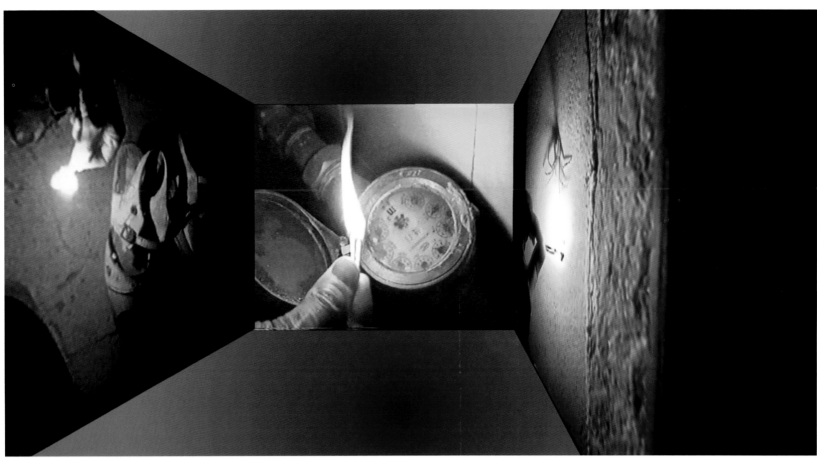

Objects

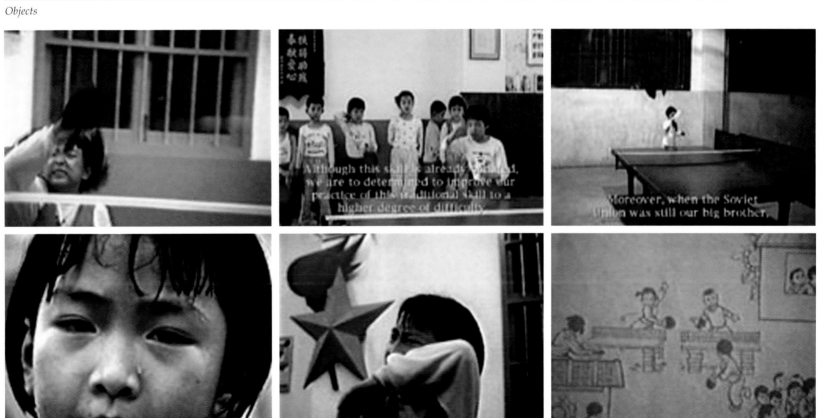

Table Tennis

Weng Fen
Butterfly
1999
video

A girl in special attire fluttering her arm presents the dance of a butterfly against the backdrop of cement buildings in a modern city. This otherwise concise metaphor of freedom and limit, self and society, has been made messy by post-production editing. Images are split and dislocated by applying digital technology. These features, plus continual rotating, present a kaleido-scopic picture suggesting the world in (an insect's) compound eye. The processed images become elusive and puzzling. The viewer of the pictures is put into the position of the subject/butterfly. The shifting of the viewer's position turns the work into the dreamland of the philosopher Zhuang Zi, but here the narrative of the dream is replaced with description of the viewer and the performer. (Wu Meichun and Qiu Zhijie)

Identity, Present, Past, Six
1997
video

In this work, video works as case history. Images of blood-taking from the fingertips of six people are juxtaposed in the scene while the people's physiological and psychological responses are revealed in their eyes and explained by a voiceover. Scenes from their daily life are presented as a visual record of their identity. In medicine, a human is a physiological being, while in psychology, a human is a historical being with a particular past and identity. The video works between these two extremes and thus makes them infiltrate each other. (Wu Meichun and Qiu Zhijie)

See page 166 for the artist's portrait and CV.

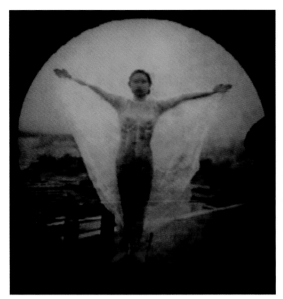
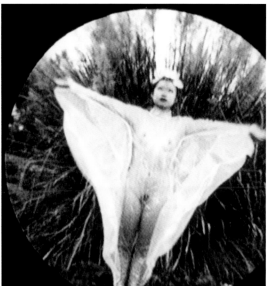
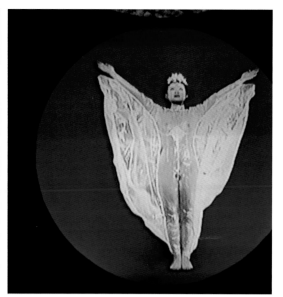

Butterfly

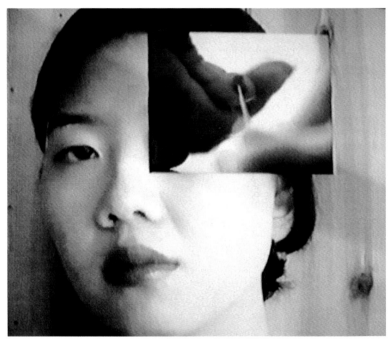

Identity, Present, Past, Six

Gao Shiming, Lu Lei, Gao Shiqiang

Fantasy as Fable

1999
video

People more and more turn a blind eye to things around themselves. Although daily-use objects are more and more indiscriminatingly used as props in films or on stage, they are usually reduced to symbols. The producers of this film, interested in presenting their living space, weave a fable-like and dreamy "sub-narration" with superficial and bewildering shots. It presents a complicated experience entangled between memory and anticipation, remote place and nostalgia, faith and doubt. (Wu Meichun and Qiu Zhijie)

Cursed Individualist

1997
video

The film has two parts. The first part is Borges-esque and displays a person's pluralistic life. The second part presents something like change of forms in Kafka's *Metamorphosis*. The two sections that are contrast in atmosphere together convey a theme: the cursed individualist, or, individualism itself as a curse. (Wu Meichun and Qiu Zhijie)

Gao Shiqiang
1971 Born, Weifang, Shangdong province, China
1998 Graduated, sculpture department, China National Academy of Fine Arts, Hangzhou, Zhejiang province, China
 Current, graduate student, sculpture department, Shanghai University, Shanghai, China

Lu Lei
1972 Born, Jiangsu province, China
1998 Graduated, sculpture department, China National Academy of Fine Arts, Hangzhou, Zhejiang province, China
 Current, graduate student, New Media Art Center, China National Academy of Fine Arts, Hangzhou, China

Gao Shiming
1976 Born, Weifang, Shandong province, China
1998 Graduated with master's degree, history and theory department, China National Academy of Fine Arts, Hangzhou, Zhejiang province, China
 Current, doctoral candidate, history and theory department, China National Academy of Fine Arts, Hangzhou, China

Group Exhibitions
1996 *Image and Phenomena*, Gallery of the China National Academy of Fine Arts, Hangzhou, China
1997 *Demonstration of Video Art '97 China*, Gallery of the Central Academy of Fine Arts, Beijing, China
1998 *Changing Media: The 11th Video Art Festival*, Berlin, Germany
 0431 Video and Computer Art, Changchun, China
1999 *Post-sense Sensibility: Alien Bodies and Delusion*, Beijing, China
 Contemporary Chinese Video Art, Macau

Fantasy as Fable

Cursed Individualist

Jiang Zhi

Shi Zhi
1999
video; 8 min., 45 sec.

The film records Shi Zhi, an avant-garde poet of the Obscure School, who received three young visitors on March 18, 1998 in a mental hospital in the Beijing suburb where he had stayed for many years. In the ensuing months, similar interviews took place, some in the hospital and others in Shi Zhi's home. The 50 year-old poet talked about his poems and his life, and at last said he was sorry that his time had gone. (Wu Meichun and Qiu Zhijie)

Fly, Fly
1997
video; 6 min.

A hand mimics flapping wings of a bird in the air. In a few shots, the film coherently epitomizes the fantasy and passion of city dwellers who are confined to small rooms. Living in small rooms, people are submissive to themselves and everything around them. When confined to small rooms, especially alone, one keenly feels tranquility, fantasy, boredom, and passion, such that one feels like flying — a way of transcending (or escaping). Can we shake off heaviness for lightness? In which direction do we flee? (Jiang Zhi)

Jiang Zhi

1971 Born, Yuanjiang, Hunan province, China
1995 Graduated, China National Academy of Fine Arts, Hangzhou, Zhejiang province, China
 Current, lives and works in Shenzhen, China

Group Exhibitions

1997 *Demonstration of Video Art '97 China*, Gallery of the Central Academy of Fine Arts, Beijing, China
1999 *Post-sense Sensibility: Alien Bodies and Delusion*, Beijing, China
 The Same but Also Changed, Shanghai, China
 Revolutionary Capitals: Beijing-London, Institute for Contemporary Art, London, UK
2000 *Asia-Pacific Multi-Media Art Festival*, Singapore
2001 *Manic Ecstasy*, Impression Gallery, Hangzhou, China
 Non-linear Narrative, Gallery of the National Academy of Fine Arts, Hangzhou, China
2002 *Contemporary Chinese Video Art*, Palm Beach Institute of Contemporary Art, Palm Beach, USA
 Pause: The Fourth Kwangju Biennial, Kwangju, Korea Republic

Shi Zhi

Fly, Fly

Song Dong
Father and Son No. 1
1998
video; 66 min.

Song Dong projects onto his body a film of him talking with his father so that his father's image appears on his face. Song Dong filmed that projection in this work. Song Dong's father relates his life since his birth in 1936. His experience is China's experience. This work links the vicissitudes of a person's life with the grand background of historical change, thus emphasizing a profound reflection on world affairs. (Wu Meichun and Qiu Zhijie)

Cloning
1997
video

This film presents a psychologically distanced image. The subject in the film scrutinizes and examines himself and finally with the aid of recorded images alienates and distances himself from his own physicality. The film reflects a fear of the power of technology to disintegrate individual identity. (Wu Meichun and Qiu Zhijie)

Song Dong

1966	Born, Beijing, China
1989	Graduated, fine arts department, Capital Normal University, Beijing, China
	Current, lives and works in Beijing, China

Solo Exhibitions

1994 *Another Lesson: Do You Want to Play with Me?*, Gallery of the Central Academy of Fine Arts, Beijing, China
1997 *Look*, video installation, Contemporary Art Gallery, Beijing, China
 Slap, video installation, Ruins for Art, Berlin, Germany
2000 *Song Dong in London*, Gasworks, London, UK

Group Exhibitions

1995 *The First Kwangju Biennial*, Kwangju, Korea Republic
1998 *Inside Out: New Chinese Art*, Asia Society Galleries, PS 1 Contemporary Art Center, New York, USA
 It's Me!: A Profile of Chinese Contemporary Art in the Nineties, Beijing, China
1999 *Cities on the Move*, Museum of Modern Art, Helsinki, Finland
 Transience: Chinese Experimental Art at the End of the Twentieth Century, Smart Museum of Art, University of Chicago, Chicago, USA
 Supermarket, alternative non-art space, Shanghai, China
2000 *The 18ᵗʰ World-Wide Video Festival*, Amsterdam, the Netherlands
 Fuck Off, Eastlink Gallery, Shanghai, China
 Cancelled: Exhibiting Experimental Art in China, Smart Museum of Art, University of Chicago, Chicago, USA
2001 *Living in Time*, Hamburg Bahnhof Museum of Contemporary Art, Berlin, Germany
 Pause: The Fourth Kwangju Biennial, Kwangju, Korea Republic
 The Fourth Asia-Pacific Triennial of Contemporary Art, Queensland Art Gallery, Brisbane, Australia

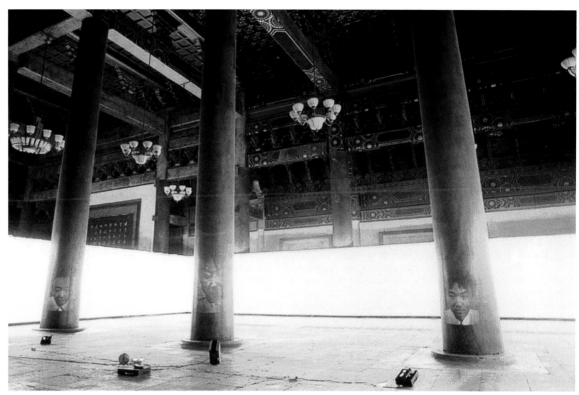

Father and Son No. 1

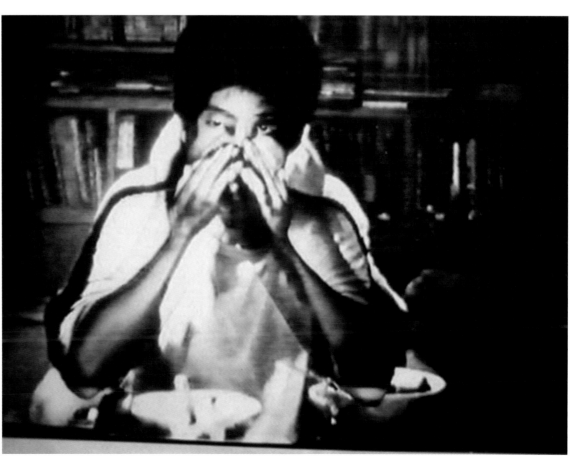

Cloning

Zhou Xiaohu
Journey of Desires
1999
cartoon video; 3 min., 30 sec.

The artist was inspired by wash on a clothesline, which though removed from the human body, still retain the outline of the human form. As the real substance is abstracted, the soulless form keeps human gesture and its cultural and social properties. This also points to some indescribable state and memory in life. (Wu Meichun and Qiu Zhijie)

Zhou Xiaohu

1960 Born, Changzhou, Jiangsu province, China
1989 Graduated, Sichuan Academy of Fine Arts, Chongqing, China
 Current, lives and works in Changzhou and Beijing, China

Solo Exhibition
2002 *Zhou Xiaohu 's Photography*, part of Art Moscow, Moscow Artists' Center, Moscow, Russia

Group Exhibitions
1996 *In the Name of Art*, Liu Haisu Museum of Art, Shanghai, China
2000 *Shanghai Spirit: The Third Shanghai Biennale*, Shanghai, China
2001 *Living in Time*, Hamburg Bahnhof Museum of Contemporary Art, Berlin, Germany
 Non-linear Narrative, Gallery of the National Academy of Fine Arts, Hangzhou, China
 Chengdu Biennale, Chengdu Modern Art Museum, Chengdu, China
2002 *Golden Autumn*, Zagreb National Museum, Zagreb, Croatia
 CHINART: Contemporary Art from China, Kuppersmuhle Museum, Duisburg, Germany
 Too Much Flavor, 3H Art Center, Shanghai, China
 The Fourth Annual Video Marathon, Art in General, New York, USA
 Future of the New Asia, Kuanhoon Gallery, Seoul, Korea Republic

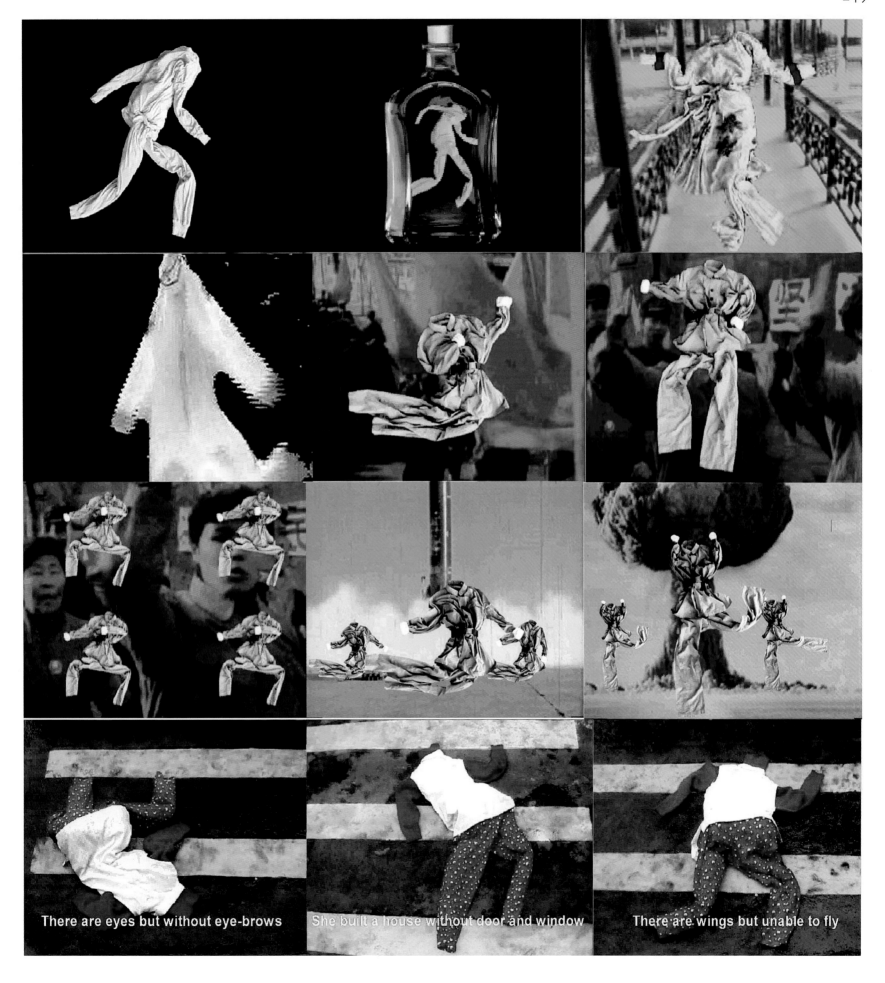

There are eyes but without eye-brows

She built a house without door and window

There are wings but unable to fly

Part Two: Artists and Works
Theme 2 Self and Environment

Self and Environment

Wu Hung

Among all branches of contemporary Chinese art in the 1990s, experimental art most sensitively responded to the drastic changes in the environment—the vanishing of traditional landscapes and lifestyles, the rise of post-modern cities and new urban cultures, and the large-scale immigration of populations. This art also most sensitively responded to changes in the artist's livelihood and social role: during this period, a large number of experimental artists moved from the provinces to major cosmopolitan centers, where they reinvented themselves as independent artists working for international exhibitions and a global art market. Not coincidentally, these artists were intensely concerned with their identities; their own images became a constant subject of their work. The result was a large group of self-representations in all forms of visual art —painting, photography, performance, installation, and video. Taken together, these works reflect an urgent quest for individuality in a transforming society.

Underlying the heightened interest in representing the environment and the artist's self was a "generational shift" in experimental art. Most artists who favored these subjects came to the forefront in the early and mid-1990s. Many of them started from the initiatives of the New Generation artists, but their more active engagement with social issues led them to abandon the impassionate pictorial realism of New Generation painting. Their works, often taking the forms of installation, performance, and photography, document their direct and sometimes aggressive interaction with China's current transformation. An important aspect of this transformation, one that attracted much of their attention, was the rapid development of the city. A striking aspect of a major Chinese metropolis like Beijing or Shanghai in the 1990s was a never-ending destruction and construction: the forest of cranes and scaffolding, the roaring sound of bulldozers, the dust and mud. Old houses were coming down everyday to make room for new hotels and shopping malls. Thousands and thousands of people were relocated from the inner city to the outskirts. In theory, demolition and relocation were conditions for the capital's modernization. In actuality, these conditions brought about a growing alienation between the city and its residents: they no longer belonged to one another.

This situation is the context and the content of many works in 1990s experimental art. Zhan Wang's *Temptation* (p. 304), for example, is about the disappearance of the human subject —a basic phenomenon associated with any form of demolition and dislocation. The installation consists of a group of "human shells" made of clothes and glue. The extremely contorted gesture of each torso gives the impression of passion, pain, torture, and a life-and-death struggle. But there is neither a subject struggling nor an object to struggle against. Empty and suspended, these human forms are created not as self-contained sculptures, but as individual "signs" of desire and loss that have the infinite potential to be installed in different environments. A specific location is what gives specific meaning to the general signification of these manufactured forms. Suspended on scaffolding, they gain a heightened instability and anxiety. Placed on the ground, they are associated with the dirt and evoke the notion of death. The most dramatic installation is to scatter these hollowed mannequins in a demolition site. Both the ruined houses and the mannequins testify to fascination with torn and broken forms and a shared attraction to destruction and injury, although it is by no means clear what is actually wounded other than the buildings and the empty shells themselves.

Rong Rong's photographs of Beijing's demolition sites are also devoid of human figures, but he has filled the vacancy with images left in the half-destroyed houses, which originally decorated an interior but which has now become the exterior. A pair of dragons probably indicates a former restaurant; a Chinese New Year painting suggests a similarly traditional taste. The majority of such "leftover" images are various pin-ups from Marilyn Monroe to Hong Kong fashion models (p. 264). Torn and even missing a large portion of the composition, these images still exercise their alluring power over the spectator—not only with their seductive

figures but also with their seductive spatial illusionism. With an enhanced three-dimensionality and abundant mirrors and painting-within-paintings, they transform a plain wall into a space of fantasy. These works can be viewed together with photographs by Zhang Dali, the most famous graffiti artist in China, who developed a personal "dialogue" with Beijing through his art. From 1995 to 1998, Zhang Dali sprayed more than 2,000 images of himself —the profile of a shaven head—all over the city, often in half-destroyed, empty houses (p. 262). He thus transformed these urban ruins into sites of public art, however temporarily. The locations he chose for his performance/photographing projects often highlight three kinds of comparisons. The first kind contrasts a demolition site with an official monument. The second contrasts abandoned residential houses with preserved imperial palaces. The third contrasts destruction with construction: rising from the debris of ruined houses are glimmering high-rises of a monotonous, international style.

Zhang Dali's interest, therefore, lies not simply in representing demolition, but in revealing the different fate of demolished residential houses from buildings that are revered, preserved, and constructed. His photographs thus serve as a bridge from Rong Rong's "urban ruin"pictures to another popular subject of 1990s Chinese experimental art—representations of the emerging new cityscape. Ni Weihua's *Linear Metropolis* (p. 268), for example, registers the artist's fascination with the intricate, abstract patterns of new types of buildings and roads, patterns that stimulate sensations never before experienced in Chinese visual culture. The new Chinese city seems deliberately to rebel against its predecessor: whereas a traditional Chinese city has the typical, orderly image of a chessboard-like space concealed inside a walled enclosure, the new city is sprawling yet three-dimensional, fast and noisy, chaotic and aggressive. It refuses to stay quiet as a passive object of aesthetic appreciation, but demands the artist's participation to capture its vitality. Whereas Ni Weihua interacted with this city through his excited gaze, Zhao Bandi enriched the city's image with his "public welfare" art (p. 298), and Lin Yilin and Liang Juhui —two members of Guangzhou's experimental group Big-tailed Elephant —made their art part of the city's very movement. Lin Yilin conducted his 1995 performance *Safely Crossing Linhe Road* (p. 274) on one of the busiest streets in Guangzhou. He first built a freestanding brick wall on one side of the street, and then took away bricks one by one from the wall to build a second wall next to the first. He continued this process many times, until the wall "moved" to the other side of the street. While simulating simultaneous construction and destruction, this performance interrupted Guangzhou's traffic, and hence posed itself as an integral feature—and problem of the city. Liang Juhui also synchronized his performance *One-Hour Game* (p. 276) with the city's movement, but moved vertically instead of horizontally: he played computer games for a whole hour in an exposed elevator of a future high-rise.

The emerging city attracts experimental artists not only with its new buildings and roads but also with its changing population—an increasingly heterogeneous people living in an increasingly crowded place. To Chen Shaoxiong, another member of the Big-tailed Elephant, a heterogeneous city resembles the stage of a plotless tableaux; what unites its characters is the place they share. This notion underlies his photographic installations collectively entitled *Streets* (p. 272), which are conceived and constructed exactly like a series of puppet theaters. Representing a street or square in Guangzhou, each installation consists of two detached layers: in front of a large panoramic photograph are cut-out miniatures—passersby, shoppers, and policemen amidst telephone booths, traffic lights, different kinds of vehicles, trees, and anything one finds along Guangzhou's streets. These images are crowded in a tight space but do not interact. The mass they form is nevertheless a fragmentary one, without order, narrative, or a visual focus.

Similarly, the Tianjin artist Mo Yi learned his city through studying its residents. This research started in

the late 1980s, after he was criticized for his "detached, lonely, and suspicious" images of Tianjin people, which the critic considered a reflection of the photographer's anti-social mentality. This criticism propelled him to conduct an experiment to eliminate his subjective intervention in photographing the city. Tying the camera behind his neck or hanging it behind his waist, he used an extension cord to take pictures on the street —he could therefore separate the camera lens from his gaze, and see what people and the city look like when they were not subjected to his eyes. The experiment grew into a multi-year project, producing a large group of random photographs that have acquired a unique anthropological significance. Most interestingly, these images record the gradual changes on people's faces over the years, from expressionless and apathetic to a measure of moderately relaxed and animated. Mo Yi has thus titled the series *Expressions of the Street* (p. 294).

There is no doubt that 1990s Chinese experimental art owes a great deal to the transformation of the city and the emergence of new urban spaces and lifestyles. The city also realized its impact on artists in a negative way: sometimes, the chaos and high pressure associated with urban life drove artists to rediscover nature through their art. Thus, when Wang Jianwei made a video about continuous cycles of planting and harvesting crops (p. 256), or when Song Dong tried to affix a seal on the surface of a river (p. 258), they were not imitating ancient literati or zen monks. Rather, these and other attempts to engage with nature all symbolize the artists' return to a different time and space—a departure from the time and place to which they actually belong.

The examples discussed above make it clear that experimental representations of the environment are inseparable from the artists' self-representations. Such a close interrelationship, in fact, sets experimental art apart from other branches of contemporary Chinese art. For example, although academic painters also depict landscape and urban scenes, they approach their subjects as belonging to an external, observed reality. Experimental artists, on the other hand, find meaning only from their interaction with the surrounding world. When they document such interaction they customarily make themselves the center of a photograph or video, as seen in Zhang Dali's *Dialogue* or Song Dong's *Imprint on Water* or Zhu Fadong's performance/video project *This Person is For Sale* (p. 296) again exemplifies this representational formula. The video presents him as a member of the "floating population"—people who have left the countryside and entered large cities for jobs. It records the many trips Zhu Fadong took in Beijing during 1994: every morning he went out, with two lines written on his back: "This person is for sale; please discuss price in person." Following him we travel all over Beijing: Tiananmen Square, a McDonald's restaurant, the National Art Gallery, Beijing University, the East Village of experimental artists, and a labor market where he mingled with other members of the floating population. This video thus brings a city, a population, and the artist into a single representation; but the artist remains at the center.

When we shift our focus to artists' self-images, we find four basic modes frequently employed by experimental artists in the 1990s to represent themselves. The first is an "interactive" mode discussed a moment ago: the artist discovers or expresses him/herself through interacting with the surroundings. The subject of interaction, however, includes not only the environment but also people, as seen in Zhuang Hui's *Group Portraits* (p. 300) and Chen Shaofeng's *Dialogue with Peasants of Tiangongsi Village* (p. 302). Both works, the former a series of large-format photographs and the latter a huge assembly of oil portraits, are "preformatted" in nature. To Zhuang Hui, taking a group picture of an entire crew of 495 construction workers, or of the 600-strong employees of a department store, requires patient negotiation as well as skilled orchestration. Such interaction with his subjects is the real purpose of his art experiment, whereas the photograph, in which he always appears way over to the side, merely certifies the project's completion. Chen

Shaofeng developed a similar approach in conducting his interactive project: when he was painting portraits of more than 300 men, women, and children from Tiangongsi village, he also invited his sitters to sketch him at the same time.

The second mode of self-representation discourages explicit depiction of individual likeness. Rather, artists express themselves through symbolic images and objects. Zhan Wang's *Temptation* discussed above is one such representation, as the hollowed"human shells"imply the artist's own disappearance. To Cai Jin, the image of the banana plant is deeply associated with her personal life and memory, and she has painted this image on canvases as well as on various objects (p. 316). Yin Xiuzhen's *Suitcase* (p. 308) offers another outstanding example in this genre. Folding her old clothes and packing them into a suitcase of her own, she then seals the clothes with cement mortar. The performance is therefore a symbolic burial of her past symbolized by her "relics," now unseen underneath solid concrete. Cang Xin's performance *Trampling on the Face* (p. 322) takes a different form but conveys a similar sense of self-sacrifice: covering a courtyard with plaster masks made from his own face, he and his guests stepped on them and smashed them into pieces.

At the opposite spectrum from these symbolic representations, the third mode demands an explicit display of the body, which the artist employs as an unambiguous vehicle for self-expression. This body art emerged in Beijing's East Village, where artists like Zhang Huan and Ma Liuming developed two types of performance characterized by masochism and gender reversal. Exemplifying the second type, Ma Liuming invented his female alter-ego, Fen-Ma Liuming, as the central character in his/her performances (p. 320) Masochism is a trademark of Zhang Huan: almost every performance he undertook involved self-mutilation and simulated self-sacrifice. In some cases he offered his flesh and blood; in other cases he tried to experience death, either locking himself inside a coffin-like metal case or placing earthworms in his mouth. By subjecting himself to an unbearably filthy public toilet for a whole hour (p. 318), he not only identified himself with the place but also embraced it. With the same spirit, Yan Lei photographed his beat-up face in 1995 (p. 324). Masochistic self-representation acquired an even more extreme form in the late 1990s, as represented by several works in *Infatuated with Injury*, a private experimental art exhibition held in 1999 in Beijing.

The fourth and last mode of self-imaging is that of self-portraiture, which constitutes an important genre in 1990s experimental art. A common tendency among experimental artists, however, is a deliberate ambiguity in portraying their likeness, as if they felt that the best way to realize their individuality was through self-distortion and self-denial. A particular strategy for this purpose—self-mockery—became popular in the early 1990s, epitomized by Fang Lijun's skinhead youth with an enormous yawn on his face (p. 344). A trademark of cynical realism, this image encapsulated a dilemma faced by Chinese youth in the post-1989 period, and introduced what may be called an "iconography of self-mockery," which many experimental artists followed in the second half of the 1990s. Another method of self-denial is "self-effacing": making one's own image blurry, fragmentary, or in the act of vanishing. Many works in the 1998 exhibition *It's Me* fall into this category. More than one third of the self-portraits by experimental artists in a recent publication, *Faces of 100 Artists*, also use this formula.[1] The same idea underlies Jin Feng's self-portrait in this catalogue, entitled *The Process in Which My Image Disappears* (p. 334). It shows the artist writing *en face* on a glass panel: as his handwriting gradually covers the panel, they also blur and finally erase his image.

1 Shen Jingdong, *100 ge yishujia miankong* (Faces of 100 Artists). Private publication, 2001.

Wang Jianwei
Circulation — Sowing and Harvesting

1993-1994
performance,video

Circulation — Sowing and Harvesting was part of Wang Jianwei's "Gray Series"of philosophical works. It also represented a new framework within which to create art. The work comprises the documents and reports following the completion of an action, with details of its time scale, its process and result. In an experimental fashion, Wang Jianwei explored the trends in the relationship between human structure and awareness. He expanded this to the environment, society, humanism, and a more open arena as he turned the earth, planting and growing to a piece of action art, as a complete cycle. Seeking relationships between natural, social, and fundamental human rules, and the boundaries of or possibilities for art. Wang Jianwei's work habitually carries a sense of experimentation and scientific research. This series of works, in a wholly local language, drew upon nature and society, bringing it into his art. It was to give rise to a positive new approach within Chinese experimental art. (Huang Zhuan)

Wang Jianwei

1958 Born, Shuining, Sichuan province, China

1988 Graduated, oil painting department, Zhejiang Academy of Fine Arts, Hangzhou, Zhejiang province, China
Current, lives and works in Beijing, China

Group Exhibitions

1995 *The First Kwangju Biennial*, Kwangju, Korea
1996 *The Second Asia-Pacific Triennial of Contemporary Art*, Queensland Art Gallery, Brisbane, Australia
1997 *Documenta X*, Kassell, Germany
1998 *Cities on the Move*, Bordeaux Museum of Contemporary Art, Bordeaux, France
1999 *The Tenth Yamagata International Documentary Film Festival*, Yamagata, Japan
2000 *Kunsten Festival des Arts*, Brussels, Belgium
Revolutionary Capitals: Beijing-London, Institute of Contemporary Art, London, UK
2001 *Translated Acts*, Haus der Kulturen der Welt, Berlin, Germany
2002 *The 25th Sao Paulo Biennial*, Sao Paulo, Brazil

Song Dong
Imprint on Water
1996
performance

In this performance, Song Dong sits in the Lhasa River in Tibet and stamps the continuously flowing river water with a seal inscribed with the Chinese character for water. The existence and disappearance of culture, the disappearance of the present against the existence of the future, run through the whole process of the performance. The existence of culture is real (in that the Chinese character for water is stamped on the water) and unreal (in that no trace of the character can be seen on the water). Its non-existence also is real and unreal (in that the character is stamped on the water and extends along the course of the river) as well. The technically subtle handling endows the work with great capacity to contain, increasing the value of culture, and highlighting various possibilities of artistic thought. (Zhang Wenwu)

See page 246 for the artist's portrait and CV.

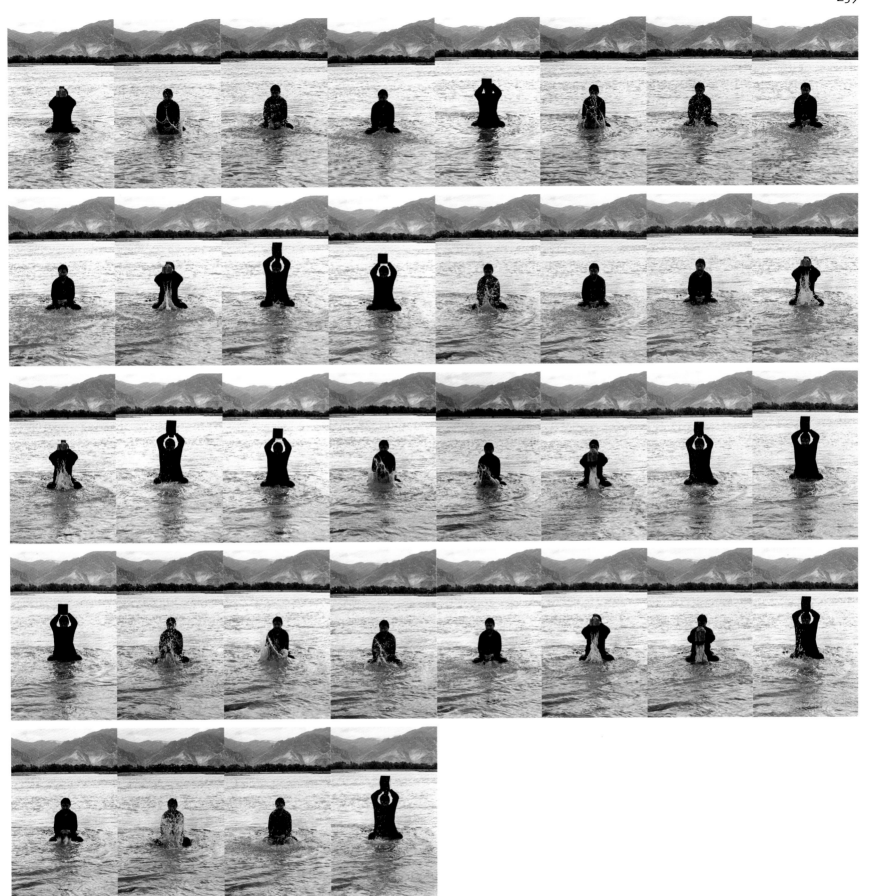

Huang Rui
Four Waters
1992
installation; water, cisterns
4 pieces, 100 x 65 cm each

In the series of works created by Huang Rui from 1992 to 1994, the memory of living and real life are placed into images of daily experience or natural scenes. They carry the sense of enlightenment emphasised in Zen Buddhism, and reflect the changes in a space through time via still life, living things such as small animals, and the contrast of stillness to motion. These works contain the collision of humanity and reality, and a sense of helplessness and pain. (Feng Boyi)

Huang Rui

1952　Born, Beijing, China
Current, lives and works be-
tween Osaka, Japan and
Beijing, China

Solo Exhibitions
1986　*Beijing Summer, 1986*, Shangtian Warehouse, Beijing, China
1992　*Forty Faces*, Huang Rui Studio, Beijing, China
1994　*Water + Bamboo*, Huang Rui Studio, Beijing, China
1995　*Water, Wood, Paper*, Ruins for Art, Berlin, Germany
　　　Kobe Customs, Tokyo Gallery, Tokyo, Japan

Group Exhibitions
1979　*The First Stars Art Exhibition*, outside the China Art Gallery, Beijing, China
1980　*The Second Stars Art Exhibition*, China Art Gallery, Beijing, China
　　　Ma Desheng, Huang Rui, Wang Keping, Baixin Road Elementary School,
　　　Beijing, China
1989　*Stars: Ten Years Exhibition*, Hanart TZ Gallery, Hong Kong
1996　*Origin and Myths of Fire: New Art from China, Japan and Korea*, Museum of
　　　Modern Art, Saitama, Japan
　　　From East of Eurasia, Oxy Gallery, Osaka, Japan
2000　*Stars Twenty Years*, Tokyo Gallery, Tokyo, Japan
2001　*Dream 2001, Chinese Contemporary Art*, Atlantis, London, UK

Zhang Dali
Dialogue
1998
photographs

Things are happening all over this city, and so do my performances. Demolition, construction, traffic accidents, sexual proclivity and drunkenness seize every opportunity to make this a violent, explosive environment. The expanding of the city and the ambiguous dissemination of information impart excitement, restlessness and insecurity. The walls I select are the changing screens of the city. I seek to locate and uncover the hidden portions of true reality. In times of peace, truth is hard to pinpoint; people are easily distracted from their responsibilities. I firmly believe people are the products of their environment, and changes in the environment actively alter the nature of the people. (Zhang Dali)

Zhang Dali

1963 Born Harbin, Heilongjiang province, China
1987 Graduated, Central Academy of Art and Design, Beijing, China
 Current, lives and works in Beijing, China

Solo Exhibitions
1988 Gallery of the Central Academy of Fine Arts, Beijing, China
1990 La Rupe Gallery, Bologna, Italy
1991 Rocca Municipale, Montefiorino, Italy
1994 Peter Dunsch Gallery, Essen, Germany
1999 CourtYard Gallery, Beijing, China
 Chinese Contemporary, London, UK
2000 *Dialogue, Shanghai*, Shanghai, China
 AKA-47, CourtYard Gallery, Beijing, China
2001 *AKA-47*, Base Gallery, Tokyo, Japan

Group Exhibitions
1989 Salone Italiano Arte Contemporanea, Firenze, Italy
1997 *W²-Z²*, Gallery of the Central Academy of Fine Arts, Beijing, China
1999 *The World is Ours*, Beijing Design Museum, Beijing, China
 Revolutionary Capitals: Beijing-London, Institute of Contemporary Art, London, UK
 Food for Thought: An Insight into Chinese Contemporary Art, Canvas World Art, Amsterdam, the Netherlands
2000 *Fuck Off*, Eastlink Gallery, Shanghai, China
2001 *Cross-Pressures*, Oulu Art Museum, Oulu, Finland
 Osaka Triennial, Osaka, Japan
2002 *Globalizing Asia*, Barcelona, Spain

Rong Rong
1996 No.1 (1)
1996-98
photograph
127 x 183 cm

Rong Rong's photographs affiliate the artist with not only physical ruins but also an "aesthetic of ruins." Unlike the representations of the bygone destruction of the Cultural Revolution, these images have their focus in the present, and transport a startling sense of loss and absence in a contemporary Chinese urban environment. (Wu Hung)

Rong Rong

1968 Born, Zhangzhou, Fujian province, China

1988 Graduated, painting department, Fujian School of Art and Design, Fujian province, China

Current, lives and works in Beijing, China

Solo Exhibitions

1997 *Photography by Rong Rong*, Cultural Department, French embassy, Beijing, China

1998 Galerie HS Steinek, Vienna, Austria

2001 *Rong Rong: Contemporary Chinese Photography*, Chambers Fine Art, New York, USA

2002 *Rong Rong*, Galerie Loft, Paris, France

Group Exhibitions

1997 *Zeitgenössische Fotokunst aus der Volksrepublik China* (Contemporary Photography from the People's Republic of China), Kunstverein, Berlin, Germany

1999 *Transience: Chinese Experimental Art at the End of the Twentieth Century*, Smart Museum of Art, University of Chicago, Chicago, USA

L'Inviation a la Chine: Biennale d'Issey, Issey, France

1998 *Big Torino 2000*, Torino, Italy

Fuck Off, Eastlink Gallery, Shanghai, China

From Inside the Body, ISE Foundation, New York, USA

1999 *Promenade in Asia*, Shiseido Gallery, Tokyo, Japan

Cross - Pressures, Oulu Art Museum, Oulu, Finland

China-Naarden; Wall-to-Wall, Fotofestival, Amsterdam, the Netherlands

Zeng Li
Design for a Liang Sicheng Memorial Hall
2000
architectural design; mixed media
800 x 500 x 20 cm

Zeng Li has written, "I wish to turn my works into a means for communicating with history, for exploring our spiritual connection with tradition, for awakening our historical memory." Thus Zeng Li proposes to use glass sheets to connect the few extant segments of the ancient city wall between Chongwen and Dongbian Gates in southeastern Beijing. In this way he will connect the worn fragments of the old with the smooth radiance of the new, forming a memorial one kilometer long to Liang Sicheng—son of the famous intellectual Liang Qichao and a famous scholar of traditional Chinese architecture. Here, the plan for the Liang Sicheng memorial becomes a dialogue with history, a search for cultural artifacts. (Tao Jing)

Zeng Li

1961 Born, Linzhou, Guangxi province, China

1988 Graduated, department of set design, Central Academy of Drama, Beijing, China

Current, serves as art designer for the People's Art Theater, Beijing, China

Solo Exhibitions

1994 *Chairs and Scenery,* Beijing, China
1995 *Legacy,* International Art Palace, Holiday Inn Crowne Plaza, Beijing, China

Group Exhibitions/Designs

1998 *Turandot,* stage design for production at the Taimiao, Forbidden City, Beijing, China
 Doctor Knock, stage design, People's Theater, Beijing, China
1999 *Prague International Stage Design Exhibition,* Prague, Czech Republic
2001 *The First Liang Sicheng Architectural Biennial,* China Art Gallery, Beijing, China
 The Fourth Contemporary Sculpture Art Annual Exhibition, He Xiangning Art Museum, Shenzhen, China
 Crossroad: Urban Public Environmental Art Proposal Exhibition, Chengdu, Sichuan province, China
 Raise the Red Lantern, ballet production, stage design
 Lightning and Rain, modern dance production, stage design
2002 *Pingyao International Photography Festival,* Pingyao, China

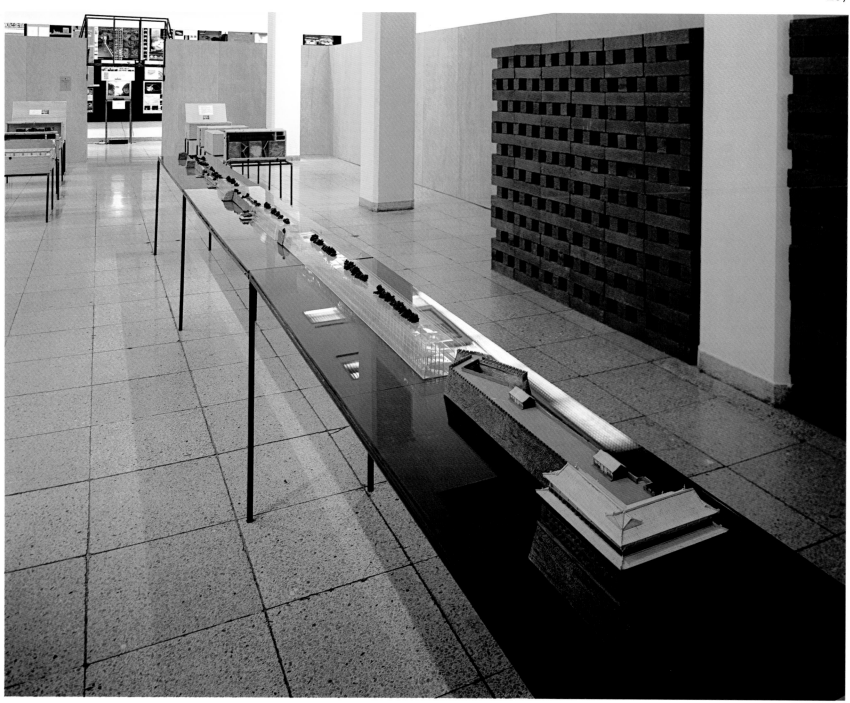

Ni Weihua / Wang Jiahao
Linear Metropolis
1997
installation, performance; map of Shanghai, wooden boards, glass

The artists directly use a map of Shanghai, dividing it into twenty squares, hanging the squares without order in a straight line on the gallery wall. Here, a simple deconstruction and restructuring of a city map becomes a complex commentary on urban life in China. The artists speak to the phenomenon of daily urbanization—and since we live in an age of digital reproduction, all of life can be represented in binary. Owing to the appearance of these phenomena, the artists create a "linear metropolis." In this way we see the worries of humanism—and the disappearance of the difference between city and country. (Shen Chan)

Ni Weihua

1961 Born, Shanghai, China
1983 Graduated, Shanghai Light Industry Technical College, Shanghai, China
Current, works for Baogang Corporation, Shanghai, China

Wang Jiahao

1975 Born, Shanghai, China
1997 Graduated, architecture department, Tongji University, Shanghai, China

Solo Exhibition

1989 *New Expression: '89 Ni Weihua Painting Exhibition*, Shanghai, China

Group Exhibitions

1992 *Works by Ni Weihua and Wang Nanming*, Beijing, China
1995 *The Language of Installation*, Shanghai, China
1996 *In the Name of Art*, Liu Haisu Museum of Art, Shanghai, China
1997 *New Asia, New City, New Art: Contemporary Art from China and Korea*, Shanghai, China
1998 *In/From China: Art and Architecture Exhibition*, Berlin, Germany
1999 *Chinese, Japanese, and Korean Art Exhibition*, Pusan, Korea Republic
2000 *The Individual and Society in Art: Works by 11 Young Artists*, Guangdong Museum of Art, Guangzhou, China

Group Exhibitions

1997 *New Asia, New City, New Art: Contemporary Art from China and Korea*, Shanghai, China
 The First Liang Sicheng Architectural Biennial, China Art Gallery, Beijing, China
1998 *In/From China: Art and Architecture Exhibition*, Berlin, Germany
1999 *Chinese, Japanese, and Korean Art Exhibition*, Pusan, Korea Republic
2000 *The Individual and Society in Art: Works by 11 Young Artists*, Guangdong Museum of Art, Guangzhou, China

Xu Tan
Made in China and at Home
1997-98
video

In the information age, collecting, producing, and transmitting images has become democratic. All one needs is a camera or a home video camera, and he or she can make images. Between 1997 and 1998, I chose Beijing, Shanghai, Guangzhou, and Shenzhen—four classic Chinese metropolises. I shot the cities and my personal life, as if I were spying on myself. I also shot some urban scenes in contrast to these "internal" matters. In this way, I made the most of this style of viewing. (Xu Tan)

Xu Tan

1957 Born, Wuhan, Hubei province, China
1989 Graduated with master's degree, oil painting department, Guangzhou Academy of Fine Arts, Guangzhou, China
 Current, lives and works between Shanghai and Guangzhou, China

Solo Exhibitions
1996 Farmington Arts Center, Farmington, USA
2002 Location 1 Arts Center, New York, USA

Group Exhibitions
1996 *Big-tailed Elephant 96*, Guangzhou, China
1997 *Another Long March: Chinese Conceptual and Installation Art in the Nineties*, Fundament Foundation, Breda, the Netherlands
 Cities on the Move, The Secession, Vienna, Austria
1998 *Big-tailed Elephant*, Berne, Switzerland
 Inside Out: New Chinese Art, Asia Society Galleries, PS 1 Contemporary Art Center, New York, USA
 Site of Desire, 1998 Taipei Biennial, Taipei, Taiwan
1999 *The Third Asia-Pacific Triennial of Contemporary Art*, Queensland Art Gallery, Brisbane, Australia
2000 *Fuck Off*, Eastlink Gallery, Shanghai, China
2002 *Pause: The Fourth Kwangju Biennial*, Kwangju, Korea Republic
 The Second Berlin Biennial, Berlin, Germany

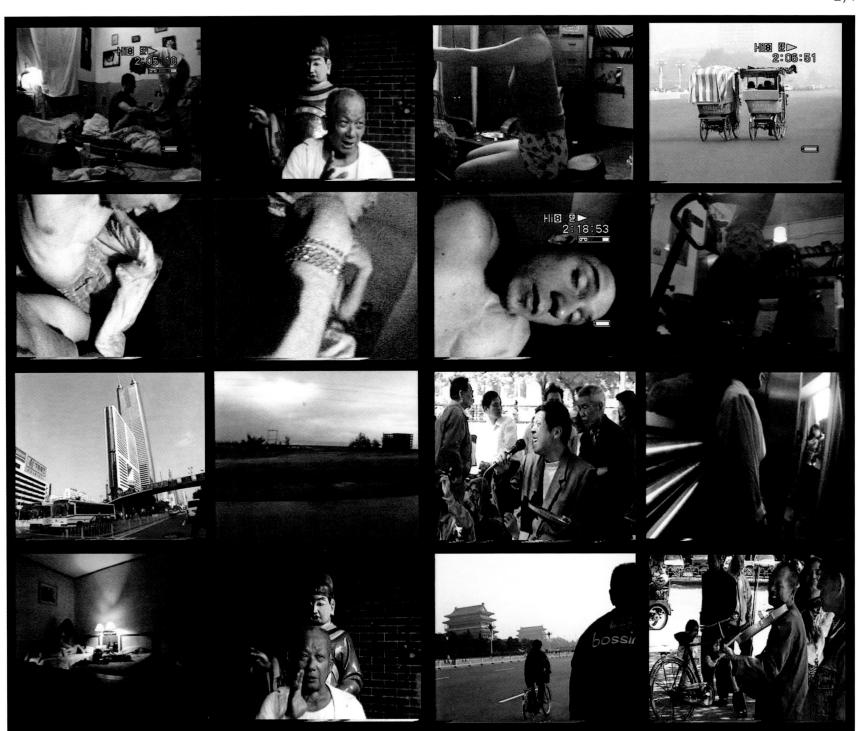

Chen Shaoxiong
Second Avenue
1997-98
photograph
1000 x 30 x 30 cm
Collection of the Annie Wong Art Foundation

Every thing in the city is temporary: streets, buildings, shopping centers, train stations, airports, transit ways, road markings, and even the crowds. It doesn't matter if the residents are permanent or temporary, nothing is fixed. I use my photographic approach to fix these transient objects and then put the images I have fixed back into the physically moving backgrounds. My goal is to dispel uncontrollable rules and confusing magic. I have to record what I see. As a witness, I want to keep the memory of my life inside my built-up small-scale worlds, or to build a scenic monument to this ever-changing city. (Chen Shaoxiong)

Chen Shaoxiong

1962 Born Shantou, Guangdong province, China
1984 Graduated, print-making department, Guangzhou Academy of Fine Arts, Guangdong province, China
Current, teaches at Guangdong Art Normal School, Guangzhou, China

Group Exhibitions

1997 *Anther Long March: Chinese Conceptual and Installation Art in the Nineties*, Fundament Foundation, Breda, the Netherlands
Cities on the Move, PS 1 Contemporary Art Center, New York, USA
1998 *16th World-Wide Video Festival*, Amsterdam, the Netherlands
1999 *Ninth International Photography Biennial*, Image Center, Mexico City, Mexico
2000 *Our Chinese Friends*, Bauhaus-University and ACC Gallery, Weimar, Germany
2001 *Living in Time*, Hamburg Bahnhof Museum of Contemporary Art, Berlin, Germany

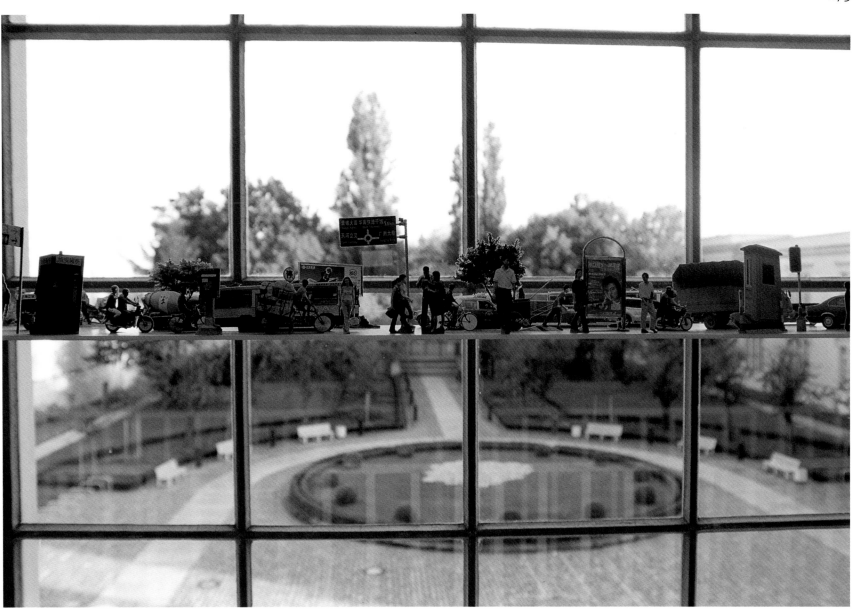

Lin Yilin
Safely Crossing Linhe Road
1995
video of performance; 90 min.

On one of the busiest streets in the new area of Guangzhou, Li Yilin chose the most congested point at which to move a wall of breeze-blocks from one side to the other, one by one. In this way, maintaining the form of the wall, Lin Yilin moved the entire structure across the road. Not only did he turn a "solid" into a moving entity but invoked a sense of speechless surprise in passersby as this bizarre form disrupted the traffic, leading to one jam after another. In this dense, intense portion of the city, through this work, Lin Yilin created his own new space within the chaos. The pace of cityscapes is being altered, the lives of the people made increasing, hectic by the rigors of advancing economics. Against this, the temporary space that Lin Yilin offers might just allow the people to contemplate the changes taking place within human nature. As the pace of city life accelerates it also becomes more rigidly standardized. Against the growing bombardment of information, people's lives become less stable even as they become more independent. (Hou Hanru)

Lin Yilin

1964 Born, Guangzhou, China
1987 Graduated, sculpture department, Guangzhou Academy of Fine Arts, Guangzhou, China
Current, lives and works in Guangzhou, China

Group Exhibitions

1991 *Exhibition of Big-tailed Elephant Group*, Guangzhou No.1 Worker's Palace, Guangzhou, China
1993 *China Avant-garde*, Haus der Kulturen der Welt, Berlin, Germany
Third Exhibition of Big-tailed Elephant Group, Red Ants Bar, Guangzhou, China
1997 *Another Long March: Chinese Conceptual* and Installation Art in the Nineties, Fundament Foundation, Breda, the Netherlands
The Second Johannesburg Biennale, Johannesburg, South Africa
Cities on the Move, The Secession, Vienna, Austria
1998 *Site of Desire, 1998 Taipei Biennial*, Taipei Fine Arts Museum, Taipei, Taiwan,
Inside Out: New Chinese Art, Asia Society Galleries, PS 1 Contemporary Art Center, New York, USA
2000 *Fuck Off*, Eastlink Gallery, Shanghai, China
2001 *The Fourth Contemporary Sculpture Art Annual Exhibition*, He Xiangning Art Museum, Shenzhen, China
2002 *Pause: The Fourth Kwangju Biennial*, Kwangju, Korea Republic

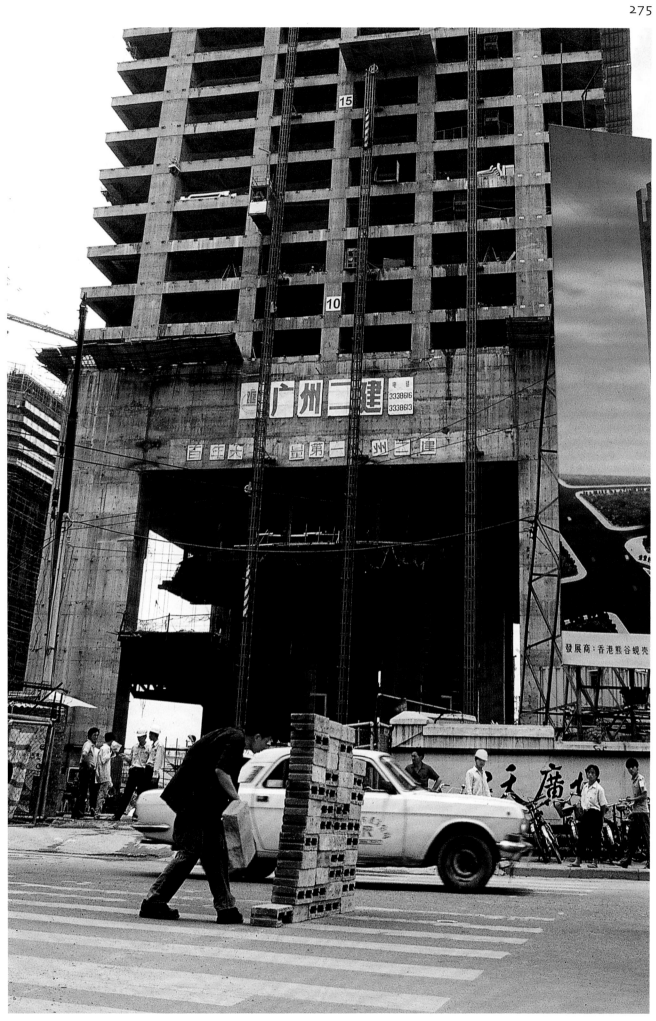

Liang Juhui
One-hour Game
1996
installation, performance

This performance work was completed in an under-construction skyscraper on a building site in Tianhe Xingxing City, Guangzhou. A color television set was placed in the external elevator on the side of the building, together with an electronic gameboy, and a box of game tapes. Here, the artist remained for one hour. In this way he affected a perpendicular motion and action that served to disrupt the regular advance of the surrounding development, caving out a personal space within the public arena. In this context, the elevator became a symbol for the architecture, involved in the structure through its complicity in the game, and transformed into a moving game arcade. The work was related not to an object as art but to a defined space that could express the tension between personal and public space. Thus Liang Juhui highlighted the awareness of consumerism and the autocracy of culture. (Huang Zhuan)

Liang Juhui

1959 Born, Guangzhou, China
1992 Graduated Guangzhou Academy of
 Fine Arts, Guangzhou, China

Group Exhibitions
1986 *Southern Artists' Salon's First Experimental Exhibition*, Zhongshan University,
 Guangzhou, China
1991 *Exhibition of Big-tailed Elephant Group*, Guangzhou No.1 Worker's Palace,
 Guangzhou, China
1997 *Another Long March: Chinese Conceptual and Installation Art in the Nineties*,
 Fundament Foundation Breda, the Netherlands
 Cities on the Move, The Secession, Vienna, Austria
1998 *Big-tailed Elephant*, Kunsthalle, Bern, Switzerland
 Inside Out: New Chinese Art, Asia Society Galleries, PS 1 Contemporary Art
 Center, New York
2000 *House, Home, Family*, 4/F Yuexing Furniture Corporation, Shanghai, China
2001 *Chengdu Biennale*, Chengdu Modern Art Museum, Chengdu, China
2002 *Pause: The Fourth Kwangju Biennial*, Kwangju, Korea Republic

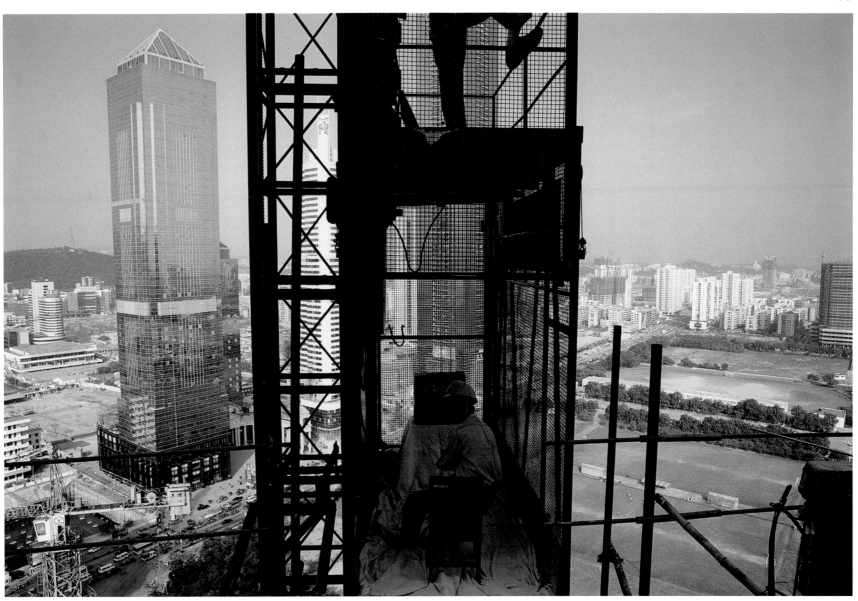

Kong Yongqian
Thematic Cultural Clothes
1991
site-specific work

In the Cultural Clothes that Kong Yongqian produced, from "I'm Fed Up," "Leave Me Alone ," "Never Achieved Nothing / Going Nowhere," "Knackered," and "tuojia," to his "Residency Papers," "Identity Card," "Ration Coupons" —all typical documents of daily life in China—the artist employs the humor of Cynical Realism to achieve the same goal but via a very different route. Through appropriating a means from the consumer culture that swiftly became embraced in large cities like Beijing, he effected a true Pop approach. The rapid rise of consumer culture has also caught the attention of world news organizations, government organizations, public security, making it a most ordinary fact of daily life and the most accurate and effective grasp of the mood of contemporary Chinese society. Kong Yongqian captures this mood expressed in a casual and roguishly humorous approach. (Li Xianting)

Kong Yongqian
1962 Born, Beijing, China
 Current, lives and works in Shenyang,
 Liaoning province, China

Group Exhibition
1993 *Mao Goes Pop, China Post-1989*, Contemporary Art Museum, Sydney, Australia

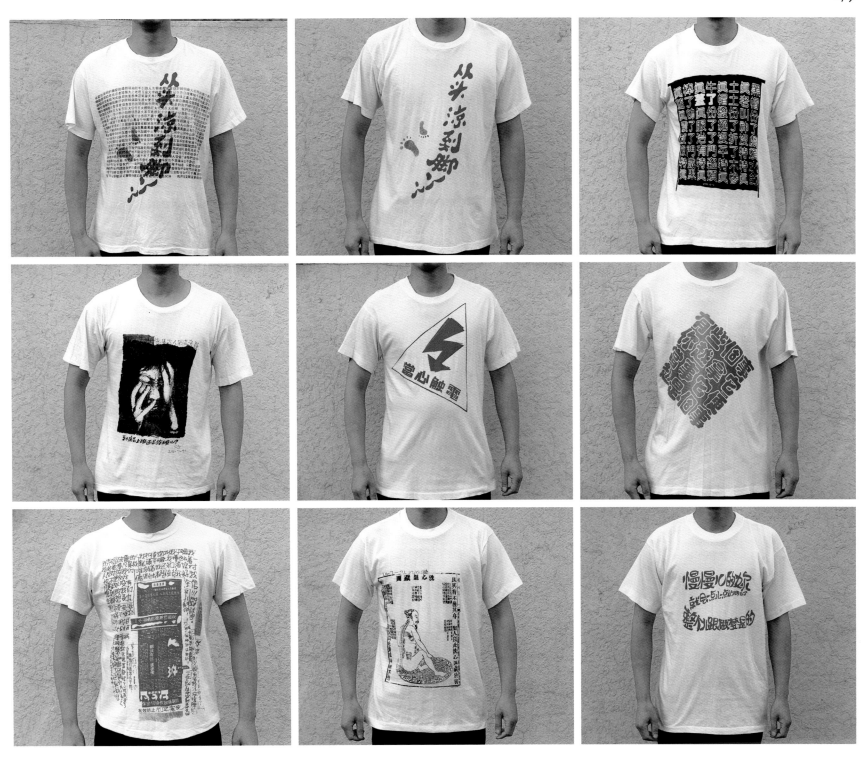

Hu Xiangdong
Dream Plant

1998
sculpture, installation; resin
360 x 240 cm

Hu Xiangdong uses resin to create cabbages. Titled *Dream Plant*, the works imitate crystal and thus instantly raise the value of cabbage. It is like the difference between Tai Lake and ordinary lakes, the first magical, the others, ordinary. This sense naturally aligns itself with human propensity towards idealism, but in an age of ideology where people had lost the skills of classical men of letters, ideals had no way to transcend the scope of daily life. With no way or money to use a precious material like jade, Hu Xiangdong used plastic resin. Yet by giving cabbage wings, it could be passed off as jade. At the same time, the plastic resin also carries a modern feel and thus comfortably enters the contemporary age. (Li Xianting)

Hu Xiangdong

1961 Born, Jiangsu province, China
1988 Graduated, Nanjing Academy of
 Fine Arts, Nanjing, China
 Current, lives and works in Beijing,
 China

Group Exhibitions

1983 *Jiangsu Young Artists Week*, Jiangsu Art Museum, Nanjing, China
1996 *Reality: Present and Future*, International Art Palace, Holiday Inn Crowne
 Plaza, Beijing, China
1998 *Personal Touch*, TEDA Contemporary Art Museum, Tianjin, China
1999 *Food for Thought*, De Wette Dame, Eindhoven, the Netherlands
 Ooh, La, La Kitsch!, TEDA Contemporary Art Museum, Tianjin, China
 Poly Phenolrene, Bow Gallery, Beijing, China
 Contemporary Chinese Art, Zurich, Switzerland
2000 *Post-Material: Interpretations of Everyday Life by Contemporary Chinese Artists*,
 Red Gate Gallery, Beijing, China
1998 *Different Words*, Artists' Storehouse, Beijing, China
 Red Hot: A Special Exhibition of Contemporary Chinese Art, Red Gate Gallery,
 Beijing, China

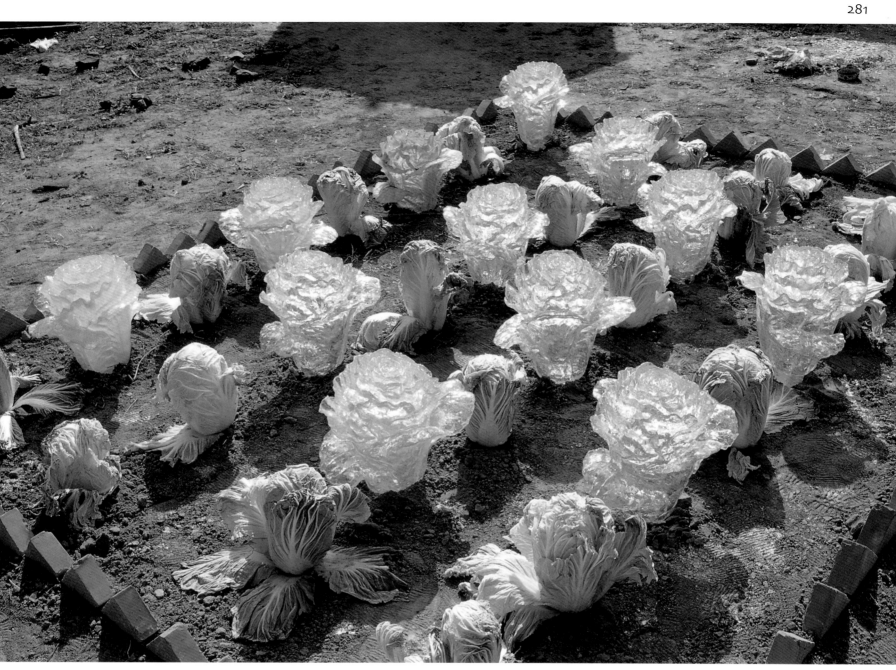

Wang Bo
A Chain of Dreams
2000
Internet art

This work is built as if of many small rooms, most of which are the same. As you move the mouse across the spaces on the screen, each place might offer the opportunity to enter into another. Or equally it might only present a boring dead-end. You might come across a person, and explore on together. Perhaps, in a moment of carelessness you will destroy the person. Different paths will have different outcomes. This will test your luck and the complexity of my endeavor. To my eye, rather than changing something essential to life, Internet art only uncovers the hidden nature of the games concealed in the seemingly quiet daily life. It also restores the immediate attribute of action and communication. On the Internet, like people running about in a labyrinth, we translate interactive intentions and enter directly into a chain of nightmares. (Wang Bo)

Wang Bo
1971 Born, Shanxi province, China
1996 Graduated, art department, Shanxi University, Taiyuan, Shanxi province, China
Current, lives and works in Beijing, China

Solo Exhibitions
2001 *Play with Me: Wang Bo | Three Internet | Multi-media Works*, Loft New Media Art Space, Beijing, China

Group Exhibitions
1998 *Chapter 1*, Beijing, China
1999 *Chapter 2: From a Point of Common Sense*, International Art Palace, Holiday Inn Crowne Plaza, Beijing, China
Sharp New Insights: Born in the Seventies, Beijing, Guangzhou, China
2000 *Intent on Communicating: Chinese Conceptual Photography*, Genoa Asian Contemporary Art Archives, Milan, Italy
2001 *Chapter 3: Formatting*, Hanmo Gallery, Beijing, China
Trace, Annual Exhibition of Video and Photography, Artists' Storehouse, Beijing, China
China-Germany, New Media Arts Festival, Loft New Media Art Space, Beijing, China
2002 *Three Expressions of Time*, Beijing, China

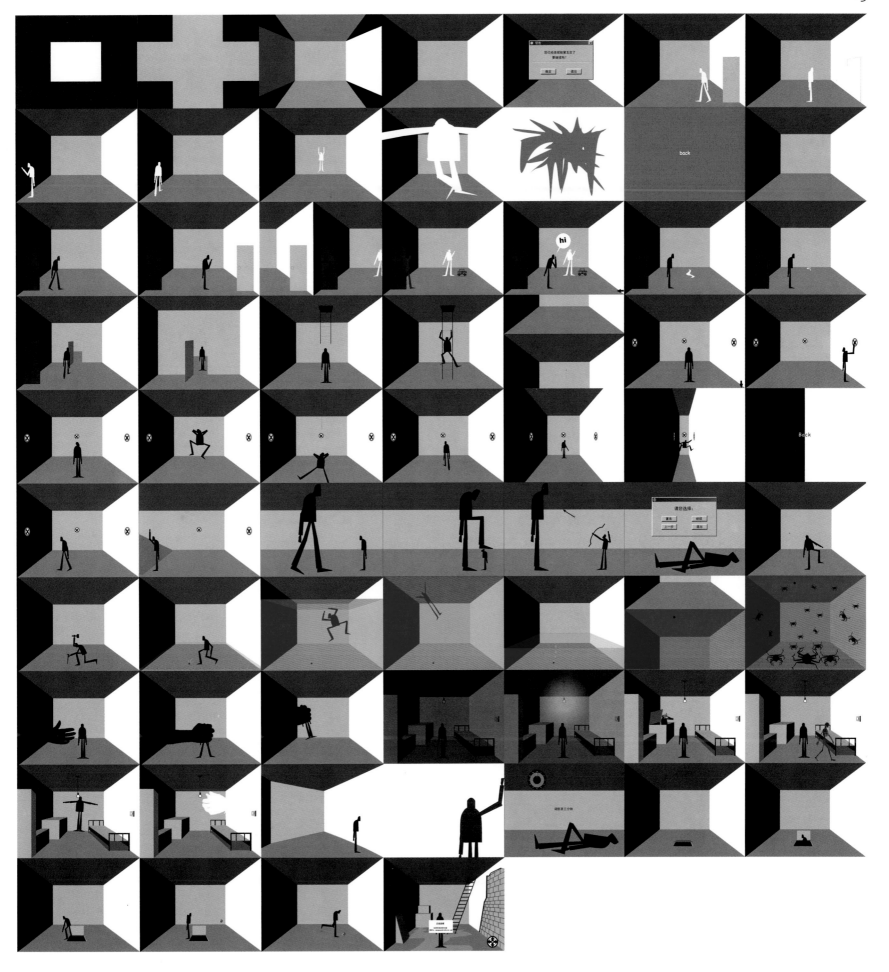

Shang Yang
Grand Panorama
1999
acrylic and oil on canvas
130 x 486 cm

From a wide landscape of broken and flat areas like part of a text book analyzed and dissected, I used my own approach to explore the chaotic cultural environment, the state of human life and the direction of civilization. This naturally includes art for everything exists in this grand panorama. As an artist, my work has no way to avoid contemplating and questioning this. At the same time, I draw on all my enthusiasm in this quest for the form of a painting and a language of expression. All this is combined in the creative process. History offers a rich resource, which makes us look anxiously in all directions in search of inspiration. History also provides a multiplicity of visual expression. Today, as time rolls on, unceasingly giving rise to new visual experience, this makes me advocate the use of time, a combination of styles and a free manner of expression, taking delight in blending them together in a contemporary landscape. (Shang Yang)

Shang Yang

1942 Born, Hubei province, China
1981 Graduated, oil painting department, Hubei Academy of Fine Arts, Wuhan, Hubei province, China
Current teaches in the fine arts department, Capital Normal University, Beijing, China

Group Exhibitions

1991 *The First Annual Chinese Oil Painting Exhibition*, Museum of Chinese History, Beijing, China
1992 *The First Guangzhou Biennale: Oil Painting in the Nineties*, Guangzhou Exhibition Center, Guangzhou, China
1994 *Invitational Exhibition of Works Selected by Chinese Critics*, China Art Gallery, Beijing, China
1996 *The First Shanghai Biennale*, Shanghai Art Museum, Shanghai, China
1998 *Contemporary Chinese Art*, Leiweinei Royal Youth Museum, Italy
2000 *Gate of the New Century*, Chengdu Modern Art Museum, Chengdu, China
20th Century Chinese Oil Painting Exhibition, China Art Gallery, Beijing, China
2001 *Chengdu Biennale*, Chengdu Modern Art Museum, Chengdu, China

Deng Jianjin
Tomorrow's Vast Blue Sky
1994
oil on canvas
190 x 160 cm
Collection of the Guangdong Museum of Art, Guangzhou

Through almost a year of creating paintings, I discovered I enjoyed evoking the collision of contradictions against the elegance of the soul. This attitude expressed a mutual entanglement, common sameness and mutual anxiety. It allowed both myself and others to observe the unfolding of these contradictions and deduce one after the other in an endless stream the ideals and desires of the real world. In this work, the composition is flat and without a central focus. The exaggeration and displacement between the figures and the space and the repeated use of objects to fill up the space is there to reflect relationships with the masses that are invisible, intangible and complex within the maze of society, and individual pressures between people. (Deng Jianjin)

Deng Jianjin

1961 Born, Guangdong province, China
1986 Graduated, fine arts department, Jingdezhen Porcelain Institute, Jiangxi province, China
 Current, assistant professor at the high school attached to Guangzhou Academy of Fine Arts, Guangzhou, China

Solo Exhibition

1988 *Deng Jianjin Art Works*, Guangzhou Xinghe Exhibition Hall, Guangzhou, China

Group Exhibitions

1993 *The First Chinese Painting Biennial*, China Art Gallery, Beijing
1994 *The Second China Oil Painting Exhibition*, China Art Gallery, Beijing, China
1995 *The Third China Oil Painting Exhibition*, China Art Gallery, Beijing, China
1997 *Towards a New Century, Young Chinese Oil Painters' Exhibition*, China Art Gallery, Beijing, China
1999 *The 14th International Asian Art Exhibition*, Fukuoka Museum of Asian Art, Fukuoka, Japan
 Gate of the New Century, Chengdu Modern Art Museum, Chengdu, China
2000 *One Hundred Years of Chinese Oil Painting*, China Art Gallery, Beijing, China
 Contemporary Chinese Painting Exhibition, Villa Breda Foundation, Padua, Italy

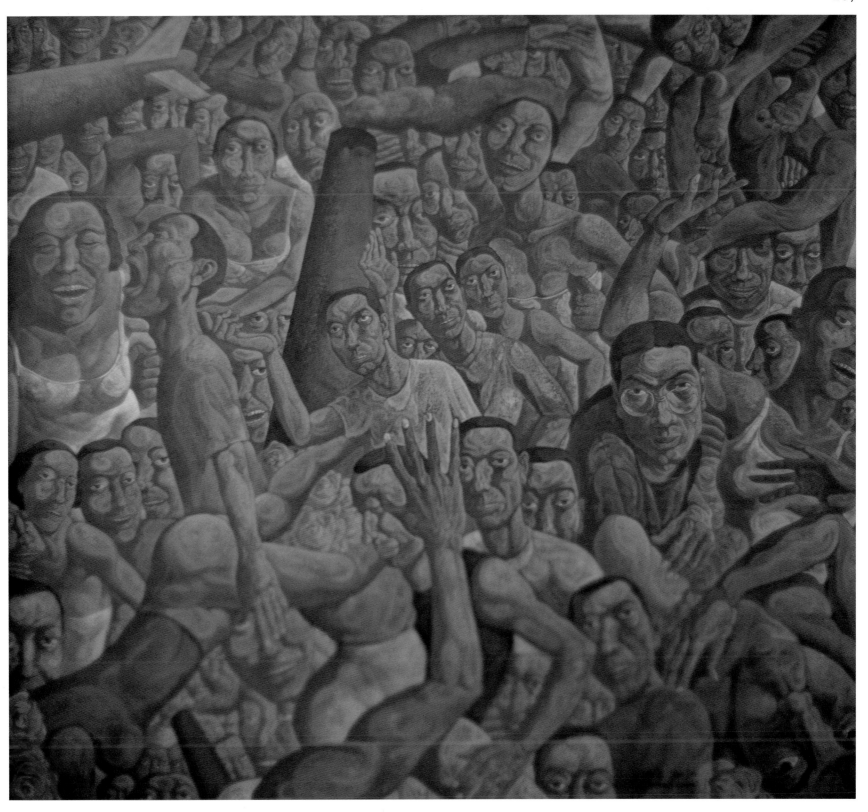

Sun Liang
Human Tree
1990
oil on canvas

This work was created in 1990, which was a very particular time. From the end of the 1980s to the mid-1990s, many of my works were related to life and death. Trees grow, blossom and produce fruits. To produce fruit is splendid, but eventually the tree dies. That is life. Loneliness, aimlessness, confusion, agony, all deny hope. These kind of thoughts arise frequently and are inescapable, and like a cornered beast they pace up and down as they weigh up the possibility of death or escape, which is exactly how I and people like me feel. (Sun Liang)

Sun Liang

1957	Born, Hangzhou, Zhejiang province, China
1982	Graduated, design department, Shanghai Light Industry Technical College, Shanghai, China
	Current, teaches at Shanghai University Institute of Fine Arts, Shanghai, China

Group Exhibitions

1988	*The Second Aotu Exhibition: The Last Supper*, Shanghai Art Gallery, Shanghai, China
1989	*China / Avant-garde*, China Art Gallery, Beijing, China
1992	*Encountering the Other*, K-18, Kassell, Germany
1993	*The Eastern Road: The 45ᵗʰ Venice Biennale*, Venice, Italy
1995	*Change — Modern Art from China*, Goteburg Art Museum, Goteburg, Sweden
1999	*The First Fukuoka Triennial of Asian Art*, Fukuoka Museum of Asian Art, Fukuoka, Japan
2000	*One Hundred Years of Chinese Oil Painting*, China Art Gallery, Beijing, China
2001	*Towards a New Image*, China Art Gallery, Beijing, China

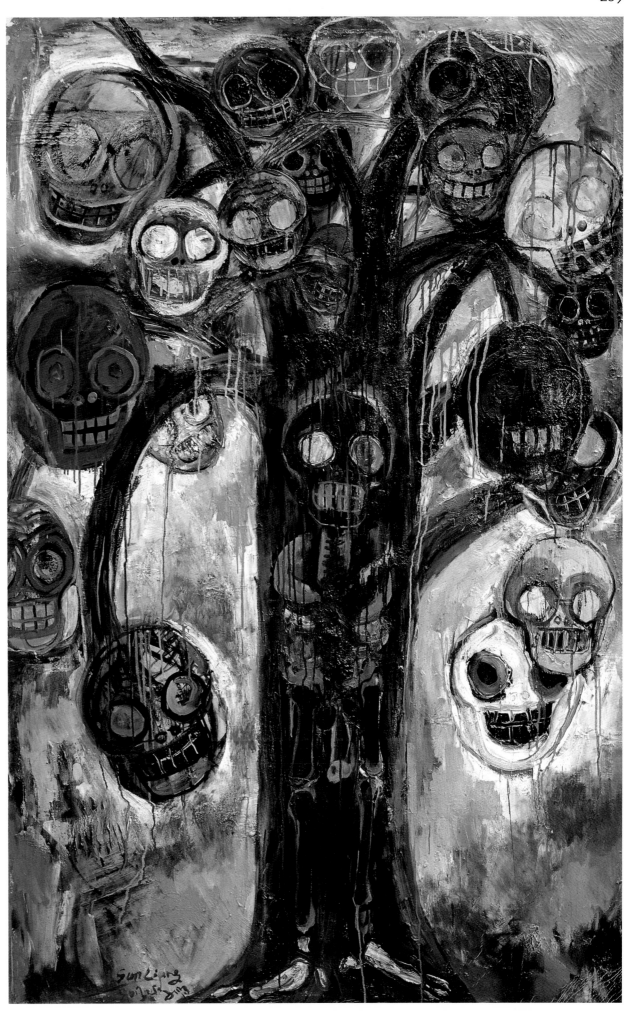

Jiang Hai
Alien Spaces–Sublime
1994
oil on canvas
120 × 105 cm

In the series of paintings titled *Alien Spaces*, the background is of a light yellowish earth or warm gray color, representative of the male *yang*, enforced by a complex maze of brush strokes. The female *ying* is represented in the bottom half of the paintings and it appears as if the woman is being mistreated. The female forms are painted in pinkish tones at times "powdered with rouge" and are simplistic by contrast to the complexity of the male forms. Within the male form, the dynamic lines and complexity of the brush strokes result in a juxtaposition of composite components. It is as if a violent machine is oppressing the female. Within this context the violent machine becomes representative of a cultural institution. (Yi Ying)

Jiang Hai
1961 Born, Qingdao, Shandong province, China
1986 Graduated, print-making department, Tianjin Academy of Fine Arts, Tianjin, China
 Current, art editor for *Tianjin Daily*

Solo Exhibitions
1991 Art Gallery, Beijing Concert Hall, Beijing, China
1995 International Art Palace, Crowne Plaza, Beijing, China
1999 *Phantasmagoric Technique*, CourtYard Gallery, Beijing, China
2002 *The Reality and Illusion of Magical Cities*, Shanghai Art Gallery, Shanghai, China

Group Exhibitions
1987 *BT5 Painting Exhibition*, Gallery of the Central Academy of Fine Arts, Beijing, China
1989 *China/Avant-garde*, China Art Gallery, Beijing, China
1992 *The First Guangzhou Biennale: Oil Painting in the Nineties*, Guangdong Exhibition Center, Guangzhou, China
1995 *China Oil Painting Biennial*, China Art Gallery, Beijing, China
1996 *The Second Exhibition of Chinese Oil Painting*, China Art Gallery, Beijing, China
1997 Jiangsu Art Monthly *Twentieth Anniversary Exhibition*, Nanjing, China
1997 *Towards a New Century*, China Art Gallery, Beijing, China
2000 *One Hundred Years of Chinese Oil Painting*, China Art Gallery, Beijing, China

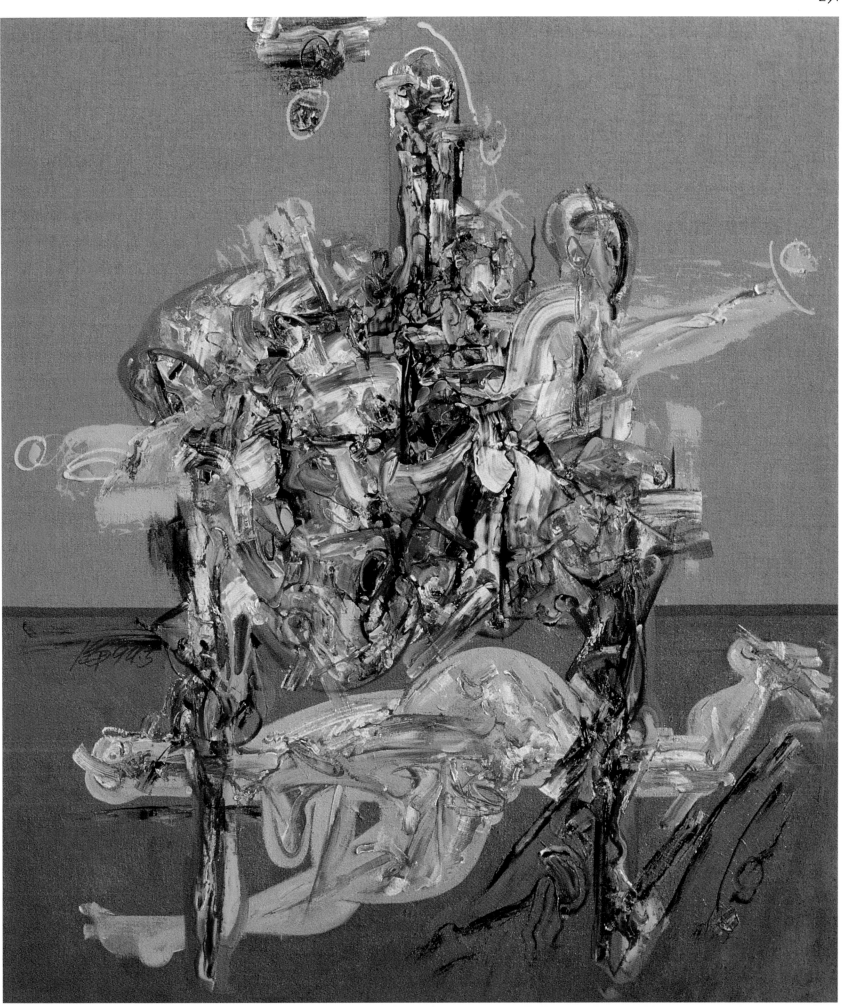

Fang Shaohua
Damp Proof – Echo
1995
oil on canvas
238 x 183 cm

In Fang Shaohua's new expressionist works, the bright red city gate is a monument against the disordered, gray and scrawled buildings and forms a concise parable effect. The free touches, purified and steady colors, and in particular the hand holding an umbrella eternally to the sky, introduce an air of enlightenment to the work. In all the paintings, visual elements such as historical heritage, society and sex are often presented not in an illustrated state but a fixed state of disorder which implies a visual questioning of the direction in which society is heading. (Huang Zhuan)

Fang Shaohua

1962 Born, Shashi, Hubei province, China

1982 Graduated, oil painting department, Hubei Academy of Fine Arts, Wuhan, Hubei province, China
Current, teaches in the fine arts department, Huanan Teaching University, Guangzhou, China

Group Exhibitions

1983 *Sixth National Art Exhibition*, China Art Gallery, Beijing, China

1987 *First Chinese Oil Painting Exhibition*, Shanghai Art Gallery, Shanghai, China

1992 *First Exhibition of Chinese Oil Painting in the 1990s*, Redwood City Exhibition Hall, California, USA

1996 *China!*, Kunstmuseum Bonn, Bonn, Germany
First Academic Exhibition of Chinese Contemporary Art, Hong Kong Arts Centre, Hong Kong

1999 *New Art From China*, Kunsthaus, Vienna, Austria
Quotations Marks, Singapore Art Museum, Singapore
Dialogue with China, Charlottenburg Exhibition Hall, Copenhagen, Denmark

2000 *One Hundred Years of Chinese Oil Painting*, China Art Gallery, Beijing, China
Shanghai Spirit: The Third Shanghai Biennale, Shanghai Art Museum, Shanghai, China

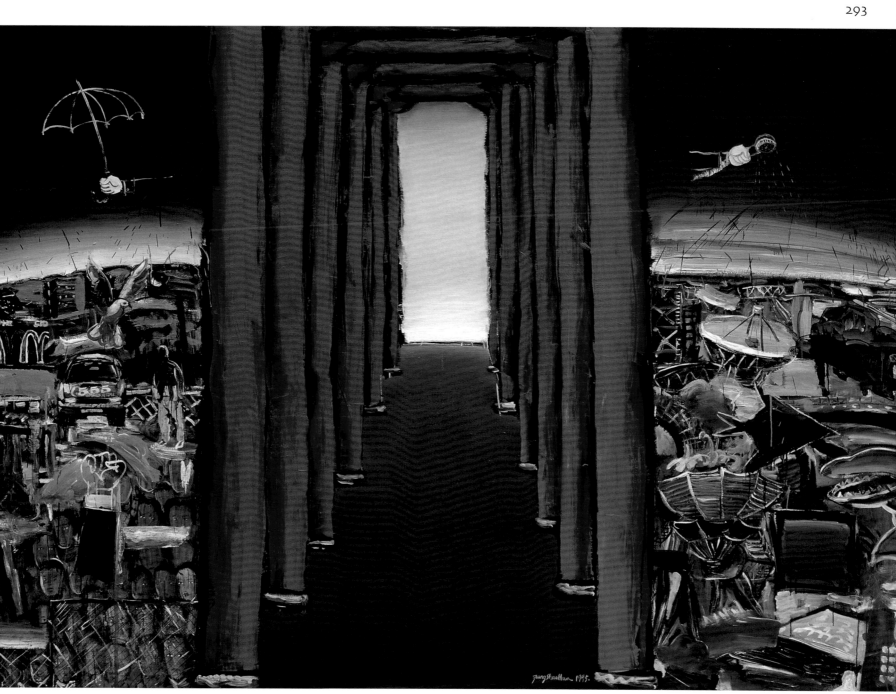

Mo Yi
Expressions of the Street
1988-1990
photographs
60 x 50 cm each

I remove the camera lens from the subjective choice of my own vision, equipping it with an automatic drive by which it is employed as a machine, a tool to record not to choose. Using a wide-angle lens with a long focus to achieve a long depth of field, I put the camera at the back of my neck, supported by one hand. The exposure is controlled by hand-operating the shutter by an attached line, making the act of taking a photograph reckless, random, like a game. In the busiest streets I take one frame every ten steps. In this ten-step, playful fashion, I aim to capture in a totally chance manner the mood of people and the city; how both appear when no choice has been made to compose "reality." (Mo Yi)

Mo Yi

1958 Born, Tibet, China
Current, lives and works in Tianjin, China

Solo Exhibitions
1988 *Expression of the Street*, performance, Binjiang Avenue, Tianjin, China
1995 *Pictures in Hutongs*, performance, Tianjin, China
1996 *City Space*, Zeit Foto Salon, Tokyo, Japan
1999 *Street of Dance*, Zeit Foto Salon, Tokyo, Japan

Group Exhibitions
1989 *Qu Ye Performance Exhibition*, Tianjin, China
1995 *New Image: Conceptual Photography Exhibition*, Beijing, China
1998 *Zeitgenössische Fotokunst aus der Volksrepublik China (Contemporary Photography from the People's Republic of China)*, Neuer Berliner Kunstverein, Berlin, Germany
1999 *Transience: Chinese Experimental Art at the End of the Twentieth Century*, Smart Museum of Art, University of Chicago, Chicago, USA
2001 *Traces*, Beijing, China
 Oneself, Shandong International Museum, Ji'nan, China
2002 *Fake: Chinese Photography Exhibition*, Beijing, China

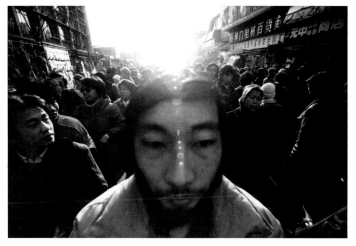
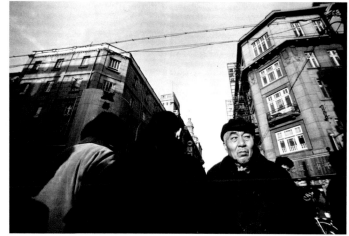
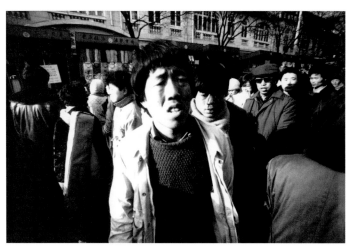
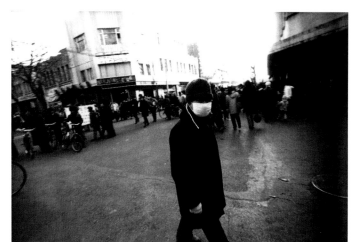

Zhu Fadong
This Person is for Sale

1994
performance, video
Collection of the Smart Museum of Art, University of Chicago, USA

When art became a way of life, as a reflection of the life around the artist and his / her expression of it, "art" as it had previously been understood lost its basic text (instruction guidelines). Art became foremost the artist's concept. From the outset, I sought an approach to art that reached out to the public, to the audience. The kind of relationship I intended to establish was not about pleasing people. It was about whether or not an individual artist could arrive at a suitable means of communication via an appropriate conduit for his/her ideas. Intermediaries primarily should evoke an artist's sustained, concerted creative endeavor. In 1993 I completed the work *Missing Person*, which employed a state of existence / reality as its subject, with myself as the object it focused upon. In 1994, in Beijing, I began work on an idea which lead to the performance piece *This Person is for Sale*. During the entire year it took to complete, I was able to gain a different understanding of the issue (of the relationship between artist and audience) from another perspective. (Zhu Fadong)

Zhu Fadong

1962 Born, Kunming, Yunnan province, China

1985 Graduated, department of fine arts, Yunnan Institute of Art, Kunming, China

Current, lives and works in Beijing, China

Solo Exhibitions

1990 *Zhu Fadong Art Exhibition*, Yunnan province, China
1997 *The Final Employment of Zhu Fadong*, Beijing Art Museum, Beijing, China

Group Exhibitions

1992 *The First Guangzhou Biennale: Oil Painting in the Nineties*, Guangdong Exhibition Center, Guangzhou, China
1993 *The Second Chinese Oil Painting Exhibition*, China Art Gallery, Beijing, China
2001 *Dream of China*, Yanhuang Art Museum, Beijing, China
1999 *Transience: Chinese Experimental Art at the End of the Twentieth Century*, Smart Museum of Art, University of Chicago, Chicago, USA
Revolutionary Capitals: Beijing - London, Institute of Contemporary Art, London, UK
2001 *Usual and Unusual*, Yuangong Art Museum, Shanghai, China
2002 *Hot Pot*, Kunsternes Haus, Oslo, Norway

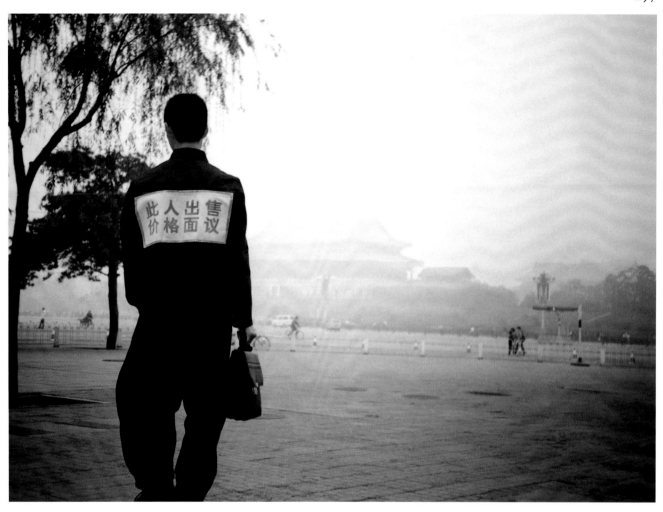

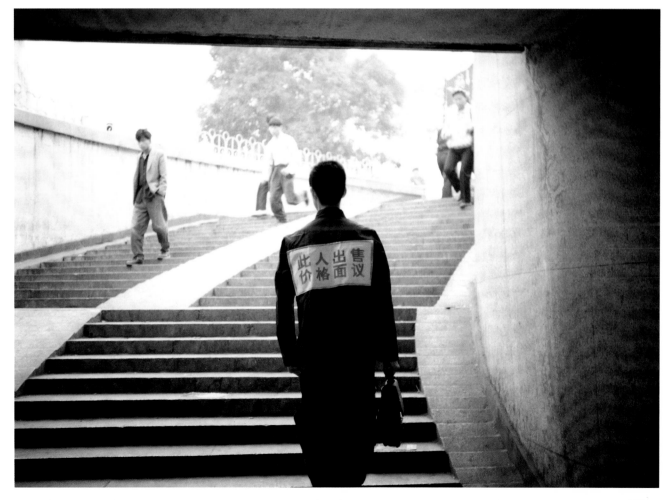

Zhao Bandi
Zhao Bandi and the Little Panda
1999
lightbox, printed poster

Zhao Bandi and the Little Panda is directly aligned with popular culture. The use of images that are humorous and comic disguises the deeper meaning closeted within the works. Here, Zhao Bandi succeeds in taking avant-garde art beyond the difficulties that many audiences have in reading it. The various visual elements provide for various readings and play of the imagination, generating a large space in which to interpret them. This effectively reduces the distance between the audience and the work. Further, it takes advantage of the audience's passivity, turning it into a proactive, or dynamic, understanding. (Huang Zhuan)

Zhao Bandi
1963 Born, Beijing, China
1988 Graduated, oil painting department, Central Academy of Fine Arts, Beijing, China
 Current, lives and works in Beijing, China

Solo Exhibitions
1999 Beijing Subway Station
2000 *Zhao Bandi and the Little Panda*, Pudong International Airport, Shanghai, China
2001 Fabricaeos Galerie, Milan, Italy

Group Exhibitions
1996/8 *Sydney Biennial*, Art Gallery of New South Wales, Sydney, Australia
1999 *The 48th Venice Biennale*, Venice, Italy
 Revolutionary Capitals: Beijing - London, Institute of Contemporary Art, London, UK
2000 *Shanghai Spirit: The Third Shanghai Biennale*, Shanghai Art Museum, Shanghai, China
2001 *Cross Pressures*, Oulu Art Museum, Oulu, Finland

Zhuang Hui
Group Portraits

1997
photographs

Zhuang Hui's approach to making art is to use a camera that can swivel through 180 degrees to photograph the workers or employees of a particular factory or company, village people, school or university students or army soldiers. The result is a wide panoramic photograph in the form of a hand scroll such as was frequently seen in China around the 1940s. The form of group portraits represents the image of both individuals and the group. At the same time, it also reveals the organizational work that goes into producing such an image. The artist repeatedly used this approach to explore the role of public relations in the past, its state, its public profile, and the validity of its existence. It also illustrates the artist's record of the changes taking place in the social structure and system. Here, Zhuang Hui's approach illuminates areas of contemporary life that might otherwise pass unnoticed. (Feng Boyi)

Zhuang Hui

1963 Born, Yumen, Gansu province, China
Current, lives and works in Beijing, China

Solo Exhibition

1992 *Zhuang Hui Installation Art*, Workers' Palace, Luoyang, China

Group Exhibitions

1997 *Zeitgenössische Fotokunst aus der Volksrepublik Cina* (Contemporary Photography from the People's Republic of China), Kunstverein, Berlin, Germany
1998 *The Fourth International Foto-Triennial Esslingen*, Galerie der Stadt, Esslingen, Germany
1999 *The First Fukuoka Triennial of Asian Art*, Fukuoka Museum of Asian Art, Fukuoka, Japan
Representing the People, Laing Art Gallery, Newcastle, UK
The 48th Venice Biennale, Venice, Italy
Partage d'Exotismes: The Fifth Lyon Biennial of Contemporary Art, Lyon, France
2001 *Cross Pressures*, Oulu Art Museum, Oulu, Finland
2002 *Run, Jump, Crawl, Walk*, East Art Center, Beijing, China

August 13, 1997, Hebei Province, Daming County, Jiuzhi Township, Gaozhuang Village — group photograph of village residents; photograph, 101 x 579 cm

July 23, 1997, Hebei Province, Handan City, PLA Regiment 5141, Fourth Artillery Squadron — group photograph of officers and soldiers; photograph 101 x 614 cm

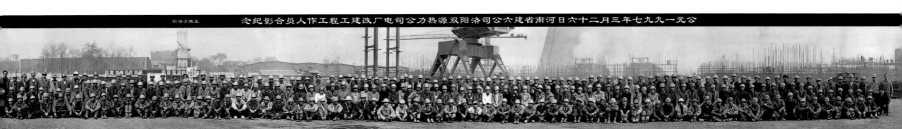

March 26, 1997, Henan Province No. 6 Construction Company/Luoyang City Shuangyuan Heating Plant, Power Plant Construction Project — group photograph of involved workers; photograph, 101 x 735 cm

Chen Shaofeng
Dialogue with the Peasants of Tiangongsi Village

1993
performance, installation
23 x 28 x 200 cm

Since 1993, my concept has been to break the elitism of art, bringing art and life together by inviting the villagers to participate in my performance. This investigation into the images of society and art employed the approach of sketching from life that did not rest on the simple meaning of gathering resource materials and first deciding a topic and form, then going out into life to find typical or representative images and then returning to the studio to combine these images to a composed theatrical scene. My approach allowed for a new type of relationship between the artist and the audience. For me, the villagers were not viewed as a conventional model upon which to extrapolate a theme, but were viewed as individual people, and equal participants in my work. In my art, they became an inseparable element. This non-art element conversely becomes a powerful aspect in my art. For most of the villagers, the experience of participating made them aware of talents they did not know they had, which was a pleasure in itself. (Chen Shaofeng)

Chen Shaofeng

1961 Born, Tongchuan, Shanxi province, China
1991 Graduated, Central Academy of Fine Arts,
 Beijing, China
 Current, lives and works in Beijing, China

Group Exhibitions

1992 *Transition 1*, Beijing Contemporary Art Gallery, Beijing, China
1993 *Transition 2*, China Art Gallery, Beijing, China
1995 *The Third Oil Painting Exhibition*, China Art Gallery, Beijing, China
1996 *Focus on China*, Munich, Germany
1997 *Art from Around the World*, Haus der Kulturen der Welt, Berlin, Germany
1998 *Traditional & Anti-traditional Art*, German embassy, Beijing, China
2000 *Gate of the New Century*, Chengdu Modern Art Museum, Chengdu, China
2002 *The Second Fukuoka Triennial of Asian Art*, Fukuoka Museum of Asian Art,
 Fukuoka, Japan

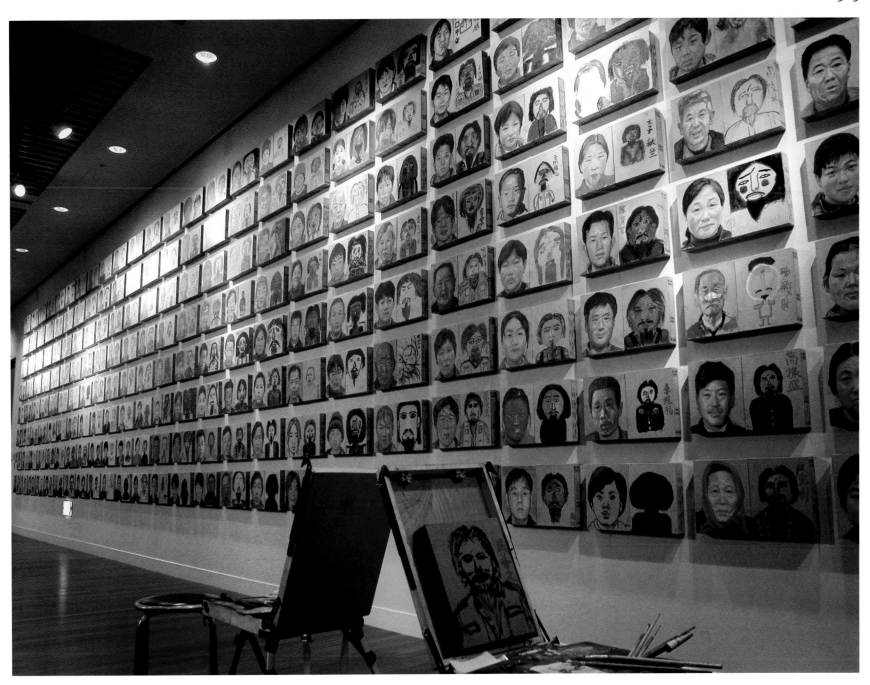

Zhan Wang
Temptation: Mao Suit Series No. 1
1994
Mao suits, mixed media
1000 x 1000 x 200 cm

Here, with the "body" removed, all that is left is the hollow form of the clothes. Yet by retaining movements, gestures and the folds of the clothing, the apparent emptiness is permitted to retain the actuality of a form poised on the brink of change. The physical motion of these forms indicates a spiritual motion too. The instant prior to a shift in position sets up a sense of extreme pain almost like a spasm that goes beyond any normal degree of paralysis or convulsion. Conversely, in material and form, the work is both empty and light. The Mao suit is not only a recognizable style of fashion, but is also the symbol of a particular era of Chinese history. These suspended suits, all different in form, of a wide variety of gestures and movements, hint at unlimited possibilities in the search for innate human potential. Empty and light, these Mao suits invoke the human thirst for freedom. (Zhan Wang)

Zhan Wang

1962 Born, Beijing, China

1988 Graduated, sculpture department, Central Academy of Fine Arts, Beijing, China
Current, affiliated with the creative research department for sculpture, Central Academy of Fine Arts, Beijing, China

Solo Exhibitions

1994 *Kong-Ling-Kong Seduction Series*, Gallery of the Central Academy of Fine Arts, Beijing, China
Cleaning the Ruins, redevelopment area of Wangfujing, Beijing, China

2001 *Capping the Great Wall*, Badaling Great Wall, Beijing, China
Artificial Nature: Zhan Wang's Stainless Steel Ornamental Stones, Hanart TZ Gallery, Hong Kong
In and Out, Reproduction Plan, Goteburg, Sweden

Group Exhibitions

1991 *New Generation*, China History Museum, Beijing, China

1995 *Development Plan*, the ruins of the sculpture department, Central Academy of Fine Arts, Beijing, China
Women/Here, Contemporary Art Gallery, Beijing, China

1997 *Cities on the Move*, The Secession, Vienna, Austria

1998 *Trace of Existence*, Beijing, China

1999 *Transience: Chinese Experimental Art at the End of the Twentieth Century*, Smart Museum of Art, University of Chicago, Chicago, USA
The Second Contemporary Sculpture Art Annual Exhibition, He Xiangning Art Museum, Shenzhen, China

2000 *Shanghai Spirit: The Third Shanghai Biennale*, Shanghai Art Museum, Shanghai, China

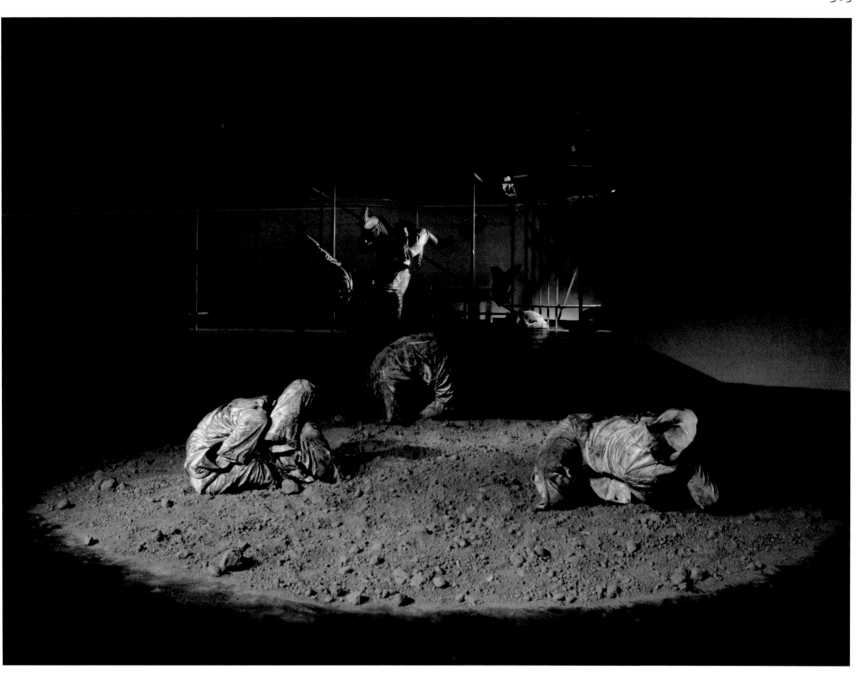

Gu Dexin
1990.9.16
1990
clear plastic
20 x 15 x 9 meters

Plastic goods suddenly flooded daily life in Gu Dexin's childhood. The inherent properties of plastic, its instability, and "vulnerability" left a profound impression upon him. From 1984, he began to create artworks by means of burning plastic. In an intuitive way, Gu's work seeks to remind people of the vulgarity behind lofty, glorious and pretentious ideas. It combines the beautiful with the obscene, the grand with the capricious. These transitory works mock eternity, the act of collecting and the commercial value of artworks. Gu usually titles works with the exhibition date. He believes that it is a privilege for artists to explain their works: one that he has deliberately given up so that the audience has more space to contemplate his work freely. (Li Xianting)

Gu Dexin
1962 Born, Beijing, China
 Current, lives and works in
 Beijing, China

Solo Exhibitions
1986 International Art Palace, Holiday Inn Crowne Plaza, Beijing, China
1993 *1993.10.6*, Galerie Arnaud Lefebvre, Paris, France
2000 *2000.8.1*, Loft New Media Art Space, Beijing, China

Group Exhibitions
1989 *China /Avant-garde*, China Art Gallery, Beijing, China
 Les Magiciens de la Terre, Centre Georges Pompidou, Paris, France
1993 *China's New Art, Post-1989*, Hong Kong Arts Centre, Hong Kong
1995 *Out of the Middle Kingdom: Chinese Avant-garde Art*, Santa Monica Arts
 Center, Barcelona, Spain
 The 46th Venice Biennale, Venice, Italy
1997 *Another Long March: Chinese Conceptual and Installation Art in the Nineties*,
 Fundament Foundation, Breda, the Netherlands
1998 *Site of Desire, 1998 Taipei Biennial*, Taipei Fine Arts Museum, Taipei, Taiwan
 Inside Out: New Chinese Art, Asia Society Galleries, PS 1 ContemporaryArt
 Center, New York, USA
2000 *Fuck Off*, Eastlink Gallery, Shanghai, China
2001 *Living in Time*, Hamburg Bahnhof Museum of Contemporary Art, Berlin,
 Germany
 *Transplantation In Situ: The Fourth Contemporary Sculpture Art Annual
 Exhibition*, He Xiangning Art Museum, Shenzhen, China
2002 *Pause: The Fourth Kwangju Biennial*, Kwangju, Korea Republic

Xing Danwen
Sleepwalking
2000
video installation; DVD player in perspex case
533 x 400 x 1000 cm

Memories belong to the past. Every instant becomes a memory of the past. My work relates to a dislocation between memory and space-time, between reality and invention. The work expresses the contemporary urge towards similarity and assimilation in cities and images, and the similarities and differences between East and West. The cultural differences and similarities between East and West are found in sounds and images. At the same time, I seek to explore the human brain both biologically and psychologically, to see if time and space can become another kind of world of memory. (Xing Danwen)

Xing Danwen

1967	Born, Xi'an, Shaanxi province, China
1992	Graduated, Central Academy of Fine Arts, Beijing, China
2001	Graduated, department of photography and new media, School of Visual Arts, New York, USA
	Current, lives and works between New York, USA, and Beijing, China

Solo Exhibitions

1994	*With Chinese Eyes*, Galerie Grauwert, Hamburg, Germany
1996	*Xing Danwen Photography*, German embassy, Beijing, China
1997	*Xing Danwen Photography*, Photo Gallery, New York, USA
2001	*Nice Photography Festival*, Galerie du Chateau, Nice, France
2002	*Xing Danwen Photography*, Lee-Kasing Photo Gallery, Toronto, Canada

Group Exhibitions

1995	*China's New Photography*, Tokyo Gallery, Tokyo, Japan
1996	*China — Aktuelles aus 15 Ateliers*, Munich, Germany
1998	*Century Women*, China Art Gallery, Beijing, China
1999	*Transience: Chinese Experimental Art at the End of the Twentieth Century*, The Smart Museum of Art, University of Chicago, Chicago, USA
	Revolutionary Capitals: Beijing - London, Institute of Contemporary Art, London, UK
2001	*Living in Time*, Hamburg Bahnhof Museum of Contemporary Art, Berlin, Germany
	The First Tirana Biennial, Tirana, Albania
	Yokohama 2001: International Triennial of Contemporary Art, Yokohama, Japan

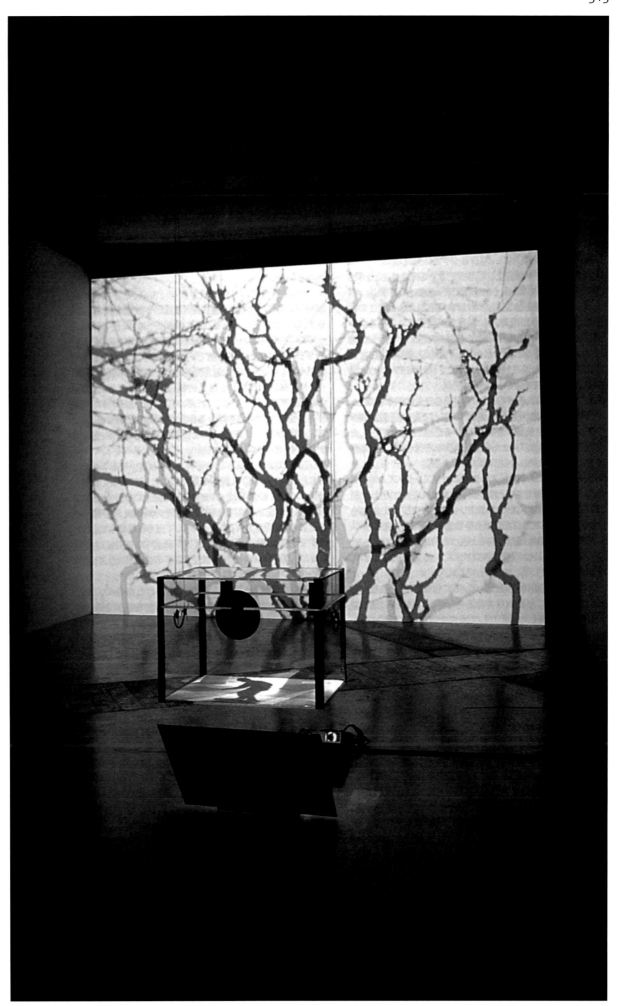

Lin Tianmiao
Plait / Braid
1999
video installation; white cotton thread, digital photographs, video
300-400 square meters

The digital photograph, 4 meters high and 2.5 meters wide, is that of a head portrait of a figure, which is out of focus. On the face, there are thousands of ends of threads which run across through the photograph and are plaited into a large thick braid at the back. The braid becomes thinner as it gets longer until there are only three threads left at the end, which are drawn to the screen of a small TV on the floor. The image on the screen is a pair of hands braiding the three threads. (Feng Boyi)

Lin Tianmiao

1961 Born, Taiyuan, Shanxi province, China
1984 Graduated, fine arts department, Capital Normal University, Beijing, China
1989 Art Student League, New York, USA
Current, lives and works in Beijing, China

Solo Exhibitions

1995 *Open Studio*, Baofang Hutong, Beijing, China
1997 *Bound: Unbound 1995-97*, Gallery of the Central Academy of Fine Arts, Beijing, China

Group Exhibitions

1995 *Women's Approach to Contemporary Art*, Beijing Art Museum, Beijing, China
1997 *Crack in the Continent*, The Watari Museum of Contemporary Art, Tokyo, Japan
1998 *Inside Out: New Chinese Art*, Asia Society Galleries, PS 1 Contemporary Art Center, New York, USA
 Century Women, China Art Gallery, Beijing, China
1999 *Revolutionary Capitals: Beijing-London*, Institute of Contemporary Art, London, UK
 Gate of the New Century, Chengdu Modern Art Museum, Chengdu, China
2000 *House, Home, Family*, 4/F Yuexing Furniture Corporation, Shanghai, China
2001 *Broken Image*, Cleveland Art Center, Ohio, USA
 Floating Delusion, Aida Ecke Culture Centre, Stockholm, Sweden
 Translated Acts, Haus der Kulturen der Welt, Berlin, Germany

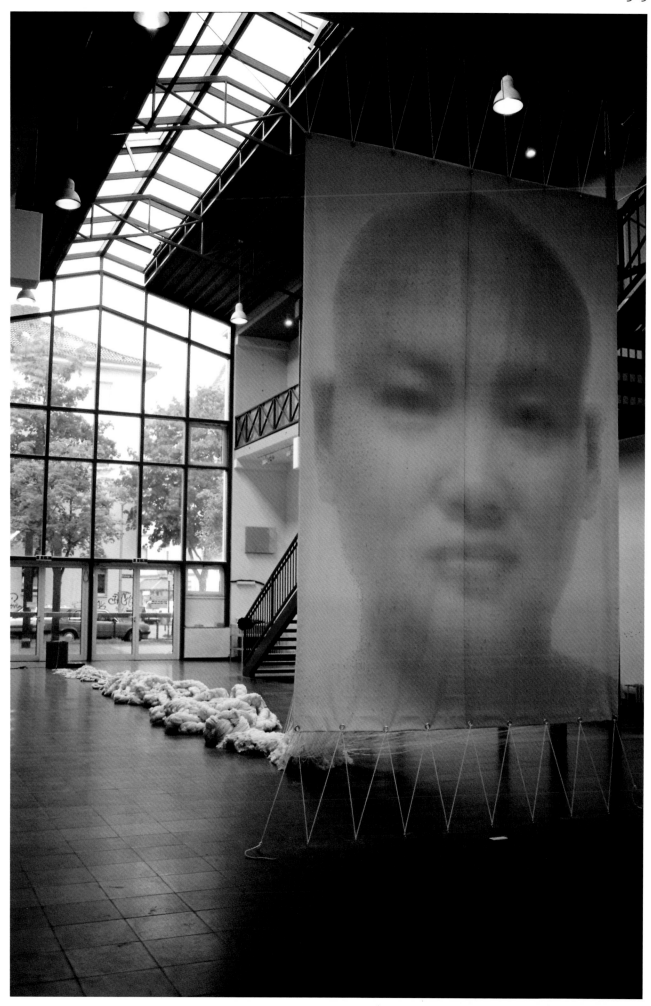

Cai Jin
Canna Plant No. 106

1997
installation; bicycle seats, oil paint
actual size
Collection of Hanart TZ Gallery, Hong Kong

From the beginning of the 1990s, Cai Jin conscientiously absorbed herself in producing the *Canna Plant* series. Employing the theme of flora in a totally unique way, her painting negates the traditional meaning of the beauty of flowers within classical Chinese painting. Between pleasure and pain, neither rational nor beautiful yet simultaneously both, like a beautiful woman that has been hurt, Cai Jin evidences a bitter outlook on life. To further emphasize the visual power of her approach, she transposed her paintings of plant life as a new skin on familiar objects from daily life, such as old cushions, bicycles seats, mattresses, high-heeled shoes, lengths of silk and brocade. The forms she creates give rise to an uncontainable sense of perplexity. This kind of feeling flows out from the heart and over the canvas as if seeking to connect with the world. Yet, it effectively destroys the protective membrane between the emotion and the intellect that people entrust to it. (Francesca dal Lago)

Cai Jin

1965 Born, Tunxi, Anhui province, China
1986 Graduated, art department, Anhui Teaching University, Wuhu, Anhui province, China
1991 Further studies, oil painting department, Central Academy of Fine Arts, Beijing, China
 Current, teaches at Tianjin Art Academy, lives between Beijing, China and New York, USA

Solo Exhibitions

1991 Gallery of the Central Academy of Fine Arts, Beijing, China
1995 *Cai Jin Recent Works*, Kiang Gallery, Atlanta, USA
1997 *Cai Jin: Chinese Hand Studies from Life*, Ethan Cohen Fine Arts, New York, USA
1999 *Cai Jin Banana Plants*, Asian Art Factory, Berlin, Germany
 CourtYard Gallery, Beijing, China
2000 Tiaden Gallery, Cornell University, New York, USA

Group Exhibitions

1985 *Moving Forward: Chinese Youth Art Exhibition*, China Art Gallery, Beijing, China
1987 *Chinese Oil Painting Exhibition*, Shanghai Exhibition Hall, Shanghai, China
1993 *China's New Art, Post-1989*, Hong Kong Arts Centre, Hong Kong
1995 *Change — Modern Art from China*, Goteburg Art Museum, Goteburg, Sweden
 Women's Approach to Contemporary Art, Beijing Art Museum, Beijing, China
1998 *Half of the Sky*, Women's Museum, Bonn, Germany
1999 *Transience: Chinese Experimental Art at the End of the Twentieth Century*, Smart Museum of Art, University of Chicago, Chicago, USA
2000 *One Hundred Years of Chinese Oil Painting*, China Art Gallery, Beijing, China
2001 *Confessions: Contemporary Art by Asian Women*, Hammond Museum, New York, USA

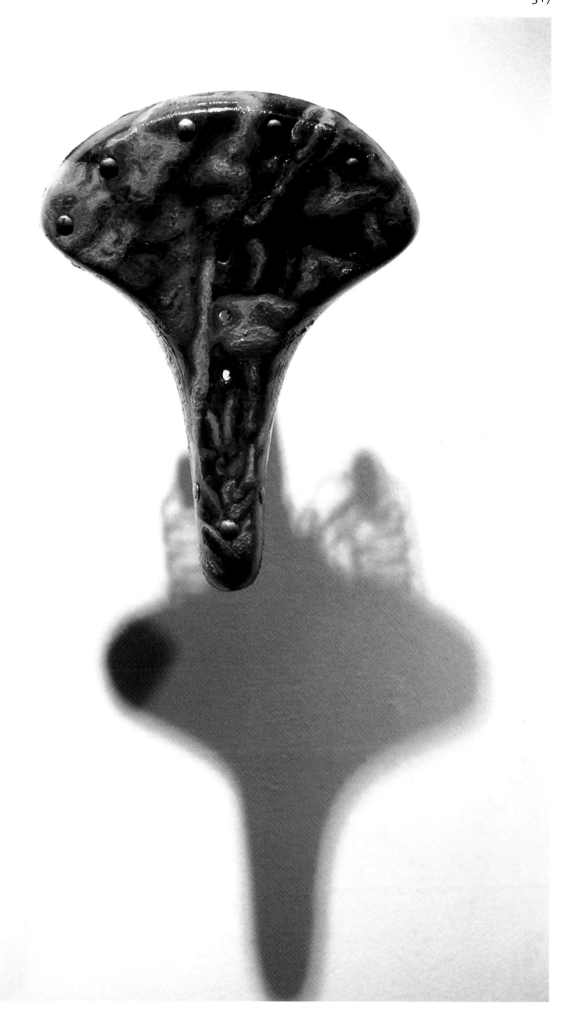

Zhang Huan
12 Square Meters
1994
performance

The inspiration for my creativity is found in the most mundane aspects of daily life which usually go unobserved. Everyday we eat, work, rest, shit. Within these mundane spheres of daily life lie the fundamental essence of mankind through which we can also experience the contradictory aspects of the contemporary living environment. That was how *Twelve Square Meters* evolved. One lunchtime, I went to a local public toilet and discovered that you could barely put a foot inside the door, because of the filth. Luckily I had my bicycle and was able to ride to another. Here, as I entered the door, clouds of flies swarmed up into the air. These experiences provided the inspiration for the artwork. In the process of making art, I try hard to bring forth actual experiences of reality. Only when the works are complete am I able to gauge what it is that I have expressed. (Zhang Huan)

Zhang Huan

1965 Born, Anyang, Henan province, China
1988 Graduated, art department, Henan University, Kaifeng, Henan province, China
1994 Further studies in the oil painting department, Central Academy of Fine Arts, Beijing, China
Current, lives and works in New York, USA

Solo Exhibitions

2000 *My America*, Deitch Projects, New York, USA
Cotthem Gallery, Belgium
Cotthem Gallery, Barcelona, Spain
2001 Luhring Augustine, New York, USA
Power Plant Museum of Modern Art, Toronto, Canada
Museo das Peregrinacions, Santiago de Compostela, Spain
Family Tree, Galerie Albert Benamou, Paris, France

Group Shows

1998 *Inside Out: New Chinese Art*, Asia Society Galleries, PS 1 Contemporary Art Center, New York, USA
1998 *The 48th Venice Biennale*, Venice, Italy
1999 *Art and Religion*, Parkabdij Heverlee, Belgium
Partage d ' Exotismes: The Fifth Lyon Biennale of Contemporary Art, Lyon, France
2001 *Yokohama 2001: International Triennial of Contemporary Art*, Yokohama, Japan
The Gift, Palazzo Papesse, Siena, Italy
Metamorphosis and Cloning, Museum of Contemporary Art, Montreal, Canada
2002 *Whitney Biennial*, Whitney Museum of Art, New York, USA

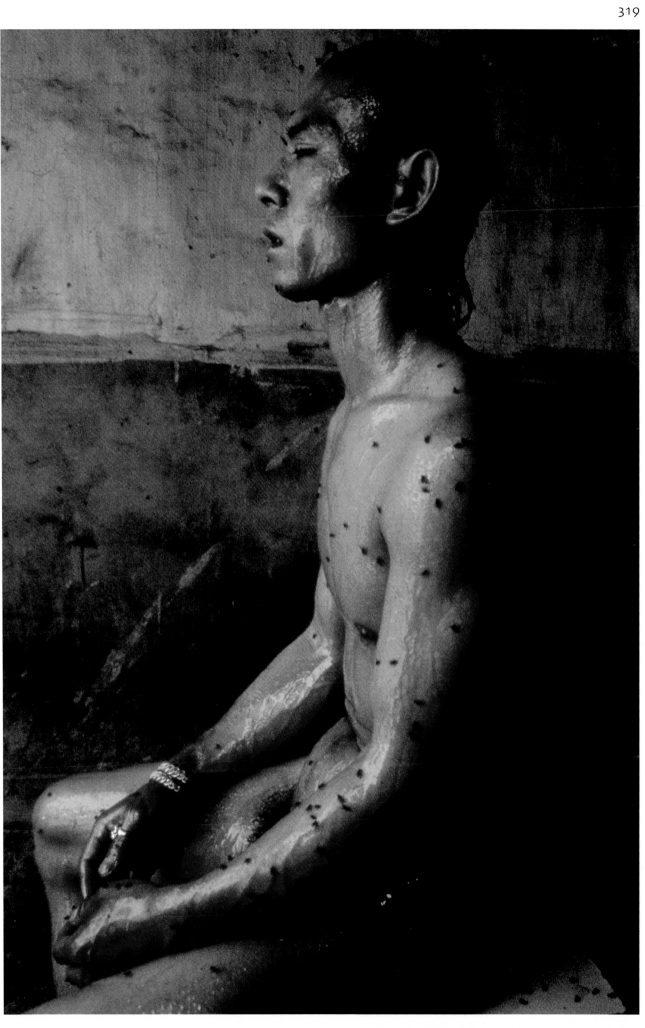

Ma Liuming
Fen-Maliuming Series No. 1

1993
performance, photographs
51 x 61 cm each
Photographed by Xu Zhiwei

Fen-Maliuming is a character I created for use in my performance work over the last few years. The trait that marks out this character is the face made up like a woman's. In China, Fen is a feminine name. It also has the same pronunciation and sound as the word to separate/distinguish between in Chinese. I combine Fen and Maliuming to create a new name, and a fabricated existence. The titles of nearly all of my works revolve around Fen-Maliuming in such and such a place. This is to emphasize the character itself and to introduce the "person" in multiple situations, interiors, exteriors, museums, classical monuments, all recorded via photography, either by collaborating with a photographer or taking the images myself and inviting the audience to be photographed with Fen-Maliuming. (Ma Liuming)

Ma Liuming

1969 Born, Huangshi, Hubei province, China
1991 Graduated, oil painting department, Hubei Academy of Fine Arts, Wuhan, Hubei province, China
Current, lives and works in Beijing, China

Solo Exhibitions

1993 *Dialogue with Gilbert and George*, performance in the East Village, Beijing, China
Fen-Maliuming I, Woman's Face and Man's Body, performance in the East Village, Beijing, China
Fen-Maliuming Says, performance in the East Village, Beijing, China
1994 *Fen-Maliuming Cooks Lunch I*, performance in the East Village, Beijing, China
Fen-Maliuming Cooks Lunch II, performance in the East Village, Beijing, China
1996 *Ma Liuming*, Chinese Contemporary Gallery, London, UK
1999 *Ma Liuming*, Jack Tilton Gallery, New York, USA
2001 *Ma Liuming*, Tensta Konsthall, Sweden

Group Exhibitions

1992 *The First Guangzhou Biennale: Oil Painting in the Nineties*, Guangdong Exhibition Center, Guangzhou, China
1995 *Anonymous Mountain Raised by One Meter*, performance in suburb of Beijing, China
1997 *De-Genderism, Detruire Dit-Elle/II*, Setagaya Art Museum, Tokyo, Japan
Another Long March: Chinese Conceptual and Installation Art in the Nineties, Fundament Foundation, Breda, the Netherlands
1998 *Fen-Maliuming at PS 1*, performance in PS 1 Contemporary Art Center, New York, USA as part of the exhibition *Inside Out: New Chinese Art*
1999 *Aperto Over All: The 48th Venice Biennale*, Venice, Italy
2000 *The Third Kwangju Biennial*, Kwangju, Korea Republic
Utopia, Rogaland Art Museum, Norway
2001 *Translated Acts*, Haus der Kulturen der Welt, Berlin, Germany
The Seventh Istanbul International Art Biennial, Istanbul, Turkey

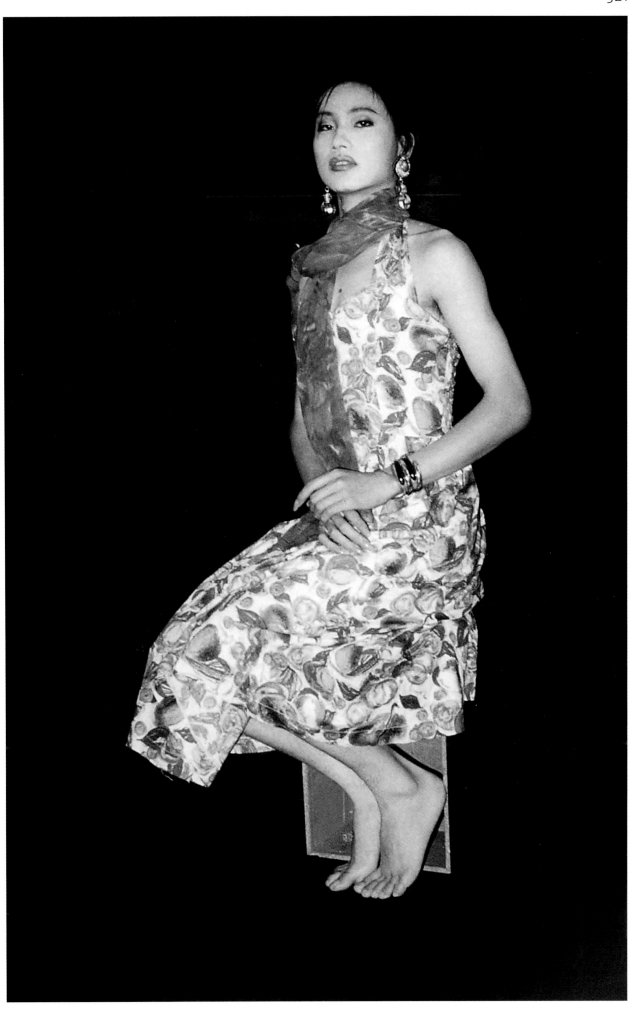

Cang Xin
Trampling on the Face
1994
performance

In the *Trampling on the Face* series, the artist created more than 1,500 plaster masks of his own face. These were laid out on the ground surrounding of his residence in Beijing. The audience was invited to walk onto the ground where the masks were laid, to walk at leisure and not side-step the masks, thus crushing them in the process. The mask is his explanation of our lost fantasy and broken reality. In this sense, after transcending the inevitable sense of helplessness, his exploration of the modern theme, existence and ruin, has reached an ideological depth and he has approached the ultimate aim of humanistic solicitude—caring for, closely questioning and rescuing life. (Feng Boyi)

Cang Xin

1967 Born, Suihua, Heilongjiang province, China

1988-99 Special studies at Tianjin Music Academy, Tianjin, China

Current, lives and works in Beijing, China

Solo Exhibitions

1993 *Disease Series No. 1*, Beijing, China
1994 *Breaking Masks No. 2*, Beijing, China
1996 *Dialogue*, Beijing, China
1997 *Patient Program*, Beijing, China

Group Exhibitions

1995 *Anonymous Mountain Raised by One Meter*, performance in suburb of Beijing, China
1999 *Pirate Books and Approach: Contemporary Artists' Photography Exhibition*, Beijing, China
2000 *House, Home, Family*, 4/F Yuexing Furniture Corporation, Shanghai, China
 Human and Animal, Beijing, China
 Usual and Unusual, Yuangong Art Museum, Shanghai, China
2001 *Hot Pot*, Kunsternes Haus, Oslo, Norway
 The Eight NIPAF, Tokyo, Nagoya, Japan
 Dialogue, Chiesa Santa Teresa dei Maschi, Bari, Italy
2002 *Sydney Biennial*, Art Gallery of New South Wales, Sydney, Australia

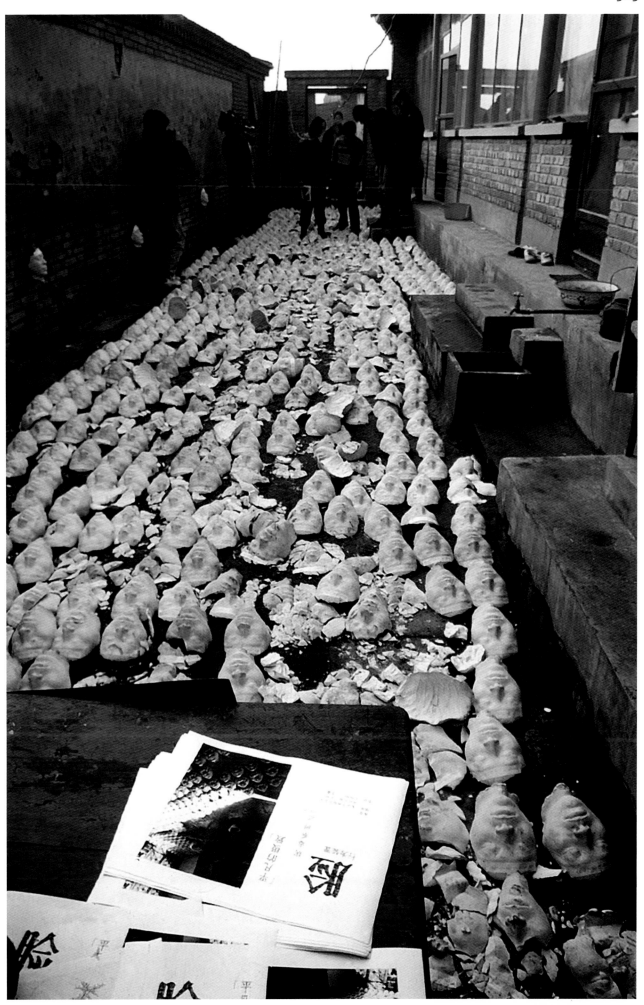

Yan Lei
No. 0310007/No. 0023283
1995
performance, photographs
Collection of China Art Archives and Warehouse, Beijing

Invasion represents the subject of physical violence in daily life. It speaks of the common occurrence of violence in modern cities as a landscape of life; surprise attacks, beatings that make for specific incidents of shock in big cities. This engenders the processes of injury, check-up and treatment. Showing the body via violence/daily life perhaps brings us to a meaningful point of departure, and yet simultaneously is a negation of meaning. Yan Lei uses his own approach to highlight the physical body, a reality that can be sensed in the presence of danger, a threat or trauma. No matter whether Yan Lei's bodies reveal an actual reality, the language of opposition appears to imply meaning and fabrication. But in truth, the work is the result of its materials and the reality revealed actually invokes a sense of missing presence, of not being immediately party to the action. (Dai Jinhua)

Yan Lei

1965 Born, Hebei province, China
1991 Graduated, Zhejiang Academy of Fine Arts, Hangzhou, Zhejiang province, China
Current, lives and works between Beijing and Hong Kong, China

Solo Exhibitions

1995 *Invasion*, Children's Art Theatre, Beijing, China
2001 *International Ink Beijing CAAW*, Artists' Commune, Hong Kong

Group Exhibitions

1989 *China/Avant-garde*, China Art Gallery, Beijing, China
1993 *China's New Art, Post-1989*, Hong Kong Arts Centre, Hong Kong
1999 *China-Korea-Japan Contemporary Art Exhibition*, Fushan University Art Museum, Korea Republic
China Maze, Otso Gallery, Otso, Finland
2000 *Usual and Unusual*, Yuangong Art Museum, Shanghai, China
2001 *Polypolis: Contemporary Art from Southeast Asia*, Kunsthaus, Hamburg, Germany
Chengdu Biennale, Chengdu Modern Art Museum, Chengdu, China
2002 *Pause: The Fourth Kwangju Biennial*, Kwangju, Korea
The 25th International Sao Paulo Biennial, Sao Paulo, Brazil

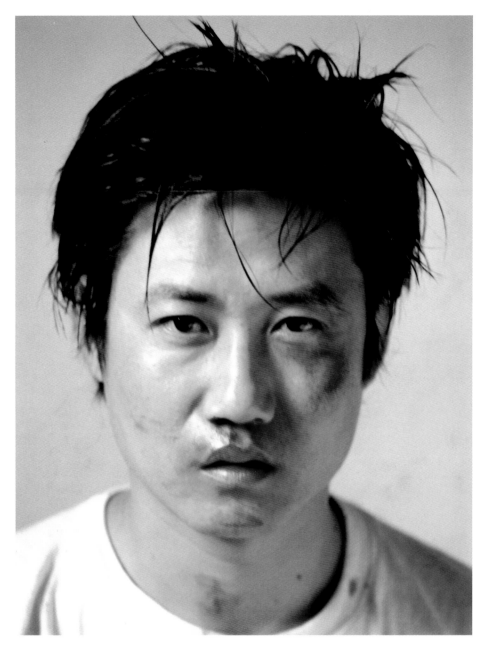

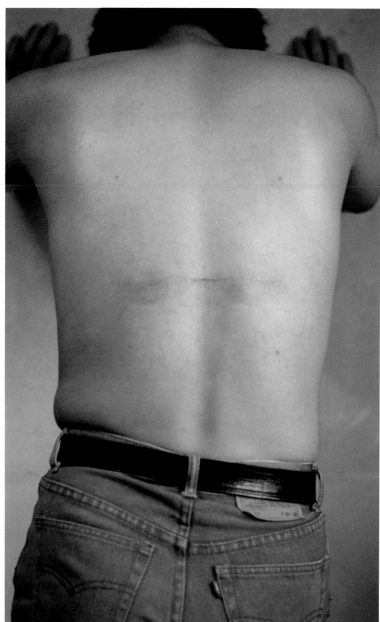

Sun Yuan (with Xiao Yu)
Shepherd
1998
performance, installation; 200 sheep bones
50 x 60 meters

This work was inspired by the words of Matthew 24: 26, which says: "So, if they say to you, 'Lo, he is in the wilderness,' do not go out; if they say, 'Lo, he is in the inner rooms,' do not believe it." Another passage of Matthew relates Jesus' description of the Apocalypse, outlining the signs that would appear and indicate its approach; Matthew 24: 24: " For false Christs and false prophets will arise and show great signs and wonders, so as to lead astray, if possible, even the elect." The people would lack the ability to judge truth from falsity and so Jesus asks the people to believe nothing they hear. (Sun Yuan)

Sun Yuan

1972 Born, Beijing, China
1995 Graduated, oil painting
 department, Central Academy of
 Fine Arts, Beijing, China
 Current lives and works in
 Beijing, China

Group Exhibitions
1998 *Inside*, Beijing, China
 Counter Perspectives: Self and Environment, Beijing, China
1999 *Post-sense Sensibility: Alien Bodies and Delusion*, Beijing, China
2000 *Art Banquet*, Beijing, China
 Infatuated with Injury, Beijing, China
 Partage d 'Exotismes: The Fifth Lyon Biennial of Contemporary Art, Lyon, France
 Fuck Off, Eastlink Gallery, Shanghai, China
2001 *Yokohama 2001: International Triennial of Contemporary Art*, Yokohama, Japan
 Out of Control, Berlin, Germany

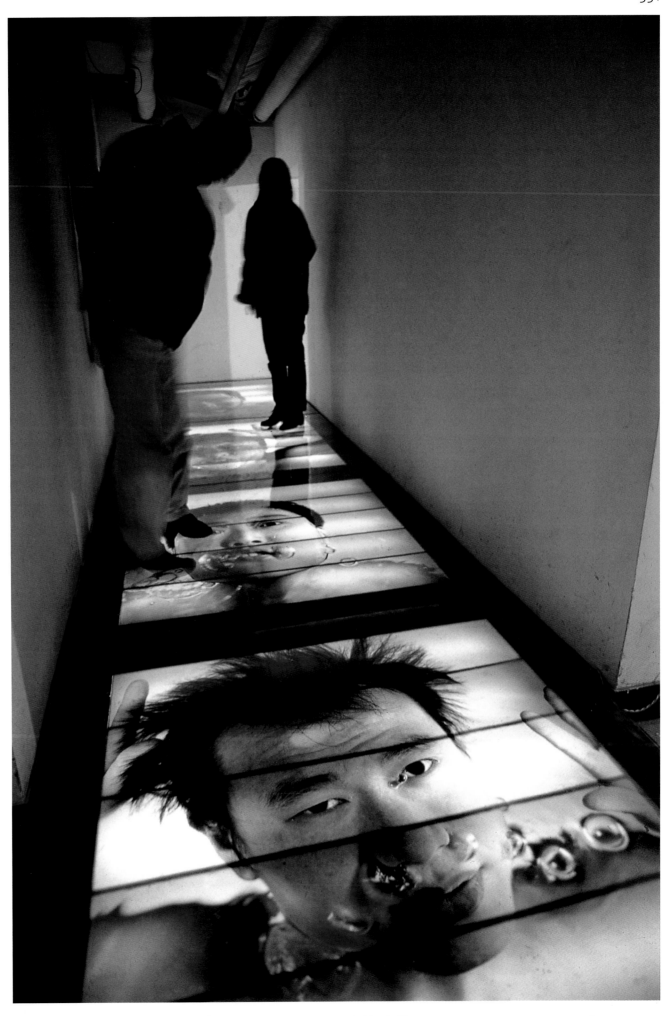

Yang Zhenzhong
I Will Die
2000
video; 11 min.

This video work arose from a single idea. It is an awkward thing to ask people to say "I will die" *(wo hui si de)*. Different people have different ways of expressing it. When they say "I will die" to camera, they are performing without thinking about it. Viewers will find this heavy as well as amusing. This might be the power of video camera! The sentence "I will die" serves as a starting point. I will continue the experiment in other countries and cultures worldwide. (Yang Zhenzhong)

Yang Zhenzhong

1968	Born, Hangzhou, Zhejiang province, China
1990	Graduated, department of fashion design, Zhejiang Institute of Silk Technology, Hangzhou, China
1993	Studied in the oil painting department, Zhejiang Academy of Fine Arts, Hangzhou, China Current, lives and works in Shanghai, China

Solo Exhibitions

1998	*Jiangnan Arts Festival*, Access Gallery, Vancouver, Canada
2001	*I Will Die*, Brussels, Belgium
2002	*As Easy as A,B,C*, Shanghai

Group Exhibitions

1994	*The Date 26 Nov. 1994 as a Reason*, Artists from Hangzhou-Shanghai-Beijing, China
1996	*Image and Phenomena*, Art Gallery of the China National Academy of Fine Arts, Hangzhou, China
1998	*310 Jinyuan Road*, Jinyuan Road, Shanghai, China
1999	*Supermarket*, non-art space, Shanghai, China
	Maya Biennial, Maya, Portugal
2000	*House, Home, Family*, 4/F Yuexing Furniture Corporation, Shanghai, China
	Fuck Off, Eastlink Gallery, Shanghai, China
2001	*Living in Time*, Hamburg Bahnhof Museum of Contemporary Art, Berlin, Germany
	Valencia Biennial, Valencia, Spain
2002	*Fantasia*, East Art Center, Beijing, China

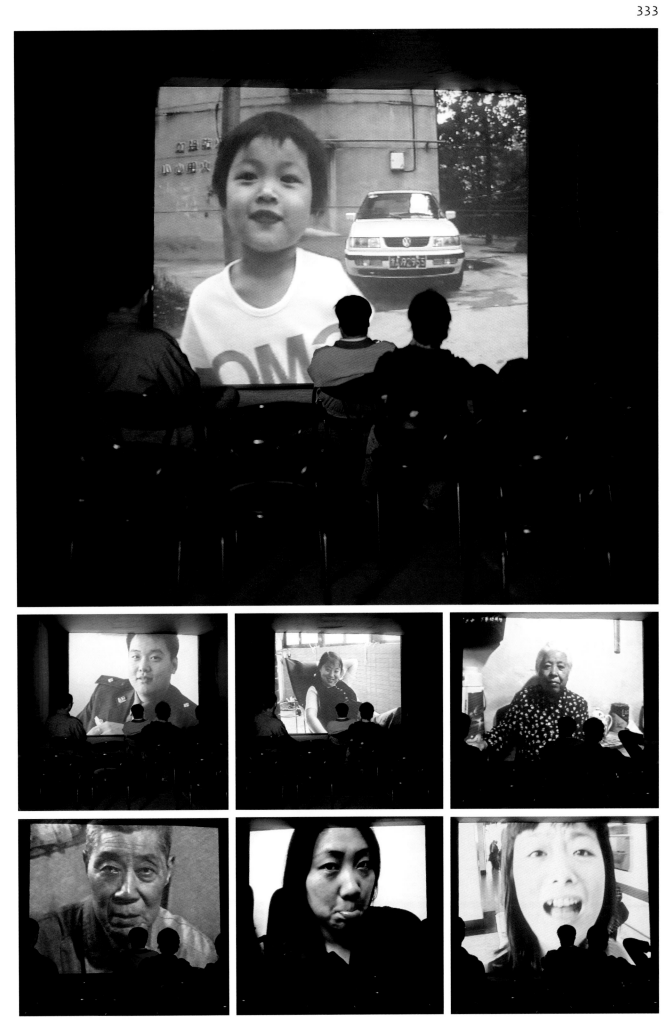

Jin Feng
The Process in Which My Image Disappears
1998
performance, color photographs
120 x 90 cm each
Collection of the Guangdong Museum of Art, Guangzhou

Jin Feng writes his own identity card number repeatedly on one side of a sheet of glass. From the other side of this glass, the audience discovers that the more he writes the number the denser it becomes, gradually obscuring his face, until at the end it is completely obliterated. Via this contrary activity, Jin Feng seeks to reveal to people that no identity is absolute. Only under certain regulated circumstances do symbols become proof of identity. Out of context, they do not represent anything. The problem does not lie in the fact that the more we assert identity the more we loose our "self," but that identity *per se* is a construct of society. The more regulations to which it is subject, the less meaning it has. (Lü Peng)

Jin Feng

1962 Born, Shanghai, China
1990 Graduated, fine arts department, Nanjing Teaching University, Nanjing, China
 Current, lives and works in Changzhou, China

Solo Exhibition

2000 *Jin Feng Solo Exhibition*, Moscow Artists' Center, Moscow, Russia

Group Exhibitions

1992 *The First Guangzhou Biennale: Oil Painting in the Nineties*, Guangdong Exhibition Center, Guangzhou, China
1996 *In the Name of Art*, Liu Haisu Museum of Art, Shanghai, China
1999 *The 14th International Asian Art Exhibition*, Modern Art Museum, Fukuoka, Japan
2000 *House, Home, Family*, 4/F Yuexing Furniture Corporation, Shanghai, China
 Usual and Unusual, Yuangong Art Museum, Shanghai, China
2001 *Nice International Photography Festival*, Nice, France
 Chengdu Biennale, Chengdu Modern Art Museum, Chengdu, China

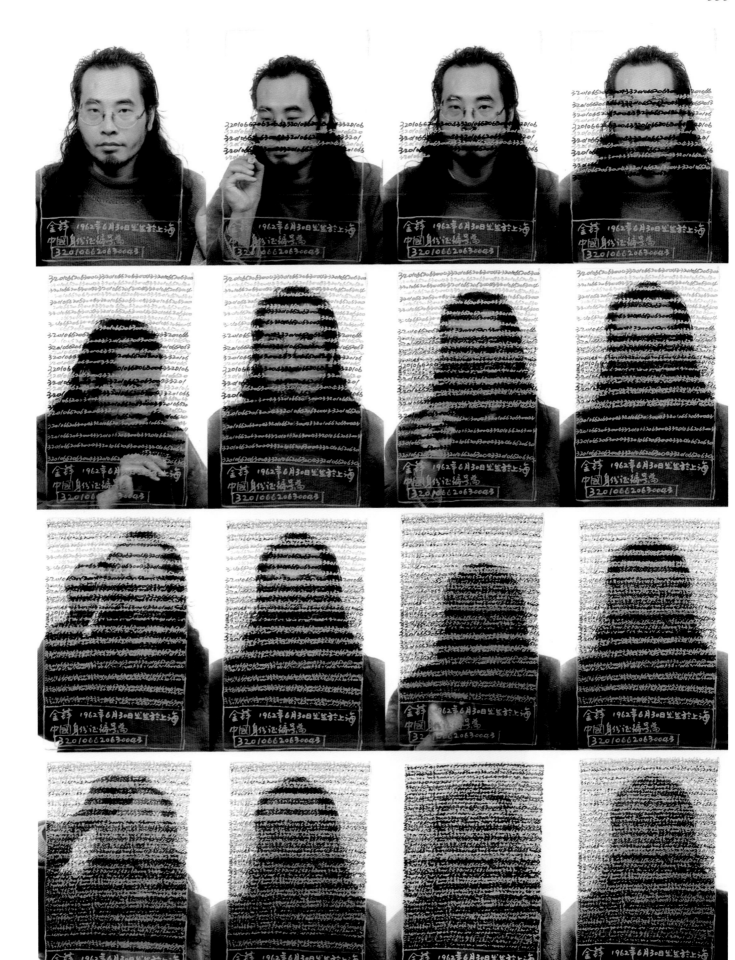

Feng Feng
Shin Brace
1999-2000
photographic installation
300 x 1542 cm
Collection of the Upriver Gallery, Chengdu

The relationship between steel and flesh is very direct. There is nothing ambiguous about it. It is like the relationship between medicine and biology, science and humanity, the culture of the West and of the East, the male and female sex. These kinds of relationships are equally absolute. But behind them lies one constant rational reason: "it is for your own good." That reason is power. That which can really shock us is always this kind of power. The power we sense here imposes a shock on our senses but equally the same kind of shock can be comforted by power. It makes us exist safely, joyfully even, within a soul-stirring state. We trust in, take perverse pleasure in, admire even this kind of injury, almost as a cure or salvation. This is what really shocks us. It is like that long piece of hard steel piercing the flesh. We see the reaction of the flesh, how swiftly it closes around the steel pin, producing a thick scab, how it is raised from the skin as if poised on the brink of an anticipated climax. (Feng Feng)

Feng Feng

1966 Born, Harbin, Heilongjiang province, China
1991 Graduated, Chinese painting department, Guangzhou Academy of Fine Arts, Guangzhou, China
 Current, assistant professor at Guangzhou Academy of Fine Arts, Guangzhou, China

Group Exhibitions

1996 *Cartoon Generation*, China Southern Teaching University, Guangzhou, China
2000 *Society: The Second Academic Invitational Exhibition*, Upriver Gallery, Chengdu, China
2001 *Virtual Future*, Guangdong Museum of Art, Guangzhou, China
 Urban Slang: Contemporary Art from the Pearl River Delta, He Xiangning Art Museum, Shenzhen, China
 Human Landscapes, Artists' Storehouse, Beijing, China
 Asia New Media Art International Exchange, National People's University, Seoul, Korea Republic
 In Transition: China, Germany, Britain Contemporary Art Exhibition, He Xiangning Art Museum, Shenzhen, China
2002 *Pause: The Fourth Kwangju Biennial*, Kwangju, Korea Republic

Chen Zhen
Internal Landscape
2000
installation
Collection of Continua Gallery, Italy

Chen Zhen draws on a traditional Chinese belief that one must treat the entire body rather than just the disease. He uses this to emphasize communication between people and nature, between people and the outside world, such ultimately representing the essence of art—recuperating and improving life. The installation *Internal Landscape* comprises a series of five interconnected sculptures made from hundreds of multicolored candles, which airily, subtly and poetically "present the coexistence of body's fragility and spirit's richness." The dialogue between urban reality and life's surrealness brings forth the tension, association and sense of distance that arise while we imagine the world. (Hou Hanru)

Chen Zhen

1955 Born, Shanghai, China
1982 Graduated, department of set design, Shanghai Academy of Drama, Shanghai, China
1986 -89 Ecole Nationale des Beaux-Arts, Paris, France
1989 -91 Further studies at the School of Plastic Arts Research Institute, Paris, France
December 3, 2000, died in Paris, France

Solo Exhibitions
1990 *Chen Zhen, Hangar 028*, Paris, with the collaboration of Musee Departemental des Vosges, Paris, France
1991 *Momification of Ready-made*, Danny Keller Gallery, Munich, Germany
1992 *Re-birth Door*, Espaces des Arts, Colomiers, France
1995 *No Way to Sky, No Door to Earth*, Jean Bernier Gallery, Paris, France
1996 *Daily Incantations*, Deitch Projects, New York, USA
1998 *In(ter)fection: Chen Zhen and Nari Ward, in the framework of Archipelago: Crash Between Islands*, National Maritime Museum, Stockholm, Sweden
2001 *Daily Incantations*, Museum of the Music, Paris, France

Group Exhibitions
1990 *Chine: Demain pour hier*, Pourrieres, France
1993 *The 45th Venice Biennale*, Venice, Italy
1995 *The 46th Venice Biennale*, Venice, Italy
1996 *The First Shanghai Biennale*, Shanghai Art Museum, Shanghai, China
1997 *The Second Kwangju Biennial*, Kwangju, Korea Repoblic
1998 *Site of Desire: 1998 Taipei Biennial*, Taipei Fine Arts Museum,Taipei Taiwan
1999 *The 48th Venice Biennale*, Venice, Italy
 The Third Asia-Pacific Triennial of Contemporary Art, Queensland Art Gallery, Brisbane, Australia

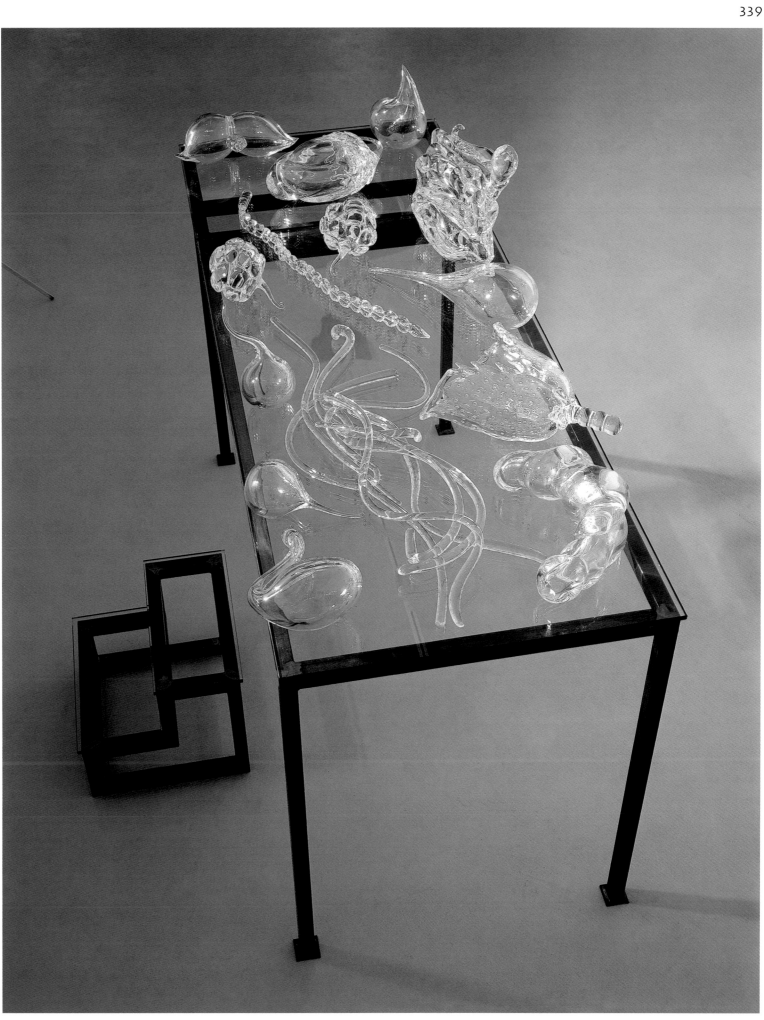

Huang Yihan
Strange Specimens
1999

installation; water cooler, cartoon toys, antique Chinese table

In this work, a water cooler and McDonald's cartoon figurines of "Beauty and the Beast" are brought into organic coexistence, revealing the nature of a generation brought up on commercialism. This generation floats in a world of computers and animation; it has come to depend on and confide in cartoons. In an age in which people and cartoons have become indistinguishable, this work symbolically expresses the changes which the cartoon generation has undergone. (Huang Yihan)

Huang Yihan

1958 Born, Lufeng, Guangdong province, China

1982 Graduated, Chinese painting department, Guangzhou Academy of Fine Arts, Guangzhou, China

1985 Earned master's degree, Chinese painting department, Guangzhou Academy of Fine Arts, Guangzhou, China
 Current, professor in Chinese painting department, Guangzhou Academy of Fine Arts, Guangzhou, China

Group Exhibitions

1987 *Works by Fifteen Young Teachers of the Guangzhou Academy of Fine Arts*, Guangzhou, China

1993 *First Exhibition of the Post-Lingnan School Painters*, Guangzhou, China

1996 *Cartoon Generation*, China Southern Teaching Univeersity, Guangzhou, China

1999 *The 14ᵗʰ Asian Art Exhibition*, Fukuoka Museum of Asian Art, Fukuoka, Japan
 Gate of the New Century, Chengdu Modern Art Museum, Chengdu, China

2000 *The Second Shenzhen International Ink and Wash Biennial*, Shenzhen, China

2001 *Another Deal of the Cards*, Shenzhen, China
 China: Twenty Years of Ink Experiment, Guangdong Museum of Art, Guangzhou, China
 Chengdu Biennale, Chengdu Modern Art Museum, Chengdu, China
 Hot Pot, Kunsternes Haus, Oslo, Norway

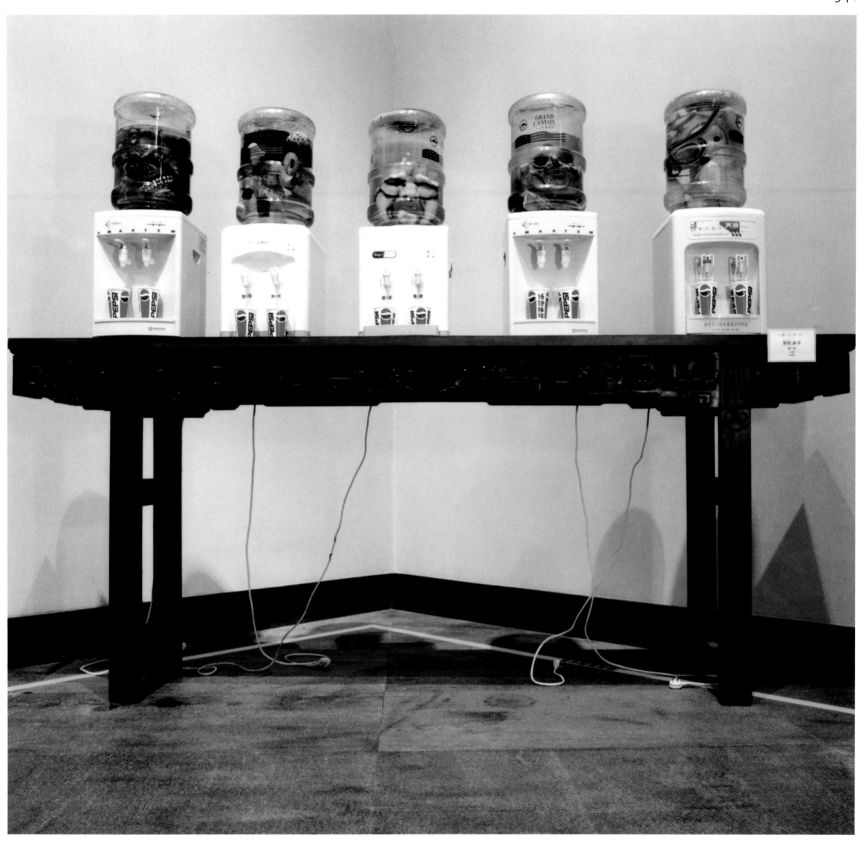

Lu Chunsheng
Water

2000
photograph
56 x 80 cm

This kind of cool direct approach to expression breaks through the single dimension of objective reality, turning space into an absurd, theoretical stage of real life. This imbues the work with an invented dynamism that is both absurd and yet points to various rules in reality. When the audience becomes immersed in this apparently absurd scene, they can also sense certain human eccentricities, life's absurdities, and the artist's sneering at reality and his questioning attitude towards existence. This turns existence into the backdrop of a mad reality. (Feng Boyi)

Lu Chunsheng

1968 Born, Changchun, Jilin province, China

1994 Graduated, sculpture department, China National Academy of Fine Arts, Hangzhou, Zhejiang province, China

Current, lives and works in Shanghai, China

Group Exhibitions

2000 *Beyond Desire*, Shanghai, China

House, Home, Family, 4/F Yuexing Furniture Corporation, Shanghai, China

Inertia and Camouflage, Shanghai, China

Fuck Off, Eastlink Gallery, Shanghai, China

2001 *Manic Ecstasy*, Gallery of the China National Academy of Fine Arts, Hangzhou, China

Living in Time, Hamburg Bahnhof Museum of Contemporary Art, Berlin, Germany

2002 *The Third Space in the Fourth World*, Shanghai, China

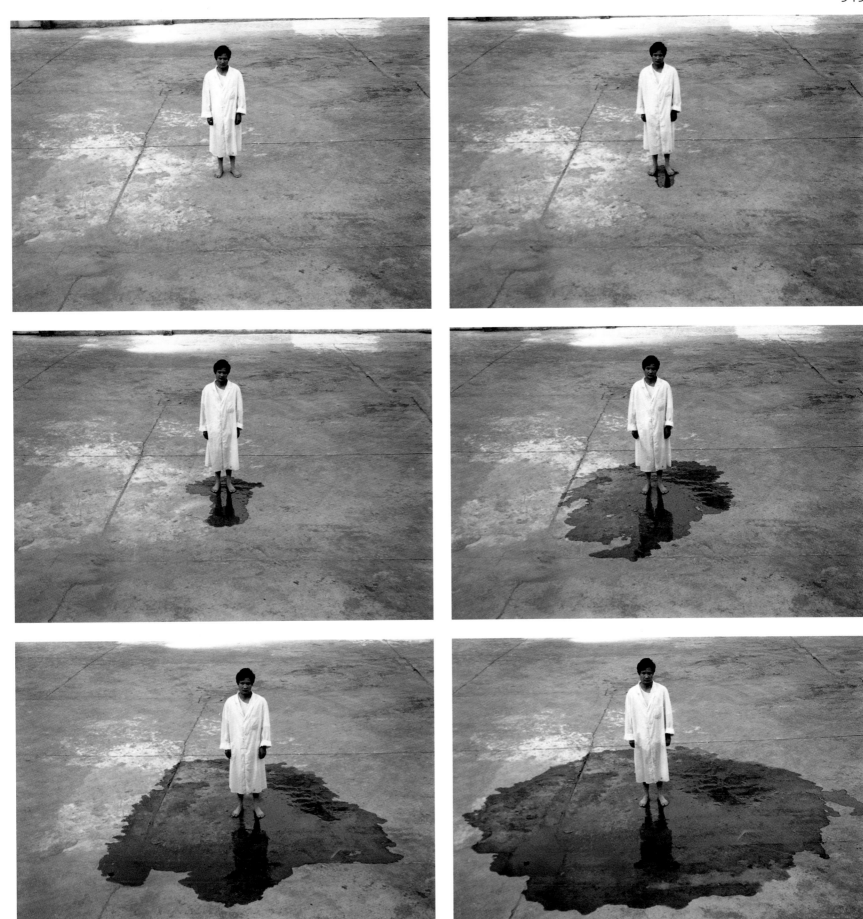

Fang Lijun
Series No. 22
1992
oil on canvas
200 x 200 cm
Collection of Ludwig Museum, Cologne, Germany

The bald-headed figures that Fang Lijun has created in his paintings since 1989 have become the lexicon of boredom and *popi* (a coined word meaning "feigning stupidity"). Grinning, staring dumbly, or yawning, they convey a sense of acute boredom, with any significant expression removed the features of their face. A rogue's shaved head with a meaningless expression transformed a form of non-meaning into a system of meaning associated with rebellion and satire. The figure became synonymous with the artist. He mocks himself and tries to escape the system of meaning. Gradually, empty and expansive blue skies with white clouds and vast oceans replaced the previous jam of figures and background, expressing a sense of self-liberation from internalized repression. Neither yielding to nor confronting ideology, the funny and bored *popi* figures have become "by-standers," without a role "on the scene," thus attaining a sense of unrestrainedness. Meanwhile, the poetically contrasting elements of blue skies, white clouds, and vast oceans set off the playful, meaningless figures. Fang Lijun's works accent a non-expressionistic indifference, highlighting the atmosphere of "not being present." His consistent use of clear and bright colors maintains the inner satisfaction of self-liberation and purification. (Li Xianting)

Fang Lijun
1962 Born, Handan, Hebei province, China
1989 Graduated, print-making department, Central Academy of Fine Arts, Beijing, China
 Current, lives and works in Beijing, China

Solo Exhibitions
1995 Galerie Bellefroid, Paris, France
 Galerie Serieuse Zaken, Amsterdam, the Netherlands
1996 *Fang Lijun: Human Images in an Uncertain Age*, The Japan Foundation, Tokyo, Japan
1998 Staedelijk Museum, Amsterdam, the Netherlands
 Max Protetch Gallery, New York, USA
2000 Soobin Art Gallery, Singapore
2002 *Fang Lijun: Between Beijing and Dali 1989-2002*, Ludwig International Art Foundation, Aachen, Germany

2001 *Mercosul Bienal*, Bodoualige, Brazil
 In Holz Geschnitten Durer, Gauguin, Penck und die Anderen, Museum Bochum, Germany

Group Exhibitions
1989 *China/Avant-garde*, China Art Gallery, Beijing, China
1992 *Fang Lijun and Liu Wei Oil Painting Exhibition*, Beijing Art Museum, Beijing, China
1993 *China's New Art, Post-1989*, Hong Kong Arts Centre, Hong Kong
 The Eastern Road: The 45th Venice Biennale, Venice, Italy
1994 *Chinese Contemporary Art at Sao Paulo: 22nd International Sao Paulo Biennial*, Sao Paulo, Brazil
1995 *The First Kwangju Biennial*, Kwangju, Korea Republic
 Out of the Middle Kingdom: Chinese Avant-garde Art, Santa Monica Arts Center, Barcelona, Spain
1996 *China!*, Kunstmuseum Bonn, Bonn, Germany
1998 *Inside Out: New Chinese Art*, Asia Society Galleries, PS 1 Contemporary Art Center, New York, USA
1999 *Aperto Over All: The 48th Venice Biennale*, Venice, Italy
2000 *Shanghai Spirit: The Third Shanghai Biennale*, Shanghai Art Museum, Shanghai, China

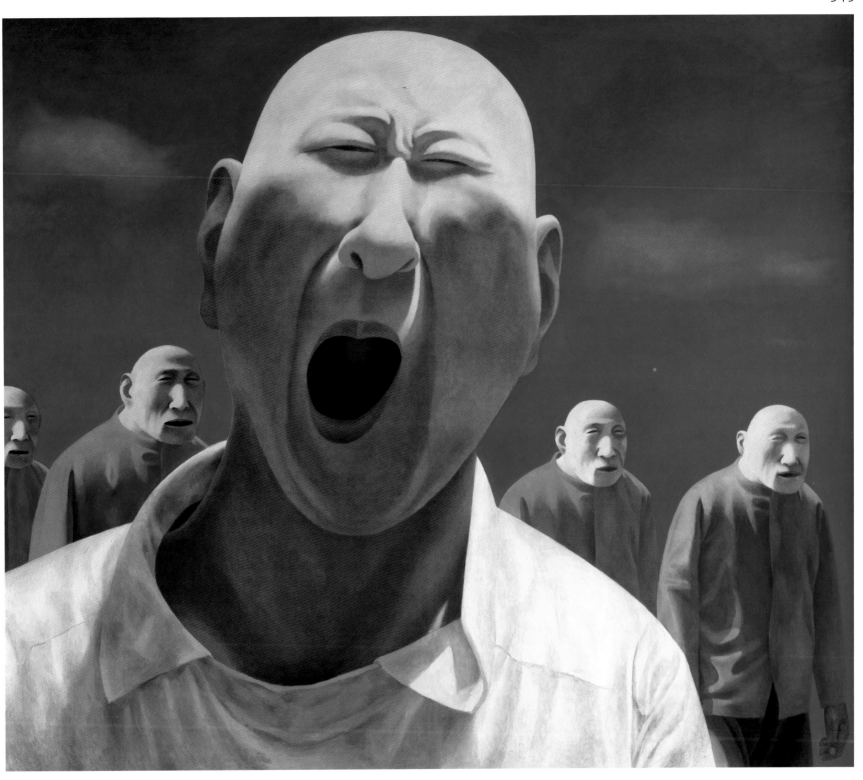

Yue Minjun

Happiness

1993
oil on canvas
180 x 240 cm
Collection of Guy and Myriam Ullens

Contemporary society is a society of idols and contemporary culture a culture of idols. I choose traditional forms of painting and sculpture and strong folk colors to create my own "portrait," aiming to create a new idol in the way that present-day media like television and film do. Great power will be effected when the figure is reproduced continuously. The spiritual meaning of the giggling figure is rooted in the traditional philosophy of Taoism (with Laozi and Zhuangzi as the main founders). When faced with social problems, scholars in history were often inclined to give up. To give up everything is an attitude towards life, a detachment from the world and the attaining of an inner world of tranquility. (Yue Minjun)

Yue Minjun

1962 Born, Daqing, Heilongjiang province, China
1983 Graduated, oil painting department, Hebei Normal University, Hebei province, China
 Current, lives and works in Beijing, China

Solo Exhibition

2000 *Red Ocean*, Chinese Contemporary, London, UK

Group Exhibitions

1994 *Faces Behind the Bamboo Curtain — Works of Yue Minjun and Yang Shaobin*, Schoeni Art Gallery, Hong Kong
1995 *The History of Chinese Oil Painting: From Realism to Post-Modernism*, Galerie Theoremes, Brussels, Belgium
1996 *China!*, Kunstmuseum Bonn, Bonn, Germany
1997 *China Now*, Littmann Kulturprojekte, Basel, Switzerland
1998 *4696/1998: Contemporary Art from China*, Art Beatus Gallery, Vancouver, Canada
1999 *Aperto Over All: The 48th Venice Biennale*, Venice, Italy
2000 *Portraits de Chine Contemporaine*, Espace Culturel Francois Mitterrand, Paris, France
 Our Chinese Friends, Bauhaus-University and ACC Gallery, Weimar, Germany
2001 *Ornament and Abstraction*, Beyeler Foundation, Basel, Switzerland
2002 *Contemporary Chinese Art*, Reykjavik Art Museum, Reykjavik, Iceland

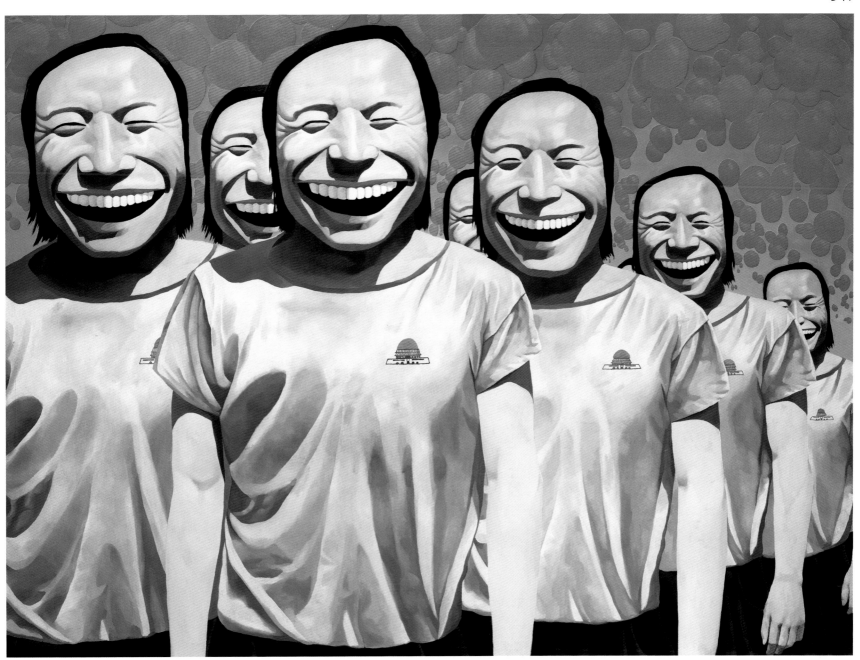

Yang Shaobin

Untitled

1996
oil on canvas
230 x 360 cm

This work is the very first of the paintings I produced after I finished with what is termed Cynical Realism. In this composition, elements of reality and history are contrasted in small parcels of the picture plane, which negates any rational sense of space. Mother and child, an assassin, Zhenbao Island war, and other political symbols here all express the complexity of the times, of geographical relations and related systems. By placing the mother and child in the midst of all this, there is a sense of danger, threat and shock. In films, images of assassins and war represent terrorism and conflict. The use of political symbols as a material is "soft" (subtle), but has no relation to the softness of the mother. They symbolize systems and power, and serve to raise questions, like exactly who is the victim. The language of art becomes a function of the work, appearing colorless and ordinary. (Yang Shaobin)

Yang Shaobin

1963 Born, Tangshan, Hebei province, China
1983 Graduated, fine arts department, Hebei Light Industry College, Tangshan, China
 Current, lives and works in Beijing, China

Solo Exhibitions

2000 Asian Arts Factory, Berlin, Germany
2001 Chinese Contemporary, London, UK
 Galerie Loft, Paris, France

Group Exhibitions

1996 *China!*, Kunstmuseum Bonn, Bonn, Germany
1999 *The 48th Venice Biennale*, Venice, Italy
2000 *Skin and Space*, Contemporary Art Center, Milan, Italy
 Our Chinese Friends, Bauhaus-University and ACC Gallery, Weimar, Germany
 Contemporary Chinese Portraits, Espace Culturel Francois Mitterand, Perigueux, France
2001 *Abbild International Contemporary Portrait and Drawing Exhibition*, Landsmuseum Joanneum, Graz, Austria
 Hot Pot, Kunsternes Haus, Oslo, Norway
2002 *Delusion*, the Netherlands

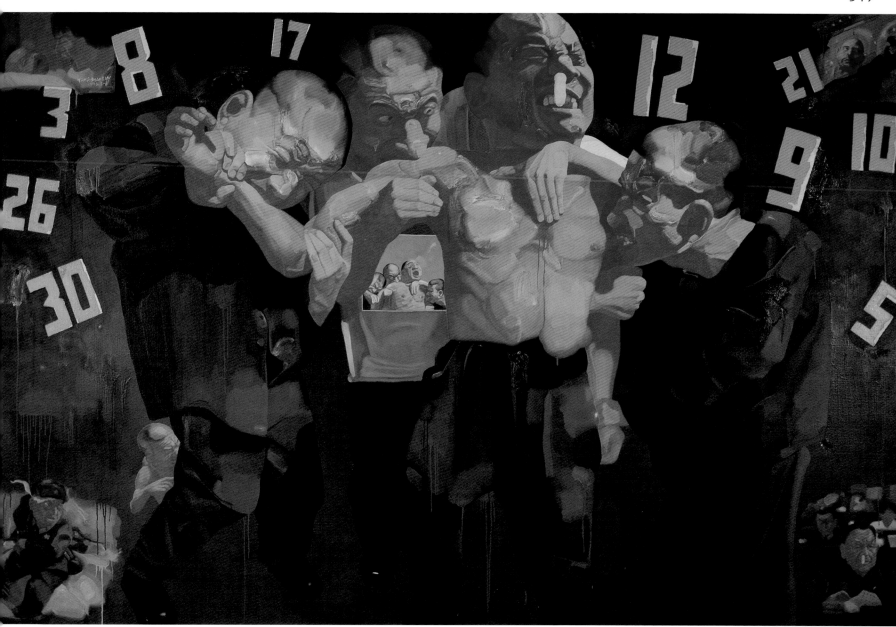

Feng Zhengjie
Romantic Journey

1997
oil on canvas
150 x 190 cm

I began the series *Romantic Journey* in 1996 as part of a continuing exploration of mass leisure culture and the changing sensibilities towards beauty in contemporary society. One example is the mainstream trend towards wedding photography, which was a major inspiration. Thus, brightly lit, delicate and colorful balloons were among the elements that found their way into my paintings. Most wedding photography is produced according to a clearly defined model in the studio, where expression, gesture, and even the outfits worn are directed by the photographer. There is not the least natural expression of emotion between the two lovers. Here it is only the superficial result that is important. The specifics of each couple are of little importance. In this work, falsity, grandeur and vapidity are brought together as the very image of what the people like to see in the same vein as New Year paintings. In this apparently cynical way I seek the real value and dignity of people in contemporary society. (Feng Zhengjie)

Feng Zhengjie

1968 Born, Sichuan province, China
1992 Graduated, education department,
Sichuan Academy of Fine Arts,
Chongqing, China
1995 Graduated, oil painting department,
Sichuan Academy of Fine Arts,
Chongqing, China
Current, teaches at Beijing Institute
of Education, Beijing, China

Solo Exhibitions
1996 *Recounting of Skin*, Art Museum of Capital Normal University, Beijing, China
2001 *Coolness*, Common Ground Gallery, Winslow, Canada
2002 *1996-2001 Works*, 3.14 Foundation, Bergen, Norway
M.K. Ciurlionis National Art Museum, Lithuania
Wrapped Up, Chen Xindong International Art Space, Beijing, China

Group Exhibitions
1995 *The Third China Oil Painting Exhibition*, China Art Gallery, Beijing, China
1999 *Ooh, La, La Kitsch!*, TEDA Contemporary Art Museum, Tianjin, China
Food for Thought, De Wette Dame, Eindhoven, the Netherlands
2001 *Chengdu Biennale*, Chengdu Contemporary Art Museum, Chengdu, China
Chinese Portraits, Galerie Loft, Paris, France
2002 *Korea Contemporary Art Festival*, Seoul, Korea Republic
Like Chinese Pop, Ray Hughes Gallery, Sydney, Australia

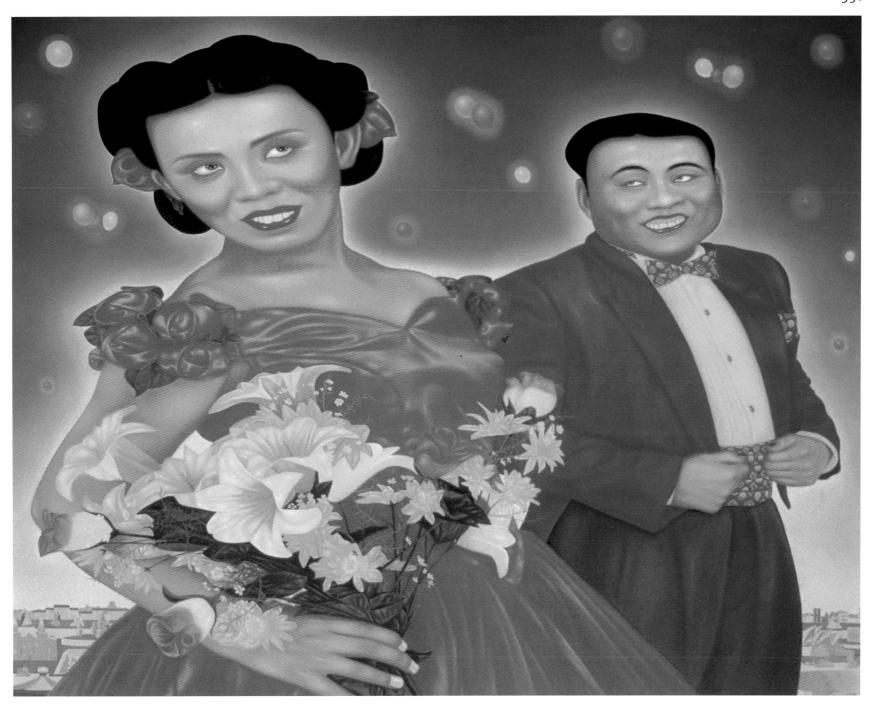

Wang Yin
Flower 2000
2000
acrylic on canvas
90 x 110 cm

In recent years, Wang Yin has completed a numbered series of paintings, in which he juxtaposes aspects of New Year paintings that can be placed against window glass with those that can be hung on the wall, and figure painting. He asked a folk artist from Henan to work with him, each of them painting over other paintings that they them had already completed. In this way Wang Yin arrived at what he felt to be a satisfactory approach. The folk artist usually produced paintings of the type characteristic of Chinese architectural structures, temples, gateways and classical buildings. Wang Yin had received some training in academic painting techniques from professional painters. In the process of creation, both destroyed or negated the style or approach of the other, denying the individual traces of style in each other's work. This called into question style against professional technique in painting, engendering a new awareness of the relation between content and form. It further forced individual appreciation of beauty to turn towards concept in art, in an attempt to overturn existing and construct new free and easy means of painterly expression between mainstream and folk art. (Huang Du)

Wang Yin

1964 Born, Ji'nan, Shandong province, China
Current, lives and works in Beijing, China

Solo Exhibitions

1994 *Wang Yin's Paintings*, Gallery of the Central Academy of Fine Arts, Beijing, China
2001 *New Works*, China Art Archives and Warehouse, Beijing, China

Group Exhibitions

2000 *Ache*, Beijing, China
Contemporary Chinese Painting Exhibition, Villa Breda Foundation, Padua, Italy
Fuck Off, Eastlink Gallery, Shanghai, China
2001 *Chengdu Biennale*, Chergdu Contemporary Art Museum, Chengdu, China
New Inspirations/Departures, China Art Archives and Warehouse, Beijing, China
2002 *WXY*, China Art Archives and Warehouse, Beijing, China

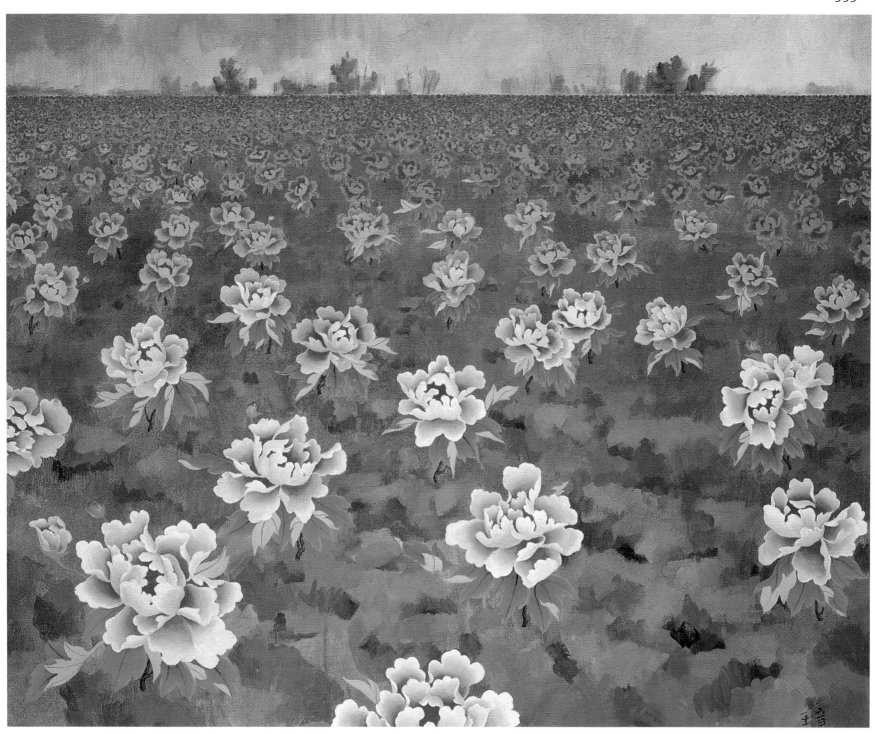

The New Analysts Group (Chen Shaoping, Wang Luyan, Gu Dexin)
Dialogue: Uecker and the New Analysts

The New Analysts Group largely took the angle of rationalism/logic applied to a conceptual art approach to analyze and explore interpersonal relationships and the fundamental structures within which human life is contained. The group frequently produced what appeared to be visually uninteresting diagramatic texts or documents, installations or performances that were the process of executing their concept. The New Analysts were keen to experiment with the expressive power of concept, to determine whether this could be more important than the visual aspects of an art work and in what way, as a means of disseminating and communicating the essence of an original concept. With the concept completed, there remained no reason for the work to exist physically, which is why the group destroyed all original materials. From its establishment to its dissolution, the New Analysts Group was a conceptual work in its own right, pivoted on collaboration and the casting aside of any individual personal characteristics, which were all subject to sets of imposed regulations. In an analytical way, they would prove that $a1$ is not equal to $a2$ is not equal to $a3$ but that through collaboration the opposite is true. Their approach to exhibiting works was to have them read within an art situation but not to be displayed as art. Only by reading the works (notes, project explanations, process) could the audience approach the actual concept. (Zi Ke)

The New Analysts Group
Members: Wang Luyan, Gu Dexin,
 Chen Shaoping
1988 Embarked upon Analysis
 explorative work
1989 Formally established as the
 New Analysts Group
1995 Group formally dissolved

Exhibitions
1990 *Analytic Exhibition*, The New Analysts Studio, Beijing, and forum organised
 together with Beijing-based critics
1991 *Chinese Avant-garde*, Museum City Project, Fukuoka, Japan
1993 *China's New Art, Post-1989*, Hong Kong Arts Centre, Hong Kong
 Dialogue: Uecker and the New Analysts, New Berlin Artists' Association,
 Berlin, Germany
1995 *Configura 2*, Erfelt, Germany
 Out of the Middle Kingdom: Chinese Avant-garde Art, Santa Monica Arts
 Center, Barcelona, Spain
1998 *Inside Out: New Chinese Art*, Asia Society Galleries, PS 1 Contemporary Art
 Center, New York, USA

Rules Governing New Analysts Group Work No. 3

a₁, a₂, and a₃ each selects "Uecker's Conversation with Dieter Honisch" in German and Chinese as original graph of a₁, a₂, and a₃ in artwork three.

Part One (Graphs in German)

(1) draw Form A with "O" as its center, use German alphabet sequence as unit for the length and breadth;

(2) original graph of a₁, a₂, and a₃ uses a word and its subordinated punctuation as unit, input into Form A in sequence;

(3) When the word being input into Form A also contains the character marking its position on the graph, its is marked and recorded in Form A as a valid graph;

(4) based on the rules above, keep on inputting the rest of original graph of a₁, a₂, and a₃ into Form A until finished 3 x a₁/3 original graph, 3 x a₂/3 original graph, and 3 x a₃/3 original graph , finally obtain 1/3 of original graph①, 1/3 of original graph ②, and 1/3 of original graph ③;

(5) original graph ① + original graph ② + original graph ③ = original graph A;

(6) input original graph A into Form A in alphabet sequence, pick valid graphs as graph A according to the rules;

(7) finish the form based on graph A in alphabet sequence.

Part Two (Graphs in Chinese)

(1) use Chinese characters as unit, input into Form A based on character sequence;

(2) pick a valid word from the first part of Form A;

(3) the rest of the rules are the same as Part One.

Dialogue: Uecker and the New Analysts, exhibited in Berlin, Germany, 1995

Yan Lei
1500 cm
1994
video

The film records four actions of a single person: washing a basin of tape, measuring out 1500 cm of tape, putting this length of tape into his mouth, and then drawing the tape out of his mouth. Despite the fact that the actions are continual, they do not make a narration. In other words, they render facts undramatically. It is direct visual representation without any interpretation, and the result is blankness. (Wu Meichun and Qiu Zhijie)

See page 324 for the artist's portrait and CV.

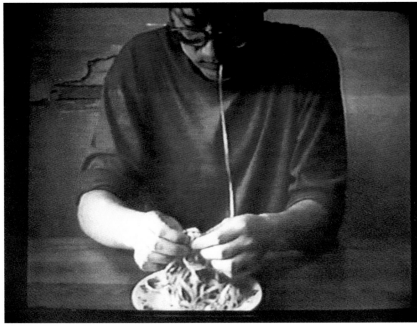
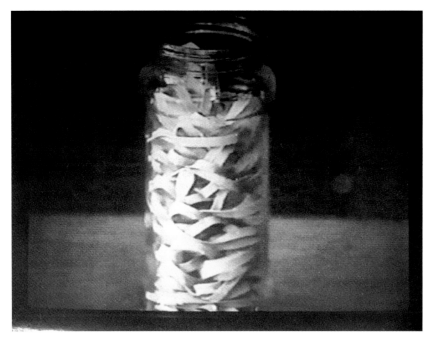

Qiu Zhijie
Washroom
1994
video

Painted across a human face and the surrounding walls, the black and white checks suggest the mosaic on the wall in a toilet and almost reduce the faces to two dimensions. When the face is calm, the lines are straight; when the face shows some emotion, the lines bend. The various sounds of water flushing in the toilet are heard. This symbolic work plays on the tension that is caused by undue harmony between man and his environment. The work provides a minimal physical view of human life. (Wu Meichun)

See page 150 for the artist's portrait and CV.

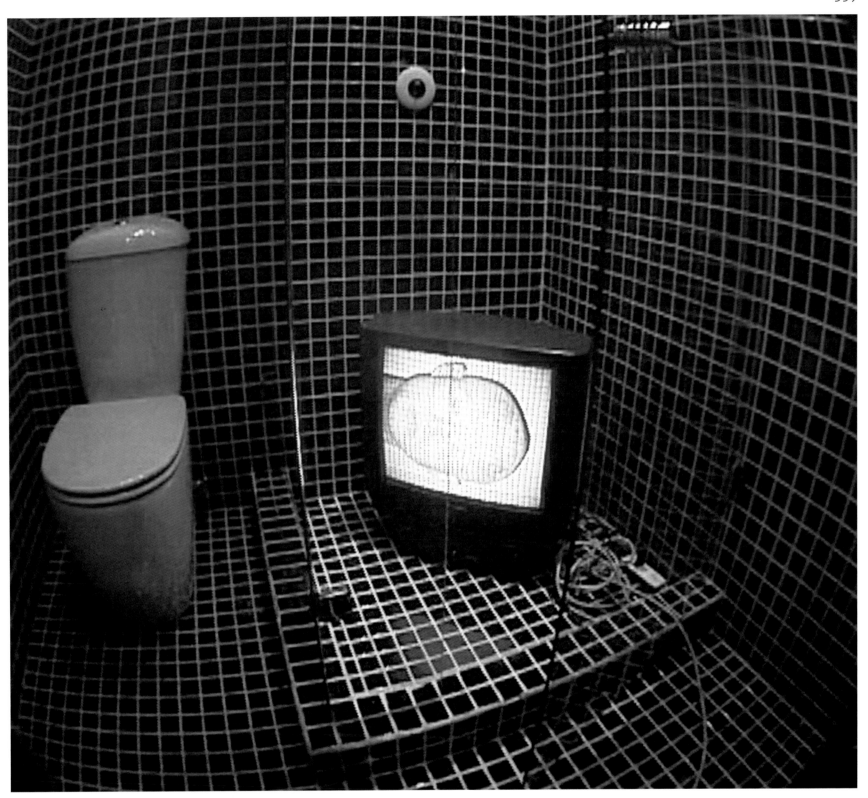

Zhu Jia
Forever
1994
video

Forever saw a camera fixed to a point on the wheel of a flatbed cart with the lens looking outwards. The camera was then set to record and the cart cycled through the city at a steady pace. My aim was to remove the gap between the camera and the subject recorded. Employing a subjective awareness, I could in this way arrive at a crude, jerky exploration of the relationship between the medium and the subject it captured. In the process, the subjective mood of the artist's vision was negated by the rolling circular motion of the camera and the randomness of the objects that passed before the lens. This forces the viewer to experience the city through the work in the way that I intended, and provides a vehicle for them to re-examine their own awareness of the familiar urban environment. (Zhu Jia)

Zhu Jia

1962 Born Beijing, China
1988 Graduated, oil painting
 department, Central Academy
 of Fine Arts, Beijing, China
 Current, picture editor, *Beijing
 Youth Daily*, Beijing, China

Group Exhibitions

1996 *Image and Phenomena*, Gallery of the China National Academy of Fine Arts,
 Hangzhou, China
1997 *Cities on the Move*, The Secession, Vienna, Austria
1997 *The Second Johannesburg Biennial*, Johannesburg, South Africa
1998 *The 11ᵗʰ Sydney Biennial*, Queensland Art Gallery, Sydney, Australia
 The 16ᵗʰ World-Wide Video Festival, Amsterdam, the Netherlands
2000 *2000 Spain Video: Record of the Centre*, Madrid, Spain
2001 *Living in Time*, Hamburg Bahnhof Museum of Contemporary Art, Berlin,
 Germany
 Translated Acts, Haus der Kulturen der Welt, Berlin, Germany
2002 *Concept of Time: 20ᵗʰ Century Contemporary Art*, MoMA New York, USA
 Shake-up: Asian Contemporary Art, Castille Contemporary Art Centre, Palma,
 Spain

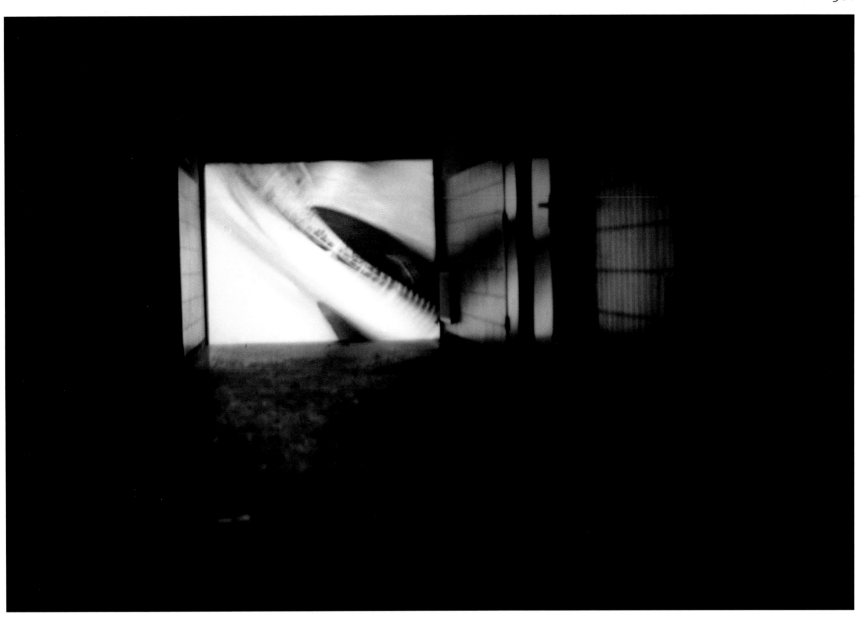

ON "FOREVER"

The video "Forever" has been realized by attaching a video camera to the left wheel of a tricycle. The lense was oriented outward. Switched on the camera, I rode this tricycle over 10 km of city streets. The camera was circling forward along with the motion of the tricycle and recording down turning-around images.

Tong Biao
Touch
1996
video; 5 min., 30 sec.

The film was shot with the artist carrying the camera on his back with the lens facing backward. Meanwhile, an assistant chased the artist in an attempt to catch him. The artist runs at full speed to escape his pursuer. Attempts to touch another's body begin in a labyrinth, then in a park, on a pedestrian overpass, and in a market as the environment becomes increasingly chaotic and confused. The lens shows bumping scenes with the pursuer now and then intruding with his extended hand. The ambient sound is erased, and only the quick and short gasps of the runners are heard. An intense but hidden vein runs through public life. As people become more intimate physically, the social gap between them widens and stokes people's desire for power. Desire to possess other people and to hurt others is omnipresent in existence. (Wu Meichun and Qiu Zhijie)

Tong Biao

1970 Born, Anhui province, China
1994 Graduated, print-making department, China National Academy of Fine Arts, Hangzhou, Zhejiang province, China
Current, lives and works in Hangzhou, China

Group Exhibitions

1998 *Transmediale '98: 11th Video Festival*, Berlin, Germany
16th World-Wide Video Festival, Amsterdam, the Netherlands
2000 *Inertia and Mask: Works on Paper*, Shanghai, China
2001 *Manic Ecstasy*, Impression Gallery, Hangzhou, China
2002 *Non-linear Narrative*, Gallery of the China National Academy of Fine Arts, Hangzhou, China

Chen Wenbo
Moisture Content
1996
video

This is a typical early Chinese video film. The artist has eluded the trouble of editing shots with ingenious planning. This film is the only work of this type that has been produced in western China. In the work, one sees a hand pouring liquid from one container to another, finally pouring the water back to the first container. When the liquid moves from one container to another, it gains weight and becomes darker and darker. The whole procedure has been filmed from one camera angle. The off-screen voice is a vocal mimicry played by the tongue. All these make the film slightly humorous. At its end, the film shows four huge tongue-like sponges saturated with water. This installation is ambiguous and allegorical. (Wu Meichun and Qiu Zhijie)

Chen Wenbo

1969 Born, Chongqing, China
1986 Studied, Sichuan Academy of Fine Arts, Chongqing, China
 Current, lives and works in Beijing, China

Solo Exhibition
2000 *Works by Chen Wenbo*, Paris, France

Group Exhibitions
1992 *The First Guangzhou Biennale: Oil Painting in the Nineties*, Guangdong Exhibition Center, Guangzhou, China
1994 *Cut to Pieces*, Chongqing, China
1997 *Demonstration of Video Art '97 China*, Gallery of the Central Academy of Fine Arts, Beijing, China
1999 *Post-sense Sensibility: Alien Bodies and Delusion*, Beijing, China
 Towards Materialism and That Sort of Beauty, Shanghai, China
2000 *The Individual and Society in Art*, Guangdong Museum of Art, Guangzhou, China
 Usual and Unusual, Shanghai, China
2001 *Next Generation*, City Art Center, Paris, France
 Chengdu Biennale, Chengdu Modern Art Museum, Chengdu, China
2002 *Too Much Flavor*, 3H Art Center, Shanghai, China
 Paris-Pekin, Espace Cardin, Paris, France
 Chinese Modernity, Sao Paulo University Art Museum, Sao Paulo, Brazil

Qian Weikang
Breath/Breath
1996
video; 7 min.

Qian Weikang's video shows a flat cartoon pattern of an eye continually opening and shutting. In the eye, images of various eyes are reproduced from posters in streets or various mass media. When the eye opens and shuts to the rhythm of a person breathing, toilet flushing is heard. "We have become a visual animal." The blinking eye in darkness and the flushing echoes through the exhibition hall, creating a humorous and physiological atmosphere. Qian does not give his opinion to the mass media, but with his graphic and sound images, he demonstrates the truth that life is a medium in and of itself. (Wu Meichun and Qiu Zhijie)

Qian Weikang

1963 Born, Shanghai, China
 Current, lives and works in
 Shanghai, China

Group Exhibitions

1993 *Two Attitudes of Image: Installation Works by Shi Yong and Qian Weikang*,
 Shanghai, China
1994 *The Third Documentary Exhibition of Chinese Contemporary Art*, Library of
 East China Normal University, Shanghai, China
1995 *Not Here Not There: Artistic Proposals by Shi Yong and Qian Weikang*, Access
 Artists' Center, Vancouver, Canada
1996 *Let's Talk about Money: The First Shanghai International Fax Art Exchange
 Exhibition*, Gallery of Huashan Art Vocational School, Shanghai, China
 In the Name of Art, Liu Haisu Museum of Art, Shanghai, China

Social Survey

Game

Hu Jieming
About Physiology
1996
video; 5 min., 20 sec.

The artist's initial motive concerns the relationship between consciousness and unconsciousness, between culture and physiology. A monitoring room monitors around the clock every patient in critical condition. This video film adopts the diagram of a critically ill person's cardiogram (on the top of the screen) and respiratory waves (on the bottom of the screen). A transparent musical staff in front of the wave diagrams shows the heartbeat and breath as its notes and the speed of the waves as its rhythm and tempo, making a melody played by a specialist according to the "staff." (Wu Meichun and Qiu Zhijie)

New Journey to the West
1998
video

The artist draws upon the visual style of the TV drama *Journey to the West*, and invites his friends who are engaged in art and live in Canada to dub the footage according to their personal life experiences. This work was completed by editing the original footage together with the visual material dubbed by his friends. After viewing the mute *Journey to the West* three times, each dubber was randomly assigned a character. Without any pre-arrangement, they each improvised lines according to their experience and understanding. To some extent those spontaneous and random lines truthfully reflect the attitudes and ideas of people from different cultural backgrounds and living conditions. (Wu Meichun and Qiu Zhijie)

See page 228 for the artist's portrait and CV.

About Physiology

New Journey to the West

Wu Ershan
Look Around
1997
video; 4 min., 25 sec.

Wu Ershan's video provides a shallow look at everyday life in Beijing. Its boredom and busyness at first appear optimistic, but with the fragmentation and restructuring of time, it reveals a certain absurd, confusing experience. The repetition of life, it seems, brings on both a rich visual experience and an inescapable din. (Wu Meichun and Qiu Zhijie)

Wu Ershan

1972	Born in Holhot, Inner Mongolia, China
1993	Studied in the oil painting department, Central Academy of Fine Arts, Beijing, China
1998	Graduated, directing department, Beijing Film Academy, Beijing, China
	Current, lives and works in Beijing, China

Group Exhibitions

1998	*Retrospection: Ourselves and Environment*, Beijing, China
	Transmediale '98, Podewil, Berlin, Germany
	Multi-media Festival '98, Kiasma Museum of Contemporary Art, Helsinki, Finland
1999	*Post-sense Sensibility: Alien Bodies and Delusion*, Beijing, China
	Supermarket, Shanghai, China
2000	*Kensten Festival of Art*, Brussels, Belgium
	18th World-Wide Video Festival, Amsterdam, the Netherlands
	Fuck Off, Eastlink Gallery, Shanghai, China
2001	*Post-Sense sensibility: Carnival*, Beijing, China

Yang Zhenzhong
Sleepwalking Therapy
1998
video; 30 min.

The artist shot this film with the camera fixed on a remote-control model car running on the floor in an apartment. The film was shot continually in motion and the sound was recorded on the spot. Like Zhu Jia's *Forever* and Tong Biao's *Touching*, this film enriches its visual effect by exploiting the camera's field of vision, and thus rectifies the one-sided "objectivity" of the long lens. The viewer of the film acquires a new perspective by following the movement of the camera, and is thus turned into a spy. Here due to the lower viewpoint of the camera and the viewer, the private space of a room is amplified into a monument and a city. (Wu Meichun and Qiu Zhijie)

922 Grains of Rice
2000
video; 8 min.

The film shows a rooster and a hen pecking a pile of rice. The number of grains of rice is calculated by counting their nods. A male off-screen voice announces the rooster's nods and a female voice announces the hen's. On the lower left corner of the screen the number of rooster's nods is synchronously displayed and on the right corner, the hen's. In the middle part of the screen one sees their total number of nods. (Wu Meichun and Qiu Zhijie)

See page 332 for the artist's portrait and CV.

Sleepwalking Therapy

922 Grains of Rice

Kan Xuan
Kan Xuan, Yes
1999
video; 5 min.

The film was shot in the public space between one platform and another at a subway station. "I ran through the crowds shouting my name and answering it, as if I were calling myself and answering myself, and also as if I were mimicking somebody calling me and mimicking myself answering the call. What interests me is how I am recognized by myself or other people when the spatial relations between the caller and the person who answers become obscure, and the result of this." In this film, the gap between performance and panned shots has disappeared without a trace. (Wu Meichun and Qiu Zhijie)

Kan Xuan
1972 Born, Xuancheng, Anhui province, China
1997 Graduated, China National Academy of Fine Arts, Hangzhou, Zhejiang province, China
 Current, lives and works in Beijing, China

Solo Exhibition
2001 *Or, Nothing*, Xiamen and Shanghai, China

Group Exhibitions
1995 *45 Degrees as a Reason*, collaborative work, Beijing, China
1999 *Supermarket*, Shanghai, China
 The Same but Also Different, Shanghai, China
2000 *House, Home, Family*, 4/F Yuexing Furniture Corporation, Shanghai, China
 Water, Beijing, China
2001 *Progressive Tense*, Shanghai, China
2002 *C'est pas du cinema*, Le Fresony National Studio, France
 Fantasia, East Art Center, Beijing, China

Xu Zhen
Scream
1999
video

Xu Zhen's action is extremely simple. Obviously it is improvised to solicit visual images. He often utters a strange cry in various public spaces, and when people turn their heads to look at him, he presses down the button on his camera. At the expense of being regarded as shameless, the artist captures a fragile moment in the collective unconscious. (Wu Meichun and Qiu Zhijie)

Xu Zhen

1977 Born, Shanghai, China
1996 Graduated, Shanghai School of Arts and Design, Shanghai, China
Current, lives and works in Shanghai, China

Solo Exhibitions

A Young Man, BizArt, Shanghai, China
Limits of Body, Vancouver, Canada

Group Exhibitions

1998 *310 Jinyuan Road*, Shanghai, China
1999 *Food for Thought*, Canvas Art Foundation, Netherlands
 Maya Biennial, Maya, Portugal
 Supermarket, Shanghai, China
2000 *Fuck Off*, Eastlink Gallery, Shanghai, China
 Turin Biennale, Turin, Italy
2001 *The First Valencia Biennial*, Valencia, Spain
 Living in Time, Hamburg Bahnhof Museum of Contemporary Art, Berlin, Germany
 The 49ᵗʰ Venice Biennale, Venice, Italy
2002 *Video Marathon*, New York, USA

Liu Wei
Hard to Restrain
1999
video; 10 min.

Liu Wei makes a habit of using a cool approach to observe the world. He is possessed of great sensitivity towards the nature and occurrence of tragedy in life. In *Hard to Restrain*, he presents a sequence of images of clusters of naked youths, filmed from a great distance rolling around as if wrestling and reduced to an illusion of flies buzzing around undisclosed remains. The comparison between human and animal is palpable. The harsh and direct beam of the searchlights that flood the figures makes them appear even smaller, and places the audience further back in the shadows. (Wu Meichun and Qiu Zhijie)

Liu Wei

1972 Born, Beijing, China
1996 Graduated, China National Academy of Fine Arts, Hangzhou, Zhejiang province, China
 Current, lives and works in Beijing, China

Group Exhibitions

1999 *Post-sense Sensibility: Alien Bodies and Delusion*, Beijing, China
 Supermarket, Shanghai, China
 Revolutionary Capitals: Beijing - London, Institute of Contemporary Art, London, UK
 The Same but Also Changed, Shanghai, China
2000 *House, Home, Family*, 4/F Yuexing Furniture Corporation, Shanghai, China
2001 *Nemesis*, Mustard Seed Gallery, Beijing, China
 Post-Sensibility: Spree, Beijing Film Academy, Beijing, China
 Non-linear Narrative, Gallery of the China National Academy of Fine Arts, Hangzhou, China
 Manic Ecstasy, Impression Gallery, Hangzhou, China
2002 *Too Much Flavor*, 3H Art Center, Shanghai, China

Feng Xiaoying
In the Situation
video; 7 min.

In the aquarium he perceives a fish; in the park he perceives happy visitors; in the swimming pool he perceives himself. As he perceives others, he is perceived by others too. Later he becomes perplexed by his perception. The fish, humans, other people and the surrounding intermix and perceive and respond to each other. Finally he vomits fish from his mouth. The images reveal the different psychological emotions people experience in different situations and the spiritual and physical existence of people in different situations. The film conveys an idea that all beings are estranged and unable to understand each other, that none can know the inner world of the others. (Wu Meichun and Qiu Zhijie)

Feng Xiaoying
1975 Born, Zhejiang province, China
Current, lives and works in Beijing, China

Group Exhibitions
1999 *Post-Sense Sensibility: Alien Bodies and Delusion*, Beijing, China
Hong Kong Short Film and Video Festival, Hong Kong
2000 *Multi-media Art Festival*, Brisbane, Australia
2001 *Beijing in Artists ' Eyes*, Beijing, China
Hot Pot, Kunsternes Haus, Oslo, Norway
Asia-Pacific Week, Berlin, Germany
2002 *Pingyao International Photography Festival*, Pingyao, China

Cui Xiuwen
Ladies
2000
video; 6 min., 12 sec.

In my work I always approach women from the angle of gender and focus on issues pertaining to women as an element of society. In *Ladies*, I chose the washroom of a luxury pub in Beijing and filmed the women who work there at night. In this specific time and space, what the public space contained and the status of women there greatly exceed the proper meaning that such a space is believed to have. This presents a current social problem that exists in a certain stage of history. On the surface my work shows the status of women, but what I focus on is the underlying social structure to this status and how people interpret my work from cultural, historical and economic angles. I chose video as the medium because it can clearly tell the audience the time, space and motif of my work. (Cui Xiuwen)

Cui Xiuwen

1990 Graduated, fine arts department, Northern China Normal University, China
1996 Further studies, oil painting department, Central Academy of Fine Arts, Beijing, China

Group Exhibitions

1998 *Century Women*, China Art Gallery, Beijing, China
 Sense and Sensibility, Schoeni Gallery, Hong Kong
2000 *Asia-Pacific New Media Art Exhibition*, Asia-Pacific New Media Art Center, Brisbane, Australia
 Post-Materialism: Photography, Beijing, China
 About Me, Documentary Exhibition of Experimental Art, Shanghai, China
2001 *China-Germany*, New Media Arts Festival, Loft New Media Art Space, Beijing, China
 Contradictions of Construction: Hong Kong/Beijing/Concept/Photography, Hong Kong Arts Centre, Hong Kong
 Dialogue: The Third Way, Bari Art Museum, Bari, Italy
2002 *Run, Jump, Crawl, Walk*, East Art Center, Beijing, China

我把女兒让我给骂跑了 没办法！
My friends were cursed away by me.What else can I do

Yang Fudong
I Don't Force You
1998
video; 2 min.

Twelve to fourteen men play a man that does not exist. Their movements done by the numbers join together to show that man speaking to himself, "I don't force you." Each of the twelve or fourteen men's performance lasts just a few frames so that scenes change rapidly. In Yang Fudong's video, the visual effect of scenes overwhelms the symbolic narrative used in early video films and makes up the self-sufficient framework of meaning. Therefore, essentially, Yang Fudong's video film refuses to be interpreted and needs no off-screen voice. (Wu Meichun and Qiu Zhijie)

City Light
2000
video; 6 min.

City light is like the spark showers that fly from the welder's torch, or the foglamp on a boat. You live in a city, crouched in a corner. This is not to say that very many people know of your existence, but nonetheless, you are a part of the city, the city is made up of a bunch of other people like you. The feeling of the city is precisely the feeling of these legions of people, living in a dream. (Yang Fudong)

See page 224 for the artist's portrait and CV.

I Don't Force You

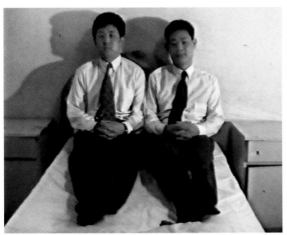
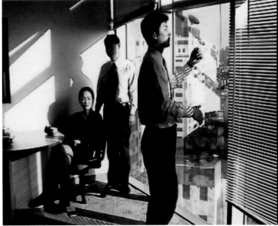
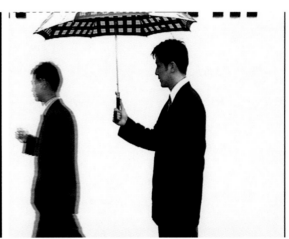

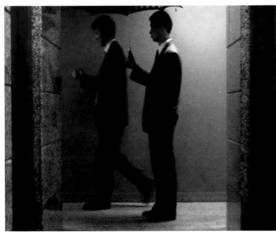

City Light

Zhou Shaobo
Several Moods in One Day
1999
video; 2 min., 26 sec.

Is behavior a mood of thought? Is mood the behavior of thought? Is behavior the material of thought? Is mood the material of behavior? Daily behavior has become people's experience and thought; when people are unconscious of the existence of behavior, this only proves that behavior has become their thought. When we encounter behavior, are we moved, are we compliant, are we tolerant? Perhaps the obliteration is the demise of thought. Therefore, recording behavior, recalling thought, experiencing mood all bring new possibilities to my individual visual perspective.

Zhou Shaobo

1962 Born, Congzuo, Guangxi province, China

1987 Studied, fine arts department, Nanjing Art Institute, Nanjing, China

Current, lives and works in Nanning, Guangxi province, China

Group Exhibitions

1992 *The First Guangzhou Biennale: Oil Painting in the Nineties*, Guangdong Exhibition Center, Guangzhou, China

1999 *Calligraphy of a Different Nature*, Nanjing, China

2000 *House, Home, Family*, 4/F Yuexing Furniture Corporation, Shanghai, China

2001 *China New Media Art Festival*, China National Academy of Fine Arts, Hangzhou, China

China-Germany, New Media Arts Festival, Loft New Media Art Space, Beijing, China

2002 *The Long March–A Walking Visual Display*, various locations, China

Global and Local

Wu Hung

The dialogue between global and local was one of the most powerful driving forces for the development of Chinese experimental art in the 1990s: it stimulated experimental artists to explore their self-identity, to expand their visual vocabulary, to make Chinese concepts and forms part of global contemporary art, and to recontextualize international art trends amid domestic concerns. Part One in this catalogue has explained the political, socio-economical, and intellectual context of this dialogue; the present discussion focuses on its impact on the content and form of artistic expression.

Globalization of Chinese art did not start from the 1990s, of course. But for a long time it was equated with the Westernization of Chinese art. From the early twentieth century onward, many Chinese artists abandoned the traditional Chinese brush. Some traveled abroad to study Western oil painting and sculpture first hand, but those who remained home also had ample opportunities to learn foreign art forms and techniques. The establishment of the People's Republic of China did not stop this historical process, but restricted the model of academic learning to Social Realist art of the Soviet Union. For more than three decades this particular "Western" style dominated contemporary Chinese art, but it became history after experimental art grew into a national movement through the '85 Art New Wave. Participants in this movement embraced all brands of modern Western art developed outside the canon of realism (including, for example, Surrealism, Dadaism, Abstract Expressionism, Conceptual Art, Body Art, and Pop Art). More importantly, they began to bridge the gap between Eastern and Western art, which had existed as a fundamental conceptual framework in which artists and historians envisioned modern Chinese art. Although the dominant influence of the '85 Art New Wave came from the West, it gave experimental Chinese artists the freedom to discover their own potential. Some of the best-known works from this period, such as Xu Bing's *Book from the Sky* and Wenda Gu's pseudo calligraphy, employ traditional Chinese idioms but reject their conventional meaning. No one disagrees that these are among the most original works of the global contemporary art of the 1980s, even though they were made in China by artists who had never been abroad (several years after creating these works, the two artists emigrated to the West).

The identity of Chinese experimental art has long been a contested issue. It is routinely caricatured by official Chinese critics as a local imitation of "decadent Western contemporary art." Within the pro-experimental art camp, some critics have divided experimental artists into two groups based on where they live. Taking a nationalist stand, they have coined the nickname "banana people" (i. e. people who have yellow skin but are "white" inside) for those artists who have emigrated to the West and gained fame there. Many Western critics tend to emphasize the relevance of Chinese experimental art to China's internal politics. Even though the art itself has transcended the East-West or global-local dichotomy, such views continue to inform discourse on the subject in different ways. Some critics based in Southeast Asia and Australia have tried to link Chinese experimental art to transnational phenomena such as the Chinese diaspora, but in so doing have often treated this art merely as a social movement.

There is no question that Chinese experimental art is related to all of these —— post-Cold War politics, global commercialization, and diaspora —— but the kind of reinterpretation pursued in this exhibition and catalogue is, first of all, an art historical one. To return to the '85 Art New Wave, this domestic movement makes it clear that from its beginning, Chinese experimental art was a branch of global contemporary art —— an identity determined not by where artists live but by the concepts and forms of their works and by their intended audience. On the other hand, this movement also makes it clear that being global does not exclude experimental Chinese artists from remaining local; the question is how they can internalize these two geo-cultural identities productively. The historical significance of the '85 Art New Wave lies not only in its

bridging of East and West, but in its initiation of numerous experiments that highlighted individual voices in global/local communication as a whole. 1990s experimental art developed against this background.

Four important developments in the 1990s brought the global/local dialogue in Chinese experimental art to a new level. First, experimental Chinese artists became regular participants in international exhibitions; many exhibitions of Chinese experimental art were also organized abroad. Second, promoted by transnational commercial galleries inside and outside China, this art became a global commodity. Third, a considerable number of experimental Chinese artists emigrated to other countries; "domestic" artists also frequently traveled to foreign exhibitions and created works around the world. Fourth, toward the end of the decade, some official Chinese museums began to develop exhibition projects that framed Chinese experimental art as part of global contemporary art.

With these changes, the global/local relationship became a constant stimulus, resulting in works that reflected different ideas and approaches. Critics have often attributed such differences to an artist's place of residence, arguing that overseas artists and those who remained in China do not have the same self-identities and points of view. But the real situation is often much more complex: during the 1990s, not only did so-called "local" artists spend increasing amounts of time abroad and deal directly with foreign institutions, curators, and audiences, while "overseas" artists also made frequent trips back home to create and exhibit their works there. It is more plausible to assume that both groups of artists developed global/local dialogues in their works based on specific situations, not on the official place of residence written in their passports. Therefore, instead of taking global and local as two external frames of classification, we should consider them as internal experiences and perspectives. The key to understanding these artists and their works is to discover how such experiences and perspectives were negotiated through specific art forms invented at a specific time and place.

For this exhibition, Wang Gongxin has recreated his 1995 video installation *The Sky of Brooklyn* (p. 400). Wang went to America in 1987 as a visiting artist in the State University of New York at Cortland and Albany, and afterwards took up residence in Brooklyn, New York. Starting from the early 1990s, he and his wife, artist Lin Tianmiao (for her work in this exhibition, see no. 00), embarked on a nomadic lifestyle, traveling between Beijing, New York and other international cities year round, hoping to create art that would convey their experience. *The Sky of Brooklyn*, which resulted from this desire, was inspired by an American folk belief that if a person dug a deep enough hole, he would emerge on the other side of the world in China. However, since Wang Gongxin is Chinese, he started his fantastic journey from Beijing, by digging a well in his small apartment there. At the bottom of the well he installed a small video monitor. As if looking through a transparent window, the visitor could see on the screen a piece of sky the sky above Wang Gongxin's Brooklyn home.

Personal experience also propelled Zhu Jinshi to create his *Impermanence* in 1996 (p. 430). The material of this striking installation included fifty thousand sheets of *xuan* paper, a standard medium for traditional Chinese painting and calligraphy. Without leaving a single stroke on the sheets, however, Zhu wrinkled and stacked them into a spectacular fortress-like structure, with a narrow passageway to the interior. The intricate construction struck the spectators as being both massive and fragile. When the exhibition ended, Zhu splattered ink on the sheets and burned them outside the exhibition hall. It is significant that the artist, who had emigrated to Germany in the early 1990s, created this work twice in 1996 as two parts of a single project. He first installed the paper-fortress in Beijing's Contemporary Art Gallery and later repeated it in Berlin's Georg Kolbe Museum. The idea seems obvious: since the installation itself derives many elements from traditional Chinese art and philosophy, by creating it both inside and outside China the artist acquires

an independent, transnational identity without losing sight of his own cultural heritage.

Cai Guo-qiang is another artist who has made the global/local dialogue a central theme of his art. His well-known contribution to the 1995 XLVI Venice Biennale, *Bringing to Venice What Marco Polo Forgot*, featured his arrival with bags of Chinese medicine in a sailboat at a theatrical setting, the Palazzo Giustinian Lolin, a seventeenth-century merchant's home. The supposed starting point of his symbolic journey was Quanzhou, Cai's home town in southeast China and, coincidentally, the port from which Marco Polo left China for Venice 700 years ago. Through this project Cai Guo-qiang makes a powerful statement that he, an artist from China, is reversing the direction of the East-West traffic, and that what he brings to the West with him are not just goods and stories, but an "Eastern view of the cosmos" that has escaped the attention of Western travelers.[1] One should not take this as a nationalist, anti-Western approach, because Cai has staged similar performances in China to "bring things to" his native country. The ambitious *To Extend the Great Wall 10,000 Meters: Project for the Aliens No. 10* (p. 404) is one such example. When Cai returned to China from Japan in 1993, he traveled along the Great Wall to its western limit. There, assisted by local people, he laid down a 10-kilometer-long fuse in the Gobi desert. Its simultaneous explosion created the spectacle of a "wall of fire," as if the Great Wall had suddenly come to life and grown to an unprecedented length.

Besides these performance-oriented projects imbued with the artists' transnational experiences, many works in 1990s Chinese experimental art conduct global/local dialogues by juxtaposing visual signifiers —— art motifs and mediums, objects in daily life, or written languages——from heterogeneous sources. Zhang Jianjun and Hu Youben both use traditional Chinese motifs to make "anti-traditional" installations. Zhang Jianjun, who resides in New York, made his *Fog Inside* (p. 408) in 1992 in Warsaw. The work is minimalist in spirit —— a large, flattened cylinder filled with ink-infused water. Although the form of the installation recalls a steel sculpture, the ink water inside it generates a sense of impermanence that is reinforced by the steam that slowly rises from the liquid and dissipates. The subtle movement of the steam has a meditative quality, reflecting an organic and wholesome understanding of the cosmos that the artist finds in Chinese philosophy. Thousands of miles away in China's Hebei province, Hu Youben fashioned huge installations that show nothing but layered black paint on a wrinkled surface, negating not only painted images but also the concept of painting (p. 432).

Scholar's rocks and Ming-style furniture——two conventional symbols of traditional Chinese culture ——are given new meaning in Zhou Chunya's and Ai Weiwei's works. In a series of paintings, Zhou, a German-trained artist, depicts scholar's rocks as living things in various stages of transformation (p. 426). The animated quality of these images, enhanced by sculpted surfaces and fluid brushwork, owes its inspiration both to German Expressionism and to the traditional Chinese *xie yi* (inscribing the mind) style. Ai Weiwei, on the other hand, deconstructs actual Ming-style furniture in a Chinese way: with techniques derived from a traditional Chinese carpenter, he takes tables, chairs, and stools apart and reassembles them into dysfunctional, post-modern sculptures. Wang Luyan has also found an iconic object for deconstruction, albeit from more recent Chinese history —— the bicycle. Although China is still "the country of bicycles" to outsiders, contemporary Chinese increasingly associate this vehicle with the Maoist era, when it provided billions of Chinese with the most basic means of transportation. This is perhaps why Wang Luyan often paints his remodeled bicycle red (no. 00). But he does more to the bicycle than merely painting it: with two small wheels added to the rear axle, the vehicle becomes a work of conceptual art, moving backward when pedaled forward.

The Chinese written language offers experimental artists a special signifier for their cultural origin. Among these artists, Xu Bing and Wenda Gu have both continued their language-based experimentation

since emigrating to America in the early 1990s. Xu Bing's recent project, *Square Word Calligraphy* (p. 416), involves the creation of a unique writing system that renders English in Chinese writing: using components of Chinese characters for English letters, he is able to transform an English word into what look like a Chinese character. While his "square words" can be considered a perfect fusion of Eastern and Western cultures, Xu Bing's ultimate goal is to create a device that can be of real service to people —— he hopes that his system will allow people to learn from one another while maintaining their own cultural heritage. Thus classrooms are set up at his exhibitions, complete with writing tables and tools, in which English speakers can practice Chinese calligraphy in English, and Chinese speakers can learn English by practicing Chinese calligraphy. By employing language-based signs, Wenda Gu executed many monumental projects in the 1990s in pursuit of a universal symbolic system. His *United Nations* —— a series of spectacular installations made of human hair —— represents different peoples, nations and countries of the world (p. 402). The global/local dialectic remains the central concept of these works, but the artist posits himself as a universal spokesman for all cultures in the world.

As demonstrated by these examples, many experimental Chinese artists are idealistic in attempting to mediate global/local perspectives and experiences; the assumption is that globalization, if freed from imperialistic and nationalist ambitions, can assimilate local creativities in a dynamic and productive way. This optimistic attitude, however, disappears in works that take international power struggles as their subject, and problematize globalization in this particular context. *Scriptures* (p. 410), a series of silk-screen map prints created by Hong Hao from 1992 to 1996, is one such work. The artist has cleverly created an optical illusion where each map has the appearance of the open leaves of a traditional Chinese thread-bound book. Each map reflects a pessimistic vision of the world: "The Division of Nuclear Arms Map" shows missiles stationed in every corner of the world, including Antarctica, which has been divided into segregated political territories. "The New World Order Map" changes the locations and shapes of different countries. "The New Geological World Map" switches sea and land. "The New Topographical World Map" alters the sizes of each country according to its military and economic power. "The Latest Practical World Map" renames cities with trendy expressions in popular culture and tosses economic charts around the earth. Fantastic and absurd, these pictures depict a world governed by violence and greed, a frightening image of the globe that the artist finds himself unable to escape.

If Hong Hao's pictures are satiric, Xu Jiang's images are tragic. His *Chess Match of the Century* depicts destroyed cities, broken monuments, and crumbling architectural spaces —— products of human civilization that humanity itself has turned into ruins (p. 412). Floating over these scenes are the disembodied hands of two chess players. Cast in relief, the hands symbolize the competing historical forces behind the destruction of civilization. Starting from the late 1980s, Xu began to use the game of Chinese chess to signify both tension and method. A chess match is motivated by the desire for control: behind a subtle, prolonged negotiation is a hunger for power and a determination to kill. A chess match is both spatial and temporal: it is never static, but consists of numerous movements on a geometric map. A chess match is both highly rational yet passionate: while following a set of rules, a player must manipulate these rules in order to win. For Xu Jiang, these are implications that make the game of chess an ideal metaphor for politics as well as for art.

1 Dana Friis-Hansen, "Towards a New Methodology in Art," in idem, et al., *Cai Guo-qiang* (London: Phaidon, 2002), p. 80.

Wang Gongxin

The Sky of Brooklyn: Digging a Hole in Beijing

1995

performance, installation, video

With his installation *The Sky of Brooklyn: Digging a Hole in Beijing,* Wang Gongxin wittily inverts an American saying "to dig a hole to China." He actually dug a hole in his private residence in Beijing, placing the "Brooklyn sky" at the other end. When you are foolishly curious enough to peer into the hole, a voice can be heard, "What are you looking at? There's nothing worth seeing here. A sky with some white clouds is not that interesting." Virtual reality induces delusive verity. The peeking desire driven by curiosity comes up against the more real and stronger emotion of boredom. Wang Gongxin employs this installation to design a trap to draw viewers in while he himself looks on coldly. This might be his attitude toward people and culture. His attempt to enable people to see a "Brooklyn sky" alerts people to his cue to two very different cultures and their social environment. (Qian Zhijian)

See page 156 for the artist's portrait and CV.

Wenda Gu
United Nations Hong Kong Memorial: Conflicts of History
1997
installation; human hair, Ming-style furniture, etc.
198 x 122 cm; 396 x 122 cm
Collection of Hanart TZ Gallery, Hong Kong

United Nations Hong Kong Memorial: Conflicts of History is the tenth work in Wenda Gu's human hair series of works for the United Nations, realized on July 1, 1997 at the Hanart TZ Gallery in Hong Kong. Owing to the exhibition's special date – the reversion of Hong Kong to Chinese sovereignty – the work was especially meaningful. He uses symmetrical images to symbolize the conflicts between East and West in the previous century. These conflicts, in turn, grow from humanity's blindness and ignorance toward history. Wenda Gu sees the conflicts of history as Oedipal tragedy. At the same time, looking at Hong Kong – itself the product of a clash between Eastern and Western civilization in the 19th century – Gu, as a Chinese, feels both his ancestors' colonial humiliation and his own courage to reflect upon this. The exquisite opium bed in the center of the installation functions as a symbol of the decadence and weakness of the late Qing. A Union Jack, symbolizing the military and technological dominance of Britain in the 19th century is set against pseudo-Chinese characters made of human hair, symbolizing the ascendancy of letters (and the corresponding decline of industry, commerce, and technology) that characterized China during the same period. In Gu's own words: "Using traditional Chinese seal-script characters has two meanings: ordinary Chinese people cannot recognize such characters, but linguistic experts who have undergone special training will discover the characters are non-existent. My pseudo-characters pose a question: in history, is there really any difference between truth and falsehood?" (Xu Xin)

Wenda Gu
1955 Born, Shanghai, China
1981 Graduated, Zhejiang Academy of Fine Arts, Hangzhou, Zhejiang province, China
 Current, lives and works in New York, USA

Solo Exhibitions
1996 *United Nations England Memorial: Maze*, Angel Row Gallery, London, UK
1997 *United Nations Taiwan Memorial: Lost Kingdom*, Hanart Gallery, Taipei, Taiwan
 United Nations Hong Kong Memorial: Conflicts of History, Hanart TZ Gallery, Taipei, Taiwan
1998 *United Nations Vancouver Memorial: Getting Hot*, University of British Columbia, Vancouver, Canada
 United Nations Temple of Heaven, SFMoMA, San Francisco, USA
1999 *United Nations Germany Memorial: A New Berlin Wall*, Berlin, Germany
2001 *No. 1 Silk Road*, Enrico Navarra Gallery, Paris, France

Group Exhibitions
1985 *Chinese Painting New Invitational Exhibition*, Wuhan Exhibition Hall, Wuhan, China
1993 *China's New Art, Post-1989*, Hong Kong Arts Centre, Hong Kong
1997 *The First Johannesburg Biennial*, Johannesburg, South Africa
1998 *Inside Out: New Chinese Art*, Asia Society Galleries, PS 1 Contemporary Art Center, New York, USA
 The Second Shanghai Biennale, Shanghai Art Museum, Shanghai, China
 Transience: Chinese Experimental Art at the End of the Twentieth Century, Smart Museum of Art, University of Chicago, Chicago, USA
1999 *The Power of Language*, Taiwan Museum of Art, Taipei, Taiwan
 The Fifth Lyon Biennial of Contemporary Art, Lyon, France
2000 *Pause: The Fourth Kwangju Biennial*, Kwangju, Korea Republic

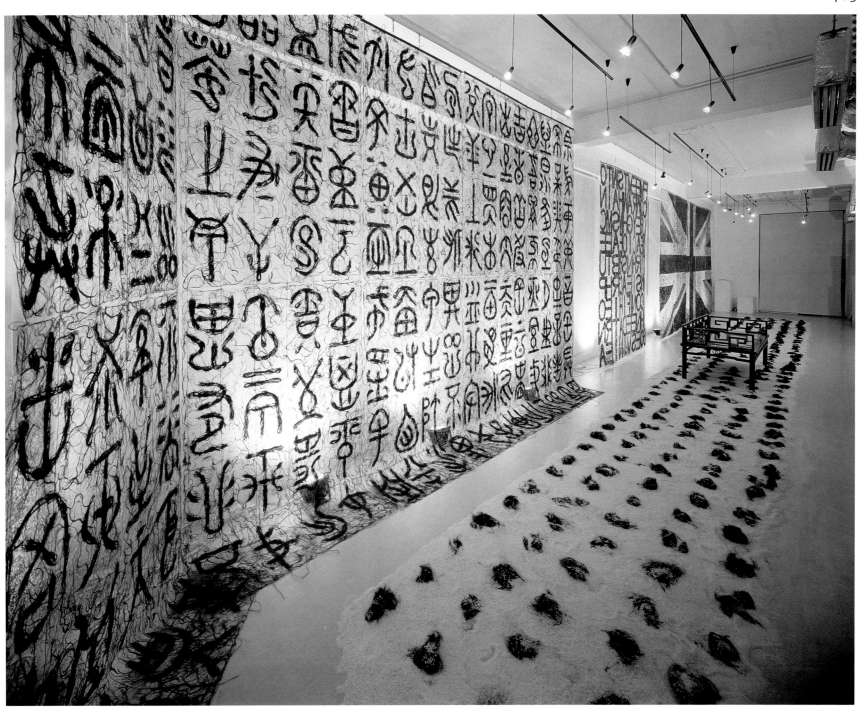

Cai Guo-qiang
To Extend the Great Wall 10,000 Meters: Project for the Aliens No.10
1993
performance

From 1989, Cai Guo-qiang embarked on the series of works "for the aliens." The aim was to send out signals to the universe and seek a channel for communication between earth and aliens. In his view, communication with aliens was more urgent than a dialogue with the West, for such communication could help us escape from under a powerful/constraining logic. In the relationship between the universe and mankind it is possible to find a true individual space. Cai Guo-qiang's works are often monumental in scale, often more than 10,000 square meters, or many kilometers. The creative process often requires more than a hundred people to realize. But these works are not meant to be seen on earth, but by those out there in the universe looking down. From this perspective, Cai Guo-qiang's works are rather on the small side. The artist's attitude is also that of one producing small-scale works. As Laozi said:"Govern a nation as one does one's own backyard. Even where nations are large, people can be greater." By saying that people can be as great as the universe makes the earth seem small. And where the world is small, conflicts between East and West pale into insignificance. Only when this is not important can the two sides enter into a dialogue. (Fei Dawei)

Cai Guo-qiang
1957 Born, Quanzhou, Fujian province, China
1985 Graduated, department of stage design, Shanghai Academy of Drama, Shanghai, China
Current, lives and works in New York, USA

Solo Exhibitions
1990 *Works 1988-89*, Osaka Contemporary Art Centre, Osaka, Japan
1993 *To Extend the Great Wall 10,000 Meters*, Jiayuguan, China
1996 *The Century with Mushroom Clouds — Projects for the 20th Century*, Nevada, Nuclear Test Site, Salt Lake, New York, USA
1997 *Cultural Melting Bath: Projects for the 20th Century*, Queens Museum of Art, New York, USA
1998 *No Construction, No Destruction: Bombing the Taiwan Museum of Art*, Taiwan Museum of Art, Taichung, Taiwan
2001 Artistic direction for APEC Cityscape Fireworks, Asia Pacific Economic Cooperation, Shanghai, China
2002 *Transient Rainbow*, MoMA, New York, USA
Cai Guo-Qiang, Shanghai Art Museum, Shanghai, China

Group Exhibitions
1985 *The Shanghai and Fujian Youth Modern Art Joint Exhibition*, Fuzhou City Museum, Fujian, China
1990 *Chine: Demain pour hier*, Pourrieres, France
1995 *The First Johannesburg Biennial*, Johannesburg, South Africa
1996 *The Hugo Boss Prize 1996*, Guggenheim Museum Soho, New York, USA
In the Ruins of Twentieth Century, PS 1 Contemporary Art Center, New York, USA
1997 *Future, Past, Present: The 47th Venice Biennale*, Italy
1998 *Where Heaven and Earth Meet*, Art Museum of the Center for Curatorial Studies, Bard College, New York, USA
1999 *Aperto Over All: The 48th Venice Biennale*, Venice, Italy
Looking for a Place, The Third International Biennial, SITE Santa Fe, USA
2002 *The Power of Art—The Second Inaugural Show of the Prefectural Museum of Art*, The Prefectural Museum of Art, Hyogo, Kobe, Japan

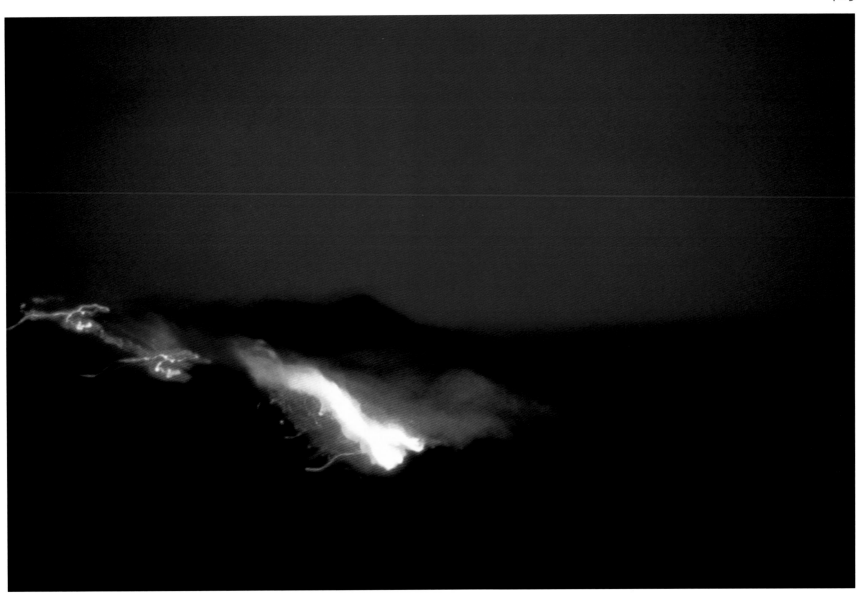

Wu Shanzhuan
No Water This Afternoon
2000
installation

No Water This Afternoon expresses Wu Shanzhuan's sensitivity to language. He is conscious of the "tyranny" and the limits of language, and thus his creation is often of a "damaging" nature. He both disregards artistic convention and disrespects linguistic order. He uses its "unknown power" to rip a hole in the traditional and powerful "net of language." In his grammatical errors and incomplete sentences we see a fracture, and perhaps the fracture may open for us a new way of thinking. (Wen Neng)

Wu Shanzhuan

1960 Born, Zhoushan, Zhejiang province, China

1986 Graduated, Zhejiang Academy of Fine Arts, Hangzhou, Zhejiang province, China

1995 Graduated, Hamburg Institute of Art, Hamburg, Germany
Current, lives and works in Germany

Solo Exhibitions
2001 *No Water This Afternoon*, Ethan Cohen Fine Arts, New York, USA
2002 *No Water This Afternoon*, Hanart TZ Gallery, Hong Kong

Group Exhibitions
1989 *China/Avant-garde*, China Art Gallery, Beijing, China
1993 *China Avant-garde*, Haus der Kulturen der Welt, Berlin, Germany:
The 45th Venice Biennale, Venice, Italy
1996 *Northern Europe Biennial: Scream*, Aachen Contemporary Art Museum, Copenhagen, Denmark
1998 *Berlin, Berlin: Platform*, Berlin, Germany
1998 *Inside Out: New Chinese Art*, Asia Society Galleries, PS 1 Contemporary Art Center, New York, USA
1999 *Global Conceptualism: Points of Origin, 1950s-1980s*, Queens Museum of Art, New York, USA
2001 *The Third Mercosul Biennal*, Bodoualige, Brazil
Chengdu Biennale, Chengdu Modern Art Museum, Chengdu, China

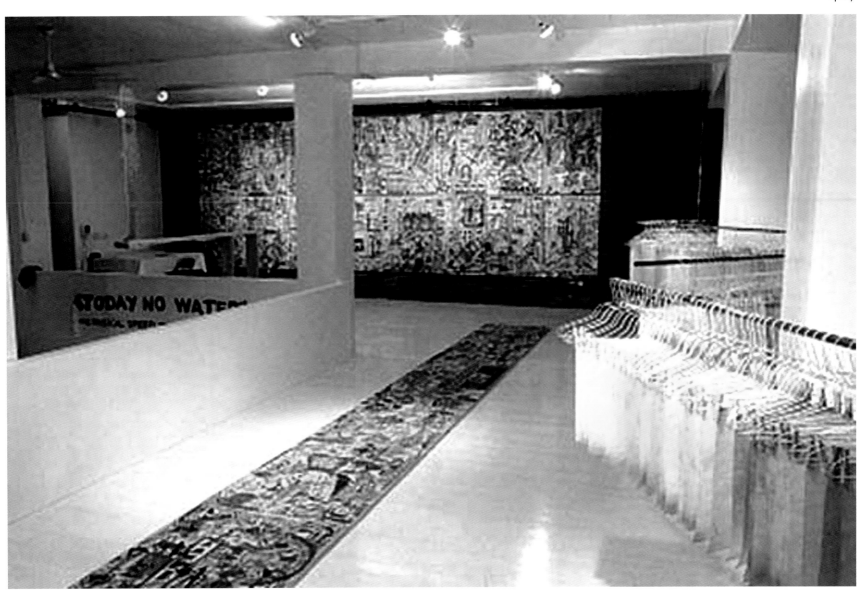

Zhang Jianjun
Fog Inside
1992
metals, ink, water
200 x 200 cm

I have always had a passion for water and black ink, and all the special traits of ink. Ink and mist arise slowly from the container in the work and drift, suspended in the air, before gently dissipating. The entire mood describes sensations that are beyond words; what is actually a personal response to experiencing the nuances of Chinese culture. (Zhang Jianjun)

Zhang Jianjun

1955 Born, Shanghai, China
1978 Graduated, fine arts department, Shanghai Academy of Drama, Shanghai, China
 Current, teaches at New York University Art Institute, New York, USA

Solo Exhibitions

1987 *Nature*, Shanghai Art Museum, Shanghai, China
1997 *Footprints*, Galerie Deux, Tokyo, Japan
2001 *International Art Plan*, New York, USA
2002 *Sumi Ink Increation Garden*, He Xiangning Art Museum, Shenzhen, China

Group Exhibitions

1983 *1983 Experimental Painting Exhibition*, Fudan University, Shanghai, China
1987 *Under Transformation: Contemporary Chinese Art*, Hong Kong Arts Centre, Hong Kong
1989 *China/Avant-garde*, China Art Gallery, Beijing, China
1996 *The First Shanghai Biennale*, Shanghai Art Museum, Shanghai, China
2000 *The Seventh Poland Biennial*, Lutz, Poland
2001 *The 49th Venice Biennale*, Venice, Italy
 Chengdu Biennale, Chengdu Modern Art Museum, Chengdu, China

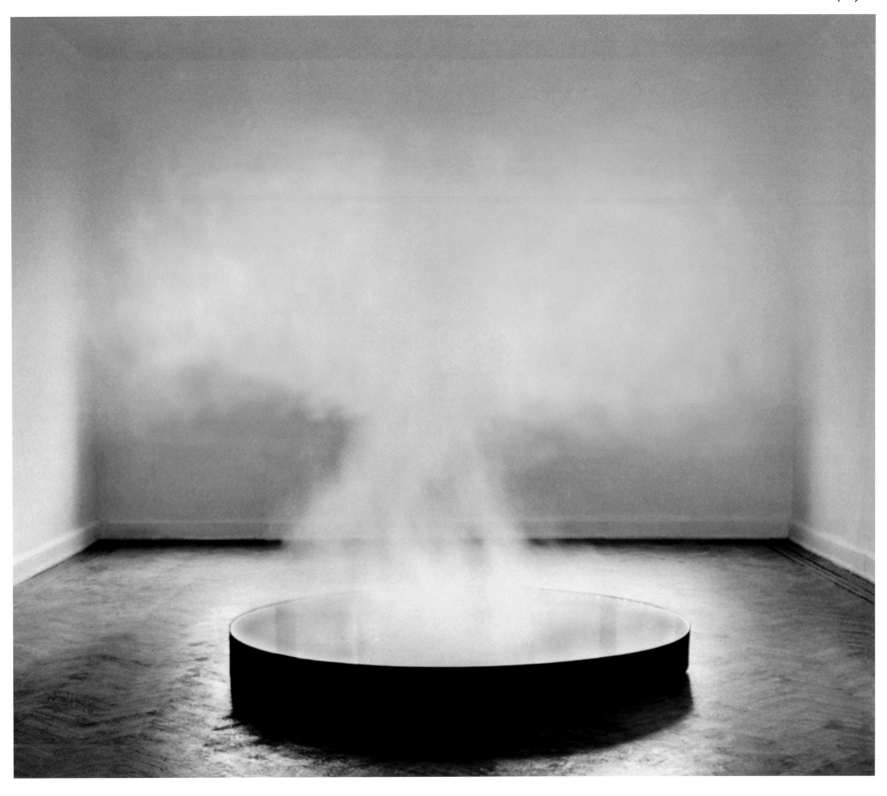

Hong Hao
Scriptures

1995
12 silk-screen prints
55 x 78 cm each

The Division of Nuclear Arms was the first of my works about maps. In this work, I placed emphasis on the mutability of maps and boundary lines, making them as strange as classical maps appear to us now. At the same time, outlining national military precincts, "unveiling" these secret regions for all to see, highlighting the danger zones of each nation. In *New World Order* I rearranged the geographical location and formation of the countries around the world, renaming them using the names of large corporations to create new nations. *New World Geography* interchanges the oceanic and physical divisions of the world turning oceans into landmasses and landmasses to sprawls of ocean, inverting land and water. The meaning lies in the challenge to conventional thinking and confusion of the visual senses. *New Topography* exploits the forms of nations in regard to their strengths and weaknesses on the global stage. So all advanced nations are accorded vast areas of land, while smaller countries are squeezed into diminished scale. In *The New World No.2*, Asian and Third World countries are brought to the fore to express a new world order in a new era. *The Latest Practical World Map* exchanges the names of the most widely known capitals across the globe with popular phrases or words. *New World Geographic Map* expands physical landmasses and employs a large amount of yellow to emphasize a sense of grandeur and splendor. (Hong Hao)

Hong Hao

1965 Born, Beijing, China
1989 Graduated, print-making department, Central Academy of Fine Arts, Beijing
 Current, lives and works in Beijing, China

Solo Exhibitions

1999 *Hong Hao – Selected Scriptures*, Canvas International Art, Amsterdam, the Netherlands
2000 *Suspended Disbelief*, Art Beatus Gallery, Vancouver, Canada
 Scenes from the Metropolis, CourtYard Gallery, Beijing, China

Group Exhibitions

1993 *China's New Art, Post-1989*, Hong Kong Arts Centre, Hong Kong
1994 *Mao Goes Pop, China Post-1989*, Museum of Contemporary Art, Sydney, Australia
1995 *Change – Modern Art from China*, Goteburg Art Museum, Goteburg, Sweden
1997 *Immutability and Fashion*, Kirin Art Space, Harajuku, Tokyo
1998 *Inside Out: New Chinese Art*, Asia Society Galleries, PS 1 Contemporary Art Center, New York, USA
1999 *Revolutionary Capitals: Beijing - London*, Institute of Contemporary Art, London, UK
2000 *Big Torino 2000: Biennial of Emerging Artists*, Torino, Italy
 Shanghai Spirit: The Third Shanghai Biennale, Shanghai Art Museum, Shanghai, China
2001 *Cross Pressures, Contemporary Photography and Video from Beijing*, Oulu Art Museum, Oulu, Finland
 Los Angeles Biennial, Los Angeles, USA
 Chengdu Biennale, Chengdu Modern Art Museum, Chengdu, China

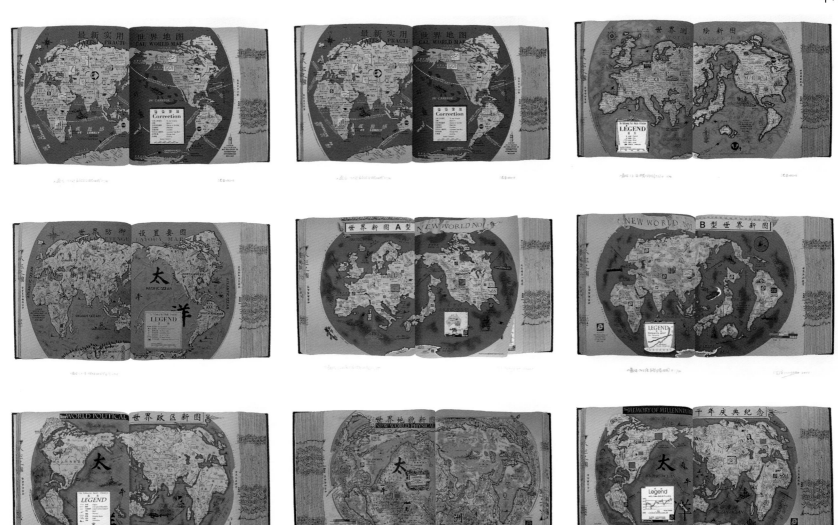

Xu Jiang
World in Transformation: Stone Stele

1998
oil on canvas, silica gel
130 x 210 cm

The scenes that Xu Jiang describes are epic. This is not because he employs a large scale of canvas but more due to the kind of heroism that characterizes the works. These scenes alone are not the main subject of Xu Jiang's art. The surface of the painting is covered with the handprints of chess players. The hands form a dialogue, raised in low-relief on the surface, as more than a recurring meaning in the painting for they interfere with the entire pictorial space. Between 1996 and 1998, Xu Jiang produced a grand series of paintings titled *Chess Match of the Century*. Here, we see cities that have been demolished, smashed memorials, and collapsed architectural structures. The fruits of human civilization are here being turned into ruins by humankind. The chess player's hand floating high above these scenes speaks for the evil concealed destroying the world beneath it, and the powerful history of confrontation. From another angle, the hand disrupts the painting in the same manner, for it denies all the possibilities of deconstruction. (Wu Hung)

Xu Jiang

1955 Born, Fuzhou, Fujian province, China
1982 Graduated, oil painting department, Zhejiang Academy of Fine Arts, Hangzhou, Zhejiang province, China
1988-89 Fellowship at Hamburg Academy of Fine Art, Hamburg, Germany
 Current, director of China National Academy of Fine Arts, Hangzhou, China

Solo Exhibitions

1986 *Spiritual Chess*, Saitou Galerie, Hamburg, Germany
1993 *Four Seasons, Eight Directions*, Hong Kong
2001 *Historical Landscapes*, Berlin, Germany

Group Exhibitions

1987 *Through the Open Door*, Asian Art Museum, Pasadena, California, USA
1993 *The First Biennial of Asian Art*, Queensland Art Gallery, Brisbane, Australia
1994 *Invitational Exhibition of Works Selected by Chinese Critics*, China Art Gallery, Beijing, China
1996 *The First Shanghai Biennale*, Shanghai Art Museum, Shanghai, China
1998 *The 24th Sao Paulo Biennial*, Sao Paulo, Brazil
1999 *The 14th International Asian Art Exhibition*, Fukuoka Modern Art Museum, Fukuoka, Japan
2000 *A Century of Chinese Oil Painting*, China Art Gallery, Beijing, China
2001 *Living in Time*, Hamburg Bahnhof Museum of Contemporary Art, Berlin, Germany

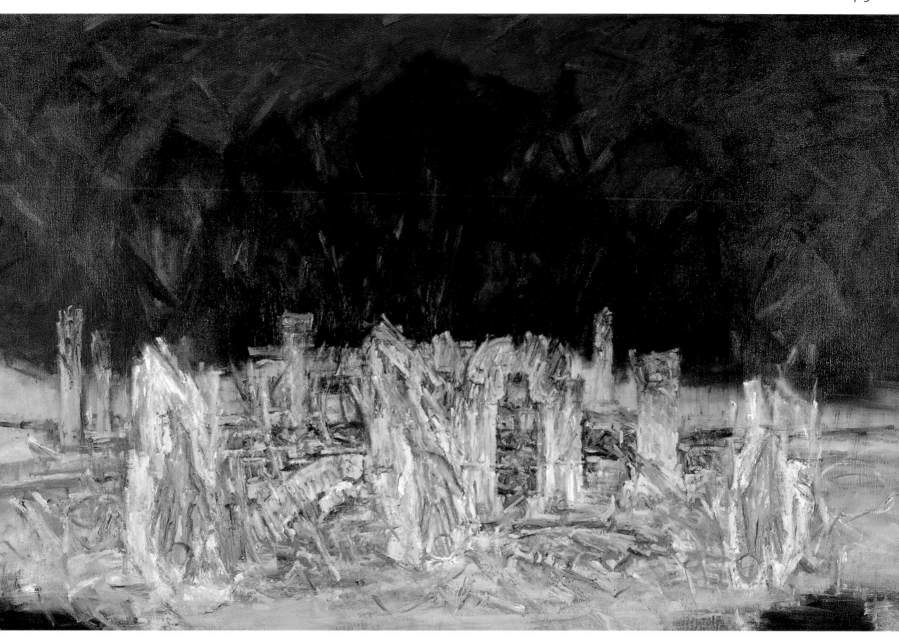

Yu Fan

Flying

1998
lead, synthetic fibre, resin
160 x 160 x 45 cm
Collection of the Qingdao Sculpture Museum, Qingdao

Submarine

1998
synthetic fibre, resin
153 x 83 x 46 cm
Collection of the He Xiangning Art Museum, Shenzhen

Between 1998 and 1999, I produced these two sculptural works. Both revealed a move towards installation art, perhaps we can say installation-style sculpture or sculptural installation. Sculpture as a language, for as long as it has existed, has been governed by content and concept. It has become our habit to ask what does this express, or what concept does it contain within? *Flying* and *Submarine* both have a sense of a shark, or a plane, but when these concrete elements come together to form the vessel I had envisaged, it both appears to be and yet is not what it seems. Ultimately, we are unable to discern a story, and perhaps feel the form to be abstract after all. This is the moment at which sculpture transcends its form to become a meaningful matter/object. (Yu Fan)

Yu Fan

1966 Born Qingdao, Shandong province, China
1988 Graduated, fine art department, Shandong Art Institute, Qingdao, China
1992 Graduated, sculpture department, Central Academy of Fine Arts, Beijing, China
 Current, professor, sculpture department, Central Academy of Fine Arts, Beijing, China

Solo Exhibitions

1996 *Between Inside and Outside*, Passage Gallery, Central Academy of Fine Arts, Beijing, China
2000 *I Live at 2208, Where Do You Live?*, Passage Gallery, Central Academy of Fine Arts, Beijing, China

Group Exhibitions

1994 *Deveplopment Plan*, former campus of the Central Academy of Fine Arts, Wangfujing, Beijing, China
 Women/Here, Contemporary Art Gallery, Beijing, China
1995 *Reality: Present and Future*, International Art Palace, Holiday Inn Crowne Plaza, Beijing, China
1999 *Transience: Chinese Experimental Art at the End of the Twentieth Century*, Smart Museum of Art, University of Chicago, Chicago, USA
 The Second Contemporary Sculpture Art Annual Exhibition, He Xiangning Art Museum, Shenzhen, China
2000 *Gate of the New Century*, Chengdu Modern Art Museum, Chengdu, China
2001 *Chengdu Biennale*, Chengdu Modern Art Museum, Chengdu, China

Xu Bing
Square Word Calligraphy Classroom
1994-96
installation; mixed media, ink, texts, brushes, classroom furniture

Xu Bing's *New English Calligraphy* is a new kind of writing style in which the words written are actually English though they appear like Chinese characters. The artist changes the gallery into a classroom for this calligraphy lesson as an installation piece. In the classroom, chalkboard, desks and chairs, writing materials such as brush and ink. and teaching guidance are provided. The artist has prepared textbooks for beginners to *New English Calligraphy*, a videotape of *New English Calligraphy* teaching and copybooks used in traditional calligraphy practice. As the audience enters the space, they enter a place of study. The Eastern calligraphy made into English culture gives the participants a brand-new experience. People's previous concepts of culture are challenged during the course of the familiar but strange transformation, thus their thoughts are stimulated to explore the essence of cognition.

Xu Bing collects *the New English Calligraphy* exercises produced by audiences world-wide and displays them in the second classroom as a display of "students" work. In addition, *New English Calligraphy* has been developed into a computer software program by the artist and a Japanese software company. This program can automatically transform English words into the form of *New English Calligraphy*. When the project is completed, a new word library will be available for people to write, access on the Internet, communicate with, print out, publish and use in design. At the entrance to the classroom a computer is installed with the program and a printer, and the audience is encouraged to write and print out their texts. (Xu Bing)

See page 146 for the artist's portrait and CV.

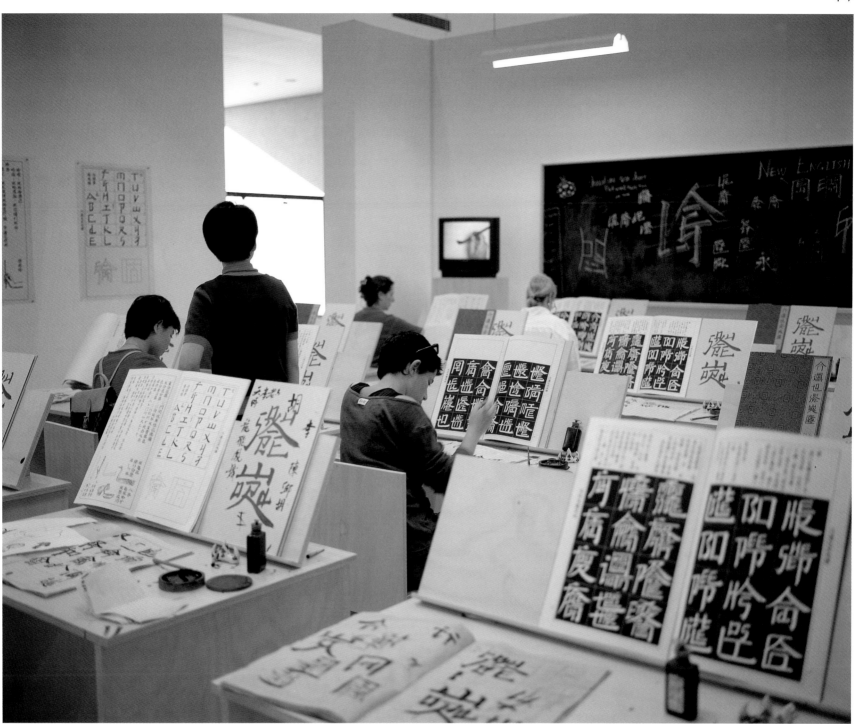

Huang Yan
Huang Yan's Postal Art
1994
performance, printed matter

Huang Yan's *Collection* series is pivoted on a set of self-imposed guidelines to which the artist had to adhere. From his "home" to the "letter" back to the "home" (the artist re-receiving the letters he had sent out) he employed a traditional, quotidian and yet personal set of conduits to restore to art a direct relationship between people. This meant that standards of beauty and private communication were exemplified from the prevailing desires for material gain and alienation from social systems, which was especially characteristic of the early stages of the market economy with its wild hype and crazy strategies.

The origin of Huang Yan's creative approach lay in the reproductive nature of print-making, the limitless potential for production, which gives rise to enormous possibilities. His action relates to this in the sense that the envelopes he used for mailing his letters were made from photocopies with a work on the back, making each letter a work in its own right. From their journey through the postal system, each bore a postmark when returned to him. The works were thus imbued with an element of performance art and a creative quest. Through this action art, by exploiting a social institution, the artwork succeeded in conveying an ulterior cultural meaning. (Wang Lin)

Huang Yan

1966 Born, Jilin province, China
1987 Graduated, art department, Changchun Normal University, Changchun, Jilin province, China
 Current lives and works between Beijing and Jilin, China

Solo Exhibitions
1996 *Carving a Chair*, Proper Art Gallery, Shenyang, China
1997 *The Postal Art of Huang Yan*, Contemporary Art Gallery, Beijing, China
1999 *Ideal Image*, Proper Art Gallery, Shenyang, China
2002 *Reflections upon Tradition*, Hanart TZ Gallery, Hong Kong

Group Exhibitions
1988 *The Image of the Object*, Art Gallery of Dongbei Normal University, Changchun, China
1992 *The First Guangzhou Biennale: Oil Painting in the Nsineties*, Guangdong Exhibition Center, Guangzhou, China
1994 *Mao Goes Pop, China Post-1989*, Sydney, Australia
1998 *Corruptionists*, Beijing, China
 Traditional and Anti-traditional Art, German embassy, Beijing, China
2000 *Gate of the New Century*, Chengdu Modern Art Museum, Chengdu, China
2001 *Hot Pot*, Kunsternes Haus, Oslo, Norway
 Red Hot: A Special Exhibition of Contemporary Chinese Art, Red Gate Gallery, Beijing, China
 Virtual Future, Guangdong Museum of Art, Guangzhou, China

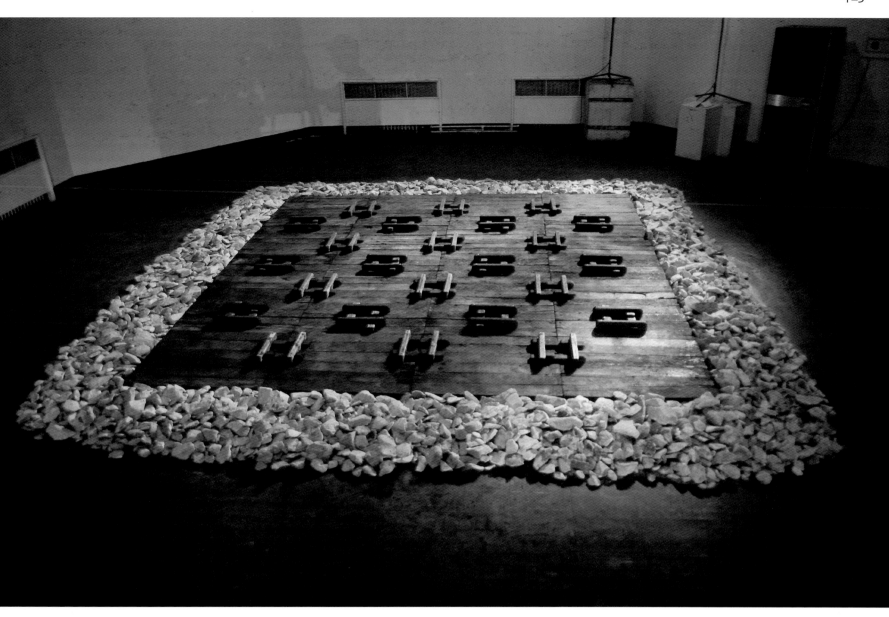

Lü Shengzhong
Red Soul: Form and Shadow
1991
installation; cut wooden boards
2000 × 1000 × 2000 cm

The figures of the "*xiao hong ren*" (small red people) are not the creation of my fancy. This figure of great stature, symmetrical in form and with four limbs outstretched, has appeared in early cultures of different nationalities in different areas of the world. It is the simplest depiction that man used to acknowledge himself, the earliest self-portrait of man, reflecting the commonality of all cultures in their childhood.

At present, when science and industry are highly developed, people no longer believe that souls exist like small people inside their bodies as primitive people did. They don't carry out rituals or rites when they fall ill or are frightened. Yet, modern people's attitudes and arrogance inflict more spiritual and psychological illness upon themselves. In the production of this work, I had no intention of recreating rites or rituals in present society. Rather, as I cut the paper with my scissors and separate the shapes that result, I am making a statement against the morbidity of the world, the malformation of history, where the soul and body have become separated. I present simplicity and perfection in a juxtaposition of positive and negative forms, or the perfect coexistence of *yin* and *yang*, as a reminder of the detached forms of the souls that will reunite with their bodies when the moment is right. This issue is profound and plain, but I feel I must put my energy into it. (Lü Shengzhong)

Lü Shengzhong
1952 Born, Dayuji Village, Shandong province, China
1978 Graduated, art department, Shandong Normal University, Ji'nan, Shandong province, China
1987 Master's degree, folk art department, Central Academy of Fine Arts, Beijing, China
 Current, professor in the folk art department, Central Academy of Fine Arts, Beijing, China

Solo Exhibitions
1988 *Lü Shengzhong Papercuts*, China Art Gallery, Beijing, China
1989 *Life – Ephemeral and Eternal*, Taipei, Taiwan
1990 *Calling the Soul Around*, Beijing, Hebei, Shanxi, Hunan, Guangxi, Liaoning provinces, China
1991 *Calling the Soul: Papercut Exhibition*, Contemporary Art Museum, Beijing, China
1992 *Red Train*, Amden, Berlin, Wiesbaden, Hamburg, Germany
1994 *Soul Stele*, Adelaide, Australia
 Soul Market, Beck Forum, Munich, Germany
 Emergency Center, St. Petersburg, Russia
1996 *Calling the Soul*, Fukuoka Art Museum, Fukuoka, Japan
2000 *Record of Emotion*, Red Gate Gallery, Beijing, China
 First Encounter, Chambers Fine Art, New York, USA
 Good-bye Sorceress, Chidao county, Xunyi, Shanxi province, China
2001 *Lü Shengzhong World!*, Fukuoka Art Museum, Fukuoke Japan
2002 *A la nuit tumbee – Lü Shengzhong*, Grenoble, France

 Traditional and Anti-traditional Art, German embassy, Beijing, China
2001 *Gate of the New Century*, Chengdu Modern Art Museum, Chengdu, Sichuan province, China
2001 *Clues to the Future*, Red Gate Gallery, Beijing, China
2002 *Delusion*, Wenrui Mental Institute, the Netherlands

Group Exhibition
1989 *China/Avant-garde*, China Art Gallery, Beijing, China
1992 *Encountering the Other*, K-18, Kassel, Germany
1993 *China's New Art, Post-1989*, Hong Kong Arts Centre, Hong Kong
1994 *Fourth Asian Art Show*, Fukuoka Art Museum, Fukuoka, Japan
1995 *Beyond the Border: The First Kwangju Biennial*, Kwangju, Korea Republie
1996 *Arcos da Lapa*, Rio De Janeiro, Brazil
 Origin and Myths of Fire, Museum of Modern Art, Saitama, Japan
1998 *Notes Across Asia*, Berlin, Germany

Zhou Chunya
Tai Lake Stone
1999
oil on canvas
150 x 200 cm
Collection of Mr. Guan Yi

Rock is the everlasting and prolonged subject of Chinese writers and artists over centuries. Its bulkiness, veins and texture on the surface provide an opportunity for expression, especially the richness and complication that Taihu rocks represent. Its round and smooth shape brings out an effect which is implicit yet strong after being rearranged manually, so that the artists can use them to form a finished figure without polishing. Taihu rocks are also called "skull rocks;" in order to exaggerate the red earth on the rocks, I intentionally painted the redness into blood running out from the holes on the rocks. I didn't think much of it, until during a lecture at the Sichuan Academy of Fine Arts, when students suggested that there might be bloodiness and violence in these works. I found the charm of Taihu rocks, but also its contradictory state and temperament. (Zhou Chunya)

Zhou Chunya

1955 Born, Chongqing, China
1982 Graduated, painting department, Sichuan Academy of Fine Arts, Chongqing, China
1988 Graduated, free arts department, Kassell University, Kassell, Germany
 Current, lives and works in Chengdu, Sichuan province, China

Solo Exhibitions

1987 Sino-German Friendship Association, Dusseldorf, Germany
 Dornach-Anhof Cultural Centre, Linz, Austria
1994 Xiaoya Gallery, Taipei, Taiwan
1997 Beizhuang Gallery, Taipei, Taiwan
2002 3.14 International Art Centre, Norway
 Contemporary Art Museum, Trento, Italy

Group Exhibitions

1981 *The Second National Youth Fine Art Exhibition*, China Art Gallery, Beijing, China
1985 *Emerging Young Chinese Oil Painters*, China Art Gallery, Beijing, China
1992 *The First Guangzhou Biennale: Oil Painting in the Nineties*, Guangdong Exhibition Center, Guangzhou, China
1993 *China's New Art, Post-1989*, Hong Kong Arts Centre, Hong Kong
1994 *Invitational Exhibition of Works Selected by Chinese Critics*, China Art Gallery, Beijing, China
1996 *The First Shanghai Biennale*, Shanghai Art Museum, Shanghai, China
 China!, Kunstmuseum Bonn, Bonn, Germany
1997 *Quotation Marks*, Singapore Art Museum, Singapore
2000 *Twentieth Century Chinese Oil Painting*, China Art Gallery, Beijing, China

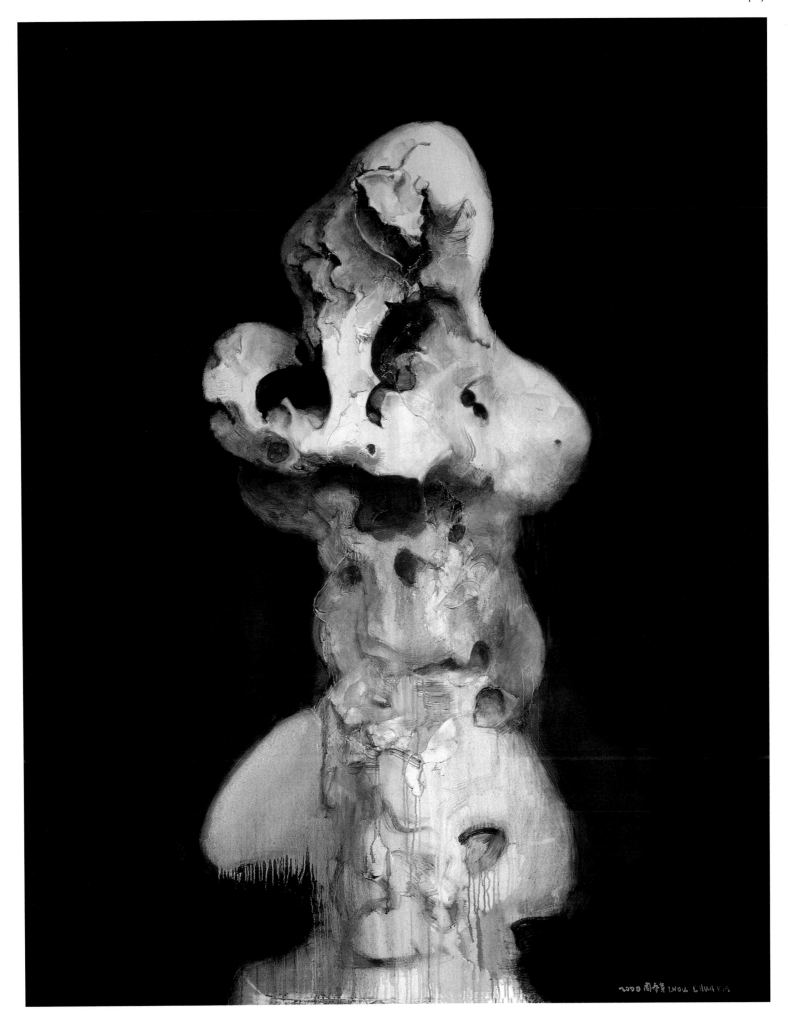

Wei Qingji
Narrative without Plot No. 9804
2000
ink painting
78 x 55 cm
Collection of Guangdong Museum of Art, Guangzhou

Employing the medium of ink, I seek to express that which lies between material and spirit, and to incorporate into the work a new literati spirit. The picture plane becomes a field for my experience and feelings. Thoughts and memories appear and disappear unexpectedly across this open space. It is in this space that we might find suspense and faith, new imaginings, personal emotion, intuition, traces of history, and the mysteries of religion. Of course, there might also be sensuality and temptation. (Wei Qingji)

Wei Qingji

1971 Born, Qingdao, Shandong province, China

1995 Graduated, Chinese painting department, Nankai University, Tianjin, China

Current, teaches in the department of fine arts, China Southern Teaching University, Guangzhou, China

Solo Exhibitions

1999 *Wei Qingji 's Ink Paintings*, Brush Work Gallery, San Francisco, USA

Group Exhibitions

1993 *The Second Contemporary Ink Painting Exhibition*, Changjiang Artists' Fine Arts Museum, Wuhan, China

1996 *Towards the 21ˢᵗ Century: Contemporary Chinese Ink Painting Research Exhibition*, Guangzhou, China

1999 *Ink and Installation*, Artists' Commune, Hong Kong

2000 *On the Periphery of Ink*, Hong Kong Art Development Art Space, Environmental Art Museum, Hong Kong

2001 *Twenty Years of Ink Experiment*, Guangdong Museum of Art, Guangzhou, China

Dusseldorf International Art Exhibition, Exhibition Center, Dusseldorf, Germany

Chengdu Biennale, Chengdu Modern Art Museum, Chengdu, China

2002 *The Brilliance of Ink: Cross-Straits Contemporary Ink Painting Exchange Exhibition*, Guofu Memorial Hall, Asian Art Center, Taipei, Taiwan

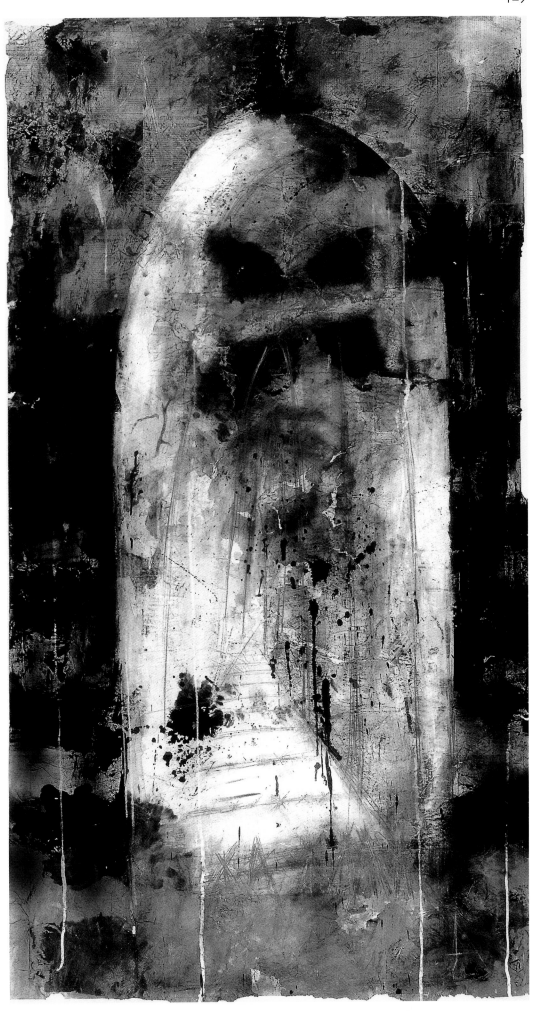

Zhu Jinshi
Impermanence
1996
installation; rice paper, bowls, water
1500 x 1500 x 300 cm

With his hands, the artist scrunched up each of five hundred sheets of rice paper and then smoothed them out again. These he then laid one on top of the other to create a wall 15 meters long by 15 meters wide and two meters high in the shape of a seal. Within this walled form lay a small space that could only be reached by passing through the narrow passages created by the wall. In this space was a small antique bowl. The whole form has a strong Taoist flavor. For the audience, Zhu Jinshi's work is very pedestrian. Both the materials and language used are simple and unadorned. Perhaps this is part of the reason he selects these materials and forms, as being what he perceives Chinese culture needs. In introducing his contemplation of the gap between Western and Chinese culture to his works, they are imbued with a sense of Chinese philosophy. By creating peaceful, composed and restful environments, he constructs his musing and exploration of Chinese culture out of his experience of Western culture. (Qian Zhijian)

Zhu Jinshi
1954 Born, Beijing, China
 Current, lives and works be-
 tween Beijing, China and
 Berlin, Germany

Solo Exhibitions
1990 DAAD Gallery
1995 Ruins for Art, Berlin, Germany
1996 *Impermanence*, Art Museum of Capital Normal University, Beijing, China;
 Berlin, Germany
1997 Vancouver Museum, Vancouver, Canada
1998 Sabuhuiken City Gallery, Germany
 Weimar Artists' Association, Weimar, Germany
 Hartwig Gallery, Bremen, Germany
 Banff Media Art Centre, Banff, Canada
1999 Artists' Association, Kapeila, Germany
 Harfeld Gallery, Berlin, Germany

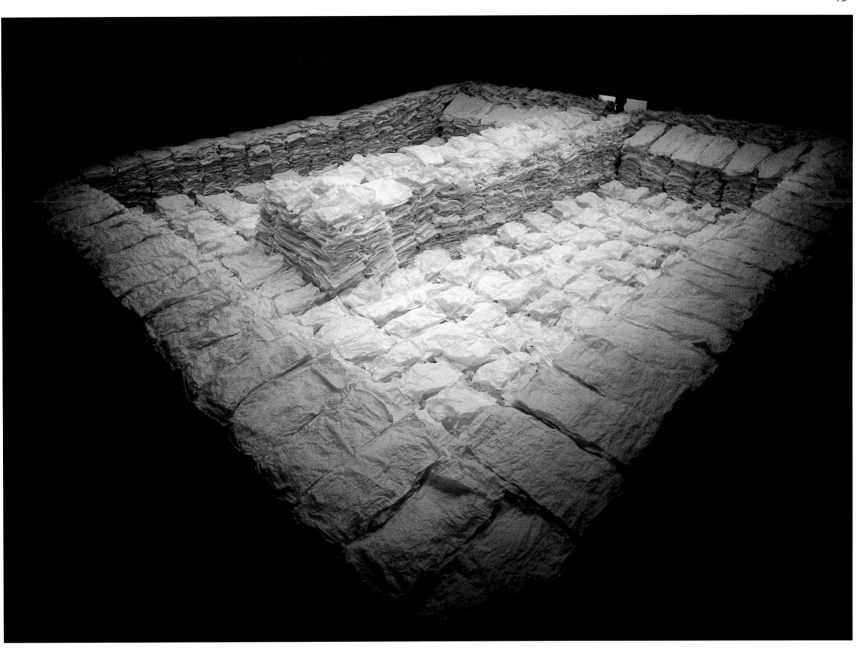

Hu Youben
Abstract Series No. 14
1997
ink painting installation
285 x 420 cm

Hu Youben's abstract works are created from ink and the lines of scrunched up paper to become powerful low-relief mural paintings. He exploits the special expressive characteristics inherent in rice paper, through the repeated action of scrunching, assemblage and compression, to which he adds free ink strokes. The artist's own emotional experience is intricately incorporated into the process of manipulating his materials and altering their conventional form and quality. The result is a rich, contemporary literati flavor and an enduring cultural form of language. At the same time, he also eludes the influence of more academic structures. The structure of the works reveals the artist's personal sensibilities and the intuitive impulses that guide the process of creation. These are not designed to be analyzed by strong first impressions. Their casual appearance of the effect of the materials is both controlled and preserved. These works alter the way in which ink reacts with rice paper, gracefully and mysteriously carrying the crease marks, multiple and dense, and the light and dark this produces. He uses a Chinese sense of perspective as a fundamental element in his compositions. The audience is thrown into the web of ink to discover the changes in every small portion of the work. (Wang Lin)

Hu Youben

1961 Born, Beijing, China
Current, professional painter at Baoding Painting Institute, Hebei province, China

Solo Exhibitions
1989 *Hu Youben Art Show*, Xilin Seal Society, Hangzhou, China
1990 *Hu Youben Art Show*, Hebei Provincial Museum, Shijiazhuang, China
1993 *Hu Youben Art Show*, Japan
1998 *Taihang Mountain Spirit: Hu Youben Contemporary Ink Works*, China Art Gallery, Beijing, China
1999 *Hu Youben Abstract Painting Show*, Paris, France
Hu Youben Painting Show, Bonn, Germany
2000 *Hu Youben Abstract Painting Show*, Frankfurt, Germany

Group Exhibitions
1998 *Traditional and Anti-traditional Art*, German embassy, Beijing, China
2000 *Gate of the New Century*, Chengdu Modern Art Museum, Chengdu, China
2001 *Reshuffling Contemporary Art*, Sculpture Park, Shenzhen, China
Twenty Years of Ink Experiment, Guangdong Museum of Art, Guangzhou, China
Chinese Video and Performance, Paris, France

Yu Gao
Suspended Objects
1999
installation
300 x 200 x 200 cm

To my eye, the world is a unknown substance existing eternally. Its origin and ultimate substance are not able to be verified beyond doubt or even imagined by mankind. All creativity seems to be wrapped and suffocated by a stronger power. Arising from this feeling, I produced the work *Suspended Objects*, aiming to create an ultimate atmosphere. I designed the dimensions of the suspended objects according to the scale of the exhibition space and continued to use a trapezoid, a stable yet variable geometric form. I choose an aberrant material — helium — to fill the balloons, which are between square and round in form, like flying objects from outer space. When the balloons are filled, they become suspended in the air in the space, and the ambience turns supernatural. The dust-like characters against the black background add a sense of distance and mystery; people can't understand them. They might remind them of the distant past, or foretell a remote future. These objects don't belong to any culture; rather, they are the embodiment of a certain spirit or wisdom that goes beyond time and space. (Yu Gao)

Yu Gao

1971 Born, Beijing, China
1996 Graduated, sculpture depart-
ment, Central Academy of Fine
Arts, Beijing, China
1999 Master's degree, Central Acad-
emy of Fine Arts, Beijing, China
Current, lives and works in
Beijing, China

Solo Exhibitions
1998 Passage Gallery, Central Academy of Fine Arts, Beijing, China

Group Exhibitions
1997 *Five Person Open Studio*, Contemporary Art Gallery, Beijing, China
1998 *Century Women*, China Art Gallery, Beijing, China
1999 *The Second Contemporary Sculpture Art Annual Exhibition*, He Xiangning Art
Museum, Shenzhen, China
2000 *Gate of the New Century*, Chengdu Modern Art Museum, Chengdu, China
Contemporary Chinese Sculpture Invitational Exhibition, Qingdao Sculpture
Museum, Qingdao, China
The Second Young Sculptors' Invitational Exhibition, Gallery of the China
National Academy of Fine Arts, Hangzhou, China
2002 *Conflict and Forgiveness: Contemporary Chinese Art*, Mantova Youth Museum,
Mantova, Italy

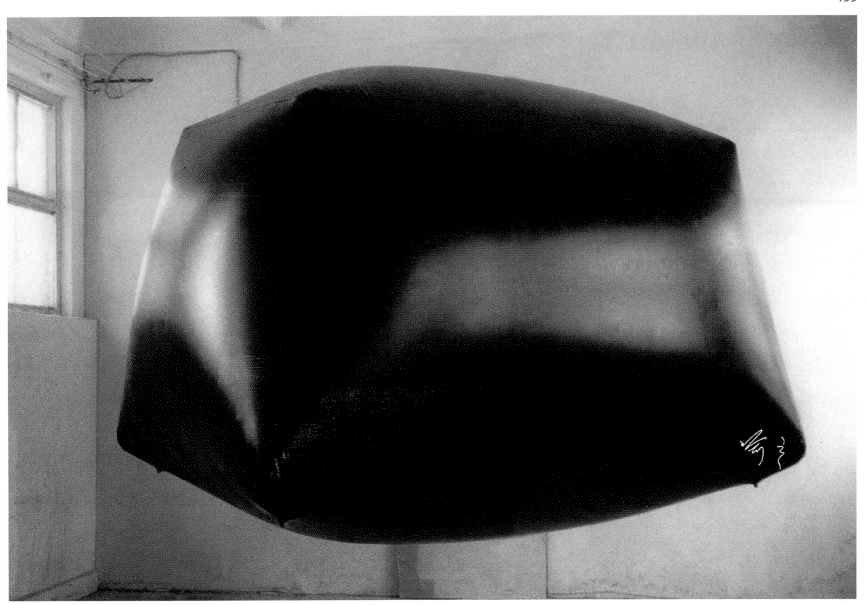

Shi Hui
Floating

2000
installation; wire netting, papier maché
300 x 800 x 600 cm

This is a post-modern sculpture. Using a non-conventional, hollow form and a rich, textural surface, it produces a strong three-dimensional form that emphasizes a contrast between monumentality and vulnerability. This is the visual wholeness that has characterised Shi Hui's works for many years. In this large work, six meters long and five meters wide, the contrast is at its most eloquent. (Wu Hung)

Shi Hui
1956 Born, Shanghai, China
1984 Graduated, Zhejiang Academy of Fine Arts, Hangzhou, Zhejiang province, China
1988-89 Research department, Zhejiang Academy of Fine Arts, Hangzhou, China
 Current, professor of the environmental art department of the China National Academy of Fine Arts, Hangzhou, China

Solo Exhibition
1995 *Woman Artist from the Academy*, Gallery of the China National Academy of Fine Arts, Hangzhou, China

Group Exhibitions
1989 *The 13th International Art Tapestry Biennial*, Lausanne, Switzerland
1996 *The First Asia-Pacific Triennial of Contemporary Art*, Queensland Art Gallery, Australia
1995 *New Art From China*, Hamburg International Young Art Center, Hamburg, Germany
2000 *Half of the Sky*, Women's Museum, Bonn, Germany
2001 *Gate of the New Century*, Chengdu Modern Art Museum, Chengdu, China
2000 *Shanghai Spirit: The Third Shanghai Biennale*, Shanghai Art Museum, Shanghai, China
2001 *Transplantation In Situ: The Fourth Shenzhen Contemporary Sculpture Art Annual Exhibition*, He Xiangning Art Museum, Shenzhen, China
 Living in Time, Hamburg Bahnhof Museum of Contemporary Art, Berlin, Germany
 The Second Italian Asia-Pacific International Contemporary Art Biennale, International Contemporary Art Museum, Genoa, Italy

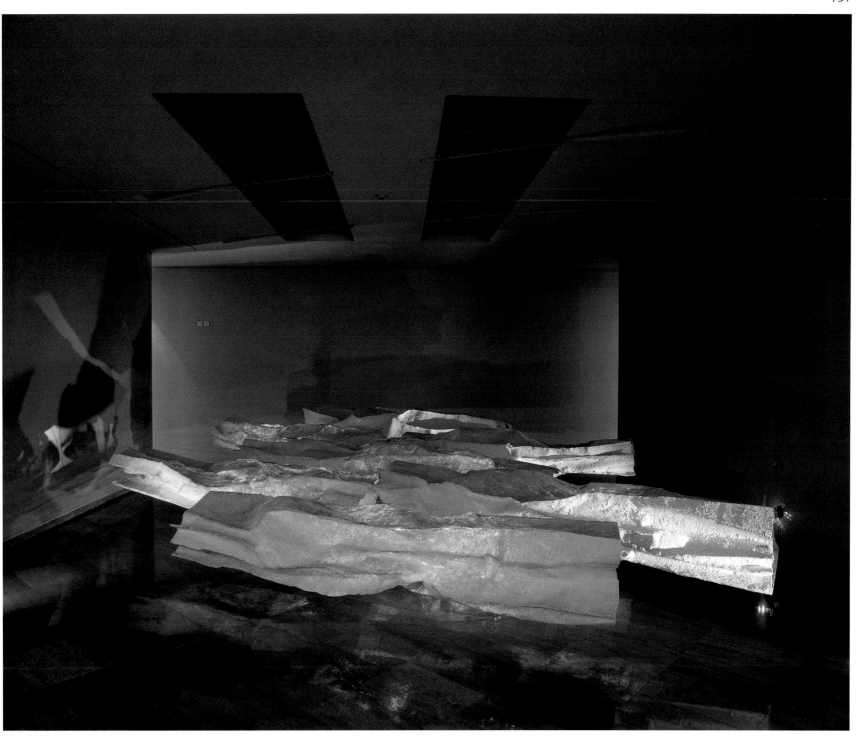

Lu Qing
Untitled

1999
Chinese silk
150 x 480 cm

Lu Qing created the first work in this series in 1996. It was a large piece composed of several strips of Chinese silk (*juan*) joined together. The motif was a lozenge, a petal like form that she subsequently abandoned as being too decorative in favor of the square. The medium was acrylic, individual spreads of translucent hues of cobalt blue, rose madders, and bronze/copper tones in squares of various sizes. As the series evolved, Lu Qing began to reduce the strength of color in each piece, turning to pale luminescent pigments with just the merest hint of a hue, and various dilutions of Payne's gray, warm or cool as the mood takes her. She also began to work on fine semi-transparent tissue paper, itself extremely fragile. Then she put paper aside to focus on long bolts of silk. These works demand much time and patience to produce. While it might be possible to suggest that such paintings are in the nature of woman and female patience, they also demand a calm aura, a meditative nature. There is something essentially Chinese in these works. Simultaneously, they demonstrate a fine understanding of, and sensitivity to, the fundamental essence of the act of painting. (Karen Smith)

I don't believe what I do is art. Most of the time, in the process of my work, the activity itself makes me forget what art is. I have no way to explain what I will do before I begin. When the work is complete I have no need of explaining it. A painting is just a painting. (Lu Qing)

Lu Qing

1965 Born, Shenyang, Liaoning province, China
1989 Graduated, print-making department, Central Academy of Fine Arts, Beijing, China
 Current, lives and works in Beijing, China

Solo Exhibitions

1989 Longmen Gallery, Taipei, Taiwan
1990 China Art Gallery, Beijing, China

Group Exhibitions

1997 *A Point of Contact*, Taegu Art and Culture Hall, Taegu City, Korea
1998 *Concept and Image*, China Art Archives and Warehouse, Beijing, China
1999 *L'Inviation a la Chine: Biennale d'Issey*, Issey, France
2000 *Fuck Off*, Eastlink Gallery, Shanghai, China
2001 *Between Art and Politics: China's Women Artists*, The Women's Museum, Denmark
 Open Perspective/Ars 01, Kiasma Contemporary Museum, Helsinki, Finland

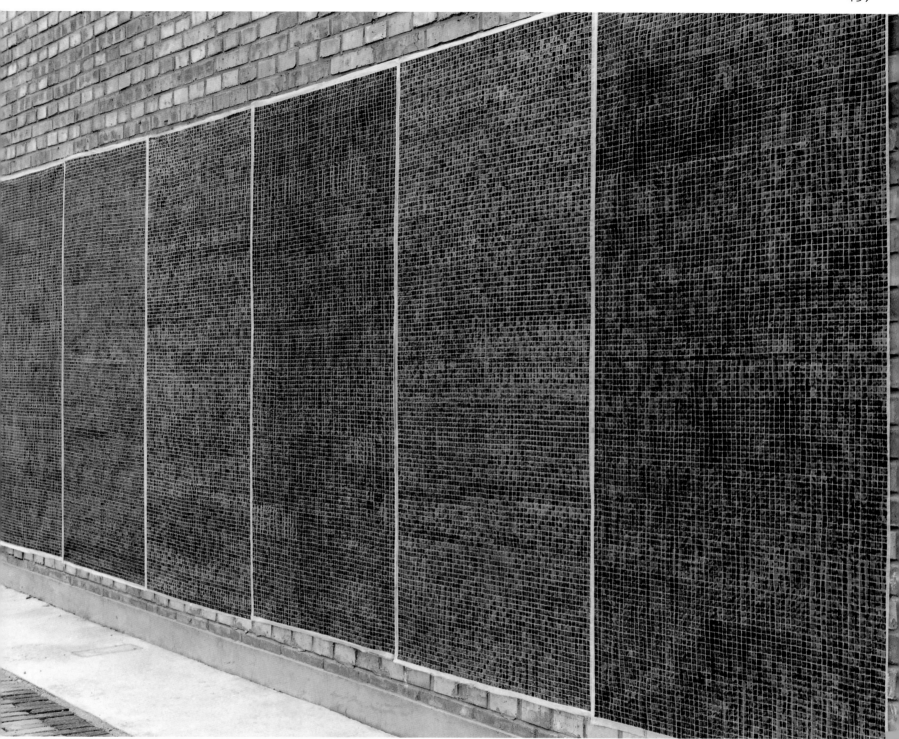

Xie Nanxing
Untitled No. 4
1999
oil on canvas
150 x 190 cm
Collection of Galerie Loft, Paris, France

Since 1998, a number of artists have adopted a particular painting style that is blurred, soft in color and flat. Their compositions appear as unfocused details from photographs, with any traces of drawing markedly absent, the color almost drained and the pictorial spaces made flat. If these elements are taken as an approach to painting, then in various ways it serves as the expression of the younger generation of painters, especially those born between the late 1960s and the early 1970s. It encapsulates their attitude towards life, a loss of faith transposed to an ambiguous or vague conceptualism. This younger generation seeks to escape the artificial greatness that society has created for itself, rid of any emotional stimulation or profundity, by focusing on the dullness and inertia of life. Their art is about their own lives alone, and themselves swamped by the flat, uninspiring fog of contemporary life. We can say that within this style Xie Nanxing has the most pronounced individual traits. He not only produces paintings that are flat, washed out and vague, but imbues them with a deeper sensation, an expression of sense of hopelessness, self-abuse and reckless need to shock that is made manifest in youth at the ultimate height of boredom and dispiritedness. (Li Xianting)

Xie Nanxing

1970 Born, Chongqing, China
1996 Graduated, print-making department, Sichuan Academy of Fine Arts, Chongqing, China
 Current, teaches at Southwest Communications University, Chengdu, Sichuan province, China

Solo Exhibitions
1998 Pulitzer Galerie, Amsterdam, the Netherlands
2000 Urs Meile Galerie, Lucerne, Switzerland

Group Exhibitions
1993 *Zero Studio*, Chongqing, China
1994 Jiangsu Art Monthly *Twentieth Anniversary Exhibition*, Nanjing, China
1999 *The 48th Venice Biennale*, Venice, Italy
2000 *Shanghai Spirit: The Third Shanghai Biennale*, Shanghai Art Museum, Shanghai, China
 Our Chinese Friends, Bauhaus-University and ACC Gallery, Weimar, Germany
2001 *Abbild International Contemporary Portrait and Drawing Exhibition*, Landsmuseum Joanneum, Graz, Austria
 Chengdu Biennale, Chengdu Modern Art Museum, Chengdu, China
2002 *Painting on the Move: A Century of Modern Painting*, Kunstmuseum, Basel, Switzerland

Open My Door 7

Open My Door 37

Wang Gongxin
Balls in Hand
1998
video; 3 min.

The film focuses on an old man's hand in which he holds two metal "balls for health." As he rotates these balls-which are used to keep the hands supple and strong-their metallic surface reveals the reflection of different scenes from the surrounding environment. Early video films often infused rich townsfolk life in monotonous, lengthy scenes with the use of mirrored images. Such films became a reflection of life. Maybe the dullness of traditional everyday life is the dullness of new media art. (Wu Meichun and Qiu Zhijie)

Paying Respects
1999
video; 2 min., 45 sec.

This single-frequency video film consists of 12 computer-processed photographs. The images make three 360-degree turns and appear in negative, black-and-white positive, and color positive. It suggests an allegorical interest in society and in technology. (Wu Meichun and Qiu Zhijie)

See page 156 for the artist's portrait and CV.

Balls in Hand

Paying Respects

Wang Jianwei
Production
1996
video

The artist chose seven county towns around Chengdu in Sichuan province, five villages around each county town, and one public space in each town. The public space chosen is the "teahouse" in each town, embodied in many different architectural styles. The teahouses serve as public spaces. Visual memory, however, retains the "teahouse" as a site but not the "production" as a combined behavior. (Wu Meichun and Qiu Zhijie)

See page 256 for the artist's portrait and CV.

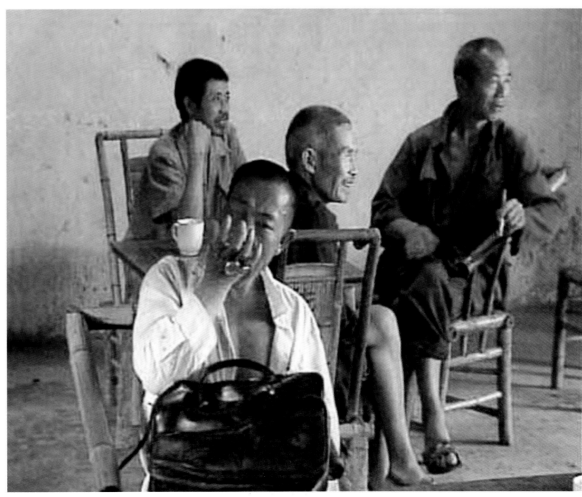

Part Two: Artists and Work

Experimentation Continues

Artists and Works

Ai Weiwei

Chandelier

2002
installation; chandelier

In large scale, dense, and rapid development of architectural structures and urban development, scaffolding is an essential and fundamental element. It has absolutely no artistic aspects or cultural value. As a component of construction, the basic concept of scaffolding overturns four thousand years of Chinese architectural theory and the inevitability of an interior structure. Chandeliers are universal objects. In the great scourges that are engendered under the guise of democratic freedom, the elegance of chandeliers when introduced into Third World countries attempts to imitate the splendid halls of beautiful imaginings, to be a measure of sensibilities and illusion to replace unhuman ideals. Regardless of when or where, scaffolding and chandeliers are architectural conduits and inalienable parts of structural ideals. (Ai Weiwei)

See page 420 for the artist's portrait and CV.

Chen Lingyang
Yue Jingjing
2002
video installation

From the corner of a greenhouse along a corridor running to the gardeners' shed are seen several very ordinary objects (the type of things a girl would have). Scattered over and around these objects are messages that speak of menstruation.

In the gardener's shed is a projection of several scenes from mundane reality. Suddenly it turns to a sense of impossible dreams, vain hopes. A girl works, a smile on her face. Suddenly, she is transformed into a martial arts fighter, her sword made of cotton and tissue, she thrashes around. After a while, as if at the end of a day of work, she walks home. Blood suddenly appears to be flowing down one leg to which she is oblivious.

Yue Jingjing is not a specific person. Perhaps she hovers on the fringe age, between heaven and hell, without a clear role. Perhaps she … … … Who knows? (Chen Lingyang)

Chen Lingyang

1975	Born, Zhejiang province, China
1999	Graduated, Central Academy of Fine Arts, Beijing, China
	Current, lives and works in Beijing, China

Solo Exhibition
1998 *Paradise or Lost Paradise*, Gallery of the Central Academy of Fine Arts, Beijing, China

Group Exhibitions
1999 *Post-Sense Sensibility: Alien Bodies and Delusion*, Beijing, China
 Supermarket, Shanghai, China
2000 *Two Studio Generation: Three-man Show*, Beijing, China
 Documentatum of Chinese Avant-garde Art in the 1990s, Fukuoka Museum of Asian Art, Fukuoka, Japan
 Fuck Off, Eastlink Gallery, Shanghai, China
2001 *Take Part*, Galerie Urs Meile, Lucerne, Switzerland
 Next Generation/Contemporary Asian Art, Passage de Retz, Paris, France
 Visibility, China Art Archives and Warehouse, Beijing, China
 Cross Pressures, Oulu Art Museum, Oulu, Finland
2002 *Run, Jump, Crawl, Walk*, East Art Center, Beijing, China

呼吸

镜子

床垫

化=1800。

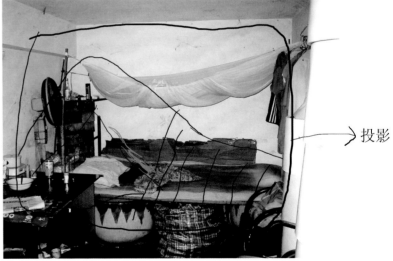

投影

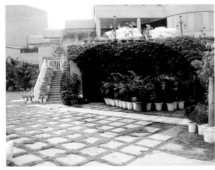

The corner of a greenhouse
and the gardeners' shed

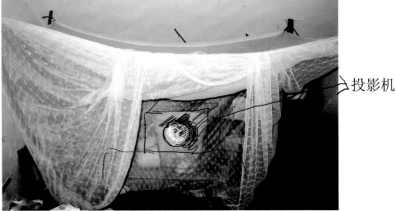

投影机

Lin Yilin (Big-tailed Elephant)
Our Future
2002
installation; bricks, ready-made sculptures

The rapid development of cities in China has brought completion of buildings each one higher than another. Because of the eagerness for quick success and instant benefit, as well as the motivation of power, the plan behind this work is about the meaning of skyscrapers as landmarks in the future. The buildings are built almost overnight, joined together in a piece. Their disappointing quality has created major visual pollution. I see these densely packed skyscrapers as our future city garbage. In a metropolis, what is the meaning of a skyscraper? Are we repeating the path of development of New York? After the tragedy of September 11, the safety of skyscrapers has come to general attention. Therefore, we have to reflect on whether a city has to have skyscrapers like New York and its Empire State Building. It is funny that lion sculptures scattered all over the city seem to have become the guardian gods of these buildings. This is a wonder of urban development in China. (Lin Yilin)

See page 274 for the artist's portrait and CV.

Xu Tan (Big-tailed Elephant)
Scene and Presence, November 18–January 19
2002
Internet installation

This work consists of two parts. The first part transmits scenes of the opening, exhibition, and symposium of The First Guangzhou Triennial via web broadcasting. In this way people around the world who are interested in contemporary Chinese art but unable to attend the Triennial themselves can view and to participate in the exhibition. Another part of the work is a documentary in the form of rock and roll music telling the life story of an old man who has been in the Pearl River Delta all his life. The live, on-site nature of the two parts attempts to illustrate the importance of he Internet as a means of transmission in our everyday life. It also demonstrates the relationship between transmitting and being transmitted, which derives from the individual experiences and lifestyles of people in a certain area in our globalized, information-age existence. (Feng Boyi)

See page 270 for the artist's portrait and CV.

Chen Shaoxiong (Big-tailed Elephant)
Hero
2002
video installation; two projectors, two DVD players, four speakers, twenty chairs

After the audience views the seven-minute long shootout video *Hero,* another one plays in the back of the audience seats for about thirty seconds. The viewer always substitutes himself or herself for the main character in *Hero*, so their experience will be interrupted by another video. The viewer is no longer the person who fires the gun, but becomes the person being hit. In this video installation, the viewer takes a beating after enjoying the experience of the main character to the utmost. Through the interchange of characters in fantasy and reality, the viewer wakes up as if from a dream. (Chen Shaoxiong)

See page 272 for the artist's portrait and CV.

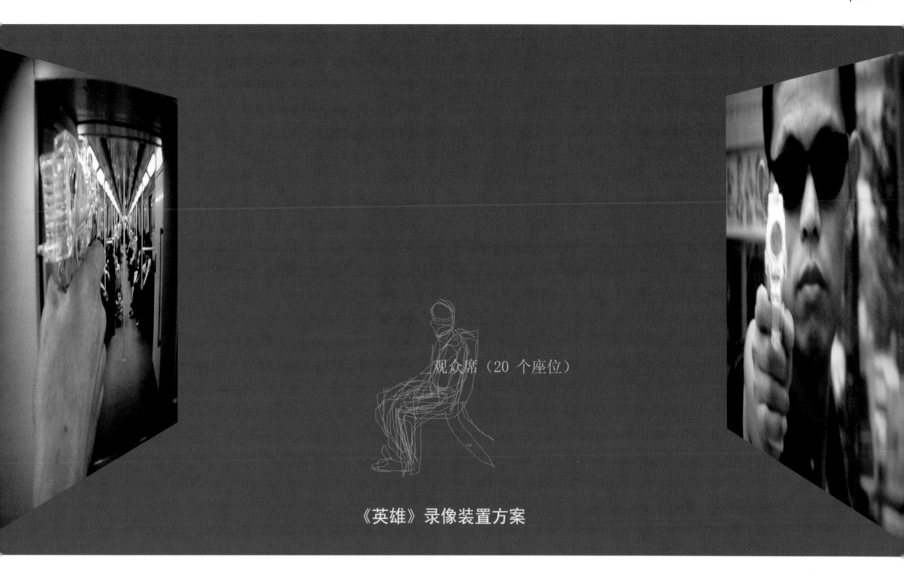

观众席（20 个座位）

《英雄》录像装置方案

Liang Juhui (Big-tailed Elephant)
Floating Transplant
photographic installation
800 x 500 cm

Human cities scatter like anthills, no matter how thriving or common they are, there will be activities, as long as "moving elements" exist. They bring all kinds of happiness, joy, and freedom to human beings, but at the same time the unbearable crowdedness and pressure also set off different kinds of desire. The pace of city life is tense; you can feel everyone disappearing quickly before your eyes when you are in public places such as stations and stores. Using the back view of human figures to express the present existing state in cities is holistic, concise, and understated. (Liang Juhui)

See page 276 for the artist's portrait and CV.

题目：漂浮的移植

材料：透明塑料

结构：充气（4cm厚）

放置：人行通道上

500CM

800CM

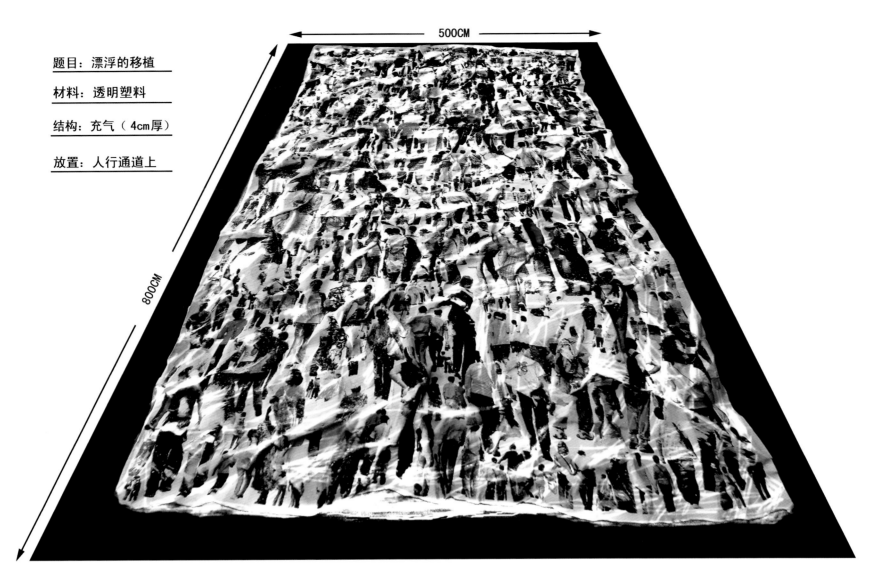

Feng Mengbo

Ah Q (The Mirror of Death, Dance Pad Version of Q4U)

2002

performance, installation; PC, dance pad, speakers

Feng Mengbo uses a computer-based technological approach to focus his concerns on commonplace lives of ordinary people. With its audio-visual, interactive property, this CD-ROM work, which is a collection of his family photos, presents a picture of the existence of ordinary Chinese people against the changes of the times. (Feng Boyi)

See page 196 for the artist's portrait and CV.

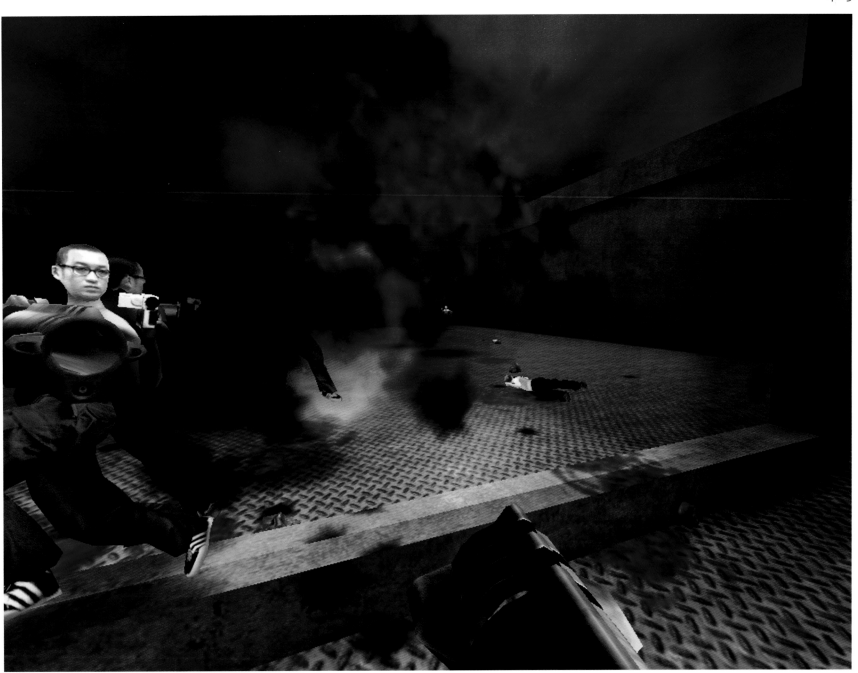

Gu Dexin
2002.11.18
2002
installation

Two Roman columns with gilded top and base are made of stainless steel. Each of the columns is 200 cm in width, and as tall as the museum entrance wall. Twelve stainless steel English letters are painted in red automobile paint, each 150 cm high and 30 cm wide. The words are taken from the motto on U.S. bills and coins: "In God We Trust" This installation is placed on top of the entrance of the museum, the logo and name of which are thereby temporarily obliterated. (Gu Dexin)

See page 306 for the artist's portrait and CV.

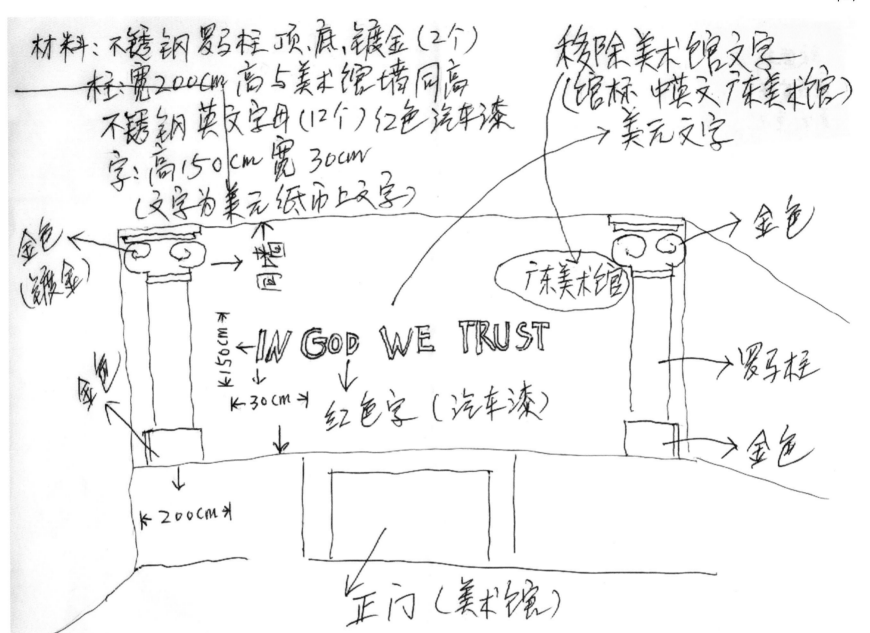

材料：不锈钢罗马柱顶、底、镀金（2个）

柱：宽200cm 高与美术馆墙同高

不锈钢英文字母（12个）红色汽车漆

字：高150cm 宽30cm

（文字为美元纸币上文字）

移除美术馆文字
（馆标 中英文 广东美术馆）
→ 美元文字

金色（镀金）

金色

广东美术馆

金色

IN GOD WE TRUST

← 150cm

← 30cm →

红色字（汽车漆）

罗马柱

金色

← 200cm →

正门（美术馆）

Huang Yong Ping
Bat Project II

2002
installaton; steel
1561 x 2000 x 600 cm

A work can be created at separate locations and times, just as an airplane can be made piece by piece. *Bat Project II* takes an airplane, altogether 35.61 meters long, and deducts the 20 meters that Ⅰ created last year in Shenzhen but was never be able to exhibit, leaving a total of 15.61 meters. Add on the left wing of the plane, and it looks like a "boomerang"—an old piece of news that becomes relevant once more—as the back of the plane will remain in Shenzhen, while the front will stay in Guangzhou.

When one plane is disassembled and flown away inside another, this can be considered a work of art in and of itself. Lift often presents works of art, but we must wait patiently to encounter them. "Disassembly" is important, a self-deconstruction of power. As Ⅰ see it, this disassembled airplane is all the more able to symbolize power and high technology. (Huang Yong Ping)

Huang Yong Ping

1954 Born, Xiamen, Fujian province, China
1982 Graduated, Zhejiang Academy of Fine Arts, Hangzhou, Zhejiang province, China
 Current, lives and works in Paris, France

Solo Exhibitions

1990 *Explosion Mount St. Victoire*, Aix-en-Provance, France
 Sketch, Avignon Academy of Art, Avignon, France
1991 *Conjuring up the Red Cross*, Xujian Hospital, Paris, France
 Do We Still Need to Build a Cathedral?, Fenster, Frankfurt, Germany
1992 *Fortune Teller's Room*, Flumen & Bitman Galerie, Paris France
1993 *108 Scorpions and Turtles*, Gutenburg University, Stuttgart, Germany
1994 *Chinese Laundry*, New Museum, New York, USA
1995 *Pharmacy*, Fluman & Bitman Galerie, Paris, France
1996 *Three Steps*, Marseilles Artists Studios, Marseilles, France
1997 *Big Xian*, Art & Public, Geneva, Switzerland
 Study of Spiders Webs No. 2, Beiman Galerie, Luxembourg
1998 *Pharmacy*, Jack Tilton Gallery, New York, USA
1999 *Crane and Deer Tracks*, Contemporary Art Centre, Kitagawa, Japan
2000 *Raising to the Bait*, Jack Tilton Gallery, New York, USA
2002 *Wenmaniba*, Jack Tilton Gallery, New York, USA

2000 *Shanghai Spirit: The Third Shanghai Biennale*, Shanghai Art Museum, Shanghai, China
2001 *Yokohama 2001: International Triennial of Contemporary Art*, Yokohama, Japan
2002 *The 25th International Sao Paulo Bienal*, Sao Paulo, Brazil

Group Exhibitions

1986 *Xiamen Dada*, People's Art Museum, Xiamen, Fujian province, China
1989 *China/Avant-garde*, China Art Gallery, Beijing, China
 Les Magiciens de la Terre, Centre Georges Pompidou, Paris, France
1990 *For China's Future*, Buyier, France
1991 *Chinese Avant-garde*, Museum City Project, Fukuoka, Japan
1993 *China Avant-garde*, Haus der Kulturen der Welt, Berlin, Germany
1997 *Cities on the Move*, The Secession, Vienna, Austria
1998 *Inside Out: New Chinese Art*, Asia Society Galleries, PS 1 Contemporary Art Center, New York, USA
1999 *The 48th Venice Biennale*, Venice, Italy

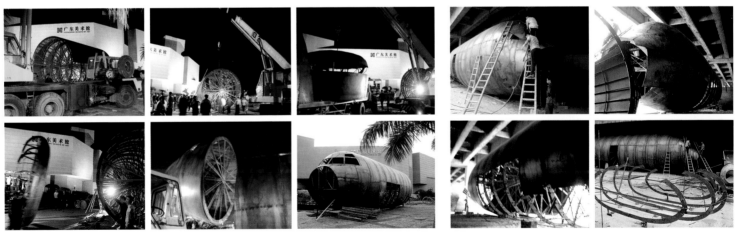

Song Dong
Laboratory
2002
installation, performance, television drama

See page 246 for the artist's portrait and CV.

【 实验室】 （继续实验部分）

装置. 事件. 电视剧制作

故事概述:

一个艺术打工者 来终 带着对艺术的梦想. 来到广州打工. 这是一个消费欲望制造梦想的集散地. 他带钱不多, 用生活废品制造他的生活实验室, 他首先来到广州最大的废品收购地购买生活用品"包装". 然后对此进行嫁接改装. 然后他带领一个清洁队 被奇 为广东美术馆清洁艺术作品, 时值广东美术馆正在进行"广东首届四三年展" 的布展工作, 云集近10年中国实验艺术届几乎所有的腕级人物, 这使他兴奋不已, 他不能错过这次难得的学习机会, 与清洁队一起帮助这些艺术家们清运制作艺术回品时产生的垃圾和包装, 并用这些"废物" 丰富自己的实验室. 回他边干活边学习, 最终制成了他的生活实验室. 从实验室可以看到广州的景象, 这个生活实验室是一个摄影棚. 虽然简陋, 但它是今天生活的写照, 是人们生活的舞台. 当他看着观众进入摄影棚观看 摆弄他的实验品时, 他感慨万分, 一出出的戏戏上演. 他的导演生活就要回开始了.

Translation:

Song Dong, an art worker with dreams of art, came to Guangzhou to work. This is a distribution center where desire for consumption creates dreams. He brought a little money and used daily garbage to produce his life laboratory. First he went to Guangzhou's largest garbage collection station to purchase used "packages" of everyday objects, then conducted grafting on to them. Afterwards, he led a janitorial squad to clean art works for the Guangdong Museum of Art when the museum was installing the exhibition *The First Guangzhou Triennial*. Almost all masters in the field of experimental art in China for the past ten years gathering together excited him tremendously; he could not miss this rare learning opportunity. He and his squad helped these artists to clean the garbage and packages left from the production of the art works, and used this "garbage" to fill up his laboratory. He learned while working, at the end created his life laboratory. This laboratory is a photography studio with scenery of Guangzhou inside. It is simple, but reflects life nowadays and is a life stage. When he sees the audience enter the studio to view and play with his lab works, all sorts of feelings well up in his mind as plays are performing and his life as a director is about to begin.

塑料暖棚

竹架
（南方使用的
竹脚手架）

【　实验室】

制作一个由塑料大棚组成
的实验室（摄影棚）

实验室中用各种商品的包装制作
生活用品、家具和摄影器材

油桶

水桶

SONGDONG

纸箱
或塑料箱
制成 家具
包装箱

Wang Gongxin
My Sun No. 1
2001
video

My Sun No. 1 presents a panorama created by three data projectors. The central figure is an old woman that is placed in a large open field. This person works the field and repeatedly outstretches to grasp an elusive piece of light. The light appears as the image of the sun rising and then entering the landscape as a visitation to this world leaving its traditional place of orbit. The light is an illogical form. Repetitively she reaches out to capture the energy and hold the abstract. The image does not resolve the success or failure of the attempt to capture the light that may represent essential meaning or just something to believe in. The panorama continues to multiply the woman's image to create an army of replicas of her. The individual becomes the masses and again Wang dwells on a reflection of individuality and symbols that oscillate between polarized identities. Is it a person or is it the People? The sense of melancholy and loss is heightened by the soundtrack from the well-known Italian aria *O sole mio* by Marcello Di Capua. The work is also visually operatic and alludes to an ongoing search, one that is never achieved or resolved. *My Sun* is perhaps Wang's most sentimental work to date but once again successfully achieves an atmosphere of sublimity. (Kim Machane)

See page 156 for the artist's portrait and CV.

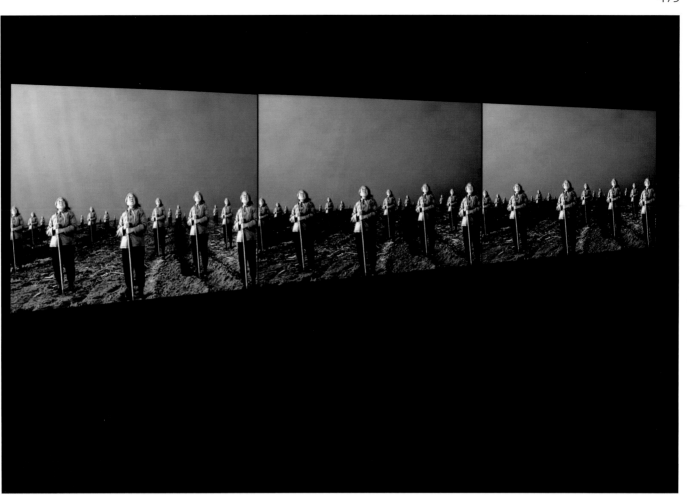

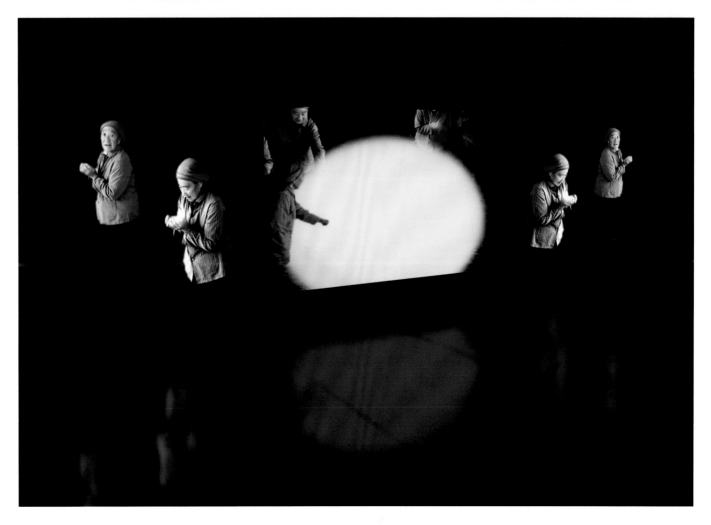

Wang Guangyi
Materialist

2001
sculpture
72 pieces, 180 x 80 x 80 cm each

In these new sculptural works, I have rid the works of any obvious cultural antagonism, instead placing emphasis on the ambiguity that is found in their simple strength. Or perhaps I could say that I seek to restructure the visual strength of Socialist motifs and meaning. This kind of strength and meaning is directly related to my life experience, and underlines the most fundamental things in our culture. The millet that is used in the work is an important material. It has the flavor of materialism, and yet an equally revolutionary meaning. It imbues these forms with a stronger sense of physicality. (Wang Guangyi)

See page 178 for the artist's portrait and CV.

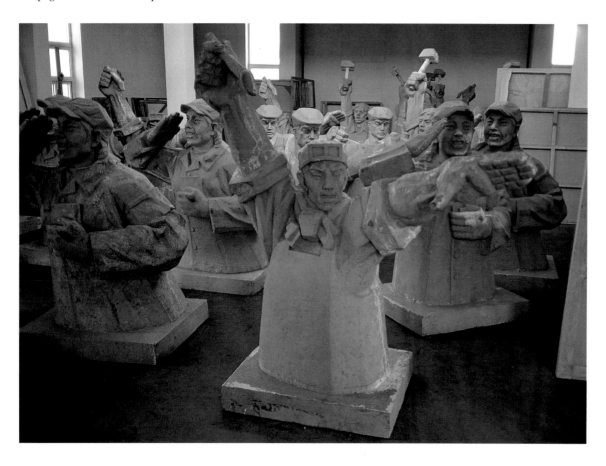

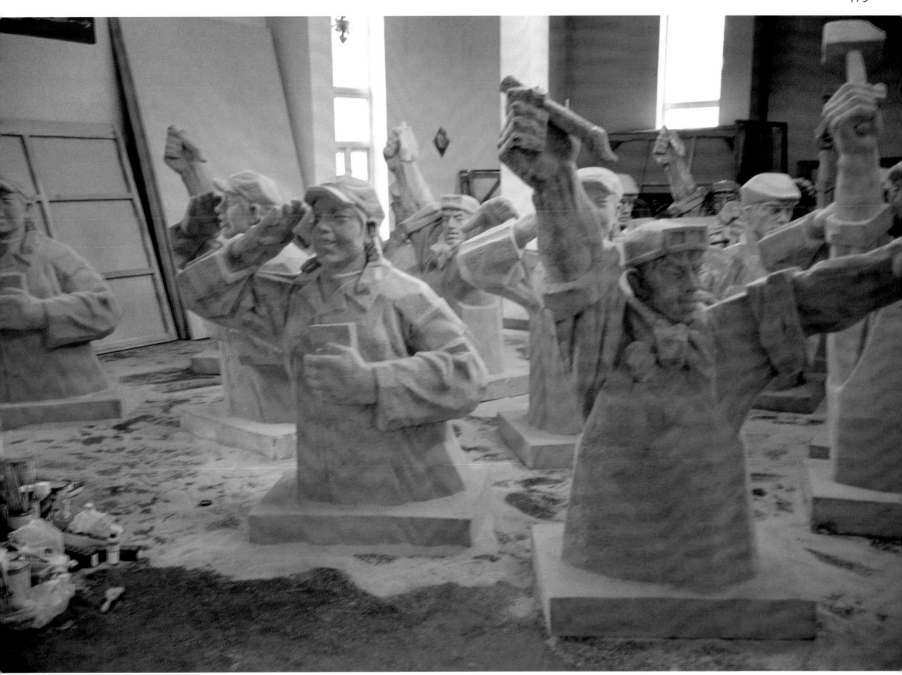

Wang Jin
: "My Teeth"
2001
installation; fired clay
3 pieces, each 120 x 140 x 117 cm; 4 pieces, each 125 x 46 x 97 cm

: "*My Teeth*" was completed after *My Bones*. Once again I used fired clay as the material to produce a solid form of life, a basic component. Teeth and bones became the material and substance of the work, being both human and yet not, biological and yet not. As a language for art, the forms were fired not sculpted, structured or painted. I was thinking about what happens when the works leave a cultural context. Do they still signify as art? Within a weak ideology, is it possible to produce strong art? (Wang Jin)

See page 200 for the artist's portrait and CV.

Wang Jianwei
Observe
2002
performance, installation

Observe contains to important elements. The first is the physical ability to "observe," the second is the relation of possibilities for observation in daily life. A mutual observation is a most ordinary action, and the most direct way in which people communicate. At the same time, "observing" can be categorized as the depth, profundity, the perception of the bodies observed. *Observe* is about attitudes. This kind of experience can be described as the art of a capability. At the same time, it also alters the capabilities of art.

The work will proceed as follows:
1. 500 - 1000 young students are invited to stand on one side as the Observers. They will all be wearing the same school uniform to identify their status.
2. Each of these students will be given a pair of sunglasses to wear. The lenses of these glasses will be covered with a reflective film. Those looking at this group will thus find their reflection thrown back at them.
3. These students will appear in the space *en masse*, marching in ranks.
4. The students will be subject to two rules. 1) They can only observe in this one spot. 2) They are only to observe the audience. This will ensure that it is in fact the audience that is viewed as much and in the same way as the works.
5. The entire process is to be the length of the students' standard class — 45 minutes.

I see *Experimentation Continues* as comprising two parts:
1. Knowledge: to a great degree, we will all be as one big school removed into an art museum. Aside from on site, the role and individual character traits, there will still be an overriding sense of the group.
2. Technique: under whatever conditions, the experience of daily life can be made to become art and perhaps gain public capital. (Wang Jianwei)

See page 256 for the artist's portrait and CV.

Xu Bing
Guangdong Wild Zebra Herd
2002

See page 146 for the artist's portrait and CV.

This thought began with a piece of news in newspaper a few years ago: In order to develop tourism, peasants in some part of southern China "decorated" normal horses into zebra. I think that today auspicious policy has brought the intelligence and creation of the masses into full play. This plan is only to borrow their intelligence and wisdom to recreate this scene. (Xu Bing)

②在草坪前面立有一个在动物园中常见的说明牌，内容：①斑马的肖像，②对斑马的学术解释，③广东斑马分布图，④一个公益宣传口号，内容为"保护野生动物，禁止虐待生灵！"

(左侧竖写：广东斑马分布)

(图中标注：200cm，广东野生斑马，保护野生动物，禁止虐待生灵，150cm，40cm，牌子铁制喷漆，文字内容)

广东野生斑马

常用名：斑马 Zebra	寿命：15 - 20 年	食物：草
学名：巴氏斑马 (Burchell's Zebra) 草原斑马 (plains zebra)	体长：1.9-2.4m 高：1.2-1.4m	体重：175 - 300kg(雌) 220 - 330kg(雄)
科类：哺乳类，奇蹄目，马科	分布于：非洲东部，中南部地区及中国广东	

繁殖：雄性斑马六至八岁左右会通过打斗争取成为种马，种马在十二月和一月的交配季节会忙于用嗅觉检查族群的雌性斑马是否发情，发情的话便要把握机会交配，以免被其他斑马偷袭。斑马怀孕期一年，单胎。

斑马身上特有的黑白条纹至今仍是个谜。有一说法是这些条纹可令猎食者难以追到，或难于分辨出头尾。

保护野生动物，禁止虐待生灵

3.需请一位马的出借者在展览期间来管理和喂喂养这些"斑马"（我希望真的马能在现场一月的时间）。同时需要在美术馆附近租借一间临时房做为马厩。

4.真马一月后离开现场后的展览期间，用一台电视代替。电视放在草坪上，播放内容是四匹"斑马"在草坪上游走的情景。

这些"斑马"象我其它作品中的那些"文字"，它们戴着面具，经过伪装；它们表里不一，现象与实质相违背。我总是对这类事情有兴趣。

(旁注：它们给你一个斑象的面孔，你却不能确定它们到底是谁。)

二〇〇二年九月初

Zhang Yonghe
Compressed House
2002

When architecture entered daily life in the form of residential buildings, people began to use nicknames nationwide for various designs and approaches on the market. For example, "two rooms and a reception area" (other examples are English equivalents of "studio," "loft," "duplex"). This revealed a basic awareness of the market for architecture in China, and demonstrated the differences in the people's grasp of these terms. It was under these variations in understanding that the residential market was developed and designed. This produced a profound effect and design has accorded much more attention to produce more possibilities for architectural space, and to specifically provide for wider visual potential (the relationship between people and activities). *Compressed House* was created to offer greater familiarity with the meaning, to employ the space to see the opposite bank of the Pearl River with its high residential developments. Within *Compressed House* the different approaches to architecture have been combined together. (Zhang Yonghe)

Zhang Yonghe

1956 Born, China
1981 Graduated, Nanjing Institute of Technology, Nanjing, China
1983 B.S. in environmental design, Ball State University, Ohio, USA
1984 Master's in Architecture, University of California Berkeley, Berkeley, USA
 Current, chief architect, Atelier Feichang Jianzhu, Beijing, China
 Chair and professor, Graduate Center of Architecture, Beijing University, Bejing, China

Solo Exhibitions

1999 Louisiana Museum of Modern Art, Denmark
 Apex Art, New York, USA

Group Exhibitions

1996 *Kwangju Biennial*, Kwangju, Korea Republic
1998 *Ke Da Ke Xiao*, Architectural Association, London, UK
2000 *Shanghai Spirit: The Third Shanghai Biennale*, Shanghai Art Museum, Shanghai, China
 The Seventh International Architectural Exhibition, Venice, Italy
2001 *Folding Clouds*, Hamburg Bahnhof Museum of Contemporary Art, Berlin, Germany

Architectural Designs

2001 Beijing University Nuclear Magnetic Resonant Instrument Laboratory, Beijing, China
 East Art Center, Beijing, China
 Southwest Bio-Tech Intermediate Test Base, Chongqing, China
1999 Crystal Imaging Office, Beijing, China
1998 Hillside Housing, Shenzhen, China
 Morningside Center for Mathematics, National Academy of Sciences, Beijing, China
1997 Cummins Asia Office, Beijing, China

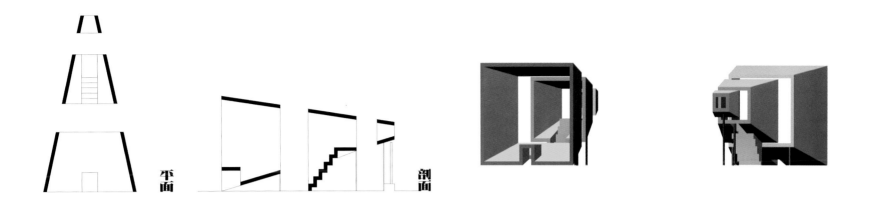

平面　剖面

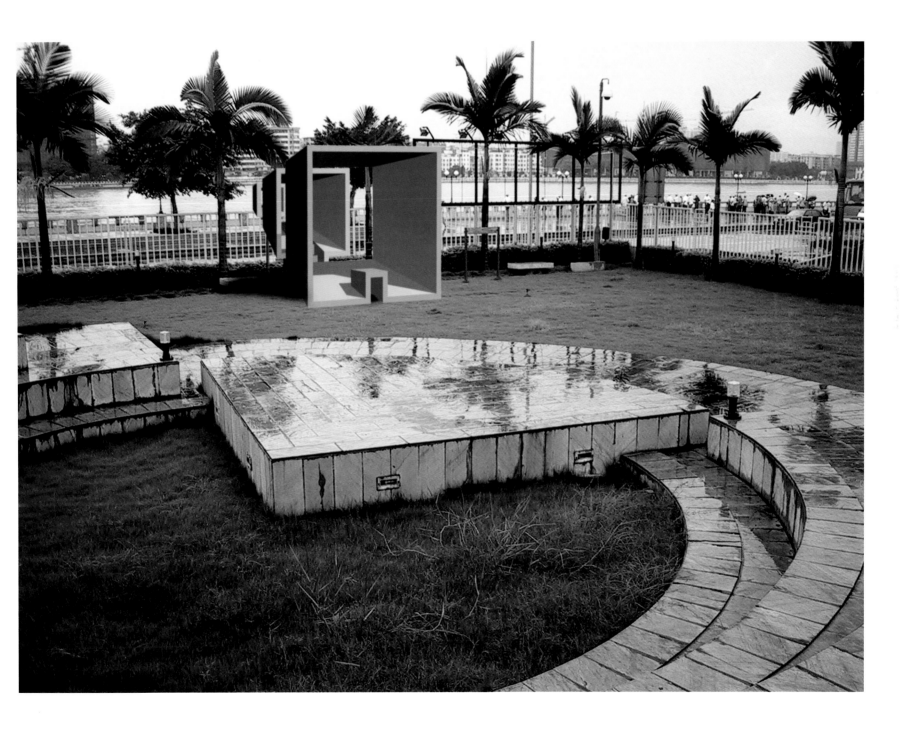

Part Three: Reference Matter

Chronicle: Experimental Chinese Art, 1990–2000

1990

January

Some artists take up residence in the Yuanmingyuan (Old Summer Palace) complex in northwestern Beijing, including Ding Fang, Fang Lijun, Wang Ying, Yi Ling, Tian Bin, and others.

January 1: In accordance with the Ministry of Culture's "Notice Concerning the Decision to Cease Publication of *China Art News*," the paper formally ceases publication. *China Art News* was established on July 5, 1985, and published 233 weekly issues. Editorial staff who worked on this paper include: Zhang Qiang, Shui Tianzhong, Lu Xiaochun, Liu Huimin, Zhang Zuying, Yang Gengxin, Zhai Mo, Tao Yongbai, Li Xianting, Chen Weihe, Gao Minglu, Wang Zhichun, Cai Rong, Xu Encun, Ding Fang, Cai Xingyi, Lang Shaojun, Zhang Huiming, Wang Yuchi, Niu Kecheng, Xiao Mo, Wang Yong, Wang Duanyan, Liao Wen, Bao Pei, Chen Weiwei and others.

March

March 21: Taipei's Longmen Gallery organizes the exhibition *Prints by Xu Bing*. Xu Bing's print installation *A Book from the Sky* is displayed.

April

The exhibition *1990 Young Painters Salon* is held at the Grand Palais in Paris. It exhibits work by 236 young artists from 47 countries and regions. It is the first time that Chinese modern artists take part in this annual exhibition. Participating Chinese artists include: Guan Wei, Mao Lizi, Wang Guangyi, Wang Luyan, Ye Yongqing, Zhang Peili, Geng Jianyi, He Jianguo, and Chen Chen.

May

May 12: The exhibition *Paintings by Liu Xiaodong* opens at The Gallery of the Central Academy of Fine Arts. Liu Xiaodong is believed to be an important representative of the "The New Generation" painters discovered in the 1990s.

May 18-June 10: Artist Xu Bing completes an early work that involved making an ink rubbing of the Great Wall at Jinshanling, Hebei province. The work required two years of planning and preparation. Lasting 25 days, and consuming more than 1500 sheets of rice paper and 300 bottles of ink, the final rubbing was 1500 square meters. Xu Bing calls this unusually challenging and tedious work *Ghosts Pounding the Wall*.

May 20-30: The exhibition *The World of Female Painters* is held in The Exhibition Hall of the Central Academy of Fine Arts (in its original location at Wangfujing, downtown Beijing), organized jointly by the Guangxi People's Press and the Central Academy of Fine Arts Young Professors Research Group. Eight female painters participate: Yu Hong, Jiang Xueying, Wei Rong, Liu Liping, Yu Chen, Chen Shuxia, Li Chen, and Ning Fangqing.

July

July 4: To commemorate the 100th anniversary of the death of Dutch painter Vincent Van Gogh, the Department of Aesthetics of the China Art Research Institute invites more than 80 Beijing art theorists and news reporters to take part in a conference on Van Gogh. During the meeting, videos and slides concerning Van Gogh are shown, provided by the Netherlands embassy in Beijing.

July 7: The exhibition *Chine: Demain pour hier* opens in Pourriéres, southern France. The event is hosted by the French ministry of culture, funded by the ministry of culture, foreign ministry, and local governments, and organized by the "Ground Zero Art" association. The subtitle for this activity is *Assembling the Chinese Avant-garde*, and it is the largest show of contemporary Chinese art to take place in the West to that point. Chinese artists residing overseas invited to participate include: Huang Yong Ping, Chen Zhen, and Yan Peiming (France); Yang Jiecang (Germany); Wenda Gu (U.S.); and Cai

Guo-qiang (Japan). Fei Dawei, former editor of Central Academy of Fine Arts journal *Fine Arts Research*, later invited to France by the Centre Pompidou and the French ministry of culture, is curator of this exhibition. A special characteristic of the exhibition is its emphasis on *in situ* creation, whereby artists are required to work in a defined site. This lends a special significance to the relationship between creation and circumstance, giving this relationship a deliberate, integrated emotional power. This exhibition also includes an academic conference on "inter-cultural misunderstanding and the illusion of the other." Speakers at the conference include: Fei Dawei, Cai Guo-qiang, Huang Yong Ping, Hou Hanru, Wu Mali, Chiba Shigeo, Monica DeMatte, and Yves Michud.

July 21-26: *The Commemorative Exhibition for the 100th Anniversary of Van Gogh's Death* takes place at the National Cultural Palace, organized by the China Sports Travel Company, the foreign exchange office of *Bridge* magazine, and the Netherlands embassy in Beijing. The exhibition displays oil paintings by young and middle-aged Beijing painters.

July 29: Three young painters from the northeast, Liu Fengzhi, Liu Hui, and Liu Yan hold the exhibition *Commemorative Oil Painting Exhibition for the 100th Anniversary of the Death of Famous Dutch Painter Vincent Van Gogh* in the gallery of the Harbin Youth Palace.

November

November 10-19: *1990 — Four Person Art Exhibition* is held at the Artists' Gallery in Guangzhou, Guangdong Province. Participating painters include: Zou Jianping, Xiao Peicang, Liu Cai, and Li Luming.

November 14-19: *1990 Annual Exhibition of New Works from the Kunming Oil Painting Research Group* takes place at the Yunnan Museum of Art. Mao Xuhui, Pan Dehai, Zeng Xiaofeng and ten other painters show a total of 32 new works.

December

December 28-January 5, 1991: The Wang Chuan solo exhibition *Mo/Dian* takes place at the Shenzhen Museum, organized by the Guangdong Shenzhen Art Salon and Hong Kong's Hanart TZ Gallery.

December 28: *Multi-faced People's Art Exhibition* opens at the Hunan Province Museum of Art in Changsha. It includes recent works by Xiao Peicang, Zou Jianping, Li Luming, Yao Yangguang, Liu Xin and other young painters.

1991

Nearly 20 painters who were headed for professional careers begin to live in Yuanmingyuan after graduating from art institutes across China. This "artists' village" is reported in the Chinese and foreign media. Important residents include Yue Minjun, Yang Shaobin, Xu Yihui, Xu Ruotao, Mo Gen, and Li Xinghui.

January

January 14: "*I Don't Want to Play Cards with Cezanne*" *and Other Works: Selections from the Chinese "New Wave" and "Avant-garde" Art of the Eighties* is held at the Pacific Asia Museum in Pasadena, California. This is the first large-scale exhibition of Chinese avant-garde art in the West. It includes 41 works by Chen Haiyan, Dai Hengyang, Geng Jianyi, Lü Shengzhong, Mao Xuhui, Xu Bing, Yu Hong, Zeng Xiaofeng, Zhang Peili, Zhang Xiaogang, Ye Yongqing, Zhou Changjiang, Li Luming, Zou Jianping, Xiao Peicang, Yao Yangguang and others. The curator is Richard Strassberg. A series of lectures and discussions about Chinese contemporary art accompanies the exhibition.

March

March 22: *Near Distance—Works by Wang Huayang* is held in The Gallery of the Central Academy of Fine Arts.

April

April 19-22: The symposium *A New Era of Artistic Creation*, also called the Xishan Symposium, is held at the Xishan Guesthouse in the western suburbs of Beijing, organized by the China Arts Research Institute. Participating artists and theorists include: Bi Keguan, Shui Tianzhong, Wang Yong, Liu Xiaochun, Chen Peng, Chen Zui, Chen Shouxiang, Huang Yuanlin, TaoYongbai, Zhang Zuying, Li Xianting, Yang Gengxin, Luo Gongliu, Du Jian, Xue Yongnian, Shao Dazhen, Wen Lipeng, Zhan Jianjun, Guo Yicong, Lu Chen, Yi Ying, Fan Di'an, Zhou Yan, Yi Jinan, Wu Guanzhong, Yuan Yunfu, Du Dakai, Liu Boshu, Zhang Shizeng, Zhao Lizhong, Li Song, Gao Minglu, Yang Yuepu, Fei Shengfu, Zhang Xueyan, Yao Zhenren, Liu Xilin, Pan Gongkai, Jia Fangzhou, Pi Daojian, Peng De, Liu Dianzhang, Gu Chengfeng, Cheng Zheng, Li Luming, Liang Jiang, Wang Lin, Wang Yanshan, Meng Hongsheng, and others, a total of more than 60. Old hands of the art circle Wu Guanzhong and Luo Gongliu lead the opening ceremony and deliver addresses. Vice-chairman of the Chinese Artists' Association Ye Qianyu records the event. During his address at the opening ceremony, chairman of the Fine Arts Research Institute Shui Tianzhong notes that the tenets of the assembled group are essentially in accordance with the spirit of the directives which Jiang Zemin had given to the world of arts and letters during a speech on the

fifteenth day of the new year, those being: to provide open argument and debate in the fields of thought and culture, to provide comradely criticism based on a notion of people as fundamentally good, to respect each other, to study from each other, to learn from each other, and to reach a new level. In three days of meetings, the assembled scholars hold fervent debates on every topic related to artistic creation in the "new period." In Chinese, this "new period" marks a very specific reference to deepening Deng Xiaoping's "Reform and Opening" policies in the wake of the events of 1989. The conference's healthy scholarly atmosphere promotes the development of the work of socialist art in China. The twelfth issue of *Fine Arts* magazine was especially devoted to summarizing "The Xishan Symposium," publishing summaries and transcripts of the proceedings. It also published three critical articles, "Which Theses from the Conference Papers Seek Truth from Facts?" by well-known Zheng Ming, "Truth Should Be Sought from Facts" by Li Qi, and "Watching the Tide Rise and Fall" by Tang Shaoyun. The September 15 issue of *China Culture News* ran a famous critical article called "What Artistic Direction Do the Organizers of the Xishan Symposium Support?"

April 20: Lü Shengzhong's exhibition of paper-cuts entitled *Red Souls* is held at the Beijing Contemporary Art Gallery. Lü covered the four walls and ceiling of the exhibition hall with large and small "little red people." Through ingenious manipulation of the lighting system, he created a total of 12 works.

May

May 1-8: *Zhixing Studio Exhibition* takes place in Luoyang, Henan Province, exhibiting dozens of works by Zhuang Hui and six other painters.

May 1-10: *Hunan Contemporary Painting Exhibition* is held at Hunan Province Museum of Art, showing works by Li Luming and 16 other young Hunan painters.

June

June 28-30: *West Third Ring Road Art Research Documents Part I* opens at the gallery of Beijing's China Painting Research Institute, showing images and documents from 45 artists and critics around the country. (These include photos, curricula vitae, recent works, artistic notes, and relevant criticism.) The theme of the research conference held simultaneously is "the independence of contemporary art in China and its relation to Euro-American cultural hegemony; a dialogue with Western art based on China's contemporary, non-traditional culture." The curator of this activity is art critic Wang Lin.

July

July 9-14: The newspaper *China Youth Daily* organizes *The New Generation* at Beijing's Museum of Chinese History. Participating in the exhibition are Wang Hu, Wang Jie, Wang Yuping, Wang Youshen, Wang Jinsong, Wang Huayang, Wei Rong, Shen Ling, Zhu Jia, Liu Qinghe, Song Yonghong, Pang Lei, Zhou Jirong, Chen Shuxia, Zhan Wang, and Yu Hong. A scholarly conference held simultaneously discusses the creative climate and future direction of the "New Generation" painters, as well as the prospects for Chinese contemporary art to enter the global artistic circuit. This artistic director is Shao Dazhen. Contributing artistic consultants include Fan Di'an, Zhou Yan, Yi Ying, Kong Chang'an, and Yi Jinan. The curator of the exhibition is Wang Shenyou.

July 13-20: At the conclusion of the *1991 Oil Painting Seminar*, held by the Central Academy of Fine Arts with the support of the Chinese Artists' Association, The Exhibition Hall of the Central Academy of Fine Arts plays host to an exhibition of more than 100 new works by more than 20 young painters, including Liu Jianping, Zhou Xianglin, Yan Ping, Gu Juanli, Cai Jin, and Tan Baojun.

August

August 28-September 29: *The Exceptional Passage—Chinese Avant-garde Art* is held at the Fukuoka Museum in Japan. The curator is Fei Dawei. Participating artists include Huang Yong Ping, Yang Jiecang, Wenda Gu, Cai Guo-qiang, and Wang Luyan. Wang represents the "New Analysts Group," (also translated as the "New Measurement Group") whose other two members are Chen Shaoping and Gu Dexin. The exhibition is divided into indoor and outdoor portions. This is the next significant exhibition of Chinese contemporary art abroad after France's *Chine: Demain pour hier* in 1990.

September

September 1-5: *Oil Paintings by Zhao Bandi and Li Tianyuan* is held in the exhibition hall on the second floor of the Tiandi Plaza (now called the Poly Plaza) in Beijing.

September 1-6: *New Academy Group II*, curated by Yang Jinsong, is held in the exhibition hall at Zhejiang Academy of Fine Arts. Thirty-two painters participate, and a scholarly conference is held during the exhibition.

November

November 14-January 14, 1992: *Three Installations by Xu Bing*, is held at the Elvehjem Museum of Art at the University of Wisconsin-Madison. For the show, Xu Bing's unfinished large-scale installation *Ghosts Pounding the Wall* (weighing a total of 410 kg) is flown to the U.S. for display. The exhibition also displays Xu Bing's installations *Five Series of Repetitions* and *A Book from the Sky* along with some other experimental works. This is Xu Bing's first major exhibition after moving to the U.S, and his first solo exhibition in the West.

November 15-December 6: *National Oil Painting Exhibition 1991* takes place at the Museum of Chinese History in Beijing, showing 177 works chosen from over 4000 works submitted in a national competition. An academic conference on Chinese oil painting is held during the exhibition. The exhibition is organized by the editors of *China Oil Painting*, the editors of *Jiangsu Art Monthly*, and the Oriental Oil Painting Exhibition Hall.

December

December 14: *Installations by Feng Mengbo and Zhang Bo* takes place at the Beijing Contemporary Art Gallery. Feng Mengbo's work is titled *Air Dry*; Zhang Bo's is titled *The Meaning of Words*. The exhibition was forced to close on the morning before its opening.

December 21-26: Organized by the art gallery of the Shenzhen International Travel Service, *The First Realistic Fantasy Painting Traveling Exhibition: Beijing, Shenzhen, Hong Kong* opens at the Beijing Contemporary Art Museum, exhibiting work by young painters Wang Changbai, Chen Guobiao, Wang Dawo, and Huang Shi.

1992

April

April 11-15: *Modern Art Exhibition* is held at the Beijing Library, exhibiting oil paintings by Wu Xiaojun and An Hong.

April 21-26: *Paintings by Liu Wei and Fang Lijun* is held at the Beijing Art Museum. Francesca dal Lago writes the preface for the exhibition catalogue. Works by the two painters counter real life with a sarcastic attitude. Because of this, their art is later called Cynical Realism by critic Li Xianting.

May

May 13-14: Artist Huang Rui, then living in Japan, holds an open studio exhibition in his Beijing home. He displays his work *Ten Fish in Water*, the second part of the *Ten Things in Water Series*.

After *China Youth Daily* runs its long report "The Artists' Village in the Ruins of Yuanmingyuan," several dozen Chinese and foreign publications also report the phenomenon.

May 29: Zhang Peili and Geng Jianyi exhibit recent works at the Beijing Diplomatic Missions Restaurant. Zhang Peili's works include *Water: Standard Pronunciation, Ci Hai* and the video *Document on Hygiene*. The latter depicts a pair of hands wearing rubber gloves repeatedly washing a live chicken. Geng Jianyi's works include the paintings *Decorative Edge*, the work *The How-to Series* which uses photocopied images, and an installation *Books*, which involves several dozen books printed with several layers of characters such that the original text is unidentifiable. The exhibition was curated by Francesca dal Lago and Enrico Perle of the Italian Cultural Institute.

May 30-June 11: *Desire for Words: An Exhibition of Installation Works by Xu Bing and Wenda Gu* takes place in Hong Kong, organized by the Hong Kong Arts Centre and the Hanart Gallery Taipei, and curated by Johnson Chang.

Kong Chang'an's article "One Hundred Years of the Venice Biennale" runs in the eighth issue of *Art and Market* magazine. It is the first comprehensive discussion of this major international exhibition to run in a Chinese publication.

June

The Yuanmingyuan community holds an internal exchange exhibition. The open-air show takes place in a grove of trees in the village, and the works are hung from the trees.

June 13-September 20: *Documenta IX* takes place in Kassell, Germany. A satellite exhibition *K-18: Encountering the Other* is held simultaneously in Kassell. It includes 110 participating artists from 22 countries and regions outside of Europe. The curator is Jan Hoet, director of the Museum for Contemporary Art, Gent. Chinese artists Li Shan, Sun Lang, Chou Deshu, Ni Haifeng, Lü Shengzhong, and Wang Youshen show works.

September

September 18: *Contemporary Young Sculptors Invitational Exhibition* is held in The Gallery of the Zhejiang Academy of Fine Arts. This is the first exhibition especially dedicated to works by young sculptors. Participating artists include Fu

Zhongwang, Sui Jianguo, Zhan Wang, Zhang Yongjian, Xu Hong, Shi Hui, Jiang Jie, Ban Lingsheng, Yang Xiaohua, Li Xiuqin, Chen Yanyin, Wei Hua, Zhang Jihong, He Yong, Huo Boyang, Yang Qirui, and Zhang Xuming. This exhibition is conceived and curated by young sculptors.

September 20: An exhibition of works by Ni Weihua and Wang Nanming and a conference about the state of contemporary art in Shanghai is held at the International Art Palace (in the Holiday Inn Crowne Plaza), Beijing. At the conference, the video works *Progressively Diffused Situation* by Ni Weihua and *A World of Letters Comes Together* by Wang Nanming are shown. Critics and artists at the conference debate questions pertaining to these works.

September 26: Di Naizhuang displays his earth art works *Mountain Colors* and *Heavenly Spring* at Xishan Badachu Park on the outskirts of Beijing. Using several bolts of white cloth and several thousand red and blue umbrellas, the work is installed at a hillside forest in the park.

October

The First Guangzhou Bienniale: Oil Painting in the Nineties opens in Guangzhou. This is the first exhibition in mainland China organized on the commercial model, as well as the first important official exhibition of contemporary art in the 1990s. Young artists from around the country participate in the exhibition. Wang Guangyi and Li Luming are awarded the Documentary Prize; Mao Yan, Shang Yang, Zhou Chunya, Shu Qun, and Wei Guangqing are awarded the Academic Prize; and Mao Xuhui, Wang Jinsong, Shi Lei, Ye Yongqing, Liu Hong, Ren Jian, Leng Jun, He Hongbei, Zhang Xiaogang, Shen Xiaotong, Gong Liyou, Han Dong, Han Fei, Ge Zhen, Zeng Xiaofeng, Guan Ce, and Dai Guangyu are awarded the Award of Merit. Political Pop is prominent in this exhibition, and begins to attract widespread attention. During the exhibition, the New History Group of Hunan Province held an activity called *Sanitizing Behavior*. The curator of the exhibition was Lü Peng.

October 22-25: *The Second Documentary Exhibition of Contemporary Chinese Art* takes place in Guangzhou. The exhibition is divided into a display of documents and materials including photos and written works and a two-part slide exhibition entitled *Pop-Abstract*. The exhibition is jointly organized by the editorial staffs of *Jiangsu Art Monthly*, *Art Gallery*, and *Perspectives on Art*, as well as the oil painting department at Guangzhou Academy of Fine Arts and the graduate school of Sichuan Academy of Fine Arts. Participating curators include Wang Lin, Wang Huangsheng, Pi Daojian, Chen Xiaoxin, Yang Li, Zhu Bin, Zhong Weifan, Liang Jiang, Gu Chengfeng, and Tan Tian.

October 23-28: *Soft Sculpture by Zhu Guangping* is held at the China Art Gallery. Works exhibited include installations by Chen Shaofeng, Li Hongjun, and Cao Hongnian, as well as paintings by Jiang Ji'an, Xu Dawei, Gong Lin, and Li Fu.

Modern Art in China, 1979-1989 edited by Lü Peng and Yi Dan, and *Chinese Contemporary Art: Documents, 1990-91* are published by Hunan Fine Arts Press. These books are the first comprehensive introductions to Chinese contemporary art, using ample text and photographs to appraise and describe the artistic issues and trends of the period.

December

December 3: At the invitation of Peking University student group The 1990s Society, more than ten Yuanmingyuan artists hold an open-air exhibition in the Triangle, the main pedestrian area of the Peking University campus. The exhibition was later shut down by the authorities. The seventh and tenth issues of *Artists' Newsletter* that year contain Zhang Xiaojun's early introductory articles about the Yuanmingyuan artists.

December 3: In the provincial capital of Taiyuan, Shanxi Province artists Song Shuangsong (aka Song Yongping), Wang Yazhong, and Li Jianwei use bicycles to put on a performance work called *CHINA Shanxi Taiyuan, December 3, 1992.*

December 8: Preparing for an exhibition on the campus of The People's University at the invitation of a student group, several of the Yuanmingyuan painters were prevented from entering the campus gate with their works. In response, the painters held up their works and marched in a brief protest.

Curated by Claire Roberts, a small but influential exhibition entitled *New Art from China: Objects from the Post-Mao Era* is held at the Art Gallery of New South Wales in Sydney, Australia.

December 8-11: *The Second National Oil Painting Symposium* takes place in Beijing. This is the largest academic conference devoted to oil painting since its predecessor in April, 1986. Famous painters and critics participate in the symposium. The substance of the meeting is dedicated to questions about the new status of Chinese oil painting and the impact of the commodification of art, and of the improvement and maturation of painting in China. During the conference, Jia Fangzhou and Yin Shuangxi lead a slide presentation of contemporary Chinese painting, and Zhang Xiaogang presents slides and materials from *Documenta IX* in Kassell, Germany.

1993

January

Zhang Peili holds a solo exhibition entitled *Operating*. It is divided into four parts: the video *Homework Assignment No.1*; the video *Document on Hygiene No.3*; the photographic work *Continuous Reproduction*; and the mixed media work *Goods Not for Sale*.

January 12: *From Chang'an Avenue to Tiananmen—Art from Beijing and Korea* is held at the China Art Gallery. Fourteen installations not accepted by the China Art Gallery are shown in a private viewing at Beijing's Contemporary Art Gallery, an exhibition space located in the high school affiliated to the Central Academy of Fine Arts. This is the first exhibition organized by cultural groups to come to the mainland after China and South Korea establish diplomatic relations, with a total of 26 participating artists. During the exhibition, the artists exchange ideas by showing slides of their works.

January 29: *Country Life Plan 1993* begins its initial activity. This is a multi-media art happening spontaneously organized by artists active in Shanxi province. Members include Song Yongping, Wang Yazhong, Liu Chun, Wang Chunsheng, Zhou Yi, Han Fei, Zhang Guotian, Fan Xiaoli, Li Shaoping, Yao Chaocheng, Li Chen, Tang Pu, Li Jianwei, Hao Zhidong and others, a total of over twenty artists. In this activity, the artists selected a suitable place to begin research along the banks of the Yellow River in the Lüliang area, and stayed in the village they selected to complete a group of paintings, a television show *(Country Life Plan 1993)*, a music video *(Country Life Plan 1993)*, and a piece of reportative literature *(Country Life Plan 1993)*. This activity began in August 1992, aimed at connecting Chinese avant-garde art with the social reality that lay below it, and getting rid of art's exhibition-centered consciousness through wide-ranging exchange with society, thus giving art back to the masses.

January 30: A large-scale exhibition entitled *China Avant-garde* opens at Berlin's Haus der Kulturen der Welt. It is later exhibited at the Kunsthal Rotterdam, the Oxford Museum of Modern Art, and the Kunsthallen Brandts Klaedefabrik, Odense, Denmark. Seventeen artists show sixty works. Artists include Huang Yong Ping, Ding Yi, Fang Lijun, Geng Jianyi, Gu Dexin, Li Yilin, Ni Haifeng, Wang Guangyi, Wang Jinsong, Wu Shanzhuan, Yan Peiming, Yu Hong, Yu Youhan, Zhang Peili, Zhao Bandi, Zhao Jianren, and Zhu Chunsheng. The exhibition is organized and curated by Germans Jochen Noth and Andreas Schmidt, and by Hans van Dijk.

January 31-February 14: Curated by Johnson Chang and Li Xianting, *China's New Art, Post-1989* is held at Hong Kong Arts Centre. It exhibits works by 54 mainland Chinese artists, most of whom attracted attention during the *China/Avant-garde* exhibition in Beijing in February, 1989. The exhibition then travels through the world for several years, its participating artists becoming a who's who list of Chinese artists famous in the West. It is one of the most influential exhibitions of the early 1990s. The exhibition includes over 200 works of painting, sculpture, and installation. The exhibition is funded by the Hong Kong Arts Centre, Hanart TZ Gallery, and the Museum of Contemporary Art, Sydney. It is divided into six parts: Political Pop, Cynical Realism, Tragic Romanticism, Emotional Bondage, Abstraction, and Endgame Art. The show later traveled to the Museum of Contemporary Art, Sydney, and to several sites in the U.S.

Artists Cui Yanjun, Wang Hui, Zhuang Hui, He Yingnan and others launch a project called *Flint* in Luoyang, Henan province.

February

February 22: *Country Life Plan 1993* begins its second activity, which continues until April 20.

At Home/Abroad: New Chinese Art opens in a gallery space in Peterborough, Canada. It is a traveling exhibition of experimental Chinese art organized by York University professor Bruce Parsons, which was also exhibited in Ottawa in August of the same year. Participating artists include He Gong, Li Ning, Tai Ming, Wenda Gu, and Gu Xiong.

March

A documentary film about the artistic lives of the Yuanmingyuan painters, *Uncompleted Documentary*, concludes filming.

Beijing's Yanhuang Art Museum invites the Yuanmingyuan painters to hold a group exhibition. When the time comes to install the exhibition, it is suspended on account of a previously scheduled official activity.

A group which calls itself the Lanzhou Art Group begins an action piece called *Burial*. They surround a dummy named Zhong Xiandai (literally, "Clock Modern") and perform a month of funerary rites for him. Artists include Cheng Li, Ma Yunfei, Ye Yiwu, and Yang Zhichao.

Jiangsu province artists Huang Su, Guan Ce, Jin Feng, Shen Qibin, Zhang Liming, Wang Cheng, Zhang Da, Zhou Xiaohu

and others realize a performance work called *Nanjing—Transmission of Documents and Materials Surrounding Chinese Modern Art*.

April

April 21-25: *Paintings by Shen Ling and Wang Yuping* is held at the China Art Gallery.

April 24-28: Li Tianyuan's solo show *Mistake! Links without Results* is held.

April 28: *New History 1993: Consumer Products Series* prepares to show at the McDonald's on central Beijing's busy shopping street Wangfujing. The exhibition is later shut down by the authorities. The exhibition is organized by the New History Group of Wuhan, and consists of Ren Jian's *Blue Jeans Series*, Zhou Xiping's *Large Portraits Series*, Liang Xiaochuan's *Large Inheritance Series*, and Ye Shuanggui's *Large Porcelain Series*.

May

Beijing's Riyue Cultural Studio and the Sichuan Cultural Development Center jointly create a "Display Room for Works from the Yuanmingyuan Artists' Colony," which shows works by some of the painters in the group.

May 2: An exhibition of paintings by Joerg Immendorf, the German painter and representative of New Expressionism, opens at the International Art Palace, Beijing, with a total of 34 canvases. Immendorf himself also comes to Beijing and talks with Chinese artists and critics.

May 25: Huang Yan begins a performance work in Changchun, Jilin Province, entitled *Dismantling and Taking Rubbings of Architectural Materials*. In this work, the artist selected typical examples of Republican, Russian, Japanese, Great Leap Forward, Cultural Revolution, and post-1978 architecture, and began to make rubbings of each. The timeframe for the work is set between 1993 and 2003.

June

June 13-October 10: Chinese artists Wang Guangyi, Zhang Peili, Geng Jianyi, Xu Bing, Liu Wei, Fang Lijun, Yu Hong, Feng Mengbo, Yu Youshen, Li Shan, Wang Ziwei, Ding Yi, Sun Lang, and Song Haidong participated in the *The Eastern Road* portion of *The 45th International Venice Biennale*. Key organizers include Francesca dal Lago of the Italian Cultural Institute in Beijing, Achile Bonito Oliva (chairman of the Venice Biennale organizing committee), and Li Xianting. Wang Youshen and Wu Shanzhuan take part in a nearby special exhibition Open'93, curated by Kong Chang'an. This is the first time that works by Chinese contemporary artists are shown in the Venice Biennale. A total of 30 works are shown, all of them easel paintings, with the exception of an installation by Song Haidong.

Zhang Peili, Gu Dexin, and Geng Jianyi participate in the *Spoleto International Arts Festival* (entitled *Artistic Meeting*) in Italy.

June 27-July 1: The second exhibition in the *Transition* series takes place at the Contemporary Art Gallery in Beijing. Participating artists include Li Hongjun, Li Fu, Li Jianli, Gong Lin, and Chen Shaofeng.

July

July 30: *Fragmented Memory: The Chinese Avant-garde in Exile* opens at the Wexner Center of the Ohio State University Museum. Participating artists are Wenda Gu, Huang Yong Ping, Wu Shanzhuan and Xu Bing. The exhibition is curated by Gao Minglu and Julia Andrews.

August

Country Life Plan 1993 opens at the China Art Gallery (it is later shut down) and the *China Daily* Art Gallery, including an art exhibition and a scholarly forum. Because the opening was shut down, aritist Song Yongping hired a barber to shave his head at the entrance to the China Art Gallery, for which he was detained.

September

September 3-October 3: Works by British contemporary artists Gilbert and George are shown at the China Art Gallery. The day after the opening, Gilbert and George go to Beijing's East Village artists' community and meet with Ma Liuming and other avant-garde artists.

In Shanghai, Ni Weihua realizes *Connection and Dispersion Series 2: 1993 Handbill Performance*.

September 8: The Yuanmingyuan painters apply to hold a large-scale group exhibition at the Beijing Art Museum. Several days after reaching an agreement, the plan is cancelled by the authorities.

September 17-October 15: *The First Asia-Pacific Triennial of Contemporary Art* opens at the Queensland Art Gallery in

Brisbane, Australia. More than 200 works by artists from 13 countries and areas in the Asia-Pacific region are exhibited. Participating Chinese artists include Zhou Changjiang, Yu Youhan, Sun Lang, Shen Haopeng, Ding Yi, Li Lei, Xu Jiang, and Shi Hui. During the exhibition, Griffiths University holds a scholarly symposium on *Identity, Tradition, and Differentiation*. Zhou Changjiang, Yu Youhan, Li Xu and Xu Hong are invited to the conference.

October

October 15: Geng Jianyi realizes his work *Marriage Law* in Hangzhou, Zhejiang Province. A notice about the activity posted that day attracts twenty interested viewers to Moganshan Middle School to take part. Once the work was over, a new debate about law, marriage, and family begins.

The SHS group realizes a performance work entitled *Large Glass—Heaven in Fantasy* at the Workers' Cultural Palace in Huangshi, Hubei province. The group was established in 1992. Members include Hua Jiming, Liu Gangshun, Han Liping, and Li Ju.

October 26: Ten minutes before the scheduled opening of the graduation exhibition *1990s Art at the China Art Gallery*, Zhang Huan realized a spontaneous performance work at the west gate of the museum entitled *Angel*. On this account, China Art Gallery immediately closed the exhibition. Five days later, after Zhang Huan had paid a fine of 2000 *yuan* and submitted a self-criticism, China Art Gallery officially cancelled the exhibition.

November

November 24: *Third Exhibition of the Big-tailed Elephant Group* takes place at the Red Ants Bar in Guangzhou. Works include Lin Yilin's *100 Yuan and 1000 Yuan*, Chen Shaoxiong's *Five Hours*, Xu Tan's *Parable of Love*, and Liang Juhui's *Empty*.

December

December 10: Ye Shuanggui realizes his work *Connection and Dispersion Series: Consumption Virus at the Tianlong Hotel* in Wuhan, Hubei province.

December 11: *China Experience*, curated by Wang Lin, opens at the Sichuan Art Museum in Chengdu, Sichuan province. Participating artists include Mao Xuhui, Wang Chuan, Ye Yongqing, Zhang Xiaogang, and Zhou Chunya. An academic conference *The Chinese Experience and Contemporary Art* is held simultaneously.

December 19: Andrew Solomon's cover story "Their Irony, Humor, (and Art) Can Save China" runs in *the New York Times Magazine*. This long feature circulates widely, and is influential in shaping early Western opinion of contemporary art in China.

December 23: Critic Gao Ling organizes a colloquium Contemporary Art Salon, aimed at "researching, discussing, and exchanging ideas about the cultural value and creative situation of avant-garde art in China." Participants include Lü Shengzhong, Pan Dehai, Liu Yan, Chen Shaofeng, Zhu Weibin, Wang Youshen, Shi Liang, Wang Mingxian, Leng Lin, Huang Du and others.

December 26: *Commemorating the 100th Anniversary of Chairman Mao's Birth: Works by Huang Rui* is held at the home of Ai Weiwei in Beijing, showing Huang's two series *Modern Documents* and *The World Speaks a New Language*.

Curated by David Elliot and Lydie Mepham, an exhibition of works by eight Chinese artists entitled *Silent Energy* is held at the Oxford Museum of Modern Art in England.

Curated by Hou Hanru, an exhibition of works by five Chinese artists entitled *Out of the Centre* is held at the Pori Art Museum in Pori, Finland.

December 31-January 2, 1994: Liu Xiangdong mounts an exhibition *Works by Liu Xiangdong—Post Cold War* in Quanzhou, Fujian Province.

1994

January

Because it has an image of Zhao Shaoruo's work *Beginning from This May* on its cover, the second issue in 1994 of the publication *Hanmo Art News* (altogether the fourth issue of the publication) is destroyed by the Public Security Bureau. The work on the cover inserts the head of the artist into well-known photographs from China's sociopolitical history, attracting the attention of the police. The artist is deported to his home province, and the editor Lin Song is fined.

January 13-March 13: Lü Shengzhong exhibits his works *Soul Store, First Aid Center*, and *Soul Stele* in Munich, St. Petersburg, and Adelaide. This is his first serial exhibition since *Red Train Paper Cutting* in Germany.

January 22: Xu Bing gives an experimental showing of *Cultural Animals* at the Hanmo Arts Center in Beijing. This is Xu Bing's first exhibition in China since leaving for the U.S. in 1990.

The Schoeni Art Gallery in Hong Kong presents *8+8: Contemporary Russian and Chinese Avant-garde Artists*, showing works by contemporary painters. Participating Chinese artists include: Li Shan, Wang Jinsong, Liu Wei, Fang Lijun, Qi Zhilong, Yang Shaobin, Yue Minjun and Zeng Fanzhi.

March

March 11: Li Yan displays 19 of his installation works in the ruins of the former Harbin Painting Institute.

March 19-April 16: Italian avant-garde artist Mimo Palladino has an exhibition at the China Art Gallery.

April

April 6: A solo exhibition of installation works by Song Dong entitled *Another Class, Do You Want to Play with Me?* opens at The Gallery of the Central Academy of Fine Arts. Thirty minutes after opening, the exhibition is shut down.

April 11: Gansu Province artist Ma Qizhi realizes a public performance work entitled *Sufficiently Attending to a Nine Square-Meter Piece of Land* in a plaza at the Northwest Nationalities Institute in Lanzhou.

April 28-May 28: The *Sculpture 1994* series of solo exhibitions begins at The Gallery of the Central Academy of Fine Arts. Participating artists include Sui Jianguo, Fu Zhongwang, Zhang Yongjian, Zhan Wang, and Jiang Jie. This event aims to re-consider and re-define "the concept of sculpture."

Artist Tian Liusha distributes over a thousand roses to passengers and passers-by on the tourist train between Guangzhou and Shanghai, and at East China Normal University in Shanghai. It is said that this work stems from her idea of "constructing an ideal space."

May

May 1: An installation exhibition *94 Art Paragraph* opens at Huashan Technical School in Shanghai. Participating artists include Shi Yong, Qian Weikang, Yin Jun, Liang Chen, Tao Huiping, Jin Lili, Li Lei, and others. The artistic director is Zhu Qi. During the exhibition, Shen Yunshen, an artist from Handan, Hebei province, wore beggar's clothes and realized a performance event entitled *Redundant Art*, which led to disagreements among the viewers.

May 2-4: *Third Historical Document Exhibition* opens at the library of East China Normal University in Shanghai. The theme of the exhibition is *Installation-Environment-Performance*. It takes the form of a display of printed materials and a slide/ video presentation related to installation works by several dozen Chinese and foreign artists in the 1990s. A conference is held simultaneously, entitled *Chinese Art in a Time of Transition*. More than fifty artists and critics participate in the discussions.

May 18: An art happening entitled *New History 1994 Green Engineering Poetic Wind* and *Green 2420 Art Activity* is held in Wuhan, Hubei province. This event continues the New History Group's *1992 Consumer Art* event; its 1993 events *Big Consumption, 100 Suns*, and *Nine Days of Forced Labor;* and its 1994 events *Green Project* and *March 15 Green Consumption*. The group stresses the connection between art and everyday life, as well as the social power of art.

June

June 5: A solo exhibition of installations by Wang Peng opens at the Hanmo Gallery in Beijing. The works on display are used objects from everyday life, including 1950s marriage photos and audio tapes of sounds from married life, as well as a questionnaire about whether or not the Berlin Wall should be rebuilt.

Chen Qiang begins to realize his *Yellow River Bridge* project. This is a multi-media project combining performance, conceptual installation, and audio-visual methods. It tries to splice mass news media into mass culture.

June 13: Zhang Huan realizes his work *Twelve Square Meters* in Beijing's East Village. In this work, he covers himself with a mixture of fish entrails and honey, and sits still in a village latrine for one hour. During this time, the entrails attract large numbers of flies, which cover his naked body.

June 14: Ma Liuming, Zhu Ming, and others hold a performance art activity. The artists were arrested and jailed for two months. The final crime with which they were charged was "pornographic performance."

June 26: At the Hanmo Gallery, Zhao Bandi holds an installation exhibition event entitled *Zhao Bandi Flies to the Moon, June 26, 1994, 3:00 PM.*

July

July 10: Zhang Huan completes a performance work in East Village entitled *65 Kilograms*. For this work, iron chains are used to suspend his body horizontally from the rafters while the artist undergoes a blood transfusion in which 250cc of his own blood flows down onto a tray in an electric oven below. The entire performance lasts two hours.

Hanmo Gallery in Beijing holds *Art Proposal Exhibition*. The gallery invites artists from Beijing, Guangzhou, Shanghai, and elsewhere to exhibit their artistic proposals, along with photos and videos of their previous works. Participating artists include Xu Bing, Lü Shengzhong, Xu Tan, Chen Shaoxiong, Wang Feng, Zhu Fadong, Shi Yong, Jiao Yingqi, Song Dong, Zhao Shaoruo, Liu Anping, and others.

Jiao Yingqi realizes an installation at Beijing's Hanmo Gallery which lasts more than a month, a performance work entitled *Space for Learning*.

Printing is completed on *Black Cover Book*. This book is the first volume of material on early 1990s Chinese experimental art to circulate among art insiders. The contributing editors are Zeng Xiaojun, Ai Weiwei, and Xu Bing. The managing editor is Feng Boyi.

The SHS Group of artists from Huangshi, Hubei province and the New Labor Group from Wuhan complete a performance work at the Xinzhi Bookstore in Huangshi entitled *Using a Piece of Rope to Fill a Bookstore*.

August

Zhu Jinshi, a Chinese artist living in Germany, curates a project entitled *Eleven Weeks in China*, which includes separate events in Beijing and Wanzhuang, Hebei province. Participating artists include Wang Feng, Song Dong, Yi Xiuwen, Zhang Lei, Ruan Haiying, and others.

Wang Gongxin, then residing in the U.S., holds an art event in his Beijing home entitled *Open Studio*. Works on display include *Edible Gray* and five other installations.

Wang Jinsong and Liu Anping play their video work *SW-Good Morning Beijing* at the Beijing Great China Movie Theater. During the screening, Zhao Shaoruo and Liu Anping douse the viewers with ink (these include critics and some artists). Later called "the ink-dousing incident," this performance leads to considerable in-fighting.

German artist Wolf Kahlen exhibits works at the Zhaoyao Gallery in Beijing. (Zhaoyao Gallery is the apartment of artist Zhu Jinshi, located in the Weigongcun area of Beijing.)

Artist Huang Rui, then living in Japan, holds an art event in his Beijing home.

Aritst Qin Yufen, then living in Germany, realizes a work Wind Lotus at the Summer Palace in Beijing.

August 30-September 3: An exhibition entitled *Zhang Li's Experiment: Expressive Ink Works 1994* is held at the China Art Gallery, showing works by experimental Chinese ink painters.

September

September 16: Zhu Jinshi curates an exhibition *Eyes Ears* at the International Art Palace in Beijing. It is aimed at realizing an exchange between modern and contemporary music, sound and installation art, and Chinese and German artists. Participating artists include Ke Shike, Liang Heping, Qin Yufen, Zhang Guangxia, Zhu Di, and Zhu Jinshi.

Wang Peng displays an installation work *We Live in Art* in Beijing's Zhaoyao Gallery.

September 30: *The Seventh Exhibition of Graduation Works by Advanced Students in the Painting Department at the Central Academy of Fine Arts* is held in The Exhibition Hall of the Central Academy of Fine Arts. Some installation works which had not received approval are not exhibited.

October

October 4: *Invitational Exhibition of Works Nominated by Chinese Critics* opens at the China Art Gallery in Beijing. Nominating critics include Shui Tianzhong, Tian Lin, Zheng Pingxiang, Liu Xiaochun, Pi Daojian, Chen Xiaoxin, Lü Peng, Shao Dazhen, Fan Di'an, Yi Ying, Li Xianting, Gu Fangzhou, Yin Shuangxi, and Peng De. Nominated artists include Ding Fang, Yu Zhenli, Wu Ershan, Mao Yan, Wang Yigang, Ye Yongqing, Xu Jiang, Shen Xiaotong, He Duoling, Yang Feiyun, Shang Yang, Luo Zhongli, Zhou Chunya, Yu Xiaofu, Hong Ling, Gong Lilong, Xia Xiaofang, Gu Difei, Chao Ge, Zeng Fanzhi and Cai Jin.

October 18: Works by Li Shan, Yu Youhan, Wang Guangyi, Liu Wei, Fang Lijun, Zhang Xiaogang are included in *The 22nd International Sao Paolo Biennial*. During the exhibition, the subject matter, particularly the nudity, in Liu Wei's work led

to protest by local Chinese.

Post-October, an installation art exhibition, is held in Beijing. Participating artists include Zhu Jinshi, Wang Peng, Song Dong, Wang Jinsong, Cang Xin, Yi Xiuwen and others.

October 25: Hosted by the China National Publishing Industry Trading Corporation Art Centre, the exhibition *China-Korea-Japan: New Asian Art* opens at The Art Museum of Capital Normal University. The title of the exhibition is *Today is the Dream of the Orient*. Participating Chinese artists include Wang Luyan, Wang Jianwei, Li Yongbin, Wang Guangyi, Wei Guangqing, Wang Youshen, Gu Dexin, and Song Dong. This is the first exhibition held in mainland China in which Chinese avant-garde artists participate in an international exchange about modern art. During the exhibition, an exchange session is held, hosted by Japanese artist Yadani Kazuhiko, in which artists and critics from the three nations enter into debate.

November

November 12-19: *Mixed Media Works by Liu Yan, 1994* takes place at the Hanmo Gallery in Beijing.

November 26-30: *The Second Art Fair* takes place in Guangzhou. This exhibition contains a specially designated "installation art area." Major participants include Guangzhou Big-tailed Elephant Group members Lin Yilin, Xu Tan, Chen Shaoxiong, Liang Juhui, and Zhao Bandi of Beijing.

Wang Peng, Song Dong, Yin Xiuzhen, and Ruan Haiying realize an experimental art activity in the Beijing suburbs entitled *Central Axis*.

Art by Wang Qiang is held at the Hanmo Gallery, Beijing.

December

Organized by the New Amsterdam Art Consultancy and the Red Gate Gallery, an exhibition of Zhang Hai'er's *Bad Girl* series is held at Beijing's Songhetang Gallery.

December 12: An exhibition of works by female artists entitled *12-12* opens at the Zhaoyao Gallery in Beijing. Participating artists include Yin Xiuzhen, Zhang Lei, Ruan Haiying, Karen Smith (U.K.), and Qin Yufen (then living in Germany). The exhibition is curated by artist Zhu Jinshi.

Xu Bing participates in the exhibition *Life and Heat: Materials of a Culture in Transition* at the Museo Nacional Centro de Arte Reina Sofia in Madrid, Spain. This exhibition is organized and curated by Dan Cameron, one of the organizers of the open exhibition at the 1993 Venice Biennale.

Two exhibitions, *The Strange Environment* and *Sliced* are held in Chongqing, Sichuan province. Participating artists include experimental painters Xi Haizhou, Zhang Bin, Guo Wei, Guo Jin, Chen Wenbo, He Sen, Zhao Nengzhi, Feng Sheng, Yi Ruilin, and others.

December 16-January 14, 1995: To celebrate the 600th anniversary of the founding of the city of Seoul, the Korean National Museum of Contemporary Art stages an international arts festival. A massive international exhibition of contemporary art entitled *Humanism and Technology* opens during the festival. Chinese artists invited to participate include Wang Youshen, Wang Guangyi, Sun Liang, and Zi Xu.

December 27: *The Eighth National Art Exhibition* opens at the China Art Gallery. Because of differences in the scoring standard, the old practice of awarding gold, silver, and bronze prizes is cancelled. Shi Chong's work *Integrated Sight* (originally called *Red Wall Memories*) and other works led to passionate disputes.

December 31: *Art from the South-West* opens at the Xinan Commercial Plaza in Kunming, Yunnan province. The more than thirty works exhibited include paintings, sculptures, and installations. Participating artists are Mao Jie, Zhuang Dong, Sun Shifan, Li Li, Chen Longsheng, Su Xinhong, Luo Xu, Tang Zhigang, and Zeng Xiaofeng.

Jiangsu Art Monthly publishes an article "Strive for Unambiguous Meaning" by art critic Yi Xiang in its December issue. The article argues that "going from ambiguous toward clear meaning should be an unavoidable trend in contemporary culture...following the daily growth of postmodern culture, 'the ambiguity of meaning' will also gradually move from the mainstream of modern art to the periphery." The arguments in this article lead to a wide-ranging debate about the role of "meaning." Qiu Zhijie, Shen Yubing, and others publish articles in later issues of *Jiangsu Art Monthly* expressing different opinions toward Yi's article.

1995

January

January 1: At the birthday party of British critic Karen Smith, artist Cang Xin throws the birthday cake at the partygoers, who include avant-garde artists and critics. This incident, like the 1994 "ink-dousing incident," incurs debate and doubt about the validity of this sort of so-called "spontaneous art."

January 22: *Installation: The Orientation of Language* opens in Shanghai, exhibiting installation works by Shi Yong, Qian Weikang, Ni Weihua, Chen Yanyin, Zhang Xin, Hu Jianping, Wang Nanming, and other Shanghai artists. The exhibition is curated by Wang Nanming.

January 23: The *Original Sound* series of artistic activities, organized by Song Xiaohong (Arianna Vabarnov) begins in the middle of the night beneath a traffic overpass in southeast Beijing. Participants include Song Xiaohong, Zhang Huan, Zhu Fadong, Ma Liuming, Cang Xin, Zu Zhou, Song Dong, Luo Lin, Gao Xiangxia, Rong Rong, Wang Shihua, and others.

February

February 2: *Change: Beijing and Shanghai Avant-garde Arts Exhibition* is held at the Goteborg Art Museum, Goteborg Sweden. Paintings, installations, and photography by seventeen artists are displayed, including Yu Youhan, Sun Liang, Ding Yi, Liang Weizhou, Zhang Enli, Ding Fang, Li Tianyuan, Yang Feiyun, Hong Hao, Cai Jin, Shi Chong, Zhang Hai'er, Ai Weiwei, Zhou Jirong, Su Xinping, Zhao Shouqing, and others.

Li Tianyuan, Sui Jianguo, Su Xinping, Wei Dong, and Ding Yi participate in an exhibition entitled *Modern Chinese Art* in Melbourne, Australia.

March

March 12: *The 30th Artists Today Exhibition* opens at the Citizens' Gallery in Yokohama, Japan. Chinese artist Hu Jieming participates in the exhibition, and Shanghai critic Li Xu is invited to give a conference address entitled *China's Avant-garde: A Landscape of Change.*

Wang Gongxin and Lin Tianmiao exhibit installation works at their home in Beijing, including *The Sky of Brooklyn* by Wang Gongxin and *Threadwinding* and *The Temptation of Saint Teresa* by Lin Tianmiao.

April

April 7-26: *Korean Modern Art* opens at the China Art Gallery, displaying works by Nam Jun Paik, Lee Hung-Yoom, Lee Seung-Teak, and others, a total of 36 South Korean artists and more than 60 works.

The book *The Chinese Contemporary Artists' Agenda (1994)* is printed. This catalogue, published with text in Chinese and English, collects proposals by 19 artists, preliminary photographs, and a few photographs of completed works. It is curated jointly by artists Wang Luyan, Wang Youshen, Chen Shaoping, and Wang Jianwei.

May

May 4-11: *Women's Approach to Contemporary Art* is held at the Beijing Art Museum. Participating artists include Cai Jin, Liu Liping, Pan Ying, Shi Hui, Liu Hong, Song Hong, Yang Keqin, Sun Guojuan, Chen Qiaoqiao, Zhu Bing, Lin Tianmiao, Zhou Jing, and others. The exhibition is curated by Liao Wen.

May 4: Di Naizhuang continues to realize his *The Earth Turns Red* art plan at Beijing's Yuyuantan Park.

May 13: *1995 Research Series of Solo Exhibitions* begins at the Exhibition Hall and Gallery of the China National Academy of Fine Arts (formerly the Zhejiang Academy of Fine Arts) in Hangzhou, Zhejiang Province. The theme of this series of exhibitions, organized by the school's research department, is *Thoughts of Female Artists from the Academic Sphere on Contemporary Trends.* Participating artists include Wang Gongyi, Chen Haiyan, Shi Hui, Li Xiuqin, and others.

A group mainly composed of artists from Beijing's East Village realizes two works of collective creation atop Beijing's Miaofeng Mountain, entitled *To Raise an Anonymous Mountain by One Meter,* and *Nine Holes.* Participating artists are Zhang Huan, Ma Liuming, Ma Zhongren, Wang Shihua, Zhu Ming, Cang Xin, Zhang Binbin, Duan Yingmei, Zu Zhou, and Gao Yang.

May 16-June 5: Tang Jiazheng realizes a work on Kunming Road and Dongfeng Road in Kunming, Yunnan Province. Entitled *Sacrificial Objects,* it involves painting the exposed faces of the stumps of blown-down trees in order to make them more visible.

May 20-26: Yin Xiuzhen has her first solo show at the Contemporary Art Gallery in Beijing.

June

June 1: A dialogue exhibition between German artist Gunther Uecker and the New Analysts Group is held in Berlin. Group members Chen Shaoping, Wang Luyan, and Gu Dexin are invited to the opening. The Group's work, called simply *Work by the New Analysts Group*, consists primarily of twelve large tables on which 2000 books lay open, clearly marked for sale at 10 marks each. The books had been printed by Dushu Press in August, 1994. The contents of this book take the printed text of a discussion between Uecker and Dieter Honisch as its primary material, and adulterated the text according to a set of principles for the completion of the work agreed upon by the group. The principles are applied *ad absurdum*, until only a phrase of mixed German and Chinese remains.

June 8: Song Dong holds an exhibition of his work *Chinese Medicine* in a Chinese-style apartment complex in Beijing.

June 10-September 10: *Configura 2* is held in Erfelt, Germany. Works by artists from nine countries—Egypt, Brazil, China, Greece, India, Mexico, Nigeria, Russia, and the U.S.—are exhibited. Organizers of the Chinese section are Hans van Dijk of the New Amsterdam Art Consultancy and Beijing-based German national Julie Noth. Chinese participants include the New Analysts Group, Ai Weiwei, Zhao Bandi, Jiang Jie, Liu Anping, and Wang Peng.

June 17: One piece of Chen Qiang's integrated art project *Agepass: Bridge on the Yellow River* is realized, a stele commemorating the water of the Yellow River at Dongying City, Shandong province, the point where the river flows into the sea.

June 18: *Out of the Middle Kingdom: Chinese Avant-garde Art* opens at the Santa Monica Arts Center in Barcelona. It is part of the *Open '95* exhibition. The exhibition is divided into sections concerning the 1979 retrospective movement, the 1985 New Wave, Political Pop, sculpture, installation, Chinese painting, and others. This exhibition is curated by Ms. Inma Gonzales Puy of the Spanish embassy in Beijing and funded by local cultural institutions in Barcelona. Invited to take part in the opening are critic Li Xianting, the New Analysts Group, artists Xu Bing, Zhang Peili, Wang Gongxin, Zhang Xiaogang, Liu Wei, Wang Guangyi, Wang Nanming, Mao Xuhui, Xi Haizhou, Zhang Jin, and others. Other artists with works exhibited include Wang Peng, Chen Tiejun, and Yang Gang. Of these, the New Analysts Group, Wang Guangyi, Zhang Peili, Wu Shanzhuan, Wang Gongxin, Xu Bing, Huang Yong Ping, and Wenda Gu are invited to complete works on the exhibition site.

The 46th International Venice Biennale is held. Participating Chinese artists include Zhang Xiaogang, Liu Wei, and Yu Youhan. One of the satellite exhibitions at the Biennale, *Asiana* is comprised of works by Chinese, Japanese, and Korean artists. Chinese participants in this exhibition include Gu Dexin, Yang Jun, Huang Yong Ping, and Cai Guo-qiang. The curator is Fei Dawei.

July

Organized by the New Amsterdam Art Consultancy, the exhibition *Chinese Modern Art in the Academy: Works by Ding Yi, Duan Jianwei, Li Tianyuan, Wu Xuefu, Zhang Hai'er, and Zhao Bandi* is held at the Goethe Institute in Beijing.

Wang Jin realizes his performance work *To Marry a Mule* in a closed showing in the courtyard of a Chinese apartment building at Laiguangying Village in eastern Beijing. In this work he dresses as a spiffy Western bridegroom and holds a wedding ceremony with a mule dressed as a bride.

New Asian Art Show 1995 is held at Kirin Tower in Yokohama, moving in August to the Exchange Center, Tokyo. It is a continuation of the series that began in 1993 with the *First Korean International Exchange Art Festival* and continued with the *China-Japan-Korea* exhibit in Beijing in 1994. Participating Chinese artists include Wang Luyan, Wang Jianwei, Song Dong, Li Yongbin, Wang Guangyi, Wei Guangqing, Wang Youshen, and Yang Jun.

August

In answer to a call from American artist Betsy Damon to protect the water resources of the Yangzi River, and to realize their *Living Water Park* project, several artists hold an exhibition and publicity activity around the theme of *Defenders of Water*. Participating artists come mainly from Chengdu, including Dai Guangyu, Yin Xiaofeng, Xu Hongpeng, Cai Jian, Zeng Xun, Liu Chengying, Yin Xiuzhen, and others.

Chinese Women's Invitational Exhibition is held at the China Art Gallery in Beijing. It is set to include non-easel works by Lin Tianmiao, Jiang Jie, and Shi Hui. However, for reasons of "fire safety," Lin Tianmiao and Jiang Jie are not able to display their actual works, and can only display photos of the works

August 29-31: The Triplicate Studio (Sui Jianguo, Zhan Wang, and Yu Fan) along with Jiang Jie, Lin Qing, and others

hold an artistic event in the ruins of the recently relocated Central Academy of Fine Arts on the busy shopping street of Wangfujing. The event is originally called *New Wangfujing Square*, but later changed to *Plan for Development*.

September

September 4-22: A photographic exhibition, *China's New Photography* is held at the Tokyo Gallery, showing more than 80 works by young photographers Xu Zhiwei, Xing Danwen, and Rong Rong. These three photographers followed the developments and transitions of the Chinese avant-garde art scene continuously since the early 1990s, creating photographic records of activities and daily life in the artistic circle. Xing Danwen and Rong Rong's work centers specifically on performance art in the East Village.

September 7: *Out of Ideology* opens in the K3 exhibition hall of the Hamburg International Arts Centre in Germany. This exhibition is jointly curated by the Hamburg Cultural Bureau, Chinese artist Dan Fan, and Chinese critic Li Xianting. Participating artists include Wang Guangyi, Wu Shanzhuan, Wang Youshen, Qiu Zhijie, Feng Mengbo, Wang Qiang, Shi Hui, Liu Wei, Zhang Xiaogang, Wei Guangqing, Zeng Fanzhi, Xu Jiang, and Shen Fan.

September 14: *Women/Here*, an exhibition of works by The Triplicate Studio of Sui Jianguo, Zhan Qang, and Yu Fan is held at the Beijing Contemporary Art Gallery.

September 16-18: An exhibition of installations entitled *Displacement* is held at The Art Museum of Capital Normal University, Beijing. Female artists Yin Xiuzhen, Zhang Lei, Ruan Haiying, and Karen Smith participate.

September 18: Xu Bing's solo exhibition *Xu Bing—Language Lost* opens in Boston, displaying the two installation works *A Book from the Sky* and *Silkworm Series*.

September 20: *The First Kwangju Biennial* opens in Kwangju, Korea. More than 500 artists from over 60 countries participate in the exhibition, entitled *Beyond the Borders*. Wang Jianwei, Lü Shengzhong, Fang Lijun, Song Dong, and Feng Mengbo are invited to display works.

October

October 6-10: Organized by Sun Zhenhua, Works by Li Xiuqin, Chen Yanyin, and Jiang Jie is held in The Exhibition Hall of the Central Academy of Fine Arts.

Song Dong displays *Room of Steles* in a closed exhibition at the Zhaoyao Gallery, Beijing.

October 21: Wang Peng exhibits photographs and taped footage from his work *Three Days* in the watchtower at the northwest corner of the outer wall of the Forbidden City. Prior to this, he had lived alone in the unrestored watchtower for three days and nights.

October 21: Yan Lei holds an exhibition entitled *Invasion* in the training room of the Beijing Number One Theater. He displays video footage and photographs of himself after being assaulted and battered. Leng Lin is the artistic director.

October 24-November 5: Jointly organized by the Ministry of Culture, the China International Exhibition Center, and the Goethe Institute of Beijing, the exhibition *German Modern Art* is held in the Taimiao Exhibition Hall at the Forbidden City. Nearly 100 paintings, sculptures, and installations by more than 20 German contemporary artists are exhibited.

Chen Yanyin, Jiang Jie, and Li Xiuqin hold an exhibition of installation works in The Exhibition Hall of the Central Academy of Fine Arts.

November

November 4-9: The exhibition *Photography by Shu Li and Han Lei* is held at Beijing's Contemporary Art Gallery, organized by the New Amsterdam Art Consultancy.

November 10-13: *Beijing-Berlin Artistic Exchange* is held at The Art Museum of Capital Normal University. Chinese participants in this exhibition of mainly installation works include Geng Jianyi, Song Dong, Wang Gongxin, Yin Xiuzhen, Zhu Jinshi, Wang Peng, Zhang Peili, and Zhan Wang. German participants include Gusztav Hamos, Jozef Legrand, B.K.H. Gutmann, Wolf Leide, The Gabriel Twins, Bernhard Garbert, and Andreas Schmidt. The Chinese curator is Huang Du, and the German curator is Angelika Stepken.

December

Artist Wei Ye's performance work *Buffet of the Future* is completed in Beijing. Themed *The Earth Needs Green*, this work invites more than ten contemporary artists to debate social, scientific, economic, cultural, and environmental "problems of the future" over a buffet meal.

December 8-13: *A New Light on Chinese Artist: Photos by Xu Zhiwei* is held at The Gallery of the Central Academy of Fine Arts.

December 16: Wei Ye and Zhao Bandi separately realize their works *Future Fast Food* and *Zhao Bandi and Zhang Qianqian* at the Black Forest Bar in Beijing.

1996

January

January 6-7: Guangzhou's Big-tailed Elephant Group holds its fifth annual exhibition, *Possibility*, in a bar in the basement of the Zhongguang Building, Guangzhou. Participating artists include Lin Yilin, Xu Tan, Chen Shaoxiong, Liang Juhui, and Zheng Guogu.

January 8: *One Way Presentation*, an exhibition of contemporary art from Fujian Province, takes place in the library of Fujian Normal University. Participating artists include Li Xiaowei, Chen Zongguang, Wang Hong, Qiu Xingxing, Chen Ye, Hu Hanping, and Liu Xiangdong.

January 28: Artists Wang Jin, Guo Jinghan, and Jiang Bo complete an installation/performance work, *Ice: Central Plains* for the re-opening of the Tianran Shopping Plaza in Zhengzhou, Henan province, one year after it had been destroyed by fire. They build a wall of ice 2.5 meters high, 30 meters long, and 1 meter thick, located in Zhengzhou's February 7 Square, known as the "key battlefield of the war for business" of the Yellow River plains region. Frozen in the wall are more than 800 consumer products including mobile phones, beepers, gold rings, wristwatches, perfume, nail polish, lipstick, televisions, calculators, flags, fire extinguishers, retirement certificates, and disposable needles, along with photos of the original shopping center. Altogether there are more than six hundred bricks of ice. As soon as the re-opening ceremony concludes, more than 10,000 people rushed to the wall bearing hammers, wooden rods, shovels, and crowbars, raucously "digging for treasure."

February

February 29-March 7: *The Third Japan International Performance Art Festival* is held at the International Forum in Tokyo and at the Workers' Welfare Cultural Center in Nagano. Chinese artist Ma Liuming is invited to participate.

March

March 2-6: *In the Name of Art* is held at Shanghai's Liu Haisu Museum of Art. Sixteen artists participate, including Chen Shaoping, Zhao Bandi, Li Qiang, Qiu Zhijie, Song Dong, and An Hong of Beijing; Shi Yong, Ni Weihua, Hu Jieming, Hu Jianping, Zhou Tiehai, and Zhang Xin of Shanghai; Chen Shaoxiong and Liang Juhui of Guangzhou; and Jin Feng and Zhou Xiaohu of Nanjing. The curator is Zhu Qi.

March 8-31: *Beyond the Gallery: Mainland, Hong Kong, and Taiwan Artists Experimental Plans in Wanchai* is held in the Wanchai area of Hong Kong. Lin Yilin and Song Dong are invited to Hong Kong to participate. This exhibition is hosted by the Hong Kong Arts Centre, and the curator is Oscar Ho.

March 18-23: *Documentary Exhibition of Chinese Avant-garde Art* is organized by and held at the Q Gallery in Tokyo.

March 19-April 7: *The First Shanghai Biennale* opens, sponsored by the Shanghai Ministry of Culture, the Shanghai Art Museum, and the Shanghai Cultural Development Foundation. The exhibition comprises mainly oil paintings, exhibiting more than 100 works by 29 artists. These include installation works by Chinese artists residing abroad Wenda Gu, Zhang Jianjun, and Chen Zhen.

March 23-30: Hosted by the New Amsterdam Art Consultancy, the exhibition *The Dust of Romantic Male Heroism: Works by Wang Xingwei* is held at The Gallery of the Central Academy of Fine Arts.

April

April 2-24: *CanTonShangHaiPeKing* is held in the Gallery of the Central Academy of Fine Arts, organized by the New Amsterdam Art Consultancy. It includes works by Zhao Bandi, Liu Yongbin, Jiang Jie, Zhang Hai'er, Hong Hao, Ding Yi, and others.

April 4: *Listening to Men Tell Women's Stories*, an exhibition of conceptual art, opens at the Yafeng Art Salon in Chengdu. Participating artists include Dai Guangyu, Xu Ji, and others.

April 5-7: Zhang Gongbo and Li Shengli hold a joint exhibition at The Art Museum of Capital Normal University.

April 13-15: Curated by Li Xianting and Liao Wen, *Gaudy Life!* opens at the Wan Fung Gallery in Beijing. Participating

artists include Yang Wei, Hu Xiangdong, Chang Xugong, Wang Qingsong, Liu Zheng, and Tian Liyong.

April 20-26: Curated by Li Xianting and Liao Wen, *Models from the Masses* is held at the Beijing Art Gallery. Participating artists include Wang Jinsong, Qi Zhilong, and Xu Yihui.

April 26-May 8: *Too Materialistic, Too Spiritualized: Works by Zhou Tiehai* is held at The Gallery of the Central Academy of Fine Arts, organized by the New Amsterdam Art Consultancy.

May

May 10: Organized by the New Amsterdam Art Consultancy, an exhibition of photography by Luo Yongjin entitled *Celebrations and Celebrities* opens at The Gallery of the Central Academy of Fine Arts.

Created and funded by Liu Zheng and Rong Rong, the magazine *New Photography* begins to circulate. Through 1998, the magazine publishes a total of four issues. It is a hand-assembled magazine of text and photos with a closed circulation.

June

June 5-7: *Conference on Contemporary Ink Painting Art on the Verge of the Twenty-First Century* is held at South China Normal University in Guangzhou, organized by the editorial committee of *The Artistic Trend of Modern Chinese Ink and Wash in the Late Twentieth Century*, the staff of *Art Gallery* magazine, and the university. A group of artists active in ink painting during recent years participate, including Fang Tu, Wang Chuan, Wang Tiande, Liu Zijian, Zhang Yu, Zhang Jin, Chen Tiejun, Yan Binghui, Liu Yiyuan, and Wei Jiqing. Participating critics include Pi Daojian, Yi Ying, Yin Shuangxi, Huang Zhuan, Qian Zhijian, Gu Chengfeng, Wang Lin, Chen Xiaoxin, Lu Hong, Wang Huangsheng, and Li Weiming. The academic chair of the conference is Pi Daojian. The main topics of debate are the trend toward deconstructing the easel painting and its ramifications for contemporary ink painting; cultural obstacles and artistic strategies for contemporary ink painting; and the locality and internationality of Chinese ink painting in the late 1990s. In discussing the position of contemporary ink painting and making some theoretical clarifications, the participants fall into rather serious disagreement.

June 29: Yuan Guang begins to curate a series of solo exhibitions entitled *Individual Style*, aimed at turning The Art Museum of Capital Normal University into a "space for experimentation." In this series, Yuan makes no curatorial intervention into the artists' proposals, allowing them to exhibit works according to their own particular method. The series begins with an exhibition of installation works entitled *Impermanence* by Zhu Jinshi, then residing in Germany.

June 30: Shenzhen female artist Liu Yi holds an exhibition of installation works, *Change*, at the Wan Fung Gallery in Beijing.

July

July 2-7: *Contemporary Chinese Ink Painting Exhibition* is held at the China Art Gallery, displaying 91 works by 19 ink painters. The exhibition focuses mainly on the trend toward Neo-Expressionism led by Zhang Li, and stresses that the form and language of such expressionist work can both retain a foundation of tradition and change to meet contemporary trends.

July 13: An exhibition of installation works by female artists Zhang Lei and Ruan Haiying opens at The Gallery of the Central Academy of Fine Arts, organized by the New Amsterdam Art Consultancy.

July 20: The second exhibition in the *Individual Style* series opens, a video installation by Song Dong entitled *Opening Up* at The Art Museum of Capital Normal University.

July 27: The third exhibition in the *Individual Style* series opens, a showing of installation art by Yin Xiuzhen entitled *Ruined City*. The exhibition is curated by Huang Du.

August

August 30: Organized by the New Amsterdam Art Consultancy, the exhibition *Video Art by Li Yongbin* opens at The Gallery of the Central Academy of Fine Arts.

August 31-September 2: The second section of American artist Betsy Damon's *Preserving the Waters* takes place in Lhasa. This is a broadening and expansion of the first *Preserving the Waters* activity that took place in Chengdu a year earlier. Participating artists from China, the U.S., and Switzerland create works around the theme of water, which are then installed near the Lhasa River. The Chinese organizer of the event is Zhu Xiaofeng of the Chengdu Academy of Social Sciences, and the official host is the Lhasa Bureau of Environmental Protection. Nearly twenty artists participate, including Betsy Damon, Dai Guangyu, Li Jixiang, Liu Chengying, Zhang Xin, Yin Xiuzhen, Zhang Lei, Ruan Haiying,

Zhang Shengquan (aka Datong Da Zhang), Song Dong, Ang Sang, and others.

September

September 14-19: *Image and Phenomena*, an exhibition of video works, is held at The Gallery of the China National Academy of Fine Arts in Hangzhou. The exhibition is aimed at discussing the connection between art and mass culture in the information age. It looks at phenomena for example, mankind's unmediated and instinctual understanding of the world, and images, i.e. these phenomena as seen through the lens of a camera. Works are divided into two large categories: "Media Research," and "Images of Verisimilitude." Participating artists include Zhang Peili, Geng Jianyi, Li Yongbin, Wang Gongxin, Zhu Jia, Yan Lei, Chen Shaoping, Chen Shaoxiong, Qian Weikang, Qiu Zhijie, Yang Zhenzhong, Gao Shiqiang, Gao Shiming, and Tong Biao. Prior to the exhibition, two volumes of relevant essays and photos are published, entitled *Video Art Documents* and *Art and Historical Meaning*. During the conference, three themed conferences are held on the topics of *Art in the Age of Image Proliferation*, *Image and Phenomena*, and *The Possibility of Video Art*. This is China's first exhibition especially dedicated to video art. The curator is Wu Meichun.

September 14-21: *The Fourth Documentary Exhibition of Contemporary Chinese Art* is held at the Sichuan Art Museum in Chengdu. The title of the exhibition is *Sculpture and Contemporary Culture*. This scholarly activity is divided into three parts: first, an exhibition of documents and materials, showing photographs and written materials of works by 30 young sculptors; second, a showing of original sculptures from the southwest of China; third, materials from Sichuan United University Institute of Art and Culture. A series of lectures is also organized, allowing for scholarly debate on contemporary culture and Chinese avant-garde art. The curator is Wang Lin.

September 26: *The Second Asia-Pacific Triennial of Contemporary Art* opens at Queensland Art Centre in Australia. More than 80 artists from 47 countries and regions are invited to participate, including China, Japan, Korea, India, New Zealand, and Australia. Participating Chinese artists are Wang Guangyi, Wang Luyan, Wang Jianwei, Chen Yanyin, Zhang Xiaogang, and Cai Guo-qiang.

October

Taiwan's most influential art publication, *Hsiung Shih Art Monthly*, ceases publication. *Hsiung Shih Art Monthly* was founded in March 1971 and published 307 issues. Since the early 1980s, the magazine reported on the artistic changes in the mainland that were happening in the wake of Deng Xiaoping's reform policies. The magazine had committed itself to publishing reviews and reports of mainland art, and became a major voice in the development of the visual arts in mainland China.

October 5-December 8: *The 23rd International Sao Paulo Biennial* is held. Chinese artist Jiao Yingqi is selected for the International Exhibition portion.

October 6-17: German artist Wolf Kahlen holds an exhibition, *Dust*, at the Beijing Art Museum. Works on display include sculptures, paintings, and installations involving dust. During the exhibition a scholarly conference is held, chaired by critic Qian Zhijian.

October 12-December 8: Organized by The Museum of Modern Art, Saitama and the Asahi Shimbun News Agency, the exhibition *The Origin and Myths of Fire: New Art from Japan, China, and Korea* opens at The Museum of Modern Art, Saitama in Japan. Participants include Cai Guo-qiang, Xu Bing, Chen Zhen, Lü Shengzhong, Huang Rui, and others from Japan and Korea, a total of 13 artists.

October 16-20: An exhibition by Shandong province artist Zhang Qiang entitled *Archaeology Report* is held at The Art Museum of Capital Normal University.

October 28-December 3: *Open Context* is held at the Jiangsu Art Museum in Nanjing. Participating artists include Ni Weihua, Hu Jianping, Wang Nanming, Mao Xiaolang, Jiang Hai, and others.

November

November 15: The Annie Wong Art Foundation is formally established in Vancouver, Canada. Its aim is to "lead and expand international recognition and understanding of contemporary Chinese art." Since its creation, the foundation has assisted and supported more than 100 ethnically Chinese artists to exhibit and create around the world. Moreover, since 1998 it has been collecting important works by ethnically Chinese artists.

November 25: The artist Feng Weidong (aka Feng Sanmao) shows his *Close Relatives* series at his temporary home in the Maigongzhuang section of Beijing.

December

Carving a Chair: A Performance by Huang Yan runs from December 1 to December 14 at the Proper Gallery in Shenyang, Liaoning province. It exhibits materials from Huang Yan's *Chiseling Chairs* performance, which lasted from September 21 through November 3, 1996. Objects on display include written documentary records, photocopies of the wood shavings from the chairs, and rubbings from cleaning up the chairs.

December 6-8: An exhibition and auction is held, organized by Sungari International Auction Co. Ltd. Entitled *Reality Present and Future: '96 Chinese Contemporary Art*, the event is held at the International Art Palace, Beijing. The exhibition shows 74 works by 73 artists. Song Dong and Wang Jin, Zhao Bandi, Xu Yihui, Sun Ping, Zhan Wang, Liu Yan and others show the first installation works ever presented at an auction in China. The overall curator for the exhibition is Leng Lin, with Feng Boyi, Li Xu, Gao Ling, Qian Zhijian, and Zhang Xiaojun serving as artistic directors.

December 7-21:*The 7th COM-ART Exhibition*, entitled *Deconstructing Toward Creation*, is held in Suwon, Korea Republic. This annual exhibition takes Chinese, Japanese, and Korean contemporary artists as its core group. Participating Chinese artists include Song Dong, Gu Dexin, Li Yongbin, Yin Xiuzhen, and Zhu Jinshi (long-time resident in Germany.) Participating critics include Qian Zhijian, along with head of The Art Museum of Capital Normal University Yuan Guang and chairman of the Modern Art Centre (formerly the China National Publishing Industry Trading Corporation Art Centre) Guo Shirui. This exhibition shows installations, performance, video, and experimental film works.

December 7-31: Curated by Fan Di'an, the exhibition *Chairs about Chairs: Works by Shao Fan* is held at The Gallery of the Central Academy of Fine Arts.

December 8-11: Curated by Leng Lin, the exhibition *New Anecdotes of Social Talk* opens at the International Art Palace, Beijing. It includes more than 30 new works by Zhang Gong, Hong Hao, and Liu Ye.

December 22: Organized by Yang Xiaoyan, a multi-media exhibition entitled *Cartoon Generation* opens at the Exhibition Hall of South China Normal University in Guangzhou. Participating artists include Huang Yihan, Feng Feng, Tian Liusha, Liang Jianbin, Sun Xiaofeng, and Lin Bing.

The First Academic Exhibition of Chinese Contemporary Art is set to open on December 31 in Beijing. On December 30, it is announced that the exhibition will not happen. The exhibition is sponsored by Hong Kong's China Oil Painting Gallery Ltd., and *Art Gallery* magazine of Guangdong, and hosted by The Art Museum of Capital Normal University and the China National Publishing Industry Trading Corporation Art Centre. The exhibition is divided into two sections, one of painting and sculpture, the other of installation and multi-media works, to be exhibited separately at the China Art Gallery and The Art Museum of Capital Normal University. Participating artists include Wang Guangyi, Wang Youshen, Xu Tan, Lin Yilin, Zhang Peili, Shi Yong, Wang Luyan, Wang Jianwei, Liu Yan, and Song Dong. The academic curator of the exhibition is Huang Zhuan. The scholarly themes of the exhibition are *The Humanistic Responsibility of Art in the Information Age* and *Existence and Environment—The Chinese Way*. The exhibition organizes a "Documentary Award" and an "Artistic Award" picked by a committee of fourteen critics. Winners of the Documentary Award are Shi Chong (*Surgeon*), Zhang Xiaogang (*The Big Family*), and Zhang Peili (*Focal Distance*). Winners of the artistic award are Sui Jianguo (*Jolly Electrified Hero*), Wang Luyan (*Restructured Bicycles*), and Shen Ling (*Beautiful Time*). The organizing committee also presents an "Art Criticism Award" and a "Contribution Award" to critics, theorists, and artists who occupied unique historical positions and had special influence since the 1980s. Recipients of the Art Criticism award are Gao Minglu, Li Xianting, and Fan Jingzhong. Recipients of the Contribution Award are Wang Guangyi and Shang Yang. The painting and sculpture portion of the exhibition is eventually exhibited at the Zhaolong Gallery, rented by the Hong Kong Arts Centre, on April 22, 1997, still sponsored by the Hong Kong Chinese Oil Painting Gallery and the Modern Art Centre.

1997

January

January 2: Chinese and Korean artists organize an exchange exhibition of experimental art entitled *Chinese City—Beijing City*, which is held at the Wanghai Tingren Teahouse on Hou Hai, a lake in central Beijing. Chinese artists Zhu Jinshi, Song Dong, and Yin Xiuzhen participate.

January 8-12: Curated by Wang Hong, *Excursion 97: Fuzhou Contemporary Art Exhibition* opens at the Fujian Provincial Art Museum. Participating artists include Zhu Qingsheng, Qiu Zhijie, Pang Lei, Song Dong, Shen Ye, Qiu Xingxing, and Zheng Yuke.

February

February 8-March 23: *De-Genderism* is held at the Setagaya Art Museum in Tokyo. Chinese artist Ma Liuming is inivited to participate.

February 22-March 3: Jointly organized by the New Amsterdam Art Consultancy and the cultural office of Siemens Corporation, *Face to Face: Chinese and German Photography* is held at the International Art Palace, Beijing.

March

March 23-27: Liao Wen curates an exhibition *Women and Flowers* at The Gallery of the Central Academy of Fine Arts. Participating artists include Cai Jin, Sun Guojuan, Chen Qiaoqiao, Liu Liping, and Song Hong.

April

April 5-July 27: *Cracking the Continent: Chinese Contemporary Art 1997* is held at the Watari Museum of Modern Art in Tokyo. It displays works by Chinese artists Wang Gongxin, Zhan Wang, Wang Jin, Lin Tianmiao, Gao Bo, Zhang Huan, and Hong Kong artist Chan Yuk-keung.

April 6-17: Shen Xiaotong's exhibition of paintings entitled *Diary of Temptation* is held at The Gallery of the Central Academy of Fine Arts.

April 21: Organized by the French Consul for Cultural and Scientific Cooperation, an exhibition *Photographic Works by Rong Rong* is held in the consul's Beijing home.

April 30-May 25: Singaporean Chua Soo Bin holds an exhibition in his Soobin Art Gallery entitled *Red and Grey: Eight Avant-garde Artists from China*. It exhibits works by Wang Guangyi, Yue Minjun, Zhou Chunya, Liu Wei, Ye Yongqing, Zhang Xiaogang, Mao Xuhui, and Wei Guangqing.

May

May 11-31: An exhibition of paintings by Song Yonghong and Song Yongping is held at the Hanart TZ Gallery in Hong Kong.

May 17-June 5: A solo exhibition of works by Zeng Jie is held at The Gallery of the Central Academy of Fine Arts.

May 20: *Documentary Exhibition of Postal Art by Huang Yan* is held at the Beijing Contemporary Art Gallery. It exhibits a series of works created by the artist between 1992 and 1997.

May 24-June 25: Organized by the China National Publishing Industry Trading Corporation Art Centre, *Look: Video Art by Song Dong* is held at the Beijing Contemporary Art Museum. It shows three video installation works, *Cold Boiled Water*, *Looking into the Mirror—Me*, and *Eagerly Looking Forward*.

June

June 15-November 9: *The 47th International Venice Biennale* is held. Chinese artist residing in the United States Cai Guo-qiang exhibits works.

June 21: *Documenta X* opens in Kassell, Germany. Chinese artists Feng Mengbo and Wang Jianwei are invited to participate.

July

Curated by Chris Dreissen and Heidi von Mierlo, the exhibition *Another Long March: Chinese Conceptual and Installation Art in the Nineties* opens at the Fundament Foundation in Breda, the Netherlands. It highlights installation and performance works by 18 Chinese avant-garde artists.

July 8-16: *The Essence of Portraiture: Works by Mao Yan and Zhou Chunya* is held at The Gallery of the Central Academy of Fine Arts.

July 9-September 24: Curated by Harald Szeemann, *The Fourth Lyon Biennial of Contemporary Art* opens in Lyon, France. Invited Chinese artists are Yan Peiming, Chen Zhen, Zhang Peili, Feng Mengbo, Wang Xingwei, Xu Yihui, and Pu Jie.

July 12-October 10: Curated by Fei Dawei, the exhibition *In Between Limits* is held at the Sonje Museum of Contemporary Art in Sonje, Korea. Participating artists include Cai Guo-qiang, Xu Bing, Huang Yong Ping, Chen Zhen, Wenda Gu, Zhang Peili, Feng Mengbo, Ding Yi, and Yang Jiecang.

July 17-September 14: *Against the Tide* is held at the Bronx Museum of Art in New York. Cai Jin, Hou Wenyi, Hu Bing, Lin Tianmiao, and Yin Xiuzhen are invited to participate.

July 19: Curated by Chen Yang, an exhibition and meeting about Zhu Fadong's *100 Days 100 Jobs* is held at the Beijing Art Museum.

July 20: Cang Xin's experimental installation—performance exhibition *Principles of Suffering Series II* is held Dongsi Alley #8-52, Dongcheng District, Beijing.

July 25-August 27: W^2-Z^2, a multi-media slide show, is held at The Gallery of the Central Academy of Fine Arts, curated by Ishikawa Iku and Nishigawa Junichi Nochi. Participating artists are Wang Jin, Wang Gongxin, Zhang Peili, and Zhang Dali.

July 29-August 30: *Between Ego and Society: An Exhibition of Contemporary Female Artists in China* is held at the Artemisia Gallery in Chicago. Artists invited to participate include Chen Yanyin, Jiang Jie, Yin Xiuzhen, Liu Liping, Cai Jin, Pan Ying, Ruan Haiying, Shi Hui, Sun Guojuan, Yu Hong, and Zhang Lei.

August

August 28: Organized by the Modern Art Centre and curated by Wu Meichun, the exhibition *Demonstration of Video Art '97 China* is held at The Gallery of the Central Academy of Fine Arts. Participating artists include Qiu Zhijie, Shi Yong, Tian Miaozi, Song Dong, Wu Ershan, Wang Gongxin, Wang Jinsong, Weng Fen, Xu Ruotao, Yang Zhenzhong, Yan Yinhong, Yan Lei, Zhu Jia, Zhu Ming, Zhao Liang, Zhang Peili, An Hong, Chen Wenbo, Chen Shaoxiong, Tong Biao, Tang Guangming, Gou Zi, Lu Lei, Gao Shiming, Gao Shiqiang, Hu Jieming, Jiang Zhi, Li Juchuan, Lin Tianmiao, Liu Yi, Li Yongbin, and Wu Minghui. Afterwards, the exhibition *Video Art by Qiu Zhijie* opens.

September

Curated by Andreas Schmid and Alexander Tolnay, *Contemporary Photography from the People's Republic of China* opens at Neuer Kunstverein Berliner in Berlin. It is one of the earliest exhibitions dedicated exclusively to contemporary Chinese photography.

September 1-November 27: *The Second Kwangju Biennial* opens in Kwangju, Korea. The theme of the exhibition is *Land Without Borders*. Participating Chinese artists include Xu Bing, Huang Yong Ping, Chen Zhen, and Feng Mengbo.

September 12: Hosted by the Modern Photographic Society and the Beijing Visual Arts Center, a preview exhibition *New Image: Conceptual Photography* and an academic conference *Theories of Conceptual Photography* is held at Beijing Theater. Participating artists include Shi Ruotian, Liu Shuxia, Qiu Zhijie, Zhao Bandi, Liu Zhuan, Mo Yi, An Hong, and Hong Lei.

September 12-25: Ma Liuming participates in the *Canada Performance Art Festival* in Quebec and other locations.

October

October 12: *Origins: Art of Life*, an exhibition of installation and performance works, is held at Dujiangyan in Chengdu. Participating artists include Liu Chengying, Zeng Xun, Dai Guangyu, Zhu Gang, Zhang Hua, Yin Xiaofeng, Yu Ji, and others.

October 25-November 25: An exhibition of works by Ye Yongqing and Liu Wei is held at The Gallery of the Central Academy of Fine Arts.

November

November 29-December 4: *Continue: Exhibition of Work by Five Sculptors* is held at The Gallery of the Central Academy of Fine Arts. It includes works by Sui Jianguo, Zhan Wang, Fu Zhongwang, Jiang Jie, and Li Xiuqin.

Curated by Dai Guangyu and chaired by Chan Changping, the exhibition *People of a Copied Time* is held in an empty work unit space in downtown Chengdu, Sichuan province. Participating artists are Dai Guangyu, Xu Ji, Yin Xiaofeng, Zhang Hua, Zeng Xun, Liu Chengying, and Zhu Gang.

December

December 13-25: A solo exhibition by Zhang Xiaogang, *Blood Lines: The Big Family* is held at The Gallery of the Central Academy of Fine Arts.

December 19-24: *New Works by Ding Yi* is held at the Shanghai Art Museum.

Curated by Zhu Qi, the exhibition *New Asia, New City, New Art: Chinese and Korean Contemporary Art 1997* is held at the Shanghai Contemporary Art Exhibition Hall. Chinese participants include Xu Tan, Ni Weihua, Wang Jiajie, Hu Jianping, Chen Shaoxiong, Yan Lei, Liang Juhui, and Shi Yong.

1997-1998: Curated by Wang Lin, *The Fifth Documentary Exhibition of Contemporary Chinese Art*, entitled *The Personality of the City 1997* is held in more than 20 cities throughout China. Lasting nearly a year, this touring exhibition comprises documentation of more than 100 group, solo, and open studio exhibitions. It includes materials about works of

photography, poetry, painting, sculpture, installation, environmental art, performance art, and video art. Collected materials are published in a book entitled *The Personality of the City and Contemporary Art*.

1998

January

January 2: Curated by Feng Boyi and Cai Qing, a closed performance and installation exhibition *Trace of Existence* is held in a private factory workshop and warehouse north of Yaojiayuan Village, Beijing. The exhibition emphasizes on-site creation and display from a peripheral perspective. Artists Wang Gongxin, Yin Xiuzhen, Song Dong, Qiu Zhijie, Wang Jianwei, Lin Tianmiao, Zhang Yonghe, Gu Dexin, Zhang Defeng, Zhan Wang, and Cai Qing are invited to participate.

February

February 26: Chang Xugong's *Embroidered Portrait Series 1995-1998* is shown at the Beijing Contemporary Art Gallery.

March

March 3-8: Organized by the Comparative Art Research Center of the China Arts Research Institute and directed by Jia Fangzhou, the exhibition *Century Women* is held simultaneously at the China Art Gallery, the International Art Palace, the Beijing Contemporary Art Gallery, and the Huanqiu Gallery. The exhibition, which centers around a century of transition in the status of women, is divided into four parts: *History and Retrospection: A Documentary Exhibition* (curated by Tao Yongbai); *Ideals and Reality: Collected Works* (curated by Xu Hong); *Self and Environment: Works from Abroad* (curated by Luo Li); and *Continuation and Performance: A Special Exhibition* (curated by Jia Fangzhou). It displays over 300 works by more than 30 female artists. During the exhibition, a scholarly conference is held on the themes of *Women Amidst Transition* and *The Femininity of Art*.

March 8: The exhibition *Understanding Beijing: A Report on Chinese Contemporary Art* is held in Beijing, curated by Mei Zi. Participating artists are Liu Ye, Zhang Gong, Li Tianyuan, Zhao Bandi, Wang Jinsong, Wei Ye, Qi Zhilong, Yue Minjun, Wang Mai, and Yang Shaobin.

March 15-29: Cooperatively organized by the China Exhibition and Exchange Center, the Netherlands embassy, and the New Amsterdam Art Consultancy, the exhibition *Mondrian in China: A Documentary Exhibition with Chinese Originals* is held at the International Art Palace, Beijing. The exhibition includes documents and materials from the life of Piet Mondrian as well as works by Chinese artists who have been influenced by him. These artists include Ding Yi, Liu Ye, Luo Qi, Mai Zhixiong, and Yi Ling. It is the first exhibition in China to include such a juxtaposition of material on display, or to combine works from China and the Netherlands.

March 28: *Zeng Fanzhi 1993-1998* is held at The Gallery of the Central Academy of Fine Arts.

March-April: Curated by Zheng Shengtian and others, a serial exhibition entitled *Jiangnan: Modern and Contemporary Art from South of the Yangzi River* is held in Vancouver. The exhibition is structured around the "Jiangnan" cultural background of its participating artists. These exhibitions include: *Modern Installations by Huang Yong Ping and Xu Bing*; *Works by Geng Jianyi and Zhou Tiehai*; a group exhibition of works by Chen Haiyan, Shi Hui, Shen Fan, and Ding Yi; solo exhibitions of works by Liang Shaoji, Gu Xiong, Hu Jieming, Chen Yanyin, Yang Zhenzhong, Shi Yong; a group exhibition of works by Ken Lum, Chen Zhen, Wenda Gu, and Zhang Peili; and an exhibition of works by "three generations" of Chinese female artists Qiu Ti, Pang Tao, and Lin Yan, a total of 13 exhibitions. An academic conference, *International Conference on Chinese Contemporary Art* is held in Vancouver, April 24-26.

April

Organized by the Modern Art Centre and compiled by Song Dong and Guo Shirui, the experimental art publication *Wild' 97* is released. Wild is a "non-exhibition space, non-exhibition form" artistic activity involving 27 artists from Beijing, Shanghai, Guangzhou, Chengdu, and elsewhere. It begins on March 5 and lasts for one year. During this time, artists from around the country enter into wide-ranging debate and exchange, and submit proposals to realize works on a relatively long timeline which reflect their particular regional backgrounds, educational backgrounds, natural surroundings, and individual identities. All materials from the activity, including proposals and process photos are compiled and published. The 27 participating artists are Chen Shaoxiong, Dai Guangyu, Gu Lei, Hu Jianping, Liang Juhui, Lin Yilin, Liu Chengying, Ma Liuming, Pang Lei, Qiu Zhijie, Shi Yong, Song Dong, Wang Jin, Wang Gongxin, Wang Huimin, Weng Fen, Xu Tan, Yin Xiaofeng, Yin Xiuzhen, Yu Ji, Zeng Xun, Zhang Huan, Zhang Xin, Zheng Guogu, Zhu Fadong, Zhu Qingsheng, and Zhuang Hui.

May

May 16-18: Organized by artists, an experimental art exhibition takes place in an abandoned apartment building in

Shanghai, named *Jin Yuan Lu 310* after the sign marking its site. Participating artists include Gu Lei, Hu Jianping, Wu Jianxin, Ni Jun, Xu Chen, Jiang Chongyuan, Cai Wenyang, Fei Pingguo, and Yang Zhenzong.

May 21-June 7: Curated by Toshio Shimizu, *Beyond the Everyday*, an exhibition of works by seven Japanese contemporary artsts, is held at the Shanghai Art Museum. Participating artists include Araki Nobuyoshi, Sugimoto Hiroshi, Doki Katao, Miyajima Tatsuo, Sone Yutaka, Hirata Goro, and Mariko Mori. This is the first large-scale exhibition of Japanese contemporary art in China.

May 23: Curated by Lu Yi and Zhao Bandi and directed by Wei Lan, a documentary film entitled *China's Non-Mainstream Art* has its premier and an exhibition of photographs at the Beijing International Club.

May 23-27: An exhibition by Zhang Dali and Matthieu Borysevicz, *City Construction and Urbanization*, is held at the Beijing Art Museum.

June

June 10: Organized by the Women's Museum, Bonn, and curated by Chris Werner and Marianne Pitzen, *Half of the Sky: Contemporary Chinese Women Artists* is held at the Women's Museum of Bonn in Germany. Mainland artists Xu Hong, Shi Hui, Chen Yanyin, Yin Xiuzhen, Lin Tianmiao, Chen Haiyan, Wang Gongyi, Pan Ying, Huang Hui, Liu Liping, Li Xiuqin, Li Jianli, Zhang Xin, Zhang Lei, Zhu Bing, Cai Jin, Jiang Jie, and Teng Fei are invited to participate, along with artists residing abroad Qin Yufen, Qiu Ping, Hu Bing, Yang Keqin, and Shen Yuan, and Taiwanese artists Chen Hsingwan and Wu Mali. At the same time, a scholarly conference is held entitled *Who Has the Better Half? The History, Standpoint, and Future of Chinese Female Artists*.

June 10-14: Curated by Huang Danhui, *Self-Salvation vs. Expiration: The First Northeastern Exhibition of Paintings by Seven Artists* is held at the Lu Xun Museum of Art in Shenyang, Liaoning province. Participating painters are Liu Yan, Wang Sai, Liu Rentao, Wang Xingwei, Xu Cheng, Yan Fei, and Huang Yan.

June 13-September 6: Curated by Nanjo Fumio, *The 1998 Taipei Biennial* is held at the Taipei City Museum of Art. Thirty-five artists from Taiwan, Japan, China, and Korea are invited to participate in the exhibition, entitled *Site of Desire*. Mainland participants are Cai Guo-qiang, Xu Bing, Chen Zhen, Lin Yilin, Xu Tan, Gu Dexin, Zheng Guogu, and Wang Jinsong.

June 20: Curated by Frenchwoman Christine Kayser, an exhibition of Chinese contemporary art, *Life*, opens at the Wan Fung Gallery in Beijing. Participating artists are Sui Jianguo, Qing Qing, Hu Jieming, Wang Gongxin, Lin Tianmiao, Li Tianyuan, Qiu Zhijie, and Zhao Liang.

June 20-July 5: *930 Group Exhibition* is held beneath viewing platform number 12 at the Workers' Stadium in Beijing. Participating artists are Liu Liguo, Yi Ling, Liu Fengzhi, Dong Lu, Xu Ruotao, Liu Feng, Tian Zizhong, and Yin Jun.

June 23-September 20: *The Second Hugo Boss Art Award Exhibition* of works by six artists is held at the Guggenheim SoHo in New York. Huang Yong Ping's installation work *Saints and Spiders* is shown.

July

July 4-12: Hosted by the New Amsterdam Art Consultancy, *Sixteen Products, Ten Thousand Customers and Other Works: Photography by Zheng Guogu* is held at The Gallery of the Central Academy of Fine Arts.

July 4-5: Curated by Huang Du, the exhibition *Space and Vision: Images of Transformation in Urban Life* is held at Beijing's Contemporary Art Gallery. Participating artists include Wang Jinsong, Hong Hao, Song Dong, Xu Yihui, and Li Yanxiu.

July 11: Curated by Shanghai-based art critic Wang Nanming and Hong Kong Polytechnic University professor Rong Nianzeng, the exhibition The Development of Chinese Installation Art opens at the Wuyue Movie Studio in Shanghai. Hong Kong artists invited to participate include: Danny Yong, Wong Shun-kit, Andrew Lam, Freeman Lau, May Fong, Siu King Chong, Eve Lyna Liang, and Anthony Yao. Mainland artists include Zhu Qingsheng, Jiang Jie, Zhang Peili, Wang Qiang, Geng Jianyi, and Zhang Kerui. This is the first such cooperative exhibition between Hong Kong installation artists and mainland artists.

August

August 4: Organized by the Cross-Straits Cultural Exchange Association and hosted by Jinbaoshan Enterprises, an exhibition of sculptures from the mainland and Taiwan opens in Taipei. Mainland sculptors Sui Jianguo, Zhan Wang, Fu Zhongwang, Jiang Jie, Li Xiuqin, Sun Wei, Wang Zhong, Zhang Bingjian, Xiao Li, and Yang Ming are invited to

participate.

August 7-November 1: An exhibition entitled *Crossings* is held at The National Gallery in Ottawa, Canada. Cai Guo-qiang, Xu Bing, and 15 other artists living outside their country of birth are invited to participate.

August 21, evening: The Taiwan Museum of Art invites Chinese artist residing in the U.S. Cai Guo-qiang to complete an installation work that involves pyrotechnics. The work is entitled *No Construction without Destruction: Bombing the Taiwan Museum of Art*.

September

September 12: Curated by Pi Li, *Mosaic: Works by Qin Ga, Sun Yuan, and Zhu Yu* is held in the Corridor Gallery of the Central Academy of Fine Arts.

September 13-January 3, 1999: Organized by The Asia Society and San Francisco Museum of Modern Art, and curated by Gao Minglu, *Inside Out: New Chinese Art* is held simultaneously at The Asia Society and P.S. 1 Contemporary Art Center in New York. It exhibits 92 works by more than 60 artists from mainland China, Taiwan, and Hong Kong created between the years of 1985 and 1998, including ink painting, oil painting, installation, performance, photography, and other media. Forty-two artists or groups of artists from mainland China are included in the exhibition, mainly those who were involved in the 1985 New Wave movement, but also some younger artists as well. After its run in New York, the exhibition travels to San Francisco, Mexico, Tacoma, Japan, Hong Kong, and Australia.

September 27-October 5: The UNESCO organ International Alliance of Art Critics (AICA) holds its congress in Japan for the first time. The 32nd International Congress-AICA Japan Congress 1998 is entitled *Transition: Changing Society and Art*. More than 100 art critics from around the world participate. Li Xianting is invited to give an address.

October

October 5-15: Curated by Wang Nanming, *The Possibility of the Media: Conceptual Art* is held at the International Artists' Studio in Qingdao. Participants include mainland Chinese artists Zhu Qingsheng, Sun Guojuan, Liu Chao, and Zhao Dewei, and Hong Kong artists Wang Chunjie, Du Huan, Huang Liangyi, Zeng Weiheng, Liu Zhongxing, Zhang Zhiping, Yuan Guocong, and Situ Bingguang.

October 6: Curated by Fan Di'an, *The 1998 Asia-Pacific Invitational Exhibition* is held in Fuzhou, Fujian Province. Artists from Canada, the U.S., Japan, and China are invited to participate. Participating Chinese artists are Shang Yang, Xu Jiang, Shi Chong, Qiu Zhijie, Shen Ye, Li Xiaowei, Chen Zongguang, Zhu Jin, Tang Chenghua, Qiu Xingxing, Hu Hannian, and Lin Jingjing.

October 24: An exhibition of computer and video art entitled *0431 Video and Computer Art* opens in Changchun, Jilin province. (0431 is the telephone code for Changchun.) Eighteen artists from Beijing, Nanjing, Shenyang, Changchun, Guangzhou, and Hangzhou are invited to participate. They are: Qiu Zhijie, Song Dong, Cang Xin, Jiao Yingqi, Jin Feng, Zhou Xiaohu, Xu Ruotao, Wu Ershan, Liu Bo, Zhang Tiemei, Huang Yan, Chen Shaoxiong, Zhao Liang, Gao Shiming, Gao Shiqiang, Zhang Xin, and Liu Tianshu. Works exhibited include video, video installation, performance, Internet, e-mail, and other new technology media. This is the first large-scale exhibition of video and computer works in northeast China.

October 27-30: Organized by the Research Department of the Central Academy of Fine Arts and *Fine Arts* magazine, *Conference on the Status and Trends of Chinese Art in the 1990s* is held at the Wang Family Courtyard House in Lingshi County, Shanxi Province. Art critics from around the country come to participate, including Shao Dazhen, Wang Hongjian, Fan Di'an, Yi Ying, Yin Shuangxi, Zou Yuejin, Pi Daojian, Jia Fangzhou, Huang Yan, Lu Hong, Huang Du, Feng Boyi, Chen Xiaoxin, Gu Chengfeng, Wang Nanming, Gao Ling, and others. Coming from different perspectives, the critics enter into macro-level analysis, summary, and debate about the status and problems of Chinese conterrmporary art.

October 24-29: Curated by Guo Xiaochuan, the exhibition *Chinese Contemporary Art: Twenty Years of Awakening* and the release of a catalogue by the same name take at the Taimiao Exhibition Hall at the Forbidden City in Beijing.

The first Chinese Contemporary Art Award is presented in Beijing. Three artists—Zhou Tiehai, Yang Mian, and Xie Nanxing—are selected from 109 applicants. Zhou Tiehai is awarded a prize of $3000. The award is established and funded by the Chinese Contemporary Art Association in Switzerland, with an eye to encouraging artists less than 35 years of age. The winners are selected annually by a four-person committee of a critic, a painter, a collector, and a curator. The first committee comprises Yi Ying, Ai Weiwei, Uli Sigg, and Harald Szeemann.

November

November 6-December 31: Chinese artists residing in Germany Qin Yufen and Zhu Jinshi hold an exhibition *Resonance* at the Art Beatus Gallery in Vancouver.

November 7-8: Curated by artists Xu Yihui and Xu Ruotao, the exhibition *Corruptionists* is held in the basement of an apartment building owned by the Chinese Artists' Association on North Third Ring Road in Beijing. Participating artists include Zhang Dali, Huang Yan, Zhao Bandi, Zheng Guogu, Lu Hao, Wang Xingwei, Zhao Qin, Liu Jian, Xu Ruotao, Xu Yihui, Cao Xiaodong, Xu Shun, Xu Hongmin, Zhao Liang, Wang Qiang, Liu Feng, Wu Xiaojun, Liu Bo, Chen Qingqing, Jiao Yingqi, Gu Dexin, and Xin Qin.

November 20-26: Curated by German Eckhard R. Schneider, *Tradition and Anti-tradition* is held at the German embassy in Beijing. The starting point for this exhibition is the question of how Chinese contemporary art responds to Chinese tradition. Works exhibited are divided into four sections: calligraphy; traditional Chinese painting; sculpture; and furniture and folk art. Participating artists include Zha Changping, Chen Guangwu, Chen Shaofeng, Fan Yang, Fu Zhongwang, Hu Youben, Huang Yan, Zhu Qingsheng, Li Xiuqin, Liang Shaoji, Liang Yue, Liu Chao, Liu Jianhua, Lü Shengzhong, Pang Lei, Wang Naizhuang, Wang Nanming, Wen Pulin, Yang Dajian, Yin Xiuzhen, Yuan Jia, Zhan Wang, Zhang Dawo, Zhang Wenzhi, Zhu Guangping, Zhu Xinjian, Zhu Yan, Qin Jianhua, Qiu Zhenzhong, Shi Hui, Song Dong, Sui Jianguo, Sun Guojuan, and Wang Huaiqing.

November 21: Curated by Leng Lin, the exhibition *It's Me: A Profile of the Development of Art in the 1990s* is planned to open at the Workers' Cultural Palace in the Forbidden City, Beijing. However, the night before the opening, the authorities close the exhibition, claiming "exhibition approval procedures incomplete." Works scheduled for inclusion in the exhibition include paintings by Fang Lijun, Li Tianyuan, Liu Ye, Ma Liuming, Ma Yunfei, Wang Nengtao, Wang Qiang, Yue Minjun, Wang Xingwei, Yang Shaobin, Xia Cheng, Zeng Fanzhi; photography by An Hong, Hong Hao, Liu Jian, Yan Lei, Zhao Bandi, Zhao Qin, Zhou Tiehai, Zhu Fadong, and Zhuang Hui; video works by Qiu Zhijie, Song Dong, and Wu Minghui; and an installation by Yin Xiuzhen.

November 21: Hosted by the He Xiangning Art Museum and the Shenzhen Sculpture Alliance and curated by Sun Zhenhua, *The First Contemporary Sculpture Art Annual Exhibition* opens outside at the He Xiangning Art Museum, lasting for one year. It displays twenty sculptures by young Chinese sculptors: Yu Fan, Yu Xiaoping, Wang Zhong, Shen Xiaonan, Xiang Jing, Liu Jianhua, Sun Shaoqun, Zhu Zhiwei, Li Xiangqun, Yu Zhiqiang, Li Xiuqin, Chen Yucai, Zhang Yongjian, Zhang Zhiping (Hong Kong), Jiang Jie, Xiang Jinguo, Zhan Wang, Tang Songwu, Sui Jianguo, and Fu Zhongwang.

November 24-December 15: Organized by the New Amsterdam Art Consultancy, the exhibition *Ding Yi: Crosses 1989-98* is held at The Art Museum of Capital Normal University.

November 25-January 18, 1999: Curated by Hou Hanru and Hans-Ulrich Obrist, *Cities on the Move* is held at The Secession in Vienna. More than 100 artists and architects from Asia are invited to participate.

December

December 3: Curated by Liao Wen and sponsored by Tianjin Taida Real Estate Land Management Company, *Personal Touch–Contemporary Chinese Art* is held at the Teda Art Museum in Tianjin. Invited Chinese female artists are Yu Hong, Jiang Congyi, Sun Man, Li Hong, Cui Xiuwen, Biao Yaomin, Feng Jiali, Xia Junna, Chen Xi, Ning Fangqian, Liu Xiuming, Fu Liya, Xu Xiaoyan, Sun Ge, Chen Shuxia, Lin Jingjing, Lei Shuang, Xun Guojuan, Liang Jieling, and Xiang Jing. Male artists are Liu Wei, Yang Shaobin, Feng Zhenjie, Hu Xiangdong, The Luo Brothers, Zeng Jie, Chen Weimin, Yang Mian, Sui Jianguo, Zhan Wang, and Xu Xiaoyu.

December 5: An exhibition with "home" as its theme and location is held in a private residence at 774 Changle Road in Shanghai. The curator is the female owner of the home, Yang Qing. Participating artists are Ding Yi, Geng Jianyi, Shen Fan, Song Dong, Wang Qiang, Wu Xuefu, Wu Yiming, Xiang Liqing, Xiao Jun, Yin Xiuzhen, Zhang Peili, Zhao Bandi, and Zhou Tiehai.

December 5: Curated by Song Zhan and chaired by the artist Yang Wei, an exhibition *In the Cities: Open Oneself* opens at the gallery in the Beijing Hilton.

December 11-30: Organized by the Shenzhen Municipal Government, *The First Shenzhen Ink and Wash Painting Biennial* opens at the Guan Shanyue Art Museum in Shenzhen. It displays 205 works of ink and wash painting, separately grouped into those from the mainland, Hong Kong, Taiwan, and abroad, including the U.S., Canada, the U.K., France, Germany, the Netherlands, Italy, Japan, Korea, Singapore, Malaysia, Iran, and other countries.

December 12-February 21, 1999: Curated by Hou Hanru, *Gare l 'Est* is held at the Luxembourg Center for Contemporary Culture. It displays works by Chinese artists residing in France Huang Yong Ping, Chen Zhen, and Wang Du, as well as works by 15 other foreign artists with close connections to Paris.

December 15-18: *The First He Xiangning Art Museum Scholarly Forum* is held at the He Xiangning Art Museum in Shenzhen. This scholarly meeting brings together young scholars from cultural, philosophic, anthropologic, literary, architectural, and arts circles to discuss the nature, problems, and prospects of Chinese art in contemporary society. The meeting is organized into a "scholarly forum" and "scholarly lectures." Formally invited scholars are Xu Youyu, Zhou Guoping, Zhao Yifan, Zhang Yiwu, Wang Yuechuan, Zhu Qingsheng, Zhang Yonghe, Wang Mingjian, Zhang Zhiyang, Liu Xiaofeng, Fan Jingzhong, Cao Yiqiang, Wang Hui, Wang Mingming, Yi Dan, Yi Ying, Yu Hong, Chen Weixing, Lü Peng, Dao Zi, Qiu Zhijie, Sun Zhenhua, Yan Shanchun, Ma Qinzhong, Pi Daojian, Li Gongming, Rao Xiaojun, Lu Hong, Tang Hua, and Huang Yan. Speakers are Zhao Yifan, Xu Youyu, Zhang Yiwu, Fan Jingzhong, Zhang Yonghe, and Yi Ying. The organizational curators for this event are Ren Kelei and Le Zhengwei; the scholarly curator is Huang Zhuan. Representative papers were collected and published in a book entitled *Contemporary Art and the Humanities*. During the forum, an exhibition was held entitled *The Collection of Upriver Gallery*, to give the forum a visual background in contemporary art.

1999
January
January 9: Curated by Wu Meichun, *Post-sense Sensibility: Alien Bodies and Delusion* is held in the basement of Shaoyaoju Building 202, Beijing. Participating artists are Chen Wenbo, Liu Wei, Wu Ershan, Chen Lingyang, Qiu Zhijie, Wang Wei, Feng Qianyu, Qin Ga, Yang Fudong, Feng Xiaoying, Shi Qing, Yang Yong, Gao Shiming, Gao Shiqiang, Sun Yuan, Zhu Yu, Lu Lei, Xiao Yu, Zhang Hanzi, Jiang Zhi, Weng Fen, and Zheng Guogu.

January 1-15: *Leaving and Returning* is held at Suojia Village, Beijing. This exhibition concerns "the 1970 generation" and its works. Participating artists are Song Chao, Yang Kui, Chi Qichun, Li Wei, Zeng Zhaoman, Zhang Zhenyu, Chen Xinnian, and Luo Lingxia.

January 29-February 18: The couple of artists living in France Huang Yong Ping and Shen Yuan hold an exhibition at the Gallery of the CCA Arts Center in Japan.

January29-February 28: Chinese artist living in France Yang Jiecang has a solo exhibition at The Gallery of the Central Academy of Fine Arts entitled *Another Turn of the Screw.*

January 30: Curated by Karen Smith, *Representing the People* opens at The Laing Museum in Newcastle, U.K. It later moves to Midlands Arts Centre in Birmingham, U.K. and The Museum of Science and Industry in Manchester, U.K. The exhibition is organized by the Chinese Art Centre of the U.K. The ten participating artists are Chen Wenbo, Duan Jianwei, Guo Wei, Huang Hancheng, Liu Rentao, Liu Xiaodong, Ma Baozhong, Zhuang Hui, Song Yongping, and Wang Jinsong.

February
February 2-26: Curated by the young French artist Evelyne Jouanno, *The New World Trend* is held at the Eric Dupont Gallery in Paris. Chinese artists Yang Jiecang, Shen Yuan, and Mi Jia participate.

February 18-April 18: *Transience: Chinese Experimental Art at the End of the Twentieth Century* is held at the Smart Museum of Art at the University of Chicago. The curator is Wu Hung. The exhibition is divided into three themes: *Demystification, Ruins*, and *Transience*. The 22 participating artists include Wang Jin, Yin Xiuzhen, Zhan Wang, Cai Jin, Zhu Fadong, Sui Jianguo, Xing Danwen, Xu Bing, Wenda Gu , Zhang Hongtu, Yu Fan, Zhang Huan, and others. On April 17, a conference entitled *The Worldview of Chinese Contemporary Art* is held, including Wu Hung, Gao Minglu, Hou Hanru, and Johnson Chang.

February 25: Chinese art critic and independent curator residing in France Fei Dawei is named by the French government to the Chevalier d'Ordre des Arts et des Lettres.

February 27: The China Art Archives and Warehouse, founded by Ai Weiwei and Hans van Dijk, opens in a renovated factory in the southern Beijing suburb of Longgua Village. It holds the exhibition *Innovations Part I*, showing works by Ding Yi, Wang Jianwei, Xie Nanxing, Zheng Guogu, Sun Kai, Zhang Hai'er, Hong Lei, and Ai Weiwei. Between April 24 and June 2, *Innovations II* is held, showing works by Sui Jianguo, Lu Qing, Gu Dexin, and Xu Hongmin.

March

March 5-18: *Köln-Beijing, Beijing-Köln Exchange Exhibition* is held at the Gallery of the Central Academy of Fine Arts. The exhibition is organized by the Central Academy of Fine Arts and the German embassy in Beijing. The curators are Tang Xin and Wu Rile. Between May 4 and May 24, the exhibition is held at the Gothaer Kunstforum in Köln, Germany. Participating Chinese artists include Lin Tianmiao, Jiang Jie, and Cai Jin. German artists are Ulla Horky, Renate Paulsen, and Porrit Nebe.

March 6-June 6: *The First Fukuoka Triennial of Asian Art* is held at the Fukuoka Museum of Art in Japan. The theme for the exhibition is *Communication: Channels for Hope*. Chinese artists invited to participate are Xu Bing, Zhang Peili, Feng Mengbo, and Zhuang Hui.

March 26: Liu Xinhua realizes a performance work entitled *Xinhua Press Opens for Business: An Experimental Debate* in which he designs a museum and artists' club for Beijing.

April

April 3-11: Curated by Zhu Qi, *Towards Materialism and That Sort of Beauty* is held at East China Normal University, Shanghai. Artists invited to participate include Zhong Biao, Xi Haizhou, Hu Jianping, Xu Yihui, Wu Xiaojun, Chen Shaoxiong, Zheng Guogu, Zhao Bandi, Chen Wenbo, Hong Hao, Zhuang Hui, Liu Jianhua, Feng Qianyu, Hong Lei, Xue Song, and others.

April 10-25: *Supermarket: Art for Sale* opens in Shanghai. The event is a cross between art exhibition and bazaar: more than 30 artists package their works of video, installation, performance, painting, photography, placing small price tags on them and laying them out on flea market tables. Viewers can select works, take them to the cashier, and make a purchase. The event is organized by the Modern Arts Centre, the organizer is Guo Shirui, and the curators are Xu Zhen, Yang Zhenzhong, and Fei Pingguo. Participating artists include Geng Jianyi, Shi Yong, Yang Fudong, Zhang Peili, Zheng Guogu, Song Dong, Yin Xiuzhen, Zhu Yu, Zhu Jia, Zhao Bandi, Xu Zhen, Yang Zhenzhong, Luo Zidan, Chen Shaoxiong, Hu Jieming, Wu Ershan, and others.

April 16-May 31: *Unveiled Reality: Chinese Contemporary Photography* opens at the Art Beatus Gallery in Vancouver. Eleven artists from China participate: An Hong, Geng Jianyi, Huang Yan, Qiu Zhijie, Rong Rong, Wang Wangwang, Xu Tan, Yan Lei, Zhang Dali, Zheng Guogu, and Zhu Jia.

April 22-May 22: Curated by Hou Hanru and Evelyne Jouanno, the exhibition *Street Theatre* opens at Apex Art in New York. It shows Zhang Yonghe's work *Abnormal Architecture*. This is Zhang Yonghe's first exhibition in the U.S.

Curated by Fan Di'an, *Sino-Japanese Contemporary Art Exchange Exhibition* is held in Fuzhou, Fujian province. The theme of the exhibition is *Modernism in Asian Art*. Seventeen Chinese and Japanese artists participate. Participating Chinese artists are Cai Guo-qiang, Huang Yong Ping, Tang Chenghua, Qiu Zhijie, Rong Rong, Yang Ming, Lin Rongsheng, Zhu Jin, Chen Jiaguang, Li Xiaowei, Shen Ye, Hu Hanping, Huang Dalai, Yuan Wenbin, Lü Shanchuan, and Hu Shengping.

May

May 7: Curated by Jin Feng and Su Lü, *Unusual Way of Writing* is held at the Art Academy of Nanjing Normal University. The 27 participating artists include: Song Dong, Zhou Xiaohu, Jiao Yingqi, Guan Ce, Lin Yilin, Zhao Bandi, Chen Shaoxiong, Lu Ming, Shu Jie, Huang Yan, Jin Feng, Cang Xin, Liang Juhui, Xu Tan, Dai Guangyu, Gao Qiang, and others.

May 8-9: A contemporary art exhibition entitled *Poly Phenolrene* opens in the southwest corner of Zhongshan Park in Beijing. The curator is Li Xianting, and participating artists include Chen Wenbo, Gu Dexin, Hu Xiangdong, Lu Hao, Wang Jin, Zhao Liang, Zhang Lei, and Zhu Ming.

May 22: Hosted by the Taiwan Museum of Art and the International Association of Independent Curators, and curated by Johnson Chang, the exhibition *Power of the Word* opens at the Taiwan Museum of Art in Taichung. Xu Bing, Wenda Gu, Wu Shanzhuan, Qiu Zhijie, along with Taiwanese artists Feng Qiuming, Wu Mali, Hou Junming, and Huang Chih-yang are invited to participate.

May 28-29: Organized by the Taiwan Wenjian Society and hosted by the Taiwan Museum of Art, a conference is held in Taipei entitled *Discovering a New Course for Asian Art: A Meeting for Curators of Asian Art*. Important curators from the Asia-Pacific region are invited to participate, including Hou Hanru, Fei Dawei, Johnson Chang, and others from Japan, Korea, mainland China, Thailand, Australia, and Taiwan.

June

June 12-November 11: Curated by Harald Szeemann, *The 48th Venice Biennale* opens in Venice. Its theme is *Aperto over All*. Nineteen Chinese artists participate, an all-time high, and more than the number of either Italian or American participants in the Biennale. These artists include: Ai Weiwei, Ma Liuming, Fang Lijun, Wang Xingwei, Zhuang Hui, Yang Shaobin, Lu Hao, Yue Minjun, Wang Jin, Zhang Peili, Liang Shaoji, Zhou Tiehai, Xie Nanxing, Chen Zhen, Wang Du, Cai Guo-qiang, Zhang Huan, Zhao Bandi and Qiu Shihua. Cai Guo-qiang's *Venice Rent Collection Courtyard* wins the Biennale's biggest international prize, but also becomes the most controversial work of the exhibition. Taken from its original political, social and cultural context, Cai duplicates the Socialist Realist sculpture *Rent Collection Courtyard*, a representative work of the Cultural Revolution period. Cai himself has very little involvement in the actual assemblage of this work; it was put together by ten sculptors who worked on the original sculpture using borrowed plans and ready-made objects. Still, Cai works as a director/producer of the massive project. The Sichuan Academy of Fine Arts, claiming copyright of the original sculpture, unexpectedly accuses Cai of illegally copying the sculpture without its approval. This controversial incident leads to widespread debate within the art community.

June 12: Hosted by the London gallery Chinese Contemporary Ltd. and curated by Julia Colman and Ludovic Bois, an exhibition of works by young Chinese artists entitled *Sconfinamenti* is scheduled to take place at the Accademia di Belle Arti in Venice, but is cancelled. Artists scheduled to participate include Liu Ye, Lü Peng, Wang Qingsong, Zhang Dali, Qi Zhilong, Guo Wei, Guo Jin, Zhao Nengzhi, Zhou Chunya, Xue Song, Mao Yan, Qin Yifeng, and Shen Fan.

June 22: Xu Bing is awarded a "genius" fellowship from the John D. and Catherine T. MacArthur Foundation, an unrestricted grant of $315,000.

June 22-27: Chaired by Wang Mingxian, the exhibition *Exceptional Space: Experimental Works by Young Chinese Architects* is held at the China International Conference Center in Beijing. It displays proposals, architectural photos, and models by Zhang Yonghe, Zhao Bing, Tang Hua, Wang Shu, Liu Jiakun, and Zhu Wen.

July

July 2: Chaired by Chen Xiaoxin and Zhu Qi, *Peripheral Vision: Works from Jiangsu*, opens at the Junxiu Museum of Art at East China Normal University in Shanghai. Participating artists include: Wang Jinrong, Han Dong, Zhang Wenlai, Mo Xiong, Lu Bin, Wu Gaozhong, Wang Haozhi, Shen Jingdong, Ge Zhen, Cui Jin, and Li Qiang.

July 23-August 29: China Art Archives and Warehouse in Beijing holds an exhibition entitled *Concepts, Colors, and Passions*.

Curated by Leng Lin and involving artists Wang Jin, Zhu Fadong, Zhang Dali, and Wu Xiaojun, the *Talents* project begins to be realized. This plan involves using "newspapers" floating through society to construct a new artistic medium that combines art and everyday life. In this plan, each artist gets one page of newspaper to use as a medium to connect directly with viewers. The final product closely resembles a typical "newspaper," and follows a broader definition of artistic transmission. The final product is to be placed in newsstands and other public spaces such that people can freely take a copy.

August

August 14-22: Organized by Taiwan's Cui Ke Art Society, chaired by Ma Qinzhong, and curated by Li Wenjun, *Chinese Invitational Contemporary Art Exhibition: 1999 On the Way to Melbourne* is held in newly constructed but not yet furnished apartment building in Shanghai. Most of the invited artists have written introductions to their work in the magazine *Art World*, and remain relatively active on the mainland. Works include mainly easel painting and sculpture, but also installations which use text, calligraphy, and mixed media.

August 20-21: Organized by the Japan International Exchange Foundation, the international academic conference *Asian Art: Watching the Future* is held in Tokyo. Chinese critic and curator Leng Lin is invited to participate.

August 20-30: The Kunsterhaus Schloss Balmoral in Germany organizes and holds an exhibition of Chinese contemporary art entitled *We Was'Ere*. Song Dong, Yin Xiuzhen, and Zhu Qingsheng participate.

August 21-September 12: A solo exhibition of works by Chinese artist residing in France Yang Jiecang entitled *Rebuilding Dong Cunrui* is held at the Chengpin Gallery in Taiwan. On the day of the opening, a conference is held on the works of Yang Jiecang and in particular the work on display.

September

An exhibition of conceptual photography curated by Yang Fudong, Xu Zhen, Alexander Brandts, and Yang Zhenzhong

and entitled *Other Than Human* is scheduled to be held between September 4-6 in the basement of the Beihai Tower in Shanghai. After a private viewing on the evening of September 3, the exhibition is closed. The exhibition includes works by Yang Fudong, Liang Yue, Xu Zhen, Kan Xuan, Wu Jianxin, Shen Fan, Hu Jieming, Alexander Brandts, Zhou Hongxiang, Liu Weihua, Xiang Liqing, Yang Zhenzhong, Jiang Zhi, and Chen Xiaoyun.

September 8: Organized by the He Xiangning Art Museum and curated by Wu Jing, *Sharp New Sights from Artists Born Around 1970* opens at the International Art Palace, Beijing. It displays over 50 paintings by Mao Yan, Xia Junna, Xu Ruotao, Li Datun, Wang Mai and others, a total of 15 young artists.

September 9-January 26, 2000: Organized by the Queensland Art Gallery, *The Third Asia-Pacific Triennial of Contemporary Art* is held. The theme for the exhibition is *Exceeding the Future*. Cai Guo-qiang, Xu Bing, Chen Zhen, A Xian, Guan Wei, Li Yongbin, Yin Xiuzhen, Xu Tan, Zhang Peili, Shi Yong, and other Chinese artists are invited to participate.

September 15-November 14, 2000: The exhibition *Les Champs de la Sculpture 2000* is held on the Champs Elysee in Paris. Sui Jianguo and Chinese artist residing in France Wang Keping are invited to participate.

September 15-19: Organized by the Teda Contemporary Art Museum, curated by Zhang Yu, and chaired by Guo Zhixi, *Dialogue* is held at the International Art Palace, Beijing. Participating artists are Zhang Yu, Song Yongping, Li Jin, Qi Haiping, Guan Ce, Zhang Huaibo, Luo Qi, and Liu Fengzhi.

Originally scheduled to open at 14:00 on September 27 at the Goethe Institute, Beijing, *Chinese Contemporary Art Documentary Exhibition* is cancelled because "application procedures do not fit code" and on account of "fire and security regulations." Curated by Shu Yang, the exhibition collects pictures and materials of representative works from the 1990s by more than 150 artists, poets, and actors.

October
October 8-November 13: Qiu Zhijie and Wu Meichun are invited to Vancouver by Art Beatus Gallery to hold an exhibition and give a lecture on Chinese contemporary art. The title of Qiu Zhijie's solo exhibition is *Internal Elements*, including installation, video, photography, and painting.

October 12: Organized by the China Oil Painting Society and the Taiwan Arts and Culture Education Foundation, and curated by Lu Rongzhi, *Plural Vision: Taiwanese Contemporary Art 1998-1999* is held at the China Art Gallery in Beijing. Showing works by 75 Taiwanese contemporary artists, this is the first large-scale exhibition of its kind in mainland China. During the exhibition, a conference is held entitled *Local Art and Globalization: Art on Both Sides of the Straits Looks at a New Century*.

October 15: Jointly organized by the Australian embassy in Beijing and the Sino-Australian Council, and curated by Linda Wallabee, *Probe: New Media Art by Australian Artists* is held at the Australian embassy in Beijing.

October 16-October 16, 2000: Organized by the He Xiangning Art Museum and curated by Huang Zhuan, *The Second Contemporary Sculpture Art Annual Exhibition* is held in Shenzhen. The theme of the exhibition is *Balanced Existence: Proposals for the Future of an Ecological City*.

October 17: *Back and Forth, Left and Right* is held in a private dwelling in Tongzhou on the eastern outskirts of Beijing. Participating artists include Song Dong, Hai Bo, Sheng Qi, Zhang Nian, Sun Xuexue, Wang Mai, Wang Wei, Wang Qiang, Wu Wenguang, Xu Ruotao, Zhu Ming, and others.

October 21: Organized by the Goethe Institute, Beijing and the German Center for Scholarly Exchange, the report meeting *The Venice Biennale: Its Changes and the Possibility of Art Today* is held at the Goethe Institute, Beijing. The keynote speaker is Kassell University professor of modern art history Ursula Panhans-Bühler.

October 13-23: *The Eighth International Performance Art Festival* is held in Mexico City, Mexico. Chinese artist Sheng Qi is invited to participate.

October 23: Zhou Tiehai's solo exhibition *Don't Be Afraid to Make Mistakes* is held at ShanghArt Gallery in Shanghai.

October 26-29: Organized by The Gallery of the Central Academy of Fine Arts and the editorial staff of *Sculpture* magazine, and curated by Zhu Qi, *Infecting: Seven Contemporary Sculptors* is held at The Gallery of the Central Academy of Fine Arts. Participating artists are Li Gang, Zhong Song, Shao Kang, Yu Gao, Tang Songwu, Zhang Weihe, and Liu Baocheng.

October 30-December 26: *New Works by Li Tianyuan and Duan Jianyu* is held at the China Art Archives and Warehouse in

Beijing.

October 31-June 30, 2000: An exhibition *Installations by Asian Artists* is held at the Mattress Factory Contemporary Art Museum in Pittsburgh, U.S.A. Chinese artists Gu Dexin and Wang Youshen are invited to participate, along with artists from Japan, Korea, and Thailand.

November

November 2-23: Curated by Toshio Shimizu and Zhang Li, *Love: Contemporary Chinese Photography and Video* takes place in Tachigawa, Japan. Participating artists include Zhuang Hui, Hong Hao, Zhao Bandi, Liu Feng, Liu Zhen, Zhao Liang, Qiu Zhijie, Feng Qianyu, Wang Jinsong, Yang Fudong, Luo Yongjin, Hong Lei, Zheng Guogu, and Peng Donghui.

November 7: Zhang Dali's solo exhibition *Demolition and Dialogue* is held at the CourtYard Gallery, Beijing.

November 9: Curated by Karen Smith and Wu Meichun, *Revolutionary Capitals: Beijing in London* is held at the Institute for Contemporary Art in London. Artists invited to participate include Wang Gongxin, Qiu Zhijie, Zhang Peili, Zhou Tiehai, Wang Wei, Liu Wei, Shi Qing, Zhao Bandi, Wang Jianwei, Xu Xiaoyu, Wang Jinsong, Lin Tianmiao, Jiao Yingqi, and others.

November 12: Chinese artist living in the U.S. Xu Bing creates a banner to be hung in front of MoMA using his New English Calligraphy. The banner reads, "Chairman Mao says 'Art for the People.'"

November 21: Part of a "China Festival" organized in the Netherlands, the exhibition *Food for Thought: Chinese Contemporary Art* is held at De Witte Dame in Einhoven, the Netherlands. The exhibition is organized by the Canvas International Art Foundation. The central question of this exhibition is "identity," with sub-questions of gender, cross-gender relations, food, and the city. Artists Lin Tianmiao, Qiu Zhijie, Zhang Peili, Xu Zhen, An Hong, Zhang Dali, Shi Yong, Shi Qing, Feng Zhengjie, and Hu Xiangdong participate.

November 23-27: Organized by the Yuangong Modern Art Museum and chaired by Ma Qinzhong, *Pop Images of the 1990s* is held at the Shanghai International Art Fair.

November 25-26: Written and directed by Wen Hui, a private showing of the experimental play Birth Policy Report is held in the small theatre of the People's Art Theatre in Beijing. Artists Song Dong and Yin Xiuzhen realize relatively independent installation works as the set for the play.

November 26-29: Organized by the Proper Gallery and curated by Gu Zhenqing, Song Haidong, and Li Xiaofeng, *Traditional Visual Images* is held at the Shanghai University Academy of Fine Arts. Participating artists are Cang Xin, Huang Yan, Jin Feng, and Wang Jinsong.

December

December 1: Artist Sheng Qi realizes a performance work at the China Art Gallery in Beijing entitled *Concept 21—AIDS*.

December 2: Jointly organized by Hong Kong's New Space Artists Alliance and the editorial department of *Artist* magazine, chaired by Ma Qinzhong, and curated by Wong Chun-kit, *Documentary Show of Installation Art of China* is held in Hong Kong. It exhibits representative photos and materials from more than 80 ethnically Chinese installation artists.

December 4-9: Curated by Liu Jin and Wang Chuyu, and chaired by Zou Yuejin, *Fixed and Beyond: Joint Exhibition by 70s Age Group Artists* is held at the Wan Fung Gallery in Beijing. Participating artists include Liu Jin, Wang Chuyu, Chen Ke, Wang Guofeng, Dong Lu, Gao Hao, Fu Tao, Xie Qi, Ai Li, Zeng Huizhi, Gao Zhonghua, Ye Shanlin, Zhao Yinuo, Sun Jianchun, Rao Songqing, Liu Liye, Wen Qing, and others.

December 6: *Study of Drapery: Works by Sui Jianguo* is held at the Gallery of the Central Academy of Fine Arts.

December 12-January 5, 2000: A solo exhibition by Cai Jin entitled *Off the Canvas* is held at the CourtYard Gallery in Beijing.

December 25: *Direction and Meaning: Installation Art by Wang Qiang and Gu Xiaoping* is held at the Yuanchuang Art Center in Nanjing.

December 26: *Li Haibin: The Same Me, the Same Eyes* is held at the Limn Gallery Beijing Representative Office in Beijing.

December 30-January 1, 2000: Curated by Shen Jingdong, the exhibition *Hundred Years, Hundred Persons, and Hundred Family Names* is held at the Exhibition Hall of the Nanjing Academy of Art, Nanjing. This exhibition invites 100 contemporary artists to create a work centered around the theme of their own family name.

December 31-January 31, 2000: *Gate of the New Century, 1979-1999 Chinese Contemporary Art* is held at the Chengdu Modern Art Museum. Artistic direction of the exhibition is divided among Lang Shaojun and Yin Shuangxi (Chinese painting), Shui Tianzhong and Deng Pingxiang (oil painting), Qiu Zhenzhong (calligraphy), and Liu Xiaochun and Wang Lin (sculpture and installation). Over 200 representative artists from the previous 20 years were invited to participate.

December 31-January 6, 2000: *Transcending: 1999 Contemporary Art from Fujian* is held at the Gallery of Fujian Art Academy. Participating artists include Huang Dalai, Hu Shengping, Hu Hanping, Lin Rongsheng, Chen Jiaguang, Li Xiaowei, Zhu Jin, Shen Ye, Yuan Wenbin, Lü Shanchuan, and Chen Minghua.

Curated by Shu Yang and Tong Aichen, an exhibition of paintings entitled *Floating* is held at the Beijing Design Museum. Participating artists include Shu Yang, Tong Aichen, Zhu Ming, Wang Chuyu, and Zhang Dongliang.

On New Year's Eve, 1999-2000, Chinese artist then living in Japan Huang Rui curates an exhibition entitled *100 Years of Memories* at his home in Osaka. The exhibition includes works of performance, installation, photography, music, and dance. Twenty-one artists from different countries participate, including Chinese artists Huang Rui, Rong Rong, Wang Mai, Bei Dao, and others.

2000

January

January 1: Xie Deqing, a Chinese artist living in the U.S. who had not released a work for 13 years, comes out with a work entitled *Public Report*. He also declares that from this point on, he will no longer make art.

January 1: On remote Xieyang Island, Guangxi Province, far from the mainland in the sea south of China, an outdoor performance art event entitled *Ways of Life in the Future* and dubbed the "Xieyang Incident" is held, chaired by SuLü. More than 20 artists from around the country participate, including Jin Feng, Cang Xin, Chen Shaoxiong, Zhou Xiaohu, Qiu Zhijie, Weng Fen, Ma Jian, Liu Chengying, Wang Guofeng, He Zhenhai, Zhou Shaobo, Tan Haishan, and others.

January 8: *2000 Internet Art of China* is held at the Exhibition Hall of the Jilin Academy of Fine Arts in Changchun. The artistic director of the exhibition is Wang Jianguo. Curators are Huang Yan, Hai Bo, and Jiao Yingqi. The exhibition includes mainly Internet, multi-media, digital video, and photographic works. It is the first exhibition of avant-garde art in China to receive the tag of "Internet art." More than 48 artists from around the country participate, including video works by Jin Feng, Huang Yan, Cang Xin, Guan Ce, Song Dong, Dai Guangyu, Zhao Bandi, Zhou Tiehai, Chen Shaoxiong, Chen Qingqing, Wang Jinsong, Wang Qiang, Yang Zhenzhong, Zhang Nian, Zhang Tiemei, Sun Yuan, and Peng Yu; multi-media works by Zhou Xiaohu, Qiu Zhijie, Jiao Yingqi, Shi Qing, Xu Tan, Li Yongbin, and Shi Yong; a documentary concerning 13 years of performance art in China by Wen Pulin entitled *China Action*; and Internet works by novelists Xiao Sen, Chen Wei, and Wang Jianhui, poets Dong Ji and Liu Yupu, and rock singers Yu Yong and Song Yuzhe.

January 8-February 13: An exhibition of paintings by Meng Huang is held at the China Art Archives and Warehouse in Beijing.

January 11-25: Organized by the Lasalle Gallery, Singapore and curated by Huangfu Binghui, *In and Out: China Australia Contemporary Art Exchange* is held at the He Xiangning Art Museum in Shenzhen. Participating artists are A Xian, Guan Wei, Jiang Jie, Su Xinping, Liu Xiaoxian, Wang Wenyi, Wang Jianwei, Wang Luyan, Wang Youshen, and Wang Zhiyuan.

January 15: Curated by Zhu Qi, *The Position of East Asia* is held at the Shanghai Contemporary Art Museum. Forty-eight artists participate, including 20 from China.

February

February 19: *Mingling Under the Spring Moon: Sino-German Painting Exchange Exhibition* is held at the German embassy in Beijing, curated by Eckhard R. Schneider. Ten Chinese and German artists participate, including Gao Dagang, Zhu Qingsheng, Yuan Yunsheng, Liu Jin'an, and Li Chunyao.

Yang Jiecang, and Zhang Peili are invited to participate in *Arco 2000* in Spain.

February 25-June 5: *Caught and Arranged*, an exhibition of photography, is held at the China Art Archives and Warehouse in Beijing.

February 28: An exhibition of photography by Zhuang Hui and Luo Yongjin is held at the Contemporary Art Museum in Milan.

Dai Guangyu curates an exhibition entitled *Living in Peace, Thinking in Crisis* at Xindugui Lake, 20 kilometers outside of

Chengdu. In addition to Dai Guangyu, artists Yin Xiaofeng, Xu Ji, Zhang Hua, Liu Chengying, and Zhou Bin participate.

March

March 8-14: *Original Color*, an exhibition of paintings by female artists, is held at the International Art Palace, Beijing. Nine young female painters participate: Yu Hong, Shen Ling, Jiang Congyi, Xu Chen, Chen Shuxia, Xia Junna, Xu Xiaoyan, Ning Fangqian, and Li Chen.

March 9: *The Seventh Japan Performance Art Festival* (*NIPAF 2000*) is held. Chinese artist Wang Mai is invited to participate.

March 10: Curated by Tang Jing, Xun Lujing, and Fang Fang, *The Second Generation: Three-Person Exhibition* is held at the Wan Fung Gallery in Beijing.

March 14-June 4: Of the 97 artists included in the *2000 Whitney Biennial* in New York, 21 were born outside the U.S. but reside in New York. Cai Guo-qiang participates in the exhibition with a large conceptual sculpture installation entitled *Does Your Feng Shui Have Problems*?

Curated by Shen Kui, *Words and Meaning: Works by Six Chinese Contemporary Artists* opens at The Art Gallery, State University of New York-Buffalo. Participating artists are Chuang Chin (Taiwan), Hou Wenyi, Xu Bing, Wenda Gu, Zhang Hongtu, and Zheng Shengtian. Works include calligraphy, painting, sculpture, and installation.

Hong Hao holds a solo exhibition at the Art Beatus Gallery in Vancouver, showing his works from the last few years.

March 29-June 7: *The Third Kwangju Biennial* is held in Kwangju, Korea, around the theme of *Man and Space*. It is jointly curated by eight curators, and involves nearly 300 artists, among them Ma Liuming, Zhang Xiaogang, Wang Qingsong, Yan Peiming, Wenda Gu, and Guan Wei. Fei Dawei is in charge of the awards committee for the biennial.

The Shanghai Art Museum formally moves to its new location at 325 Nanjing Road. A 1930s British-style building of 18,000 square meters, the space had previously been used as the Shanghai Library.

April

Early April: Winners of the Second Chinese Contemporary Art Awards are announced. The judging committee, comprising Harald Szeemann, Hou Hanru, Li Xianting, Ai Weiwei, and Uli Sigg, picked 10 finalists from a field of 109 entrants. They are: Chen Shaoxiong, Hai Bo, Hong Hao, Jiang Zhi, Lin Yilin, Xiao Yu, Xie Nanxing, Yin Xiuzhen, Yang Shaobin, and Zheng Guogu. Xiao Yu wins the award, and Zheng Guogu wins a special award for artists under 30.

April 12: Wei Guangqing's solo exhibition *Actually You Could Also Make it Wider* is held at ShanghArt Gallery in Shanghai.

April 10-14: Curated by Qiu Zhijie and Wu Meichun, *House, Home, Family* is held on the fourth floor of Yuexing Furniture Corporation in Shanghai. Sixty-three artists participate, exhibiting works of painting, photography, video, installation, and performance.

With the support of Bank of China, ShanghArt Gallery places a massive illuminated sign in the form of a public interest announcement in the newly opened Pudong International Airport in Shanghai. The "announcement" is actually a work by Zhao Bandi entitled *Zhao Bandi and the Little Panda*. This is the first instance of art and advertising intersecting in Shanghai. Since 1995, Zhao Bandi had been making work that used the world-renowned panda as his creative mascot and spokesman. In 1998, a similar advertisement of his attracted attention on a Beijing Metro platform

April 16-23: Chinese artist residing in Australia A Xian holds a solo exhibition entitled *A Xian China, China* at The Art Museum of Capital Normal University.

April 17: Curated by Zhang Zhaohui, the art event *Art as Food* is held at the popular nightclub Club Vogue in Beijing. This is an attempt to integrate art and life within a set time frame in a set location. Participating artists include Gu Dexin, Huang Yan, Zhang Dali, Zhang Nian, Luo Zidan, Sun Yuan, Peng Yu, Wang Chunhong, and others.

April 4: Sponsored by the Annie Wong Art Foundation, a delegation of distinguished international curators makes a 15-day tour of China, stopping in Hangzhou, Shanghai, Beijing, Guangzhou, Taipei, and Hong Kong and interacting with Chinese artists, critics, and curators. The delegation includes Zheng Shengtian, Yao Shouyi, Okwui Enwezor, Lynne Cooke, Chris Dercon, Ken Lum, Susanne Ghez, Sebastian Lopez, Sarat Maharaj, and Jessica Bradley.

April 21-June 30: Chinese artist residing in the U.S. Zhang Hongtu has a solo exhibition at the Chery Melinnis Gallery in New York. He displays works in which he has "re-painted" famous landscape paintings from the Song, Yuan, Ming, and Qing dynasties in the style of the Impressionists and Post-Impressionists.

April 22, 15:00: Curated by Li Xianting and held at the sculpture studio of the Central Academy of Fine Arts, *Infatuated with Injury* opens. Because it uses human and animal corpses as a creative medium, the exhibition attracts widespread attention within and beyond China. Participating artists include Sun Yuan, Peng Yu, Qin Ga, Zhu Yu, Zhang Hanzi, Xiao Yu, and Datong Da Zhang.

April 22, 20:30: *Screen*, A play written and directed by Wang Jianwei and performed by professional actors is held at the Qiseguang Children's Theatre in the center of Beijing. It combines dialogue, video, performance, and multi-media art forms.

April 23-September 2: Curated by Gu Zhenqing, the performance exhibition *Human and Animal* is held separately in several cities throughout China. The Beijing portion is held on April 23 at Shanlin Sculpture Park in Huairou, entitled *Human and Animal: Unnatural Connection*. It includes artists Sheng Qi, Jin Feng, The Gao Brothers, Cang Xin, Zhang Nian, Zhou Xiaohu, Wang Mai, Zhu Qingsheng, and Chen Qingqing. The Chengdu portion, held at March 1 Bookstore is entitled *Cultural Animals* and includes Zeng Xun, Liu Chengying, Xu Ji, Dai Guangyu, and Yin Xiaofeng. The Nanjing portion is held on May 28 at Qingjing Mountain Park, and includes Wu Gaozhong, Gu Xiaoping, Liu Ding, Wu Yuren, Hong Lei, Zhao Qin, Liu Jian, Xu Hong, Gao Bo, Han Bing, Xu Jingjing, Gu Kaijun, Dong Wensheng, Wang Qiang, Zhao Ting, and Liu Jin. The Changchun portion is held on July 2-3 in a bar beside the Yitong River, entitled *Human and Animal: Animal Games*. Participating artists include Huang Yan, Wang Chuyu, Yu Yong, Zhu Yanguang, Li Shuchun, Jin Le, Ren Jian, Zhu Xikun, Zhou Xiping, Wang Yubei, Fu Xiaoming, Qu Zhenwei, Zhu Qingsheng, Zhu Yu, Li Li, Zhang Tiemei, Tong Dazhuang, Chen Guang, Feng Weidong, Xue Li, and He Yunchang. The Guiyang portion is held on September 2 in the Huaxi Scenic Area, entitled *Human and Animal: Symbiosis*. Participating artists include Tan Haishan, Jiang Jing, Yin Guangzhong, Tao Tao, Zhou Shaobo, Liu Haibin, Wei Zhengbin, and Wang Xiaopeng.

April 9-May 3: *Right Here*, an exhibition of works by Chinese artists residing in Japan, is held in Tokyo. Participating artists include Guan Huaibin, Jin Dawei, Xiong Wenyun, Zhang Zhijun, Shen Weiyang, Yang Dongbai, and Liu Xuguang.

April 28: Curated by Zhu Qi, *Exhibition of Contemporary Chinese Art in 2000, Time of Revival* is held at the Upriver Gallery in Chengdu, Sichuan Province. This exhibition attempts to summarize the new generation of the late 1990s and the changes in its aesthetic attitudes. Artists include Xu Yihui, Xie Nanxing, Liao Haiying, Li Zhanyang, Liu Jianhua, Tian Rong, Yang Fan, Yi Haizhou, Zhang Xiaotao, Cao Kai, Wang Du, Ma Liuming, and Cai Qing.

April 28: A comprehensive Chinese art website, *Artists' Alliance* opens in Beijing. Its creators are Feng Boyi, Pi Li, and Hua Tianxue.

April 29: Chaired by art critic Wu Liang, the Room at the Top Gallery formally opens on the top floor of Xianshi Tower on Nanjing Road in Shanghai. Its first exhibition is entitled *Red #1*, collecting works by some of Shanghai's most active contemporary artists, such as Ding Yi, Sun Liang, Shi Yong, Shen Fan, Pei Jing, Hong Lei, He Yang, Zhang Long, Wang Lin, Hu Jianping, Qu Fengguo, Zhou Changjiang, and others.

Pain: Works by Wang Jin, Xiao Yu, and Yang Maoyuan is held at the Beijing Design Museum.

In order to accompany the completion of the Qingdao Sculpture Museum, the Qingdao City People's Government, the Propaganda Department of the Qingdao City Committee of the Chinese Communist Party, and the Qingdao Department of Urban Planning work with the Central Academy of Fine Arts and the China National Academy of Fine Arts to hold *Facing a New Century: A Series of Activities to Celebrate the Completion of the Qingdao Sculpture Museum*. The event includes three separate exhibitions: *Chinese Contemporary Sculpture Invitational Exhibition, Hopeful Stars*, and *Twentieth Century Chinese Sculpture Art Conference*, curated respectively by Feng Boyi, Pi Li, and Yin Shuangxi. The *Invitational* includes more than 100 works by 35 young and middle-aged sculptors, aimed at demonstrating the artistic value of the newest works by Chinese sculptors. *Hopeful Stars*, subtitled *Selected Works by Graduates of China's Nine Top Art Schools* is designed to encourage innovation and elevate the techniques of newcomers to the field. It exhibits 49 works by 46 graduates of undergraduate and graduate training programs whose work shows creative ability.

May

May 6-July 2: Curated by Jia Fangzhou, Shen Weiguang, Wang Huaxiang, and Yin Yingxi and entitled *Return to Your Roots: Rebuild the Homeland, Shangyuan Artists' Open Studio Exhibition* is held in Shangyuan Village in the Beijing suburbs. Participating artists include Tian Shixin, Deng Pingxiang, Wang Huaxiang, Cui Xianji, Feng Jiali, Ma Baozhong, Li Tianyuan, Wei Ye, Ling Zi, and Yan Shuijun.

May 26: Curated by Guan Ce, Wang Cheng, and Wang Huiqin, *2000 International Contemporary Art Exchange Exhibition*

is held at the Jiangsu Art Gallery in Nanjing. Forty-three artists from China and ten other countries participate.

May 26-July 30: *The 12th Sydney Biennial* is held, displaying works by 49 artists from 23 countries. Cai Guo-qiang and Xu Bing participate in the exhibition.

June

Led by Director of the Sichuan Academy of Fine Arts Luo Zhongli, charges are filed against curator of the 48th Venice Biennale Harald Szeemann and artist Cai Guo-qiang. Cai is accused of plagiarizing and pirating a work completed in 1965 under the auspices of the Central Ministry of Propaganda and completed by 19 students and teachers from the Sichuan Academy of Fine Arts in his award-winning piece for the 1999 Venice Biennale. Entitled *Rent Collection Courtyard,* the original work includes 114 human figures, altogether more than 100 meters long, divided into 26 separate scenes as in a picture-book. These accusations jeopardize Cai Guo-qiang's copyright and raise questions about the boundary between the artistic techniques of replication/appropriation and intellectual property rights. The incident leads to widespread contention and debate in China.

June 15: Organized by Singapore's Lasalle-Sia College of the Arts and curated by Huangfu Binghui, *Text and Subtext*, an exhibition of works by female artists, opens at the Earl Lu Gallery of Lasalle-Sia College of the Arts. Twenty-two female artists from the U.K., U.S., Australia, Japan, Korea, China (including Taiwan), Vietnam, Singapore, and elsewhere participate. During the exhibition, a three-day scholarly conference is held on the three topics of "Asia," "Women," and "Artists." Participating Chinese artists include Yin Xiuzhen, Zhang Xin, Liu Hong, and Qin Yufen (living in Germany). After concluding in Singapore, the exhibition travels to Australia, Canada, and Scandinavia.

June 17: *The Seventh Venice Architectural Biennial* opens, entitled *A Bit Less Aesthetics, A Bit More Ethics.* Curated by Massimiliano Fuksas, it includes 92 architects and 37 national pavilions. Zhang Yonghe is the only Chinese architect invited to participate. He introduces his concept of the "Bamboo-ized City," which tries to make up for the damage man has already inflicted on the natural environment, and build symbiotic spaces that blend nature with modern social needs.

June 20: *Avant-Garde Today* organizes a conference on *The Rent Collection Courtyard and Contemporary Art*, held at the People's Art Publishing House in Beijing. The meeting touches on a series of important questions in Chinese art history, as well as some new questions about contemporary art and copyright. Wu Hung, Li Xianting, Lu Xiaochun, Sui Jianguo, Chen Lüsheng, Jiang Yuanlun, Wang Mingxian, Zhu Qi, Huang Du, Li Tuo, Wang Ming'an, Qiu Zhijie, Wang Jianwei, Wu Meichun, Bao Pao, and media figures in Beijing take part in the meeting. Ma Jianjun of Shanghai's Huadong Law Firm, as well as Fei Dawei, Zhu Qingsheng, and Gao Ling provide written commentary.

June 20-October 31: Chinese artists Lin Yilin, Chen Qingqing, Wang Jinsong, Wang Jin, and Gao Bo participate in the World Expo in Hanover, Germany.

June 27-July 6: Sun Liang's *Oil Painting on Skin* exhibition is held at the Room at the Top Gallery in Shanghai.

June 27-September 24: *The Fifth Lyon Biennial of Contemporary Art* is held in Lyon, France. The curator of the biennial is Jean-Hubert Martin, a French citizen then serving as director of the Dusseldorf Museum of Art. The theme is *Partag d' Exotismes*. Nearly 130 artists from 53 countries participate, including Chinese artists Wenda Gu, Cai Guo-qiang, Zhang Huan, Yan Peiming, Sui Jianguo, Liang Shaoji, Lu Hao, Zhuang Hui, as well as the six young artists Qin Ga, Peng Yu, Sun Yuan, Xiao Yu, Zhu Yu, and Zhang Hanzi who cooperate to make a video work.

June 21-26: *The 31st Basel Art Fair* is held in Basel, Switzerland. Shanghai's ShanghArt Gallery is invited to participate, the first time a Chinese gallery is invited since the Fair's founding in 1969. Furthermore, the gallery successfully enters Zhou Tiehai's series of works entitled *Placebo* in the "Art Statements" section, a part of the Fair dedicated to showcasing avant-garde art from new galleries. Of 278 galleries that sought to exhibit in this area, only 27 were chosen.

July

July 4: The *Arles International Photography Festival* opens in France, under the theme of *Photography: Crossover and Permeation*. The festival is the work of several curators, and is divided into 18 exhibitions under the three rubrics of "echo," "interaction," and "death." An exhibition under the "echo" theme, entitled *Oriental Sunrise: Asian Contemporary Art* is curated by Alain Sayag, head of the photography division of the Centre Pompidou. It includes work by 15 Asian artists, including Chinese artists Yang Zhenzhong, Zhao Bandi, Zhang Huan, Zhuang Hui, and Liu Wei.

July 5: *20th Century Chinese Oil Painting Exhibition* is held at the China Art Gallery in Beijing, displaying over 400 works by more than 270 artists from every stage of development over the last 100 years. During the exhibition, a conference is held entitled *Introduction and Creation: 20th Century Chinese Oil Painting*, and a massive six-volume work entitled *20th*

Century Chinese Oil Painting is published.

July 12-23: *Charming China*, an exhibition of conceptual photography, is held at the Eastlink Gallery in Shanghai. The curator is Gu Zhenqing. Participating artists include Cang Xin, Dai Guangyu, Jin Feng, Liu Yan, Zhou Xiaohu, Huang Yan, Wang Jun, Guan Ce, and Wang Guofeng.

July 13-August 12: *If I Had a Dream: Four Chinese Artists in Berlin* is held at the Kunstlerhaus Bethanien in Berlin, Germany. Participating artists are Lin Yilin of mainland China, Yuan Guangming of Taipei, and Su Qingqiang and Gan Zhiqiang of Hong Kong. The curator is Li Jinping.

July 20-August 2: Hosted by the Guangdong Museum of Art and curated by Wang Nanming, *The Individual and Society in Art* is held at the Guangdong Museum of Art. Participating artists are Zhong Huobiao, He Sen, Chen Wenbo, Chang Yu, Sun Xiaofeng, Jiang Heng, Chen Shaoxiong, Zhao Bandi, Zheng Guogu, and Ni Weihua.

July 26: The Gao Brothers hold an exhibition of conceptual photography entitled *Meltdown* at the Eastlink Gallery in Shanghai.

August

August 5-20: Curated by Feng Boyi and Hua Tianxue, *Documentatum of Chinese Avant-garde Art in the 1990s* opens at the Fukuoka Museum of Asian Art in Japan. The exhibition includes photographs and texts concerning more than 200 representative works by 82 artists from the 1990s. A scholarly conference about Chinese avant-garde art is held on August 6.

Zhou Yunxia's *Bathroom Wall Paintings* are exhibited in a public latrine in Longzhua Village, Beijing.

Humanity, Mountains-and-Waters environmental art exhibition is held on a tidal island in the Li River near Guilin, Guangxi Province. Curated by Gu Zhenqing, the exhibition invites artists from China and abroad to create on-site works of outdoor sculpture, installation, landscape, and conceptual art. Participating artists include Sui Jianguo, Huang Yan, Lin Yilin, Zhang Nian, He Yong, Lu Ming, and others.

September

September 7-14: Italian artist Luigi Berardi holds a sound installation exhibition at Shanhaiguan, where the Great Wall meets the ocean, entitled *Mountain City: 100 Wind Instruments*.

September 9: Curated by Pi Li, an exhibition entitled *Cute* opens at the Beijing Contemporary Art Museum. Seven members of the "New New Generation," born in the 1970s, participate: Feng Zhengquan, Xi Haizhou, Luo Hun, Chen Yunchuan, Chen Fei, He An, and Peng Donghui.

September 10: With the theme of *The Sky is the Limit*, the Taipei Biennial opens, curated by a team of two curators working together. The first is native Taiwanese Manray Hsu; the second is the New Generation French curator Jerome Sans. The exhibition includes works by 31 artists from 18 countries. Among them are Chinese artist Wang Youshen and Chinese artist residing in France Wang Du.

September 13-30: Zheng Guogu's print, installation, and sculpture exhibition *Another Dimension* is held at the Bizart Gallery in Shanghai.

September 13-October 15: *The 18th World-Wide Video Festival* is held in Amsterdam, the Netherlands. Chinese artists Wang Gongxin, Wang Jianwei, and Song Dong participate.

September 25: Organized by the Sculpture Department of the China National Academy of Fine Arts and the Shenzhen Sculpture Museum, *The 2nd Exhibition of Invited Works from Young Chinese Sculptors* opens simultaneously at the West Lake Art Gallery in Hangzhou, the Sculpture Hall in Qingdao, and the Shenzhen Sculpture Museum. The theme of this exhibition is "Clashing and Choosing," and it is chaired by Sun Zhenhua and Gao Tianmin. Works by 73 young sculptors from around China (including some studying abroad) are exhibited. None of the works have previously been exhibited publicly. On the day of the opening, a scholarly conference is held.

October

October 1: *The Third Sex: Internet Art China* is held in Beijing, curated by Huang Yan, Cang Xin, and Wang Guofeng. Nearly 20 artists participate, including Cang Xin, Zhou Xiaohu, Shi Yong, Lin Yilin, Xu Tan, Chen Shaoxiong, Zhang Wei, Zhu Qingsheng, Yu Gao, Li Tianyuan, Jin Feng, Wang Guofeng, Xiao Sen, Zhang Tiemei, Song Dong, Weng Fen, Zhang Nian, Cao Kai, Ma Jian, Huang Yan, and others.

October 4: An exhibition of the Xi'an Performance Art Group entitled *In the Wind* is held in Xi'an. Participating artists include Zhou Bin, Fei Yongsheng, Li Long, and others.

October 21-November 30: Curated by Huang Du, *Post-Material: Interpretations of Everyday Life by Contemporary Chinese Artists* is held at the Red Gate Gallery in Beijing. Participating artists are Gu Dexin, Zhang Yonghe, Zhu Jia, Wang Jianwei, Hong Hao, Hai Bo, Ma Han, Zhao Bandi, Wang Guofeng, Xu Ruotao, Zheng Guogu, Wang Qiang, Huang Yan, Li Juchuan, Wang Jinsong, Cui Xiuwen, Wang Luyan, Hu Xiangdong, Yang Wei, Sheng Qi, Lao Zhu, Tian Zizhong, Bing Yi, and Liang Shuang.

October 22-27: Sponsored by the Huanyi Environmental Technology Company Ltd., the exhibition *Water* is held at the company's production site on the outskirts of Beijing. Curated by Pi Li, the exhibition is aimed at exploring how "water" as an element of everyday life can fit into art, and its uses and expressions in contemporary art. Fourteen young artists exhibit 12 works of sculpture, multi-media art, video, and other forms which look at survival, the environment, and water resources. These artists are: Li Liang, Zhang Zhaohong, Yang Chunlin, Song Kun, Feng Xiaoying, Liang Yuanwei, Peng Donghui, Fu Yu, Kan Xuan, Tan Xun, Xie Dong and Tang Songwu.

October 27: *Virtual and Real* is held at the Wan Fung Gallery in Beijing. Curated by Zhang Wei and Yu Gao, the exhibition includes works by Tang Hui, Ma Jun, Song Dong, Wang Guofeng, Huang Yan, Zhang Wei, Tang Songwu, Zhan Wang, Yin Xiuzhen, Zhang Zhaohong, and Yu Gao.

November

November 4-14: Curated by Ai Weiwei and Feng Boyi, the exhibition *Fuck Off* opens at the Eastlink Gallery in Shanghai. In this exhibition, 48 artists use different gestures and non-cooperative methods to express their understanding of the contemporary art system. These artists include: Ai Weiwei, Cao Fei, Chen Lingyang, Chen Shaoxiong, Chen Yunquan, Ding Yi, Feng Weidong, Gu Dexin, Xu Tan, Wang Xingwei, Lin Yilin, Huang Yan, Qin Ga, Peng Yu, Sun Yuan, Xiao Yu, Zhu Yu, Song Dong, Wang Jin, Yang Maoyuan, Huang Lei, Jin Le, Li Wen, Li Zhiwang, Liang Yue, Liang Yue, Lu Chunsheng, Lu Qing, Meng Huang, Peng Donghui, Rong Rong, Song Tao, Chen Jie, Zheng Jishun, Wang Bing, Wang Chuyu, Wu Ershan, Xu Zhen, Yang Fudong, Yang Zhenzhong, Yang Zhichao, Yang Yong, Zhang Dali, Zhang Shengquan, Zheng Guogu, and Zhu Ming.

November 4-19: Curated by Gu Zhenqing, *Usual and Unusual* is held at the Yuangong Modern Art Museum in Shanghai. The 18 participating artists include Cai Yuan, Jin Feng, Cang Xin, Song Dong, Dai Guangyu, Wang Qingsong, Wang Xingwei, Qiu Zhijie, Xu Tan, Gu Dexin, Liao Bangming, Lin Yilin, Liu Jin, Tan Haishan, Xi Jianjun, Yang Shaobin, Yang Qian, and Zhu Fadong.

November 4: An exhibition of works by Liu Dahong is held in the "Formless Gallery" of Shanghai Normal University. This is the first time that Liu Dahong's large-scale multi-panel painting *Altar* is shown. This work is different from his earlier works that assume weighty historical burdens, and uses a playful format to reproduce famous historical pictures. These paintings are seen by some as the integrating the hallmarks of Political Pop and Gaudy Art.

Novemer 5-11: *About Me: Chinese Experimental Photography* is held at the Sanya Photography Gallery in Shanghai, curated by Lin Xiaodong. The 12 participating artists are Cui Xiuwen, Gu Dexin, Hai Bo, Hong Hao, Li Haibing, Li Yu, Ma Liuming, Song Yongping, Sun Guojuan, Wang Jinsong, Wang Qingsong, and Xiao Yu.

November 5: *Useful Life: Video and Photography* is held at 713 East Daming Road in Shanghai. Participating artists are Yang Zhenzhong, Xu Zhen, and Yang Fudong.

November 5: An exhibition of paintings by Yu Youhan, Zheng Zaidong, and Liu Changyun is held at the Donghaitang Gallery in Shanghai. The curator is the head of the gallery, Xu Longsen.

November 6: *The Third Shanghai International Biennale* opens, lasting for two months. The theme of the exhibition is *Shanghai Spirit*. Sixty-seven artists from 18 countries participate in separate exhibitions of painting, sculpture, photography, installation, video, and Chinese painting, contributing a total of over 300 works. Of the participating artists, 37 are Chinese nationals, five are ethnic Chinese residing abroad, and 25 are international. Participating Chinese artists include: Sui Jianguo, Zhan Wang, Fang Lijun, Lu Fusheng, Shi Chong, Xie Nanxing, Chen Peiqiu, Tian Liming, Chen Ping, Zhang Hao, Li Huasheng, Wang Huaiqing, Liu Xiaodong, Wang Yuping, Duan Zhengqu, Guan Ce, Zhang Dongfeng, Qu Fengguo, Ren Chuanwen, Li Datun, Fang Shaohua, Hong Hao, Liang Shuo, Shi Hui, Liang Shaoji, Chen Yanyin, Wang Qiang, Zhou Xiaohu, Zhang Peili, Wang Jianwei, Zhao Bandi, Hai Bo, Zhang Yonghe, Cai Guo-qiang, Huang Yong Ping, Yan Peiming, Jiang Dahai, and others. The main curators of the Biennale are Hou Hanru, Shimizu Toshio, Zhang Qing, and Li Xu.

November 8: Curated by Li Xianting, the exhibition *Lights Are On, But Nobody Is In* opens at a loft on East Daming Road in Shanghai. Li Xianting never physically appears at the opening, but is represented by a 29-inch television screen constantly playing a video representation of him. The exhibition includes paintings, photography, installations, video, and other works by 12 artists. They are: Chen Bing, Gu Dexin, Jin Ang, Shen Xiaotong, Wang Lixin, Wang Qingsong, Wu Shanzhuan, Yue Minjun, Yu Youshen, Zhao Liang, Wang Ziwei, and Zheng Weimin.

November 8-December 5: An exhibition of more than 80 Chinese contemporary paintings is held at Bizart Gallery in Shanghai, entitled *Heads, Figures, Couples and Group Portraits*. Most of the works come from the collection of the Belgium-based Modern Chinese Art Foundation. A portion of the works comes from the collection of Chinese-art.com founder Robert Bernell. The curator for the exhibition is Hans van Dijk, one of the directors of the China Art Archives and Warehouse in Beijing.

November 19-January 7, 2001: Curated by University of Chicago professor Wu Hung, *Cancelled: Experimental Art Exhibitions in China* is held at the Smart Museum of Art at the University of Chicago. The works on display are two pieces that bear a connection to the Leng Lin-curated exhibition *It's Me*, scheduled to take place—but cancelled—in Beijing in 1998. The works are Song Dong's video installation *Father and Son: Taimiao* and Wu Wenguang's documentary of viewers after the cancellation of the exhibition entitled *Diary: November 21, 1998*. The exhibition is not aimed at presenting artists' works, but rather at gaining a deeper understanding of the environment surrounding Chinese experimental art and its connection to society by looking at two works which share an internal connection despite their different forms.

November 20: A work by Taiwanese artist residing in the U.S. Hsieh Tehching entitled *Hsieh Tehching One Year Performance* is held at the China Art Archives and Warehouse in Beijing. CAAW directors Ai Weiwei and Hans van Dijk, along with more than 50 artists residing in Beijing, participate in this photographic exchange event.

November 25: *The First Xinjiayuan Art Exhibition and Forum* is held in the Tongzhou artists' community outside Beijing at the Xinjiayuan Art Studio. Participating artists include Wang Guisheng, Wei Bin, Zhou Aimin, Ye Jianxin, Ding Mijin, Tu Xiaoqiong, Li Hanping, Cheng Pei, Zhang Guozhen, Li Tao, Shen Huaping, Li Changtao, Liu Chunmei, Huang Sansheng, Zhang Qitian, and others.

December

December 9: *Sound*, an exhibition of sound installations, is held at the China Contemporary Art Museum. The exhibition is curated by Li Zhenhua, and participating artists are Shi Qing, Zhang Hui, and Wang Wei. Their works explore the relationship between sound and environment.

December 13: Only 45 years old, Chinese artist residing in France Chen Zhen dies of illness in Paris.

December 17-January 20: Organized by the Lin Hao Culture and Art Exchange Center and the Beijing Cultural Development Foundation, *Chinese Contemporary Painting* is held in Padua, Italy. It exhibits works by Shang Yang, Wei Guangqing, Xu Jiang, Zeng Jie, Zhang Yajie, Li Xiangyang, Ma Lin, Sun Lang, Yang Maoyuan, Xu Fuhou, Duan Zhengqu, Deng Jianling, Fu Lei, Wang Yin, Shi Lei, Hu Haifeng, Wang Wensheng, Guan Yu, and others, a total of nearly 80 works by 18 artists. It is the largest exhibition of Chinese contemporary art held in Italy in recent years.

December 23-25: An exhibition of works by Yang Qing is held at the Beijing Contemporary Art Museum.

An exhibition entitled *In* is held in an empty villa at Purple Mountain in the eastern suburbs of Nanjing. The curator is Liu Ding, and the fourteen participating young artists are Wang Changping, Liu Ding, Chen Hui, Yang Zhichao, Yang Li, Yu Jie, Luo Quanmu, Dong Wensheng, Sun Jianchun, Sun Jian, Jiang Jie, Bao Zhong, Yang Fudong, and Chen Xiaoyun. The majority of these artists were born in the 1970s, and they adhere to neither classical style nor the conventions of the avant-garde, seeking instead a new link to reality, a way to use the instantaneousness of images to express the possibilities and directions of life. Their works include installation, video, performance, photography, drip painting, and computer design.

Johnson Chang and Claire Hsu begin work on the Asia Art Archive. This is Hong Kong's first non-profit center devoted to promoting and preserving the international standing of Asian contemporary visual arts. It aims to collect a uniform and complete set of relevant materials concerning contemporary art across Asia. The archive decides to make collecting materials about exhibitions in China its first collection development program.

Translated from the Chinese by Philip Tinari.

Bibliography 1: Sources in Western Languages

A

The 1994 URARC Report. Beijing: NAAC, 1994.

1995 Kwangju Biennial: INFO-Art (catalogue). Kwangju: City Museum, 1995.

Andrews, Julia and Gao Minglu, *Fragmented Memory: The Chinese Avant-Garde in Exile*. Columbus, Ohio: Wexner Center for the Arts, The Ohio State University, 1993.

Andrews, Julia F. and Gao Minglu. "The Avant-Garde's Challenge to Official Art." In *Urban Spaces: Autonomy and Community in Contemporary China*, ed., Deborah Davis et al. Cambridge: Cambridge University Press, 1995, pp. 221-78.

Andrews, Julia F. and Kuiyi Shen, ed. *A Century In Crisis: Modernity and Tradition in the Art of Twentieth-Century China*. New York: Guggenheim Museum, 1998.

Art Chinois, *Chine Demain Pour Hier* (catalogue). Paris: Carte Secrete, 1990.

Artists from China—New Expressions. Bronxville, New York: Sarah Lawrence College, 1987.

Asian Avant-Garde (auction catalogue). London: Christie's, King Street, 1998.

Avant-Garde Chinese Art, Beijing/New York (catalogue). New York: City Gallery, 1986.

Barmé, Geremie. "Culture at Large: Consuming T-Shirts in Beijing." *China Information* 8:1, 2 (1993), pp. 1-44.

_____.*Shades of Mao: The Posthumous Cult of the Great Leader*. London: M.E. Sharpe, 1996.

_____ and Linda Jaivin, eds. "An Exhibition of Anarchy: Postmodern Art in Peking," in *New Ghosts, Old Dreams: Chinese Rebel Voices*. New York: Times Books, 1992.

_____."Exploit, Export, Expropriate: Artful Marketing in China, 1989-93." *Third Text* 25 (Winter 1993-94).

B

Barrie, Lita."The Twain Shall Meet: Chinese Art and Western Influence." *Visions* 5:2 (Summer 1991), pp. 34-35. (Review).

Bell, J. Bowyer. "Double Kitsch: Painters from China." *Review: The Critical State of Visual Art in New York*, March 15, 1998.

Bernell, Robert and Shimizu Toshio. "Chinese Contemporary Photography and Video," *Contemporary Art Bulletin* 3:5 (1999).

Between Ego and Society: Exhibition of Contemporary Women Artists of China. Chicago: Artemisia Gallery, 1997.

Beyond the Future: The Third Asia-Pacific Triennial of Contemporary Art. Brisbane: Queensland Art Gallery, 1999.

La Biennale di Venezia, *XLV Esposizione Internationale d'Arte*, vol. 2. Venice: Marsilio Editori, 1993.

La Biennale di Venezia. *Identity and Alterity: Figures of the Body 1895/1995*. Venice: Marsilio Editori, 1995.

Binks, Hilary. "Stereotyping Under Attack." *Asian Art News* 9:2 (1999).

Borysevicz, Mattieu. "Zhuang Hui's Photographic Portraits." *ART AsiaPacific* 19 (1998), pp. 74-79.

Borysevicz, Mattieu and Cao Weijun. *Second Wave* (pamphlet, CIFA Gallery exhibition). Beijing: the authors, 1997.

Brouwer, Marianne, ed. *Heart of Darkness*. Otterlo: Stichting Kröller-Müller Museum, 1994.

Bryson, Norman. "The Post-Ideological Avant-Garde." In Gao Minglu, ed. *Inside Out: New Chinese Art* (catalogue). Berkeley: University of California Press, 1998.

Bull, Hank ed. *Jiangnan: Modern and Contemporary Art from South of the Yangzi River*. Vancouver: Annie Wong

Art Foundation and Western Front Society, 1998.

C

Cai Guo-Qiang, *Venice's Rent Collection Courtyard*. Vancouver: Annie Wong Art Foundation, 1999.

Cai Guo-Qiang: Calendar of Life. Nagoya: Gallery APA, 1994.

Cai Guo-Qiang: Chaos. Tokyo: Setagaya Art Museum, 1994.

Cai Guo-Qiang: Concerning Flame (catalogue/brochure). Tokyo: Tokyo Gallery, 1994.

Cai Guo-Qiang: From the Pan-Pacific. Iwaki: Iwaki City Art Museum, 1994.

Cai Guo-Qiang: Flying Dragon in the Heavens. Humlebaek, Denmark: Louisiana Museum of Modern Art, 1997.

Century Women (catalogue). Hong Kong: Shijie Huaren Yishu Chubanshe, 1998.

Chan, Lauk'ung. "Ten Years of the Chinese Avant-garde: Waiting for the Curtain to Fall." *Flash Art*, Jan/Feb 1992, pp. 110-114.

Chang, Johnson. *L'Altra Faccia: Three Chinese Artists at Venice* (catalogue, exhib. at Venice Biennale). Zanzibar, 1995. (AKA: *The Other Face: Three Chinese Artists at the Centenary Exhibition, Alteritàe Alterità* Venice, 1995).

Chang Tsong-zung (Johnson Chang). *Power of the Word*. New York: Independent Curators International, 1999.

_____."Beyond the Middle Kingdom: An Insider's View" In Gao Minglu, ed. *Inside Out: New Chinese Art* (catalogue). Berkeley: University of California Press, 1998.

_____et. al. *China's New Art, Post-1989*. Hong Kong: Hanart T/Z Gallery, 1993.

_____. *Chinese Contemporary Art at Sao Paulo* (catalogue). Hong Kong: Hanart TZ Gallery, 1994.

_____."Of Time and Power." *Asian Art News* 8:5 (Sept/Oct 1998), pp. 68-69.

_____."The Other Face." *Asian Art News*, 5:4 (Jul/Aug 1995), pp. 41-43.

_____."China without Chinas," *Asian Art News* 12:2 (Mar/Apr 2002)

Change-Chinese Contemporary Art (catalogue). Göteborg, Sweden: Konsthallen Göteborg, 1995.

Changing Cultures: Immigrant Artists from China. New York: Baruch College Gallery/ City University of New York, 1991.

Cheng, Scarlet. "At the Cutting Edge." *Asian Art News* 4:4 (Jul/Aug 1994), pp. 56-59.

Chine Demain: Art Chinois, Chine Demain Pour Hier (catalogue). Paris: Carte Secrete, 1990.

Chinese Art in Exile. Project Group "Metabolism," Kassell, 1992.

Chinese Contemporary Art at Sao Paulo (other title: *22nd International Biennial of Sao Paulo. Chinese Exhibitions*). Hong Kong: Hanart TZ Gallery, 1994.

"Chinese Type" Contemporary Art Online Magazine. Chinese-art.com, 1996-2002.

Chiu, Melissa. "Thread, Concrete and Ice: Women's Installation Art in China." *ART AsiaPacific* 20 (Autumn 1998), pp. 50-57.

"Sleight of Hand, Use of Text in Chinese Contemporary Art." *ART AsiaPacific* 29 (2001).

Clark, John, "Official Reactions to Modern Art in China since the Beijing Massacre," Pacific Affairs 65:3 (Fall 1992), pp. 334-352.

_____, ed. *Modernity in Asian Art*. Sydney: Wild Peony Press, 1993.

_____, ed. *Chinese Art at the End of the Millenium*. Beijing and Hong Kong: New Art Media, 2000.

_____. *Modern Asian Art*. Roseville East, New South Wales: Craftsman House, 1998.

_____. "System and Style in the Practice of Chinese Contemporary Art: the Disappearing Exterior?" *Yishu* 1:2 (2002).

_____. "Postmodernism and Recent Expressionist Chinese Oil Painting." *Asian Studies Reviews* 5:2 (November 1991).

Clarke, David. "Foreign Bodies: Chinese Art at the 1995 Venice Biennale." *ART AsiaPacific* 3:1 (1996), pp. 32-34.

_____. "Reframing Mao: aspects of recent Chinese Art, Culture and Politics," in his *Art and Place: Essays on Art from a Hong Kong Perspective*, Hong Kong, Hong Kong University Press, 1996.

Cohen, Joan Lebold. *The New Chinese Painting 1949-1986.* New York: Abrams, 1987.

_____. "Chinese Art Today: No U-Turn." *ARTnews* 91:2 (Feb 1992), pp. 104-107.

_____. "Post-Tiananmen Art: The 1991 Graduating Classes-Beijing/Wuhan." *Fine Art Magazine* 2:2 (Dec. 1991), pp. 17-19.

_____. "Sichuan Surprise: Cosmopolitan Chengdu." *Asian Art News*, Mar/Apr 1994, pp. 50-56.

_____. *Painting the Chinese Dream: Chinese Art Thirty Years After the Revolution.* Northampton, Massachusetts: Smith College Museum of Art, 1982.

Combs, Nicky. "The Struggle for the New." *Asian Art News* 9:3 (1999).

_____. "Post-material." *ART AsiaPacific* 31 (2001).

Cotter, Holland. "Double Kitsch: Painters from China." *New York Times*, March 13, 1998.

Cream: Contemporary Art in Culture. London: Phaidon, 1998.

Creativity in Asian Art Now. Hiroshima: Hiroshima City Museum of Contemporary Art, 1994.

Creativity in Asian Art Now, Part 3: Asian Installation Work. Catalogue supplement. Hiroshima: Hiroshima City Museum of Contemporary Art, 1994.

Croizier, Ralph. "Art and Society in Modern China — A Review Article." *Journal of Asian Studies* 49:3 (August 1990), pp. 587-602.

_____. "Qu Yuan and the Artists: Ancient Symbols and Modern Politics of the Post-Mao Era," in Unger, Jonathan, *Using the Past to Serve the Present*, Armonk: M.E. Sharpe, 1993.

D

Dai Jinhua. "Redemption and Consumption: Depicting Culture in the 1990s." *Positions* 4:1 (1996), pp. 127-43.

Dal Lago, Francesca. "Cities on the Move" (review). *ART AsiaPacific* 20 (Autumn 1998), pp. 36-38.

_____. "Inside Out: Chinese Avant-Garde Art (A Conversation with Gao Minglu)." *ART AsiaPacific* 20 (Autumn 1998), pp. 42-49.

_____. "Personal Mao: Reshaping an Icon in Contemporary Chinese Art." *Art Journal* (Summer 1999).

_____. "Open and Everywhere." *ART AsiaPacific* 25 (2000).

_____. "The Fiction of Everyday Life." *ART AsiaPacific* 27 (2000).

Dao, Zi. "True Lies: New Reportage Photography in China." *ART AsiaPacific* 13 (1996), pp. 61-65.

Des del pais del centre: Avantguardes artistiques xineses: del 19 de juny al 30 de setembre de 1995, Centre d'Art Santa Monica. Barcelona: Generalitat de Catalunya, Departament de Cultura, 1995.

Dewar, Susan. "The Human Realm and the Way of Nature: Photography in China." *ART AsiaPacific* 13 (1996), pp. 54-60.

_____. "Imagining Reality: Contemporary Chinese Photography." *Art and Asia Pacific* 3:2 (1996), pp. 55-

59.

_____. "Beijing Report." *ART AsiaPacific* 15 (1997).

_____. "Beijing Report." *Art and Asia Pacific* 3:2 (1996).

Dijk, Hans van. "Painting in China After the Cultural Revolution: Style Developments and Theoretical Debates, Part II: 1985-1991." *China Information* 6:4 (Spring 1992), pp. 1-18.

Doran, Valerie. "The Commerce of Art." *Art and Asia Pacific* 1:3 (1994), pp. 24-27.

_____, Melanie Pong, Stephen Cheung, Ying Yee Ho and Una Shannon, eds., *Chinese Contemporary Art at Sao Paulo*. Hong Kong: Hanart TZ Gallery, 1994.

_____, ed. *China's New Art: Post-1989*, Hong Kong: Hanart TZ Ltd., 1993.

Dreissen, Chris and Heidi van Mierlo, eds. *Another Long March: Chinese Conceptual and Installation Art in the Nineties*. Breda: Fundament Foundation, 1997.

Dysart, Dinah and Hannah Fink, eds. *Asian Women Artists*. Roseville East, New South Wales: Craftsman House, 1996.

E

East Meets East in the West. San Francisco: Limn Gallery, 1998.

Edwards, Folke. *Change—Chinese Contemporary Art*. Götaborg, Sweden: Konsthallen, 1995.

Egan, Charles. "The Future of the New Chinese Art." *Limn Magazine* 2 (Aug 1998), pp. 4-11.

Elliott, David and Lydie Mepham, ed., *Silent Energy*. Oxford: Museum of Modern Art, 1993.

Encountering the Others (catalogue). Kassell: K-18, 1992.

Ereums, Kris Imants. "Cancelled!" *ART AsiaPacific* 31 (2001).

Erickson, Britta. *Words without Meaning, Meaning without Words: the Art of Xu Bing*. Washington, D.C.: Arthur M. Sackler Gallery and Seattle: University of Washington Press, 2001.

_____. "Evolving Meanings in Xu Bing's Art: *A Case Study of Transference*." "*Chinese Type*" *Contemporary Art Online Magazine* 1:4 (May 1998).

_____. "Made in China: Is There a Market for New Chinese Art?" "Beyond The Confines Of The Market" "China's Virtual Galleries." *Limn Magazine* 2 (Aug 1998), pp. 24-30.

_____. *Three Installations by Xu Bing*. Madison. Wisconsin: Elvehjem Museum of Art, 1991.

_____. "The Rise of a Feminist Spirit." *ART AsiaPacific*, 31 (2001).

F

Faces and Bodies of the Middle Kingdom (catalog). Prague: Galerie Rudolfinum, 1997.

"The Faces of China's Future" (interview). *Limn Magazine* 2 (Aug 1998), pp. 12-23.

Fan Di'an, Leng Lin, and Hans van Dijk. *Ideals and Idols of Beijing* (catalogue). Hong Kong: Schoeni Art Gallery, 1994.

Farver, Jane (curator) and Reiko Tomii. *Cultural Melting Bath: Projects for the 20th Century*. New York: Queens Museum of Art, 1997.

Fei Dawei. *Art Chinois, Chine Demain Pour Hier*. Paris: Carte Secrete, 1990.

Feng Jiali. "Limitless difference." *ART AsiaPacific* 31 (2001).

Fifth Anniversary Exhibition: Selected Paintings by Twenty-Three Contemporary Artists (catalogue). Hong Kong: Schoeni Art Gallery, 1997.

The First Academic Exhibition of Chinese Contemporary Art 96-97 (catalogue). Hong Kong: China Oil Painting Gallery Ltd., 1996.

Force, Yvonne and Carmen Zita, curators. *4696/1998: Contemporary Art from China* (catalogue). Vancouver: Art Beatus, *1998.*

Fuch, Anneli and Geremie Barmé *Flying Dragon in the Heavens*. Humlebaek, Denmark: Louisiana Museum of Modern Art, 1997.

Fumio Nanjo. *Immutability and Fashion: Chinese Contemporary Art in the Midst of Changing Surroundings* (catalogue). Tokyo: Kirin Brewing Co., Ltd., 1997.

G

Gao Minglu. "From Elite to Small Man: The Many Faces of a Transitional Avant-garde in Mainland China." In Gao Minglu, ed. *Inside Out: New Chinese Art* (catalogue). Berkeley: University of California Press, 1998.

_____, ed. *Inside Out: New Chinese Art* (catalogue). Berkeley: University of California Press, 1998.

_____. "Toward a Transnational Modernity: An Overview of Inside Out: New Chinese Art." In Gao Minglu, ed. *Inside Out: New Chinese Art* (catalogue). Berkeley: University of California Press, 1998.

_____. "What Is the Chinese Avant-garde?" in *Fragmented Memory: The Chinese Avant-garde in Exile.* Columbus, Ohio: Wexner Center for the Arts, The Ohio State University, 1993 (catalogue), pp. 4-5.

Gebrochene Bilder-Junge Kunst aus China (Broken Pictures—Young Chinese Art). Hamburg: Drachenbrücke, Horlemann Verlag, Unkel/Rhein and Bad Honnef, 1991.

Gercke, Hans. *Westöstliche Kontakte* (catalogue). Heidelberg: Heidelberger Kunstverein, 1995.

Goodman, David. "Contending the Popular: Party-state and Culture." *Positions* 9:1 (Spring 2001).

Gustafson, Paula. "4696/1998: Contemporary Art from China at Art Beatus Gallery" (review). *Asian Art News* 8:5 (Sept/Oct 1998), pp. 79-80.

_____. "Jiangnan: South of the Yangtze in Vancouver" (review). *ART AsiaPacific* 20 (Autumn 1998), pp. 39-41.

Gustafson, Paula. "Unveiled reality." *ART AsiaPacific* 25 (2000).

H

Hay, Jonathan. "Ambivalent Icons: Works by Five Chinese Artists Based in the United States." *Orientations* 23:7 (July 1992), pp. 37-43.

Heart of Darkness. Otterlo: Kröller-Müller Museum, 1994.

Heartney, Eleanor. "Report from Taiwan: The Costs of Desire" (review). *Art in America* 86:12 (December 1998), pp. 38-43.

Heartney, Eleanor. "The Body East." *Art in America* (April 2002).

Here Not There. Vancouver: Vancouver Art Gallery, 1995.

Hore, Tessa. "Independence and Individuality: Six Contemporary Artists Working in Shanghai." *Asian Art Newspaper* (Belgium), January 1998, pp. 16-17.

Hou, Hanru. *On the Mid-Ground*. Hong Kong: Timezone 8, 2002.

_____. "Ambivalent Witnesses: Art's Evolution in China." *Flash Art* 61 (Nov/Dec 1996), pp. 61-64.

_____. "Beyond the Cynical: China Avant-garde in the 1990's." *ART AsiaPacific* 3:1 (1996), pp. 42-51.

_____. "Towards an Un-Unofficial Art: De-ideologicalization of China's Contemporary Art in the 1990s." *Third Text* 34 (Spring 1996), pp. 37-52.

_____, curator. *Between the Sky and the Earth: Five Contemporary Chinese Artists around the World*. Hong

Kong: Annie Wong Foundation and University Museum and Art Gallery, University of Hong Kong, 1998.

_____. "Brückenschlöge." *Neue Bildende Kunst* 5:1 (1995), pp. 58-61.

_____. "Departure Lounge Art: Chinese Artists Abroad." *Art and Asia Pacific* 1:2 (Apr 1994), pp. 36-41.

_____. "Entropy; Chinese Artists, Western Art Institutions: A New Internationalism." In *Global Visions: Towards a New Internationalism in the Visual Arts*. London: Kala Press, 1994. pp. 79-88.

_____. "Le Plaisir du Texte: Zen and the Art of Contemporary China." *Flash Art* 26 (Nov/Dec 1993), pp. 64-65.

_____. *Uncertain Pleasure: Chinese Artists in the 1990's*. Vancouver and Hong Kong: Art Beatus, 1997.

_____and Gao Minglu. "Strategies of Survival in the Third Space: A Conversation on the Situation of Overseas Chinese Artists in the 1990s." In Gao Minglu, ed. *Inside Out: New Chinese Art* (catalogue). Berkeley: University of California Press, 1998.

_____. and Hans Ulrich Obrist, eds. Cities on the Move (catalogue). Ostfildern-Ruit, Germany: Verlag Gerd Hatje, 1997.

Huang Du. "Cai Guoqiang and Huang Yongping." *"Chinese Type" Contemporary Art Online Magazine* 1:5 (Sep 1998)

_____. *Outside the Real: A New Form of Video Art in China*. Sydney: Gallery 4A, 1998.

In the Absence of Ideology (catalogue). Hamburg: Kampnagel Hamburg, 1995.

Huangfu Binghui, curator and ed., *In and Out, Contemporary Art from China and Australia*. Singapore: LaSalle-SIA College of Art, 1997.

"Foreign Compound, Global Market." *Asian Art News* 9:5 (1999)

J

Jaivin, Linda. "Sexual Realpolitik" (review). *Art and Asia Pacific* 2:4 (1995), pp. 32-33.

_____. "From the barrel of a gun." *Art and Asia Pacific* 2 (June 1992)

Jose, Nicholas. "My Search for a Shaman: The Impact of 1989 on Chinese Art." *Art and Asia Pacific* 1:2 (April 1994), pp. 78-83.

_____. "Next Wave Art: The First Major Exhibition of Post-Tiananmen Vanguard Chinese Art Seen Outside the Mainland." *New Asia Review*, Summer 1994, pp. 18-24.

_____, ed. *Mao Goes Pop, China Post-1989*. Sydney: Museum of Contemporary Art, 1993.

_____. "Notes from Underground, Beijing Art, 1985-89." *Orientations* 23:7 (July 1992), pp. 53-58.

_____. "Brokering a Space: New Chinese Art." *Art Monthly Australia* 53 (Sept 1992)

Jouanno, Evelyne. "Out of the Centre or Without the Centre." *Third Text* 28, 29 (Autumn/Winter 1994.)

Journey to the East (catalogue). Hong Kong: Art Center of Hong Kong University of Science and Technology, 1997.

K

Karetzky, Patricia Eichenbaum. *Contemporary Chinese Art and the Literary Culture of China*. Bronx, New York: Lehman College Art Gallery, 1999.

Kember, Pamela. "Transcending Stereotypes" (review of the Jiangnan Project). *Asian Art News* 8:4 (Jul/Aug 1998), pp. 61-63.

Kim, Yu Yeon, Cho Sun Rae and Andrew Eom, eds. *Translated Acts: Performance and Body Art from East Asia*

528

1990-2001. Berlin: Haus der Kulturen der Welt and New York: Queens Museum of Art, 2001.

Klein, Norman M. "Underneath the Wave: New Art by Chinese Artists." *Fine Art Magazine* 2:2 (Dec 1991), pp. 27-30.

Köppel-Yang, Martina, Schneckmann, Peter and Schneider Eckard R. *Gebrochene Bilder, Junge Kunst aus China*. Selbsdarstellungen, Bad Honnef, Horlemann, 1991.

L

Lago, Francesca dal. "Against the Tide: The United States." *ART AsiaPacific* 17 (1998), p. 100. (Review of *Against the Tide*).

Laing, Ellen Johnston. "Is There Post-Modern Art in the People's Republic of China?" In *Modernity in Asian Art: The University of Sydney East Asian Series*, no. 7, edited by John Clark. Broadway, New South Wales: Wild Peony, 1993. pp. 207-221, pls. 150-157.

Lamain, Kitty. "Art at the Handover." *ART AsiaPacific* 17 (1998), pp. 86-87.

Lee, Leo Ou-fan. "Across Trans-Chinese Landscapes: Reflections on Contemporary Chinese Cultures." In Gao Minglu, ed. *Inside Out: New Chinese Art* (catalogue). Berkeley: University of California Press, 1998.

Lee Wong Choy. "Quotation Marks: China-Watching in Singapore." *ART AsiaPacific* 17 (1998), pp. 34-35.

Leng Lin. "The China Dream," *"Chinese Type" Contemporary Art Online Magazine* 1:1 (late 1997).

_____. "Nine Chinese Artists." *"Chinese Type" Contemporary Art Online Magazine* 1:5 (Sept 1998).

_____. "Photographic Works of Hong Lei and Wu Xiaojun." *"Chinese Type" Contemporary Art Online Magazine* 1:5 (Sept 1998).

Lenz, Iris. *Balanceakte*. Stuttgart: Institutfür Auslandsbeziehungen, 1995.

Lenzi, Iola. "In and Out of China." *ART AsiaPacific* 17 (1998), pp. 32-33.

Li, Chu-tsing. "Ancient Tradition Meets Modernism in Contemporary Chinese Art." *Fine Art Magazine* 2:2 (Dec 1991), pp. 11-15.

Li Hsiao-t'i. "Making a Name and a Culture for the Masses in Modern China." *Positions 9:1* (Spring 2001).

Li Xianting. "A Gifted Artist: Liu Wei." *"Chinese Type" Contemporary Art Online Magazine* 1:2 (January 1998).

_____. "The Imprisoned Heart: Ideology in an Age of Consumption." *Art and Asia Pacific* 1:2 (April 1994), pp. 25-30.

_____. "Seven Chinese Artists and Contemporary Chinese Art after Political Pop." In Force, Yvonne and Carmen Zita, curators, *4696/1998: Contemporary Art from China* (catalogue). Vancouver: Art Beatus, 1998.

_____ and Lu Jie. *Faces Behind the Bamboo Curtain* (catalogue). Hong Kong: Schoeni Art Gallery, 1994.

_____. "After Pop: Kitsch Discourse and Satritical Parody." *Visual Arts + Culture* 1:1(1998).

Lien, Fu-Chia-Wen. "The Body as Metaphor for Feminist Expression" (review of *Site of Asia/Site of Body*). *Asian Art News* 8:4 (Jul/Aug 1998), pp. 64-69.

Lin Xiaoping. "Discourse and displacement." *ART AsiaPacific* 25 (2000).

Liu Kang. "Popular Culture and the Culture of the Masses in Contemporary China." *Boundary 2* 24:3 (Fall 1997), pp. 99-122.

London, Barbara. *Stir-Fry: A Video Curator's Dispatches from China*. New York: Museum of Modern Art, 1997. (Web-site: <http://www.adaweb.com/context/stir-fry/>)

Looking for the Tree of Life: Journey to the Asian Contemporary Art (catalogue). Saitama: The Museum of Modern Art, 1992.

Lu, Sheldon Hsiao-peng. "Postmodernity, Popular Culture, and the Intellectual: A Report on Post-Tiananmen China." *Boundary 2* (1996), pp. 139-69.

_____. "Global POSTmodernIZATION: The Intellectual, the Artist, and China's Condition." *Boundary 2* 24:3 (Fall 1997), pp. 65-97.

_____. "Art, Culture, and Cultural Criticism in Post-New China." *New Literary History* 28 (1997), pp. 111-33.

_____. *China, Transnational Visuality, Global Postmodernity*. Stanford: Stanford University Press, 2001.

Lufty, Carol. "Emigré Artists: Rocky Landings." *ARTnews* 92 (Nov 1993), pp. 49-50.

_____. "Flame and Fortune." *ARTnews* (Dec 1997), 147.

M

MacRitchie, Lynn. "Precarious Paths on the Mainland." *Art in America* 82 (Mar 1994), pp. 51-53, 55, 57.

Maggio, Meg. "From Action to Image." *ART AsiaPacific* 31 (2001).

Mao Yiling. "Pushing boundaries." *ART AsiaPacific* 24 (1999).

Martin, Jean-Hubert, et al., *Magiciens de la Terre*. Paris: Centre Georges Pompidou, 1989.

Millichap, John. "Beyond Barriers." *Asian Art News* 8:6 (Nov/Dec 1998), pp. 47-49.

N

Nanjo, Fumio. "Asian View" (review of "Asian View-Asia in Transition"). *ART AsiaPacific* 3:3 (1996), pp. 100-101.

New Art from China, Post-1989 (catalogue). London: Marlborough Fine Art, 1993.

New Generation of Asian Art (catalogue). Yonago: Yonago City Museum of Art, 1997.

"News Brief: New Art Awards." *Asian Art News* 8:6 (Nov/Dec 1998), pp. 14, 16.

Next Phase (catalogue). London: London Docks, 1990.

Nippon International Performance Art Festival '96 (catalogue). Tokyo: International Exchange Center, 1996.

Noth, Jochen, et al., eds. *China Avant-garde: Counter-Currents in Art and Culture*. Hong Kong: Oxford University Press, 1993.

O

Origins of Myth and Fire: New Art from Japan, China and Korea (catalogue). Saitama: The Museum of Modern Art, 1996.

P

Pai, Maggie. "Challenges to Change" (review of Taipei Biennial). *Asian Art News* 8:4 (Jul/Aug 1998), pp. 36-47.

Paintings, Performances and Video (catalogue). Tokyo: Setagaya Museum, 1997.

Pan Gongkai. "A New Consciousness: Chinese Art in the Aftermath of the Cultural Revolution." *Harvard Asia Pacific Review* 1:2 (Summer 1997), pp. 41-43.

Parsons, Bruce, comp. *Dangerous Chessboard Leaves the Ground*. Toronto: Art Gallery of York University, 1987.

Passagio a Oriente (catalogue). Venice: 45th Biennale, 1993.

"The Peripatetic Artist: Fourteen Statements." *Art in America*, July 1989, pp. 130-136.

Peters, Paul and Hans van Dijk, curators. *Mondrian in China: A Documentary Exhibition with Chinese Originals* (catalogue). Beijing: The Netherlands Ministry of Foreign Affairs, 1998.

Pi Li. "Chinese People, Chinese Arts, Chinese Society." *Representing the People* (exhibition at the Chinese Arts Center, Manchester, 1999).

_____. "Threading Our Way through the Images." *"Chinese Type" Contemporary Art Online Magazine* 1:3 (March 1998).

_____. "My Life, My Decision: The Political Nature of Chinese Contemporary Art." *Contemporary Chinese Art Bulletin* 2:5 (1999).

Poemes & Art en Chine, Les "Non-Officiels," Doc(k)s 114.f N.41, Paris 1982.

Pollack, Barbara. "PoMaoism." *Art and Auction*, March 1998, pp. 110-115.

Pong, Melanie, Josette Balsa, Stephen T. N. Cheung, Una Shannon and Louisa Teo, eds., *L'Altra Faccia: Tre Artisti Cinesi a Venezia*. Milan: Zanzibar, 1995.

Pöhlmann, W. *China Avant-garde*. Berlin: Haus der Kulturen der Welt and Heidelberg: Edition Braus, 1993.

Prat, Thierry, Thierry Raspail, Jean-Hubert Martin, et al. *Partage d'Exotismes: 5e Biennale d'Art Contemporain de Lyon*. Réunion des Musées Nationaux, 2000.

Preece, Robert. "Chinese Art, Manchester Style." *Asian Art News* 8:6 (Nov/Dec 1998), pp. 39-41.

Promenade in Asia (catalogue). Tokyo: Shiseido Gallery, 1994.

Promenade in Asia II (catalogue). Tokyo: Shiseido Gallery, 1997.

Puy, Imma González, et al.*Des del Pais Del Centre: Avantguardes artistiques xineses, Centre d'Art Santa Monica*. Barcelona: Generalitat de Catalunya, Departament de Cultura, 1995.

Q

Qin Yufen. *Malereien, 1984-1986* (catalogue). Heidelberg: Heidelberger Kunstverein, 1986.

R

Raddock, David M. "Beyond Mao and Tiananmen: China's Emerging Avant-Garde." *The New Art Examiner*, March 1995, pp. 25-27.

_____. "Regarding China's New Avant-garde Artists." *The New Art Examiner*, February 1995, pp. 30-33.

Rebellion and Conspiracy. Hong Kong: World Chinese Arts, 1998.

Reckoning with the Past. Edinburgh: The Fruitmarket Gallery, 1996.

Red and Grey: Eight Avant-garde Chinese Artists. Singapore: Soobin Art Gallery, 1997.

Reincarnation: Initiation (catalogue). Beijing: China Exhibition Exchange Centre, 1996.

Resistances (catalogue). Tokyo: Watari Museum of Contemporary Art, 1992.

Ripple across the Water (catalogue). Tokyo: Watari Museum of Contemporary Art, 1995.

Rizvi, Sajid. "A Bridge of Vermilion— Chinese Art in Tradition, Transition and Diaspora." *Eastern Art Report* 4:4.

_____. "Distances, Dissonance and Diversity—The Art of Chinese Artists in Britain." *Eastern Art Report* 4:4.

_____. "East in West—Ideas, Issues and Imagery in the Works of Chinese Artists in Europe." *Eastern Art Report* 4:3.

Roberts, Claire. *New Art from China* (catalogue). Sydney: Art Gallery of New South Wales, 1992.

Roe, Jae-ryung. "Revisiting Abstraction: Asian Traditions, Modern Expressions." *ART AsiaPacific* 17 (1998), pp. 24-25.

Ronte, Dieter, Walter Smerling, and Evelyn Weiss. *China! Zeitgenössische Malerei*. Bonn: Dumont, 1996.

Ronte, Dieter, Walter Smerling, Evelyn Weiss, et al. *"Quotation Marks": Chinese Contemporary Paintings*. Singapore: Singapore Art Museum, 1997.

Rowe, Peter G. "Tradition and Housing: New Homes in a Booming China." *Harvard Asia Pacific Review* 1:2

(Summer 1997), pp. 53-55.

S

Sang Ye; trans. and intro. by Barmé. "Fringe-Dwellers: Down and Out in the Yuan Ming Yuan Artists' Village." *ART AsiaPacific* 15 (1997), pp. 74-77.

Scarff, Julian. "Eight Baoding Artists at the National Art Gallery of China" (review). *Asian Art News* 8:6 (Nov/ Dec 1998), pp. 68-69.

Schell, Orville. "Chairman Mao as Pop Art," in *Mandate of Heaven: A New Generation of Entrepeneurs, Dissidents, Bohemians, and Technocrats Lays Claim to China's Future.* New York: Simon & Schuster, 1994 , pp. 279-292.

Schmid, Andreas. "Über die Aktuelle Kunstszene in Peking." *Neue Bildende Kunst* 5:1 (Feb/Mar, 1995), pp. 52-55.

_____ and Alexander Tolnay. *Zeitgenössische Fotokunst aus der VR China* (catalogue). Berlin: Edition Braus, 1997.

Schneider, Eckhard R. et al. *Im Spiegel der Eigenen Tradition: Ausstellung Zeitgenössischer Chinesischer Kunst.* Beijing: Botschaft der Bundesrepublik Deutschland, 1998.

Schwabsky, Barry. "Tao and Physics." *Art Forum*, Summer 1997, pp. 118-121, 155.

Scott, Tony. "Re-merging after Tian'anmen," *Art Monthly Australia* 73 (Sept 1994)

Seoul International Art Festival (catalogue). Seoul: National Museum of Contemporary Art, 1994.

Shen Kuiyi. *Word and Meaning: Six Contemporary Chinese Artists* (catalogue). Buffalo, New York: State University of New York at Buffalo Art Gallery, 2000.

Sichel, Berta. "Antilinear." *Flash Art* (Mar/Apr 1997), 72.

Silent Energy. Oxford: Museum of Modern Art, 1993.

Smith, Karen. "Another Long March." *ART AsiaPacific* 17 (1998), pp. 26-28.

_____. "Breaking the Silence: New Art from China." *Art Monthly* 186 (May 1995), pp. 24-25.

_____. "Century: Woman at the China Art Gallery/ Modern Art Museum/ International Art Palace." *Asian Art News* 8:3 (May/Jun 1998), pp. 82-83.

_____. "Chinese Conceptual Art at the Kazerne." *Asian Art News* 7:5 (Sept/Oct 1997), pp. 98-99.

_____. "Contemporary Chinese Art." *ART AsiaPacific*, no. 16 (1997), pp. 89-90. (Review of Watari-um exhibition).

_____. *Representing the People* (catalogue). Manchester: Chinese Arts Centre, 1999.

_____. "Notes on China's Video Installation Art." *Asia-Pacific Sculpture News* 2:4 (Autumn 1996).

Solomon, Andrew. "Their Irony, Humor (and Art) Can Save China." *The New York Times Magazine*, December 19, 1993, 42-72.

Stein, Judith E. Stein. "Report on Australia: The Asia-Pacific Triennial and the Sydney Biennale." *Art in America*, June 1997, pp. 57-63.

Strassberg, Richard E. ed. *"I Don't Want to Play Cards with Cézanne" and Other Works: Selections from the Chinese "New Wave" and "Avant-Garde" Art of the Eighties.* Pasadena, California: Pacific Art Museum, 1991.

Sturman, Peter C. "Measuring the Weight of the Written Word: Reflections on the Character-Paintings of Chu Ko and the Role of Writing in Contemporary Chinese Art." *Orientations* 23:7 (July 1992), pp. 44-52.

Sullivan, Michael. *Art and Artists of Twentieth Century China.* Berkeley and Los Angeles: University of

California Press, 1996.

Szeemann, Harald. "Interview: Ai Weiwei on CCAA, Identity and His Recent Conceptual Work." "*Chinese Type*" *Contemporary Art Online Magazine* 1:6 (January 1999).

Szeemann, Harald and Cecilia Liveriero Lavelli, eds. *La Biennale di Venezia, 48th Esposizione Internationale d' Arte*. Venice: Marsilio Editori, 1999.

T

Tao Yongbai. *Huayun-Thoughts of a Woman Critic* (from Chinese Contemporary Art Research Series). Jiangsu Art Press, 1995.

Thiek, Catherine. *Four Points of Reference* (4 Points de Recontre: Chine, 1996) (catalogue). Paris: Galerie de France, 1996.

Tsang, Henry. "Uncertain Pleasure." *ART AsiaPacific* 17 (1998), pp. 29-31.

Tsao Tsing-yuan. "The Birth of the Goddess of Democracy" in Wasserstrom, Jeffrey N.,Perry, Elizabeth J., eds., *Popular Protest and Political Culture in China*. Boulder,Westview Press, 1994.

Thomas, Bronwyn. "Art and the Critic in Contemporary China" (based on interview with Wang Youshen). *Orientations* 23:7 (July 1992), pp. 59-61.

Thomas, Greg. *Global Roots: Artists from China Working in New York* (catalogue). New York: Purdue University, 1998.

Thorpe, Robert and Richard Vinograd. *Chinese Art and Culture*. New York: Harry Abrams, 2001.

V

Van Dijk, Hans and Inge Lindermann. *China, China-Aktuelles aus 15 Ateliers* (catalog). Munich: Herausgeber Hahn Produktion, 1996.

Van der Plas, Els. "Heart of Darkness" (review). *Art and AsiaPacific* 2:3 (1995), pp. 118-119.

Vanhala, Jari-Pekka, ed. *Out of the Centre*. Pori, Finland: Porin Tadeimuseo, 1994.

Vine, Richard. "Report from Shanghai." *Art in America,* July, 2001.

W

Wang, Jing. *High Culture Fever: Politics, Aesthetics, and Ideology in Deng's China*. Berkeley: University of California Press, 1996.

Wang Yuejin. "Anxiety of Portraiture: Questioning Ancestral Icons in post-Mao China," in Liu Kang and Tang Xiaobing, eds., *Politics, Ideology and Literary Discourse in Modern China*. Durham: Duke University Press, 1993.

Wang Mingxian. "Notes on Architecture and Postmodernism in China." *Boundary 2* 24:3 (Fall 1997), pp. 163-175.

Wang, Val. "Do You Mind My Art?" *ART AsiaPacific* 28 (2001).

Watson. R.C. "Revealing the Soul of a Rural World." *Asian Art News* 2:2 (Mar/Apr 1992).

Waves of Asia (catalogue/brochure). Tokyo: Tokyo Gallery, 1991.

Wear, Eric Otto. "Uncertainties at the Sao Paulo Bienal." *Asian Art News* 7:2 (Mar/Apr 1997), pp. 92-93.

Welland, Sasha. "Travelling Artists, Travelling Art, Ethnographic Luggage." *Yishu* 1:2 (2002).

Werner, Chris, Qiu Ping, and Marianne Pitzen eds. *Die Hölfte des Himmels: Chinesische Künstlerinnen*. Bonn: Frauen Museum, 1998.

The Witness of the Contemporary Art in China (catalog/brochure). Tokyo: Tokyo Gallery, 1995.

"Works from the Premier Collection of Hanart TZ Gallery's Tsong-zung Chang." *"Chinese Type" Contemporary Art Online Magazine* 1:5 (Sep 1998).

Wu Hung, "Variations of Ink: A Dialogue with Zhang Yanyuan," in the exhibition catalogue, *Variations of Ink: Abstract Paintings of Five Chinese Artists*. New York: Chambers Fine Art, 2002.

_____, ed. *Chinese Art at the Crossroads: Between Past and Present, Between East and West*. Hong Kong: New Art Medium, 2001.

_____. *Exhibiting Experimental Art in China*. Chicago: Smart Museum of Art, the University of Chicago, 2000.

_____, ed. *A Special Issue on Exhibitions and Curatorial Practices*. *"Chinese Type" Contemporary Art Online Magazine* 3:5.

_____. *Transience: Chinese Experimental Art at the End of the 20th Century*. Chicago: Smart Museum of Art, University of Chicago, 1999.

_____. "Photographing Deformity: Liu Zheng and His Photographic Series My Countrymen." *Public Culture* 13:3 (2002).

_____. "The 2000 Shanghai Biennale: The Making of a Historical Event." *ART AsiaPacific* 31 (2001), pp. 42-49.

_____. "Beyond Polarities: The Art of Xu Jiang and Shi Hui," in *Xu Jiang and Shi Hui*. Chicago: Columbia Collage, 2001.

_____. "Rong Rong and His Ruin Pictures," in *Rong Rong and His Ruin Pictures*. New York: Chambers Fine Art, 2001.

_____. "Das Gesicht der Autoritaet: Maos Portraet am Tiananmen," in Helga Glaeser, ed., *Blick·Macht·Gesicht*. Berlin: Karlsgartenstr, pp. 70-104.

_____. "Zhang Dali's Dialogue: Conversation with a City." *Public Culture* 12:3 (2000), pp. 749-68.

_____. "Experimental Art and Experimental Exhibitions: A Roundtable Discussion on Exhibitions and Curatorial Practices," in Wu Hung, ed., *Special Issue on Exhibitions and Curatorial Practices*, *"Chinese Type" Contemporary Art Online Magazine* 3:5 (2000).

_____. "Exhibiting Experimental Art in China," in Wu Hung ed., *Special Issue on Exhibitions and Curatorial Practices, Chinese Type Contemporary Art Online Magazine* 3:5, 2000.

_____. "A Chinese Dream by Wang Jin." *Public Culture* 12:1 (2000), pp. 74-92.

_____. "Ruins, Fragmentation, and the Chinese Modern/Postmodern," in Gao Minglu, ed., *Inside Out: New Chinese Art*. Berkeley:University of California Press,1998, pp. 59-66.

_____. "The Hong Kong Clock—Public Time-Telling and Political Time/Space." *Public Culture* 9 (1997), pp. 329- 354.

_____. "Hong Kong 1997—T-shirt Designs by Zhang Hongtu." *Public Culture* 9 (1997), pp.417-421.

_____. "Once More, Painting from Photos," in Ackbar Abbas, *Chen Danqing: Painting After Tiananmen*. Hong Kong: Hong Kong University, 1995.

_____. "A Ghost Rebellion: Xu Bing and his Nonsense Writing." *Public Culture*, 1993.

_____. "Tiananmen Square: A Political History of Monuments." *Representations* 35 (1991), pp. 84-117.

X

Xu, Hong. "Dialogue: The Awakening of Chinese Women's Consciousness." *Art and Asia Pacific* 2:2 (Apr

1995), pp. 44-51.

_____. "The Spotted Leopard: Seeking Truth from History and Reality: Trends in the Development of Chinese Art." *Art and Asia Pacific* 1:2 (Apr 1994), pp. 31-35.

Y

Yang, Alice. *Why Asia? Contemporary Asian and Asian American Art*. New York: New York University Press, 1998.

Yang Xiaoyan. "A Glimpse into Recent Contemporary Art in Guangzhou." *"Chinese Type" Contemporary Art Online Magazine* 1:4 (May 1998).

Yao, Catherine. "Shanghai's Lonely Avant-Garde." *Asian Wall Street Journal*, February 2-3,1996, 7.

Yee, Lydia. *Against the Tide* (exhibition brochure). New York: Bronx Museum of the Arts, 1997.

Yi Ying. "Bad Painting." *"Chinese Type" Contemporary Art Online Magazine* 1:3 (Mar 1998).

_____. "First Annual Chinese Contemporary Art Award: A New Perspective." *"Chinese Type" Contemporary Art Online Magazine* 1:6 (January 1999).

_____. "Liu Xiaodong: A Retrospective." *"Chinese Type" Contemporary Art Online Magazine* 1:1 (late 1997).

Yin Ji'nan. "What Next, Ultra Postmodernism?" *"Chinese Type" Contemporary Art Online Magazine* 1:4 (May 1998).

Z

Zacharopoulos, Denys and Hou Hanru. *Huang Yong Ping: La Biennale de Venise 48e Exposition Internationale d'Art Pavillon Français 1999*. Association Français d' Action Artiqtique-Ministere des Affaires Etrangeres, 1999.

Zha, Jianying. *China Pop: How Soap Operas, Tabloids, and Bestsellers Are Transforming a Culture*. New York: The New Press, 1995.

Zhang Jianjun, Liu Xilin, and Yin Shuangxi. *Symphony of Landscapes* (catalogue). Hong Kong: Schoeni Art Gallery, 1995.

Zhang Zhaohui. "Raise the Red Lantern." *ART AsiaPacific* 20 (Autumn 1998), pp. 28-29.

_____. "A Return to the Real: New Art and New Spaces." *ART AsiaPacific*, 31 (2001).

Zhu Qi. "Do Westerners Really Understand Chinese Avant-garde Art?" *"Chinese Type" Contemporary Art Online Magazine* 2:3 (June 1999).

Bibliography 2 : Sources in Chinese

A

《阿仙》2000 个人作品集

艾未未、曾小俊编《灰皮书》非公开出版物 1997

艾未未、冯博一策划《不合作方式》非公开出版物 2000 展览图录

艾未未、曾小俊、徐冰编《黑皮书》非公开出版物

艾未未、曾小俊编《白皮书》非公开出版出版物

安格莉卡·斯戴泊肯、黄笃编辑《张开嘴——闭上眼，北京——柏林》1996 展览图录

B

包儒生、戴汉志策划《蒙德里安在中国——蒙德里安文献与中国艺术家的作品》 非公开出版物 1998 展览图录

C

《从意识形态出发——中国新艺术展》汉堡 1995

《出口——入口》2001 展览图录

《出走与返魅——有关"70年的一代"及艺术个案》非公开出版物 1998 展览图录

《匆若禅去：冯斌 1997-2000》非公开出版物 2000 个人作品集

《城市俚语——珠江三角洲的当代艺术》非公开出版物 2001 展览图录

《村落·实验剧》非公开出版物 1994

《此时此刻》1997

《蔡国强艺术展》上海书画出版社 2002 展览画册

《蔡锦》人民美术出版社 1995 个人作品集

《超越画布·蔡锦》四合苑画廊 非公开出版物 1999 个人作品集

《错觉时态》前波画廊 非公开出版物 2001 展览图录

《陈文骥》四合苑画廊 1999 个人作品集

Christine Kayser 策划《活着》非公开出版物 1998 展览图录

Clayton Spada 策划《心声》非公开出版物 1999 展览图录

崔岫闻《性别空间——崔岫闻油画作品 1996-1997》国际文化艺术出版社 1998

曹斐《链》非公开出版物 2000 个人作品集

柴中建编著《一了之境——关于朱明的实验文本》香港天马图书有限公司 2001

程昕东策划《与达利对话》非正式出版物 2001 展览图录

苍鑫《生存的转译》 2002

《蔡国强》东京画廊 非公开出版物 1994 展览图录

蔡斯民、叶永青策划《男孩女孩》非公开出版物 2001 展览图录

陈孝信、岛子艺术主持《边缘视线4 知识分子与艺术意义》2000 展览图录

陈孝信、朱其艺术主持《边缘视线'99 江苏青年艺术家作品集》1999 展览图录

陈强策划《黄河的渡过》非公开出版物 1994 图录文献

陈进、朱冥、舒阳策划《第一届开放艺术平台——行为艺术》香港 新世纪出版社 2000

陈默学术策划《残骸艺术展》成都 非公开出版物 2001 展览图录

D

《大尾象》非公开出版物 1998

《当代中国肖像》多尔多涅省文化发展协会及巴黎法兰廊共同制作出版 2000

《德国艺术家巩特尔·约克尔和北京"新刻度"小组的对话》北京 非公开出版物 1994

《第三性 网络艺术 中国》'北京 第一回'北京 非公开出版物 2000 展览图录

《典藏》杂志 台湾

《丁乙》香格纳画廊 1997 个人作品集

《东方》杂志 中国东方文化研究会主办

《东方广场 中国现代雕塑品展》非公开出版物 2000 展览图录

《东方艺术》杂志 河南省艺术研究所主办

《读书》杂志 生活·读书·新知三联书店

《堆积情感》北京梵画廊 非公开出版物 2001 展览图录

戴汉志主持《月光号 赵半狄》1994 个人作品集

当代艺术家丛书《原女性艺术》云南美术出版社 1995

邓鸿、刘骁纯主编《2001 成都双年展》2001 展览图录

丁正耕编著《中国当代艺术 1990-2000》辽宁美术出版社 2000

董冰峰、羊子、马尚、刘天舒策划《北方当代独立影像艺术展》非公开出版物 2002 展览图录

《都市人格书当代艺术》香港 艺术潮流杂志社 1998 展览图录

F

《方力钧、顾德新、张培力、张晓刚》巴黎 1996-1997

《方土 二十一世纪中国新水墨艺术家丛书 1》岭南美术出版社 2000

《放大的道具》非公开出版物 2001年 作品集

《风化与凝聚——丁方艺术展 1981-2001》2002 个人作品集

《附体·影像艺术展》非公开出版物 2001 展览图录

范迪安、许江主编《希望之星 中国高等美术院校雕塑毕业作品选拔展作品集》2000 展览图录

范迪安、宋晓霞策划《刘小东 1990-2000》非公开出版物 2000 展览图录

范迪安、许江主编 殷双喜执编《二十世纪中国雕塑学术论文集》青岛出版社 2000

范迪安、许江主编 冯博一执编《中国当代雕塑邀请展作品集》青岛出版社 2000 展览图录

范迪安艺术主持《'98 福州亚太地区当代艺术邀请展作品集》海风出版社 1998

范景中编《当代的西绪福斯：邱振中的书法、绘画和诗歌，1994年》中国美术学院出版社 1994

《方力钧》非公开出版物 1996 个人作品集

房方、孙路静、汤静策展《二厂时代 三人提名展》北京 中央美院陈列馆 非公开出版物 2000

冯博一、蔡青策划《生存痕迹——'98 中国当代艺术内部观摩展》非公开出版物 1998 展览图录

冯博一策划《魔幻都市的现实与虚妄》非公开出版物 江海个展图录

俸正杰《皮肤的叙述》非公开出版物 1996 个人作品集

俸正杰著《包装》2002 个人作品集

G

《个人主义》非公开出版物 1996 展览图册

《高氏兄弟》四合苑画廊 非公开出版物 2001 个人作品集

《观念 概念——谈中国当代艺术现状的泛化》非公开出版物 1999 展览图录

《广东现代艺术图片影像作品邀请展作品集》非正式出版物 2001 展览图录

《郭伟和郭晋新作品展》四合苑画廊 2000 展览图录

高名潞等著《中国当代美术史 1985-1986》上海人民出版社 1991

高名潞著《中国前卫艺术》江苏美术出版社 1997

耿建翌《百分之五十》 1999 作品集

顾振清《外在与内在》唐人画廊 2002

顾振清策划《虚拟未来——中国当代艺术展》2002 展览图录

顾振清策划／主编《拆——传统视觉倾向》非公开出版物 展览图录

顾振清策划／主编《中国魅力》观念摄影艺术展 非公开出版物 2000 展览图录

顾振清主编《精神景观》非公开出版物 2001 个人作品集

顾振清主编／策划《趣味过剩》非公开出版物 2002 展览图录

顾振清主编／策展人《异常与日常》非公开出版物 2000 展览图录

郭盍策展《中国影像》2002 年度展 非公开出版物 2002 展览图录

郭小川主编《中国当代美术二十年启示录》文化艺术出版社 1998

郭雅希、徐香林策划《与你有关 影像装置展》非公开出版物 2002 展览图录

H

《汉字纬度》非公开出版物 2000 展览图录

《何森作品1999》非公开出版物 1999 个人作品集

《后批判一九九九》非公开出版物 1999 作品集

《画廊》岭南美术出版社

韩磊《疏离 韩磊摄影展》北京 非公开出版物 1995 个人作品集

杭间著 中国当代美术现象批评文丛《新具象艺术——在现实和内心之间》吉林美术出版社 1999

何浦林策划《曾梵志》非公开出版物 2001 个人作品集

何浦林策划《张恩利作品1992-2000》非公开出版物 2000 展览图录

何森《那些女孩》非公开出版物 2000 个展图录

何兆基、张芳展览统筹《建构的真实：北京观念艺术摄影》非公开出版物 2001 作品集

黑阳、牧石《蓝肚皮画室》非正式出版物 1994 作品集

侯翰如、范迪安、柯嘉比策划《生活在此时》 2001 展览图录

皇甫秉惠展览策划《进与出——中澳华人当代艺术交流展》拉萨 - 新航艺术学院出版 1997

黄丹麾、胡戎著中国当代美术现象批评文丛《新表现艺术——情感的栖息地》吉林美术出版社 1999

黄丹麾策划《失效→←自救——首届东北油画新锐七人展》1998 展览图录

黄笃、洪浩编辑《空间与视觉：北京都市生活嬗变之印象1998》非公开出版物 1998年 展览图录

黄笃、冰逸策划《制造中国》世界华人艺术出版社 2002

黄笃、王瑞林策划《再造形象与符号》非公开出版物 2001 展览图录

黄笃策划、编辑《后物质》世界华人艺术出版社 展览图录

黄京、杨小彦等策划《开放的语境——'96南京艺术邀请展》非公开出版物 1996 展览图录

黄锐《纪念毛泽东主席诞辰一百周年黄锐绘画专册》非公开出版物 1993

黄岩、海波、焦应奇策划《2000 中国·网络影像艺术》非公开出版物 2000 展览图录

黄岩策划《身份＝边界展》非公开出版物 2000 展览目录

黄致阳《恋人絮语》非公开出版物 1999 展览图录

黄专（中方）、阮戈琳贝（法方）、程昕东（法方）策划《第四届深圳当代雕塑艺术展——被移植的现场》2001 展览图录

黄专、乐正维文献编辑《当代艺术和人文科学》湖南美术出版社 1999

黄专编辑《社会——上河美术馆第二届学术邀请展》非公开出版物 2000 展览图录

黄专学术主持《第二届当代雕塑艺术年度展》（平衡的生存）深圳 何香凝美术馆 1999 展览图录

J

《基本教欲》台湾 太平洋文化艺术基金会出版 1995 展览图录

《计文于》非公开出版物 1997 个人作品集

《江南：现代与当代中国艺术展览》非公开出版物 1998 展览图录 文献

《江苏画刊》杂志 江苏美术出版社

《今日先锋》杂志 生活·读书·新知三联书店（1-6 期)天津社科出版社

《进入都市——当代水墨实验专题集》广东美术馆、深圳美术馆合编 广西美术出版社 1999 展览图录

《就在这里没错》非公开出版物 2000 展览图录

贾方舟编《世纪·女性艺术展》香港世界华人艺术出版社 1998 展览图录

金锋主编《异质的书写方式》广西美术出版社 1999

K

《卡通一代 第二回展》非公开出版物 1998 展览图录

《跨越 4＋4 中国·欧洲青年艺术家视觉交流展》非公开出版物 2001 展览图录

凯伦·史密斯策划《中国当代艺术特展 火红 红火》非公开出版物 2001 展览图录

凯伦·史密斯策划《2000 第二届当代中国艺术奖》非公开出版物 2000

L

《李天元画展》非公开出版物 1993 展览图录。

《李占祥雕塑作品选》非公开出版物 1999 展览图录

《刘大鸿》香港 Schoeni 东方艺术出版 1992 个人作品集

《刘炜》非公开出版物 1997 个人作品集

《刘野》明经第画廊 非公开出版物 1997 个人作品集

《罗永进·新民居》广西美术出版社 2001

冷林、张栩编《中国之梦——97 中国当代艺术》今日中国出版社 1997 展览图录

冷林策划《是我！九十年代艺术发展的一个侧面》非公开出版物 1998 展览图录

冷林策划《现实：今天与明天'96 中国当代艺术》非公开出版物 1996 展览图录

冷林等《现实：今天与明天》

冷林主持《世说新语》非公开出版物 1995 展览图录

冷林著《是我》中国文联出版社 2000

黎英东、喻旭东策划《城市引擎（2000-2001）》非公开出版物 2002 展览图录

李超著《上海油画史》上海美术出版社 1995

李虹《叛逆与共谋》世界华人艺术出版社 1998 李虹油画作品集

李路明、周继平、李晓山、孙平、易丹、邹建平、郭雅希、岛子、高岭、郁涛、刘向东、邹跃进主编《当代艺术》系列

丛书（1、解构主义——当代的挑战；2、建构主义——文本化趋势；3、转换主义——生成与置换；4、多元主义——挪用的策略；6、回顾与反省——"广州九十年代艺术双年展"；7、本土回归——面对当代世界文化水墨语言的转型策略；8、作为艺术的行为能指；11、当代中国艺术批评；12、临界大十字架系列及其它；13、女性与艺术的生态自述；15、艳俗艺术的语境与定位）湖南美术出版社

李路明主编《中国当代学术文献》（1990-1991）综合材料与波普倾向；个体话语与新形象；现实主义倾向；对新文人画的反驳 1992 湖南美术出版社

李向阳主编《形而上2001》上海抽象艺术展图录 2001

李晓峰展览策划主持《都市抽象——上海抽象艺术沙龙邀请展》1999

栗宪庭策划《十二花月》非公开出版物 2001 陈羚羊个人作品集

栗宪庭策划《死亡档案 1998-2001》非公开出版物 2001 毛同强、宋永平二人展览图录

栗宪庭策展《酚苯乙烯》非公开出版物 1999 展览图录

栗宪庭著《重要的不是艺术》江苏美术出版社 2000 论文集

廖雯、栗宪庭策划《跨世纪彩虹——艳俗艺术》湖南美术出版社 1999

廖雯策划《两性平台》艺术展 非公开出版物 1998 展览图录

廖雯策划《女性与花》非公开出版物 1997 展览图录

廖雯策划《中国当代艺术中的女性主义》非公开出版物 1995 展览图录

廖雯著中国当代美术现象批评文丛《女性艺术——女性主义行为方式》吉林美术出版社 1999

林国主编《先锋艺术》非公开出版物 1999 作品集

林国主编《中国先锋艺术》非公开出版物 1996 展览图录

林林、周一斌、肖宏、张慧策划《反视——自身与环境展》非公开出版物 1998 展览图录

林松策划《复制品》非公开出版物 2001 展览图录

林晓东《与我有关》中国实验艺术图片展图录 美国彼岸艺术公司出版 非公开出版物 2000

刘瑾、王楚禹策划《给定与超越——70年代艺术家架上绘画作品联展》非公开出版物 1999 展览图录

露芮·英格兰《鸟兽果花》Bow画廊 1999 展览图录

鲁虹主编 黄专主持《中国当代美术图鉴 1979-1999 观念艺术分册》湖北教育出版社 2001

吕澎、易丹著《中国现代艺术史 1979-1989》湖南美术出版社 1992

吕澎等《美术文献》湖北美术出版社 1994-1998

吕澎著《中国当代艺术史 1990-1999》湖南美术出版社 2000

吕品田著中国当代美术现象批评文丛《新生代艺术——漫游的存在》 吉林美术出版社 1999

吕胜中著《觅魂记》湖南美术出版社 1996

吕胜中著《走着瞧》生活·读书·新知三联书店 2000

M

《'94陌生情境展》非公开出版物 1994 展览图录

《美术》杂志 中国美术家协会

《美术观察》杂志 中国艺术研究院

《美术家通讯》杂志 内部刊物 中国美术家协会

《美术批评家年度提名展(1994油画)》1994 四川美术出版社

《美术研究》杂志 中央美术学院

《美苑》杂志 鲁迅美术学院

《木木——蒋志摄影作品展》非公开出版物 1999 展览图录

《目击成长·喻红》现代艺术出版社 2002 个人作品集

梅子策划《"喻言北京"中国当代艺术报道》 非公开出版物 1998 展览图录

莫妮卡·德玛特艺术主持 《复数·个性》 非公开出版物 1998 展览图册

N

《'95女性李虹·袁耀敏油画展》 非公开出版物 1995 展览图录

P

《浦捷》非公开出版物 1996 展览图录

卜列平、魏立刚、阎秉会、楚桑总策划《巴蜀点兵'99成都20世纪末中国现代书法回顾》非公开出版物 1999 展览图录

潘星磊《潘星磊艺术档案 1988-1998》非公开出版物 1998 个人作品集

潘缨《艺术之维——当代艺术语言新指向》湖南美术出版社 1999 个人作品集

彭德、鲁虹、唐小禾、贺飞白、刘鸣主编《美术文献》,(2 中国后具像专辑1994; 3 九十年代彩墨画1995; 4 中国女画家专辑1995; 5 乡土油画专辑1995; 6 中国版画专辑1996; 7 想象性油画专辑1996; 8 中国当代雕塑专辑1997年; 11 象征与寓意油画专辑1998; 12 现代都市题材绘画专辑1998; 14 当代水墨画专辑 2000; 15 男性艺术专辑2000; 16 当代图片艺术专辑2002)湖北美术出版社

彭德著《视觉革命》江苏美术出版社 1996

皮道坚学术主持。日本福冈亚洲美术馆《第14届亚洲国际艺术展（中国）》1999 展览图录

皮道坚主编 刘子建、一墨策划《九十年代中国试验水墨》世界华人艺术出版社 1998

皮力策划《可爱》非公开出版物 2000 展览图录

Q

《庆庆 装置作品》非公开出版物 1998 个人作品集

《庆庆（1996-2000）》世界华人艺术出版社 2000 个人作品集

瞿广慈特约主持 《中国当代雕塑的若干标准像》非公开出版物 2000 展览图录

钱海源著《新时期美术思潮》湖南美术出版社 1996

清水敏男策划《爱：中国当代摄影与录像》1999 展览目录

邱志杰策划《后感性：狂欢》非公开出版物 2001 展览图录

邱志杰主编《录像艺术文献——现象影像1996年》非公开出版物

邱志杰主编《艺术与历史意识》(《现象·影像》录像艺术展文献) 非公开出版物 1996

R

任卓华编《后八九中国新艺术》香港汉雅轩 1993 论文集

荣荣、刘铮编辑《新摄影》共四期非公开出版物 1996-1998

S

《20世纪中国油画展作品集 1900-2000》广西美术出版社 2000

《'96上海美术双年展》上海美术馆 1996 展览图录

《'98上海美术双年展》上海美术馆 上海书画出版社 1998 展览图录

《2000上海美术双年展》上海美术馆 上海书画出版社 2000 展览图录

《2002上海美术双年展》上海美术馆 上海书画出版社 2002 展览图录

《三回合展——格式化》北京春夏翰墨画廊 非公开出版物 2001 展览图录

《上下左右》2001 成都现代艺术馆夏季学术邀请展展览图录

《邵帆》非公开出版物 1996 个人作品集

《深圳人的一天》公共艺术丛书之一 深圳雕塑院编 湖南美术出版社 2001

《生活类型》非公开出版物 昆明艺术家工作室 作品集

《生活礼赞——王庆松摄影作品》2001 个人作品集

《生命寓言》钟飙油画 个展画集 非公开出版物 1997

《时间的一个点》非公开出版物 2000 展览图册

《世纪末艺术系列·女娲之灵》珠海出版社 1999

《世纪之门——中国艺术邀请展作品选 1979-1999》四川美术出版社 1999

《世界美术》杂志 中央美术学院

《视线边缘第 2 回展》1997 江苏青年艺术家作品展图录

《首届当代艺术学术邀请展 1996-1997》湖南美术出版社 1996 展览图录

《私密的新青年》香港汉雅轩 1999 展览图录

《宋海东》非公开出版物 1993 个人作品集

《宋永红——灼热的现实》香港汉雅轩 1995 个人作品集

《苏新平石版作品集》文化艺术出版社 2000

《孙良、宋海东二人展》东京画廊 非公开出版物 1994 展览图录

邵忠、马钦忠主编《艺术家》(丛书)

申伟光、王华祥、尹希英策划《上苑艺术家工作室开放展》非公开出版物 2000 展览图录

申玉策划《与性别无关》非公开出版物 2001 展览图册

沈敬东策划《100 个艺术家的面孔》非公开出版物 1999 展览图录

沈敬东策划《百年，百人，百家姓》非公开出版物 1999 展览图录

沈小彤《诱惑日记 1996-1997》非公开出版物 1996 个展图录

盛剑锋策划《 N 重身份》2002 展览图录

石磊著《意念图像》湖南美术出版社 2000

石心宁《捏造·真实》非公开出版物 2001 个人作品集

史耐德主编《传统反思——中国当代艺术展》非公开出版物 1998年 展览图录

舒阳、童爱臣策划《飘浮》油画展 非公开出版物 1999 展览图录

宋冬、郭世锐策划、编辑《野生——1997 年惊蛰始》非公开出版物 1997 展览图录

宋永红《慰藉之浴》非公开出版物 2001 个展图录

孙津著 中国当代美术现象批评文丛《波普艺术——断层与绵延》 吉林美术出版社 1999

孙平、李小山、吕澎主编《艺术——市场》杂志（现已停刊）湖南美术出版社

孙振华著《走向荒原》广西美术出版社 1999 论文集

T

《汤国》香格纳画廊 非公开出版物 1997 个人作品集

《疼》非公开出版物 2000 展览图录

《天涯》杂志 海南省作家协会

唐昕策划《感受金钱》当代艺术展 2001 展览图录

W

《王成》非公开出版物 1998 个人作品集

《王广义 东欧风景》香港汉雅轩 展览图录

《王强》非公开出版物 2001 个人作品集

《王书刚》非公开出版物 2000 个人作品集

《魏东》东方艺术基金会画廊 非公开出版物 1999 个人作品集

《文化与道德》非公开出版物 1996 文献作品集

《文化与艺术论坛1》人文科学与艺术文库编委会编 东方出版社

《文化与艺术论坛2》星座文化艺术研究中心主编 艺术潮流杂志社

万岭策划《失控》非公开出版物 1999 展览图录

王林、岛子艺术主持《失语观念艺术》2000

王林编《九十年代的中国美术：中国经验》1993 画展图录

王林编辑《雕塑与当代文化》艺术潮流出版社出版 1997

王林艺术主持《"现在状态"展》非公开出版物 1995 展览图册

王林主编《都市人格与当代艺术》艺术潮流杂志社出版 1998

王林著《当代中国的美术状态》江苏美术出版社 1995

王迈策划《前后左右》非公开出版物 1999 展览图录

王南溟策划《艺术中的个人与社会——中国十一位青年艺术家作品展作品集》2000 展览图录

王南溟著《理解现代书法》江苏教育出版社 1994

王能涛《锦绣人间》非公开出版物 2002 个展图录

王能涛《世界是你们的也是我们的》非公开出版物 2000 个人作品集

王彤策划《明白》展览图录 非公开出版物 2001

王易罡策划《中国北方当代艺术邀请展》2000 展览图录

王友身策划《新生代艺术》北京青年报社 1992

王友身等编《1994 中国当代艺术家工作计划》非公开出版物 1994

魏宏斌展览策划《迷幻空间》非公开出版物 1999 展览目录

温普林著《江湖飘》中国前卫艺术家外传（上、下）湖南美术出版社 2000

翁菱策划《杨诘苍·再拧一圈螺丝钉》非公开出版物 1999 展览图录

乌日勤策展《科隆——北京 北京——科隆 女性艺术交流展》1999 展览图录

吴亮著《画室中的画家》上海三联书店 1997

吴美纯、邱志杰学术策划《家？当代艺术提案》世界华人艺术出版社 2000 展览图录

吴美纯策划《'97 中国录像艺术观摩》非公开出版物 1997 展览图录

吴美纯策划《后感性——异形与妄想》非公开出版物 1999 展览图录

吴文光、文慧、宋冬、尹秀珍策划《为了纪念那座厂房》非公开出版物 2001 展览图册

吴文光 《我看我的纪录片》《艺术世界》 1998 第 3 期

吴文光 《回到现场：我理解的一种纪录片》《东方》1996 第 5 期

吴小军编《偏执》非公开出版物 1999 展览图录

伍劲策划《尹朝阳》非公开出版物 2002 个人作品集

X

《先锋学术论丛》《文化研究第一辑》天津社会科学院出版社 2000

《现代艺术》杂志

《香港梦·我的梦》香港艺术家之家有限公司出版 1997 六人装置／行为艺术展图录

《向京 1995–2000》非公开出版物 2000 个人作品集

《肖像性质》毛焰、周春芽 非公开出版物 1997 展览图录

《新潮》杂志 四川画报社、成都贝森集团

《新锐的目光——1970 年后出生的一代》吉林美术出版社 1999 作品集

《新生代艺术展》非公开出版物 1991 展览图录

《新铜时代·林玉莲作品集》1998 个人作品集

《新状态展第三回 江衡 孙晓枫油画艺术》广东美术馆 非公开出版物 2001 展览图录

《新自然现代作品展》非公开出版物 1998 展览图录

《星星 15 年》东京画廊 非公开出版物 1993 展览图录

《形象的两次态度93》施勇、钱喂康 装置艺术实验展 非公开出版物 1993 展览图录

《幸福幻想》非公开出版物 1995 展览图录

《雄师美术》杂志（台湾）（现已停刊）

《徐冰版画展》非公开出版物 1990 展览图录

《血缘：大家庭 1995–1997》非公开出版物 1997 张晓刚个展图录

夏悠悠《这是一个大逃亡的时代——北京兴起独立制片热》《中国时报周刊》1992

忻海州 、张轮《泡沫＋糖》非公开出版物 作品集

徐浩然主编《中国环保第一人舒勇 1989–2001 年》广东旅游出版社 2001

徐震、杨振忠等编辑《超市》非公开出版物 1999 展览图录

许晓煜著《谈话即道路——对二十一位中国艺术家的采访》实验艺术丛书 湖南美术出版社 1999

Y

《1998–1999 艺术工作总第一辑》艺术座谈录 周 Sir 工作室 非公开出版物 1999

《亚细亚散步》资生堂当代艺术中心出版 2001 展览作品集

《亚洲·多元提升——第 16 届亚洲国际艺术展》湖南美术出版社 2001 展览图录

《颜磊——港深新干线》香港艺术发展局出版 1999 个人作品集

《艺术潮流》杂志（现已停刊）台湾

《艺术当代》杂志 上海书画出版社

《艺术家透视——徐志伟摄影作品集》新疆美术摄影出版社 1995

《艺术界》杂志 安徽省文学艺术界联合会

《艺术世界》杂志 上海文艺出版总社

《艺术新闻》杂志 台湾

《有效期——录像摄影展》 非公开出版物 2000 展览图录

《愉悦与幻想 刘建华》

《侵入——颜磊'95 作品》非公开出版物 1995 个人作品集

《视觉艺术》杂志 羊角文学艺术研究学会编辑 非公开出版物 1987

杨春临《生存与变裂》非公开出版物 1998 展览图录

杨福东、徐震、飞苹果、杨振忠策划《物是，人非》非公开出版物 1999 展览图录

杨茂原《那人那土》家画语系列丛书 辽宁美术出版社 2000

杨清《爆破的诱惑》非公开出版物 2000 个人作品集

野雪 田子仲主持《平面 北京当代绘画邀请展》非公开出版物 2000 展览图录

叶永青《生活在历史中》非公开出版物 1995 个人作品集

易玛策划《艾安：沈默的城》非公开出版物 1997 展览图录

易英、殷双喜学术主持《第三届当代雕塑艺术年度展》何香凝美术馆 2000

易英著《刘小东》中国当代油画名家个案研究 湖北美术出版社 2000

易英著《学院的黄昏》湖南美术出版社 2001 论文集

殷双喜编辑《本色：女画家的世界 第三回展》非公开出版物 2000 展览图录

尹秀珍《建筑材料》非公开出版物 2000 个人作品集

英格·琳德曼、德克·路克武策划《相会在北京》1997 作品集

余丁著中国当代美术现象批评文丛《新古典主义艺术——世纪末的回声》吉林美术出版社 1999

俞洁《日常欢娱》非公开出版物 2000 个人作品集

郁人主编《二十世纪末中国现代水墨艺术》黑龙江美术出版社 1999

袁冬平《精神病院》非公开出版物 1996年 个人作品集

Z

《45°作为理由》耿建翌等艺术家作品集 非公开出版物 1995

《'89-'92 中国现代艺术》江苏美术出版社出版 1994 文献 作品集

《'99 中日当代艺术交流展作品集》福建省艺术馆、日本现代美术的视点事务局 1999

《2001 中国↑∞↓艺术展》上海美术馆 2001 展览图录

《曾梵志：假面》香港汉雅轩 个人作品集 1995

《曾浩》中央美术学院画廊非公开出版物 1997 个人作品集

《曾力》非公开出版物 1998 个人作品集

《展望·关于不锈钢假山石》非公开出版物 1999 个人作品集

《张大力》四合苑画廊 1999

《张念》非公开出版物 2002 个人作品集

《张奇开个展——从东京到柏林》非公开出版物 2000 上河美术馆展览图录

《张羽的水墨立场与文化问题》《灵火系列》春夏翰墨画廊 1999

《赵半荻和熊猫咪》非公开出版物 1998 个人作品集

《赵能智：面部表情 1999》非公开出版物 1999 个人作品集

《中、港、台当代摄影展》香港艺术中心出版 1994

《中国——八九后艺术》香港艺术潮流杂志社 1997

《中国当代水墨画》《当代艺术》第16期 湖南美术出版社 1999

《中国广州·首届九十年代艺术双年展（油画部分）作品文献》四川美术出版社 1992

《中国郭氏兄弟前卫画集》斯民艺苑出版 1998

《中国平民艺术实验村落　专号》（简报）非公开出版物 1994

《中国水墨实验二十年（1980——2000)》广东美术馆 黑龙江美术出版社 2001 展览图录

《中国现代美术展》韩国光州市立美术馆 2002 展览图录

《中国现代艺术展》非公开出版物 1989 展览图录

《中国艺术》杂志（现已停刊）中国美术出版总社

《钟飙 1996-1997》 非公开出版物 1997 个人作品集

《钟飙 1998-1999 作品》 非公开出版物 1999 个人作品集

《重新洗牌——以水墨的名义》长沙 湖南美术出版社

《朱尚熹井盖艺术展》非公开出版物 2000 展览图录

《转型期的中国艺术研讨会》四方工作室 1998

张朝晖策划《从中国出发》1999

张朝晖策划《面对脸》红门画廊 2002 展览图录

张离主编《1981-2001 新形象》2001 展览图录

张念潮主编《中国新锐艺术 23 位前艺术家作品实录》中国世界语出版社 1999

张晴主编《九十年代中国当代美术 1990-1992》新疆美术摄影出版社 1996

张玮、喻高策展《虚拟与真实》非公开出版物 2000 展览图录

张晓刚策划《上河美术馆　99学术邀请展》成都上河美术馆 1999 展览图录

张晓凌 孟禄新著 中国当代美术现象批评文丛《抽象艺术——另一个世界》吉林美术出版社 1999

张羽艺术策划《对话?1999 艺术展》泰达当代艺术博物馆策划出版 1999 展览图录

赵能智《表情》非公开出版物 2000 展览图录

赵树林策展《对话?困惑》中国现代艺术巡回展 2001 展览图录

赵树林策展《中国2001"对话 ? 第三状态"2002 意大利》2002 展览图录

周春芽、戴光郁学术策划《"执白"装置艺术展》非公开出版物 2001 展览图录

朱冰《天堂玫瑰》非公开出版物 2000 个人作品集

朱其策划《影像志异》非公开出版物 1999 中国新概念摄影艺术展巡回展图录

朱其策划《在路边 昆明青年艺术家八人展》 非公开出版物 2001 展览图册

朱其策划《转世时代——2000 中国当代艺术展》上河美术馆 2000

朱其艺术主持《扩散——当代雕塑七人作品集》人民美术出版社 展览画集 1999

朱其艺术主持《新亚洲，新城市，新艺术——'97 中韩当代艺术展》1997 展览图录

朱其艺术主持《在市场和乌托邦之间》2001

朱青生著《没有人是艺术家，也没有人不是艺术家》商务印书馆 2000

祝斌著《石冲　中国当代油画个案研究》湖北美术出版社 2002

邹跃进著《他者的眼睛——当代艺术中的西方主义》作家出版社 1996

The First Guangzhou Triennial

Chief Curator: Wu Hung

Curatorial Committee: Wu Hung

 Wang Huangsheng

 Huang Zhuan

 Feng Boyi

The First Guangzhou Triennial

Organizer

广东美术馆
GUANGDONG MUSEUM OF ART

C0-Sponsors

China Southern Airlines Company Limited

TCL Corporation

Profit Palace Group

Media Sponsors

CCTV Art Space	Art World
Modern Art	Artists' Alliance
Contemporary Art	Chinese-Art.com
Fine Arts Research	CL2000.com
World Art	GDMOA.org
Museum of Art	Guangzhou Window
Art World	Century Online
Eastern Art	21cn.com
Jiangsu Art Monthly	gz.tom.com
Art Observer	South Voice & Screen Weekly
Avant-Garde Today	Art News
Vision 21	Beijing Youth Daily
Art & Collection	Southern Weekend
Art News	China Daily
Sanlian Life Weekly	China Art News
New Weekly	China Culture News
Art Life	

Asia Society and Museum

Asia Society Hong Kong Center

Annie Wong Art Foundation

Hanart T Z Gallery

Qingdao Sculpture Museum

China Art Archives & Warehouse

He Xiangning Art Museum

China Club Hong Kong

Smart Museum of Art, University of Chicago

Hong Kong Arts Development Council

Ethan Cohen Fine Arts

CourtYard Gallery

Upriver Gallery

Dongyu Museum of Art

ShanghArt Gallery

Galerie Loft

PHASE Audio Visual CO., LTD

Galleria Continua

Hong Kong Museum of Art

Guangdong Overseas Chinese Museum

Contemporary Art Research Center Nanjing Academy of Arts

Eslite Gallery

German Consulate, Guangzhou

Jiaotong Corporation of Guangdong Province

Zhujiang Brewery Corporation

People's Insurance Corporation of China, Guangdong

Hotel Landmark Canton

White Swan Hotel

Hesheng Chuangzhan Real Estate

Baiyun Golf Garden

Art Media Resources. Ltd

Macao Publishing House

Guangzhou Cultural Transmission Firm

Guangdong Tianyou Culture Company

Guangdong Wanpin Culture and Art Company

Artron Colour Printing Co. Ltd

Guangzhou Hengyuan Color Prnting Co. Ltd

Guangdong Huilai Resources Co.

Guangdong Art Alliance Art and Book Distribution Center

Guangzhou Sunflower Co. Ltd

Teff Plus

Mr. Chang Tsong-Zung

Mr. David Tang

Mrs. Annie Wong

Mr. Yao Shouyi

Mrs. Zhu Jinluan

Myriam & Guy Ullens

Mr. Ethan Cohen

Mrs. Anny Xiaoyan Yu

Mrs.Yue Zhengwei

Mr. Cai Puzeng

Mr. Lu Peng

Mr. Tang Buyun

Mrs. Zhang Yan

Mr. Guan Yi

Mrs. Meg Maggio

Mr. Ding Bing

Mrs. Zhao Shujin

Mr. Jojo Tanaka

Mrs. Ikuko Ishikawa

Mr. Marcello Kwan

Mr. Jean Marc Decrop

Mr. Kong Yongqian

Mr. Feng Boyi

Symposium Co-Sponsor

Hong Kong Arts Development Council

Reinterpretation: A Decade of Experimental Chinese Art (1990–2000)

Chief Editor: Wu Hung

Editors: Wang Huangsheng, Feng Boyi

Managing Editor: Feng Boyi

Special Editors, video works: Wu Meichun, Qiu Zhijie

Associate Editors: Wang Jia, Karen Smith, Joy Le, Philip Tinari, Guo Xiaoyan

Editorial Staff: Hu Bin, Huang Dansong, Wang Haiying, Isabella X. Guan,
 Pan Dajun

Copy Editing: Philip Tinari, Rayila Dilxat

Translation: Karen Smith, Joy Le, Philip Tinari, Wen Jingen, Mao Weidong,
 Zhang Shaoning, Zhang Zhiqiu

Design: Wu Tao, Tan Peng, Zhi Zhi, Tang Yan